About the Author

Terry Breverton is the author of twenty books of Welsh interest, five of which have been awarded 'Welsh Book of the Month' by the Welsh Books Council (more than any other author). He lives in Cowbridge in the Vale of Glamorgan.

Praise for Terry Breverton:

100 Great Welshmen
Welsh Book Council Book of the Month June 2001
'A celebration of the remarkable achievements of his countrymen' *The Guardian*

A-Z of Wales & the Welsh
'A comprehensive overview of Wales & its people' *The Western Mail*
'A massive treasure chest of facts & figures' *Cambria*

The Welsh Almanac
Welsh Book Council Book of the Month August 2002
'A must for anyone with a drop of Welsh blood in them' *The Western Mail*

100 Great Welsh Women
'A fascinating read' *The Daily Mail*
'Breverton's breadth, generosity and sheer enthusiasm about Wales are compelling'
The Sunday Express

WALES

A HISTORICAL COMPANION

TERRY BREVERTON

AMBERLEY

In memory of Derek Rhys Williams Father of Angharad and Llywelyn Kernelbet Vras 2009

First published 2009

Amberley Publishing Plc
Cirencester Road, Chalford,
Stroud, Gloucestershire, GL6 8PE

www.amberley-books.com

Copyright © Terry Breverton 2009

The right of Terry Breverton to be identified as the
Author of this work has been asserted in accordance with
the Copyrights, Designs and Patents Act 1988.

ISBN 978 1 84868 326 6

British Library Cataloguing in Publication Data.
A catalogue record for this book is available from the
British Library.

Typeset in 10 pt on 12 pt HS Garamond
Typesetting and Origination by Diagraf (www.diagraf.net)
Printed in the UK.

Introduction

No single volume can tell the reader about the 'hiraeth' (longing for home), history and 'hwyl' (joie de vivre) that make for Wales and Welshness. It is hoped that this book will stimulate the reader to learn more about a country that has a history largely unknown to, and unacknowledged by, the rest of the world. Some may find this book more skewed towards the personalities who made history, rather than to dates and places, but the history of Wales is largely an oral history. It consists of people, not dry facts, and has been overlooked in the canon of the history of the British Isles, which generally begins with the Saxons and is told from an Anglo-centric viewpoint. The book is also unashamedly 'pro-Welsh', but then again similar history books of all other nations proclaim their virtues, for instance downplaying the more disappointing periods of their past, glorifying villains, exaggerating achievements and ignoring defeats. To a great extent this work is far, far less biased than Japanese, English, German, American and French versions of their own histories. This book is thus revisionist in one sense, trying to undo a history of Wales that has been adversely influenced by English sources and writers since the Venerable Bede 1,300 years ago.

The Welsh Dictionary of National Biography details hundreds of nonconformist preachers but omits many, many worthy persons who are included here. Some of the individuals described in these pages have altered the course of world history. Little is known of the part played by Wales and the Welsh in the survival of Christianity, for example. Who knows that Wales has the longest unbroken Christian heritage in the world? Or that five of the first six Presidents of the USA acknowledged their Welsh stock. Or that the USA owes its geography to Welshmen. Or that Wales was the Centre of the Industrial Revolution. Or that it gave England its greatest dynasty, its people revolutionised science and engineering, that it was the most literate country in the world, its language is the oldest in Europe, and that its laws were the most humane in the world for over a millennium. Of course, there is another side to a nation's history, such as Wales had the most famous pirate of the Elizabethan era, followed by the most successful privateer in the world in the seventeenth century and the most successful pirate of all time in the eighteenth century. John Callice, Henry Morgan and Black Bart Roberts have been excised from history books until recently.

Few people realise that the history of their countries is a politically correct one that magnifies victories and forgets shame and defeats. Nationalism of the worst kind stems from this mis-reading of history, whereby every country's citizens are programmed to believe that their nation is 'the best'. Luckily having worked in many countries and to have travelled all over the world, one not only realises that different nations have different versions of history, but that no one nation is 'best' or ever can be 'best'. History has been written by the conquerors, and peddled by academics who rely upon what their professors were taught. Only today some of us realise that Kit Carson was not a Western hero but a murderous thug who slaughtered the Navajo. Or that Richard I was not a heroic 'Lionheart' but a French-speaking homosexual sadist, who hardly visited Britain. Or that Edward I was not the affable 'Longshanks', but a man who personally invented the gruesome torture of hanging, drawing and quartering in England, Scotland, Ireland and Wales to prop up his barbarous regime. Or that British history was rewritten by Bishop Stubbs to justify the German Hanoverian monarchy, coming from a backwater the size of the Isle of Wight to control the greatest empire the world has seen. Thus to successive generations of historians, British civilization started with the invasion of the pagan Angles and Saxons – their defeat of the Christian Britons is ignored. Who is taught that Queen Victoria's first language was German?

Unlike many other nations, the Welsh have neither abused nor proclaimed their history. Much has been deliberately destroyed as its abbeys and great libraries were burnt in successive invasions. Much has relied upon oral tradition and the existence of Welsh place-names in the landscape. Wales is now a nation where over one-third of its population were born outside the country, as English retirees and unemployed have escape the pressures of population increase in their own country for a different type of life. This in itself is creating immense strains upon the survival of Welsh heritage and culture, as Welsh-speaking heartlands become the retreat of a people generally hostile to any 'foreign' languages. Even today Wales is not given any credit for what it has given to civilization, as English polemicists honestly believe (from their version of history) that England has 'civilized' Wales. Wales itself means 'foreign' in the Saxon language. However, Cymru is a nation which over 2,000 years has never declared war upon another nation. The survival of its language, Cymraeg, is a miracle, when neighbouring a country whose language has spread globally like no other. The story of Cymru is a marvellous and uplifting one of survival against overwhelming odds. In the words of the wonderful Dafydd Iwan song – 'Yma o Hyd!' - 'We're Still Here!'

ABBEYS & RELIGIOUS HOUSES Like castles, their remains dominate the Welsh landscape. The austere Cistercian order, in particular, identified strongly with the Welsh princes and their people, and was severely punished in successive invasions. The Cistercian ethos was at one with the Celtic Church. The Benedictines were generally strongly identified with the hated Normans, and their practices of indulgences and pardons were not seen as Christian practices. All of the Cistercian houses are mentioned in this book. By 1135, the monastic orders of Cluny, Tiron, Savigny and Citeaux all had houses in Wales. Priests also followed the Rule of St Augustine at Carmarthen, Llanthony, and Haverfordwest. There were Benedictine priories at Abergafenni, Caldey Island, Usk, Chepstow, Goldcliff and Ewenni, all 'Norman' areas for centuries. There were Benedictine friaries at Brecon and Denbigh and an abbey at St Dogmael's (Llandudoch), which was previously run by the Tironian order. Neath Abbey was Sauvignac and Haverfordwest had an Augustinian priory. Neath later became Cistercian, and there were Cistercian foundations at Tintern, Margam, Whitland, Strata Florida, Aberconwy (moved to Maenan), Valle Crucis, Strata Marcella, Llantarnam (Caerleon), Cwm Hir, Cymer and Basingwerk. At the time of the Dissolution of the Monasteries in 1536, there were twenty-seven monasteries in Wales.

ABERCONWY, BATTLE OF, 1194 Prince Llywelyn ap Iorwerth, just twenty-two years old, forced his uncle Dafydd ap Owain Gwynedd to surrender, in his campaign to take over Gwynedd. The sons of Owain Gwynedd, Dafydd and Rhodri, had divided Gwynedd between them and had defeated their brother Hywel at Pentraeth. Combined with his victory at Porthaethwy, Llywelyn now controlled all of Gwynedd, on his way to becoming recognised as 'Llywelyn the Great'.

ABERDARE On the southern edge of the Brecon Beacons and at the head of the Cynon Valley, Aberdare was hugely important in the production of coal, but all the local collieries have been closed. St Elvan's Church is Victorian, but commemorates Saint Elfan (Elfanus), who with Dyfan, Medw and Ffagan helped evangelise Wales in the second century. There is a statue of Griffith Rhys Jones in the town centre, the conductor who led the South Wales Choral Union to win the first choir competition, held in the Crystal Palace in 1872.

ABERDULAIS FALLS Copper smelting started at this site north of Neath in 1584, and the power of the waterfall was used for 400 years in manufacturing. Europe's largest electricity-generating water wheel can be seen in action here.

ABERDYFI (ABERDOVEY) CASTLE Near Machynlleth, in Ceredigion, it was built by The Lord Rhys in 1156 in response to a threat from Owain Gwynedd, who had assembled an army

in the north. Roger de Clare seems to have taken it in 1158, but The Lord Rhys retook it in the same year. Llywelyn ap Iorwerth held an assembly there in 1216, granting land to other princes. It is also known as Domen Las (Green Mound) and Castell Abereinion.

ABEREDW CASTLE The original motte may date from 1093 and have been built by the invading Baskervilles. The Welsh regained it from 1135-1150 and seem to have built the second castle near it. The Braose family took the area in 1195, and after constant attacks over some years, lost the new castle in 1208. Gwallter Fychan ap Prince Einion Clud then controlled this castle from *c.* 1213, and it was mainly Welsh or in vassalage to the Mortimers, until the murder of Llywelyn ap Gruffydd in 1282. The Mortimers, who had killed Llywelyn, then took over the castle. It was crenellated on the orders of the king from 1284, but played little part in later history.

ABEREDW CHURCH The Church of St Cewydd is on a sixth-century Celtic foundation of St Cewydd, whose association as the patron saint of rain predated that of Swithin by centuries. There is a nearby motte and bailey. Tradition is that John Giffard, the constable of Builth Castle nearby, refused to assist Llywelyn II shortly before he was killed. His wife pleaded for Llywelyn to have a Christian funeral, as Llywelyn had been to mass in Aberedw church on the morning of his death, and had called for a priest as he lay dying on 11 December 1282.

ABERFAN DISASTER 31 OCTOBER 1966 Coal has been a mixed blessing for Wales. It attracted people from all over Britain to the unspoilt Welsh valleys, and they assimilated into the Welsh culture. It gave jobs, albeit dangerous ones – and later generations of miners' children were encouraged to 'improve' themselves and go into teaching rather than go 'down the pit'. There are still disproportionate numbers of Welsh people in British education at all levels. There were some terrible disasters, like the Senghenydd explosion in 1913 when 440 men and children died in the mine. However, nothing in recent Welsh history hurt the nation as much as the Aberfan disaster of 1966. A coal slag tip, which the National Coal Board had been repeatedly warned was unstable, collapsed down a mountainside onto Aberfan village. The village primary school was drowned in black slurry, with 116 children and 28 adults killed. There was no counselling for parents who lost their children, or for the men who dug the crushed little bodies out of the thousands of tons of black slag and slurry. A Disaster Appeal raised £3 million from the public for the remaining parents and the village, to build a new, smaller, school and make a memorial cemetery.

However, £150,000 was taken out of this villagers' Disaster Fund in 1967 by the Labour government, to pay for the removal of the coal waste that could once again engulf the village. Under the thirty years *Freedom of Information* rule, it was discovered in 1996 that the then Secretary of State for Wales, George Thomas, recommended that this money be taken out of the fund, which had been raised by the public specifically for the suffering people of Aberfan. In 1997, after thirty years' campaigning by Plaid Cymru, the Labour Government repaid the money. However, it did not repay the millions it was worth after thirty years of inflation, only the original £150,000. This terrible event, when a whole school was wiped out, seems to have been airbrushed from British history. Today, few people under forty have ever heard of Aberfan, the greatest tragedy to hit Britain since the Second World War. No apology has ever been given to the people of Aberfan. If the disaster had happened in Nottingham or Metz or anywhere else in Europe, it would be a place of pilgrimage. Instead the disaster has been so effectively covered up that it is passing from both written history and human remembrance. For George Thomas' role in the event, he is not given an entry in this book.

As a footnote, on the night of 31 October 1966, the National Coal Board's chairman, Lord 'Alf' Robens, celebrated his installation as Chancellor of the University of Surrey at a party. He knew of the terrible disaster of that morning, but ceremonial robes and a drinks party were more important. Miners at the same time that Robens was sipping his port were desperately working under floodlights, hoping to find survivors, but only digging out the crushed bodies of children. They used their bloodied, bare hands to dig, instead of picks and shovels, as they did not wish to

harm any body they found. Initially the National Coal Board tried to minimise its responsibility by offering £50 compensation to each of the bereaved families (in 2009's value, that is just £650!). The NCB, a nationalised industry, later settled for what it called a 'generous settlement' of £500 for every child killed (just £6,500 in today's value). As noted above Lord Robens ensured that the NCB recovered all this £58,000 compensation money (116 children at £500 a head) by taking £150,000 from the Aberfan Disaster Fund, to pay for the removal of the remaining coal tips. Under the thirty years rule, it was also discovered that the NCB exaggerated the cost of removing the tips, and obstructed a private contractor's offer to do the work far more cheaply. The 1967 Report on the disaster was devastating, but as usual in Britain, no-one was made to suffer, only the villagers:

> The Aberfan Disaster is a terrifying tale of bungling ineptitude by many men charged with tasks for which they were totally unfitted, of failure to heed clear warnings and of total lack of direction from above.

More information has emerged from a 1999 study by Nuffield College, Oxford, sponsored by the Economic and Social Research Council. Professor Iain McLean stated:

> The Charity Commission and outdated charity law obstructed the Aberfan Disaster Fund in its attempts to help bereaved parents and other victims. At one point the Charity Commission wanted to insist that the fund should only pay grants to those parents shown to have been close to their dead children.

Please re-read that last sentence - the Charity Commission wanted in effect to set up a slide rule and put grieving parents under scrutiny to see who deserved what from the deaths of their children. The Commission also stopped any payments being made to families where children were not injured. The Commission would not back the trustees of the Disaster Fund who wanted the Labour government to remove the remaining dangerous tips overlooking their village. Thus the trustees were literally forced to hand over the exaggerated cost of £150,000 for the removal of those slag-heaps. Jeff Edwards, a magistrate, was a survivor when the school was covered, and stated in 1999 that it was twenty years before his family received any payment. He had seen his classmates die. In other cases, many families received nothing. He stated 'Parents of uninjured children also went through the trauma - they had to live with the sleepless nights, the nightmares and the tantrums for years afterwards.' There is a collective consciousness that wants to forget Aberfan - to forget means that it will be repeated, and some politician or official will yet again be in the media stating the mantra 'Lessons will be learnt'. To forget something like Aberfan means that the guilty will always escape justice. To forget breaks one's ties with truth and honesty, and means colluding with the perpetrators of injustice. To forget means that those who died meant nothing. Some may believe that this is an over-long entry in this book, but the purpose of historical non-fiction is not to regurgitate other books, but to question the given version of events and to highlight what is being deliberately lost. The Labour Cabinet, the managers of its coal industry, 'Lord' Robens, civil servants, George Thomas, and the Charity Commission - none has ever been properly blamed for wiping out the children of a village. NCB managers were shown to have lied about there being running water under the tips. The much-honoured Baron Robens, who left school aged fifteen, lived until he was eighty-nine in Laleham Abbey, always insisting that his tenure at the NCB was a success, having been exonerated in the 1986 official history of the NCB. George Thomas lived until he was eighty-eight, again much honoured and becoming Viscount Tonypandy. Deeply opposed to Welsh nationalism, the confirmed bachelor, Privy Counsellor and former Speaker of the House of Commons was treated like a demi-God by the media in Wales. He was 'deeply religious' but this author has no desire to go to the same place as 'the right honourable' Thomas, who died in 1997.

ABERFFRAW ROMAN FORT There is little to see of this first-century fort on Anglesey (Ynys Môn), but its presence may have led to the princes of Gwynedd making Aberffraw the site of their main court (llys). This court was in use until the death of Llywelyn II in 1282, then sacked and its treasures removed to England.

ABERFFRAW, SACKED 853 The Danes attacked and burned the royal court of Gwynedd in this year.

ABERGAFENNI (ABERGAVENNY) Surrounded by mountains and with the Usk running through it, Abergafenni has been an important market town for centuries. The Church of St Mary was originally the chapel of an eleventh-century Benedictine priory, and has tombs dating from the thirteenth century, and fourteenth-century choir stalls.

ABERGAFENNI, BATTLE OF, 3 MARCH 1263 In November 1256, war came to Wales when Prince Llywelyn ap Gruffydd and his brother Dafydd invaded the Marches of Wales to re-annexe them to the principality of Gwynedd. From November to December 1262, they convincingly defeated Roger Mortimer at the Battle of CEFN LLYS, and seized much of Radnorshire and Breconshire from the Marcher Lords. The princes returned to Gwynedd, and the Marcher Lords counter-attacked, defeating the princes of Deheubarth at the battle of Abergafenni.

ABERGAFENNI CASTLE Within the walls is the motte built by the Norman de Ballon before 1090. In the twelfth century the same family endowed the local Benedictine priory and built a stone keep. The Hastings family fortified the site in the thirteenth and fifteenth centuries, and the gatehouse was added around 1400 in response to the threat from the war of Owain Glyndŵr. It was always the base of the Norman lords of Abergafenni, standing over the Usk and securing that valley. The most infamous event here occurred on Christmas Day 1175 when William de Braose invited Seisyllt ap Dyfnwal, Lord of nearby Arnallt, his son Geoffrey and other local Welsh lords, for a celebratory dinner. They were all slaughtered in cold blood when sitting at the table. De Braose then seized Seisyllt's lands, murdering his son Cadwaladr and capturing Seisyllt's wife. In response, the Welsh Lord of Caerleon, Hywel ap Iorwerth, burnt Abergafenni Castle in 1182, and then destroyed Dingestow Castle. In the twelfth century, the castle changed hands several times. Giraldus Cambrensis noted the power of the longbow of the men of Gwent in one battle. In this 1182 siege, Welsh arrows penetrated an oak door that was 4in thick, with the iron tips visible on the inside of the door. Charles I ordered its slighting in 1645 to prevent Parliamentarians using it.

ABERGAFENNI ROMAN FORT 'Gobannium' was built *c.* 57-400 CE, with timber granaries.

ABERGLASNEY HOUSE AND GARDENS Around 1480, Lewis Glyn Cothi recorded 'nine green gardens' with orchards, vines and lakes here. The reclaimed gardens date from the mid-seventeenth century and include a remarkable 'yew tunnel', a pool garden and an extremely rare cloister garden. Near Llangathen and the National Garden Centre, the house was one of the most imposing in Carmarthenshire, and JOHN DYER lived here.

ABER LLECH, BATTLE OF, 1096 Gruffudd and Ifor, the sons of Idnerth ap Cadwgan (and thus the cousins of King Hywel ap Goronwy), rallied the men of Buellt (the area around Builth Wells), to defeat a Norman force which was invading Brycheiniog. Both Oystermouth on the Gower Peninsula and Ogmore in the Vale of Glamorgan were called Aberllech at some time, but the battle has been placed somewhere between Brecon and Swansea. This was the second of two armies that had been sent into Wales, and the first had been defeated at CELLI TARFAWG. After Aber Llech, '*the war-band of Cadwgan ap Bleddyn despoiled the castle at Pembroke.*'

ABERLLEINIOG, BATTLE OF, 1098 Robert of Rhuddlan built a castle here on Anglesey, and Gruffudd ap Cynan's forces tried to prevent this happening. Gruffudd Gellan, the pencerdd (chief bard) of Gruffudd, was noted as being killed in this battle, and is thus the first named harpist in Welsh records.

ABERLLYNFI CASTLE In Breconshire, it dates from at least 1180 and was held by Walter de Clifford in the Barons' Rebellion against Henry III.

ABERMIWL, ABERMULE, BATTLE OF, 1263 *The Chronicle of Ystrad Fflur* notes:

> In this year John Lestrange, constable and bailiff of Baldwin's castle, gathered a mighty host and came by night through Ceri. And the Welsh gathered in pursuit of them and slew two-hundred of the English, some in a field, others in the barn at Aber-miwl (Dolforwyn). And the barons of England and the Welsh rose up against Edward (the son of Henry III) and the foreigners, and desired to cast them forth from the kingdom of England. And Llywelyn ap Gruffudd and his host took and destroyed the castles of Carreg Faelan and Deganwy. And Gruffudd ap Gwenwynwyn destroyed the castle of Y Wyddgrug (Mold).

In the following year Henry III was defeated at Lewes in the Barons' Revolt, but regained the ascendancy a year later at Evesham.

ABERRHEIDOL CASTLE, CASTELL TAN-Y-CASTELL, OLD ABERYSTWYTH CASTLE This is probably the original castle at Aberystwyth, build by Gilbert de Clare in 1110. It was razed by Owain Gwynedd in 1136, after the battle of CRUG MAWR. It seems to have been rebuilt and was in Welsh hands from 1136-1143. It was retaken by Roger de Clare in 1158, but The Lord Rhys took it in 1164. It changed hands at least five times in the early thirteenth century, but was captured and destroyed by Llywelyn ap Iorwerth in 1221.

ABER TYWI, BATTLE OF, 1044 Gruffudd ap Llywelyn defeated a Danish force led by Hywel ap Edwin, and killed Hywel at Abertywi (Carmarthen).

ABERYSTWYTH A seaside resort in Ceredigion, the Vale of Rheidol railway runs inland from here. As well as the first University College of Wales, it contains the superb National Library of Wales. In term time, students make up a quarter of the population.

ABERYSTWYTH CASTLE This is a mile to the north of Aberrheidol/Castell Tan-y-Castell. Aberystwyth Castle was built to replace it by Llywelyn ap Iorwerth, Llywelyn the Great, on a promontory next to the Rheidol estuary. Aberystwyth Castle was then rebuilt as a link in the great *'iron ring'* of castles, starting in 1277. In 1282, the incomplete castle was taken by Llywelyn ap Gruffudd's forces under Gruffudd ap Maredudd and Rhys Fychan ap Rhys ap Maelgwn, so James of St George came to oversee the completion of the building. By 1289, £4,300 had been spent building the huge concentric fortress, and a Welsh siege in 1294 was finally beaten off, as reinforcements and supplies arrived by shipboard. Glyndŵr took the castle in 1404, but later lost it. It was very badly slighted by the Parliamentarians in the English Civil War, but was once one of the finest Welsh castles, on a par with Harlech and Conwy.

ABRAHAMS, WILLIAM (MABON) (1842-1922) Born in Cwmafon, Glamorgan, he became a collier at the age of ten. In 1873 he became a Miners' Agent and in the 1885 General Election became the Lib-Lab MP for the Rhondda. Abraham was a marvellous public speaker and the miners gave him the nickname Mabon (the Bard). Abraham remained active in the trade union movement and by 1907 was President of the South Wales Miners' Federation, and Treasurer of the Miners Federation of Great Britain. Abraham won Rhondda in seven successive parliamentary elections, and remained an MP until he retired in 1920. He is still remembered fondly as a spokesman for the common man.

ACTS OF UNION 1536 & 1542 Henry VIII's Act of Union between England and Wales in 1536 tried to make the two countries indissoluble, with Wales being governed upon English lines. The Act proceeded to deal a hammer blow to the language – 'from henceforth no Person or Persons that use the Welsh Speech or Language shall have or enjoy any Manner of Office or Fees within this Realm'. It is ironic that a king with a Welsh father did most to Anglicise Wales. Henry was brought up at the English court, and subject to English influences, unlike his elder brother Arthur, who had been brought up as a Welsh-speaking Welshman by HENRY VII. If Arthur had lived and become king, the structure of Welsh history would have been immensely altered and Britain would probably be overwhelmingly a Roman Catholic nation. The Acts of Union also abolished the remaining Marcher Lordships, which were incorporated into England. Wales was at last given representation in Parliament, with the Welsh being granted equal rights to the English, but unfortunately what was left of Welsh law was finally abolished.

ACTORS Notable Welsh actors include Gwen Frangcon Davies, Hugh Griffith, Ray Milland, Stanley Baker, Catherine Zeta Jones, Sian Phillips, Jonathan Pryce, Timothy Dalton, Richard Burton and Anthony Hopkins, the latter two being noted international film actors. Myrna Loy, star of the 1930's *Thin Man* films, was born Myrna Williams, of Welsh parents, and Bette Davis was proud of her Welsh ancestry. The actress-singer Deanna Durbin had parents from Tredegar, and for over a decade from 1936 she was one of Universal Studio's biggest stars. The newer generation of actors include Michael Sheen, Ioan Gruffudd, Matthew Rhys and Rhys Ifans.

ADAMS, PRESIDENT JOHN (1735-1826) The family of John Adams (second President of the USA 1797-1801) came from Llanboidy in Carmarthenshire. He was been a member of the Continental Congress and signed the Declaration of Independence, during which he was 'the colossus of the debate'. Along with two others, he had helped THOMAS JEFFERSON draft the Declaration, and it was Adams who then proposed George Washington as commander-in-chief of the armed forces. In 1779, Adams went to France and negotiated the treaty with England which ended the American War of Independence. In effect the first American ambassador to England, he became Washington's Vice-President and was the first President to occupy the White House. He died on 4 July aged almost ninety-one, the oldest age any ex-President has achieved, just a few hours later than his great friend Thomas Jefferson.

ADAMS, JOHN QUINCY (1767-1848) John Adams' son, John Quincy Adams, was sixth President from 1825-1829, and previously had negotiated the famous Treaty of Ghent, to end the War of 1812 between England and America. This treaty warned off any further European colonisation in the Western Hemisphere, in return for US non-interference in Europe. He was thus the real author of the so-called 'Monroe Doctrine', which has been a recurring strategic theme in American policy ever since. Adams also negotiated the treaty to take Florida from Spain, and was a noted anti-slaver. Thus Welshmen were responsible for peaceably taking both Spanish and French territories for the new country of the USA, as Jefferson had previously effected the Louisiana Purchase. Adams has been called 'the greatest Secretary of State in American history', was known as 'the diplomat President', and was a noted anti-slavery pioneer.

ADAMS, SAMUEL (1722-1803) The cousin of President John Adams, this chief instigator of the BOSTON TEA PARTY (1773) was called by the English Governor of Massachusetts 'the greatest incendiary in the (British) Empire'. In 1765 he organised opposition to the Stamp Act, then organised the Non-Importation Association. In 1776 he called England 'a nation of shopkeepers', well before Napoleon. He was the most effective leader of the Radicals seeking independence from Britain and is known in America as 'the Father of the American Revolution.'

AGE OF THE SAINTS This paralleled the Dark Ages across the rest of Europe including England, when Christianity had died out in the face of barbarian advances. Christianity

probably existed in Wales from the first century, and was certainly tolerated by the end of the fourth century, with a Chi-Rho symbol dating from 375 being found in Caerwent. In 410 the Emperor Honorarius informed the Britons that Rome could no longer defend it, and a 'Welsh' Christian people emerged out of the Romano-British, in the face of the Anglo-Saxon takeover of England and the pagan invasions of Ireland and Scotland. By the time of Augustine's mission in 597 to convert the English, there was an established Celtic Church in Wales, with over a thousand recognised saints over the previous 200 years and more. There are saints attributed from the first century in Wales, and it has the longest unbroken Christian heritage in the world.

The poems of this time attest to the Christian nature of the British, and to their being pushed back by the pagan Saxons, Vikings, and Irish. ST PATRICK, a native Briton, evangelised Ireland, as did other Welsh saints, who also were culted in Brittany. The missionary to England, Augustine was rebuffed by Welsh bishops in 602 and 604, mainly because the Welsh-British had no interest in co-operating with a race which had driven them out of England and were still attacking them. Because of this, the Venerable Bede later took great pleasure in English pagans massacring Welsh monks at BANGOR-IS-COED. The only Saxon king to come to an accommodation with the Welsh was Alfred, who wanted to improve learning in the new English church. He recruited a monk named ASSER from St David's, who became his close confidante and wrote Alfred's life.

AGINCOURT 1415 Almost sixty years after Poitiers, Prince Harry of Monmouth (later Henry V) met the French around thirty miles from Creçy, at Agincourt. He was outnumbered, against 20,000 French troops, as he had just 4,000 Welsh archers and 1,000 knights, squires and foot soldiers remaining of his invasion force. The preponderance of Welshmen in his army was as a direct result of the Glyndŵr War of 1400-1415 – Wales had been desolated and there was no employment. Joining the English army meant escaping both poverty and persecution. The archers drove forward-pointing stakes into the ground as some protection against a French cavalry charge and unleashed the first onslaught of arrows from their longbows. Henry had deployed solid wedges of Welsh archers between his men-at-arms, and two blocks on either wing to shoot through the compressed three lines of French cavalry. As heavily armoured knights died, pierced by arrows, those following could not get through the rider-less horses, the dead, wounded and dying. Hundreds of thousands of arrows had poured into the French. From just 100 yards, Welsh archers had been able to pinpoint the joints in the armour that allowed the limbs to move. They had used armour-penetrating arrowheads with four cutting edges, waisted to part the metal and for the arrow to slide through into the muscle. Arrows moved at 200ft per second, shattering muscle and bone. One shot in the shoulder would spin a knight around and leave him incapacitated on the ground. Thousands of Frenchmen were killed (including three dukes, five counts and ninety barons) and thousands captured in this most one-sided battle of the 100 Years War. Among the French dead was Henry Gwyn, Lord of Llansteffan, and many of Owain Glyndŵr's old soldiers lay among the slaughtered French. English losses were only 500, including the Welsh Davy Gam, who was knighted as he lay dying on the battlefield.

He or ROGER WILLIAMS was the model for Shakespeare's Fluellen. The Welsh archers had been led by William ap Thomas (WILLIAM HERBERT), the builder of Raglan Castle.

ALMEDHA, SAINT – FIFTH-SIXTH CENTURY Also known as Eiliwedd, Elinud and Alud, this daughter of Brychan Brycheiniog was martyred by Saxons near Brecon and remembered at the foundation of Llaneleu, where the church has two seventh-century pillar stones outside its porch.

AMERICAN EXPLORATION Wales has many connections with the USA, and has to a major extent shaped both its history *and* its independence. The legend of its discovery is found under the entry for MADOC. Some say that America was named after RICHARD AP MEURIC, otherwise known as Richard Amerik, a merchant from Glamorgan who sponsored

John Cabot's second voyage from Bristol. This was fifteen years before the voyage of Columbus. A successor in American exploration, like Cabot looking for the passage to India and China, was Robert Mansel of Margam, who named Mansel Island. New Wales in Hudson's Bay was named by Welshmen under Thomas Button of St Lythan's, also seeking the North-West Passage. In 1617, the Welsh poet William Vaughan set up a colony in Newfoundland, and Roger Williams (c. 1604-1684) founded Rhode Island colony in 1636, upon the basis of democracy and complete religious freedom. Williamsburg was founded in 1632, and this historic tourist venue was capital of the colony of Virginia from 1699 to 1779. Without the purchase of French and Spanish territories by the Welsh-Americans Jefferson and Quincy Adams, the USA may not have spread west and south from the original thirteen colonies in the northeast of the country. MERIWETHER LEWIS, JOHN EVANS and DAVID THOMPSON were all extremely important in the mapping of North America.

AMERICAN IMMIGRATION In the nineteenth century, Welsh emigrants, driven to move by tolls, tithes for an Anglican Church they did not believe in, infant mortality, appalling working conditions and wage reductions, looked to America. Between 1815 and 1850, around 75% of Welsh emigrants left the rural West and Mid-Wales to go to New York, Pennsylvania, Ohio, Wisconsin and Illinois, mainly carrying out agricultural work. They were later joined by workers from the South Wales and Clwyd coal and steel areas, some of whom joined the California Gold Rush. However, two towns in particular were magnets – Scranton and Wilkes-Barre in Pennsylvania. More than 40,000 Welsh went to Scranton alone, and at the start of the nineteenth century, there were 19,000 Welsh speakers in Scranton. The fledgling American ironworks industry drew on equipment and skilled workers from Pontypool, in order to get started. Benjamin Franklin had visited Pontypool to see how iron could be rolled instead of hammered flat, and the first American rolling mill was built by David Morgan from Pontypool, in Sharon Pennsylvania in 1871. David Thomas of Neath first enabled anthracite to be used for iron and steel manufacture in the States, allowing it to become the world's greatest producer.

By 1872 there were 384 Welsh Language chapels in the USA, and twenty-four Welsh periodicals. The oldest ethnic language newspaper in America, *Y Drych*, was established in Utica. It took over *Baner America* of Scranton in 1868 and survived independently until recently, although the Welsh communities have dispersed. It has recently merged with the other American-Welsh newspaper, *Ninnau*, edited by the remarkable Welsh-Patagonian-American Dr Arturo Roberts. Incidentally, with Marion Jones, Jesse Owens, Carl Lewis, Florence Griffiths-Joiner, etc., many have noticed that there is a disproportionate number of Black American athletes with Welsh-origin surnames. This is borne out by the Black American population in general. It seems that many slaves adopted the name of their owners, and the Welsh therefore had a disproportionately high number of early colonists.

AMERICAN REVOLUTION Robert Morris, of a Montgomery family, was known as 'the financier of the American Revolution'. A member of the Continental Congress, he organised the finances for Washington's military supplies, and signed the Declaration of Independence. In 1782 he founded The Bank of North America, but died bankrupt in 1806. Fourteen of the generals of the Revolutionary Army were Welshmen, and the Declaration of Independence was written by a Welshman, THOMAS JEFFERSON. A third (eighteen of fifty-six) of its signatories were of Welsh descent. Jefferson's original draft was severely pruned by Congress, with North Carolina and Georgia being responsible for the removal of anti-slavery promises. Jefferson said that his father came from the Snowdon foothills, and a US State Department official unveiled a plaque at Llanfair Ceiriog in 1933, 'To the Memory of a Great Welshman, Thomas Jefferson'.

Another Welshman, the one-legged lawyer Gouveneur Morris (1755-1835), wrote the final draft of the Constitution and as such is commemorated on a plaque on Philadelphia Town Hall, along with William Penn, Jefferson, Robert Morris and John Marshall. Gouveneur Morris was later Minister to France and a senator. The plaque reads:

Perpetuating the Welsh heritage, and commemorating the vision and virtue of the following Welsh patriots in the founding of the City, Commonwealth and Nation: William Penn, 1644-1718, proclaimed freedom and religion and planned New Wales, later named Pennsylvania; Thomas Jefferson, 1743-1826, third President of the United States, composed the Declaration of Independence; Robert Morris, 1734-1806, foremost financier of the American Revolution and signer of the Declaration of Independence; Gouveneur Morris, 1752-1816, wrote the final draft of the Constitution of the United States; John Marshall, 1755-1835, Chief Justice of the United States and father of American constitutional law.

AMERICAN UNIVERSITIES The name Yale derives from Iâl, the village of Llanarmon yn Iâl, near Wrexham in Clwyd. The Yales had a house here and David Yale was one of the Pilgrim Fathers who sailed to America. Yale University was founded by Elihu Yale (1648-1721), David Yale's grandson. He had made a fortune with The East India Company, and had been Governor of Madras. 'Hiraeth' pulled him home to Wrexham, and Elihu Yale is buried in a tomb in The Church of St Giles, Wrexham, where is carved 'Born in America, in Europe bred'. Bryn Mawr (Great Hill), the leading female college in the USA, is of Welsh origins, and Brown University, Rhode Island, was founded by a Welshman, Morgan Edwards of Pontypool, who died in Delaware in 1795. Another Welshman instrumental in founding an American university (and a hospital) was John Hopkins (1795-1873). Both Johns Hopkins University and Morgan State University in Baltimore have strong Welsh connections. Princeton University in 1757 had as its president the Welsh theologian Jonathan Edwards.

AMERICAN SINGERS Jerry Lee Lewis is of Welsh stock. Jerry Lee (the 'Killer') stated 'I never said I was the King of Rock 'n' Roll. I said I'm simply the best.' 'The Killer' is still the only man to top all three US pop, country music and R&B charts with one record, *Great Balls of Fire* in 1958. The man who discovered Elvis and founded the great Sun Records was another Welsh-origin American, Sam Phillips of Memphis. Sam Phillips was responsible for promoting and popularising Elvis Presley, Ike Turner, BB King, Carl Perkins, Roy Orbison, Jerry Lee Lewis, Charley Rich and Johnny Cash, amongst others, turning minority blues into the rock and roll we know today. The modern American crooner Jack Jones had an equally famous singing father, Alan Jones from Wales, who starred in musicals and had a worldwide hit with *The Donkey Serenade*. Hiram (Hank) Williams (1923-1953) from Alabama revolutionised country music in his short life. The renowned country singer George Jones is of Welsh stock, and the Hall of Fame country star, Conway Twitty, was born Harold Lloyd Jenkins, with Welsh parents.

AMERICA'S FORGOTTEN PRESIDENT President James Polk, the 11th President, had left the White House and Zachary Taylor was due to become President on 4 March 1849. However, 4 March was a Sunday, so the Welsh Senator David Rice Atchison of Missouri became President 'pro tempore' for that day, serving under the provisions of the Senate, until Taylor was sworn in on the Monday.

ANGHARAD, QUEEN FERCH OWAIN AP EDWYN (1066?-1162?) She was wooed by the great GRUFFUDD AP CYNAN, marrying him around 1079, on his accession to the throne of Gwynedd, and their son was the remarkable OWAIN GWYNEDD, born in 1080. Two years later, Hugh the Fat, Earl of Chester, asked Gruffudd to attend peace talks under a safe conduct. With the Earl of Shrewsbury, Hugh the Fat treacherously captured Gruffudd and put him in Chester Prison. Gruffudd's small Irish bodyguard had their thumbs cut off and were released, now useless as fighting men. The Normans then over-ran North Wales, and Angharad and two-year-old Owain fled to Angharad's father's court at Englefield. In 1094, Gruffudd escaped and in 1096 Angharad and her sixteen-year-old son made the dangerous journey across occupied Wales, to Gruffudd's court at Aberffraw on Anglesey. In 1098, with Gruffudd, they were forced to flee to Ireland where another son, Cadwaladr and a daughter Mared were born. Gruffudd again returned to Wales, taking back

Gwynedd and Anglesey, and Angharad bore Cadwallon and four more daughters, Susanna, Ranullt, Nest and GWENLLIAN. Cadwallon was later killed on the borders. Gruffudd took over more of Wales and died in 1137. Angharad, as by custom, took half his estate. It was said that Angharad outlived Gruffudd by twenty-five years, which would have made her almost a centenarian.

ANGLE (NANGLE) CASTLE This was built by Robert de Shirburn during the reign of Edward III (1327-77). One of the very few pele towers in Wales, it is rectangular in shape.

ANGLESEY – MONA, YNYS MÔN Ynys Môn is connected to the mainland by two bridges, the original Menai Suspension Bridge (carrying the A5), built by Thomas Telford in 1826 as a road link, and the newer, twice reconstructed Britannia Bridge, carrying the A55 and the North Wales Coast Railway line. There are numerous Megalithic monuments and menhirs (maen hir = long stone) here, with twenty-eight cromlechs on uplands overlooking the sea. Anglesey became the centre of learning for European DRUIDS, as the Romans slowly took over the Celtic tribes in Europe. In 61 CE the Roman general Suetonius Paulinus, determined to break their power, attacked the island, destroying their shrines and the sacred groves. In 78 CE Agricola systematically wiped the druids out. After the Romans, the island was invaded by Vikings, Saxons, and Normans before falling to King Edward I of England, in the thirteenth century.
The Romans called the island Mona, and 'Old Welsh' names are Ynys Dywyll (Dark Isle) and Ynys y Cedyrn (Isle of Brave Folk). It was called Mam Cymru (Mother of Wales) by Giraldus Cambrensis. Other names are Clas Myrddin in the *Triads* (the Precinct or Enclosure of Merlin), and Y Fêl Ynys (Honey Isle). According to the *Triads*, Anglesey was once part of the mainland, as geology proves, and in the seventeenth century, Ogilby's map shows that the stagecoach from London to Holyhead crossed the Menai Straits at low tide. The island also has the longest official place name in the Britain, Llanfairpwllgwyngyllgogerychwyrndrobwllllantysiliogogogoch, known as Llanfairpwllgwyngyll. The road from Llanfairpwllgwyngyll to Holyhead was originally a Roman road, and the foundations of HOLYHEAD are the Roman fort known as Caer Gybi. From the end of the Roman period to the early fifth century, Irish pagans colonised Anglesey and the nearby Llŷn Peninsula. In response to this, a Brythonic warlord from the north of Britain called Cunedda came to the region and began to drive the Irish out. This process was continued by his son Einion ap Cunedda and grandson Cadwallon Lawhir, until the last Irish were defeated in 470 CE. As an island Môn was a good defensive position, so the Roman port of Aberffraw became the site of the court (llys) of the kings and princes of Gwynedd. It remained their stronghold until the thirteenth century, when the English navy made it untenable. Anglesey threw off the English temporarily in the Glyndŵr War of 1400-1415.
In the Middle Ages Anglesey was referred to as 'the bread-basket of Wales', so was strategically important in the wars between the Welsh and Norman/English. Following the conquest of Wales by Edward I it was created a county under the terms of the Statute of Rhuddlan of 1284. Prior to this it had been divided into the cantrefs (cantrefi) of ABERFFRAW, Rhosyr and Cemais. In 1974 it formed a district of the new large administrative county of Gwynedd, until in the 1996 reform of local government it was restored as an administrative county. BEAUMARIS (Biwmares), to the south of the island, features Beaumaris Castle, built by Edward I as part of his campaign in North Wales. The town of NEWBOROUGH (Niwbwrch), was created when the people of Llanfaes were relocated to make way for the building of Beaumaris Castle. Niwbwrch was built on the site of Llys Rhosyr, another of the courts of the mediaeval Welsh princes. Llangefni is located in the centre of the island and is the island's administrative centre. The town of Menai Bridge (Porthaethwy) expanded when the first bridge to the mainland was being built, in order to accommodate workers and construction. A short distance from this town lies BRYN CELLI DDU, a remarkable Stone Age burial mound. Amlwch is in the northeast of the island and was once largely industrialised, having grown during the eighteenth century to support the copper mining industry at Parys Mountain. Ynys Môn is 261 sq miles, and is Wales' largest island. The island's entire rural coastline is an Area of Outstanding Natural Beauty.

ANGLICISATION OF PLACE NAMES Dinbych-y Pysgod, the ancient 'little fort of the fish', has become TENBY, which means nothing. One of the holiest places in Europe, the site of the claimed 'oldest university in the world' became Llantwit, celebrating the llan or ancient holy place of some saint called Twit instead of the great monastery of Illtud, as in LLANILLTUD FAWR. As for the nearby village of Saint Athan, there was no saint called Athan. TATHAN flourished in the fifth to sixth century, the uncle of the founder of Newport's cathedral, and was related to King ARTHUR. The local council has given an alternative name, Sain Tathan, whereas the previous name of the old settlement was Llandathan, or the Holy Place of Tathan (the t is mutated to d in Welsh). Wick in the Vale of Glamorgan was Y Wig Fawr (the Great Wood) but previously Llanildas, the holy place of St Gildas. The original Welsh name for Bonvilston was Tresimwn. The original of Boverton was Trebeferad, which was multilingually signposted. However, when the local council amended its signs to 'Welcome to Boverton' and 'Croeso i Drebeferad' there was a host of hostile letters in the local media complaining about the change of name from Trebeferad to Drebeferad, from incomers with no interest in, or knowledge of, the Welsh language and its mutations. The same people go to Spain and make no attempt to ask for their alcoholic fix in Spanish.

Newport's cathedral is known as ST WOOLOS – this is an English approximation of Saint GWYNLLIW, who founded the church around the sixth century. To Welsh people with knowledge and a love of history, it is extremely important that the old names are revived. This cannot be the generation that finally loses nationhood. Many, many churches were also rededicated by the Normans away from Welsh saints to Biblical saints, destroying the link with the foundation of the village or hamlet in the fifth to seventh centuries. Another problem is that old names and history reside not just in place names but in field names. The senseless EU law of numbering fields is slowly forcing the loss of field names, many of which remember holy wells, battles, saints and the like. In part, the EU is constantly destroying national cultures in an attempt to wipe out nationalism. In the case of Wales, because so much Welsh written history was destroyed in over a millennium of warfare, the topographic evidence of original place-names, field-names, wells and churches are often the only clues we have to our cultural history. The EU is so corrupt that auditors have been unable to sign off its accounts for the last fifteen consecutive years, a situation that hopefully could not happen with a democratically elected national government.

ANGLO-SAXON INVASION Constantine declared himself Western Roman Emperor and left Britain with his legions in 407 to try and take Rome. The Romans never returned, despite pleas from the British. Frisian and Saxon pirates were constantly harrying the shores of Britain. Around 455 Hengist from Jutland, the land of the Jutes, established himself in what would then become the Kingdom of Kent. The Venerable Bede states that the first Angles or Saxons arrived in, or just after 449. He says that the South Saxon Aelle was the first 'bretwalda', or overlord of the Saxons. However, Aelle may have been killed by Ambrosius Aurelius and/or Arthur at the Battle of Badon Hill, some time between 493 and 518. This victory is supposed to have gained a respite from the remorseless Saxon pressure on the Britons. Before long, however, the Celtic Britons were pushed back into the west, especially Wales and Cornwall, but also confined to Cumbria and Strathclyde (Ystrad Clud). From Wales and Cornwall many escaped to what would become BRITTANY, where Breton and Welsh speakers can still understand each other. The incoming Germans became organized into several kingdoms. In the south the Jutes, who would soon disappear from their homeland because of its conquest by Danes, established themselves in Kent and the Isle of Wright. Further north, Angles likewise disappeared from the southern part of Jutland but then gave their name to the whole of England (Anglia), establishing Mercia, East Anglia, and taking over Celtic Bernicia and Deira, (the latter two united to form Northumbria). Finally, in the south the Saxons, who would remain an important power on the continent, established the Kingdoms of the South Saxons, Sussex; of the East Saxons, Essex; and of the West Saxons, Wessex. Wessex started to absorb all the others to create a united kingdom of most of England.

Wessex was not able to absorb all of England, for the Vikings began arriving. This started

with the sacking of the monastery at Lindisfarne, in Bernicia, in 793. Eventually, Northumbria, East Anglia, Essex, and the north-eastern half of Mercia were overrun and became part of the Danelaw. At first the Vikings raided and carried off slaves, or were bought off with 'protection' money (Danegelt). However, Danes and Norwegians then began to establish their own kingdoms. They also attacked Ireland (settling in Dublin and other ports) and the Isle of Man, and began encroaching from Ireland and Man to attack Wales and England. This finally led to the outright annexation of England to Denmark by King Canute in 1016, though the Danish kings only lasted until 1042 when Edward the Confessor became the penultimate Anglo-Saxon king. Harold Godwinsson succeeded him, and William the Bastard arrived with the Normans in 1066. It is important to note how few British place-names survived the Germanic invasion, and even fewer words from the British (Welsh) language. Recent DNA testing has confirmed that the Celtic Britons were shifted to the west or wiped out by the Anglo-Saxon invasion. Testing on English men confirms their identity as being a match for the inhabitants of Friesland in modern Holland. Dr Mark Thomas of University College of London's department of Biology states that England today is 'a population of largely Germanic genetic origin, speaking a principally German language.'

ANIMALS Along with the famous Welsh Black CATTLE and Welsh Black Mountain SHEEP, the British Black Adder is only found in Tregaron Bog, and Dyfed's Black Bog Ant is only found elsewhere in parts of Dorset and Hampshire in England. Staying with the colour for the moment, there a Welsh Black Cob (horse breed), a Welsh Black Fowl (chicken) and there was a Welsh Black PIG, which is possibly extinct. The last appears to have died in Australia. Hares, along with cockerels and geese, were regarded as sacred by the CELTS – they are often represented in Celtic arts, and Caesar tells us that it was unlawful to eat them. Queen Buddug (Boadicea) of the Iceni released a hare while praying to her goddess before beginning her anti-Roman campaign, and hare legends run through Celtic folklore. Saint MELANGELL is the patron saint of hares. Pine Martens and Polecats roam the great swathes of Forestry Commission land, both increasing in numbers, and a unique type of vole lives on Skomer Island. Martens' fur is almost as beautiful as sable and the old Welsh laws dictated that marten fur could only be worn by kings, its value only being surpassed by the fur of a beaver. Beavers lingered on in Wales long after the rest of Britain. According to Giraldus Cambrensis, on his 1188 *Journey Through Wales*, the last beavers in England and Wales lived in the River Teifi in Cardiganshire. *The Laws of Hywel Dda* mention beavers and wolves, and the last wild wolves of Britain were said to be those of seventeenth-century Powys, the last of which kept watch in Chirk Castle in the 1680's. However, another report states that the last wolf was killed on Cader Idris in 1768. The last Welsh wild cat is thought to have lived in the eighteenth century near USK (Brynbuga), but other reports say they lasted in the hills until the nineteenth century. Brown bears may have lasted until medieval times. A third of the world's population of Atlantic Grey Seals are found around the Pembrokeshire islands and coasts.

AP Map, or Mab (the *p* is soft-mutated to *b* in front of vowels) is the equivalent of mac in Scottish lineage, meaning '*son of*'. Mab is the Welsh word for youth. This is one of the reasons that Welsh is the branch of Celtic languages known as Brythonic, or p-Celtic, while Erse and Gaelic are c-Celtic or q-Celtic (map compared to mac). Sons became known as, for example, Llywelyn ap Gruffudd (son of Gruffudd) or Meirion ab Einion (son of Einion). The reason the custom died out in Wales (but has been revived) was that the Act of Union in 1536 stated that Welsh could no longer be used for legal or official purposes, so surnames had to be anglicised. In practice, Llywelyn map (son of) Rhobat became Llywelyn ap Rhobat, and thus Llywelyn ap Robert in the sixteenth century became Llywelyn Probert. Ap Hywel became Powell; ap Siencyn, Jenkins; ap Rhys became Price, Prees, Preece; ap Harri became Parry; ap Huw changed to Puw or Pugh; ap Henri to Penri, etc. Equally, ab Evan became Bevan, ab Owen became Bowen and so on, with the mutation to 'b' being caused by the vowel starting a name. For females, merch means

daughter or girl, so Eira ferch Gwenllian served the same purpose as ap, m being soft-mutated to f. The nickname for someone who pretended to have forgotten his language and identity was 'Dic Sion Dafydd'. From the sixteenth century it became necessary for Welshmen to petition Parliament to be 'made English' so they could enjoy privileges restricted to Englishmen, such as the right to buy or hold land. It was at this time that the custom of using ap or ferch began to die out, and that Ioan became Jones, ap Hywel became Powell, etc. Other noble families anglicised their names under English pressure, for instance the House of Gwenwynwyn became 'de la Pole' rather than ap Hywel, Powel. There are resonances today when some 'upper-class' Powels pronounce their name to rhyme with pole instead of vowel.

Bishop Rowland Lee, President of the Council of Wales from 1534, ordered the deletion of ap and the introduction of English surnames, so in many cases English Christian names were chosen – this is why there are so many Hughes, Davies, Johns, Williams etc. in Wales. Jones (from Ioan) is the most common Welsh surname but there is no 'j' in the Welsh alphabet. Gwyn Alf Williams in *When Was Wales* records the bankrupt Welshman who signed himself as 'Siôn ap William ap Siôn ap William ap Siôn ap Dafydd ap Ithel Fychan ap Cynrig ap Robert ap Iorwerth ap Rhyrid ap Iorwerth ap Madoc ap Edwain Bendew, called after the English fashion John Jones.' Thomas Pennant (1726-1798) noted the lineage of Evan Llwyd whose family had lived at Cwm Bychan since at least 1100 – 'Evan ap Edward ap Richard ap Edward ap Humphrey ap Edward ap Dafydd ap Robert ap Howel ap Dafydd ap Meurig Llwyd o Nannau ap Meirig Vychan ap Ynyr Vychan ap Ynyr ap Meuric ap Madog ap Cadwgan ap Bleddyn ap Cynfyn, prince of North Wales and Powys'... 'Thomas ap Rhisiart ap Hywel ap Ieuan Fychan (lord of Mostyn) and his brother Piers (founder of the family of Trelacre) were the first who abridged their names and that on the following occasion. Rowland Lee, Bishop of Lichfield and president of the Marches of Wales, in the reign of Henry VIII, sat at one of the courts on a Welsh cause and, wearied with the number of aps on the jury, directed that the panel should assume their last name or that of their residence, and that Thomas ap Richard ap Hywel ap Ieuan Fychan should for the future be reduced to the poor di-syllable Mostyn, no doubt to the great mortification of many an ancient line.' Old family Bibles are often a major source of Welsh family history because of the practice of recording genealogies, births and marriages in them. There is a dislike of naming a son after a father in Wales, so Gruffudd ap Gruffudd was uncommonly written. Gruffudd Fychan was the preferred name of the son in such a case, 'bychan' meaning 'little' being mutated. There is a similar practice when Americans refer to John son of John as 'John jr.' From Fychan comes the common Anglicised Welsh name Vaughan.

AP MEURIC, RICHARD, RICHARD AMERIKA (fl. 1497) He partly financed the Cabot brothers' voyage from Bristol to America in 1497, and was Bristol's chief customs official. It seems that the brothers inscribed their maps as Amerika in his honour. English merchants afterwards referred to the New World as 'Amerik's Land.' The claim of Amerigo Vespucci with his later voyages may be wrong, as it is unknown for a country to be named after its discoverer's Christian name.

ARCHERS The longbow was developed by the Welsh in Gwent from the shorter bow in popular use, and gained popularity under Edward I for use against the Scots in the Highlands. In the Scottish wars, the English soon discovered that foot soldiers, armed with longbows and trained to keep a disciplined line, could repulse a charge of armoured knights by aiming at their horses. Thus, in 1337, in preparation for his French wars, Edward III prohibited on pain of death all sport except archery, and cancelled the debts of all workmen who manufactured the bows of yew and their arrows. The longbow rapidly became the critical success factor in battles, before the development of reliable cannons and guns. Measuring about 6ft, and with arrows measuring around 3ft, the bow was easily portable. A skilled archer could fire 10 to 15 arrows a minute, with an accurate killing range of over 200 yards. A hail of arrows demoralised any army, and its rapid rate of fire, made the crossbow obsolete. A crossbow could fire only 1-2 bolts per minute, and in the rain was useless.

The longbow was lighter, and strings were kept dry in the archers' hats. With the salvage of Henry VIII's *Mary Rose* in 1982, it was found that the draw-weight of these bows was twice what had been previously thought – up to 180 pounds – which some experts said could not be drawn. To shoot arrows using this power needed practice from youth, and from then on a regular daily basis. With Edward III in command, for the sea battle at Sluys, he placed only one ship of men-at-arms between each two ships of longbow men, with extra ships full of archers in reserve. From their 'castles', or fighting platforms, Welsh archers in Edward's pay decimated the French. It was said afterwards that the 'fish drank so much French blood that they could have spoken French if God had given them tongues'.

Even today, the descendants of the bowmen of CRECY and POITIERS, The Society of the Black Hundred, has an annual celebration in Llantrisant. The rights to Llantrisant Common were granted in perpetuity, for the service of the archers who were with the Black Prince at Crecy in 1346. The longbow changed the face of European warfare, causing the end of the armoured cavalry charge and preceding reliable artillery. It changed combat from hand-to-hand to killing from distance. The Welsh longbow at Crecy (1346), then Poitiers (1356) and finally at AGINCOURT (1415) extended the 'killing zone' from an arm's length to hundreds of yards, radically altering the nature of war. French nobles in armour plate and chain mail were cut to shreds by starving soldiers from the lowest ranks of society. Some were pinned to their dead horses. The concept of chivalry died when nobles could be killed from a distance by their inferiors. From Crecy, Poitiers and PILLETH, where Glyndŵr's archers decimated Mortimer's forces in 1402, the so-called 'English longbow' has always been a Welsh weapon, invented in Welsh-speaking Gwent. Historians claim that the relevant archers were the English middle classes, 'yeomen', whereas in fact they were poor Welsh mercenaries, many from the Welsh-speaking border areas. After the defeat of Llywelyn the Last, Edward I used Welsh troops to win the battle of FALKIRK against the Scots in 1298. 5,000 Welshmen were also in Edward II's army at Bannockburn in 1314, and 6,200 served in his 1322 Scottish campaign. We see unbroken battles from 1298 to 1415 with Welsh bowmen with Welsh bows, but modern history books record only 'English' archers with the 'English' invention of 'English' longbows. For those that claim that the 'men of Gwent' were English, the area was still almost completely Welsh-speaking as recently as 1850, with more Welsh monoglots than any other Welsh county.

ARCHITECTURE (SEE CLOUGH WILLIAMS-ELLIS, INIGO JONES, JOHN NASH, FRANK LLOYD WRIGHT)

For anyone wanting a taste of traditional Welsh buildings over the last 500 years, a visit to the MUSEUM OF WELSH LIFE at SAINT FFAGAN'S, Cardiff, is thoroughly recommended. In the castle grounds, over thirty buildings from all over Wales have been re-erected. A typical Welsh farmhouse was the tŷ-hir, 'long-house', thousands of which can still be seen, converted into family homes. On either side of a central corridor, there was a room, one for humans and one for animals. The heat from the animals served as a rudimentary central heating system – not quite as elegant a solution as the Roman villa, but quite effective. Similar houses can be seen in Brittany. A notable example of community co-operation was the tŷ unnos, 'one-night house', where twenty to forty men built a house overnight, usually on moor land, in the belief that such a building became the legal property of the builder if smoke issued from the chimney the following morning. This turf dwelling would then be superseded by a second, more permanent house adjoining it by the autumn, and the tŷ unnos converted into an adjacent cowshed. The unenclosed lands, upon which these squatters' cottages were built, were later enclosed by Acts of Parliament in the late eighteenth century. Squatters who had occupied their houses for at least twenty years before the acts were allowed to keep them. Fields in the Llŷn Peninsula show the effects of this haphazard settlement, compared to the neatly geometric holdings where land was legally parcelled out. The smallest house in Britain is a fisherman's cottage on the quay in Conwy, with just two small rooms and a staircase. It is only 10ft 2in high, 6ft wide and 8ft 6in in depth. The longest breakwater in Britain is at Holyhead. Built in 1873, it is almost one and a half miles long. Wales has the most powerful lighthouse in Britain,

at Strumble Head off Fishguard, with a visible range of twenty-five miles. Britain's longest railway tunnel connects Wales with England under the River Severn, and is four miles long. Built over a period of thirteen years, and completed in 1886, it used over 76 million bricks.

AREAS OF OUTSTANDING NATIONAL BEAUTY 1. Gower Peninsula – This was the first piece of land in Britain to be declared an 'AONB' in 1956. The peninsula is around five miles wide and juts out into the sea for fourteen miles. Many sheltered sandy beaches with clean water make it ideal for holidays, and it includes the famous Penclawdd cocklebeds, where cockles are still picked by hand for the markets of Swansea and Neath. It covers 73 sq miles.
2. The Wye Valley – Stretching fifteen miles between Monmouth and Chepstow, it passes one of Wordsworth's favourite beauty spots, Tintern Abbey, and the 800ft Wyndcliff where one can watch peregrine falcons hunting. Covering 45 sq miles, there is a further part of it in England.
3. The Isle of Anglesey Coastline, designated in 1966, is 83 sq miles.
4. The Llŷn Peninsula Coastline, designated in 1966, is 60 sq miles.
5. The Clwydian Ranges, designated in 1985, are 60 sq miles.
Three other beautiful areas of Wales belong to the Ministry of Defence – Germans trained their Panzer divisions for decades across great swathes of coastal South Pembrokeshire. Mynydd Epynt and the Brecon Beacons are also home to military manoeuvring. There are also thirty-one country parks designated across Wales, and forty per cent of the Welsh coastline is designated as '*Heritage Coast Area*'. Skomer Island is an official Marine Nature Reserve, and there are 'marine conservation areas' existing at the Menai Straits and Bardsey Island. There is potential for the Cambrian Mountains to also be named an area of outstanding national beauty, hopefully preventing the spread of even more wind farms.

ABBOT ARMEL (d.c. 570) Feasted in July and August, this 'prince of Glamorgan' became a Breton saint. With his nephew St SAMSON he helped restore the throne of Domnonia (Brittany) to its rightful heir, King Iuthael in 550. The territory granted him by the grateful king includes Brocieland and the forest of Paimpont, the traditional Breton home of Arthur, Merlin, Morgan le Fay and Arthur's knights. There are many striking parallels between Prince Arthrwys ap Meurig ap Tewdrig ap Teithfallt of Glamorgan and Gwent, King Arthur and the warrior-saint Abbot Armel. The name Armel or Ermel is composed of the old Breton-Welsh 'arth', meaning bear, and the Breton 'mael', meaning prince.

ART (SEE SIR FRANK BRANGWYN, JAMES DICKSON INNES, AUGUSTUS JOHN, GWEN JOHN, GOSCOMBE JOHN, DAVID JONES, CERI RICHARDS, IVOR ROBERTS-JONES, ANDREW VACARI, KYFFIN WILLIAMS, RICHARD WILSON) The most famous 'Welsh' picture is probably that by the Edwardian artist Sydney Curnow Vosper, of the congregation of Llanbedr's Salem Chapel. The old lady in the stovepipe hat who dominates the picture has a Paisley shawl, allegedly with the face of the Devil in it. Its massive popularity shows the essential duality of Welshness – a God-fearing up-front façade, with an acknowledged pagan past. Wales has inspired many notable English painters like J.M.W. Turner and David Cox. There are collections of Welsh painters in the National Museum at CARDIFF, and SWANSEA'S Glynn Vivian Gallery. Like Turner, Graham Sutherland was inspired by Wales, in particular Pembrokeshire. From 1967 he returned to Wales every year from his home in Menton, France, to paint, inspired by the landscape and light of Dyfed. George Chapman, born 1908, was equally moved by Wales, but in a diametrically different way, with his visit to Rhondda in 1953. His *Rhondda Suite* and all his later work reflect the importance of the industrialised valleys to his vision. Merlyn Evans (1910-1973) was a surrealist painter who won the Gold Medal for Fine Art at the 1966 National Eisteddfod. Will Roberts (1907-2000) used slabs of paint to evoke the hardship of crouching miners. Josef Herman specialised in pictures of people, especially miners, struggling in gloomy surroundings Using sombre colours he shows miners bent double – a Polish refugee from the dark years of 1938, 'Jo Fach' influenced a generation of Welsh painters from his base at Ystradgynlais.

ARTHUR (d.*c.* 539, 547 or 570) The time of Arthur is the most debated aspect of British history. The time from when the Romans left in 390, until *c.* 600 was known as 'the Dark Ages' across Europe, but as 'the Age of the Saints' in Wales, where Christianity never died out. Arthur was a Romanised Celtic Christian warlord, around whom the mythology of Guinevere, Merlin, Lancelot, The Holy Grail and the Round Table revolve. He fought back the Saxon threat from the East, the Pictish threat from the North and West and suffered internal friction with other British leaders. It appears, despite claims from various areas, that he was Prince Arthrwys ap Meurig ap Tewdrig, or Arthmael – the Bear Prince. His son Morgan became King of Glamorgan. This was accepted in most reference books until around the 1920's, when the 'Arthur industry' began and pushed Arthur into the West Country, North Wales, Scotland and elsewhere.

There is a persuasive case that Arthur's court of Gelli-weg was Llanmelin Hillfort, the ancient capital of the Silures, which overlooks Caerwent Roman town. Nearby is the 'round table' of Caerleon amphitheatre. In the *Welsh Triads*, Gelliwig in Cernyw was one of Arthur's three principal courts. Cernyw was once the name of part of the coastal area of South-East Wales, and Coedkerniw is between Cardiff and Newport. Cornwall was not known as Cernyw until the tenth century, post-dating the *Triads* by hundreds of years. Gelliwig means small grove, and Llanmelin's previous name was Llan y Gelli (church of the grove). Llanmelin is situated in Gwent-is-Coed, Gwent below the Wood (now called Wentwood), where Arthur's uncle and chief elder Caradoc Freichfras (Sir Craddock) ruled when Arthur was campaigning. Barber and Pykitt thus believe that Caer Melin, as Llanmelin was known to the Romans, and where Scapula was defeated by the Silures in 53 CE, was the site of the fabled Camelot.

Nennius, from South-East Wales, wrote around the end of the eighth century about Arthur and his famous twelve battles. Arthur is also referred to in *The Gododdin* (written around the end of the sixth century), early Welsh poetry, some of the *Lives of the Saints*, and in the early Welsh *Triads of the Islands of Britain*. Around 110 Welsh saints of the sixth century are associated with Arthur (ap Meurig), in stories which predate the medieval romances. (See this author's *The Book of Welsh Saints*). Many of the characters in Arthurian legend previously appear in Welsh legend and literature. MERLIN was identified with Myrddin in Welsh history, both St ILLTUD and Gwalchaved with Sir Galahad, both Gwalchmai and St Govan with Sir Gawain, Cei with Sir Kay, and Peredur and Bedwyr in the *Mabinogion* with Sir Percival and Sir Bedivere. Peredur, who glimpses the Holy Lance and Grail in *Peredur, Son of Erawc*, has an uncle Bran the Blessed, who is the model for *The Fisher King*. Eigyr passed into legend as Igraine, the mother of Arthur, and both Gwenhwyfar and Gwendolena the flower maiden are remembered as Guinevere. The Welsh prince Medraut ap Cawrdaf became Mordred, and the Druidic goddess Morgen has been associated with Morgen le Fay. Morgen was the patroness of priestesses, who lived on Avalon, Bardsey Island, with nine sisters. Peredur, or Pryderi, brought about the devastation of South Wales by sitting on *Perilous Mound*, but as Percival, in *Didot Perceval* causes enchantments to fall on Britain by sitting on the *Seat Perilous* at King Arthur's Court.

Sir Lancelot may be based on Maelgwn Gwynedd, or Llwch Llawinawg, Lord of the Lakes, and Sir Tristram with Drustanus, the son of Marcus Conomorus, a prince of Glamorgan. Sir Howel is identified with Howel (Riwal) Mawr of Ergyng, who fought Lancelot, became Dux Brittanorum after Arthur's death, and was buried at Llanilltud Fawr. The fabulous Castell Dinas Brân, perched high on the rocks overlooking Llangollen, is identified with Grail Castle. Both Bran (from the *MABINOGION*) and the Fisher King had wounds which would not heal, and King Bran is associated with the castle. Bran also had a magical 'cauldron of plenty' (see THIRTEEN TREASURES), which is identified with the Holy Grail. Another of the Thirteen Treasures seems to be linked with Excalibur. Lloegr is the Welsh name for England, and Logres is the name of England in Arthurian legend. Pendragon, the title first taken by Arthur's father and then by Arthur, is a combination of the Old Welsh 'dragwn', dragon/leader, and the Brythonic 'pen', or head. At the top of Snowdon, there was a tumulus commemorating one of Arthur's victims. Arthur sailed across Snowdonia's Llyn Llydaw on his way to Avalon, after

fighting Mordred at Bwlch y Saethau (Pass of the Arrows). Bedevere threw Excalibur into Llyn Llydau, which seems to be a continuation of the Celtic throwing away of a dead warlord's weapons into water, which was sacred to them. Avalon seems to be Afallach, the sacred and holy isle of Bardsey off the Llŷn Peninsula. Barber and Pykitt believe that Arthur recovered from his wounds incurred at Camlan, at the monastery of Bardsey, and went to Brittany, where he was known as St Armel.

Arthur ap Meurig ap Tewdrig was married to Gwenhwyfar, and his son Gwydre was killed by the Twrch Trwyth (in the *Tale of Culhwch and Olwen* in the *Mabinogion*) at Cwm Cerwyn, near Nevern. Nearby are the Stones of the Sons of Arthur (Cerrig Meibion Arthur). Arthur had returned from Brittany to defeat Mordred. Again tradition states that he survived the battle, but was grievously wounded while resting after he had won (by Eda Elyn Mawr, according to *Harleian mss 4181* entry 42). Arthur was soon succeeded as Pendragon by Maelgwn Gwynedd, sometimes identified with Lancelot. At OGMORE Castle was found a sixth-century memorial stone recording a land grant by Arthur. It is now in the National Museum, and the Latin inscription reads *'Be it known to all that Arthmail has given this field to God to Glywys and to Netart and to Bishop Fili'*. In St Roque chapel ruins at nearby Merthyr Mawr, another stone reads *'Conbelan placed this cross for his (own) soul (and for) the soul of St Glywys, of Nertain, and of his brother and father prepared by me, Sciloc'*. And in the church of St Illtud at Llanilltud Fawr, just a few miles away, the famous Pillar of Abbot Samson reads:

In the name of the MOST HIGH GOD
was begun the cross of the Saviour which
Samson the Abbot prepared for his soul
And for the soul of king Iuthahel
And for Artmal the dead.

This stone seems to be wrongly dated as ninth century, and instead is a sixth century tribute to Arthur and King Iuthael of Brittany from St Samson, Arthur's kinsman. Both Armel/Arthur and Samson fought in Brittany to regain Iuthael/Judicael's throne from Marcus Conomorus at the Battle of Brank Aleg.

ASAFF, SAINT St Asaff (Asaf) succeeded St Kentigern as Abbot and became the first Bishop in 560 or 570, dying around 600. Many sites around Holywell commemorate him, such as Ffynnon Asa, Asaff's Well.

ASAFF CATHEDRAL, SAINT, St Asaph (Asaff Sant) is the smallest cathedral in Britain, and has been destroyed twice since its foundation by St Kentigern (Mungo) at his monastery at Llanelwy in 537 CE. The Welsh name of the town of St Asaph is Llanelwy, and because of its cathedral it should be awarded city status.

ASHLEY, LAURA (1925-1985) Born in Merthyr, her 'country-look' fashions became popular, with factories being set up to produce them, enjoying a backlash against the 'sexist' fashions of the 60's. This Welsh fashion designer, with her husband Bernard, built up a global fabric and furnishings empire, unfortunately no longer British-owned. Recently her last remaining factory in Wales closed, with its production transferred overseas. Bernard Ashley, also of Merthyr, renovated the remarkable Llangoed Hall as a hotel, near Llyswen in Brecon.

ASSER, BISHOP OF SHERBOURNE (d.c. 908) A Welsh monk at St David's, he was requested by Alfred to join his court, where in 893 he wrote the *Life of King Alfred*. He spent half of each year at St David's and half at court, and his work is the reason we have more information upon Alfred than any other Saxon king.

ATHLETICS Lynn Davies ('Lynn the Leap') set the UK record for the long jump of 27ft in Switzerland in 1968, and had won the gold medal in the Olympic Games at Tokyo in 1964. Steve Jones won the London Marathon in a record 2 hours 8 minutes and 16 seconds in 1985, and won the New York Marathon three years later. Wales' most well-known runner was Colin Jackson, who set the World Record for the 110m hurdles in Stuttgart in 1993, and has won the World Championship. The record was not broken for thirteen years. In 1948 Tom Richards of Pontnewydd, 'an ardent beer-drinker who habitually ran in Woolworth's Red Flash daps' (i.e. plimsolls, quote from *The Western Mail* 7 August 1998), was just beaten for the gold medal in the Olympic Games marathon. He thought he was lying in fourth position until he entered Wembley Stadium, and just saw two runners in front of him, so accelerated and caught one of them to achieve what he thought was the bronze. A mix-up at a drinks station had cost him over ten seconds, and he finished in far better shape than the Argentinean winner. His initial euphoria at finishing second when he thought he was lying fourth, turned to annoyance in later years when he realised he could have won the race. He had a few pints that night to celebrate, and started work at 6.30 the next morning, as a hospital nurse.

ATLANTIS For every century in the last few thousand years, the sea has risen around 10in. Thus since the time of Christ, the sea around Britain has risen 16ft, and from the time of Arthur around 12ft. Stories of drowned lands are prominent in old Welsh literature, perhaps based on folk memories of when Wales was only separated from Ireland by a narrow, shallow strip of water around 10,000 years ago. The *Mabinogion* story of Bran the Blessed describes him as a giant of a man, helping his soldiers to cross the sea to fight in Ireland. As early as the seventeenth century, expeditions were being made to see the sunken ruins of Llys Helig, an estate two miles off the mouth of the river Conwy. Traditionally this palace ('llys') had been flooded in the Dark Ages. Llys Helig, the lost realm of Helig ap Glannowg, joins Cantre'r Gwaelod and Caer Arianrhod to form a triad of lost kingdoms off the Welsh coast. In 1816 Edward Pugh again 'identified' Llys Helig and its causeway, and in 1864 the site of the palace ruins was measured at five and a half acres. A nearby hill at Trwyn yr Wylfa, at Penmaenbach, is said to be where Helig's subjects fled from the sixth-century inundation.

In the twentieth century, straight lines of boulders have been found under the sea, some at right angles to each other, but modern scientific thought is that these are 'boulder trains' left behind by the retreating ice at the end of the Ice Age. The fabled Caer Arianhod, off the southern entrance to the Menai Strait, also seems like a sunken castle. This is three quarters of a mile offshore from Dinas Dinlle on the Llŷn Peninsula. Nearby the great stone 'Maen Dylan' commemorates Arianrhod's lost son, Dylan eil Don. Welsh folklore mentions a vast land from Bardsey Island in the North to the mouth of the River Teifi in the South, extending over Cardigan Bay, around 800 sq miles with sixteen cities, ruled by Lord Garanhir of Gwyddno. This lowland was controlled by sluice-gates and embankments. However, Seithennin the gate-keeper drank too much at a banquet, forgot to close the sluices and the sea rushed in. An ancient Welsh triad tells of the flooding of Cantre'r Gwaelod (The Hundred Homesteads of the Lowlands) – 'by this calamity sixteen fortified cities, the largest and finest that were in Wales, excepting only Caerleon upon Usk, were entirely destroyed, and Cardigan Bay occupies the spot where the fertile plains of the cantref had been the habitation and support of a flourishing population.'

A new translation of *The Black Book of Carmarthen* by Rachel Bromwich reads...

Stand forth, Seithenhin,
and look upon the fury of the sea;
it has covered Maes Gwyddneu.
Accursed be the maiden
who released it after the feast;
the fountain cup-bearer of the barren sea.

The 'maiden' has parallels in Breton folklore as the scourge of God, punishing the land because of the wickedness of its people. There are submerged petrified forests off Borth on the Ceredigion coast, and auroch bones have been found in the sands. There certainly seem to be racial folk memories of a greater Wales, narrowly separated by the shallow sea (that Bran walked across) from Ireland. The original name of Borth was Porth Wyddno – 'The Gate of the City Under Waves', and spring tides still regularly flood the town.

The haunting old song, *The Bells of Aberdyfi*, was composed by Charles Dibdin for the 1785 operatic entertainment, *Liberty Hall*. It tells the legend of old church bells still tolling in the waters of West Wales. Leland refers to the lost Cantre'r Gwaelod being eaten away by the Irish Sea. Legends of the times when Ireland was united by a land-bridge with Wales are linked by Cynfelin (Shakespeare's Cymbeline, Cunobelinus), and one of the three strange ridges of rock reaching out from Cardigan Bay to Ireland being called Sarn Gynfelin (Cymbeline's Causeway).

These ridges are exposed at very low tides. The most northerly is Sarn Badrig (St Patrick's Causeway), near Shell Island, traditionally thought to be the road to the flooded land known as Cantre'r Gwaelod, where church bells still ring. It runs for fifteen miles out into Cardigan Bay, and a giant boulder thirteen feet across can be seen. The flattened glacial boulders here look very much like sea-battered embankments. King Bran Bendigeidfran in legend waded to Ireland across here, starting from Harddlech in Ardudwy (Harlech). Sarn Badrig itself is between Harlech and Barmouth. Between Barmouth and Towyn is Sarn-y-Bwch, lying directly offshore from Tonfanau Iron Age fort. Sarn Cynfelin lies between Towyn and Aberystwyth, and can be walked for about half a mile when there is a falling spring tide. This 12,000 year-old Ice Age remnant runs about six miles towards Ireland, and acted as a natural breakwater for small coasters landing limestone for local shore-based kilns. Further south, Aberaeron has lost Castell Cadwgan to the sea, and off the Glamorgan coast, Porthkerry (Porthceri) Castle has gone under the waves. Even recently the sea has hit coastal settlements. 300 years ago the village of Hawton near Ferryside in Pembrokeshire was wiped out by a high sea and the twelfth-century church at Cwm-Yr-Eglwys (Church Valley) in Pembroke was smashed apart by the massive 1859 storm, leaving only the belfry standing.

Gwyddneu Garanhir, ruler of the lost country flooded under Cardigan Bay, asked for protection from Gwyn, the God of War and Death, in *The Black Book of Carmarthen* – Gwyn's unhelpful response includes:

I have been in the place where was killed Gwendolau,
The son of Ceidaw, the pillar of songs,
When the ravens screamed over blood.
 I have been in the place where Bran was killed,
The son of Iweridd, of far extending fame,
When the ravens of the battlefield screamed.
 I have been where Llacheu was killed,
The son of Arthur, extolled in songs,
When the ravens screamed over blood.
 I have been where Meurig was killed,
The son of Carreian, of honourable fame,
When the ravens screamed over flesh.
 I have been where Gwallawg was killed,
The son of Goholeth, the accomplished,
The resister of Lloegyr (England), the son of Lleynawg.
 I have been where the soldiers of Britain were slain,
From the east to the north:
I am the escort of the grave.
I have been where the soldiers of Britain were slain,
From the east to the south:
I am alive, they in death!

AUSTRALASIA (SEE BILLY HUGHES) New South Wales was so named by Captain Thomas Jones of Llanddewi Skirrid. From 1870, many Welsh artisans had taken up the offer of a free passage to Australia. As Merthyr Tydful was probably the largest industrial exporting town in Europe at the time, and Welsh industrial expertise was about a generation in front of the rest of Europe. This was equivalent to modern technology transfer, as Australia wished to develop its massive mineral resources. (Similarly, although Welsh settlers had moved to farm in Natal from 1824, the discovery of gold in South Africa thirty years later led to an influx of Welsh miners and engineers to exploit the mineral). New Zealand, to counter the move of emigrants to Australia, offered massive sheep farms to Welsh flock-masters and farmers. To some extent, this lasting link with Wales has led to the development New Zealand's national sport. New Zealand and Wales were the only two countries in the world where rugby was the sport of passion for the majority, but recently countries like Tonga, Samoa, Fiji etc. have also become committed to the game.

BADON HILL, BATTLE OF, *c.* **516 or 518** At Mynydd Baddon, Mons Badonicus, this important battle has been placed as early as 493 or 503 CE, and could have been outside Bath or outside Maesteg at Mynydd Baidon. It is recognised as a great battle between the British and the Saxons, after which there was relative peace for many years, except for the Battle of Camlan, which may itself have been a battle between the kingdoms of Gwynedd and Glamorgan. Arthur, according to Taliesin, led the British at Badon Hill. Other sources state that the Dux Bellorum was Ambrosius Aurelianus fighting Aell, King of the South Saxons. There may have been more than one battle at this place.

BALDERT BRIDGE, BATTLE OF, 1170 In 1165 Henry II used Shrewsbury as his base for invading north Wales, but after the campaign visited Chester, to meet the ships which he had ordered to harry Gwynedd. Shortly afterwards Chester appears to have been involved in a further attack on the Welsh, for in 1170 Hugh II was said to have built a mound at Boughton out of the heads of Welshmen killed at the 'bridge of Baldert', possibly Balderton (in Dodleston), south of Chester. In 1211 King John also attacked the Welsh from his base at Chester.

BAKER, SIR STANLEY (1927-1976) Before his early death in 1978, he had made many films and was regarded as 'by far Wales's most important movie star' (Peter Stead, *Western Mail* 13 June 1998). He had played Captain Horatio Hornblower aged just twenty-four, and starred in *The Cruel Sea* a two years later. At the age of just thirty-three, Baker produced and starred in the award-winning film *Zulu*, giving Michael Caine his big break into films.

BALA This tourist centre and village lies next to Llyn Tegid (Lake Bala) in Gwynedd, and narrow-gauge trains run in summer around the lake shoreline. Tom Ellis, the leading Liberal MP and reformer was born here and is commemorated by a statue.

BALA CASTLE, TOMEN Y There are three Roman forts and four earthwork castles in the vicinity, and the mound overlooks Bala.

BANGOR A university town in Gwynedd, its Tudor town hall was formerly the home of its bishop. Between the town hall and the cathedral is the Bishop's Garden (Gardd yr Esgob), including the wonderful 'Biblical Garden' which contains most of the trees, shrubs and flowers mentioned in the *Bible*. Bangor allegedly has the longest High Street in Britain. The name 'Bangor' reflects its ecclesiastical origin in the sixth century by St Deiniol, meaning a quarter or corner which contained a choir. Its original meaning was a strong plaited rod, making a fence or wattle building. The circular fenced enclosure became holy land, a llan. There are places named Bangor in Ireland and Brittany, all being holy sites from the 'Age of the Saints'.

BANGOR CATHEDRAL St Deiniol founded a monastic settlement at Bangor, named Y Cae Onn (The Ash Tree) in 525, and this became a bishopric in 546, the oldest in Britain. The present cathedral fabric dates from the thirteenth to the fifteenth centuries. The Cathedral was destroyed and rebuilt by the Normans in 1071, and subsequently damaged by King John, Edward I and Owain Glyndŵr in turn. John's invading army killed and raped the citizens of the town and dragged the bishop from the sanctuary of the cathedral, before burning it. John demanded a ransom of 200 hawks for the bishop. Bangor Cathedral (Eglwys Gadeiriol Bangor) has the longest continuous use of any of Britain's cathedrals. It is the oldest diocese in Britain, predating Canterbury by eighty-one years, and was rebuilt by Sir George Gilbert Scott in 1884.

BANGOR-IS-COED MONASTERY The oldest monastery in Britain was founded in 180 at Bangor-is-Coed. By the seventh century it was said to have an establishment of 2,000 monks, of which 1,200 were butchered after the Battle of CHESTER in 616. They were praying for the Princes of Powys, who were defending Chester and North Wales from the invading King Aethelfrith of Northumbria, and were massacred. The survivors fled west to Bangor, which was a related Celtic foundation. The Battles of Chester and DYRHAM effectively sealed off the Celts in Wales from the other Britons, and made the modern border of Wales. PELAGIUS was said to have studied here.

BARDS 'Bardd' means 'poet' in Welsh, and 'barddoniaeth' means 'poetry' (literally 'the work of bards'). A poem is a 'cerdd', so the head bard in each lord's household was known as the 'pencerdd', or 'head of poems'. Like the druids, the bards were a class of learned men in early Celtic societies, principally concerned with music and poetry. Merlin was supposed to have retired to Bardsey (the Isle of the Bards) with nine bardic attendants, to guard the *THIRTEEN TREASURES OF BRITAIN*. Bards survived after the Celtic era, attached to the courts of Welsh princes, and when the LORD RHYS established the first Eisteddfod in 1176, their existence gained a new life. Music and poetry contests carried on through the Middle Ages, and were revived on a national basis in 1789, thanks to Iolo Morgannwg. Their influence upon the spoken word has affected the course of Welsh literature and its leaning towards poetry. The Celts prized bards more than warriors, and the tradition has continued.

The four main periods in the history of Welsh literature begin with the age of the 'Cynfeirdd', or primitive bards, from around 460-500 to the middle of the eleventh century, and their work was inspired by the struggles of the Britons against the invading Saxons. The *Triads* record that the original bards of Ynys Prydain ('the Isle of Britain') were Alawn, Gwron and Plenydd. The 'Books' of Aneirin, Carmarthen, Taliesin and Hergest commemorate some of these ancient poems. As well as Aneirin and Taliesin, Myrddin (Merlin) and Llywarch Hen were notable bards recorded in these manuscripts. The poems used rhyming and alliterative devices, to assist the bards in repeating them and handing them down to future generations. Their work was called 'cerdd dafod', the craft of the tongue. Hywel Dda gave the bards legal status and high honour in his *Laws* in the tenth century.

The next period was that of the 'Gogynfeirdd', from the mid-eleventh century onwards, when the bards began to travel from court to court, like troubadours. Over thirty poets from the twelfth and thirteenth centuries are known from existing works. Gwalchmai ap Meilyr, the pencerdd (chief bard) at the court of Owain Gwynedd was best known, and Cynddelw is also famous. Some bards were also soldiers and nobles, such as Dafydd Benfras, who died fighting for Llywelyn Fawr in 1257, and Bleddyn Fardd, who died fighting the Normans. Owain Cyfeiliog and Hywel ab Owain Gwynedd were bardic poet-princes of this time, learned men with their own courts.

After the death of Llywelyn the Last in 1282, it was the age of 'Beirdd yr Uchelwyr', the Bards of the Nobles, who entertained the higher classes. They introduced a revolutionary new metre, the 'cywydd', to blend with traditional 'cynghanedd', (rhyming internal consonance), and Wales' greatest poet, Dafydd ap Gwilym flourished. Between 1300 and 1420, the other leading bards were the remarkable Siôn Cent, Rhys Goch Eryri and Iolo Goch, who composed the famous panegyric

to Owain Glyndŵr. They were followed by Lewis Glyn Cothi, Llawdden, Guto'r Glyn and the great Dafydd ab Edmwnd of Hanmer. Edmwnd Prys and Gruffydd Hiraethog thrived under the Tudors, but apart from Huw Morus the bardic tradition began to be replaced by prose. In 1694, the last known household bard, Sion Dafydd Las, died. He was the family poet of the Nannau family in north-west Wales.

The renaissance, and the fourth period of bardic activity, was sparked by the Machynlleth Eisteddfod of 1702. Grinding poverty forced the poet Goronwy Owen to emigrate to America. Lewis Morris, Alun (John Blackwell), Ceiriog (John Ceiriog Hughes), the wonderful Islwyn (William Thomas) and many others pushed out the frontiers of Welsh poetry with little reward. However, they set the background and have been an inspiration for Welsh twentieth and twenty-first-century poets, writing in both English and Welsh. Bards have directly been responsible for the survival of the Welsh language. Celtic languages have all but died out in Ireland and Scotland, despite the former being an island, and the latter a large mountainous region far from the English seat of power in London. Wales as a country was the first to be invaded by England, is within easy reach of it, and had its language proscribed by the 1536 Act of Union. However, from Celtic times through medieval times the bard was one of the most important members of a noble's household. Bards remembered and retold in verse the battles and deeds of famous Britons against the Romans, Irish, Vikings, Picts, Saxons, Mercians, Normans, Angevins and Plantagenets. As scholars, they studied the language and wrote handbooks and dictionaries to maintain its purity. Thankfully, as the old Welsh aristocracy and their attendant court bards died out in the sixteenth century, to be replaced by absentee English landowners, the 1588 translation of the Bible into Welsh saved the language.

BARMOUTH, ABERMO This port on the Mawddach estuary was transformed into a resort in the nineteenth century, with a two-mile promenade. The original Welsh name was Aber Mawddach, the mouth of the river Mawddach, which by 1284 had been abbreviated into Abermau.

BARRI (BARRY) Barri was once Wales' eighth largest island at 170 acres, known as Ynys Peirio after the founder of its monastery. The mainland village and its island were transformed in the 1880's by DAVID DAVIES into the busiest coal-exporting docks in the world, and Barry has grown into Wales' fourth largest centre of population (after Cardiff, Newport and Swansea). Davies built a causeway to link Barri Island to the mainland, and his docks and railway effectively ended the monopoly of Lord Bute, with all the Merthyr and Cynon Valley coal previously having to be shipped through Bute's Cardiff Docks. With the replacement of coal as shipping fuel by oil in the 1930's, the town's fortunes declined dramatically. Billy Butlin built an ugly holiday camp on one of the former island's twin headlands, land with prehistoric remains that was given in perpetuity to the people of Barri for leisure. With the closing of the camp, however, houses were built, even over the site of St Baruc's holy well, which dated from the sixth century. The site of St Baruc's chapel has been saved, and St Dyfan was also associated with the town, with an ancient church there. On the other headland of Barri Island are hut circles. A Celtic Christian monastery existed on Barri Island, and the area is surrounded by Neolithic, Iron Age, Dark Age and Roman remains. The Vale of Glamorgan, of which Barri is the administrative capital, has more castle sites per square mile than anywhere in the world.

There were plans to demolish the remarkable Barri Dock Offices, but they have survived. The superb Town Hall was left as an unattended eyesore for twenty years until 2003, since when it has been restored. The swimming pool at Cold Knap, next to the Island, was 130 yards long, the second longest in Europe. It has now been demolished after being deliberately left derelict by the council for years. From Barry and nearby Penarth throughout the summer months, the *Waverley* offers cruises in the Bristol Channel. This is the only surviving ocean-going paddle steamer in the world. Trainloads of day-trippers from the Rhondda Valley used to come down on weekends, in the days before there were any pubs on Barri Island.

Let's go to Barry Island, Maggie Fach,
And give all the kids one day by the sea,
And sherbet and buns and paper hats,
And a rattling ride on the Figure Eight;
We'll have tea on the sands, and rides on the donkeys,
And sit in the evening with the folk of Cwm Rhondda,
Singing the sweet old hymns of Pantycelyn,
When the sun goes down beyond the rocky islands...

(from Idris Davies' *The Angry Summer*).

BARRI CASTLE A fortified thirteenth to fourteenth-century manor house, on the site of a previous earthwork, it was the seat of the de Barry family. It was destroyed by Llywelyn Bren, along with another dozen or so castles in the Vale of Glamorgan.

BARRI ROMAN PORT BUILDING Possibly part of a major Roman complex at Cold Knap, but new buildings cover the rest of the site. There used to be an inlet here, now filled in with the harp-shaped Cold Knap Lake.

BASINGWERK ABBEY Probably founded in 1131 by the Earl of Chester, it was a Savignac foundation, but in 1147 the order merged with the Cistercians. Its remains date from the twelfth and thirteenth centuries, with a huge dining hall.

BASINGWERK, THE BATTLE OF, 821 King Cenwulf of Mercia, Offa's son, was killed here and the Mercians routed. He had previously invaded Wales in 798, 816 and 818, killing Caradog ap Meirion, King of Gwynedd in 798.

BASINGWERK CASTLE Also known as Holywell Castle and Bryn-y-Castell, it was built by Normans inside the site of a Saxon frontier fortress and near the Holy Well of St GWENFREWI (Winifred). Before 1155 it had been destroyed during King Stephen's rule, and in 1157 was rebuilt by Henry II, who stayed there when visiting Gwenfrewi's Holy Well. In 1165 as Henry II retreated from the Berwyn Mountains, the town and castle were besieged by Owain Gwynedd, who then destroyed the castle in 1166. In 1177 it was held by Owain's son Dafydd, then in 1209 burnt by Ranulf, Earl of Chester, following complaints from the monks of Chester that they had lost the income from pilgrims to the well. Ranulf then rebuilt it, but it was taken by Llywelyn ap Gruffudd before 1140. Dafydd ap Llywelyn inherited it and he confirmed the well's revenues to the monks at Basingwerk. The building of nearby Flint Castle made Basingwerk Castle obsolete.

BASKERVILLE HALL Now a hotel in 130 acres of grounds near Clyro, Hay-on-Wye, it was built in 1839 by Thomas Mynors Baskerville for his second wife, Elizabeth. The Baskervilles were related to the Dukes of Normandy and first came to Britain to help William the Conqueror in 1066. Arthur Conan Doyle was a family friend who often came to stay here. During his visits he learnt of the local legend of the hounds of the Baskervilles, and it is believed that on nearby Hergest Ridge he translated this into the most famous case for his detective Sherlock Holmes. However, at the request of the family, he set the book in Devon 'to ward off tourists'.

BASSEY, SHIRLEY (1937-) Born in Tiger Bay, Cardiff, she has transformed into an international diva, with many hits over the years. A powerful singer, in 1977 she received the Britannia Award as 'the best female singer of the last fifty years.' She is the only artiste to have performed three James Bond film themes, *Diamonds are Forever*, *Moonraker* and *Goldfinger*.

BEAUMARIS, BIWMARIS Opposite the castle is the seventeenth-century County Hall of Anglesey, with a branding iron once used to stamp convicts for theft. The Courthouse was built in 1614. Trials were always held in English, so the local jury had no chance of following proceedings. The defendant also had no opportunity of a fair trial with English judges, as no Welshmen were allowed to judge cases. The Bull's Head was built in 1472 and has the largest door in Britain, 13ft high by 11ft wide. The fourteenth-century Church of St Mary and St Nicholas contains the stone coffin of Joan, the wife of Llywelyn the Great. Above the empty coffin is a slate panel inscribed: 'This plain sarcophagus, (once dignified as having contained the remains of Joan, daughter of King John and consort of Llywelyn ap Iorwerth, Prince of North Wales, who died in the year 1237), having been conveyed from the Friary of Llanfaes, and alas, used for many years as a horsewatering trough, was rescued from such an indignity and placed here for preservation as well as to excite serious meditation on the transitory nature of all sublunary distinctions. By Thomas James Warren Bulkeley, Viscount Bulkeley, Oct. 1808'.

BEAUMARIS CASTLE Beaumaris was the final link in the iron chain of castles around Gwynedd, and although uncompleted, is probably the most sophisticated example of a concentric castle (with ring within ring defences) in Europe. The most technically perfect castle in Britain, it was built on a flat swamp, 'Beautiful Marsh' in south-eastern Anglesey, where high tides used to sweep around its walls. Begun in 1295, it was the last of Edward I's castles in Wales, on an entirely new site, in response to the rising of Madog ap Llywelyn in 1294-95. It is unfinished because funds dried up for the master builder Master James of St George. Its six huge inner towers are only rivalled in size by William Marshall's tower at Pembroke Castle and by William ap Thomas's tower at Raglan Castle. In 1404 Glyndŵr's French allies defeated an English force here.

BEAUPRÉ CASTLE, OLD, Between St Athan and Cowbridge, on the banks of the Thaw, it is a stylish fortified medieval manor house, built around two courtyards. In the sixteenth century, it was modernised by Sir Rice Mansell and then the Bassett family. It is said that the Magna Carta was first drafted here.

BEER The cyfarfod cymorth (assistance meeting) was held for hundreds of years for the benefit of poor people, or for people having problems with their rent, or to help a grieving widow meet her bills. It was a meeting with cwrw bach (small, meaning weak, beer) brewed by the householder. The beer was free, to comply with legislation, but the pice (small cakes) were highly priced, to ensure the householder made a fair profit. There was dancing, singing, and sometimes love tokens were exchanged, as this was one of the few freewheeling occasions in Welsh society. Meth (mead) was also sometimes made. Even up until the late nineteenth century, mead was traditionally mixed with spiced beer in some villages to celebrate Easter Monday. After the disappearance of many Welsh breweries owing to takeovers, there has been a notable increase in small breweries offering a wide range of real ales. The largest surviving Welsh brewer, Brain's, sponsors the national rugby team.

BENEDICTINES One of the Norman kings' first acts was to introduce the Benedictine Order into Wales, as their Marcher Lords expanded through the borderlands and south Wales. Up until then there were no Welsh monasteries following the Rule of St Benedict, a cohesive Latin influence on unifying European politics and Christianity. In 1071, the Normans founded an abbey in the border town of CHEPSTOW, and by 1150 had established no less than seventeen new Benedictine monasteries in Wales. These monks owed their allegiance to higher monastic houses in England, and to the parts of France which were also held by the Normans. The Welsh 'clasau', the ancient monastic houses such as Llancarfan and Llantwit Major, were given to English monasteries at Gloucester and Tewkesbury, ending hundreds of years of the Celtic Church's independence from Rome. The first Welsh Bishop to succumb to Canterbury's rule was the Norman, Urban of Llandaf, who ruled the diocese of Glamorgan from 1107-1134.

BETHESDA The site of the largest slate quarry in the world is Fronllwyd Mountain in Gwynedd, which faces the town. Bethesda grew with the beginning of the quarry in 1765, which is noted for its high quality red, blue and green slate. The slate quarry in 1200 feet deep and covers 560 acres. The town, like its sister slate town Blaenau Ffestiniog, is one of the last strongholds of Welsh as a first language.

BETWS-Y-COED The village developed in the nineteenth century to serve the needs of growing numbers of tourists to Snowdonia, and is situated in the hills of the Gwydir Forests, at the confluence of the rivers Llugwy, Lledr and Conwy. The Conwy waterfall and the Llugwy's Swallow Falls are both two miles away, and the iron bridge over the Conwy was built by Telford in 1815.

BEUNO, SAINT (d. 642 or 660) There are over 900 recorded Welsh Celtic saints with known dedications and genealogies, and hundreds of others have been 'lost'. Feasted on 21 April, and educated in Caerwent, he was the son of noble parents, and is the North Wales equivalent of St DAVID. Beuno founded a monastery at Clynnog Fawr in 616 or 630, which was a place of pilgrimage to his grave until the end of the eighteenth century, and an assembly point for pilgrims wishing to make the dangerous crossing to the holy isle of Enlli (Bardsey). There are many dedications to him, and he instructed many saints. His *Vita* was written by the 'anchorite of Llanddewi Brefi' in the early fourteenth century, and he restored St Gwenfrewi to life. The *Vita* tells us that Beuno left Montgomeryshire for Caernarfonshire when he heard a pagan Saxon across the river calling his dogs. Beuno rushed to his monks and told them 'My sons, put on your clothes and shoes, and let us leave this place for the nation of this man I heard setting on his hounds has a strange language which is abominable and I heard his voice. They have invaded our lands and will keep it in ownership.' St Beuno's Well at Tremeirchion has its waters gushing from a human head of unknown date, recalling the link between sacred springs and the Celtic cult of the prophetic severed head.

BEVAN, ANEURIN (1897-1960) The National Health Service was pioneered in Britain and copied in civilised countries all over the world, largely based upon the example of a Welsh valley community scheme. Tuberculosis and pneumoconiosis were rife in nineteenth-century Wales, but in the 1890's Tredegar established the Workmen's Medical Aid Society, with its own doctors. Workers paid the equivalent to just over 1% of their income, for dentistry services, spectacles and midwives. Its doctors included A.J. Cronin, who wrote about the new scheme and its effects in *The Citadel*. In 1923, Aneurin ('Nye') Bevan was elected to the Hospital Committee, allied to the Medical Aid Society. As Minister of Health just over three decades later, he launched the National Health Service. A leader in the Welsh Miners' strike in The General Strike of 1926, Bevan had become a Labour MP in 1931, and in World War II was frequently a 'one-man opposition' to Winston Churchill. One of the most attractive aspects of Nye's personality was that he never tried to disguise his roots – not for him the claret-smooth old boy networks of miner's son Roy 'Woy' Jenkins. Nye Bevan was unequivocal in his attachment to the working classes: 'No amount of cajolery, and no attempts at ethical and social seduction, can eradicate from my heart a deep burning hatred for the Tory Party... So far as I am concerned they are lower than vermin.' Bevan ostensibly resigned from the post-war Attlee Government over charges being introduced for teeth and spectacles. However, the real reason was the foreign and defence policy of that Labour Government. The scale of the arms budget, forced upon Britain by the U.S. government during the Korean War, was unsustainable. Even his implacable enemy Winston Churchill later acknowledged that Bevan was right. He was deputy leader of the Labour Party when he died of cancer. Demonised by the press in his lifetime, this noble and honest man is commemorated in a statue at the west end of Cardiff's Queen Street.

BEVAN, BRIDGET (1698-1779) A great philanthropist and educationist, she was known as 'Madam Bevan'. Born Bridget Vaughan, she had assisted GRIFFITH JONES with the work

of his circulating schools, so on his death he left her the funds of his schools and his private fortune. She carried on his work with great success, so that the year 1773 saw the pinnacle of the movement with 242 schools and 13,205 pupils.

BEVAN, EDWARD JOHN (1856-1921) He studied chemistry at Manchester and in 1892, with Charles Cross, patented the viscose process of rayon manufacture. Using cellulose, either yarn (rayon, or artificial silk) or film (cellophane) could be manufactured, giving the world a quantum leap in materials technology.

BIRD, WORLD'S OLDEST The oldest living bird in 2008 was a Manx Shearwater on Bardsey Island, first ringed in 1957. It is thought that it was born in 1952, and to have travelled well over 5 million miles. More than half the world's population of Manx Shearwaters breed in Wales, with around 16,000 pairs on Bardsey. There are 120,000 breeding pairs on Skomer and a further 45,000 pairs on Skokholm, making the two islands the largest known concentration of this species in the world. Young Manx Shearwaters go to sea, at night, without their parents, and immediately head for the winter quarters off the coast of southern Brazil and Argentina. Ringing studies on Skokholm and Skomer show that some of the young make this 6,000-7,000 mile journey in less than a fortnight.

BISHOPS CASTLE The motte in Shropshire was founded by the Bishop of Hereford around 1120, and captured by Llywelyn ap Iorwerth in 1233. Much of Shropshire, like other Marcher counties, was still Welsh-speaking at this time.

BLACK DEATH 1348-49 Even before this plague, the climate was deteriorating with wet summers, and disease was rife among animals and humans. Carried by rat fleas, the Black Death reached Abergafenni and Carmarthen in December 1348. In 1349, many rents could not be collected and courts could not be held, as at least a quarter of the population of Wales had died. However, Wales suffered less than other European countries because of the lack of major towns. One of the impacts we know is that whereas lay brothers used to work for the abbeys and monastic granges, within a few years of the plague ending most of the monastic estates had been leased out to tenants, because of lack of manpower across Wales. Fewer monks meant that unfortunately there is a paucity of chronicles for the second half of the fourteenth century, and English clerics started taking over Welsh livings. There was emigration to England to escape excessive taxation. Plague struck again in 1361 and 1369. In 1349, Ieuan Gethin lamented: 'We see death coming into our midst like black smoke, a plague which cuts off the young, a rootless phantom which has no fair countenance. Woe is me of the shilling in the armpit; it is seething, terrible, wherever it may come, a head that gives pain and causes a loud cry, a burden carried under the arms, a painful angry knob, a white lump. It is of the form of an apple, like the head of an onion, a small bulb which spares no one. Great is the seething, like a burning cinder, a grievous thing of an ashen colour... the early ornaments of black death, cinders of the peelings of the cockle weed, a missed multitude, a black plague like halfpence, like berries. It is a grievous thing that they should be on a fair skin.'

BLACK WILLIAM, GWILYM DDU (*c.* 1200-1230) William de Braose, tenth Baron Abergavenny and Lord of Builth was detested by the Welsh, hence his nickname. The de Braose family, out of all the Norman Marcher lords, was probably the most treacherous, which is an accolade indeed. William de Braose married a daughter of William Marshal, Earl of Pembroke, and his own daughters married Dafydd ap Llywelyn, Roger Mortimer, Humphrey de Bohun and William de Canteloup. De Braose was captured at Ceri, near Montgomery in 1228, fighting the forces of Llywelyn the Great. He was ransomed for £2,000 and allied with Llywelyn, arranging for Llywelyn's son Dafydd to marry his daughter Isabella de Braose. On a visit to Llywelyn in Easter 1230, Black William was found with Llywelyn's wife Siwan (Joan, the daughter of King John) in Llywelyn's private bedchamber. *The*

Chronicle of Ystrad Fflur tells us: 'In this year William de Breos the Younger, lord of Brycheiniog, was hanged by the Lord Llywelyn in Gwynedd, after he had been caught in Llywelyn's chamber with the king of England's daughter, Llywelyn's wife.' William was publicly hanged by Llywelyn on 2 May 1230, at Aber Garth Celyn, the marshland at the foot of the royal palace of GARTH CELYN. He was hung at the outlet of the sewers of the palace at Abergwyngregyn. The place is still known as Gwern y Grog, 'Hanging Marsh.' Llywelyn wrote to Black William's wife asking if she still wanted the marriage of his son Dafydd and her daughter Isabella to go ahead, which she confirmed. He also informed her of his infidelity, and asked if she wanted his body. She refused it, so Llywelyn placed it in a mountain cave to be eaten and distributed by wolves. Llywelyn forgave Siwan, and he genuinely grieved when she died in 1237, founding a Franciscan friary on the seashore at Anglesey, opposite Garth Celyn.

BLAENAU FFESTINIOG The town at the centre of a huge slate quarrying complex is one of the last bastions of the Welsh language. Its narrow-gauge railway to Porthmadog on the coast, once used for the slate trade, is now a wonderful visitor attraction, passing through marvellous scenery. One can visit the huge Llechwedd Slate Caverns here.

BLAENAFON INDUSTRIAL LANDSCAPE In Monmouthshire, this site was added to the World Heritage Sites list by UNESCO in 2000. The area retains evidence of the days of the Industrial Revolution in coal mining and iron manufacture, with quarries, buildings, mines and furnaces.

BLAENLLYNFI CASTLE In Breconshire, it belonged to the Fitzherberts from 1208 to 1215, then to the de Braoses, but went back to the Fitzherberts before Llywelyn ap Iorwerth sacked it in 1233. It was rebuilt, but taken by Llywelyn ap Gruffudd in 1262. A Fitzherbert was back in control in 1273, but the castle was seized by the Crown in 1322 and given to the Despensers.

BLAENRHONDDA IRON AGE SETTLEMENT
On high open moor land near Treherbert, this sprawling village is remarkable in that it has no defences, perhaps signifying the strength of the local tribe.

BLEDDFA CASTLE In 1195, Richard I gave Huge de Say a licence to refortify this Norman castle in Powys, but that same year de Say was killed in battle at RADNOR. It was destroyed in 1162 by Llywelyn ap Gruffudd, after he captured it from the Mortimers. Much castle material was used in building the nearby church tower, after the church was destroyed by the Welsh in 1403.

'BLUE BOOKS' 1847 After riots in Wales in the 1830's and 40's the Government commissioned a number of reports into the restlessness, one of which investigated education. Published in 1847 and known as the *Blue Books Report* from its bindings, it caused lasting anger in Wales. The report criticised both the Welsh language and the morals of the Welsh. The 1851 Census showed that Anglicans were a minority in Wales, and the findings of the Blue Books became part of a bigger religious debate about the defects of Nonconformism against the state religion.

BOG Wales possesses seven RAMSAR Sites, 'wetlands of international importance', at Burry Inlet, the Dee Estuary, Llyn Tegid (Lake Bala), Cors Caron, Cors Fochno and the Dyfi, and Crymlyn Bog. The Dyfi Estuary is a Biosphere Reserve of 2100ha, designated in 1977 to conserve a major type of ecosystem. Major upland peat bogs are presently being destroyed forever by wind farms and their assorted pylons, substations and access roads. Britain has 15% of the world's peatlands, which contain roughly 5,000 tonnes of carbon per hectare and absorb carbon from the air at a rate of 0.7 tonnes per hectare per year. There is more carbon in peat bogs than in the whole of the earth's atmosphere. If peatlands are growing naturally, they have the potential to store this carbon indefinitely and continue to absorb more of it. When disturbed, drained and mined, the peat

decays and releases the carbon back to the atmosphere in massive quantities. These precious bogs cannot be replaced – whereas a tree can be grown in 100 years, a bog takes thousands of years to restore itself.

BOOK OF ST CHAD This wonderful illuminated missal, in reality the *Teilo Gospels*, was taken to Llandaf with ST TEILO'S relics from Llandeilo before 850, and at some stage was appropriated by Lichfield Cathedral. It is marginalised with notes on Welsh land transactions of the sixth century onwards. The manuscript is comparable with the *Book of Kells* and the *Lindisfarne Gospels*, but church authorities refuse to return it. An early medieval Welsh poem notes 'the book grabbing monks of Lichfield.' Wales had scriptoria before Ireland, Scotland or England, and nothing remains of this learning except the *Book of Teilo*. In the thirteenth century a monk called Ysgolan was charged with destroying Welsh records, deeds and the libraries, of those princes which had not yet been burnt by the Normans, Vikings, Saxons or Irish. One reason was to destroy all writings tainted with Pelagianism, but the main reason was to destroy records of land ownership so that the Welsh could not reclaim their lands. Most Welsh history has therefore come from oral sources, or from Breton records. Because so much has been destroyed, authorities refuse to believe that the Welsh (Christian when England, Scotland and Ireland were barbarian) could have had scriptoria and illuminated manuscripts, whereas large scriptoria are actually recorded at Margam, Llanbadarn Fawr and other monasteries.

BOOTH, RICHARD, MBE (1938-) In 1971, on 1 April, Richard George William Pitt Booth declared independence for Hay-on-Wye and crowned himself King of Hay, having created of the world's first 'Book Town'. His horse was created and named *Prime Minister*. Recently he has developed the barter currency, 'Boothos'. He lives in Hay Castle and is credited with transforming the town into a global attraction for second-hand book lovers. In 1961, he opened his first second-hand bookshop in Hay, shipping in hundreds of books from across the globe. Booth was convinced that a town full of book stores could become an international attraction – 'you buy books from all over the world and your customers come from all over the world'. Where he led, others followed and there are now almost forty bookshops in the tiny town – many of which used buildings which had been long neglected. Richard Booth's first store, for example, was housed in the Old Fire Station. By the late 1970s, Hay had become the world's first official Book Town. There are now more than sixty Book Towns across the globe with plans for several more. April Fool's Day 2000 saw Richard Booth organize another event which gained mass media attention. In the State Room of Hay Castle, he held an investiture of 'The Hay House of Lords' and created twenty-one new hereditary peers for the Kingdom of Hay. As Hay's reputation as a Mecca for book-lovers grew, so too did the idea for an annual book celebration and in 1988, the first ever Hay Literary Festival was held. Under the direction of Peter Florence, the week-long festival now brings in around 70,000 visitors every year and attracts some of the biggest names on the circuit. In 2002, former US President Bill Clinton was the star speaker. He described Hay-on-Wye as 'my kind of town' and (his script-writers) likened the festival to a '*Woodstock of the mind.*' What a priapic liar has to do with literature is another matter. Booth has now started 'The Real Hay Festival' from 2008 to bring events back into the town and help local trade, away from the pavilions in the fields to the west. The author and Richard Booth made a presentation to the Vale of Glamorgan Council offering to turn the desolated centre of Barri into the world's first 'bookport' and regenerate the town's economy but were met by overwhelming apathy. Barri is Wales's fourth biggest centre of population and does not have a single bookshop.

BOSHERSTON Bosherston Lakes, also known as Bosherston Lilyponds, are three long fingers of water dammed in the eighteenth century to make a country estate, complete with an Iron Age camp on one of the peninsulas. Nearby are the sheltered beaches of Broad Haven and Barafundle Bay. St Govan's sixth-century chapel is in a cleft in the nearby rocks. Legend links Govan with Gawain, of Arthurian Round Table fame.

BOSTON TEA PARTY On the night of 16 December 1773, SAMUEL ADAMS led a band of the 'Sons of Liberty' disguised as Mohawk Indians. They boarded three British ships in Boston Harbour and dumped 342 chests of tea into the water. They did this to prevent the tea being landed, in which case the colonists would have to pay an exorbitant tax on the tea. Their act was copied across the North American harbours, destroying the East India Company's monopoly of trade and forcing coercive laws from George I's government. The Welshman Adams and his cousin JOHN ADAMS fomented rebellion, leading directly to the actions at Lexington and Concorde in 1775, and the decision by the Second Continental Congress to declare war with England on 10 May 1775. Adams signed the Declaration of Independence, along with fellow Welshmen John Adams, THOMAS JEFFERSON, William Williams, Stephen Hopkins, Francis Lewis, Lewis Morris, Robert Morris and Button Gwinnett. More than any other man, Adams united the various factions in Congress and New England to begin the War of Independence.

BOSWORTH FIELD, BATTLE OF, 1485 Sailing from France with 2,000 men to land near Milford Haven, HENRY TUDOR headed across Wales and gathered forces, as the Lancastrian claimant to the throne. The Yorkist Richard III had 11,000 to 12,000 men drawn up on Ambion Hill near Market Bosworth in Leicestershire. Henry had gathered a force of 5,000-7,000 troops, but there were also forces belonging to Lord Stanley and his brother, of 5,000, and 3,000 men, to the north and south of Richard's army. Richard expected the Stanleys to help him, but had taken hostages to be sure. It seems that the Earl of Oxford led part of the Lancastrian army to attack Richard's right flank, while the Stanley armies remained uncommitted. Northumberland's royalist troops also stayed static, and Henry's army approached Stanley's men. Richard saw Henry's banner moving towards Lord Stanley and led a charge to cut him off, almost succeeding, but was killed as Stanley's men joined Henry's army. Henry VII and the Tudor Dynasty was established.

BOTANY Wales has several tracts of ancient woodland, including the Pengelli Forest in Pembrokeshire, with sessile oaks and midland hawthorn. The *Wild Service* tree appears to have its last foothold in Britain, at a secret site near Aberthaw. Rare arctic-alpine plants, remnants of the Ice Ages, are found in Cwm Idwal in the Ogwen Valley, the Brecon Beacons and Snowdonia, for example the *Snowdon Lily* (Lloydia serotina) is only found around Snowdon, probably discovered in the seventeenth century by EDWARD LHUYD. Other rare alpine species are the purple saxifrage, moss campion, tormentil and mountain avens. The coastline supports Sea Holly, Sea Lavender, Devil's Bit Scabious, Sea Campion, Sea Vetch and Sea Aster, with glorious banks of pink sea thrift. The *Welsh Poppy*, bright yellow, can sometimes be seen in mountain areas, and the *Tenby Daffodil* and the *Pembrokeshire Primrose*, a pink variety, are fairly common in the south-west. Wales used to be covered with oak trees, and the famous oak at Bassaleg Village near Newport was converted into 2,426 cubic feet of timber for Nelson's warships in 1802, then the most ever recorded from a single tree. Unfortunately, the Forestry Commission has now covered vast swathes of Welsh hillsides with Sitka Spruce as a cash crop. The mountains never recover from the alteration in the acidity of their soil. The landscape is altered irrevocably and archaeological sites have been ruined forever by the Forestry Commission.

BOY STOOD ON THE BURNING DECK
This line is the beginning of *Casablanca*, a poem by Felicia Hemans (1793-1835), who regarded Wales as *'the land of her childhood, her home and her death.'* She also was the first to write the phrase 'the stately homes of England'. Her romantic poetry was popular at the same time as that of Wordsworth, Shelley, Scott and Byron, and she wrote many Welsh patriotic verses, being known as 'a poet for Wales'.

BOXING see JIM DRISCOLL, TOMMY FARR, FREDDIE WELSH, JIMMY WILDE, JOE CALZAGHE Boxing was a traditional route out of the Welsh valleys. Percy Jones was Wales' first world champion, at flyweight in 1914. In one of the great fights in history, Tommy Farr almost beat Joe Louis in his prime at Madison Square Garden in 1938. Howard Winstone was world featherweight champion in 1968, and Colin Jones fought three times for the world welterweight championship, drawing in 1968, then losing on a split decision and then being stopped for a bad cut. Johnny Owen died in 1980 fighting for the world bantamweight championship, after being knocked out in the twelfth round. In December 1997, Barry Jones won the WBO super-featherweight championship to join the flyweight Robbie Regan (1995) and Joe Calzaghe as world champions. Steve Robinson held the WBO featherweight championship in the 1990's also. Calzaghe beat Roy Jones Junior at the Madison Square Gardens in 2008, to remain undefeated in 46 fights, before retiring unbeaten in 2009. He had been a World Champion at different weights since 1997.

BRANGWYN, SIR FRANK (1867-1956) He painted huge murals for The Royal Exchange, Lloyds, and the New York Rockefeller Centre etc. His murals for The House of Lords are now in Swansea Guildhall, and there are museums dedicated to his life and work in Orange (France), and Bruges (his birthplace).

BRAN, FIRST CENTURY CE The father of Caradog (Caractacus), he was said to have spent seven years in exile with his son in Rome, where he became a Christian and met St Paul. Bran Fendigaid (the Blessed) supposedly brought Christianity back to Britain in the first century, to Trefran, near Llanilid in Glamorgan. Llanilid itself was said to be founded by Joseph of Arimathea, St Ilid.

BRANWEN FERCH LLYR, FIRST CENTURY CE This is Queen Bronwen of Ireland, whose legend links the first-century King Bran and the *Mabinogion*. The daughter of Llyr (King Lear), she married King Matholwch of Ireland to halt the incessant wars between the Irish and Welsh nations. Mathowch had come to Twr Bronwen (later called Caer Collen and then HARLECH) with thirteen ships to seek her hand from Bendigeidfran (BRAN the Blessed, the father of Caradog), to form an alliance across Ynys Prydein, the Isle of Britain. The wonderful story is too long to recount, but ends with the Welsh invading Ireland, King Bran being fatally wounded and Branwen dying heartbroken on the bank of the River Alaw in Anglesey, where the tomb Bedd Branwen commemorates her.

BRECON (ABERHONDDU) The three highest peaks in South Wales are near this town, being Pen Y Fan, Cribin and Corn Du, and the town was built where the Usk meets the Honddu, hence its original Welsh name, Aberhonddu – the mouth of the Honddu. Brecon is named after the sixth-century Brychan Brycheiniog, and was the county town of Breconshire, with a charter dating back to 1246. Another charter of 1366 gives it the right to hold fairs (which are still held), and the annual Brecon Jazz Festival has been a highlight of the Welsh cultural year. The town has architecture dating back to medieval times. The Monmouthshire and Brecon Canal (1797-1812) terminates outside the town. Christ College is on the banks of the Usk and was founded in 1541, becoming a public school in 1853. It incorporates the chapel of a twelfth-century friary. The Brecon Museum is an excellent repository of local folklore and history, and the South Wales Borderers' Museum has thirteen of the twenty-three VC's awarded to the regiment's soldiers.

BRECON, BATTLE OF, EASTER 1093 RHYS AP TEWDWR, Prince of Deheubarth, was killed here, allying with his brother-in-law Bleddyn ap Maenarch (the last Prince of Brycheiniog) against the Norman Bernard de Neufmarche. This event was followed by a general invasion of South Wales by the Normans. It is not certain whether there was a battle, a skirmish or whether

Rhys had been lured to a meeting and killed by treachery. Near the village of Battle there is Cwm Gwyr y Gad, 'the valley of the men of battle'. Rhys ap Tewdwr was also supposed to have been killed at Hirwaun in battle. According to *The Chronicle of Ystrad Fflur*, Rhys, 'king of the South, was slain by Frenchmen who were inhabiting Brycheiniog – and with him fell the kingdom of the Britons. And within two months the French overran Dyfed and Ceredigion – and made castles and fortified them.' His daughter was Princess NEST.

BRECON CASTLE On an ancient site, and near vital fords over the Usk, its first motte and bailey castle was built by Bernard de Neufmarche around 1100, after taking the land from the Welsh. The keep and parts of the structure date from the thirteenth century, and the castle became the headquarters of the Lordship of Brecon. Attacked by the Welsh six times between 1215 and 1273, it was taken three times, in 1215, 1264 and 1265. A hotel is now part of the castle.

BRECON CATHEDRAL The thirteenth-century Priory Church of St John was designated a cathedral in 1923.

BRECON ROMAN FORT – Y GAER Y Gaer is at Aberyscir, founded about 75 CE near the River Usk. The perimeter walls still exist and finds are in Brecon Museum.

BRECONSHIRE, BRECKNOCKSHIRE, SIR FRYCHENIOG (SEE THIRTEEN SHIRES) Brycheiniog is one of thirteen historic counties of Wales. The kingdom of Brycheiniog dates from the fifth century. In the Norman period, the area was classified as a lordship, generally subject to the Marcher Lords, the Mortimers, who controlled much of south and east Wales. Henry III transferred its Lordship to Llywelyn ap Gruffudd in 1267 by the Treaty of Montgomery. However, the Marcher Lords Roger Mortimer and Humphrey de Bohun attacked Brycheiniog in 1276, destroying the peace between Llywelyn and King Henry. The consequent dispute ended in Prince Llywelyn's retention of only Gwynedd, and to his eventual ambush and murder in 1282. Brycheiniog was then made subject to the King of England, and became a county modelled on the English shire system under the Laws in Wales Acts of 1535-1542. The county now corresponds roughly to the combined territories of the former kingdom of Brycheiniog and the kingdom of BUILTH (Buallt), which were brought together under the 1284 Statute of Rhuddlan.

BREIDDIN HILLFORT, Y Occupied from the Bronze Age, through the Iron Age and during the Roman occupation, the site survives (after some quarrying) on a ridge near Welshpool. Round Iron Age huts were replaced by rectangular buildings during later Roman times.

BRIDGEND (PEN-Y-BONT AR OGŴR) At the southern end of the Ogŵr (Ogmore), Garw and Llynfi valleys, the River Ogŵr runs through the town. Because of its strategic position, guarding against the Welsh coming from the north into the prosperous Vale of Glamorgan, there is a Norman castle (Newcastle) overlooking the town, plus other powerful fortresses within two miles at COITY and OGMORE. (Also see EWENNI PRIORY and CANDLESTON CASTLE). There is a fifteenth-century stone bridge, repaired in the eighteenth century, across the river. From nearby Island Farm POW camp, seventy Axis officers escaped in 1945, but were all recaptured. The hut they escaped from still stands.

BRIDGES Being a nation of hills and rivers, Wales is obviously notable for its number of bridges. The arched bridge in PONTYPRIDD, built in 1775, was once the largest single-span bridge in the world, a single high arch of 160ft, successfully erected after three collapsed attempts by its self-taught stonemason, the Methodist Reverend WILLIAM EDWARDS. His three sons also became bridge-builders. Thomas Telford's Menai Suspension Bridge, completed in 1825, was the world's first iron suspension bridge, carrying the London to Holyhead (A5) road across the

Menai Straits. A masterpiece of nineteenth-century engineering, it is 1,265ft long with a central span of 579ft, the longest single span of its time. It had to be 100ft above the Strait to allow sailing ships to pass. All the wrought iron work was heated and soaked in linseed oil before being put in place, not quite as the White Knight told Alice:

> I heard him then, for I had just
> Completed my design
> To keep the Menai Bridge from rust
> By boiling it in wine.

The great Robert Stephenson's Britannia rail bridge, finished in 1850, also stands near the Menai Bridge. The second Severn Bridge, completed in 1996, is the UK's longest-span cable-stayed bridge, with a main span of almost 1500 feet. The overall length of the structure, around 17,000 feet makes it the longest bridge in Britain. The tallest multi-span bridge in Britain was the Crumlin Viaduct at 200 feet, which was criminally demolished in 1966. (It is a pity that councillors and planning officials cannot be prosecuted for destroying buildings). The tallest bridge in Britain is now the Mewbridge Bypass in Clwyd at 188 feet. The longest bridged aqueduct in Britain is the fantastic Pont Cysyllte, built to carry the Shropshire Union Canal over the River Dee. It was designed by Thomas Telford, opened in 1805 and still in use today. It is 1006 feet long, and has nineteen arches up to 121ft higher than low water on the River Dee below it. Sir Walter Scott called Pontcysyllte Aqueduct 'the greatest work of art the world has ever seen.' Telford also built the beautiful Llangollen Canal aqueduct in 1801, in the Ceiriog Valley, seventy feet above the river.

Newport's Transporter Bridge is a rare survival. Built between 1902 and 1906 by a Frenchman, Ferdinand Arnodin, it can carry cars across the river Usk on a cradle platform hung from cables. It was built to accommodate tall ships and some of the highest tides in the world. It is 250 feet high, and four iron pillars support an iron grill, under which runs an electrically-powered platform holding the cars. Barmouth Bridge is built on 113 wooded trestles to take the Cambrian Coast railway across the wonderful Mawddach estuary. Opened in 1866, there is also a walkway which serves as a promenade to admire the river mouth and mountains. One of Wales' most beautiful villages is the thatched Merthyr Mawr, near Bridgend. Its 'Dipping Bridge' over the Ogmore River has been used for centuries. A flock of sheep is driven onto the bridge, and improvised gates erected at both ends. Sheep are then pushed through special holes in the parapet to drop six feet into the cold waters below. They swim to the bank, where watchful sheepdogs guide them back into the flock.

BRITHDIR ROMAN FORT Near Dolgellau, it was abandoned as early as 120 CE, and there is evidence of lead smelting and tanning on the site.

BRITONS The English were known as the English, and the Scots as the Scottish, up until the time of Elizabeth I. The Welsh were always known as the Britons until JOHN DEE invented and developed the concept of a 'British Empire' to justify the expansion of Elizabethan England. Hence the Welsh Assembly should be known as the British Assembly.

BRITTANY Ancient Armorica, the north-west part of France, was the centre of a confederation of Celtic tribes. In the fifth and sixth centuries many British Celts fled there, across the old trading routes, to escape the growing pressure from Germanic Angles and Saxons invading Britain from the East. There were three main waves of emigration from Cornwall and Wales. They called their new home Brittany or Britain, to distinguish it from Great Britain, Grande Bretagne. These Britons, later called Bretons, converted the Armorican Celts to the Celtic Christianity they had practised in their old land. The legend of Cynan (Conan) Meriadoc persists that he led an army of Britons from Wales to support Macsen Wledig (the Emperor Maximus), to defeat the Roman

emperor Gratian. Upon the death of Maximus, this army settled in Armorica, where they spoke the same language. Brocielande, in Brittany, has strong connections with Arthur and Merlin. In its centre, in the Abbey at Paimpont, there is an exhibition of a banners of the holiest Breton saints – of their 'SEVEN FOUNDERS', six are of Welsh missionaries, the other being the Cornish Briton, Corentin. Brittany was settled in the fifth century by Welsh and Cornish Celts, and their language is very similar to Welsh and Cornish. The Breton 'k' disappeared from Welsh a few hundred years ago, but the 'z' of Breton remains in the Cornish alphabet but not the Welsh. The region the Bretons call Armor, the ports and nearby coastal villages, is made up of the Welsh words ar (at or on) and mor (the sea). Their internal, formerly heavily wooded areas, Argoat, has the same derivation – ar and coed (at the woods), with the 'c' being mutated to 'g' in Welsh making Argoed. In 1488, Brittany lost its independence to France, just three years after their Welsh cousins took over the English throne. Duchess Anne of Brittany married Charles VIII of France. The Union was ratified in 1532, just four years before the Act of Union joined England and Wales under the Tudor dynasty. Since then the attempts to stamp out the Breton language have been even fiercer than those by the English government against the Welsh. The Bretons, however, kept their culture by not going through the fervent religious revival that Wales underwent in the eighteenth and nineteenth centuries. As a result their dance, song and costume have survived more or less intact. Each village still has processions (pardons) or a night feast (fest noz) devoted to its local saint on a special annual saint's feast day.

BRONLLYS CASTLE North of Brecon, an 8oft-high round keep surmounts the massive Norman motte. On the confluence of the Llynfi and Dulais rivers, it was built to protect Brecon from Welsh attacks. In 1233 it changed hands twice, and from 1311 was owned by Rhys ap Hywel ap Meurig, as a reward for his loyalty to Edward I. However, for rebellion he lost his properties until 1326. In 1328, Rhys rebelled against Edward II, and with Henry of Lancaster, captured Edward and sent him to Berkeley Castle to be killed. Henry de Bohun convinced the king that Bronllys should be taken from Rhys's son Philip and given to him, and it later passed to the king in 1399, and then to the Vaughans and the Dukes of Buckingham.

BRON-YR-ERW, BATTLE OF, 1075 Gruffudd ap Cynan and his Irish and Norse mercenaries were defeated by Trahaearn ap Caradog of Powys and Gruffudd was expelled from Wales, once more to exile in Ireland. The battle took place above Clynnog Fawr, after Gruffudd had defeated Trahaearn at Gwaed Erw in Meirionnydd, and was occasioned by the Welsh in the Llŷn Peninsula rising in revolt against the behaviour of Gruffudd's Danish bodyguard.

BRUNT, SIR DAVID FRS (1886-1885) Born at Staylittle, Montgomery, the tenth child of a farm worker, he won scholarships to Aberystwyth and Cambridge universities, and achieved first-class degrees in both. At Imperial College, he was the first full-time Professor of Meteorology in Britain, and became the most distinguished meteorologist in Britain. The fundamental period of atmospheric oscillation is known internationally as the 'Brunt Period' after this scientist, and for some reason the head of the Meteorological Office has nearly always been Welsh.

BRYCHAN BRYCHEINIOG – FIFTH-SIXTH CENTURY Mention should be made of the family of Brychan Brycheiniog, a contemporary of Cunedda and Vortigern in 'The Dark Ages'. From his kingdom of Breconshire, many of his children became saints commemorated across Wales. His male offspring who became saints include Cynog, Clydog and Berwyn. Other sons included Arthen, Gwen, Gerwyn and Pasgen. Cynin Cof mab Tudwal Befr (Cynin, son of Bishop Tudwal) was a grandson of Brychan and a character in the *Mabinogion* story of *Culhwch and Olwen*. Some of Brychan's many daughters commemorated as saints are Arianwen, Tudful (martyred at Merthyr Tydfil), Tybie (Llandybie), Dwynwen (Llanddwynwen), Hawystl, Mwynen, Cain (Llangain and Llangeinor), Eleri, Ceingar the mother of Saint Cynidr (Llangynidr), and Meleri the grandmother of Dewi Sant. Other daughters included Bechan or

Bethan, Ceindrych, Ceinwen, Goleuddydd, Gwen (Gwenllian or Gwenhwyfar, who may have married King Arthur), Gwawr (the mother of the poet-soldier Llywarch Hen) and Tangwystl (Ynystanglws, near Swansea). Brychan's daughter, Saint Gwladys, married Saint Gwynlliw, King of Gwent (after whom St Woolo's Cathedral in Newport is named), and their son was Saint Catwg (CADOG, Cadocus), who established the famous monastery at Llancarfan and churches throughout South Wales, Cornwall and Brittany.

BRYN CELLI DDU BURIAL CHAMBER In Anglesey, sunrise at dawn on the Summer Solstice, 21 June, passes along the narrow chamber to hit the wall at the back of this tomb, similar to the effects at Newgrange in Ireland.

BRYN DERWEN (DERWYN, DERWIN), BATTLE OF, 1255 On the Llŷn Peninsula, near Clynnog and on the borders of Arfon and Eifionydd, this was the final in a series of bloody battles between the young Llywelyn ap Gruffudd and his brothers Owain and Dafydd. Owain was imprisoned in CRICIETH and DOLBADARN castles and Dafydd escaped to assist Henry III against Llywelyn. Within weeks of his final victory Llywelyn, before turning his attention to the rest of Wales, set about bringing all of Gwynedd under his control. In 1256 he attacked Gruffudd ap Gwenwynwyn, the prince of Powys, forcing him to flee for protection into the arms of the Anglo/Norman garrison at the castle in Shrewsbury. He then wrested Builth castle from its castellan Mortimer, before recovering the counties of Cardiganshire and Carmarthenshire for the Welsh. Treaties with Deheubarth and Powys made him the pre-eminent prince in Wales. Bryn Derwen was the critical point in his rise to power.

BRYN EURYN HILLFORT – THE BATTLE OF NANT SEMPYR (see Ednyfed's Castle) At Mochdre, it covers two summits and the hollow of a steep hilltop. Here a Roman expeditionary force led by Sempronius was ambushed and exterminated, in the valley between Bryn Euryn and the hills to its east. The valley is called Nant Sempyr, the Valley of Sempronius.

BRYNFFANIGLE UCHAF EARTHWORK This motte near Abergele is notable for being the home of Ednyfed Fychan (d. 1246), Chancellor and Chief Councillor to Llywelyn the Great, and the ancestor of the Tudor dynasty.

BRYN OWEN, BRYN OWAIN – BATTLE OF, 1401 & 1405 The site is still marked on old maps but does not feature on Ordnance Survey maps. On Stalling Down, near Cowbridge, Owain Glyndŵr and his French allies fought for up to eighteen hours, defeating Henry IV's army, with the king retreating. In the ravine, it was said that the blood was fetlock-deep. Both dates are given for battles during the Glyndŵr War of Independence, the second one being that when the French were involved. The ruins of Llanquian Castle are on Stalling Down, and it may have played a part in the battle, as may the nearby hillfort. There may have also been a battle here in 1403.

BRYN Y CASTELL HILLFORT Near Ffestiniog, it has been partially reconstructed, and there is evidence of iron smelting both in the Iron Age and soon after the Roman occupation.

BRYN-Y-GEFEILIAN ROMAN FORT Near Capel Curig, there are remains of a bathhouse, but it was only used c. 90 CE-c. 120 CE, possibly to protect lead and silver smelting nearby.

BUDDUG (BOADICEA) (d. 62) Her husband was King Prasutagus of the Iceni, and as a client-king of Rome followed the usual practice of leaving his kingdom to his two daughters, with the Emperor of Rome as co-heir. While the governor, Suetonius Paulinus was fighting in Anglesey,

his procurator Decianus Catus took over the Iceni kingdom in 60 CE, flogging Buddug, with her daughters being raped. The Iceni rose and wiped out the IX Legion and then Colchester, having also heard of the massacre of the bards at Anglesey. The Trinobantes joined the uprising and the 40,000 inhabitants of London were killed and the city razed. St Albans (Verulanium) was next to be destroyed and from 60-61 the Romans were repeatedly beaten. In 62 Boadicea was finally defeated and took poison, possibly at Newmarket (Trelawnyd) in Flintshire.

BUILTH CASTLE Not generally realised, this was one of Edward I's 'iron ring' of castles, but has lost its stonework over the centuries. In 1183 there had been a battle at the original motte and bailey site, and it the 1240's it was first fortified with stone. It had been besieged in 1223 by Prince Llywelyn, given to him in 1229, and on his death passed back to the Normans. It was repeatedly besieged from 1256 to 1260, when it fell and was demolished by the Welsh. From 1277, Edward I transformed it into a powerful castle with six strong towers. In 1282, Llywelyn ap Gruffudd left his castle at Aberedw, three miles away, to ask for support from Builth Castle, and was shortly after entrapped and murdered. Owain Glyndŵr failed to take the castle. The nearby castle at Caer Beris was destroyed by The Lord Rhys in 1168 and stayed in Welsh hands when it was rebuilt.

BUILTH WELLS, LLANFAIR-YM-MUALLT The original Welsh name for Builth means 'The Church of Mary in the Cow Pasture'. The people of Builth Wells have had a nickname until the nineteenth century of 'bradwyr Buallt', 'Builth traitors', because of the story that they would not let Llewelyn Olaf (Llywelyn the Last), into their gates just before he was killed. Its sulphur waters were known as far back as 1740. Saline water was later discovered there in 1830, and by the late nineteenth century, the spa had a Central Pavilion for gentlemen and ladies to come and 'take the waters'. The wells were most popular around 1890, when the chalybeate and saline springs were used by those suffering from heart, kidney and gout disorders. The Royal Welsh Agricultural Show at adjoining Llanelwedd, held over four days every year on a permanent site, is one of Europe's finest shows of its kind.

BULWARKS CAMP This is a double-banked Iron Age coastal fort at Chepstow, which was also settled in Romano-Celtic times.

BULWARKS IRON AGE FORT Outside Porthkerry in Glamorgan used by the Silures and also in Roman times, it is a double-banked promontory fort, some of which has been lost to the sea.

BURIAL CHAMBERS/CHAMBERED MOUNDS Usually Neolithic and found in the coastal or lowland areas, some of the most impressive are: Parc Cwm, Capel Garmon, Ffostill North, Gwernvale, Nicolaston, Pentre Ifan, Pen y Wyrlod, Tŷ Illtud, Tŷ Isaf and the remarkable Tinkinswood. Some of these stone chambers, like Tinkinswood near Cardiff, were covered by a mound of earth up to 150ft long and 75ft wide and would have stood at least 10ft high.

BURRY HOLMS Off Rhosili Bay on the Gower Peninsula, the rocks can be reached at low tide, and there is an Iron Age settlement and remains of a twelfth-century church. In the Burry Estuary, Amelia Earhart landed in 1928, becoming the first woman to cross the Atlantic in her seaplane *Friendship*. With her companions Wilbur Stultz and Louis Gordon, she thought she had landed in their intended destination of Ireland.

BURTON, RICHARD (1925-1984) Born Richard Jenkins, he came from the same neighbourhood near Port Talbot as Anthony Hopkins, and after Oxford University trained at RADA. A superb stage actor, he also received seven Academy Award nominations and twice married Elizabeth Taylor. His Oscar nominations were for best supporting actor in 1952 for *My Cousin Rachel* and then six best actor nominations for *The Robe, Becket, The Spy Who Came In From The Cold, Who's*

Afraid Of Virginia Woolf, Anne Of The Thousand Days and finally *Equus* in 1977. Laurence Olivier sent Burton a telegram when he was filming *Cleopatra* when Burton and Taylor were carrying on a 'scandalous' affair. It read 'Make your mind up, dear boy. Do you want to be a great actor or a household word?' Burton cabled back one word: 'Both.' His villa where he was buried, on Lake Geneva, was called 'Pays de Galles' (French for 'Wales'), and *Sospan Fach* was played at the funeral of this hard-drinking Celtic genius. With 'Nye' Bevan, Burton shared an almost pathological hatred of Winston Churchill for his sending troops to TONYPANDY to keep order when the miners were starving.

BURTON HOARD A collection of fourteen gold adornments and bronze tools originally buried in a pottery vessel, found by metal detectorists in 2003 near the River Alyn in Denbighshire. Declared treasure trove in 2004, the gold items include a flange-twisted torc, a wire-twisted bracelet, a composite pendant, four beads and three penannular rings. The tools include two Transitional palstaves and a trunnion tool. The hoard contains two pieces that are unparalleled anywhere else in the UK: a bracelet with strands of twisted gold and a pendant consisting of a gold bi-conical bead. The Rossett Hoard of gold and other Bronze Age artefacts were also found nearby.

BUTTINGTON, BATTLE OF, 893 One of the most important battles of the Dark Ages, in the Severn Valley, where King Alfred the Great and King Merfyn of Powys, and some of Anarawd of Gwynedd's men defeated the Danes led by Haesten. Mentioned in the *Anglo-Saxon Chronicles*, it is either in north or south Wales. It is possibly Buttington in Powys, where 400 scarred skulls were found in the 1830's, or at somewhere on the Severn shore. The Danes had made their way by boat up the Thames and Severn rivers, and occupied a fort where they were besieged and beaten.

BWLWARCAU IRON AGE FORT, Y On Mynydd Margam near Llangynwyd, there is a central pentagonal enclosure, enclosed by a bank and a deep ditch, and then an outer bank, another ditch, then two to three more defensive banks.

CADOG, SAINT (*c. 497-577*) He was first named Cadfael – 'Battle Prince' and was associated with Arthur. St Cadog, Cadoc, Cadocus, Cattwg or Catwg was the son of Prince GWYNLLIW and GWLADYS. Both parents later became saints. Educated in Caerwent, he founded the famous monastery at Llancarfan in Glamorgan in 535, where there are still traces of the settlement. He visited Brittany and there are about twenty churches which were his foundations in South Wales, plus one in Cornwall and a few in Brittany. St DEINIOL, who founded the monastery at Bangor, the precursor of the cathedral, was taught by St Cadog. He was an important figure in early Welsh history, and just like DYFRIG, GWENFREWI, BEUNO, TEILO or PADARN, he could have been Wales' patron saint.

CADW Cadw is the authority in charge of many of Wales' most precious historic monuments – others are in the care of The National Trust, or of various councils (e.g. Cardiff Castle). Cadw means 'keep' in Welsh, which is a wordplay upon preserving the past, and the central architectural feature (the keep) of the hundreds of castles surviving in Wales. In CADW's care are the following, most of which are described in this book:
Castles at: Beaumaris, Bronllys, Caernarfon, Caerphilly, Carreg Cennen, Castell Coch, Castell-y-Bere, Chepstow, Cilgerran, Coity, Conwy, Cricieth, Denbigh, Dolbadarn, Dolforwyn, Dolwyddelan, Dryslwyn, Ewloe, Flint, Grosmont, Harlech, Cydweli (Kidwelly), Laugharne, Llanbleddian (Llanblethian), Llansteffan (Llanstephan), Llawhaden, Loughor, Monmouth, Montgomery, Newcastle, Newport, Ogmore, Old Beaupré, Oxwich, Raglan, Rhuddlan, Skenfrith, Swansea, Tretower, Weobley, White Castle and Wiston.
Medieval Houses and Fortified Sites at: Caernarfon Town Wall, Carswell Old House, Conwy Town Wall, Denbigh Town Wall, Hen Gwrt Moated Site, Kidwelly Town Gate, Penarth Fawr Medieval House, Twthill and Tretower Court.

Roman Sites at: Caer Gybi, Caer Leb, Caerleon, Caerwent, Segontium, and Y Gaer near Brecon.

Religious Sites at: Basingwerk Abbey, Capel Lligwy, Carew Cross, Cymer Abbey, Denbigh Friary, Leicester's Church and St Hilary's Chapel, Derwen Churchyard Cross, Eliseg's Pillar, Ewenny Priory, Gwydir Uchaf Chapel, Haverfordwest Priory, Lamphey Bishop's Palace, Llangar Old Parish Church, Llanthony Priory, Maen Achwyfan Cross, Margam Stones Museum, Neath Abbey, Penmon Cross and Priory, Rug Chapel, Runston Chapel, St Cybi's Well, St David's Bishop's Palace and Close Wall, St Dogmael's Abbey, St Non's Chapel, St Seiriol's Well, St Winifred's Chapel and Holy Well, Strata Florida Abbey, Talley Abbey, Tintern Abbey and Valle Crucis Abbey.

Post-Medieval and Industrial Sites at: Blaenafon Ironworks, Bryntail Lead Mines, Dyfi Furnace, Penmon Dovecote and Pont Minllyn.

Prehistoric Burial Chambers at: Barclodiad y Gawres, Bodowyr, Bryn Celli Ddu, Capel Garmon, Carreg Coetan, Din Dryfol, Dyffryn St Lythans, Lligwy, Parc le Breos, Pentre Ifan, Presaddfed, Tinkinswood, Trefignath, Tŷ Mawr and Tŷ Newydd.

Prehistoric Sites at: Caer y Tŵr, Castell Bryn Gwyn, Chepstow Bulwark Camp, Din Lligwy Hut Group, Holyhead Mountain Hut Circles, Llanmelin Wood Hillfort, Penrhos Feilw Standing Stones and Tregwehelydd Standing Stone.

CADWALADER, THOMAS (1707-1779) – THE DISCOVERER OF LEAD POISONING

He was born into a Welsh Quaker family in Philadelphia, and after studying medicine with his uncle Dr Evan Jones, he travelled to London to study medicine. After his return to Philadelphia in 1731, he became active in inoculating people during the smallpox epidemic of the late 1730s. His best-known published medical work is his 1745 tract 'Essay on West India Dry Gripes', published by Benjamin Franklin, describing lead poisoning and including three case studies. Cadwalader believed that many people became poisoned through Jamaican rum, because it had been distilled in lead pipes. However, his findings were ignored. The first discovery of lead poisoning in the United States with a traceable source was not to be until 1914, when a child chewed some paint off his crib.

CADWALADR, BETSI (1789-1860) – 'THE REAL LADY OF THE LAMP' Betsi Cadwaladr

was born at Pen-rhiw farm near Bala, and was originally known as Beti Cadwaladr or Beti Pen-rhiw. She joined the service of a rich Liverpool family aged just fifteen, and travelled with them over the Continent. As they could not say 'Cadwaladr', she called herself Elizabeth Davis. She left their service and worked on ships travelling to the West Indies, Australia, Tasmania, China, India, Africa and South America. Betsi returned to London, and was accepted by Guy's Hospital to train as a nurse, in her fifties at the time. In September 1854, at the age of sixty-five, she read in *The Times* about the terrible Battle of Alma in the Crimean War, and that hundreds of British troops were dying from cholera and the intense cold, as well as from untreated wounds. She just missed Florence Nightingale's first group, but joined the second to go to Scutari. The wounded had to be taken in ships, with unattended wounds, across the Black Sea to Scutari. Betsi became one of the very few women who actually nursed in the war. Nightingale only visited the Crimea twice, never nursing but only organising the Scutari hospital. Records show that men were twice as likely to die in Nightingale's Scutari hospital as in a hospital tent at the front. Nightingale knew nothing of nursing, refused to delegate, had a low opinion of women in general and the hospital was built over a cesspit. Betsi did not like Nightingale or her set-up at Scutari and wrote a personal letter to Lord Raglan asking to nurse troops at the front line in Balaclava. He granted permission, and Betsy took a troopship to the base hospital there. As she said, 'By the time the wounded soldiers get across the Crimea to Turkey and the Scutari hospital they are dead. I want to be there close to the battlefield'. An account of the time reads 'Her work saved hundreds of lives. She supervised the feeding of the wounded men and their medication.'

Betsi's bedroom was rat-infested, unsanitary and not even rain-proof. She took eleven other

nurses with her, and took charge of the kitchens by day and the wounded at night. When her health broke under the deplorable conditions, many soldiers and officers came to thank her in person for saving their lives, before she returned to London. Betsi's true opinions of the saintly Florence Nightingale were said to be unprintable, and she left nursing after yet another quarrel with the haughty and imperious woman. She died in poverty in 1860, and leaves behind no gravestone, just a two-volume autobiography of her adventures, the *Autobiography of Elizabeth Davis* in 1857. Betsi was the true heroine of the Crimea. The Crimean campaign was such an unmitigated disaster that the government of the day was desperate for a hero or heroine (Nightingale) and even made the Charge of the Light Brigade into a 'glorious' example of bravery rather than of stupidity. Government propaganda is now called 'spin', presumably to remove the term from the memory of communist or fascist propaganda, but it is the same 'creative truth' peddled to the masses, and hopefully believed by fewer and fewer people.

CADWALADR, KING AP CADWALLON AP CADFAN (*c*. 630-682) Cadwaladr Fendigaid, Saint Cadwaladr the Blessed, was the High King of Britain and is said to have joined forces with Penda of Mercia in 642 to avenge his father CADWALLON. Cadwallon had been killed by Edwin of Northumbria in 635. Cadwaladr and Penda killed King Oswald of Northumbria at the battle of Maserfield (MAES COGWY), near Oswestry. However, in 655 the Mercians and Britons (Welsh) were beaten at Winwaedfield (HEAVENFIELD) by Oswin of Northumbria, and this was the end of Welsh attempts to recover the North of England from the Danes. Welsh chroniclers consider Cadwaladr to be one the greatest British kings to have ever lived, Geoffrey of Monmouth including him in his *Historia Regum Britanniae* as the last in the line of legendary Kings of the Britons. Cadwaladr's standard, the red dragon, was later adopted by Henry VII of England, founder of the Tudor dynasty, who claimed descent from Cadwaladr. Cadwaladr eventually had reclaimed his family's throne of Gwynedd from Cadfael Cadomedd, and went on to challenge the West Saxons in Somerset in 658, unsuccessfully. Cadwaladr was arguably the last Welsh ruler to mount a serious counteroffensive against the Anglo-Saxon forces, that had overrun Southern Britain since the fall of the Western Roman Empire. It may be for this reason that Geoffrey of Monmouth chose to end his narrative of British kings with Cadwaladr. He is wrongly culted by Catholics as a 'saint of the Saxon church' having fought for the British (Welsh) against the Saxons for all his lifetime. Churches are dedicated to him from Glamorgan and Monmouthshire to Anglesey.

CADWALLON AP CADFAN (d. 635) The father of Cadwaladr, Cadwallon was the greatest military and political leader of Wales after the time of his grandfather Maelgwn Gwynedd. He had defended Gwynedd against attacks by Edwin of Northumbria, winning at CEFN DIGALL in 625. In 632, Cadwallon made a pact with Penda of Mercia, who may have been a fellow-Briton rather than a Saxon, and attacked Edwin at Heathfield, (HATFIELD MOORS) possibly near Doncaster in 634. Edwin was killed and Northumbria subdued. Cadwallon killed Osric, Edwin's son in the following year in battle at York. However, Aethelfrith's son Oswald killed Cadwallon at Heavenfield near Hexham in 635. Cadwallon was known as '*the last hero of the British race*'. The plaque at the battle site next to Hadrian's Wall indicates a victory that established a Christian king, Oswald, ignoring the Christianity of Cadwallon and the paganism of the Northumbrians. As ever, each nation believes its own version of the truth.

CADWALLON LAWHIR (*c*. 460-534) Cadwallon Lawhir (Long-Handed), Cadwallon ab Einion Yrth ap Cunedda, finally took the Isle of Anglesey from the Irish that his father Einion had been fighting for years. The decisive battle was fought at Cerrig y Gwyddyl at 520, near Trefdraeth in Anglesey. Usually the Celtic tribes rode to battle and fought dismounted. Cadwallon ordered his army to tie their horses' fetlocks together so there could be no quick escape – they had to stand and fight. He assimilated Anglesey forever into the kingdom of Gwynedd, and his son was Maelgwn Gwynedd.

CAE GAER ROMAN FORTLET 'Camp field' is a Roman fortlet near Llangurig, possibly built to protect quartz mining.

'CAER' AND ROMAN CAMPS It used to be thought that this was derived from the Latin 'castra', or fort, but it appears to be an original Welsh word. The prefix denotes the site of a castle, fortified camp or the like. Many of Wales' hundreds of Iron Age hill forts are prefixed Caer, Din or Dinas. All signify an ancient fortified site, but usually Caer has strong Roman connections. The prefix of din or dinas usually refers to an even more ancient defended site. The Roman fort/towns of Carmarthen and Cardiff are derived from Caerfyrddin and Caerdydd. Caerlaverock Castle, in the south-west of Scotland, has the same origins. Y Gaer is the site of a Roman fort near Brecon. After the defeat of Caractacus in 51 CE, the Welsh tribes were still troublesome, and the small camp of Wroxeter (Uriconium) near Shrewsbury (Pengwern) on the River Severn was expanded to become home to the XIV and then the XX legions. It became the fourth largest Roman city in Britain. Because of the numerous Celtic hill-forts, it was not until 78 CE that Wales was conquered, and the Romans could put in an extensive road system. Their marching camps and forts were called caerau, the plural of caer, and many were on the site of previous fortifications or encampments guarding valleys, fords and other strategic sites. Increasingly, evidence is being found that Roman roads followed the lines of existing Celtic roads, so common sense dictated that they used the same sites.

After BUDDUG'S (Boudicca's) rebellion, the Roman frontier moved further west towards Wales, with Cirencester (Corinium) fort being dismantled and CAERLEON (Isca Silurum) taking its place. Caerleon seems to come from 'caer legionis', camp of the legion. In a move reminiscent of the Normans with their Marcher castles and Edward I's 'iron ring of castles', the Romans placed their largest legionary fort in Britain, for the XX Legion, on the north end of the Welsh borders, at Caer Legionis or Caer Leion (CHESTER, the Roman Deva) in 79 CE. Chester has the largest amphitheatre in Britain, and its mediaeval city walls sometimes follow the line of the Roman walls. For two centuries Rome kept two of its three British legions on the Welsh borders, with around 5,000-6,000 in each legionary centre. In Caerleon, the II Legion Augusta was stationed. Chester gave access to silver from Flint, copper from Anglesey and North Wales, and lead and silver from the west coast. Caerleon and Carmarthen gave an easier route to DOLAUCOTHI gold mines. There were also thirty Roman forts in Wales, including the fully garrisoned Caerfyrddin (CARMARTHEN) and CAERNARFON (Segontium), which probably each had around 1,000 troops garrisoned there. At Caerfyrddin (Moridunum) there was also a Roman town, possibly even bigger than Caerwent. The Romans came to Britain to exterminate the centre of European Celtic resistance, the Druids in ANGLESEY, and for access to Wales' massive mineral resources, traded across the Mediterranean. The evidence for this thesis is in the locations of the legions in Britain. In York, the IX Legion Hispania was succeeded by the VI Legion Victrix. It covered a large part of Scotland and the North of England. On what is now the Welsh border, the XX Legion was stationed in the north, and the II Legion in the south. It was almost unique for any country in the Roman Empire to have two legions stationed there, let alone three, with two only 100 miles apart. Many countries had no legion after their conquest, but for 300 years the Wales had two legions, with the other in York. There were only thirty Roman legions in total scattered over Africa, Asia and Europe. This information does not appear in history books.

CAERAU CASTLE HILLFORT On Cardiff's eastern outskirts, and overlooking the Ely River, a medieval ring work castle was placed inside the Iron Age fort, which has a spring for the defenders to use. On the site of the bailey is the vandalised thirteenth-century St Mary's Church.

CAERAU PROMOTORY FORTS Twin Iron Age sites on the coast near St David's, they are linked by a bank and ditch. Like many Welsh coastal hill forts, the builders used promontories as the main site and then dug ramparts and ditches across the 'neck' of the promontory for defence.

CAER DREWYN HILLFORT This has a commanding position on a hilltop overlooking Corwen, with an inturned entrance and guard chambers.

CAER DREWYN 1165 – THE ROUT OF HENRY II This ancient hillfort marked two seminal and defining moments in Welsh history. Henry II had prepared and mounted what was hoped to be the final blow to the recalcitrant Welsh princes. He commandeered men from the continent and Scotland, and a fleet was summoned from Dublin 'proposing to destroy the whole of the Britons'. He assembled a force of 30,000 men at Weston Rhyn in Shropshire and began to march across Wales, heading up the Ceiriog Valley to Corwen. However, OWAIN GWYNEDD, the son of the great GRUFFUDD AP CYNAN, and the brother of the executed Princess GWENLLIAN, was waiting on the hills above Corwen. With Owain ap Gruffudd (OWAIN CYFEILIOG) of Powys, he had united with Gwenllian's son The Lord Rhys, gathering forces including those of Cadwallon ap Madog and his brother Einion Clud, at Corwen in the Dee valley. RHYS AP GRUFFYDD, the Lord Rhys of Deheubarth, was also with his followers in the Welsh army. With the three ancient kingdoms of Wales, Gwynedd, Deheubarth and Powys united, this was probably the largest Welsh army ever assembled.

Henry had made the tactical mistake of trying to march from Oswestry up the Ceiriog valley and across the Berwyn range, rather than follow the traditional coastal routes. Owain Gwynedd had rallied Welsh forces from across Wales on Caer Drewyn. There was a stand-off for several days, with both sides occupying high ground with Corwen in the valley between them. Both armies were unwilling to move first and lose the advantage. Henry thus retreated back across the Berwyn Mountains to England, rather than risk an attack, ending the invasion. This defeat of Henry enabled Owain, Rhys and Madog to concentrate their efforts on building a sustained peace, although Gruffudd ap Rhys was poisoned soon after. This also allowed the Welsh to take the initiative once more, regaining some ground on the Welsh borders. Henry never expected the Welsh to ally themselves and gather such a great army. *The Chronicle of Ystrad Fflur* records 1165 thus: 'In this year Henry the king came to Oswestry, thinking to annihilate all Welshmen. And against him came Owain and Cadwaladr, the sons of Gruffudd ap Cynan, and all the host of Gwynedd with them, and Rhys ap Gruffudd and with him all the host of Deheubarth, and Owain Cyfeiliog and the sons of Madog ap Maredudd and the host of all Powys with them, and the two sons of Madog ab Idnerth and their host. And both sides stayed in their tents until the king moved his host into Dyffryn Ceiriog and there he was defeated at CROGEN. And then the tempest drove him back to England. And in rage he had the eyes of twenty-two hostages gouged out; and these included two sons of Owain and two sons of Rhys. And Rhys took the castles of Cardigan and Cilgerran. And through the will of God and at the instigation of the Holy Spirit, and with the help of Rhys ap Gruffudd, a community of monks came to Ystrad Fflur. And died Llywelyn ab Owain Gwynedd, the flower and splendour of the whole land.' Despite having their sons blinded, neither Rhys or Owain looked for similar revenge against any captives.

CAER DREWYN 1400 – THE START OF GLYNDŴR'S WAR Glyndŵr raised his Golden Dragon banner here, and was acclaimed by other Welsh nobles as their prince to lead their renewed fight for liberation against the English. The place had been symbolically chosen because of the successful unification of the Welsh princes in 1165 to fight off Henry II. The Welsh had to pay taxes not applicable in England, they could not own land within ten miles of a town, and were not allowed to carry weapons unless they swore allegiance to the king. Combined with Glyndŵr's treatment by Lord Grey and the usurper king Henry IV, Welshmen across Wales felt the need for action. It appears that Glyndŵr also used the site as a refuge in his war against the English.

CAERFFILI (CAERPHILLY) It was renowned for the crumbly Caerphilly Cheese, and lies in the Rhymni Valley coalfield. From 1902 to 1964 it was also famous for its locomotive and carriage workshops. DAVID WILLIAMS was born in the Carpenter's Arms at nearby Walford. There is an annual Cheese Festival and Fair ('The Big Cheese') centred on the parkland near the castle.

CAERFFILI CASTLE Caerffili Castle (Caerphilly), is probably the biggest military castle in Europe, (discounting Windsor as a palace that has never seen any action) and was built mainly between 1268 and 1271. Llywelyn II destroyed the previous Norman castle. 'Red Gilbert' de Clare, the Anglo-Norman Lord of Glamorgan, had built it to defend his territories from Llywelyn. De Clare had taken the lordship of Senghenydd (including Caerffili) from the Welsh in 1266 to stop Llywelyn ap Gruffudd's southern expansion. Llywelyn attacked it twice during its building, taking temporary possession in 1270. Its thirty acres of water defences are not equalled in Europe, featuring a flooded valley, with the castle built on three artificial islands. The dams are a superb engineering achievement, with the south and north lakes deterring any sort of attack. The east wall is effectively a huge fortified dam, and together with the west walled redoubt, defends the central isle.

This central core has a double concentric circuit of walls and four gatehouses. The depth and width of the moat was controlled from within the castle. It was the first truly concentric castle built in Britain, and its concentric system of defences was copied by Edward I in building his 'iron ring' of castles around Gwynedd. It was again attacked in 1294-95 and 1316, and Queen Isabella besieged it from 1326-27 to try and capture her husband Edward II. Nevertheless, Caerffili fell in Glyndŵr's uprising. Its leaning tower, at 10 degrees tilt, out-leans that of Pisa, possibly because of damage during the Civil War. When Lord Tennyson first encountered it, he exclaimed 'This isn't a castle. It's a whole ruined town.' Caerffili is the only castle in the world with full-size replicas of four different 'siege-engines'. On certain days they are demonstrated, with huge stones being hurled into the lakes.

CAERFFILI ROMAN FORT Covering twenty-one acres, with a bathhouse, it was built around 103-112 CE, and is near the castle site.

CAER GAI ROMANO-BRITISH FORT Outside Llanuwchllyn, this fort and settlement was seemingly abandoned, like many Roman sites in Wales, around 120 CE.

CAER GYBI ROMAN FORT At this third-century fort at Holyhead, the walls survive.

CAERGWRLE BOWL This beautiful gold-foil decorated bowl (about 7in across the rim), was found in a bog at the foot of Caergwrle Castle Hill. It is perhaps the most extraordinary piece of gold work found in Wales. It may be twelfth to eleventh-century BCE and is made of shale, with a design deeply cut into it. Originally all the elements in the design were filled with tin, over which was placed decorated gold foil. The decoration has been interpreted as forming the gunwales, oars and keel of a boat with waves running along its hull.

CAERGWRLE (HOPE) CASTLE In Flintshire, it was built by Prince Dafydd ap Gruffudd in 1277, being probably the last Welsh-built castle. From here Dafydd attacked Hawarden in 1282, and then slighted Caergwrle when retreating during King Edward's invasion. Edward I rebuilt it, using 1,000 workmen, who took two months to clear its well. It reverted to its English name of Hope Castle, but it accidentally burnt down shortly after. It lies in the corner of an Iron Age hillfort and has a Welsh D-tower.

CAERHUN ROMAN FORT – CANOVIUM In Gwynedd, it seems to have had a turbulent history, being built first of timber in 75 CE and then in stone. It was destroyed around 200 CE, reused in the fourth century and abandoned around the beginning of the fifth century.

CAERLEON ROMAN LEGIONARY FORT AND BARRACKS – ISCA SILURUM Caerleon, Isca Silurum, has the best-preserved Roman amphitheatre in Britain, for centuries thought of as King Arthur's Round Table, and was the headquarters of the Second Augustan Legion in Britain. The amphitheatre could hold 6,000 men, the total population of the garrison. Isca was built to help control the Silures, at that time Rome's most difficult enemy. According

to Geoffrey of Monmouth, Arthur was crowned there. Marie de France, in *The Lay of Sir Launfal* wrote in the twelfth century 'King Arthur, that fearless knight and courteous lord removed to Wales, and lodged at Caerleon-on-Usk, since the Picts and Scots did much mischief in the land. For it was the wont of the wild people of the North to enter the realm of Logres (England), and burn and damage at their will'.

Caerleon fort's walls still stand up to 12ft high in parts, and it possesses the only Roman legionary barracks visible in Europe. The site covers fifty acres. The monumental bath complex was built on the scale of a mediaeval cathedral, and some of it is now exhibited under the cover of a purpose-built museum. It is the only legionary bath visible in Britain. Caerleon was built at the mouth of the River Usk, in 75 CE, as the strategic base for the conquest of South Wales, and for ease of reinforcement and access to the gold mines at Dolaucothi. The site was named Isca by the Romans after the Welsh River Wysg, now known as the Usk. The position was also chosen because it was close to Llanmelin hill fort, the capital of the Celtic Silures tribe, which controlled south-east Wales. There is a Roman watchtower attached to the Hanbury Arms pub, overlooking the site of the Roman port on the River Usk. Tennyson wrote much of '*Idylls of the King*', his epic Arthurian poem, while staying at The Hanbury Arms. In the third century, Cardiff (Caerdydd) took over from Caerleon as the Romans' South Wales headquarters. Caerleon was important as a port until the late nineteenth century, when the new Newport Docks took its trade.

CAERLEON CASTLE Built by the Normans in 1085, it was taken by the Welsh in 1173 and 1217, but held out in 1231. Iorwerth ab Owain was Prince of Gwynlliwg, the area encompassing much of Monmouthshire. Henry II asked him to meet at Caerleon Castle in 1172, which the king had taken from the Welsh. Iorwerth attended with his sons Hywel and Owain, expecting to be given the castle back. *The Chronicle of Ystrad Fflur* recounts: '1172 – And the king granted truce to Iorwerth ab Owain and his sons to come and discuss peace with him. And Owain ab Iorwerth was slain by the earl of Bristol's men. And after that Iorwerth and Hywel, his son, placing no trust in the king, ravaged the lands around Gloucester and Hereford, pillaging and slaying with no mercy.' Iorwerth ab Owain may have been the only noble who later escaped from the disgraceful Christmas Day massacre three years later at ABERGAFENNI in 1175. The constant treachery of the Marcher Lords and English kings, from the Normans through to the fifteenth century and the last wars of independence, are missing (and still missing) from history books since the nineteenth century.

CAERNARFON (ABERSEIONT) The walled bastide town is dominated by its castle, and situated where the River Seiont meets the Menai Straits. The visitor should also see the thirteenth-century Llanbeblig Church, built on the site of the cell of St Peblig (Publicius), said to have been the Romano-Welsh uncle of Emperor Constantine the Great. The battle site of TWT HILL is nearby, on a Bronze Age site with views to Anglesey and Snowdonia. Caernarfon was created a Royal Borough in 1963 and since 1974 a Royal Town.

CAERNARFON CASTLE – WORLD HERITAGE SITE This is on the site of a Norman motte and bailey dating from 1090, and was in Welsh hands from 1115 until 1282. Then Caernarfon Castle was rebuilt as a symbol of English power after the defeat of Llywelyn the Last. Edward 1 also built substantial town walls, destroying the native Welsh settlement. Perhaps the greatest of Edward's castles, it was meant as a royal residence and seat of government for North Wales. It is probably the finest example of military architecture in Europe, its main gate being designed for no fewer than six portcullises, with assorted 'murder holes' above them. The hundreds of arrow slits were designed for three archers to fire from each, in rapid succession. There are two gatehouses, nine massive towers and walls 20ft thick. Built by Master James of St George, its appearance, with the banded towers and eagles, was based upon Edward's experience of the Crusades, having seen the fortifications of Constantinople. Overlooking the Menai Straits, it was strategically important, allowing easy access to the other coastal castles of Harlech, Conwy and Beaumaris. Glyndŵr besieged it unsuccessfully in 1403 and 1404, and its Royalist defenders surrendered it to Parliamentary forces in 1646. Llywelyn

ap Gruffydd (Llywelyn the Last) had been recognised as Prince of Wales in 1267, the last native Prince of Wales, but was killed by the English in 1282. The future Edward II was born here in 1284, and Edward I created him Prince of Wales seventeen years later in Lincoln. Edward II's elder brother Alphonso, Earl of Chester, had died in 1284, saving us from a King Alphonso of England. The castle was intended as the capital of North Wales, and as a palace for the new Prince of Wales. In 1969 Charles Saxe-Coburg-Gotha-Schleswig-Holstein-Sonderburg-Glucksburg (also known as Charles Windsor) was crowned Prince of Wales at the castle, despite protests by the Welsh Language Society and nationalists.

CAERNARFON ROMAN FORT – SEGONTIUM Many stones of the fort of Segontium, associated with Magnus Maximus (Macsen Wledig), were used by Edward I in building his castle, and there is an interesting museum. The site is on Llanbeblig Hill, just half a mile from the castle, and there is a smaller and later fort nearby.

CAERNARFONSHIRE Caernarfonshire (Sir Gaernarfon), was formerly spelt as Carnarvonshire and is one of thirteen historic counties of Wales. The county was created by the Statute of Rhuddlan in 1284 and included the cantrefs of: Llŷn, Arfon, and Arllechwedd and the commote of Eifionydd (the northern portion of Dunoding). The Local Government Act of 1888 created an elected Carnarvonshire county council in 1889. The administrative county of Caernarfonshire was abolished under the Local Government Act 1972, becoming part of the new county of Gwynedd, split between the districts of Dwyfor, Arfon and part of Aberconwy, including Merionethshire and Anglesey. Since the Local Government (Wales) Act 1994 came into force in 1996 on 1 April (a wonderful day for the constant reorganisations that affect local authorities). The county has been divided between the unitary authorities of Gwynedd to the west and Conwy to the east. A large part of the Snowdonia National Park lies in the county including Eryri (Snowdon), the highest mountain in Wales. The major towns are Bangor, Betws-y-Coed, Caernarfon, Conwy, Llandudno, Porthmadog and Pwllheli.

CAERSWS ROMAN FORTS The first fort was built quickly as the Romans fought their way through Wales. The second, larger fort also supported a civilian settlement.

CAER PENRHOS CASTLE Built within an Iron Age hill fort, near Llanrhystyd in Ceredigion, Castell Cadwaladr is a superb ringwork castle probably built by Cadwaladr ap Gruffudd ap Cynan.

CAERWENT ROMAN TOWN – VENTA SILURUM – THE BEST-PRESERVED ROMAN WALLS IN BRITAIN The fortified fourth-century town of Caerwent has the best-preserved Roman walls in Britain, a mile in length around the village. There are excavated houses, shops and temples here, and the town was built to become the tribal capital of the troublesome Silures when they made peace with Rome. One of the most important inscriptions from Roman Britain is on the Paulinus Stone, erected here in the third century. It reads: 'To Tiberius Claudius Paulinus, legate of the Second Legion Augusta, proconsul of the province of Narbonensis (modern Provence), emperor's propraetorian legate of the province of Lugudensis (the largest province in Gaul), by decree of the council, the Republic of the Silures set this up.' This is inscribed on a base which once held a statue of Paulinus, and confirms that the Silures administered the city of Caerwent. The Normans built a motte within the Roman walls, as in Cardiff. A Romano-Celtic temple there may have been associated later with St TATHAN. Caerwent is thought to have been destroyed in a Saxon attack.

CAER Y TWR This hill fort is on the top of Holyhead Mountain, and its walls remain up to ten feet high in places. The Romans placed a watchtower on the site to look out for Irish raiders, from where signals could have been sent by semaphore to the legion's headquarters in Chester.

CALDEY ISLAND AND MONASTERY Caldey Island, or Ynys Byr, can be reached by boat from TENBY, and until recently a rusty old wartime amphibious vehicle (a DUKW) transferred visitors to the island off the boat. In 1962 the monks requested that the DUKW was replaced with a hovercraft, but the 'Duck boat' was still operating in the 1990's (DUKW is General Motors terminology. D=Designed in 1942; U=Utility amphibious; K=All-wheel drive; W−2 powered rear axles). Other ex-military landing craft are now used at low tide. Caldey was settled by Celtic monks in the sixth century, and in 1136 Benedictine monks built a priory. There is now a monastery of Reformed Cistercians here, and one can buy their perfumes, honey and cream, and wander around the 600-acre island and its old buildings. The fourteenth- century St Illtud's Church is now the oldest British church in Catholic administration. It is the fifth largest island in Wales. The adjoining twenty-acre St Margaret's Island was once connected to Caldey by causeway, and is a nature reserve with breeding cormorants.

CALDICOT CASTLE Near Chepstow, it stands on the Via Julia to Caerwent (Venta Silurum), and a motte and two baileys were built in 1086. Humphrey de Bohun built the round keep in 1221 and the fortifications passed on to Thomas de Woodstock, Duke of Gloucester and the thirteenth son of Edward III. Responsible for Caldicot's great gatehouse, Woodstock was imprisoned on the orders of his uncle, Richard II in Calais in 1397, and there smothered to death by four assailants. In the ensuing feuds, Henry Bolingbroke was exiled and his father John of Gaunt was said to have died of the grief caused by his younger brother's death. Richard II now extended Henry's exile to life, not allowing him to claim his inheritance. Bolingbroke returned to Britain and Richard II was captured at Conwy Castle during peace talks. Richard II was starved to death at Pontefract Castle, Bolingbroke becoming Henry IV. A later owner, the Duke of Stafford, was beheaded by Henry VIII in 1521. As at Cardiff Castle, one can enjoy medieval banquets here.

CALLICE, JOHN (fl. 1571-1587) 'The most famous English (sic) pirate of sixteenth century', he was followed in the next century by the most renowned privateer in the world, Captain HENRY MORGAN, and then in the eighteenth century by the most successful pirate of all time, Black BART ROBERTS. Born in Tintern, Callice had powerful friends amongst the gentry and at the Elizabethan court, including his Welsh kinsman William Herbert, but equally was called 'the most dangerous pyrate in the realm'. Master of the *Oliphant* (Elephant) he was friendly with Sir JOHN PERROTT and with assorted pirates in the Bristol Channel and beyond. When imprisoned for piracy he incriminated his father-in-law the Sheriff of Glamorgan, Nicholas Herbert, and was released on bail. He fled his parole and carried on pirating in his next ship '*The Golden Challice*' but seems to have been killed on the Barbary Coast.

CALZAGHE, JOSEPH WILLIAM 'JOE' (1972-) From Newbridge, the world champion was undefeated when he retired in February 2009, with 46 consecutive professional boxing wins including 32 knockouts. A southpaw, he began boxing aged nine, winning 4 schoolboy ABA titles, followed by 3 consecutive senior British ABA titles (British Championships) from 1991 to 1993. He retired as undisputed World Light Heavyweight Champion, having held the WBO super middleweight title for over ten years until he relinquished the title to concentrate on fighting at light-heavyweight. As his super-middleweight and light-heavyweight reigns overlap, he had the longest continual time as world champion of any recently active boxer.

CAMBRIAN COMBINE STRIKE 1910 Eight-hundred colliers were locked out from this pit in November 1910 following a dispute about pay for working difficult and abnormal veins of coal. The dispute escalated and soon 12,000 men were on strike, leading to the TONYPANDY RIOTS. The strike ended in October 1911, the workers being forced to return on the owners' terms and conditions.

CAMBRIOL This is the 'forgotten colony' of 'New Wales', which existed around Trepassey Bay in Newfoundland from 1616. It was founded by Sir William Vaughan of Llangyndeyrn. Settlements were established named Vaughan's Cove, Golden Grove, Cardiff, Glamorgan, Pembroke, Cardigan, Brecon and Carmarthen. Vaughan wrote *Cambrenseia Caroleia* and *The Golden Fleece* there, returning to publish them, before returning again to Cambriol. The settlement was pillaged by pirates and the French and abandoned by 1637, although some place names remain.

CAMDDŴR, BATTLE OF, 1075 The kings of south Wales, Rhys ab Owain and Rhydderch ap Caradog, overcame Llywelyn ap Cadwgan ap Elystan, his brother Goronwy ap Cadwgan and Caradog ap Gruffudd of Morganwg in Maelienydd, probably near the River Camddŵr around Llanbister. Rhys had been attacked probably in vengeance for his killing of Bleddyn ap Cynfyn of Powys in that same year. Rhydderch ap Caradog was slain in the next year by his cousin Meirchion ap Rhys. Some of this internecine warfare obviously assisted the Norman Invasion of Wales.

CAMLAN, BATTLE OF 539 OR 532 Camlan means crooked riverbank or crooked shore, and there are many claimants for this site of ARTHUR's last battle where he was severely wounded. It is not certain if he was fighting with Mordred or against him. It may be that this final battle was against the forces of MAELGWN GWYNEDD, who succeeded Arthur as Pendragon and has been identified with Lancelot. Barber and Pykit state that Arthur fought his final British battle at 'Cadlan' on the Llŷn Peninsula where Mordred (Medraut) had territories, then recovered from his wounds at Bardsey Island, and died in 562 at St Armel des Boschaux in Brittany. A persuasive case for the final Battle of Camlan being at Maes-y-Camlan (Camlan Field), just south of Dinas Mawddwy, has also been made. This tradition was recorded in Welsh by a local bard in 1893. In the area are two Camlans, Bron-Camlan, Camlan-uchaf and Camlan Isaf. Across the valley from Maes Camlan are Bryn Cleifion and Dol-y-Cleifion (Hill of the Wounded, and Meadow of the Wounded). The nearby ridge overlooking the Dyfi River is Cefn-Byriaeth (Mourning Ridge) where graves were discovered. Five miles east is the site where Mordred's Saxon allies are said to have camped the previous night, and the stream there is still called Nant-y-Saeson (Saxon Stream). The date was 537 in the *Welsh Annals*, but the Celtic Church may have dated this from the crucifixion of Christ (instead of his birth), making it actually 574. The *Welsh Annals* are generally wrongly dated by one or two years, because of the discrepancy between the Celtic and Roman calendars. Another candidate for Camlan is at Nevern, where the llan (holy place) is on the Caman River.

CAMPSTONE HILL, BATTLE OF, 1404 Three miles southwest of Grosmont Castle, the Earl of Warwick's force were said to have defeated Owain Glyndŵr's followers and captured his standard from Richard ap Elis. However, it is unsure if this skirmish occurred – it may have been propaganda from Richard Beauchamp, Earl of Warwick, to cover his later loss at CRAIG-Y-DORTH.

CANALS These were built to facilitate the growth of the Industrial Revolution, replacing packhorses and carts to transport iron, coal and the like. The Glamorganshire Canal ran from Merthyr Tydful to Cardiff. Construction began in 1790, funded by the Merthyr ironworks owners seeking a means of transporting their iron to the sea. The canal was completed in 1798 with the addition of a sea lock in Cardiff docks. It was around twenty-five miles long, with a drop of around 542ft requiring fifty-two locks. The shares in the canal were bought in 1883 by the Marquess of Bute to consolidate his ownership of Cardiff Docks. The canal lost favour after the Taff Vale Railway opened, and only limited traces of the canal remain. The Neath and Tennant Canals were two independent but linked canals in South Wales that are usually regarded as a single canal. They are being restored and meet at Aberdulais Basin. The Glan-y-wern Canal is a branch

of the Tennant Canal which branches northwards near Crymlyn Burrows. Swansea Canal was constructed by the Swansea Canal Navigation Company between 1794-1798, stretching sixteen miles from Swansea to Abercraf. There were originally thirty-six locks on the canal to raise it from sea level at Swansea to 375ft at Abercraf. Aqueducts at Clydach, Pontardawe, Ynysmeudwy, Ystalyfera, and Cwmgeidd were built to carry the canal across major rivers. It transported coal from the Upper Swansea Valley to Swansea for export, or for use in the metallurgical industries in the Lower Swansea Valley. The period 1830-1840 saw the development of towns around the canal. Clydach, Pontardawe, Ynysmeudwy, Ystalyfera, Ystradgynlais, Cwmgeidd and Abercraf came into being as industries developed at those locations. The canal remained profitable until 1902, when losses were first reported. This decline in revenue and profits was due to the competition from the Swansea Vale Railway. The last commercial cargo carried on the Swansea Canal was in 1931, when coal was conveyed from Clydach to Swansea.

The Monmouthshire & Brecon Canal, for most of its thirty-five mile length, is in the Brecon Beacons National Park. The *'Mon and Brec'* is actually two canals – the Monmouthshire Canal from Newport to Pontymoile; and the Brecon and Abergavenny Canal running from Pontymoile to Brecon. Places on or near the canal include: Brecon, Talybont-on-Usk, Llangynidr, Crickhowell, Abergavenny, Pontypool, Cwmbran, and Newport; and on the Crumlin Arm, Risca and Crosskeys. Fourteen Locks is a series of locks on the Crumlin arm of the Monmouthshire Canal, at Rogerstone in Newport. Widely regarded as Britain's most remarkable staircase lock system, the canal level was raised 160ft in just 800 yards. The Montgomery Canal runs thirty-three miles from Frankton Junction with the Llangollen Canal in Shropshire, England, to the town of Newtown, via Welshpool. The Llangollen Canal initially formed the majority of the Ellesmere Canal, and later was part of the Shropshire Union Canal. With the increasing popularity of pleasure boats, it was renamed the Llangollen Canal in an effort to attract more visitors. It links Llangollen with Nantwich in Cheshire, via Ellesmere in Shropshire. It was the first major civil engineering work undertaken by Thomas Telford and was intended to provide a route from coalfields and ironworks near Wrexham to the sea. It also linked to the Montgomeryshire Canal from near Llanymynech. The canal's most notable features include the spectacular PONTCYSYLLTE Aqueduct, engineered by Telford to carry the canal over the valley of the River Dee east of Llangollen. Another aqueduct carries the canal over the River Ceiriog at Chirk. There are tunnels at Whitehouses and Chirk, and another southeast of Ellesmere.

CANDLESTON CASTLE Amongst the wonderful sand dunes at Merthyr Mawr (once part of the largest sand dune complex in Britain), this fortified manor house was built by the de Cantelupes in the fourteenth century. The Welsh original name is Treganlaw – 'the place/town of 100 hands', but the original settlement is lost under the dunes.

CANTREFS AND COMMOTES From 'cant' (hundred) and 'tref' (home, or town), this was the old subdivision of land. The 'gwlad' (land) of King Morgan (which became the county of Gwlad Morgan, Glamorgan) was divided into cantrefs of around one hundred hamlets, each with its own sub-chief. The cantref had to supply military men to the king or prince when needed, and each cantref had its own court. As cantrefs grew too large to deal with legal matters, the 'cymyd' (commote) was created, with several commotes in each cantref. On the Isle of Anglesey, Mon, there were cantrefs at Aberffraw (the royal court), Cemais and Rhosyl, each divided into six commotes with its own court. Many of these ancient boundaries have survived the 'shiring' of Wales.

CAPITAL Cardiff is Europe's youngest capital city, being awarded the nomenclature against competition from Swansea and Aberystwyth in 1955. Machynlleth also had claims, being the site of Owain Glyndŵr's first Welsh Parliament. 2005 saw celebrations in Cardiff to celebrate its 50th year as a capital and 100 years as a city.

CARADOG/CARACTACUS (d.c. 54AD) Leader of the Catuvellauni tribe that was defeated by Aulus Plautius in 43 CE, Caradog fled to lead the Silures of southeast Wales against the Roman invasion. He led attacks upon the Romans in 47 CE and 48 CE but was finally defeated in 51 CE, betrayed by Queen Cartimandua of the Brigantes and taken with his family in chains to be led in triumph in Rome, as its greatest enemy. Caradog was marched in chains with his brother, wife and daughter in the triumphal procession for the Emperor Claudius in Rome. Such captives were always publicly executed as enemies of Rome, but Caradog's proud bearing and speech to the Tribunal is again recorded by Tacitus: 'To you the situation is full of glory; to me full of shame. I had arms and soldiers and horses; I had sufficient wealth. Do you wonder that I am reluctant to lose them? Ambitious Rome aims at conquering the world: does the whole human race then have to bend to the yoke? For years I resisted successfully: I am now in your hands. If vengeance is your intention, proceed: the scene of bloodshed will soon be over, and Caradog's name will fall into oblivion. If you spare my life, I shall be an eternal memorial to the mercy of Rome.' Uniquely, Caradog was pardoned by the Emperor Claudius, and after seven years' captivity is said to have been allowed to return to his home at ST DONAT'S, near Llanilltud Fawr. His family was housed in the British Palace in Rome, which became the acknowledged centre for the new Christian religion. It is thought that his daughter Eurgain married a Roman (Lucius Fawr), and brought back Christianity to Wales, founding a first-century monastic settlement called Cor Eurgain in Llanilltud Fawr.

CARDIFF It may be that Cardiff was named after the Roman general Aulus Didius, being originally Caer Didius, and the huge Roman fort is at the heart of the city. It was given a Royal Charter by Elizabeth I, and was a haunt of pirates in Tudor times. Cromwell's men took the castle from the Royalists in the Civil War. Cardiff used to be the busiest exporting docks in the world, taken over for a short time by Barry, with all the valleys' coal pouring through. Cardiff's City Hall, the jewel in the crown of one of the finest civic centres in the world, was built in only five years, and opened in 1906. The Hall cost £129,708 and the adjoining Law Courts £96,583, massive costs at the time. With the adjoining National Museum, Temple of Peace, Welsh Office and University buildings, these glittering white Portland stone edifices represent a time when Britannia really did rule the waves. Huge 12-ton and 15-ton blocks of Portland stone were carried by teams of six shire horses to the Town Hall site, where eight 5-ton cranes lifted and placed them. The cranes, operated by a local firm, Turner and Sons, made Cardiff Civic Centre the first all-electric building site in the world.

The National Museum of Wales in the Civic Centre contains superb Impressionist paintings, donated by the Davies sisters. St David's Hall is one of Europe's newest concert halls, with 1900 seats, and The New Theatre is an Edwardian gem. The Welsh National Opera used to perform at the New Theatre but is now based in Cardiff Bay's Millennium Theatre. Just west of the main shopping centre and civic centre is the magnificent Cardiff Castle, built on Roman remains. There are six Victorian shopping arcades, the old covered market, pedestrianised shopping areas and covered shopping malls. Castle Arcade is the only three-storey arcade in Britain. Another third of shopping space has been added by another huge mall on the south side of the main shopping centre, opened in 2009. The 1891 galleried indoor market still has one of the original traders, Ashton's Fishmongers, and nearby St John's Church was founded at the end of the twelfth century. It was sacked by Glyndŵr in 1404, and its wonderful tower and endowed by the wife of the future Richard III in 1473.

The European Council of Ministers met at Cardiff in June 1998. 'The European', (15-21 June 1998) carried a banner headline on Cardiff's hosting of the EU leaders' conference 'From slag heap to summit of achievement'. There are no coal or iron deposits in Cardiff, and hence there has never been a slagheap within miles of the capital. To Cardiff's west is Bro Morgannwg, the beautiful and fertile Vale of Glamorgan with hidden thatched pubs and its 'Heritage Coastline'. To the south is only the sea. To the east are the intriguing Wentloog (Gwynlliwg) levels and the rolling hills of Monmouthshire. To the north are the hills, in which were found mineral deposits.

The Rugby World Cup Final was held in the new Millennium Stadium in 1999. This all-purpose £100 million stadium has a retractable roof, and takes seventy-five thousand spectators. It held six FA Cup Finals and also Rugby League Cup Finals because of the delay in building the new Wembley Stadium. The last FA Cup Final was held there in 2006, just two years before Cardiff City appeared in the Final at Wembley. Football supporters have been so impressed by the city that at least one in ten has returned to Cardiff for a break or a holiday. There are no other capital city sports stadia, as integrated into the heart of the city, as is this futuristic white stadium on the banks of the Taff. One can walk past Cardiff Castle and follow the adjoining Bute Park alongside the River Taff, walking through parkland for a couple of miles to LLANDAFF CATHEDRAL and its ruined Bishop's Palace (sacked by Glyndŵr). The city celebrated 100 years as a city and fifty years as a capital (Europe's youngest) in 2005, and the author had the pleasure of organising an International Celtic Festival to mark the event, with acts from Ireland, Scotland, Wales, the Isle of Man, and Patagonia in a series of shows with the main concert being given by the Breton harpist Alan Stivell.

CARDIFF BAY Europe's largest urban regeneration scheme impounded the outfalls from the Taff and Ely rivers to create a 500-acre freshwater leisure lake with eight miles of shoreline. This is fronting a half-mile long 'Arc of Entertainment' with clubs, restaurants and bars. The Cardiff Barrage, built to link Cardiff and Penarth and keep the fourteen-metre tides out was completed in 1998. The new Inner Harbour area easily surpassed its target of 2 million visitors a year by 2000, and the Atlantic Wharf leisure complex cost £30 million. The whole project took over a sixth of the area of the capital, costing over £2.4 billion. Baltimore USA was used as the model for this fabulous concept, but Cardiff's regeneration is far bigger. The new Bute Avenue links up the city centre with its waterside at last. The avant-garde visitors' centre, the elliptical silver 'Tube', was unfortunately designed to be temporary. However, it has been so popular that it is still in situ. The new Millennium Centre has been locally christened 'The Armadillo' and is an exciting new theatre and the home for the Welsh National Opera. The new Senedd building for the National Assembly is another excellent new building.

CARDIFF CASTLE The first motte and bailey may have been founded by William the Conqueror when he made his pilgrimage to ST DAVID'S in 1081. In the heart of the city, this is on the site of a massive Roman fort and of an earlier castle belonging to Ifor ap Cadifor. The first Norman castle dates from 1091. Robert Curthose, William the Conqueror's eldest son and heir, was captured at the battle of Tinchegrai in 1106 by his younger brother, Henry I. He was incarcerated in Cardiff Castle for the remaining twenty-eight years of his life. Ifor ap Meurig scaled the walls of Cardiff Castle in 1158 to capture William, Earl of Gloucester and his wife and son. Ifor, Lord of Senghenydd, was known as IFOR BACH because of his height, and refused to release his prisoners until the Earl promised to give Ifor back his lands. Huge eagles are said to guard Ifor's treasure at Castell Coch. In 1183-84 a Welsh uprising damaged the castle, and in the 1270's it was strongly refortified by de Clare in response to the threat from Llywelyn ap Gruffudd. The Despensers then took over the castle and imprisoned Llywelyn Bren there, before illegally hanging, drawing and quartering him. In 1321, it was captured by barons rebelling against Edward II, as Despenser was hanged at Hereford, Edward being murdered at Berkeley. Glyndŵr's forces attacked and sacked the castle in 1404 and burnt the town. Other owners included the Earl of Warwick (King-Maker), the sister of Richard II and the great warlord Jasper Tudor. The Herberts offered Charles I refuge at the castle in 1645, but it was taken by Cromwell's forces. Cardiff Castle, up until the Second World War, was the longest continually-inhabited building in Britain. It now features Roman fort walls, a Norman shell keep on a moated motte, and a restored mediaeval castle with eight acres of castle green. Restored in the nineteenth century by the third Marquis of Bute and the architect William Burges, like CASTELL COCH and CAERFFILI CASTLE, it is one of Wales' greatest visitor attractions, and the adjacent Bute Park Grade 1 listed gardens were laid out by Capability Brown.

CARDIFF COAL EXCHANGE Coal traders used to chalk up the changing prices of coal on slates outside their offices, or struck deals in the local taverns, but as Cardiff became the biggest coal port in the world, a building was designed to facilitate these deals. The Coal Exchange was built between 1883 and 1886, and hundreds of coal owners, ship owners and shipping agents met daily on the floor of the trading hall. Up to 10,000 people would use the building each day, and in 1907 the world's first million pound deal was struck at the Exchange. Around this time the price of the world's coal was decided here, and other attractive opulent banks and offices opened around Mountstuart Square - Baltic House, Ocean Building, Cory's Buildings, Cambrian Buildings etc. The use of oil in ships was the death-knell for coal, and with the end of the last war the docks went into even further decline. Much of Cardiff's merchant shipping had been destroyed, and other countries were producing cheaper coal. The Coal Exchange closed in 1958, with coal exports ending in 1964. The building was earmarked in 1979 as a future home of the proposed Welsh Assembly, but that plan for devolution was rejected in a referendum. It was run as a venue for rock and folk concerts, but was closed in autumn 2007 for redevelopment into flats and bars. Its central trading floor is listed, and will reopen as an entertainment venue.

CARDIFF ROMAN FORT This large fort was occupied until the end of the first century, and then another shore fort was built of stone in the late third century, with walls ten feet thick to defend against the Irish. The nine-acre fort was abandoned in the fourth century, and features in the *Mabinogion* tale of *Geraint and Enid* as the home of King Ynwyl. Its splendid remains can be seen when one visits Cardiff Castle.

CARDIGAN - ABERTEIFI The county town of Ceredigion (Cardiganshire), the River Teifi enters the Irish Sea here, and markets are held in its Guild Hall.

CARDIGAN CASTLE From the eleventh century, this was the site of constant battles between Norman invaders and the princes of Deheubarth. The Lord Rhys took it around 1170 and refortified it in stone, making it the first recorded Welsh masonry castle. In 1176, he held a huge eisteddfod at the castle, with contests between bards and poets, and between harpers, crowthers and pipers, with two chairs for the victors. Giraldus Cambrensis stayed with Rhys in 1188 when recruiting for the Crusade. Rhys's sons fought for the castle and it passed into Norman hands until Llywelyn the Great retook it. It then changed hands several times between the Welsh and Normans, and it was slighted by Cromwell. It is presently being restored after many years of private neglect.

CARDIGAN ISLAND (YNYS ABERTEIFI) Off Gwbert in Ceredigion, it is noted for its Atlantic seals, shags, choughs, dolphins and an unusual breed of Viking Soay sheep, which are chocolate-coloured. It covers forty acres and is a SSSI. When thick white mists roll in from the Irish Sea, Cardigan people used to say 'The children of Rhys Ddwfn will be coming to market today.' Far out in Cardigan Bay lie the Cormorant Isles (Ynysoedd Mulfrain), invisible to all but those who have eaten a certain herb from a small patch of ground near Cemaes (magic mushrooms?). The children of Rhys Ddwfn have lived on the islands for centuries, and come to the mainland to buy corn for their bread, but no-one has ever seen them. Cardigan Island Farm Park on the mainland is an excellent venue for watching seals and dolphins.

CAREW CASTLE Carew Castle was the site of the last medieval-style tournament held in Britain, in 1507, attended by HENRY VII, his son Arthur and Arthur's wife Catherine of Aragon. 600 knights attended, and the arms of each member of the royal family can be seen on the south porch. It commanded a crossing point on the Carew River, and Gerald Fitzwalter (Gerald of Windsor) built the first castle around 1100, on an impressive Iron Age site that had no less than five defensive ditches. Its lands had been part of the dowry of Gerald's wife, Princess NEST. At one time King John seized it, but it passed in 1480 into the hands of Rhys

ap Thomas, later a hero of Bosworth Field. With the new King Henry VII's patronage Rhys ap Thomas turned it into a superb fortified mansion. Sir JOHN PERROTT added the great North Wing, and it was partially slighted during the Civil War.

CAREW CELTIC CROSS A superb eleventh-century stone with Celtic knotwork, commemorating the death of Maredudd ap Edwin in battle in 1035.

CARMARTHEN (ABER TYWI) Its Welsh name of Caerfyrddin refers to its Roman name of Moridunum Demetarum, and the fort was built to pacify the Demetae after the Silures in the southeast had agreed to stop fighting. Caerleon, Cardiff and Carmarthen are probably the oldest recorded towns in Wales. The old manuscript from its priory, *The Black Book of Carmarthen,* is the oldest surviving manuscript in the Welsh language, and is in the National Library of Wales. The town was granted a Royal Charter by King John in 1201, and its 1405 eisteddfod was one of Wales earliest recorded festivals. Only 300 years ago, with its population of 4,000, Carmarthen was the largest town, and main port, in Wales. The medieval town walls, four gates and the Augustinian priory and Franciscan monastery have all disappeared.

CARMARTHEN, BATTLES OF, 1222-1224 In April 1222 Llywelyn ap Iorwerth attacked and took William Marshal's castles of Carmarthen and Cardigan (Aberteifi), and Marshall, the Earl of Pembroke returned from Ireland to take them back in the same year. The earl built a new stone castle at Cilgerran and re-established his hold on Cydweli during this time. For the next two years there was intermittent local warfare between Llywelyn, Gruffydd ap Llywelyn, and Marshal until Llywelyn was forced to peace terms by Henry III.

CARMARTHEN, BATTLE OF, 1258 *The Chronicle of Ystrad Fflur* tells us that in 1258 all the Welsh nobles made a pact to ally together, upon pain of excommunication, but Maredudd ap Rhys went against his oath, agreeing treachery with the Norman-French... 'And Dafydd ap Gruffudd and Maredudd ap Owain and Rhys ap Rhys went to parley with Maredudd ap Rhys and Patrick de Chaworth, seneschal to the king at Carmarthen. And Patrick and Maredudd broke the truce and swooped down on them. And then Patrick was slain, with many knights and foot-soldiers.' The site seems to be unrecorded as yet.

CARMARTHEN, BATTLE OF, 1405 This took place on Glyndŵr's march through South Wales to invade England, and the castle was surrendered.

CARMARTHEN (CAERFYRDDIN) CASTLE On a prominence above the river Tywi, its first name was Rhyd y Gors, mentioned in 1094. A Norman castle was built on the site by 1104, and in Crown ownership it became the administrative centre of southwest Wales. In the twelfth and thirteenth centuries it was the scene of many battles between the Welsh and Normans, and was destroyed by Llywelyn the Great in 1215. The Earl of Pembroke began rebuilding from 1223, and it was sacked by Glyndŵr in 1405. Edmund Tudor, the father of Henry VII, died here in prison in 1456.

CARMARTHEN ROMAN TOWN Moridunum Demetarum became the 'civitas' or tribal capital of the Demetae, just as CAERWENT (Venta Silurum) was for the Silures. The fort there was founded in 75 CE, on the site of a Celtic hillfort. The amphitheatre, seating 5,000, is one of only eleven in Britain, of which the finest is at CAERLEON. Giraldus Cambrensis tells us that in the twelfth century, parts of the Roman town's walls were still standing.

CARMARTHENSHIRE, SIR GAERFYRDDIN Carmarthenshire is the largest of the thirteen historic counties, and around 60% of its population are Welsh speakers. Fforest Fawr and Black Mountain extend into the east of the county and the Cambrian Mountains

into the north. The south coast contains fishing villages and sandy beaches, and the main towns are Ammanford, Burry Port, Carmarthen, Cydweli, Llanelli, Llandeilo, Newcastle Emlyn, Llandovery, St Clears, Whitland and Pendine. Although Llanelli is larger, the county town is Carmarthen, because of its central location. Under the Local Government Act 1972, the administrative county of Carmarthenshire was abolished in 1974, and the area of Carmarthenshire became three districts within the new county of Dyfed: Carmarthen, Dinefwr and Llanelli. Under the Local Government (Wales) Act 1994, Dyfed was dissolved on 1 April , 1996, and the three original counties Ceredigion, Carmarthenshire, and Pembrokeshire were re-established to form unitary authorities. The alteration of Wales original counties into super-counties and then back again has been an utter waste of taxpayers' money, and the re-organisation date of All Fools' Day is relevant for all the politicians and planners involved.

CARNDOCHAN CASTLE On a rocky summit near Llanuwchllyn, it was built by Llywelyn the Great, and bears similarities to his Castell-y-Bere, and has wonderful views. It is only a mile from Caer Gai Roman fort.

CARN FADRYN CASTLE & HILLFORT On the Llŷn Peninsula, this is a stone-walled hillfort with stone huts, with a tower was built in the twelfth century by the sons of Owain Gwynedd, noted by Giraldus Cambrensis as being one of the earliest Welsh stone castles. Until the twelfth century, Welsh castles had mainly been of earth and timber construction.

CARN GOCH, BATTLE OF, 1136 On New Year's Day, rebellion broke out in the Norman lordships of South Wales, starting near Loughor. The Normans were defeated and a memorial stone has been laid on Carn Goch Common, but Cadle (place of the battle, or place of the army) also has a claim to being the battle site. However, the word Cadle may refer to the training ground of the Roman troops who were stationed at Loughor. The Welsh had been led by GRUFFUDD AP RHYS, the husband of GWENLLIAN, who then went north to try and involve the princes of Gwynedd in the southern war of independence. While there, his wife was captured and executed.

CARN INGLI HILLFORT Near Newport, Pembrokeshire, this covers two peaks, and did not require defending on its steep southern cliff. There were three gateways, and about twenty-five house sites can still be seen. The ramparts originally stood 10ft high.

CARNO, BATTLE OF, 950 The death of Hywel Dda inaugurated a period of internecine fighting among the Welsh princes. The sons of Hywel Dda fought the brothers Idwal and Iago ab Idwal at Nant Carno, and in the following year Idwal and Iago ravaged Dyfed. In the same year Cadwyn ab Owain was killed by invading Saxons. There was also a battle at Mynydd Carno in 728, according to the *Annales Cambriae*. This latter place is in Glamorgan.

CARREGHOFFA CASTLE This Powys castle saw turbulent times after it was built in 1101 by Robert de Bellesme, and then captured by Henry I in 1102. Garrisoned by Henry II from 1159-1162, it was taken by the joint forces of Owain Cyfeiliog and Owain Fychan in 1163. It was taken back by Henry II in 1165, but recaptured by Owain Fychan by 1187. However, Owain was killed in a night attack by his cousins Gwenwynwyn and Cadwallon, and then it was retaken by the English. Carreghoffa was near a silver mine, which may have been the reason for this constant conflict. In 1197, Gwenwynwyn was given the castle to secure the release of Gruffudd ap Rhys. In 1212-1213 Robert de Vipont rebuilt the site but it seems to have fallen to Llywelyn the Great in the 1230's and was slighted. Thus there were at least nine changes of hands that we know about in its 120 years of history.

CARREG CENNEN CASTLE A superbly sited castle near Llandeilo, it dominates the surrounding landscape and ravens, red kites and buzzards abound. It seems that there was Dark Age and Roman occupation of the crag, and a legend relates that Urien Rheged and his son Owain, knights of King Arthur, lived there. The Welsh Princes of Deheubarth built the first stone castle there, and probably The Lord Rhys in the late twelfth century made the greatest contribution. Rhys Fychan of Deheubarth had the castle and it was betrayed by his mother, the Norman Matilda de Breos, but he had wrested it back by 1248. His uncle Maredudd ap Rhys Grug then took it, and it was captured in 1277 by Edward I. Glyndŵr's forces caused damage when taking it. Despite its demolition by the Yorkists in 1462 during the Wars of the Roses, it is a formidable fortress. What remains was mainly built by the Giffards after the death of Llywelyn the Last. A tunnel in the castle leads down to a limestone cave and permanent water supplies.

CASTELL Y BERE Near Abergynolwyn in Gwynedd, it was built by Llywelyn the Great, on a great rock dominating a valley floor. Cader Idris looms over the site, and it was the last castle to fall to Edward I during the war of 1282-83. Madog ap Llywelyn failed to take it in 1295.

CASTELL BRYN GWYN IRON AGE FORT Near Brynsiencyn, it is unusually on level ground, despite being named 'White Hill'. It has a well-preserved circular bank 11 yards wide, and a filled-in, formerly deep, ditch.

CASTELL CAER LLEION This hillfort lies at the summit of Conwy Mountain, impregnable from the north, and with its entrance in the southwest. There are the remains of *c.* 50 stone huts and house platforms.

CASTELL COCH The 'red castle' was rebuilt on a thirteenth-century site overlooking the Taff Valley north of Cardiff. Now looking like a fairy-tale castle, it is testament to the remarkable decorative work that William Burges carried out for the Marquis of Bute in the 1870's.

CASTELL COLLEN ROMAN FORT Near Llandrindod Wells, it was occupied until the early third century, and finds are in Llandrindod Wells' museum.

CASTELL CONWY, SIEGE OF, 1401 On 1 April, 1401, the garrison of 50 men-of-war and 60 archers of the mighty Conwy Castle were assembled in the town church for Good Friday services. A Welsh carpenter asked the guards to enter the castle for urgent repairs, and as the gates opened forty men, led by Gwilym and Rhys ap Tudur of Anglesey, rushed in and took the castle. Henry of Monmouth (later Henry V) and Harry Hotspur, Earl of Northumberland, besieged the castle. Owain Glyndŵr did not have the forces to raise the siege, and there was no way out for the defenders. After three months, there was no food left. A deal was made whereby nine of the forty Welshmen would be executed, and thirty-one allowed to go free and be pardoned, including the Tudur brothers. The nine were publicly hung, drawn and quartered, helping fuel greater resistance from Glyndŵr's forces, who went on to fight for a further fourteen years.

CASTELL CRUG ERYR This small motte and bailey on a high Radnorshire hill seems to have been built by Cadwallon ap Madog, and is mentioned by Giraldus Cambrensis in his *Tour of Wales* in 1188. It was captured by the Normans but retaken by the princes of Maelienydd, and later 'defaced' by Glyndŵr.

CASTELL CYNFAEL Near Tywyn, at Bryn-y-Castell, it was built by Cadwaladr ap Gruffudd in 1147. However, by 1152 Cadwaladr was in exile, and Gwynedd was in the hands of his brother Owain Gwynedd, another son of King Gruffudd ap Cynan. The castle guarded a crossing across the Dysynni at the junction of the Fathew and Dysynni valleys.

CASTELL DINAS Near Talgarth, it seems that the first castle was built in 1070 by William FitzOsbern. The castle was taken in 1233, then retaken by the Normans, and then fell again to Llywelyn the Last in 1262-63. It was slighted by the Welsh during the Glyndŵr War of Liberation.

CASTELL DINAS BRÂN On a 750-foot high crag overlooking Llangollen and the River Dee, it seems impregnable. There was a castle there as early as 1073, on an Iron and Dark Age site, and the legend of King Bran is associated with it. The ruined stone fortress belonged the princes of Powys Fadog, probably dating from the time of Gruffydd ap Madoc around 1260. It was besieged by the Earl of Lincoln in 1277, and its Welsh defenders fired it when they abandoned the castle. The Earl told the Edward I that it could be rebuilt as the greatest castle in all of Wales, but only modest repairs were made. Dafydd ap Gruffudd held it in 1283 but was captured and executed, and it was in ruins when taken by Glyndŵr in 1402. By the reign of Henry VIII, Leland stated that its only inhabitants were eagles.

CASTELL DINERTH Near Aberarth in Ceredigion, it was built by the de Clares around 1110. Gruffudd ap Rhys took it in 1116 and razed it to the ground, but it was rebuilt and destroyed by Owain Gwynedd in 1136. Hywel ab Owain captured it in 1143 and Cadwaladr ap Gruffudd took it in 1144, but by 1158 it was back in Norman hands. The Lord Rhys sacked the castle in 1164, and it passed to his son Maelgwn who lost it in civil war to his brother Gruffudd. Maelgwn ap Rhys was back in control by 1199. However, when Llywelyn the Great took over the sovereignty of Deheubarth, Maelgwn completely destroyed the castle rather than give it to him.

CASTELL HENLLYS IRON AGE FORT Near Newport in Pembroke, the buildings dating from 300 BCE have been reconstructed. There are three huge roundhouses, a smithy, a grain-store raised off the ground and a chieftain's house.

CASTELL HYWEL, BATTLE OF, 1153 Humphrey's Castle, between Lampeter and Newcastle Emlyn, was destroyed by the Welsh in 1136 and rebuilt by Hywel ab Owain Gwynedd in 1153 as Castell Hywel. This battle with Cadell ap Gruffudd of Deheubarth effectively moved control of southern Ceredigion from Hywel, after years of fighting. He fled for Ireland , then returned to fight and die at PENTRAETH.

CASTELL MACHEN Near Caerffili, Morgan ap Hywel used this castle in the early thirteenth century, after losing Caerleon Castle to the Normans. In 1236, Gilbert Marshall, Earl of Pembroke, took Castell Machen and fortified it further, and from 1248 it belonged to Morgan's grandson Maredudd, being also known as Castell Meredydd from this time. The de Clares later took it.

CASTELL MOEL This small Iron Age hillfort was later castellated, and overlooks the Roman Road (A48) at Bonvilston, a few miles west of Cardiff. Many stone slingshots and stone balls for ballistas have been found here, indicating an unknown battle between the Romans and Celts. Professor Bernard Knight lived near here, and has a collection of the shot from his gardens, authenticated by the National Museum of Wales.

CASTELL TINBOETH Northeast of Llandrindod Wells, this was a thirteenth-century Mortimer castle, surrendered to the king in 1322 with the disgrace of that family.

CASTELL CAEREINION Built in 1156 by Madog ap Maredudd of Powys, it was improved by The Lord Rhys and Owain Gwynedd in 1166, and its motte lies in the churchyard of St Garmon's Church.

CASTLES Later castles, with rings of walls are complicated buildings. Even if the outer walls are breached, there is little room to use a battering ram. As there are no inner ramparts, anyone

climbing on top of a wall is a simple target for those behind the higher inner walls. Walls were often surrounded by water, to make undermining impossible. An attacker had thus to get through the barbican (the outer defence defending the main gate), over a drawbridge, past the gatehouse, portcullis, murder-holes and machicolations, through a bailey, another gatehouse with its obstacles, another bailey before reaching the keep. This last defence was often built on a steep motte (mound), with a moat filled with water. Even if the attackers succeeded in getting into a main tower or the keep, they had to charge up stairs that 'went the wrong way'. Spiral staircases wind away to the right, so that the ascending attacker's sword arm is obstructed by the central pillar. In some castles, there are some staircases that go in the opposite direction, so if the defending force lost a floor, it knew the easiest way to retrieve it was going down that staircase. Another interesting device was the placing of 'false steps' on the staircase, not at the same level as the normal ones. The attacking man-at-arms would run towards the defender, eyes on his opponent's sword, keeping his impetus up, but misplace his footing and fall, just where the defender expected him to stumble. The wonderful atmosphere of Welsh castles derives from the fact that they were never showpieces like Windsor – they saw continuing real action, and all have a different story.

The Normans, within the space of four years from 1066, had totally overwhelmed England. It took hundreds of years to do the same to Wales, with its tiny population. As late as 1405, Glyndŵr virtually reconquered Wales for the Welsh and invaded England. The Norman 'Marcher Lords' built frontier castles along the border from which they moved slowly westwards, trying to hold on fresh gains by establishing castles, garrisons, cruelty and institutionalised torture. Huge Norman Marcher Castles such as Chirk, Ludlow and Chepstow controlled the Marches, or borders with Wales. After centuries of the Welsh fighting back the Saxons, the Norman earls of Shrewsbury, Hereford and Chester managed to push westwards over Offa's Dyke. They embarked upon a massive castle-building programme to subdue the Borders and South Wales. Caerphilly and Pembroke were two of the most powerful castles in Europe. Beyond the new Norman territories remained those inhospitable mountainous parts of Wales, which are still the strongholds of the language and culture. It had been realised that the main bases of Norman attacks on Wales, at Chester, Shrewsbury, Montgomery and Hereford, were too far back, leaving extended and vulnerable lines of communication. Therefore the French lords of the Welsh Marches slowly pushed forwards, consolidating gains by building castles. Edward I, who reigned from 1272-1307, at the same time fortified strategic sites along the Welsh coast that could be supplied by sea. In return, the Welsh princes also built around fifty castles. King Edward I spent half of his crown's annual incomes in building the 'iron ring' of castles to isolate Snowdonia and the Princes of Gwynedd from the rest of Wales.

After Edward's successful war against Llywelyn in 1277, he built the castles at Flint, Rhuddlan, Builth Wells and Aberystwyth, and upgraded some captured Welsh castles. The second uprising by Llywelyn in 1282 saw Edward hire the greatest castle builder of the age, James of St George d'Esperanche, to extend the ring of castles around Gwynedd. These great castles of Harlech, Beaumaris, Caernarfon and Conwy cost massive amounts from the royal purse. These last four links in the Iron Ring of castles, including the defensive town walls of Conwy and Caernarfon, are a World Heritage Listed Site. Each castle was integrated with a dependent town, a 'bastide' as in France, populated by English settlers, where the Welsh were not allowed to trade or bear arms. Bastides were given economic and other liberties, in return for defending their lords' territories. In South Wales, Pembrokeshire ('Little England beyond Wales') became a major base of Norman settlement, with many castles. Pembroke Castle's keep is 80ft high with massive walls 20ft thick. Because of the ever-present danger of attack, many Pembrokeshire castles stand close to the sea or on navigable estuaries and rivers, for example Tenby, Manorbier, Pembroke, Carew, Upton, Benton, Picton, Haverfordwest, Newport, and Cilgerran. Another line of castles including Roch, Wiston, Lawhaden and Narberth gave a defensive frontier, the so-called Landsker that still defines the difference between the English place-named, English-speaking territory of 'Little England Beyond Wales', and the troublesome Welsh on the Preseli Hills and beyond. There are many Welsh native castles such as Dolwyddelan (where Llywelyn the Great was born in 1173) and Dolbardarn.

Castell Dinas Brân was built by the Prince Madog ap Gruffydd Maelor of Powys, as a superb base overlooking Llangollen, to attack the English borders. They were often taken by the Normans and Plantagenets and refortified. Some changed hands up to nine times in the course of wars. Castell y Bere and Dolforwyn Castle were built by Llywelyn the Great. Ewloe was started by Llywelyn the Great in 1210 and completed in 1257 by Llywelyn the Last. Narberth Castle in Pembrokeshire was the ancient home of Welsh princes, and features as the 'Court of Pwyll' in the Mabinogion. Wales thus has easily the highest density of castles in the world, with hundreds hardly known. If we just look at the small Vale of Glamorgan, in the area south of the A48, the old Roman Road, there are over thirty castle sites.

CATHEDRALS The foundation of the Welsh cathedrals predates all the earliest other British cathedrals such as Canterbury, Westminster and Winchester by around a century. The four ancient provinces of Wales each had a dominant Celtic tribe. Anglesey and Gwynedd, around Snowdonia, was ruled by the Deceangli. (A smaller tribe, the Gangani, occupied the Llŷn Peninsula). Powys, the Berwyn Hills district, Radnor, Flint, Shropshire and Cheshire were controlled by the Ordovices. Dyfed and Ceredigion, around the Pumlumon Mountains, belonged to the Demetae, who became centred in Carmarthen. The Silures, based in Cardiff and around Newport ruled Morgannwg and Gwent, the Black Mountains, Hereford and Worcester. Thus the four ancient dioceses of BANGOR, ST ASAF, ST DAVID'S and LLANDAF are at the centres of these four ancient Celtic kingdoms. After the druids were massacred in their stronghold of the holy island of Anglesey in 61 CE, and the Welsh tribes finally succumbed to Rome in 78 CE, the Celts seemed to have adopted Christianity quickly, with a flourishing Celtic church outlasting the Roman departure in the fourth century. Tradition states that Wales was Christian soon after Jesus' death. There are other major cathedrals in BRECON and NEWPORT, and a Catholic cathedral in Cardiff.

CATRIN O'R BERAIN (1534-1591) Katherine of Berain was later called 'Mam Cymru', the Mother of Wales, because of her many descendants. A granddaughter of Henry VII, she allegedly had six wealthy husbands, killing five of them by pouring molten lead in their ears as they slept. She then buried them in Berain orchard. The story is that the sixth locked her up and starved her to death. In Lloft y Marchog (the Knight's Bedroom) at Berain are irremovable stains of blood on the wall, where 'Catrin Tudor' is supposed to have attacked her second husband, Sir Richard Clough. A more dispassionate reading of history reveals that she was born Katheryn Tewdwr in the mansion of Berain, Llanefydd, She actually married four times (all to men influential in Welsh affairs), and had six children, so founding several dynasties of the Welsh upper classes. At the funeral of her first husband, John Salesbury of Lleweni, Denbigh, she was led out of the church by Maurice Wyn of Gwydir, who asked her to marry him. She politely declined, as she had already accepted a proposal from Richard Clough on the way to the funeral. Maurice Wyn of the famous family of the 'Princes in Wales' at Gwydir, tried again on Clough's death and she married him. She predeceased Edward Thelwal, of Plas y Ward, Ruthin, her fourth husband.

CATTLE The native (pre-Roman) breed of Wales, Welsh Black Cattle were the ancient Britons' most prized possessions as they retreated westwards under successive waves of Saxon invasion. For centuries, Welsh Black Cattle were herded in huge numbers along the old drove roads to England, giving them the nickname of 'black gold', before that epithet was applied to coal. John Williams, the Welsh Archbishop of York, called the droves 'the Spanish fleet of Wales, which brings hither the little gold and silver we have'. The returning Welshmen were prey to highwaymen, providing the stimulus for Britain's first commercial bank, the Welsh Bank of the Black Ox, now Lloyds Bank. Until last century, Welsh Blacks were also used for ploughing and pulling wagons. Smaller and far hardier than the Friesian and Charolais interlopers, they are making a comeback as a breed for both meat and milk. Their climatic adaptability makes them a suitable breed for North Canadian winters or Saudi Arabian summers, and because herd

records go back to last century, each animal can be traced over many generations – Welsh Black Beef has always been free of BSE.

Of the ancient Celtic White (or Park) Cattle, with their long horns, there is a relic wild population at Dinefwr Castle, and at Glynllifon and Vaynol in Gwynedd. These former are the descendants of the 'white kine of Denefawr' mentioned in Hywel Dda's Law a thousand years ago. Yr Ychen Bannog, long-horned oxen, often appear in Welsh mythology, and one of Culhwch's tasks in 'The Mabinogion' is to reunite the remaining pair on either side of Mynydd Banawg. Llanddewi Brefi church preserved a horn-core of one of these beasts, known as 'Mabcorn yr Ych Bannog', and it is now in The Museum of Welsh Life. It actually belonged to the 'great urus' (Bos Primogenius), the pre-Roman wild long-horned cattle, which are thought to be the ancestors of the Celtic White Cattle. There is also supposedly a herd of the rare Glamorgan Cattle at Margam Country Park, a pretty, light brown breed, with a white stripe along the backbone. These 'red cattle' were bred in the Southern lowlands, along with oxen. However, from this author's local research in the Vale of Glamorgan, the true Glamorgan cattle were a black breed with a white stripe and are extinct.

CECIL, WILLIAM, LORD BURGHLEY (1520-1598) His family's name was Anglicised under the Tudors from Seisyllt to Cecil, and he entered Henry VIII's Parliament aged just twenty-three in 1543. He served under Edward VI, but refused an offer to serve Queen Mary, later becoming Elizabeth's Chief Councillor and Secretary, a post he held for forty years. Before Elizabeth became queen, Cecil ensured that she came to no harm, sheltering her at Hatfield House from the court of her Catholic half-sister Queen Mary. Cecil became Lord High Treasurer under Queen Elizabeth, and is known as 'the architect of Elizabethan England'. Queen Elizabeth's most valued advisor and friend, as Lord Burghley he built the greatest Elizabethan building in Britain, Burghley House. The Spanish ambassador summed up his value to Elizabeth as her chief administrator, statesman, economist and diplomat, calling him 'the man who does everything.' A consummate master of Renaissance statecraft, he was rightly famed across Europe and the only man who Elizabeth ever completely trusted. Without Burghley there could have never been an 'Elizabethan Age.' The son of William, Robert Cecil was groomed by his father to succeed him as Elizabeth's Secretary in 1596.

CEFN DIGALL, BATTLE OF, c. 625 CADWALLON defeated Edwin of Northumbria in Powys as he invaded, on Hir Mynydd. There is a circular enclosure on the top of the summit, known as the Brecon Ring, which may have featured in the battle. It was said that the Severn was coloured red from its source to its estuary, such was the bloodshed.

CEFNLLYS, THE BATTLE OF, 1262 After the seizure of Cefnllys Castle, Roger Mortimer and Brian Brampton levied the Welsh Marches and rode out from Wigmore Castle to retake it. Llywelyn II had led his main force south, and met the Marcher Army outside Cefnllys Castle and heavily defeated it in the Battle of Cefnllys in November. Mortimer was forced to take refuge for three weeks in the unprovisioned and sacked castle. Llywelyn left a force surrounding the castle and went on to take Mortimer's castles at Knucklas, Presteigne, Knighton and Norton. These surrendered as Llywelyn had siege engines. He then returned to Cefnllys to give his cousin Mortimer safe passage back to Wigmore Castle, but kept Cefnllys until 1267. Under the terms of the Treaty of Montgomery it was returned to Mortimer. Llywelyn was repaid for sparing Mortimer's life with Mortimer treachery when Llywelyn was murdered by Roger Mortimer's son in 1282.

CEFNLLYS CASTLE Built by the Mortimers near Llandrindod Wells between 1240 and 1245, it was taken by the men of Maelienydd in November 1262, who then were joined by the princes of Deheubarth and the Constable of Llywelyn II. By the Treaty of Montgomery in 1267, Llywelyn the Last was forced to return Cefnllys and Maelienydd to Roger Mortimer, after which the

right to the lands should be settled between the Welsh Prince and the Marcher Lord. However, Mortimer would not negotiate. In 1294, Cefnllys fell to the men of Maelienydd again, in the general revolt led by Madog ap Llywelyn of Meirionydd, Cynan ap Maredudd of Deheubarth and Morgan ap Maredudd of Gwynlliwg.

CELLI TARFAWG, BATTLE OF, 1096 There was a rising of the men of Buellt, Gwynlliwg and Gwent, and a Norman army was sent by William Rufus. Another army had been sent north into Brycheiniog. The 'French' found no opposition, and were returning to England when ambushed and defeated in Gwent. If they were returning along the old Roman road, then the battle could have been at Caerwent. Carnant is an alternative name for the battle, from Caer Nantes, and is also a corruption of Caerwent.

CELTIC CALENDAR Parts of the Celtic Calendar which survive are:

November 1 – New Year's Day – the first day of winter, when the goddess Cailleach made the ground hard, by hitting it with a hammer;
December 18 – the day of Epona, the goddess of horses;
December 21 – the longest night;
December 31 – Feast of Oimelc. Every year the Winter Hag, Cailleach, sends her dragon to kill the lamb of 'Brigit of Spring'. Each year the lamb wins, and celebrations are held – this is the real origin of the present New Year's Eve festivities;
January 25 – Dwynwen's Day – love tokens were exchanged;
February 1 – Imbolc – the start of the lambing season. This was also known as Ogronios – the 'Time of Ice';
March 21 – Alban Eiler day – the days begin to be longer than the nights;
April 30 – the 'Eve of Beltain' – along with Oimelc, the greatest night for drinking;
May 1 – Beltain – the first day of summer – the cattle were driven from shelter onto the grass meadows for grazing. Two bonfires were lit to represent the life-giving sun, and the cattle forced to pass between them, to protect them from evil;
June 20 – Midsummer's Eve;
June 21 – the Longest Day. Celts could stay up all night (the 'death-watch') and see the spirits of those who would die in the coming year;
July 14 – Well Day – when wishes could be made at sacred wells;
July 31 – Feast of Lughnasadh – women choose husbands, sometimes for trial marriages. There was a festivity for the gods. Crops were ripening, and the Celts wanted to ensure their safe gathering in;
September 21 – nights grow longer than days;
October 31 – Eve of Samhain – the spirits of the dead roam the land.

CELTIC STONES AND CROSSES Many have been broken up for lime or walls, used in buildings, incorporated into fieldbanks or just lost underground over time. Some were even blown up by the Forestry Commission. However, Celtic crosses still abound throughout Wales, with collections in the National Museum at Cardiff, Llanilltud Fawr church and Margam Abbey. The tallest Celtic cross in Britain is Maen Achwyfan (Stone of Lamentation) near Holywell. The fine cross erected to Meredydd, Prince of Deheubarth, near Carew Castle, shows typical Celtic knotwork designs. The Pillar of Eliseg states that King Eliseg freed Powys from the English and is dated around 750 AD. In the north aisle of Llangadwaladr Church in Aberffraw, Anglesey is St Cadfan's Stone, probably eighth century. It reads *'King Catamanus (Cadfan) wisest and most renowned of kings.'* In St Cadfan's Church in Tywyn, the eighth-century Cadfan stone in the church is almost certainly the earliest known example of written Welsh. This gives strong support to Welsh being Europe's oldest living language. There are three fine Celtic stones in St Illtud's Church, Llanilltud Fawr (Llantwit Major). These are the Houelt Cross, for Hywel

ap Rhys, king of Glywysing; the St Illtud or Samson Cross, and the Pillar of Samson, all with Latin inscriptions. The Cross of Houelt is translated as 'In the name of God, the Father and the Holy Spirit, Hoult prepared this cross for the soul of Res his father.' Hywel ap Rhys, King of Glywysing, is recorded as dying in 886, which makes the cross late ninth century. The Pillar of Samson reads 'In the name of God Most High begins the cross of the Saviour which Samson the Abbot prepared for his soul and for the soul of Iuthahelo the king and Artmail (and) Tecan.' This is said to be late ninth century, but is almost certainly sixth century as it seems to relate Abbot Samson, his kinsman Arthur and King Iudicael of Brittany whom Arthur and Samson helped retrieve his throne. The Illtud Stone, or Cross-Shaft of Samson reads 'Samson erected this cross', '(Pray) For his Soul', 'Of Iltyd', 'Of Samson the King', 'Samuel' and 'Ebisar' on different panels. Again, this is sixth century.

According to tradition, in the ancient churchyard at Nevern, the weeping red sap from the old yew trees will dry up, when Wales regains its independence. Its 13ft high Celtic Cross of St Brynach is probably tenth century, with twenty-one carved panels. Each encloses a different type of love-knot pattern of endless interlacing ribbon, the symbol of eternity. St Brynach was a friend of St David, founded seven churches, and is said to have gone to Carn-Ingli Mountain to die alone in 570. Another stone near the gatepost has Latin and Ogham inscriptions. In the church is the 'Maclogonus son of Clutari' Stone, again with Latin and Ogham carvings, and another beautifully carved cross. Some have attributed it as a memorial of Maelgwn Gwynedd. There is also an early cross-marked stone and an inscribed stone to VITILIANI EMEREOTO, Vitalianus Emeretus. It may be a fifth-century memorial stone to King Vortigern, Gwrtheyrn. Castell Nanhyfer, the nearby multiple-banked promontory fort, is linked with this holy site of Nevern. There are around fifty stones with Ogham script, a series of slashes, in Wales. One such stone in Llandudoch (St Dogmael's) Church in Dyfed has inscribed on its face 'Sagrani Fili Cunotami'. This Latin inscription, matched against the Ogham carvings on the edge of the stone, enabled scholars in 1848 to decipher for the first time the Ogham code. There must be hundreds of ancient stones remaining hidden in Wales. Many were used for building, or destroyed for their 'pagan' origins, or used as gateposts in old fields and covered. Without Iolo Morgannwg's recollection of an old conversation, a fabulous cross at Llanilltud Fawr would never have been found in the graveyard. The Arthur stone was being used as a stepping stone at Ogmore Castle and was found during excavations. There have to be many buried or hidden or used in walls around the site of Llancarfan monastery, as none have been found there. The author remembers being told forty years ago, of old marked stones in a field near Rhos (Pontardawe), leading up to Mynydd March Hywel. Old people in the village were definite that there had been a great battle on the mountain, and there were tumuli of the dead there. The stones were covered with bramble and bracken as the farmer did not want people trespassing on his fields. There is also somewhere in the fieldbank boundaries at St Elvis' Farm, Solva, a stone with a Celtic face on it, which was taken from the monastery on that site.

CELTIC TRIBES The four ancient provinces of Wales each had a dominant Celtic tribe, and their territories correspond almost exactly to the four ancient Welsh bishoprics of St David's in the southwest, Llandaf in the southeast, Bangor in the northwest and St Asaf in the northeast.

CELTS Historians believe that the Beaker Folk came to Wales around 2000 BCE, from the Rhine area, with metals, bronze knives and battle-axes. By 1000 BCE, the Iron Age saw these peoples grouped around large hill forts for protection, with settled farming and extensive copper mines. These Celtae (Roman) or Keltoi (Greek) formed a huge organized culture and social structure that stretched from Ireland and Spain in the West to Anatolia and the gates of Thessaloniki in the East. The Celts sacked Rome in 389 BCE, but a lack of political unity amongst the tribes ultimately led to defeat by the Roman legions, and the Celtic languages in continental Europe were replaced by those stemming from Latin bases (with the exception of Brittany and Spain's Galicia region). More Celts had settled in Wales from around 600 BCE, bringing the La Tène

art style, iron weapons instead of bronze, coins and the language. In Wales, the great Celtic tribes were the Silures in the southeast of Wales and the areas of Hereford, Worcester and Gloucester and southwest; the Demtae in the southwest of Wales; the Cornovii in the West Midlands adjoining modern Wales; the Deceangli in northeast Wales and the Ordovices in the centre, west and northwest of Wales. There was also a smaller tribe, the Gangani, in the Llŷn Peninsula. Tacitus recorded the submission of the Deceangli near Chester, which gave us the first written record of Wales. The tribes had all submitted to Rome by 78 CE, but Roman rule had ended by 390 CE. After fighting off incursions by the Irish and Vikings, during these Dark Ages, most of the energies of the native Celts were spent in fighting off the Anglo-Saxon threat from the East.

The Battle of Dyrham near Gloucester cut off the Celts in Wales from those in the West Country, especially Cornwall, in 577. Then the Battle of Chester in 616 effectively cut off the Welsh Celts from those of Cumbria in 616. Thereafter, Wales was a single nation, with its princes and kings fighting constantly against not only Mercians but also Saxon, Irish and Viking invaders until the Norman Invasion of Wales in 1070. The Brythonic Celts were effectively pushed into Cornwall, Wales, Cumbria/The Lake District and southwest Scotland. Genetic anthropologists at London University have shown that the English are racially identical with Frisians (a province of Holland). It appears that between 50% and 100% of the 'true Britons' living in England were wiped out, with Offa's Dyke acting as some kind of 'genetic barrier' for the Welsh. A UCL researcher stated that 'it appears England is made up of an ethnic cleansing event from people coming across from the Continent after the Romans left.' There are strong genetic links between the Welsh and the Basques of the Franco-Spanish border, understood to be the 'oldest' population of Europe. Tests were carried out using the male Y-chromosome, passed from father to son, and the Welsh were statistically indistinguishable from the Basques. Genetic similarities exist between the Cornish, Scottish, Irish and Welsh. Tests upon English men showed that they were indistinguishable from men in Northern Germany and Denmark as well as Friesland.

CENTRE FOR ALTERNATIVE TECHNOLOGY A pioneering 'village of the future' near Machynlleth, which has had over a million visitors since its foundation in 1975. Styling itself 'Europe's leading eco-centre', it educates and entertains all ages. There is a water-powered Cliff Railway, wave power displays, water and wind turbines, solar power and organic gardens.

CEREDIGION, CARDIGANSHIRE Cardiganshire (Sir Aberteifi) is a traditional county in Wales that came into being in 1282, Cardigan being an Anglicisation of the name for the historic kingdom of Ceredigion. The county became a district under the name Ceredigion in 1974, in the new county of Dyfed, but since 1996 has returned to its original status as the county of Ceredigion. The highest point is Pumlumon (Plynlimon) at 2,486 feet, in which five rivers have their source: the Severn, the Wye, the Dulas, the Llyfnant and Rheidol, the last of which meets the Mynach in a 300-foot fall at Devil's Bridge. Ceredigion's main towns are Aberaeron, Aberystwyth, Cardigan, Lampeter, New Quay, Newcastle Emlyn (partly in Carmarthenshire) and Tregaron.

CERI, BATTLE OF, 1228 *The Chronicle of Ystrad Fflur* states 'In this year Henry, king of England, and with him a vast host came to Wales, planning to subdue the Lord Llywelyn and all the Welsh. And the Welsh gathered together in unity with their prince and attacked him in the place that is called Ceri. And the king after peace had been arranged... without kingly honour, he returned to England.' Outside Montgomery, the forces of Llywelyn I heavily defeated those of Hubert de Burgh, Justiciar of England, and the wounded William de Braose the Younger was taken prisoner. The Welsh, as Giraldus Cambrensis records, were a hospitable people, but when in 1230 William was found in Llewellyn's bed-chamber with 'King John's daughter, the prince's wife' he had transgressed the bounds of permissible behaviour. De Braose was summarily hanged. In 1231 Llewellyn burned the towns of Baldwin's Castle, Radnor, Hay, and Brecon, 'and he destroyed the castles to the ground'. Llywellyn the Great remained a danger to his enemies in Wales and the Marches until his death in April 1240.

CERRIG Y GWYDDYL, BATTLE OF, 517 OR 520 CADWALLON Lawhir defeated the Irish at Trefdraeth near Llangefni and drove them out of north Wales. The site is also known as Cerrig Ceinwen, and the ancient farm there is called Cerrig y Gwyddel, Rock of the Irish. Cadwallon defeated the invaders in several bloodthirsty clashes including the Battle of Cerrig-y-Gwyddyl, at which the Welsh horsemen tied their feet to their horses, in case their courage should desert them. In 517, Cadwallon forced the Irish into a mass retreat back to Holy Island. From here, many of them escaped in boats but their leader, Serigi Wyddel (the Irishman), was cut down at Llam-y-Gwyddyl (Irishman's Leap). His bravery was much respected by the Welsh, who later erected a church over his grave at Llanbabo.

CHAPELS Because of the religious revival, 7,000 chapels were built in Wales, of which fewer than 5,000 are left, but unfortunately only 400 are listed. Meirionydd had a chapel for every 159 people, and chapels dominated Welsh culture and education. Of the people who were counted in the religious census of 1851, 80% were nonconformists and by 1905 4,280 chapels were operating, many being rebuilt and extended several times. For instance Capel Als in Llanelli was built in 1780 and enlarged twice in the next fifty years, then rebuilt to the designs of Thomas Thomas in 1852-3 and again in 1894-5. Capel Als was a typical working-class church whose membership was entirely Welsh-speaking. Nowhere in Europe, probably the world, had so many places of worship per person as Wales at the end of the nineteenth century. The rights to the great hymn 'Guide Me O Thy Great Jehovah' were sold to build a chapel in Cwm Rhondda (the Rhondda Valley), after which its tune was named. The Church in the 1990's planned to dispose of 2,000 chapels in Wales 'with a view to establishing church unity in the next millennium'. The Welsh book *Rhys Lewis* by Daniel Owen (1836-1895) has the following wonderful lines (translated by D.M. Lloyd) – 'That's the difference between "church" and "chapel"' said Will. 'You church people think yourselves good when you are bad, and the chapel people think themselves bad when they are good.'

CHARLES, JOHN (1931-2004) Possibly the greatest football player of all time, in his pomp he stood 6ft 3in and weighed fourteen stone. From Manselton in Swansea, he played for Swansea before joining Leeds, whose manager Frank Buckley called him 'the best in the world.' A natural footballer, he played left-half, then right back then centre half, but he was moved to centre forward to make way for the emerging Jack Charlton. In his first season as centre forward, 1952-53, he scored 30 goals, and then a club record of 42 goals in his second season. He scored 157 goals in 297 games for Leeds and in 2002 its supporters voted him their greatest player of all time. Leeds Football Club was financially forced to sell him in 1957 to Juventus, where he became known as 'The Gentle Giant', never being sent off or cautioned in Italian (or English) football. In his first season in the toughest league in the world to score goals, he scored the winner in his first three games, and scored 28 goals in total. He eventually scored 93 goals in 155 games and helped Juventus win 3 championships and 3 cups. Often, after scoring to give Juventus the lead, he was switched to centre half to protect their lead. In 1958 he was voted Italy's 'Footballer of the Year', and was rated the most valuable player in the world. In 1997 Juventus supporters voted the Welshman, who was fluent in Italian, their finest ever foreign player. He left Italy, despite being offered personally a massive £18,000 to stay with Juventus, returning to Britain for the sake of his children's education. He played for Cardiff aged 32 and scored 19 goals in 66 games, leaving in 1966, aged 35.

John Charles was Wales' youngest international, and missed the 1958 narrow loss to Brazil in the World Cup quarter-final because he had been kicked so badly in the preceding game. Brazil went on to win the final, starring the young Pele. Cliff Jones had sent in many superb crosses that Charles would have converted, and Pele scored an extremely lucky goal. History might have been different for Wales if it had won the World Cup in Sweden in 1956, instead of Brazil. Jack Charlton said that Charles 'was a team unto himself' and that he was the most effective footballer in history. Billy Wright, the famous England captain and centre half, was

asked the greatest centre forward he played against and answered 'John Charles'. When asked for the greatest centre half, he gave the same answer. No other player has led both forwards and the defence with such authority, and he is in Sir Alex Ferguson's all-time World XI. A campaign for a deserved knighthood was cut short by the death of this unassuming and brilliant footballer. There is a statue of Charles outside the Juventus ground, and its team wore black armbands in their next match upon hearing of his decease, forty years after he left the club. John Charles' brother Mel was a noted international who also played against Brazil, and a long-time Arsenal player.

CHARTISM A new working-class militancy was a strong breeding ground for the doomed Chartist Movement, a campaign for basic human rights in the nineteenth century. The 1838 People's Charter called for universal male franchise, payment of MP's, equal electoral districts, secret elections and the abolition of property qualifications to vote. LLANIDLOES was a hotbed of Chartist activity, and its mayor asked for three policemen to be sent from London, 'a course which combined the maximum of irritation with the minimum of security' according to a local commentator. Mayor Thomas Marsh had already appointed 300 local special constables, fearing a threat to the established order. In 1839, Marsh provoked a riot, and the three policemen were briefly held imprisoned in the Trewythen Arms, for which three ringleaders were transported for fifteen years. The mob had controlled Llanidloes for a few days before troops from Brecon had restored order. Most activity supporting Chartism, trying to stop wealthy landowners buying votes from the enfranchised few, took place in the industrialised parts of South Wales. NEWPORT's 'Chartist Uprising' ended when troops killed at least twenty-four Chartists. Perhaps seven thousand marchers, mainly miners, had come down Stow Hill to be met by a hail of bullets by soldiers hiding in The Westgate Hotel. Queen Victoria knighted the mayor who gave the order to shoot the marchers, whose ringleaders were sentenced to be hung, drawn and quartered. This is in 1839! The political show-trial was called by Michael Foot 'the biggest class-war clash of the century'. Public protest led to the sentence being commuted to transportation for life without a last meeting with their families. The historian, Macaulay, called the ringleaders 'great criminals... who would, if their attempt had not been stopped at the outset, have caused such a destruction of life and property as had not been known in England for ages.' Macaulay believed universal suffrage to be incompatible with civilisation as he knew it. He thought democracy would hurt the English property-owning classes. A recent book, *The Man from the Alamo*, traces the importance of JOHN REES ('Jack the Fifer') in leading and starting the Newport Riot.

Just like the MERTHYR RISING, there was negligible publicity in England. As Coupland says: 'Nothing happened in England to match the march of some five thousand Welshmen down from the coal valleys through the darkness and drenching rain of a winter night to Newport... nobody remarked that the trouble was suppressed by English soldiers who were paid to do it and shot down twenty Welshmen and wounded several others in the doing.' John Frost, a former Mayor of Newport and JP, was pardoned when he was seventy-one and returned from Australia. Frost was honoured in Newport, being carted through the town in a flower-bedecked carriage, drawn by his former Chartist comrades. The main square in Newport is now named John Frost Square after him, and you can still see bullet holes in the Westgate Hotel. The 'Corn Laws' were repealed in 1846, making bread cheaper for the starving masses, but not until 1867's Great Reform Bill was the electorate doubled, adding another 1 million voters. At last some working people could vote - Chartism had helped change British history. The Anglicisation of Newport and its environs since this time has been rapid. John Frost had addressed the Chartists in Welsh, and Gwent, even on its Herefordshire borders, was a Welsh-speaking county. A few years earlier, Iolo Morgannwg had stated that Gwent had the highest proportion of monoglot Welsh speakers of all the counties in Wales. In 1847, the Government's official 'Report on the State of Education in Wales' at least apportioned some blame for the rise of Chartism 'I regard the degraded condition (of the people of Monmouthshire) as entirely the fault of their employers, who give them far less tendance (sic) and care that they bestow on their cattle, and who with few exceptions, use and

regard them as so much brute force instrumental to wealth, but as no wise involving claims upon humanity'... 'Brynmawr contains 5,000 people, nearly all of whom are the lowest class... Not the slightest step has been taken to improve the mental or moral conditions of this violent and vicious community'. At this time, the ironmasters and colliery owners like Crawshaw Bailey were living in heavily defended castles and mansions, guarded from the hatred of their employees.

CHAPTER This was a groundbreaking experiment, now copied all over the world to reinvigorate large old buildings. In Canton, Cardiff, a disused Victorian school was taken over as an Arts Centre. There are practising craft-workers, painters, sculptors, acting and dance troupes, a progressive cinema, theatre workshops, rock bands, bars and a restaurant.

CHEPSTOW CASTLE The formidable Chepstow Castle in Gwent, built in 1067, is the oldest dateable secular stone building in Britain, although Dinas Powys also has a claim to be the oldest stone castle. Chepstow also had the oldest door in Britain until an Anglo-Saxon door was recently discovered in Westminster Abbey.

CHESTER Formerly the chief town in North Wales, and known as Caer Legionis and to the Romans as Deva, it is near the Welsh border, and has been the English stronghold to subdue North Wales for centuries. It is the best-preserved walled city in England, and has England's largest amphitheatre.

CHESTER, BATTLE OF, 616 Aethelfrith of Northumbria won the battle of BANGOR-IS-COED (Bangor on Dee) near Chester, beating Brochfael the Fanged (whose arms were three severed Saxon heads – Ednyfed Fychan, the ancestor of Henry VII, later took over this emblem). Kings Selyf Sarfgaddau (Selyf – the Serpent of Battles) of Powys and Iago of Gwynedd were killed. The pagan Aethelfrith had massacred the monks of Bangor-is-Coed, who had been supporting the Britons, and went on to defeat the main Welsh force at Chester. This fateful battle marked the final separating of the Welsh from their fellows (Cymry) in the Lake District and Cumbria. The border with Wales, between Celtic nation and Saxon-controlled Britons, had been formed, and is still virtually the same. The earlier battle at DYRHAM had cut off Wales from the West Country Britons of Domnonia.

CHIRK CASTLE It was the last of a chain of castles built to secure English rule in Wales, built by Roger de Mortimer from 1295 on a hilltop overlooking the Ceiriog Valley. It was never completed, but three of the five towers are in their almost original condition. In the Elizabethan Age, Sir Thomas Myddelton converted the castle into a mansion after buying it for £5,000 (around £1.25 million today). His son Sir Thomas backed the Parliamentarians in the Civil War, but Royalists seized the castle in 1643. Myddelton did not wish to use cannon to regain his home, and a surprise night attack through a 'sink-hole' or cess pit was a bloody failure. He then bribed the Royalist leader with £200 (c. £70,000 today) to surrender the castle. Sir Thomas later became disenchanted with the Republican Government and declared for the exiled Charles II, so General Lambert's troops severely damaged the castle in 1659. It is now a 'stately home', still lived in by the Myddelton family with a superb pair of iron entrance gates. These were made between 1719 and 1721 by the Davies Brothers of Crosfoel Forge near Bersham, and feature the 'bloody red hand', the badge of the Myddelton family.

CHOIRS One of the most spine tingling events for a Welshman is to hear the National Anthem sung by a choir, or at the old Arms Park by the crowd before and during rugby internationals. The Welsh are Europe's great survivors, and choirs, like the language, have over the centuries cemented its nationality, inviolate against the forces of foreign nationalism and now globalisation. Welsh language hymns, sung by male voice choirs, are to some the expression of pacifist rebellion against constant attack upon the Welsh language and customs. Most choirs are

in what used to be the industrial south of Wales – The Treorchy Male Voice, The Pendyrus, The Cwmbach Male Voice, The Morriston Orpheus, Dunvant and Dowlais are all renowned. Rhos Choir in North Wales is also well-known – there used to be fifty pits around the Wrexham area. Most choirs were sustained by miners and steel workers. Now the pits and foundries have gone, it is sadly more and more difficult to get the numbers or the quality in the 300 remaining choirs. Carlo Rizzi, noting the Welsh tendency towards song, called them 'Italians in the rain.'

CHOLERA Epidemics were widespread in the Industrial Revolution because of unsanitary conditions, polluted water, crowded housing and the like. There were four major epidemics in Wales in the nineteenth century. In 1852, thirty-two died in eight days in Denbigh – 'the dead were quickly buried, in their clothes, in deep trenches in the churchyard.' Selected mortalities across Wales were: Merthyr 160, Swansea 152, Denbigh 47, Caernarfon 30, Flint 18, Haverfordwest 16 and Newport 13. A more severe epidemic in 1849 had Lady Charlotte Guest noting that over twenty a day were dying in Dowlais, with eight men working constantly to make coffins. Deaths were: Upper Merthyr 1005, Lower Merthyr 462, Aberdare 185, and Gelligaer 30 making 1682 for the 'Merthyr District.' Other deaths were Cardiff 396, Swansea 262, Neath 245, Margam 241, Aberystruth 223, Newport 209, Tredegar 203, Ystradgynlais 107, Carmarthen 102, Crickhowell 95, Pontypool 61, Bridgend 50, Holywell 46, Llanelli 45, Holyhead 42, Flint 35, Welshpool 34, Maesteg 33, Amlwch 22, Caernarfon 16 and Newtown 6. In 1854, Merthyr again was hit, with 455 deaths, followed by Cardiff 225, Neath 54, Brecon 54, Haverfordwest 40 and Newtown with 19. The final major epidemic was in 1866, with Swansea 521 deaths, Neath 520, Llanelli 235, Merthyr 225, Carmarthen 143, Bedwellty 122, Holywell 88, Bridgend 80, Cardiff 76, Caernarfon 75, Newport 61, Pontypridd 48, Pembroke 42, Newcastle Emlyn 42, Haverfordwest 40, Holyhead 27, Wrexham 23, Narberth 18 and Bangor 14.

CHRISTIANITY From around 250 CE Irish raiders were attacking the western and northern coasts of Wales. At this time of the relative peace of the 'Pax Romana', the Celtic Deisi tribes were spreading Christianity throughout south Wales. Irish attacks continued, and after the Romans left in 390 CE, the British tribes in Wales were being increasingly pressed by invasions of other British fleeing the Anglo-Saxon-Jute threats from England in the east. During these Dark Ages, there was the 'Age of the Saints' in Wales. The priests and monks were drawn from the higher strata of society, from the families of chiefs and princes, and some were more warriors than saints. There was an upsurge of Christianity at this time in Ireland also, and Welsh and Irish monks took their message to Scotland, Cornwall, Brittany and parts of Europe. The huge church at Llanilltud Fawr (the great church of St Illtud) has been anglicised into the English 'Llantwit Major.' It is the site of the first Christian College in Britain (and can claim to being the first university in Europe, instead of Bologna), being where St Paulinus tutored St David. It was said that this great monastic school had over 2,000 students, including kings, princes, Taliesin, Gildas and saints like St Paul Aurelian and St Samson, who became Archbishop of Dol in Brittany. This college-monastery is said to have lasted for over 700 years, until the Norman conquest of the Vale of Glamorgan. The nearby town hall was a medieval guildhall, and next to it, the Old Swan Inn is thought to have been a mint and banking house of Iestyn ap Gwrgan, the last Welsh prince of Glamorgan.

The Celtic Church was well-established, sending missionaries all over Europe, by the time that St Augustine came from Rome to Dover in 597 to reintroduce the Christian faith to pagan England. Welsh monks had evangelised their Celtic cousins in Ireland, Brittany and Cornwall, but had wanted nothing to do with converting the hated Saxon invaders. In turn, Breton and Irish monks evangelised the continent of Europe. In his *A History of the Anglo-Saxons*, R.H. Hodgkin states 'it was a consolation to them to think that the invaders who had stolen their lands, and slain their clergy, were heading straight for hell-fire and an eternity of punishment.' The Welsh Church obviously did not want to be ruled by the new authority of Canterbury, with its Roman habits and allegiances. They disagreed with the date of Easter, on the type of tonsure, how to conduct baptisms, and the distancing of the priesthood from the laity. Easter was as agreed at Arles in

314, not the later date decided by the Roman church which adopted the *Table of Dionysius*. The Celtic-Welsh monks preferred to follow the ideas of the British monk Pelagius, whose doctrine of self-determination was the greatest theological controversy of the fifth century. Pelagius was from Usk or Bangor-is-Coed and had possibly first preached his 'heresy' from Castell Caereinion Churchyard. His doctrine that man was free from God's will, was ruthlessly exterminated by the Roman church, but appears to be returning to doctrinal favour at long last. The early Catholic Church had formulated a doctrine whereby only the church could absolve man of his sins, preferably with payment being transferred to the church treasuries. Any bypass of this profitable system simply had to be proscribed.

Augustine of Rome had landed in Kent in 597, and gradually the Saxons went over to Christianity. According to The Venerable Bede, no friend of Welshmen, Augustine invited the Welsh bishops to meet him in either 602 or 603 on the banks of the Severn, in England. His haughtiness was found distasteful by the Welsh representatives – he did not rise to meet them, so they would not acknowledge him as their archbishop, feeling that he would be even more contemptuous of them if they submitted. Although Augustine's mission to England was successful, the Celtic Christians of Wales kept their distance from these new Romanised converts. Saint Augustine gave his blessing to the Saxon armies, saying that 'if the Welsh will not be at peace with us, they shall perish at the hands of the Saxon'. The Venerable Bede, himself a Saxon, recorded with relish the victory of Aethelfrith over the Welsh at Chester in 613, including the murder of most of the monks at Bangor-is-Coed. This battle helped formalise the Anglo-Welsh border for the first time, and soon the Welsh were cut off from fellow Celts in the North and the West of England. In the second half of the seventh century, St Aldhelm of Wessex complained that the Celtic Christians across the Severn not only declined to join in any act of worship with the Saxons, but would throw any scraps of food left by the Saxons to dogs and pigs, and refused even to eat off the same dishes until they had been thoroughly scoured with cinders or sand. The Welsh Celtic Church was not formally united with the Catholic Church for another 200 years, and did not accept all its unusual new practices for another six centuries. Easter was not altered to the new Roman date until 768, and the use of married clergy persisted until 1138. In 1091 a Breton was appointed by the Normans to be Bishop of Bangor, followed by a Norman Bishop of Llandaf (Urban) in 1107 and another Norman at St David's in 1115 (Bernard). The Welsh church, despite the best efforts of Giraldus Cambrensis, succumbed to the Norman Catholicism of Canterbury in 1203. Norman bishops controlled Welsh sees, and Norman priests took over many churches. It is a wonder that the language survived this influx of influence.

The translation of the *Book of Common Prayer* in 1551, and of the *New Testament* in 1567 by William Salesbury, and the translation of the entire *Bible* in 1588 secured the survival of the language. About this time, John Penry of Cefn Brith, Powys, was calling the Anglican bishops '*soul murderers*', and he was hanged for treason in 1593. This saintly Christian's four daughters were named Sure Hope, Safety, Comfort and Deliverance. In 1639 the first Nonconformist chapel in Wales was established, the so-called 'Jerusalem of Wales', at Llanvaches in Monmouthshire. It was followed in 1649 by the first Baptist chapel at Ilston in Gower, and also by 1649 the Quakers had established their prayer meetings. Because of relentless persecution by the established church, over 2,000 Welsh Quakers had emigrated to Pennsylvania before the 1689 Act of Religious Tolerance. A governing elite had taken over the churches by the eighteenth century. Between 1714 and 1870, no Welsh-speaking bishops were appointed to a Welsh see. One Bishop of Llandaf lived in the remote Lake District of England, and one Bishop of Bangor probably never entered Wales, but placed his nominees in all the livings in his see. Hywel Harris led the Methodist Revival in Wales from 1735, and founded a religious settlement, 'The Connexion', at Trefeca near Talgarth. The members farmed the land and lived a strictly communal life in the eighteenth century, the precursor of many modern movements in Christianity. This revival swept Wales, and originated independently of English Methodism, following the stricter doctrines of John Calvin rather than the teachings of John Wesley. The established Church of England soon came to be seen as the church of the gentry and of 'the English', whereas the common people went to Welsh-speaking chapel. The

power of the spoken word and the fervour of hymn singing hit a strong chord with the Welsh, allied to a natural hostility to an established church, with absentee English placemen as rectors.

Thus the first Methodist chapel was built at Groes Wen, near Caerphilly, in 1742. The Methodists really kick-started the Nonconformist Revival into the force it became, entering nearly everyone's lives. Before long, the Welsh church wanted separation (once again) from the Church in England – a movement called Disestablishmentarianism. With over 5,000 chapels, more than in England and Scotland combined, the movement was a great force in preserving the Welsh language. (The separatist movement also gave us the longest 'natural' word in the English language – 'antidisestablishmentarianism'). The downside of this Christian revival was the Calvinist suppression of popular music and dance, self-denial being the answer to this life's cares, and the constant competition for men's souls between the different sects of Baptists, Methodists, Calvinist Methodists etc. etc. With their separate competing chapels, there came to be more places of worship per head of population in Wales than any other country in the world. By the middle of the nineteenth century, 80% of the population belonged to a chapel, and by 1891 the Liberal Party controlled Wales, because of the Liberals' policies of opposition to landlords and their other anti-establishment policies. In 1906 the Liberal Government passed a law 'disestablishing' the Church of England in Wales.

CHURCH IN WALES This was established in 1920 with its own Archbishop to officially represent Anglicanism in Wales.

CIDER This was a traditional alcoholic drink in Wales (as it always has been in Brittany), as it was self-fermenting, long before the arrival of sugar and hops in Britain. Farms traditionally brewed their own cider for their workers in the fields, and the history of Welsh cider is displayed in the Museum of Welsh Life. Earthenware jugs of cider were taken by workers out into the fields when they worked, and kept cool in streams. There has been a recent upsurge in the brewing of cider and perry (cider made from special small pears) across Wales.

CILGERRAN, BATTLE OF, 1166 *The Chronicle of Ystrad Fflur* records 'in this year the French and the Flemings came to Cilgerran. And after many of them had been slain, they returned again empty-handed.'

CILGERRAN CASTLE It is on a promontory overlooking the river Teifi at its tidal limit, so the castle was able to control both a natural crossing point and be supplied from the sea. It appears to be the Norman castle called 'Cenarth Bychan' from which Nest, the wife of Gerald of Windsor, ran off with Owain, son of the prince of Powys during a Welsh attack in 1109. (Others believe that it was the motte and bailey castle at Cenarth itself). Cilgerran is first mentioned by name in 1165, when the Lord Rhys captured it after Henry II's retreat from the Berwyn Mountains. It was retaken by William Marshal, Earl of Pembroke, in 1204, only to be taken again by the Welsh during Llywelyn I's campaigns in 1215. However, eight years later, William's son regained control, and it was probably he who built the castle we see today. It was badly damaged by Glyndŵr's forces in 1405.

CILT The Scottish kilt was an invention of the eighteenth century, whereas the Welsh cilt is based upon the 'brycan'. It was a length of hard-wearing wool, two yards by six yards, which the Celts wore by day and used for a blanket at night. In active pursuits, the brycan was belted at the waist to kilt (tuck up) the folds, so a 'skirt' fell to the knees – the cilt in its embryonic form. The Welsh Cilt Company, based in Swansea, is helping in a resurgence of the cilt across Wales, with different plaids for different family names.

CISTERCIANS While the Normans were associated with the Benedictines, the Welsh princes and people accepted the Cistercian approach to replacing Celtic monasticism. From Citeaux in

Burgundy, this was a simpler and ascetic form of monasticism, rejecting wealth and working with the people. Wearing coarse, undyed wool, they became known as the 'White Monks'. Fifteen Cistercian abbeys were established in Wales. Tintern (1131), Margam (1147) and Neath (which became Cistercian in 1147) were established by Marcher Lords, but most were associated with, and supported, the native Welsh princes. Whitland (1140), Strata Florida (1164), Aberconwy (1186) and Valle Crucis (1201) were all assisted by the local Welsh princes. The Lord Rhys of Deheubarth took over the patronage of Whitland and Strata Florida. Monks from Whitland founded Strata Marcella in 1170 and Abbey Cwmhir in 1176. Those from Strata Florida founded Caerleon (at Llantarnam) in 1179, and Aberconwy (1186). Monks from Abbey Cwmhir settled at Cymer Abbey in 1198, and monks from Strata Marcella founded Valle Crucis in 1201. Basingwerk and Tintern were the first Cistercian settlements to be established, near the northeast and southeast borders of Wales in 1131. Although the mother-church of the Cistercians in Wales was a Norman foundation, Whitland in 1140, and held its allegiance to Citeaux in France, these 'White Monks' were respected most of all the 'Latin' orders. In 1164, there was another Norman Cistercian foundation at Strata Florida, Ystrad Fflur. However, with the growing influence of The Lord Rhys, Rhys ap Gruffydd, it seems that these were absorbed into the Welsh way of life. Many of the abbeys were in lonely, desolate places, and they were adopted by more Welsh princes as a replacement for the 'clasau'. Strata Marcella was founded in Powys by Prince Gwenwynwyn in 1170, Cwm Hir in Maelienydd in 1176, Llantarnam in Gwent in 1179, Aberconwy in Gwynedd in 1186, Cymer in Merioneth in 1198 and Valle Crucis in Powys Fadog in 1202. The monks followed a simple independent life, with a duty to the Abbot at Citeaux rather than to Rome or Normandy. All the Welsh princes tried to put a foundation in their territories. By 1212, King John was threatening to destroy Strata Florida because it 'harboured our enemies'. *The Hundred Years' War* cut off links between Citeaux and its Welsh cells, so the Cistercians *'went native'*, identifying with their Welsh princes against the constant attacks by the Anglo-French. The Abbots of Aberconwy, Strata Florida, Whitland and Llantarnam were among Owain Glyndŵr's closest advisers in his war of independence, and a friar at Cardiff was executed for supporting his cause. John ap Hywel, Abbot of Llantarnam, one of Glyndŵr's advisers, died fighting for him. By 1536, all but three of the twenty-seven monasteries of full status in Wales were dissolved. As John Davies says in his *A History of Wales,* 'Apart from the castles, the monasteries were he most splendid of all the buildings of medieval Wales; they were mercilessly vandalised at the time of the Dissolution and subsequently – a cruel blow to the architectural heritage of the Welsh'.

CIVIL WAR Most of Wales stayed Royalist during the Civil War, with the notable exceptions of the soldier/politicians John Jones and Philip Jones. The former was one of the signatories of the death warrant of King Charles I, and was himself executed on the return of Charles II in 1660. The latter was conveniently absent on his Welsh estates around Fonmon Castle when it was time to sign, and prospered under both Cromwell and King Charles II. The Battle of St Ffagan's effectively was the last in the Second Civil War – the mainly Welsh Royalists were routed by the Parliamentarians, and 250 Welsh prisoners were despatched to Barbados as indentured slaves for the rest of their lives.

CLARK, PETULA SALLY OLWEN (1932-) With Welsh parents, she had her own radio show aged eleven in 1943, entertaining the troops. *Downtown* established her as a successful artiste across the world, and she has sold over 70 million records, with over 1,000 songs and seventy films to her credit, winning two Grammies.

CLARKE, GILLIAN (1937-) Born in Cardiff, she writes wonderful poetry with a visionary lyricism, and has made an outstanding contribution to the arts in Wales.

CLAUDIA, SAINT (36-c.110) Gwladys ferch Caradog was at her father's side when he was marched in triumph in Rome, according to Tacitus. Known as Claudia, she is mentioned by

Seneca and in Paul's *Second Epistle to Timothy*, being instrumental in the survival of the early Christian church. She is feasted upon 7 August, and her six children were all saints. The church that her daughter Praxedes asked Pius I to build has been called 'the cradle of the Western Church.' The church is dedicated to Praxedes' sister Pudentiana and is the only one in Rome with early Celtic knotwork in its sculptures.

CLIMATE Wales is warmed by the Gulf Steam, and has a similar climate to Eire and Brittany. The old joke is that 'if you cannot see the mountains, it's raining – if you can see the mountains, it is going to rain'. As a result, Pembrokeshire usually produces the earliest new potatoes in mainland Britain. The climate is described at 'temperate'. Dale Peninsula in Pembroke sometimes lays claim to the highest sunshine levels in Britain, with an annual average over 1,800 hours. It is also one of the windiest places in Britain, with wind speeds of over 100 mph having occurred at least five times since the Second World War. Llyn Llydaw in Snowdon has the highest recorded monthly rainfall in Great Britain, with 56.5in, in October 1909, and 246in fell in 1922 in Llyn Glaslyn in Gwynedd, ten times the London rate. The peak of Snowdon is the wettest place in Britain, with an average of 180in rainfall per year, and a record of 246in in 1922. In Cowbridge (Y Bontfaen) 2.9in of rain fell in half an hour in 1880 – Wales can be one of the wettest places in Europe. The longest lasting rainbow ever recorded, visible for over three hours, was reported on the coastal border of Clwyd and Gwynedd on 14 August 1979. Britain's greatest snowfall over twelve months was 60in, in the Denbighshire Hills in 1947 (a record shared with Upper Teesdale). The largest recorded earthquakes in Great Britain were both in Wales, in the Llŷn Peninsula, 19 July 1984, and in Swansea, 27 June 1906, both measuring 4.8 on the Richter Scale.

CLUN, BATTLE OF, 1263 After beating Llywelyn's forces at Abergafenni in March 1263, Roger Mortimer repeated the feat in April at Clun. However he was badly wounded by an arrow and his leaderless men were chased back to his base at Wigmore. Mortimer went on to be heavily involved in the Civil War in England, winning at Northampton, losing at Lewes and in 1265 personally killing Simon de Montfort at Evesham with a lance thrust to his throat. Mortimer, whose life Llywelyn had spared in 1262 at Cefnllys, charmingly sent the head and genitals of de Montfort to his wife Matilda Braose as a birthday present. Roger Mortimer's sons later lured Llywelyn into the ambush where he was murdered near Aberedw.

CLYRO, BATTLE OF, 52 AD Caradog (Caractacus) had been taken by Rome after Cartimandua's treachery in 51 CE, and Tacitus informs us that '... A camp-prefect and some legionary cohorts, left behind to construct garrison-posts in Silurian territory, were attacked from all quarters; and, if relief had not quickly reached the invested troops from the neighbouring forts – they had been informed by messenger – they must have perished to the last man. As it was, the prefect fell, with eight centurions and the boldest members of the rank and file...' This is possibly Clyro, with the near annihilation of the XX Valeria Legion: 'the enemy, out of compassion for so great a king (Caradog), was more ardent in his thirst for vengeance. Instantly they rushed from all parts on the camp-prefect, and upon legionary cohorts left to establish fortified positions among the Silures, and had not speedy succour arrived from towns and fortresses in the neighbourhood, our forces would then have been totally destroyed. Even as it was, the camp-prefect, with eight centurions, and the bravest of the soldiers, were slain; and shortly afterwards, a foraging party of our men, with some cavalry squadrons sent to their support, was utterly routed. Ostorius then deployed his light cohorts, but even thus he did not stop the flight, till our legions sustained the brunt of the battle. Their strength equalized the conflict, which after a while was in our favour. The enemy fled with trifling loss, as the day was on the decline. Now began a series of skirmishes, for the most part like raids, in woods and morasses, with encounters due to chance or to courage, to mere heedlessness or to calculation, to fury or to lust of plunder, under directions from the officers, or sometimes even without their knowledge.
Conspicuous above all in stubborn resistance were the Silures, whose rage was fired by words

rumoured to have been spoken by the Roman general, to the effect, that as the Sugambri had been formerly destroyed or transplanted into Gaul, so the name of the Silures ought to be blotted out. Accordingly they cut off two of our auxiliary cohorts, the rapacity of whose officers let them make incautious forays; and by liberal gifts of spoil and prisoners to the other tribes, they were luring them too into revolt, when Ostorius, worn out by the burden of his anxieties, died, to the joy of the enemy, who thought that a campaign at least, though not a single battle, had proved fatal to general whom none could despise. The emperor (Claudius), on hearing of the death of his representative, appointed Aulus Didius in his place, that the province might not be left without a governor. Didius, though he quickly arrived, found matters far from prosperous, for the legion under the command of Manlius Valens had meanwhile been defeated.'

In the 50's, the renowned XIV Gemina Legion was also fighting against the Welsh tribes: the south-eastern Silures, the north-eastern Ordovices, and the north-western Deceangli. It was based at Viroconium (Wroxeter on the river Severn). In 52 CE, under the command of Gaius Manlius Valens (6-96 CE), the XIV Gemina Legion was badly defeated by the Silures, between the death of one governor, Publius Ostorius Scapula, and the arrival of his replacement, Aulus Didius Gallus. It may be that the XX had been moved to relieve the defeated XIV and allow its withdrawal, so this battle could have been at Clyro. In 52/53 CE the Silures stormed the legionary base at Gloucester and killed the commander in charge. Later, when Queen Boudicca (Buddug) revolted in 60, the legion acquitted itself well and was rewarded the honorific title Martia Victrix ('victorious, blessed by Mars'). The Emperor Nero thought that the XIV was the best legion he had. In 78, the Governor Julius Frontinus built Caerleon as the legionary headquarters for the II Legion Augustus, next to the Silures' capital, and there was an arranged peace with the Silures.

CLYRO ROMAN FORTS Occupied at two different times, the Clyro vexillation fortress is situated on the north-eastern flanks of a small hill just north of Hay-on-Wye and immediately east of Clyro Castle, on the western bank of the River Wye in Powys. In addition to the large campaign base there is a temporary marching camp nearby at Clyro itself, and a Roman fort lies four miles to the north-east at Clifford. The earliest piece of Samian ware dates from around 60 CE. The fortress measures 1,300 feet from northeast to southwest, by 860 feet transversely.

COAL 'Black Gold' originally referred to Welsh Black Cattle, when they were herded to England in the Middle Ages onwards. The discovery of vast amounts of the 'Black Diamond' or this other 'Black Gold' effectively changed the nature of much of Wales forever. The beautiful wooded valleys of Rhondda Fach and Rhondda Fawr were suddenly filled with tightly packed terraced communities made up of workers from all over Britain and Ireland. In the 1840's, fewer than 1,000 people lived in the Rhondda valleys, but by the 1920's, with Rhondda coal being considered the best in the world, there were forty pits and 160,000 inhabitants. A single canal boat could handle as much coal or iron as 200 packhorses, so the fifty-two-lock Merthyr-Cardiff and Neath canals were built. The world's first steam locomotive ran from Penydarren to Abercynon in 1804. The advent of steam trains meant that canals were rapidly superseded and new docks had to be built at Barry, Penarth, Cardiff and Swansea to handle the increased output of coal. Production peaked in 1913 with 57 million tones, when a third of the world's coal was being dug by 250,000 Welsh miners. Welsh steam coal was needed for ships and railways around the globe, but the rise of the oil industry depressed demand severely, as ships etc. switched to the new fuel.

After Mrs Thatcher's decision to rely on subsidised foreign coal rather than the most efficient coal-producing industry in the world, employment in the coalfields collapsed. There were only twenty-eight pits still open at the end of the strike, which Thatcher used the police to help break. There are now none of those twenty-eight pits left, and Britain is dependent on imported coal. Tower Colliery remained until its closure in 2007 as the only deep pit left in Wales, after a buy-out by its miners, with just 240 employees. There are two drift mines in Betws and Cwmgwili

employing around another 220 men. There are some large-scale open-cast operations run by Celtic Energy, producing around 2.5 million tonnes per annum. It is a long way from the 1930s when Wales produced a third of the world's consumption, and there were over sixty-five pits in the Rhondda Valley alone. Subsidised imports from Poland, Vietnam, Colombia or South Africa took over, much of it mined under conditions which would not be tolerated in the Western World. In Colombia children work down the pits. Cardiff and Barry shipped a world record 13 million tonnes in 1913 – now nothing goes out. The present total output of Welsh pits is miniscule, compared to 57 million tonnes in the old days.

In August 1914, the South Wales Miners' Federation proposed an international miners' strike to stop the outbreak of war – unfortunately they were abused by the politicians and media – but there continued to be an anti-war movement in the South Wales mining areas. A massive increase in food prices, coupled with record profits for coal-owners, caused a demand for a new wage agreement in 1915. It was refused, so the South Wales miners went on strike. They were opposed by the Government, coal-owners, the Great Britain Miners' Federation and the national newspapers, and the government threatened to imprison any strikers. However, the strike was solid. The then Minister of Munitions, Welshman David Lloyd George, intervened and settled the strike, acceding to most of the demands of the South Wales Miners' Federation. Disputes continued, however, and in 1916 the Government took over control of the South Wales Coalfield. A year later, all other coalfields were effectively nationalised by the state, and in 1919 a Royal Commission recommended the continuation of nationalisation, as being in the best interests of the state and miners. After appearing to accept the Report, the Government handed back control of the industry in 1921 to the coal-owners. The coal-owners demanded lower wages, and on 1 April 1921, began a lock-out of the million miners in Britain who refused to accept the new terms. After three months, the South Wales Miners' Federation accepted defeat, after not being supported by the Transport Workers and Railwaymen, who reneged on their promise of solidarity with the miners.

In 1926, the miners refused to work an extra hour a day, which was being coupled with large pay cuts of 16-25%. On 30 April, those miners refusing the terms were 'locked out' and the pits stopped producing. On 3 May 1926, the 'General Strike' began. The mood in South Wales was almost revolutionary at this time, and when the TUC called off the strike just nine days later, the Welsh were left to fight on, alone and betrayed. Almost a quarter of a million men stayed away from the pit-heads. Police were called in from outside Wales to keep order, until the starving miners were forced back to work at the end of 1926. The effects on that South Walian generation solidified a feeling of 'us against the world' for decades.

Between 1921 and 1936, investment fell in the industry, and 241 mines were closed in South Wales, with the number of working miners falling from 270,000 to 130,000. One company owned 80% of anthracite coal production in South Wales, so kept employment conditions poor and wages low. In Dowlais, 73% of men were without work. 500,000 people left South Wales between the wars, looking for work. Edward VIII had made a famous visit to the coal-mining valleys in 1936, telling the 200,000 unemployed miners struggling through the Great Depression, 'Something must be done. You may be sure that all I can do for you I will.' Within three weeks he had abdicated, never returning to Wales. H.V. Morton, writing *In Search of Wales* in 1932, reported a South Wales miner in the 1930's as saying: 'Some of the worst cases of hardship I've known have been in homes where the father was trying to keep six children on 25s. a week and was too proud to accept help off anyone... When you're on a shift you fall out for twenty minutes and eat bread and butter, or bread and cheese which your wife puts in your food tin... One day we were sitting like this talking when Bill didn't answer... He'd fainted. So I lifted him and carried him to the pit bottom to send him home, but before I did this I gathered up his food tin. There wasn't a crumb in it! He'd been sitting there in the dark pretending to eat, pretending to me – his pal – Now that's pride.'

In the 1960's seventy-four coalmines closed, and by 1985, only thirty-one were left. In 2007, only one deep pit, owned by the workers, was left at Tower Colliery but soon closed. From 1948,

with 250 pits employing 113,000 miners, Wales has nothing. In the disastrous 1984 national miners' strike, the Welsh pits were the last to return to work. Maerdy, known as 'Little Moscow', was the last pit in the Rhondda, and closed in 1990. An Ogmore Vale collier defended the strike – 'Why on earth do they think we're fighting to defend stinking jobs in the pitch black? There are no lavatories or lunch-breaks, no lights or scenery... We're fighting because our community and our culture depends on it.'

Big Pit, at Blaenafon, was sunk in 1860, but some galleries were worked for fifty years previously. It is now open as a mining museum, and the guided underground tour requires miners' helmets, and a 300ft drop in a pit cage to the coal seam. Afan Argoed at Cymmer is the Welsh Miners' Museum, giving visitors an insight into the hardships of the old colliers and their communities. Little children pulled coal wagons ten to twelve hours a day, six days a week, for two old pennies (less than one new penny) and were forced to repay one penny for the cost of their candles. The Cefn Coed Colliery Museum in the Dulais Valley also simulates life underground, based at the Blaenant Colliery, which was one of the last Welsh mines to close in 1990. The Rhondda Heritage Park is based around the former pits at Lewis Merthyr and Tŷ Mawr collieries in Trehafod. Many ex-miners still suffer in agony from 'The Dust' in their lungs, pneumoconiosis or silicosis, a few of which receive a pittance of a pension for it. All Welsh colliery records were removed to England by the NCB, to make it extremely difficult for NACODS (a mining union) to prove rights to compensation for the survivors. There has recently been a scandal with various firms of solicitors fraudulently robbing miners of their compensation for pit-related injuries such as 'vibration white finger' and lung-related diseases.

COED LLATHEN, BATTLE OF, 1257 This was the most crushing defeat upon English forces before the battle of Bryn Glas in 1402, barely recorded in history books. Henry III's army had landed near Carmarthen and laid siege to Dinefwr castle, but the Welsh forces attacked, forcing the English to dismount, before moving back at nightfall. The English pursued the Welsh west towards Broad Oak. However, the heavily wooded countryside meant that the English forces were stretched and continually ambushed. The fighting lasted all day, and covered an area from Langathen west towards Broad Oak and north towards Llanfynydd and Capel Isaac. It was a running battle with dispersed groups fighting from Coed Llathen to Cymerau, and is also sometimes referred to as the battle of Cadfan or Cymerau. Cadfan can be translated as the 'peak of the battle' or as 'the corner of the battle', and there is an ancient farmhouse named Cadfan in the Tywi Valley here. Sources say that 3,000 of Henry's army were killed, with many nobles captured for ransom. The army's leader, Stephen Bayzan (Bacon), a friend of Henry III, was killed near Pentrefelin and the small bridge there, Pont Steffan, is named after the event. It is recorded that Prince Llywelyn ap Gruffydd was present, returning to Gwynedd with huge booty.

In 1867, the Rev Lloyd Isaac wrote 'the men at war prepared to devastate the lands of Ystrad Tywi... arrived at Llandeilo-fawr... where they fearlessly tarried over the night... but the surrounding woods and valleys were filled with the followers of Meredydd ap Rhys Grug and Meredydd ap Owain, who had been summoned from Ceredigion and Ystrad Tywi... on 10 June, the guide of the English, Rhys ap Rhys Mechell, forsook them and escaped in disguise to the castle of Dinevor... from daybreak till noon the battle carried on in the deep woods...near Coed Llathen, the English lost all their provisions... they arrived as far as Cymerau...more than 3,000 English were slain that day... the Welsh rendering thanks to God returned homewards, laden with the spoils and the arms of the enemy... this memorable battle was fought between Castell-y-Gwrychion and Cefn Melgoed and Hafodnethyn, a basin about four miles in circumference... covered in woods... the old name Cefn Melgoed has become extinct, and Cadvan, the battlefield, has taken its place... the following names on the map of the parish (are) all within the circumference aforesaid... Rhywdorth, the hill of reinforcement; Llaindwng, the slang of oath; Conglywaedd, the place of shouting; Caeyrochain, the field of groans; Caetranc, the field of dying; Caefranc (Cae Ffrainc), the field of Normans; Cadvan, the field of battle; Caedial, the

field of retribution, or vengeance; also Cilforgan, Caer Capel etc.' These field names all surround Cadfan Farmhouse, which has an upper medieval banqueting hall. Other local place names still record the carnage. Near the Cottage Inn is Rhiw Dorth mentioned above and also Rhiw Cymorth – 'the hill where the wounded were given help, and comfort'. There is also Castell y Cwreichion – the hill where flaming spears were thrown at the enemy. As with many English defeats, it is hardly recorded in history. There was another battle in the Llandeilo area in 1282 where an English force from Carmarthen was defeated.

COED YSPWYS, BATTLE OF, 1094 In *The Chronicle of Ystrad Fflur*, 'In this year the Britons being unable to bear the tyranny and injustice of the French, threw off the rule of the French, and they destroyed their castles in Gwynedd and inflicted slaughter on them. And the French brought a host to Gwynedd and Cadwgan ap Bleddyn drove them to flight with great slaughter at Coed Yspwys. And at the close of the year the castles of Ceredigion and Dyfed were all taken except two.' (The 'French' are the Normans.) In the next year, 'William, king of England, moved a host against the Britons but he returned home empty-handed having gained naught.' The Britons here are, of course, the Welsh.

COITY (COETY) CASTLE Payn de Turberville began building this castle on the outskirts of Bridgend in the early twelfth century, as a simple ringwork. It was at the western extent of the Norman invasion of South Wales, and Newcastle and Ogmore Castle were built nearby to consolidate the expansion. In the 1180's Coity was fortified in stone by Gilbert de Turberville, and most of its remains date from the fourteenth century. Glyndŵr failed to take it on his rampage through Glamorgan.

COLBY MOOR, BATTLE OF, 1645 On 29 July, Rowland Laugharne took to the field with 800 men. On the same day Admiral Sir William Batten arrived at Milford Haven and met with Laugharne to decide tactics to beat the Royalist army under Sir Edward Stradling. On 1 August, Laugharne drew up his forces against Stradling at Colby Moor, between Wiston and Llawhaden. The battle was evenly matched, but Admiral Batten had landed 200 men from the Parliamentary frigate *Warwick* on the northeast corner of Milford Haven, and they attacked Stradling's rear, resulting in a crushing Parliamentary victory. Other Royalist strongholds in Pembrokeshire then surrendered, and put Charles I in immediate danger, as he was in South Wales at that time.

COLESHILL, BATTLE OF, 1150 Because King Stephen was involved in civil war with Matilda, Owain Gwynedd took advantage to push the boundaries of Gwynedd further east. He had taken Mold Castle in 1146 and Rhuddlan in 1150. Madog ap Maredudd, the last King of Powys, allied with Ranulf, Earl of Chester, to stop Owain Gwynedd pressing upon both their territories. Owain defeated them near Flint and took lands off both.

COLES HILL (CONSYLLT), BATTLE OF, 1157 Henry II's first campaign against Owain Gwynedd ended in a truce in 1157. OWAIN GWYNEDD, with his sons Dafydd and Cynan, had waited for Henry's army in the woods at Coed Eulo (Cennadlog) near Basingwerk, on the Dee estuary. The Constable of Chester, Eustace Fitz John, a close friend of Henry II was killed. Owain took Henry prisoner, but he escaped through the woods. This Welsh victory in the pass at Coles Hill is hardly noted in British history, but two medieval texts tell us that Earl Henry of Essex thought that Henry II had been killed. He thus threw away the standard to escape, and later was forced into a duel because of his cowardice: 'Near unto this river Alen, in a certain strait set about with woods, stands Coles-hall, Giraldus terms it *Carbonarium collem*, that is, *Coles Hill*, where when King Henry the Second had made preparation with as great care as ever any did to give battle unto the Welsh, the English by reason of their disordered multitude drawing out their battalions in their ranks, and not ranged close in good array, lost the field and were defeated, yea and the very King's standard was forsaken by Henry of Essex, who in right of inheritance

was Standard-bearer to the Kings of England. For which cause he, being afterwards charged with treason, and by his challenger overcome in combat, had his goods confiscated and seized into the kings hands, and he, displeased with himself for his cowardice, put on a broule [hood] and became a monk'... 'In the year 1157, he (Henry of Essex) went with his Standard to attend King Henry, our blessed Sovereign (whom we saw afterwards at Waltham), in his War with the Welsh. A somewhat disastrous War; in which while King Henry and his force were struggling to retreat Parthian-like, endless clouds of exasperated Welshmen hemming them in, and now we had come to the 'difficult pass of Coleshill,' and as it were to the nick of destruction, – Henry Earl of Essex shrieks out on a sudden (blinded doubtless by his inner flaw, or 'evil genius' as some name it), That King Henry is killed, That all is lost, – and flings down his Standard to shift for itself there! And, certainly enough, all had been lost, had all men been as he; – had not brave men, without such miserable jerking tic douloureux in the souls of them, come dashing up, with blazing swords and looks, and asserted that nothing was lost yet, that all must be regained yet. In this manner King Henry and his force got safely retreated, Parthian-like, from the pass of Coleshill and the Welsh War.'

COLWYN BAY The railway line to Holyhead from London was opened in the 1840's and skirted the bay. It attracted holiday-makers and English retirees, and by 1900 the population had grown to 8,000. There is a three-mile beach and a Victorian pier. St Trillo's Chapel is at nearby Rhos-on-Sea, built over his sixth-century holy well. The Mountain Zoo is a visitor attraction.

CONWY A statue of Llywelyn the Great stands in Conwy's Lancaster Square, and he endowed the Cistercian Aberconwy Abbey, where he was buried. Four decades after his death, Edward I symbolically chose the monastery as the site for his greatest castle, after the murder of Llywelyn's grandson. The monks of Aberconwy were moved to Maenan Abbey, and the castle was built over Llywelyn the Great's burial place. Conwy's town walls are 35ft high and 6ft thick, and the mile of walls contain over 200 listed buildings. Conwy is not only the best example of a mediaeval walled town in Britain, but it also has the finest example of an Elizabethan town house, Plas Mawr. Nearby Aberconwy House, belonging to the National Trust, dates from the fourteenth century and may be the oldest house in Wales. On the quay is Britain's smallest house, 10ft high with a 6ft frontage. Thomas Telford built the suspension bridge to Anglesey, which was used from 1826-1958. Robert Stephenson's railway bridge to Anglesey is another marvellous piece of engineering.

CONWY, BATTLE OF, 881 Anarawd ap Rhodri became King of Gwynedd after the death of his father Rhodri Mawr in battle in 878. At this battle at the mouth of the River Conwy, Aberconwy, the Earl Aethelred and his invading Mercians were slaughtered. It was known as 'dial Rhodri' (Rhodri's revenge), being noted in the *Annales Cambriae* as 'vengeance for Rhodri at God's hand.'

CONWY CASTLE Conwy Castle and town walls were completed in 1287, in a superb strategic position. Eight-towered Conwy was called 'incomparably the most magnificent castle in Britain' in a 1946 British Academy report. Specially designed curves in the castle walls led attackers to a literal dead end in the West Barbican, where missiles and molten lead could be poured down from the murder-holes and machicolations above. As the guide-book states, 'forced entry is a virtual impossibility'. Edward I held out there in 1295 against the revolt of MADOG AP LLYWELYN. Shakespeare was wrong when he placed Flint Castle as the place where Richard II was betrayed to Henry of Lancaster – it was at Conwy Castle in 1399. In 1401 Gwilym and Rhys ap Tudur of Anglesey took the castle, as part of Glyndŵr's War of Independence, but Hotspur negotiated its surrender. The Parliamentarian John Mytton besieged it for three months in the Civil War before it surrendered. Standing where the river Conwy enters the Menai Straits between Caernarfonshire and Anglesey, the Castle is at the centre of many Welsh legends. The most beautiful is that of Arianrhod's son, Dylan eil Don in *The Mabinogion*. This 'Son of the

Wave', was at home in the seas, but was killed by his uncle Govannon. *The Book of Taliesin* tells us that the waves of Britain, Ireland, Scotland and the Isle of Man wept for him. The sound of the waves crashing on the beach is the expression of their desire to avenge their son. The sound of the sea rushing up the Conwy River was still known in the nineteenth century as 'Dylan's death-groan'. A nearby promontory, Pwynt Maen Dulen, preserves his name.

COOPER, TOMMY (1922-1984) 'The comedian's comedian' and Britain's best-loved comic was born in Caerffili. After serving in the Second World War from 1940, he left the army in 1947 becoming a full-time comic in music hall, and evolving his act of magic going wrong. From working in the Windmill Theatre, and appearing on television, he was given his own live TV series in 1957. He was introduced on America's famous Ed Sullivan Show as 'the funniest man who has ever appeared on this stage.' Increasingly suffering from alcoholism, Cooper died on stage during a live TV broadcast, the compère and audience thinking that it was part of the act.

COPPER Apart from the gold in DOLAUCOTHI, the Romans mined copper at Parys Mountain, near Amlwch in Anglesey. The Roman road from London to Holyhead in Anglesey, now the A5, was driven by the dual need to extirpate the Druids and source Welsh copper. Before the Romans, the Celtic Ordovices exploited the mineral for over two-thousand years. By the eighteenth century it had become the world's largest and most productive copper mine, following its rediscovery in 1768. Records at this time show that Amlwch had 6,000 inhabitants and 1,125 ale-houses, and its tiny port was one of the busiest in Europe. By the end of the eighteenth century, The Parys Mine Company employed 1,200 men producing 3,000 tons of copper ore annually. The pollution in the harbour was so bad that the iron hulls of ships did not corrode. When this was noticed, ships' hulls began to be sheathed in copper by their owners and boat builders, making another lucrative market for the mine. Because the world's leading supplier of copper was in Britain, the Royal Navy began copper-cladding its warships well in advance of any other navy. This directly led to its ships being faster and more easily sailed than those of other navies, leading to mastery of the seas. Wooden hulls were attacked by the teredos worm, and barnacles and other marine growths made ships unwieldy and slow. Copper sheets hammered onto the wooden hulls of sailing ships prevented this happening. This, in turn, enabled the growth and protection of the British Empire, with the supremacy of the seas protecting trade. By the end of the nineteenth century, the mountain was worked out and left in the weird state we see today.

The awful conditions at Parys were described in Welsh by T. Rowland Hughes (1903-1949) in *From Hand to Hand:* 'To my grandmother fell the task of tending the two cows, two pigs and three dozen chickens on the homestead, while her husband was employed in the Parys Mountain Copper Mines, where he had started work at the age of eight for a wage of four pence for a twelve-hour day. He was only twelve when he 'went below' to mine copper, and there he toiled like a galley slave for the rest of his life. On many a 'settling-up Saturday, he used to return home without a halfpenny to bless himself with, after a whole month of accursedly hard toil, for the owners followed a system of 'stoppages' against the cost of the candles, powder, sharpening augers and hoisting the ore from the mine. There were times, indeed, when my grandfather returned home, at the month's end, actually in debt to the owners, since this shameful levy totalled more than he had earned in a month of sweated, sweltering labour underground. My grandmother tried to induce him to give up the work, but they could not make a living on the homestead with its three small, mean fields, and food had to be provided for themselves and their two children... every morning at six, in the prayer meeting that was held in the smithy on the surface, he gave thanks to God that he was able to keep his children from starvation.' Copper smelters needed three tons of coal for every ton of copper ore, so ore was shipped from Anglesey and Cornwall to the Swansea Valley, the centre of the world copper industry, for processing.

On the Great Orme in Llandudno, copper workings dating from the Bronze Age are open to visitors, showing how prehistoric men mined for copper. It is the only Bronze Age mine in the world open to the public. Because the extraction process was simplified by a rock-softening process, known as dolomitization, this was once the most important copper mine in the world, before Parys Mountain took over. One Bronze Age cavern, 130ft below the surface, and measuring at least 50ft across, is the largest prehistoric man-made cavern in the world. Previously, the Great Stope Chamber was the largest man-made cavern discovered, on the same site. The site is the oldest copper mine in the world, as well as the largest Bronze Age mine ever discovered at 25ft high, 25ft in width and 60ft in length. (Copper makes up 90% of bronze). Its network of caverns were not rediscovered until 1987, with four miles of tunnels so far excavated to a depth of 200ft. Surveys suggest there are ten miles of tunnels, and 30,000 bone tools and scrapers and 3,000 stone hammers aged up to four thousand years have been found. The site is far more extensive than the prehistoric copper mines in Austria, China or Grimes Graves flint mines, and tools have been dated back to 1850 BCE. The Grimes Graves mines are older, but only go down 30ft, compared to the Great Orme's 226ft so far explored. Around 1,800 tons of metal would have been produced, from the surveyed area alone. The Sygun Copper Mine near Blaenau Ffestiniog, which was worked until 1903, has also been restored and is open to the public.

CORACLES The Romans described Celtic tribes using boats covered with skins, which have survived as the Irish 'curragh' or the Welsh 'cwrwgl' or coracle. With a basketwork frame, these one-man and two-man boats are extremely difficult to learn to handle, but ideal for netting sewin and salmon when worked in pairs.

Dating from around the time of Christ, these primitive boats are used in the tidal River Tywi by twelve fishermen, with hereditary licences to net salmon. Their coracles are saucer-shaped replicas of the skin-covered boats used by the ancient Britons, but now use canvas stretched over wooden laths. The 1923 Salmon and Freshwater Fisheries Act effectively stopped all coracle fishing on the Severn, and restricted fishing severely on other Welsh rivers. Opposition from fly fishermen and legislation has almost killed the craft – licences are not renewed, and generally with the death of a coracle man, the licence is withdrawn on that particular river. Only a few remain – 3,000 years of tradition are being killed in front of us to favour a rich fly-fishing elite, mainly from outside Wales, who have bought the rights to fish long stretches of the best rivers. Wales is supposed to be protecting its cultural heritage to promote tourism, but this author has seen little sign of any political will to help preserve tourist attractions, unless politicians believe that thousands of wind turbines are attractive. (They cannot be justified upon scientific, environmental or economic grounds). Different types of coracles are displayed in the Welsh Folk Museum at St Ffagan's. There is also the National Coracle Centre, including nine varieties of Welsh coracle, and examples from Vietnam, Iraq, India and North America, at Cenarth Falls in Carmarthenshire. The best place to see these pre-Roman boats in action used to be on the River Teifi at Cenarth. It is believed that coracle fishing is now only practised on three Welsh rivers, the Teifi, Tywi and Tâf. Salmon fishermen, in the four villages of Llechryd, Cenarth, Abercuch and Cilgerran on the Teifi, formed closed communities where particular reaches of the river belonged to each village. In 1807, Malkin wrote that there was 'scarcely a cottage in the neighbourhood without its coracle hanging by the door'. Last century there were hundreds of licences, but now sadly only a couple of dozen at most – a pressure group is needed to help keep the craft alive. Designs and materials varied a great deal, depending upon the build of the fisherman and the type and flow of river – there are thirteen known different designs, Teifi, Tywi, Tâf, Cleddau, Ironbridge Severn, Welshpool Severn, Shrewsbury Severn, Conwy, Upper Dee Lllangollen, Lower Dee Bangor and Overton, Usk and Wye, Dyfi and Loughor. There is a coracle regatta every August in Cilgerran, near the craggy castle where Nest (Helen of Wales) was abducted by a Welsh prince from her Norman husband in 1109.

COWBRIDGE (Y BONTFAEN) ROMAN MILITARY SITE AND TOWN WALLS Many Roman remains have been found in this beautiful town, situated along the main Roman road from Cardiff to Carmarthen. A bath-house was found, and a statuary lion, and it is thought that it was defended by Roman walls, like Caerleon, Caerwent and Cardiff. Cowbridge (Bomium or Bovium) has the only walls remaining of Glamorgan's medieval walled towns, up to 14ft high and over 12ft wide, with the South Gate still in place. Its church is almost the largest early Norman building in Wales, a fine example of a fortified medieval church. There is a plaque where Iolo Morgannwg had his bookshop in the High Street, and a 'Physic Garden' has been created next to the town walls.

CRACHACH Sean O'Neill gave an unbiased Irish view of this Welsh phenomenon in *The Daily Telegraph* in 1998. The 'crachach' 'is a university-educated, Welsh-speaking grouping with positions mainly in publicly-funded or recently-privatised bodies and service on the governing committees of universities, museums and charities.' He goes on to name prominent Welsh people in positions of power, and quotes Dr Deian Hopkin as saying 'Wales does not have that great, eminent, dominant, rich landed aristocracy that England has, so it has created a surrogate aristocracy, people who have rank and esteem depending on their contribution and role within Welsh society... In England, the dynastic link is often done by transfer of title or money. In Wales, there is a kind of cultural heritage handed on from generation to generation'. Crachach translates as 'petty gentry, conceited upstarts and snobs', and those outside its boundaries tend to dislike it. Dr Kim Howells MP calls it 'the colonial class which runs Wales because they are born into certain families rather than because they are good at their jobs', deriding it as 'probably the most effective back-scratching organisation outside Sicily'. Howells goes on to complain that 'it is dominated by a public school educated, Welsh-speaking elite. It has a very restricted membership but has grown over the last two decades as the result of the growth in Welsh language broadcasting, which offered a nice career structure, and the rising number of quangos'. Howells has done nothing to address the situation, becoming a member of the crachach himself. The Leader of the Welsh Assembly Government, Rhodri Morgan is a member of the crachach, having a professor for a brother, a professor for a father, and an MP wife.

CRAFTS Potters, wood-carvers, ceramicists, textile artists and painters exist in every corner of Wales. Welsh copper lustre pottery, of the type that used to adorn Welsh dressers all over Wales, was last made in Aberthaw Pottery, Glamorgan. The owners learned about its manufacture from the last surviving maker, just twenty years ago, but the pottery changed hands and no longer makes lustre pottery. Ewenni Pottery, near Bridgend, is Wales' oldest surviving pottery, but allowed its ancient beehive kiln to be moved to the Museum of Welsh Life, where the potter still makes beautiful traditional 'wassail bowls'. Portmeirion Pottery is known all over the world, with its beautiful flora and fauna prints. At old Woollen Mills at Trefriw, Penmachno, Capel Dewi, Brynkir, Solva, Castle Morris, Dre-fach Felindre, and at the Museum of Welsh Life, one can watch the processes of carding, spinning, dyeing and weaving to make traditional Welsh shawls, bed-covers and the like. There are also old working flour mills open to the public at Pengoes and Llanddeusant (a working windmill), and a brochure on all these and more Welsh mills is available from the Welsh Mills Society, Y Felin, Ty'n-y-Graig, Ystrad Meurig, Ceredigion SY25 6AE.

From the sixteenth century, 'lovespoons' were carved out of a single block of wood, over the winter, by farmhands to give their sweethearts. They were also presented by young men to girls to try and start a relationship. The more difficult and intricate to carve, the more the lovespoon symbolised the maker's love. Some really intricate seventeenth century ones can be seen at the Museum of Welsh Life at St Ffagans. Craftsmen throughout Wales will sell or make special lovespoons, which seem to have been the origin of the word 'spooning' so beloved by 1930's popular songwriters e.g. the lyrics 'then we will spoon, to my honey I'll croon, sweet tunes' in *By the Light of the Silvery Moon*. The most expensive lovespoons are those featuring wooden spheres

in a long cradle, held by chain links. It may be that the love spoon represented an early type of engagement ring, or that its presentation and acceptance confirmed the beginning of a serious courtship. Certain symbols represent promises or wishes - triple spoons symbolise a couple and a hoped-for family, a wheel is a willingness to work hard for a loved one, a key symbolises 'my house is yours', flowers mean courtship, and balls in a cage mean captured love or the number of children desired, etc. Another popular craft has been making 'corn dollies', which can be bought in many souvenir shops. Their origin is 'Y Gaseg Fedi' ('The Harvest Mare'), celebrating the last sheaf of corn to be harvested. This last tuft of corn, symbolising the forces of natural growth, was plaited carefully, and a contest followed where the workers took it in turns to shape it with their reaping hooks. The successful reaper then shouted a traditional rhyme (in Carmarthenshire the last line was 'I've got a little harvest mare'). He then had to try to carry it to the harvest feast without it being soaked by women throwing water. If he succeeded, he sat in a place of honour and could drink as much beer as he wanted. If he failed, he was ritually scorned and was not offered beer. The harvest mare was kept in the house until the next harvest as a decoration. Over time they became more and more ornamental and complex.

CRAIG Y DORTH, THE BATTLE OF, 1404 Warwick's forces were beaten by Glyndŵr's army between Monmouth and Abergafenni, perhaps in a counter-attack after Campstone Hill. English sources record a 'horrific massacre' with the survivors being chased to the gates of Monmouth, 'with the Welsh snapping at their heels'.

CREÇY, THE BATTLE OF, 1346 The French belief in the power of the armoured nobility should have been shattered at Creçy in Picardy in 1346. Of Edward III's invasion army of 12,000 men, almost 8,000 were recruited from landowners in Wales and the Marches. 4,000 were Welsh archers, with around 3,500 Welsh spearmen. King Edward almost reached Paris, but decided not to besiege it, as Edward had no idea where Philip VI's French army was. By forced marches, the French army of 40,000 caught up with the Anglo-Welsh army at Creçy at 4 p.m. King Philip wished to rest for the night, but his army saw the smaller force, and advanced expecting an easy, and glorious victory. Seeing the momentum could not be halted, Philip IV ordered his 6,000 Genoese crossbowmen to shatter the foreign army. However, a sudden downpour made the Genoese crossbow strings slack, but the Welsh archers had kept their strings dry, coiled under their helmets. When the sun reappeared, the Genoese were trying to replace their bow strings, while the Welsh slaughtered them at a range of almost 300 yards, aiming six arrows a minute - a contemporary report said that the arrows 'fell like snow'. Welsh archers relentlessly poured arrows into fourteen or fifteen French cavalry charges until midnight, when the carnage stopped. The French king had been led away, wounded by an arrow, and the Welsh followed up with long knives, skewering around 4,000 fallen Frenchmen as they lay helpless on the ground.

The Prince of Wales had been in charge of one of the English battle groups, and took the crest of three ostrich feathers and the motto 'Ich Dien' from the dead King John 'the Blind' of Bohemia, ever after to serve as the crest of Wales. French losses of 11,000 compared to just 1,000 of the invading force. This battle, with the consequent capture of Calais, effectively started the *Hundred Years War* between England and France, and made the longbow an integral part of many European battle plans for the next 200 years. The Welsh bowmen wore the national colours of green and white, the same colours later worn by Henry Tudor at his coronation in 1485. This was probably the first national uniform in European warfare. The Welsh also knew that if the French caught them, the two fingers of their draw hand were cut off to stop them ever firing an arrow again. This is the origin of the infamous 'V' sign, where the Welsh gesticulated to distant troops that they had the full use of their right hands.

CRIBINAU This tiny island off Aberffraw contains the medieval St Cwyfan's Church, which is known as 'the church in the sea.'

CRICIETH Born in nearby Llanystumdwy, David Lloyd George grew up in this Gwynedd seaside resort, and its superb castle was built on the site of a Celtic hillfort.

CRICIETH (CRICCIETH) CASTLE Built by Llywelyn the Great, it was eventually captured from the Princes of Gwynedd, and refortified by Edward I from 1283 to 1290. In *Brut y Tywysogion* we find that Llywelyn the Great's son Gruffudd was imprisoned here from 1239 by his half-brother Dafydd. Llywelyn the Last began another building phase in the 1260's, including a curtain wall. In 1292 it withstood a siege by Madog ap Llywelyn. Supplies from Ireland enabled the garrison to hold out for months. Sir Hywel ap Gruffudd (Hywel of the Battleaxe), was appointed its constable for his services at Creçy. Glyndŵr, with the assistance of a French naval blockade, starved it into submission in the 1400-1415 War, and burnt the castle.

CRICKET Glamorgan has won the Cricket County Championship upon three occasions, 1948, 1969 and 1997, and the Sunday (one-day) league in 1993, 2002 and 2004. In 1997, fourteen players received Championship medals, eleven of whom had come through the Wales Schools system, and two of whom had played for Glamorgan Colts. Glamorgan's batsman Steve James topped the batting averages in 1996-97, and was chosen as the 'Cricketer of the Year' by his fellow-professionals, the cricket writers, and *Wisden* – a hat-trick of the game's three top awards. He was not chosen for the MCC touring team for the West Indies, for reasons not obvious to this author. Probably the finest cricketer from Wales was Cardiff's MAURICE TURNBULL, and Tony Lewis of Glamorgan captained the MCC. St Ffagans has won the Village Championship Trophy four times, Marchwiel twice and Gowerton and Ynystawe once each, the only times these trophies have been taken out of England.

CRICKHOWELL CASTLE Crughywel was probably built by the Turbervilles in the twelfth century, being rebuilt by stone in 1272. Glyndŵr sacked it.

CROGEN, BATTLE OF, 1165 Chirk 'parish is remarkable in history as the scene of a conflict between part of the forces of Henry II and the Welsh, which took place in 1165, in a deep and picturesque valley, along which runs the river Ceiriog, on the west and south sides of Chirk Castle. Henry, with a view to the conquest of Wales, collected an army at Oswestry, whilst the Welsh prince, Owain Gwynedd, mustered his forces at Corwen; and being eager to decide the struggle, the English monarch hastened to meet the enemy, but was interrupted in this valley by almost impenetrable woods, which he commanded his men to cut down, in order to secure himself from ambuscade, posting the pikemen and flower of his army to protect those at work. When thus engaged, a strong party of Welsh fell upon the English with indignant fury, and a battle ensued, which, while it ended in the retiring of the former, so reduced the strength of Henry, that although he contrived to advance to Corwen, yet, harassed by the activity of Owain, who cut off his supplies, he was at length compelled to fall back into the English territory, and relinquish his design. This encounter, in which numbers of men were slain on both sides, is called the battle of Crogen, and the place where it was fought Adwy'r Beddau, (the pass of the graves.)' – *A Topographical Dictionary of Wales* (1849). The Battle of Crogen was at Bron-y-Garth in the Upper Ceiriog Valley, when Henry II narrowly escaped with his life. Owain Gwynedd's men fought with such valour that for many years after the English soldiers used *'Crogen'* as their rallying call for courage. Henry was said to have led an army of 30,000 men, many levied from his French possessions, and the victory was so complete that no serious invasion of Wales was attempted for another fifty years.

CROMIE, FRANCIS (1882-1918) From Fishguard, he was educated at Haverfordwest Grammar School. His awards include the Legion d'Honneur, CB, DSO, China Medal, and he was decorated three times by Tsar Nicholas, including receiving the Order of St George, the Russian equivalent of the Victoria Cross. He served in the Boxer Rebellion, being given the Royal Humane Society's

Bronze Medal for saving one of his men from drowning. He led a flotilla of submarines in the Baltic in 1915 allying with the Russians against the German Navy. His main duty was sinking Swedish carriers taking iron ore to Germany. In the Baltic his force was then caught between fighting the Germans and the forces of the Bolshevik Revolution. Trotsky pulled Russia out of the war, and Cromie, by now a fluent Russian speaker, refused to surrender his submarines to the Germans. In 1917 he scuppered his seven submarines and sent his 200 men home via Murmansk. He remained in the empty British Embassy in Petrograd until murdered by agents of the Cheka, the Soviet secret service.

CROMLECHAU Wales has many stone circles and standing stones, and has the highest density in Britain of dolmens, or cromlechs, groups of massive stones holding a capstone. They are the earliest permanent structures, older than the Pyramids. About 150 dolmens still exist in Wales. The great Tinkinswood Cromlech, just outside Cardiff, was possibly the burial site for hundreds of people. Dating from 4000 BCE, its capstone of 40.6 tonnes is the largest in Britain. A mile away, the 10ft high St Lythan's Cromlech is also known as 'Gwal-y-Filiast', the 'Kennel of the Greyhound Bitch'. Pentre Ifan, on the Preseli Hills, looks over Cardigan Bay, and is possibly the most revered Welsh site because of its situation. Made of the same Preseli bluestones as Stonehenge, its capstone is 16ft across. The inner circle at Stonehenge originally consisted of forty to fifty of these holy 'bluestones', each 9 to 10ft high, 2 to 3ft wide and weighing up to 2 tons each. Laboriously cut and shaped by flint, they were probably dragged down to ancient Narberth, rafted up the Bristol Channel, and dragged across to the Wiltshire Plains on rollers. Anglesey's Bryn Celli Ddu is a 'passage grave' type of burial chamber, where a long passage leads to a central chamber with an upright stone, lit up at the Summer Solstice. The impressive Neolithic Burial Chamber, Barclodiad-y-Gawres, at Rhosneigr, Anglesey, has inside it five standing stones ornamented with zigzags, spirals, lozenges and chevrons. The only parallel in the British Isles is probably Newgrange in Ireland. The majority of these communal burial chambers, cromlechau, are found in Anglesey, with about fifty, and Pembrokeshire with forty-five. They are similar to other megalithic monuments as far away as India. Excavation at Barclodiad-y-Gawres (The Giantess's Apron) revealed a strange and ancient 'witches' broth' residue consisting of frogs, toads, snakes, mice, (sacred) hares, eels, wrasse and whiting. Other important Neolithic monuments are the Long House Cromlech at Trefin, Tŷ Isaf in the Black Mountains, and Capel Garmon near Llanrwst.

There are some fascinating burial mounds that have legends attached to them. Bedd Taliesin, the Grave of Taliesin, is on the slopes of Moel-y-Garn, near Talybont. TALIESIN was a famous bard and warrior, perhaps a contemporary of Merlin. The barrow only consists now of a long stone slab and cairn, as many stones were removed for building. In the nineteenth century, local people tried to remove Taliesin's bones to re-inter them on a Christian burial site. During excavation, lightning struck the ground nearby, and the workers fled, never to try again. Taliesin was also one of the seven warriors who survived Bran's invasion of Ireland. The story is recounted in the *Mabinogion*. Bedd Branwen (Branwen's Grave) is on the banks of the river Alaw, a mile north of Anglesey's Treffynon Church. This cromlech was excavated in 1813, and a Celtic urn, inside a stone chest, with the cremated bones of a woman was found. BRAN died when he attempted to bring Branwen back from King Matholwch of Ireland. According to the *Mabinogion*, Branwen died of a broken heart because of the destruction carried out in her name, at the place where the female bones were found. Local farmers carried away most of the stone for building after 1813, and now one large stone remains there, Carreg Branwen (Branwen's Stone).

CROMWELL, OLIVER (1599-1648) In the English Civil War, Oliver Cromwell's New Model Army was the element that swung the English Civil War towards the Parliamentary forces and led to the Inter-Regnum. Morgan Williams of Llanishen (which is now a northern suburb of Cardiff), moved to London to become a brewer and innkeeper. He married a daughter of Walter Cromwell of Putney. Their son Richard adopted his mother's name, as his master Thomas

Cromwell was of great importance in Henry VIII's court. Richard Williams was made a baronet and Privy Councillor in 1527, and his sons and grandsons signed their names as 'Cromwell *alias Williams*'. In his early years so did his great grandson, Oliver Cromwell, who overthrew King Charles I and set up the parliamentary republic in Britain as its Lord Protector. Apropos of the Parliamentary expenses scandal in May 2009, Cromwell's speech dismissing the Rump Parliament (20 April 1653) is germane: 'It is high time for me to put an end to your sitting in this place, which you have dishonoured by your contempt of all virtue, and defiled by your practice of every vice; ye are a factious crew, and enemies to all good government; ye are a pack of mercenary wretches, and would like Esau sell your country for a mess of pottage, and like Judas betray your God for a few pieces of money. Is there a single virtue now remaining amongst you? Is there one vice you do not possess? Ye have no more religion than my horse; gold is your God; which of you have not bartered your conscience for bribes? Is there a man amongst you that has the least care for the good of the Commonwealth? Ye sordid prostitutes have you not defiled this sacred place, and turned the Lord's temple into a den of thieves, by your immoral principles and wicked practices? Ye are grown intolerably odious to the whole nation; you were deputed here by the people to get grievances redressed, are yourselves gone! So! Take away that fool's bauble there (the Parliamentary mace), and lock up the doors. In the name of God, go!' Britain needs an honest man – not a politician – to clean out the troughs of the Gadarene swine who are regularly elected to its House of Commons.

CRUG MAWR, THE BATTLE OF, 1136 The Welsh revolt in South Wales over captured lands had started with a battle at CARN GOCH with 500 Normans killed. Richard de Clare, Lord of Ceredigion had rushed from the Welsh borders towards Ceredigion and had been killed at Carn Goch by Iorwerth ab Owain, whose Gwent territories had been taken into Norman hands. The news of Richard de Clare's death induced Cadwaladr and Owain Gwynedd, sons of Gruffydd ap Cynan, King of Gwynedd to invade de Clare's lordship of Ceredigion. The Welsh had 6,000 foot soldiers and 2,000 cavalry to recapture Ceredigion from the Normans, and the battle of Crug Mawr took place just two miles from Cardigan Castle. In alliance with Gruffudd ap Rhys of Deheubarth, whose wife Gwenllian and son Morgan had been executed by the Normans a few weeks previously, Owain and Cadwaladr won a crushing victory over the Normans. All the Norman lords of South Wales were present, FitzMartin of Cemaes, Fitzstephen of Cardigan, and Fitzgerald. Fleeing the battle, many Normans drowned when the bridge over the Teifi collapsed. It as reported that some prisoners were guarded by Welsh women, such was the despondency caused by the defeat where 3,000 died. The town of Cardigan was next taken and burnt, and Richard de Clare's widow, Adelize, took refuge in Cardigan Castle with Fitzstephen. She was rescued by Miles of Gloucester who led an expedition to bring her to safety in England. The entry in *The Chronicle of Ystrad Fflur* for 1136 is as follows: 'In this year Gwenllian died, brave as any son of Gruffudd ap Cynan. And Morgan ab Owain slew Richard FitzGilbert. And thereupon Owain (Gwynedd) and Cadwaladr, sons of Gruffudd ap Cynan, the splendour of all Britain and her defence and her strength and her freedom, held supremacy over all Wales and moved a mighty fierce host to Ceredigion. And they burned the castles of Aberystwyth, Dineirth and Caerwedros. Towards the close of the year they came to Ceredigion again with a numerous host and against them came Stephen, the constable, and all the Flemings and all the knights. And after fierce fighting, Owain and Cadwaladr honourably won the victory at Crug Mawr. And the Normans and Flemings returned home weak and despondent, having lost about three thousands men. And Geoffrey wrote the history of the kings of Britain.'

CRUSADE In 1188, GIRALDUS CAMBRENSIS (Gerald of Wales) recorded his recruiting campaign across Wales after the Saracens had taken Jerusalem. He accompanied Archbishop Baldwin of Canterbury, Bishop Peter of St David's, Abbot John of Whitland, Abbot Seisyll of Ystrad Fflur, other clerics and The Lord Rhys.

CUSTOMS Many Welsh folk customs died out during the 'reign of terror' of nonconformist righteousness in the nineteenth century, but it is interesting to comment upon one type of social control exerted on the community by a custom called 'y ceffyl pren', 'the wooden horse'. An effigy of a person who had offended the moral code was paraded on a wooden pole, and a noisy procession of people banging saucepans and chanting approached the house of the offender. A typical cause of such an event might be a potential mis-match in the age of two people about to be wed. Adultery was also often punished by the members of the procession tying the offending couple back to back and pelting them with rotten eggs. Mock courts were sometimes held as late as the early nineteenth century, and in Llanfyllin, Montgomeryshire, a ceffyl pren was taken to the door of a husband and wife who quarrelled openly, and a traditional verse dialogue recited to the argumentative couple. It has been said that the REBECCA RIOTS were an extension of the ceffyl pren, as a means of keeping social norms intact.

Around New Year in Llangynwyd, the traditional 'Mari Lwyd' ('Grey Mary' or 'Grey Mare') celebrations still involve rhyming and a roaming artificial 'horse', one with rather a different function to 'y ceffyl pren'. All over South Wales until this century, the Christmas and New Year saw people taking from door to door a horse's skull covered with a white sheet, and decorated with colourful ribbons. A man underneath the sheet could open and close the 'mare's jaw'. The party, often dressed up as Punch and Judy, Leader, Sergeant and Merryman, sang outside a house until they were permitted to enter, and the 'mari' would chase any girls around the house, snapping its jaws. It seems now to be only carried out in Llangynwyd, Glamorgan. In Tregatwg (Cadoxton), Barri, the custom was carried out on Christmas Eve until the early 1900's, as was 'Sul y Blodau', whitewashing and bedecking graves with flowers on Palm (Flowering) Sunday. Another Tregatwg custom was blocking the church exit of a newly-married man – a 'Happy Billy' – unless he gave everyone money for a drink to toast his health. With the influx of strangers to build Barri Docks (the population of Tregatwg and Barri rose from 500 to 33,763 between 1881 and 1911), this custom died out. 1892 records show however, that a newly-wed 'Happy Billy' was dragged roughly along the graveyard of St Cadoc's Church, for refusing to acknowledge the local custom.

Wassailing and 'Hunting the Wren' were also carried out in this same time, from Christmas Eve to Twelfth Night, and may be associated with a pre-Christian fertility cult. Revellers called at houses, accompanied by a beautiful wassail bowl with looped handles. Once in a house, the bowl would be filled with warm spiced beer, and sometimes apples, and there would be ritual singing and dancing, wishing the family health and good crops and livestock. Wassailing was also celebrated on 2 February, the Feast of Mary of the Candles, and on May Day, and copies of these ornamental bowls can be bought at The Museum of Welsh Life at Saint Ffagans. Hunting the Wren involved men in Pembrokeshire carrying a covered cage with a wren in it, the funeral 'bier' being covered with ribbons, to the house of a sweetheart of one of the men. They sang carols, and also visited other houses, where they drank beer. The ceremony was still carried out in the early 1900's, and is thought that originally the wren was sacrificed as a fertility rite for livestock and the land. Many old customs, such as the 'wren house', 'candlemass', 'hel solod' and the 'Mayor of Wakes' are described in Trefor Owen's Pocket Guide to The Customs and Traditions of Wales.

'Calennig' was the custom of giving a New Year's gift. On New Year's morning children would go from house to house, carrying an apple or orange fixed on three short wooden skewers, and decorated with oats and holly. The children sang or chanted wishes of happiness for the New Year, and were given fruit or new pennies in exchange. The custom hardly survives now in rural areas, and should be revived. The last traditional 'cadi ha' was seen in Holywell in the 1930's. This 'Fool', with a group of Morris dancers with equally blackened faces, carried the decorated 'summer branch' ('cangen haf') around the villages on May Day. Dressed half as a male and half as a female, the Cadi painted his lips, cheeks and around his eyes a vivid red. An ancient Glamorgan custom practised in churchyards such as at Welsh St Donats, was 'raising the summer birch'. A birch branch was bedecked with ribbons by the ladies of the parish, and the men assisted them in lifting it up onto the churchyard cross on Easter Day. The birch was guarded for four days and nights against

surrounding villages, and it was a disgrace for a parish to lose its birch. Any parish that retained its birch and captured another was held in great esteem, and broken bones were commonplace in some encounters.

CWMHIR, ABBEY North of Llandrindod Wells, in the secluded Clywedog Valley, this peaceful Cistercian site dates from the patronage of Prince Cadwallon ap Madog of Maelienydd. Llywelyn I began to rebuild it, but was halted by war, and it later passed to the Mortimers who neglected it in favour of Wigmore Abbey. Its importance is indicated by the fact that its nave, at 242 feet, was only exceeded in length by those at the cathedrals of York, Durham and Winchester. Cwmhir was sacked in 1402. Traditionally, Llywelyn II's body was buried here in 1282. It is said that on the occasion of the Reformation, monks transferred his body a monastery at Llanrumney in Cardiff, where Llanrumney Hall now stands. In 1644 Cwmhir's buildings were besieged and captured by Myddleton's Roundheads and dismantled.

CWMYOY CHURCH The valley in Monmouthshire to the north of Abergavenny splits a mountain in the shape of an oxen's yoke, hence the Welsh name Cwmiau, Valley of the Yoke. St Martin's Church is unique in that no part is square or at right angles, owing to the geological formation of the underlying rock.

CYDWELI (KIDWELLY) CASTLE A superb Norman castle overlooking the Gwendraeth River, it could be supplied from the sea when the tide was in. The Welsh took it several times in the twelfth and thirteenth centuries, and in 1159 The Lord Rhys burnt it, but he rebuilt it in 1190. By 1201 it was Norman and was never again taken by the Welsh. Glyndŵr's forces sacked the town and besieged the castle for three weeks in 1403, until it was relieved by an English army. There was much damage done during the siege, and it was further strengthened in the fifteenth century. Rhys ap Thomas was granted the castle by Henry VII. Cydweli still has the street pattern of its medieval walled town, and the South Gate still stands. A Benedictine priory was established in 1114. Cydweli's coat of arms and official seal shows a black cat. In the ninth century the town was called Cetgueli, and since has been recorded as Cadwely, Catwelli, Kadewely, Keddewelly, Kadwelye, Kedwelle and Kidwelli. There is a legend of someone named Cattas, whose habits included sleeping in an oak tree in the area. It may be that the town's mascot was originally an otter, once common, and one is depicted in a carved memorial in St Mary's churchyard. However, the Welsh for otter is dwrgi or dyfrgi - a water dog, not cat. Others say that the black cat was the first creature seen alive after the great plague hit the town. It was therefore honoured as a symbol of salvation and deliverance and subsequently used as Cydweli's heraldic symbol. This author's theory is that there was an unrecorded battle in the water-basin, or flat land there, and cad and gwely = cadwely.

CYDWELI, BATTLE OF, 1136 On New Year's Day, 1136, GWENLLIAN ferch Gruffudd's husband GRUFFUDD AP RHYS joined other Welsh forces in north Wales planning an attack upon the Norman invaders. Maurice de Londres, the detested Norman Lord of Cydweli (Kidwelly) then attacked the Welsh in south-west Wales. Gwenllian of Dinefwr Castle rallied the few defenders that were left in the area, although her youngest son, Rhys, was only four years old. Giraldus Cambrensis stated that 'she marched like the Queen of the Amazons and a second Penthesileia leading the army'. She led her army against Maurice de Londres' Normans at Cydweli. Another Norman army had landed in Glamorgan, and was marching to join the force of de Londres. Gwenllian stationed her rapidly assembled volunteers at the foot of Mynydd-y-Garreg, with the river Gwendraeth Fach in front of her, and Cydweli Castle just two miles away. She sent some of her forces to delay the oncoming invasion force from Glamorgan, but it evaded them and her remaining small army was trapped between two Norman attacks. One son, Maelgwn was captured towards the end of the fighting. Gwenllian ferch Gruffydd ap Cynan and her son Morgan were captured and executed, Gwenllian being beheaded over the body of Morgan. She had pleaded for

mercy for her son and herself, but was beheaded on de Londres' express order. The battlefield is still called Maes Gwenllian, a mile and a half north of the castle, and a stone marks the place of her death. Her four year-old son Rhys became The Lord Rhys, the most powerful lord in Wales.

CYFEILIOG, OWAIN (*c.* **1125/30-1197**) Owain ap Gruffudd ap Maredudd was known as Cyfeiliog to distinguish him from Owain ap Gruffudd, Prince of Gwynedd, who is remembered as the great Owain Gwynedd. Cyfeiliog married Owain Gwynedd's daughter Gwenllian. He was the nephew of Madog ap Maredudd, the last Prince of all of Powys, who had given him the commote of Cyfeiliog in 1147. On Madog's death in 1160 Owain became ruler of most of southern Powys. In 1163, with Owain Fychan he took Carreghofa Castle from the Normans. In 1165 along with The Lord Rhys and Owain Gwynedd he faced the English army of Henry II at CAER DREWYN. In this year Owain Gwynedd gave him Tafolwern Castle, but Cyfeiliog was later expelled from his lands by The Lord Rhys for some time for assisting the Normans. In 1170 Owain gave land for the abbey of Strata Marcella (Ystrad Marchell) to be founded. He refused to meet Giraldus Cambrensis and Archbishop Baldwin upon their campaign for a crusade, and was excommunicated. Owain Cyfeiliog gave his lands to his son Gwenwynwyn and retired to Ystrad Marchell in 1195. He was known as one of the finest poets of the era, although only one poem survived, *Hirlas Owain*, celebrating his raid to rescue his brother Meurig from prison in Maelor.

CYMANFA GANU A singing festival, the first of which was held in Aberystwyth in 1830, has been a major feature of Nonconformist worship in Wales. By the end of the nineteenth century, chapel choirs were often performing full oratorios at Christmas and Easter.

CYMER ABBEY This was founded in 1198 by Cistercians from Abbey Cwmhir, with help from Maredudd ap Cynan, the grandson of Owain Gwynedd. The monks kept sheep, were involved in mining, and bred horses for Llywelyn the Great.

CYMER CASTLE Near Dolgellau, this is the first recorded mention of a native Welsh castle, built by Uchdryd ap Edwin in 1116.

CYMRY The Welsh word for Wales is Cymru. The Welsh people are Cymry, and the adjective Welsh is Cymraeg. The words come from the Brythonic Celtic 'Combrogi', meaning fellow-countrymen, and are also the origin of the word Cumbria, the British in the northwest of England.

CYMRU FYDD (YOUNG WALES) Founded in 1886 by London Welshmen including T.E. ELLIS, its objective was to gain self-government for Wales.

CYMRU FYDD UNION This was founded in 1941 by the amalgamation of the Union for Welsh National Movements and the Committee for the Defence of Welsh Culture. Its conference in 1950 at Llandrindod Wells led to the Parliament for Wales Campaign, with Megan Lloyd George as its president. Its influence helped in the establishment of the Welsh Office, headed by the Secretary of State for Wales, with a seat in the Cabinet.

DAFYDD AP GWILYM (*c.* **1320-c. 1380**) He is the most celebrated Welsh poet, who is said to be buried under the old yew tree in the churchyard adjoining the ruins of Strata Florida Abbey. Indeed, 'the nightingale of Dyfed' is one of the greatest of all European medieval writers. Many of the Welsh princes are also buried with him at Strata Florida, the Latin translation of 'Ystrad Fflur', 'The Way of the Flowers'. He innovated in his use of language and metrical techniques. The seven-syllable rhyming couplet form known as 'cywydd' became his true 'metier'. His reputed birthplace at Llanbadarn Fawr is marked by a celebratory plaque. Ted Hughes and Seamus Heaney named their verse compendium for young people *The Rattle Bag* after Dafydd ap Gwilym's poem of the

same name. Many of the features of his poetry cannot be adequately translated into English, but *Morfudd fel yr Haul* (Morfudd like the Sun) begins with the lines:

Gorllwyn ydd wyf ddyn geirllaes,	I woo a softly spoken girl,
Gorlliw eiry man marian maes;	Pale as fine snow on the field edge;
Gwyl Duw y mae golau dyn,	God sees that she is radiant
Goleuach nog ael ewyn.	And brighter than the crest of foam,
Goleudon lafarfron liw,	White as the glistening garrulous wave's edge,
Goleuder haul, gwyl ydyw.	With the sun's splendour; gracious is she.

DAFYDD AP GRUFFYDD AP LLYWELYN FAWR On Llywelyn's death, his brother Dafydd III pronounced himself Prince of Wales, and survived for ten months, using guerrilla tactics against Edward's forces in Snowdonia. Dafydd ap Gruffydd escaped from Dolwyddelan Castle before its capture, probably moving down to Dolbadarn Castle. For a month he then operated from Llywelyn Fawr's former castle, Castell y Bere and the Cader Idris foothills. Just before 4,000 troops under William de Valence reached there, he was forced back to Dolbadarn, as Castell y Bere was captured. The net was closing in on him. An army from Anglesey and a force of Basque mercenaries moved to encircle Snowdonia. He next hid with his son in the hills above his palace at Garth Celyn, above Abergwyngregyn. Upon promise of pardon, some of his own men gave him up. After over 200 years of struggle, the French-speaking Normans, with their Saxon troops and foreign mercenaries, had overcome the nation of Wales. With Dafydd's capture, the English tried to destroy the dynasty of the Gwynedd Line of Cunedda. Llywelyn's only child, the year-old Gwenllian, was incarcerated for the rest of her life in Sempringham convent in Lincolnshire. A recent plaque marks her possible resting-place. Dafydd's son Owain was imprisoned for over twenty years in a cage in Bristol castle until his death. Dafydd's other son, Llywelyn, also died in Bristol Castle, probably starved to death. His daughter Gwladys, like her cousin Gwenllian, was locked up for the rest of her life in an English convent at Six Hills. In 1317, Aberffraw, the traditional home of the Princes of Gwynedd, was obliterated by the English – the last of the Welsh royal palaces to be demolished, although GARTH CELYN somehow remained. Edward I ('Longshanks') personally invented the practice of hanging, drawing and quartering for Dafydd. This Norman cruelty to their victims echoes the obscene *'blood eagle'* killing of their Danish/Viking forebears. The Prince of Wales, Dafydd III, was dragged by horses through the streets of Shrewsbury, and at the High Cross he was hung, castrated before his eyes, cut open and the heart and entrails ripped from his living body. His corpse was then quartered, and his joints salted for preservation and distributed to York, Winchester, Bristol and Northampton for display. (The second known instance of hanging, drawing and quartering was meted out by Edward I to William Wallace, Braveheart, two decades later). The representatives of York and Winchester disputed over which city should have the honour of receiving the right shoulder of Dafydd – it went to Winchester. Dafydd's head was led on a pole through the streets of London, with a crown of ivy, to the sound of horns and trumpets. It was spiked on the White Tower in London, next to his brother Llywelyn's. The families of the princes of the House of Gwynedd were systematically exterminated, and Conwy Castle was symbolically built on the tomb of Llywelyn the Great. By 'The Statute of Rhuddlan', in 1284, Edward formally took control of Wales.

DAFYDD AP LLYWELYN (1208-1246), DAFYDD II OF GWYNEDD, DAFYDD I OF WALES In 1220, Llywelyn the Great had his son Dafydd officially recognised by Henry III as Prince of Wales, the first man to 'officially' hold this title (in the eyes of the French kings of England). Dafydd took over Gwynedd in 1240 on his father's death, assisted by Edfnyfed Fychan, his father's seneschal. However, Henry III broke his treaty with Llywelyn and invaded in 1241, forcing Dafydd to give up all his lands outside Gwynedd. In 1244 Dafydd joined with other Welsh princes in war across Wales. Prince Dafydd invaded the lordship of Huntington and

defeated the armies of Ralph Mortimer and Humphrey Bohun in his attempt to regain his land and castles. These events are hardly recorded in British history. Dafydd died unexpectedly and heirless in 1246 at his palace of Garth Celyn, suspected of being poisoned. With his death, his nephews Llywelyn ap Gruffydd and Owain ap Gruffydd were forced in 1247 to go Woodstock to surrender more Welsh territory, in return for peace.

DALBY, DR DAVID This Welsh academic has travelled for forty years looking for endangered languages, and had established the world's largest register of extant languages and dialects – he has identified 10,000 living languages. Preserving a multilingual world is his obsession, as he states: 'Monolingualism is as bad as illiteracy... there is something very sinister about a group of upper-class English people who dominated the world in the days of Empire and then imposed their own language on subdued peoples.'... 'The last line of my national anthem, Land of My Fathers, is "May the old language live forever"; could there be any better motto for those of us who care about the wealth of living language in this world?' He is Director of the Linguasphere Observatory, an organisation dedicated to researching the world's languages.

DALE CASTLE In Pembrokeshire, this thirteenth-century castle is now in private hands, having been remodelled in the early eighteenth century.

DANCE The strong Nonconformist Revival with its Calvinist overtones, which swept through Wales in the eighteenth and nineteenth centuries, almost exterminated Welsh folk music and dancing. However, Lady CHARLOTTE GUEST and others in the nineteenth century collected and published dances, and folk dance is seeing a resurgence, with 'Twmpath Dawns' being held more regularly. As early as 1703 Ellis Wynne had attacked the evils of dance, worried about the effects of the closeness of the sexes and the effects of alcohol. In 1714 Rhys Prydderch, a minister in Carmarthenshire, wrote a list of the twelve major sins, which included cock fighting, long hair and sorcery. However, the first sin he considered was 'dawnsio cymmyscedig', mixed dancing. By 1791 the Reverend Thomas Charles was commenting that 'The revival of religion has put an end to all the merry meetings for dancing, and singing with the harp, and every kind of sinful mirth, which used to be so prevalent among young people here. And at a large fair, kept here a few days ago, the usual revelling, the sound of music, and vain singing, was not to be heard in any part of the town.' These revels were largely replaced by open-air preaching festivals.

Edward Jones in *Bardd y Brenin* (The King's Bard), 1802, referred to the influence of the religious revival: *The Great Awakening* upon dance and music: 'The sudden decline of the national Minstrelsy, and Customs of Wales, is in great degree attributed to the fanatick impostors, or illiterate plebeian preachers, who have too often been suffered to over-run the country, misleading the greater part of the people from their lawful Church; and dissuading them from their innocent amusements, such as Singing, Dancing and other rural Sports and Games, which heretofore they had been accustomed to delight in, from the earliest time... The consequence is, Wales, which was formerly one of the merriest, and happiest countries in the World, is now become one of the dullest.' Welsh folk dance was extremely exacting and complicated, as Richard Warner commented in *A Walk Through Wales* in 1799: 'Men and women individually selected us to dance. As the females were very handsome, it is most probable we would have accepted their offers, had there not been a powerful reason to prevent us – our complete inability to unravel the mazes of a Welsh dance. 'Tis true there is no great variety in the figures of them, but the few they perform are so complicated and so long, that they would render an apprenticeship to them necessary in an Englishman.'

Traditional Welsh dance falls into two categories, of which one is 'stepping'. Similar to Irish dancing, there is film of this dance in The Museum of Welsh Life, and stepping competitions between two men at a time were very popular. Clog and step dancing was also known as 'jigs and hornpipes'. There has been a renaissance in the dance, and excellent 'steppers' of all ages can thankfully now be seen in festivals and eisteddfodau. Because of the energetic nature of the heel

and toe clogging, with high leaps and Cossack-style dancing, dancers or 'jiggers' often followed each other individually at wakes and revels until the instrumentalists were too tired to play. The second type of dance is 'folk dancing', which survived the Nonconformist attack by the thinnest of threads. To know the history of Welsh dance is to realise how important it is to preserve the Welsh language. *The Llanover Welsh Reel* was recalled in 1918 by Mrs Gruffydd Roberts, daughter of Thomas Gruffydd, the last harpist at Llanover Court. He was employed there from 1844 until his death in 1888. The reel was then fortunately revived by local schoolchildren, and for many years was regarded as the only genuine Welsh folk dance. However, the publication of the old *Llandagfan Dances* in 1936 gave fresh impetus, along with many people beginning to research the dances before time and memories ran out.

Then Mrs Margretta Thomas of Nantgarw, born 1880, remembered her childhood at local Sunday school tea parties, and dancing at homes and Caerphilly and Tongwynlais Fairs. She also remembered when 'stepping' was popular in the Long Room in the local tavern. Her daughter, Dr Ceinwen Thomas, painstakingly committed these memories of tunes and dances to paper. Thus, only since 1954 we have the *Nantgarw Dances*, forming part of all folk dance group repertoires. They include the *Flower Dance* (with a beautiful costume), the *Dance of St John's Eve, Rali Twm Sion, the Grasshopper Dance, Caerphilly Fair, the Snowball Dance* and the *Ball Dance. Dawns y Pelau* (the Ball Dance) is spectacular, with each man and woman holding a multicoloured ball on elastic string, and each ball is decked with long ribbons in the national colours of Red, White and Green. Mrs Thomas said of the present dancers '... they've a long way to go before they can dance the way the old people danced. The boys dance too much like women, you see. They're not muscular enough. The boys years ago would jump higher than the women, and because they were so energetic, the women looked more feminine.' Her own family had come to regard dancing as a one-way ticket to hell and damnation. Her husband's grandfather, Ifan Tomos, a well-known 'stepper' until his conversion in 1859, used to 'run past the tavern in the dark when he heard the harp and dancing outside, because the urge to join in was well nigh intolerable.'

Many of the dances were performed at 'taplasau haf' or 'mabsant', assemblies of dance and song held most weekends in the summer months. For many centuries the most popular festival in Welsh calendars was the 'gwylmabsant', a wake or revel associated with the feast day of the parish saint. Work could be suspended for days. These in time were replaced by 'twmpathau', which often took place after the taverns shut, and so were disapproved of by 'respectable' folk. On some maps, 'dancing fields' or 'dancing grounds' are still marked. The feast days of local saints are still celebrated across all the towns and villages of Brittany, and these also feature processions in local costume – 'pardons', with folk music and dance following. It may be that some Celtic-Welsh dances can also be rescued from the Breton traditional dances. Cwmni Dawns Werin Canolfan Caerdydd, Cardiff's Welsh dance troupe, has toured America and Japan over the last thirty-five years, and Nantgarw, Bridgend and Brynmawr also have flourishing dance societies. The Welsh Folk Dance Society, Cymdeithas Ddawns Werin Cymru, publishes dance pamphlets and a book on the subject.

DAN YR OGOF CAVES Near Abercraf (Abercrave), this is the largest show cave complex, in the largest system of underground caverns in Western Europe, twisting and turning for nine miles under the Swansea Valley. A further ten miles are believed to exist. Its Cathedral Cave is named after its main feature, called the Dome of St Paul's, a 42ft high chamber approached by a long passage. Half a mile of the nine-mile system is open to the public, with spectacular stalactites, stalagmites and a Bone Cave. In the Second World War, TNT and art treasures were stored here. Old photographs show the Morgan brothers exploring the three underground lakes in coracles in 1912, shortly after they discovered the complex.

DARK AGES An article in *The New Welsh Review* (Summer 1997), by Brian Davies, points to how early Welsh history was deliberately distorted by Victorian historians and archaeologists. They wished to present Christian civilisation as an achievement of the English, so dismissed the

very early Celtic Christian crosses at Merthyr Mawr, Coychurch, Margam and Llanilltud Fawr (Llantwit Major) as crude eleventh century masonry. Davies believes that history was distorted to fit the 'Victorian master-race theory' that was popular with the upper classes of the time: 'It was an uncomfortable problem that the foundation of the Church of England can be pushed back to 597 CE when Augustine landed in Kent, while the major figures of the Welsh "Age of Saints" were active between half a century and a century earlier... Christian civilisation in Britain had to be represented as an achievement of the English. The Welsh church could only be allowed some vitality after the time of Alfred, the celebrated founder of the Saxon state... In order to create the "Dark Ages" required by Saxon triumphalism, the evidence of the continuous history of the Welsh church back to Roman times, preceding the foundation of the "national" church of England by many centuries, had to be pushed to the margins of consciousness and, if possible, be literally buried.' Davies goes on to say that it is unfortunate that medieval scholars do not normally study nineteenth-century political history – 'If they did, they would realise that the basic framework of interpretation of early British history, which they still innocently use, is not the product of calm, objective collection and assessment of data. It is a politically motivated construct; a falsification of history for the purposes of English nationalism.' Basically, historians need to reassess the Dark Ages and the survival of a purer form of Christianity from a British, non-Saxon point of view, and from a post-Imperialist perspective, but this would not fit with the way they have been taught by historians who simply regurgitate what they themselves have been taught. The history of the British Isles was deliberately rewritten to help justify the accession of the German Hanovers and their constant marriages with other German dynasties. Thus British history starts with the Germanic invasions of the Saxons, Angles and Jutes 'civilizing' the barbarian British, not the barbarian Germans exterminating the Christian British. What the distinguished, honoured and respected English historian A.J.P. Taylor called 'the lesser breeds' – the Welsh (British), the Irish (Scots) and the Scottish (Picts) have been traduced and ignored in the rewriting of British history. It is far easier for historians who escaped the university history academic regime and studied other subjects to accept this verifiable fact.

DAVID, ELIZABETH (1913-1992) Easily most influential of all British chefs, born Elizabeth Gwynne, her scholarly books (*Mediterranean Food* of 1950, *French Country Cooking* of 1951 and *Italian Food* of 1954) brought the attention of the British to such exotic substances as olive oil, previously only sold in chemists. Versed in the history of gastronomy, she influenced successive generations of chefs to the extent that good British restaurants now rival their equivalents anywhere in the world. Prue Leith labelled her the most important cookery writer of the twentieth century. A review of her biography states '... her legacy goes beyond her name. From pizza to pasta, not to mention sun-dried tomatoes and rocket (she discovered it on Syros), people to whom the name of Elizabeth David means nothing have a whole way of life to thank her for.' She single-handedly 'brought English cooking into the 20th century.' David was a 'one-off' who revolutionised British cuisine – modern celebrity chefs are only multiple extensions of her work.

DAVID, SAINT (520-1 March, 589) Dewi Sant, Saint David spent his life reforming the church in Wales, and fighting druidic remnants of belief. He was born on the shore of St Bride's Bay, and the chapel dedicated to his mother St Non is said to mark the place. Not far away is St David's Cathedral, on the spot where Dewi founded a monastery. Like Illtud, he was an ascetic with a strong sense of discipline, and a vegetarian. He was known as 'Dewi Ddyfrwr', 'David the Waterdrinker'. Over fifty churches are still dedicated to this patron saint of Wales. His *Life* was written by Rhigyfarch at Llanbadarn monastery in 1090, in an attempt to stop the growth of Canterbury's influence, following on from constant Norman attacks. St David held a meeting in the church at Llanddewi Brefi to denounce the Pelagian Heresy. In this meeting, known as the Synod of Brefi, legend says that the ground rose so that he could be heard by the crowds, and the old church stands on a prominent mound. He seems to have died around 589, and was reputed to

have been a centenarian. David was canonized during the reign of Pope Calixtus II, around 1120. In 1398 the Archbishop of Canterbury decreed that the Festival of St David be held on 1 March, and the Welsh continued to keep this special saint's day all through the period of the Commonwealth, when saints' days were forbidden. His feast of 1 March is now Wales' national day, when Welshmen all over the world wear the symbols of leeks and daffodils, and there is a movement to make it a national holiday. There is now an annual and growing St David's Day procession in Cardiff, through the city and down to the Assembly Building in Cardiff Bay.

DAVID'S CATHEDRAL, SAINT, St David's Cathedral vies with Bangor as the oldest cathedral settlement in Britain, founded by St David in 550 and based on his monastic site. The ruined Bishop's Palace of 1342 stands next to the present cathedral, which was burned down in 645, ravaged by Danes in 1078 (when the Bishop Abraham was killed), burned again in 1088 and rebuilt from 1176 by Peter de Leia. By 1120, Pope Calixtus II had decreed that two pilgrimages to St David's equalled one to Rome, and three pilgrimages would equate to one to Jerusalem. Santiago de Compostela in Spain was given the same dispensation, showing the importance of St David's in European Christian history. St David's boasts that it is Britain's smallest city, if we take the definition of a city as a town with a cathedral. The tower collapsed in 1220, and the structure was also damaged by an earthquake in 1248. Relics of St David and his confessor St Justinian were thought to be in the Holy Trinity Chapel, with its wonderful fan-vaulted ceiling. Its situation in the Vallis Roșina, a sheltered and hidden 'valley of roses', reminds one of the siting of Llanilltud Fawr, Llancarfan, and other ancient holy sites, with the ever-present threat of Irish, then Viking destruction and desecration.

DAVIES, CLEMENT (1884-1962) Clement Davies was Liberal MP for Montgomery from 1929 until his death (even now this is a Liberal seat, albeit held by an Estonian celebrity seeker called Lembit Opik who believes that the earth will be hit by a major asteroid). Davies was one of those instrumental in forcing Neville Chamberlain to resign as Prime Minister in World War II. He was leader of the Liberal Party in the House of Commons from 1945 to 1956, refusing ministerial office under different Conservative governments in order to keep the Liberal Party separate. Through his actions the Liberals remained a national party, with seats in England, Scotland and Wales. He conducted a brilliant parliamentary defence against Labour and Conservative colonial secretaries in support of Seretse Khama, which led to Khama becoming Prime Minister of Bechuanaland and its President, when it was renamed Botswana.

DAVIES, DAVID (1819-1890) Born the eldest of nine children, in Llandinam, in Montgomeryshire, a wonderful statue of David Davies is placed outside the Docks Offices in Barri. His is the story of a major Welsh industrialist of the nineteenth century. His father ran a small sawmill, and Davies' nickname from working there stayed with him all his life – 'Dai Top-Sawyer'. Later, as a contractor then financier, he took part in the building of seven Welsh railway lines, thereby earning another soubriquet, 'Davies the Railway'. In 1865, he bought mineral rights in the heavily wooded Rhondda Valley, looking for coal. He sank the two deepest coal shafts ever made at that time, anywhere in the world. Running out of money, he addressed the workers, saying that he only had a half-crown piece left (about 12 pence in modern money), and could not afford to pay them any more wages. A man shouted 'We'll have that as well', and Davies threw him the coin. The men promised to work just one more week without wages, and in March 1866 a coal seam was found at the unheard-of depth of 660ft – it became one of the richest in the world.

Tired of delays and the monopoly charges at the Scottish Lord Bute's Cardiff Docks, Davies built a railway line to Barri, and had built the most modern docks in history at Barri by 1889. (Incidentally, the Marquis of Bute became the richest man in the world through his control of Welsh coal, docks and shipping). Barri became the busiest port in the world, shipping coal everywhere. Davies *Ocean Coal* wagons rolling down to Barri Docks gave him his third nickname, 'Davies the Ocean'. A fourth nickname had been 'David Davies Llandinam' to distinguish him from all the other men named

David Davies across Wales. He became a Liberal MP and philanthropist, and his granddaughters Gwendoline and Margaret were responsible for the bequest of Impressionist Art, which made The National Museum of Wales at Cardiff the envy of many other European museums. His grandson David Davies, first Baron Llandinam, was the major benefactor of the first Welsh university and the National Library of Wales at Aberystwyth, as well as a chain of hospitals across Wales. A close ally of David Lloyd George, Baron Llandinam strongly supported The League of Nations, and erected the Temple of Health and Peace in Cardiff. He also founded the New Commonwealth Society and campaigned strongly for an international police force.

DAVIES, DONALD WATTS, CBE FRS (1924-1999) The son of a Treorchy coalminer, he was a computer pioneer, 'the scientist who enabled computers to talk to each other' and thus 'made possible the internet.' At Imperial College, he had gained a First in physics in 1943 and a First in Mathematics in 1947. At the National Physics Laboratory in 1966, he coined the term 'packet switching' for the data transmission system that is fundamental to the internet. He presented his design for a computer network using packet switching to the US Department of Defence in 1967, enabling the American internet prototype, ARPANET. There was never substantial funding in the UK for him to develop systems, and he moved into the field of data security, working towards the development of 'smart cards' and authorised usage of open networks for EFTPOS, used at most retail tills to pay our bills by credit or debit card.

DAVIES, EMILY (1830-1921) By the late 1850's, Davies was recognised as a leader of the nascent women's movement, and in 1862 wrote a paper on *Medicine as a Profession for Women*. Through her efforts, girls were allowed to take Cambridge Senior and Junior examinations from 1865. In 1866 she wrote and published the book *On the Higher Education of Women* and was one of the organisers of the first suffrage petition of that year. She worked for women to be enabled to study for university degrees at Oxford and Cambridge, and was the founder of Girton College to effect this breakthrough. Girton students were at last allowed full membership of Cambridge University in 1948.

DAVIES, GWENDOLINE ELIZABETH (1882-1951) & DAVIES, MARGARET SIDNEY (1884-1963) The granddaughters of David Davies of Llandinam, they were orphaned from the ages of four and six, with their grandmother dying just two years later. They inherited half a million pounds each, and became passionate art collectors, buying J.M.W. Turners and building up a fantastic French Impressionist collection. Their purchases included works by Monet, Rodin, Corot, Daumier, Millet and Carrière. They settled at Gregynog Hall near Newtown, where a unique printing press was established, and the house and grounds were later given to the University of Wales. The sisters left their fabulous art collection of 256 paintings and sculptures, including works by Cezanne, Renoir, Van Gogh, Pissarro and Richard Wilson to the National Museum of Wales in Cardiff.

DAVIES, GWEN FFRANGCON, DBE (1891-1992) Her acting debut was in 1911, and she acted throughout eight decades, with her last performance in 1991. A 'living legend', the *New York Times* called her 'the last link with the world of the Victorian theatre.' Her DBE was not granted until she was 100 years old, after a campaign from leading figures in the theatre.

DAVIES, SIR HENRY WALFORD (1869-1941) A prolific writer of religious music, he was an influential educator on music through radio talks.

DAVIES, HUGH MORRISTON (1879-1965) He wrote the first textbook on thoracic surgery, and was a pioneer of chest surgery in Britain. His contemporary Arthur Tudor Edwards (1890-1946) was the other leading pioneer, the first British surgeon to remove a lobe of a lung, and a lung. Horace Evans, Baron Evans of Merthyr Tydfil, was physician to Queen Mary, George VI and Elizabeth II.

DAVIES, IDRIS (1905-1953) Rhymney-bred Davies was a miner as a fourteen-year-old, who became a London teacher and extra-mural lecturer. A Welsh speaker, he learned English at school. He was the poet of the valleys, and died of stomach cancer, aged only forty-eight. His *Gwalia Deserta* was published in 1938 with his poems recommended by T. S. Eliot: 'They are the best poetic document I know about a particular epoch in a particular place, and I think that they really have a claim to permanence.' *Gwalia Deserta* shows a socially and politically committed poet, full of the imagery of mining-valley life in the terrible days of the 1930's. Much of his work describes the impact of the Industrial Revolution, and its terrible decline, upon his beloved countryside and people. A Celtic Christian Socialist, he epitomised Welsh bardic tradition with a respect for fellow humankind, rather than for wealth based upon property. He wrote: 'Any subject which has not man at its core is anathema to me. The meanest tramp on the road is ten times more interesting than the loveliest garden in the world. And instead of getting nearer to nature in the countryside I find myself craving for more intense society'. Davies is the most approachable of all Welsh poets, and verse XV of his *Gwalia Deserta* was set to music by Pete Seeger and also recorded by The Byrds. It begins:

O what can you give me?
Say the sad bells of Rhymney.
Is there hope for the future?
Cry the brown bells of Merthyr.
Who made the mine owner?
Say the black bells of Rhondda.
And who robbed the miner?
Cry the grim bells of Blaina...

DAVIES, JOHN (1567-1644) From Llanferres, he was one of Wales' greatest scholars, given the Holy Day of 15 May by the Church in Wales. As Rector of Mallwyd he compiled the great *Welsh-Latin Dictionary* of 1632, and the Welsh Grammar, *Antiquae Lingua Britannicae*. He also seems to have assisted Richard Parry's Welsh *Bible* of 1620 and made an immense contribution towards the survival of the Welsh language.

DAVIES, RON (1946-) A councillor in Caerffili, and then its MP from 1983, as Secretary of State for Wales he pushed through the formation of a National Assembly for Wales, which the electorate narrowly voted for in 1997. He would have become First Minister of the Assembly, not Alun Michael, but for an incident on Clapham Common in 1998. Still an MP, he rebuilt his reputation until another scandal occurred in 2003, and he stood down from the Assembly. Whatever the problems of his private life, he is more than anyone else responsible for the National Assembly, now the Welsh Assembly Government.

DAVIES, W.H. (1871-1940) This *'tramp poet'* from Newport, Gwent, wrote in *Leisure*:

What is this life if, full of care,
We have no need to stand and stare?

A descendant of the French criminal-poet, Francois Villon, Davies lost a leg in a railroad accident in 1899, while wandering across the Klondike, and ended up living in doss-houses and selling shoe-laces on the streets of London. The poems of *The Soul Destroyer* in 1905 recount his experiences with hoboes like Frisco Fatty and Red-Nosed Scotty, and with prostitutes like Kitty and Molly. George Bernard Shaw wrote the introduction to Davies' *Autobiography of a Super-Tramp*, which opened the doors of admirers like Vita Sackville-West, Ottoline Morrell and Edith Sitwell to the peg-legged tramp. Davies later married and settled in Gloucester, in a

house he named Glendower (the Anglicised version of Glyndŵr). Spurning convention to the last, his pet was a toad called Jim, which he fed saucers of milk. Lines from his *The Kingfisher* are as follows:

It was the rainbow gave thee birth
And left thee all her lovely hues

DAVIS, HOWEL (*c*. 1680-1719) The man responsible for Black Bart's adventures, Pembrokeshire's Howel Davis, also is famous in pirate annals. He was serving as a mate on the *Cadogan* in 1718, when it was captured by Captain Edward England, who invited him to become a pirate. Davis refused, whereupon England gave him the *Cadogan* and sailed away. Davis sailed it to its destination, Barbados, but the authorities were suspicious of Davis' story and clapped him in irons. After three months with no evidence, they released Davies, but no-one trusted him any longer, and he could not get employment. The frustrated and penniless Davis thus stole a ship, the *Buck*, in late 1718 and made a short speech to the volunteers with him, 'the substance of which was a Declaration of War against the Whole World.' He was noted for his mercy, affability and good nature, unlike most other pirates. The pirates sailed from the Caribbean to the Guinea Coast, plundering and acquiring a new and better ship, the *King James*. After attacking the island of Sao Tiago, Davis set sail for Gambia, sailing into the harbour with English ensigns flying and most of his crew hidden below decks. He went ashore to see the Governor at the Royal African Company fort, pretending to be a merchantman fleeing from the French. He noted the defences, and being entertained by the Governor at dinner that night drew his pistols at the table, and gave a signal for his men to over-run the fort. Having looted Gambia, there was then an equally successful attack on Sierra Leone, with Davis now commanding three pirate ships.

In the Gulf of Guinea, sailing alone again, the pirates took on a heavier-armed Dutch vessel and a terrible fight lasted for thirty-two hours, with Davis eventually taking the Dutch ship as his own ship was sinking. He renamed her the *Royal Rover*. With the *Royal Rover*, he took another Dutch vessel with £15,000 in sterling on board, a fortune in those days. He was known as 'the Cavalier Prince of Pirates' for his dashing exploits. One of Davis' cleverest exploits was the capture of two French ships in 1719. He forced the prisoners from the first ship to masquerade as pirates and hoisted a dirty tarpaulin as a black pirate flag. Bluffed into believing that the captured French ship was another pirate ship, the second ship surrendered. At the Portuguese island of Principe off Gabon, he repeated his 'friendly merchantman' trick, but an escapee managed to get word to the Governor. Just before the evening's meeting, Davis was fatally shot in the stomach in an ambush, and BARTHOLOMEW ROBERTS, a Welshman he had just captured, was chosen captain in his place.

DAVIS, JEFFERSON (1808-1889) John Davies emigrated from Wales to Philadelphia in 1701. His son Evan married a Welsh widow named Jane Williams, and the couple had a son, Samuel. The family moved to Augusta, Georgia, when Samuel was a boy, and her two Welsh sons by her earlier marriage enlisted in the Revolutionary army. Young Samuel Davies followed into the army as a mounted gunman, later forming his own infantry company, fighting the British in Georgia and the Carolinas. At the end of the war, he was granted land in Georgia, then moved to Kentucky to breed racing horses on 600 acres of land, later known as Christian County. Here, in 1808, the last of his ten children was born, and named Jefferson, after the great Welshman just finishing his second term as President of the United States. The cradle, in which his mother Jane rocked the baby Jefferson Davis, is in The Confederate Museum in New Orleans. (At some stage the spelling of Davies changed to Davis).When the child was three years old, the family moved to Louisiana and in 1812 to Mississippi. While Thomas Jefferson had created the new country of the United States, his fellow-Welshman Jefferson Davis grew up to almost break it in two. A graduate of West Point, Jefferson Davis served in the Indian Wars, being wounded and becoming a hero in the Battle of Buena Vista against the Mexicans. In 1838 he was elected to the House of Representatives, and sat in the US Senate from 1847 to 1851. Davis was Secretary of War from

1853 until 1857, when he returned to the Senate, becoming leader of the Southern Democrats. In 1860 South Carolina issued a declaration of secession from the USA. By January 1861, Georgia, Florida, Alabama, Mississippi, Florida, Louisiana, Texas and Arkansas had also seceded from the union. Virginia and North Carolina soon followed. Jefferson Davis was elected in February 1861 as President of the Confederate States of America. The ensuing bitter Civil War lasted from 1861 to 1865, with the vast military capability of the Union North eventually overcoming the Confederate Southern states.

The great and brutal battles of Manassas (where Davis took the field), Appomattox, Shiloh, Gettysburg, and the two battles at Bull Run echo through history, and the South has still not forgotten Sherman's devastation. 359,528 Union and 258,000 Confederate troops had died in the young republic. The turning point in the war, more than any other, was the mass-production of the Springfield rifle in Connecticut. It had greater accuracy and three times the range of the old smooth-bore rifle. On the fateful third day of Gettysburg, 12,000 Confederate soldiers had mounted one last, great, Napoleonic assault on the Union lines. All but 300 were mown down before they reached the Northerners. After his capture, Jefferson Davis was put in shackles and imprisoned. His Welsh wife, Varina Howell, fought for his early release after he had endured two years in poor conditions. The *New York World*, not a Southern sympathiser, called Jefferson Davies 'the best equipped man, intellectually, of his age, perhaps, in the country'. Joseph McElroy, in his biography of Davis, says that 'Lincoln sought to save the Union; Davis did not wish to destroy the Union; he sought to preserve states' rights, under his interpretation of the Constitution.' Like Jefferson before him, the right to liberty justified revolution for Davis – for him the Civil War was not about slavery but about freedom for the states and their individuals. He 'was convinced that Lincoln's aim was to convert a Federal republic of sovereign states into a consolidated nation with the right to dominate the states, the old idea which had precipitated the American Revolution.' In the South, the Civil War is still referred to as *The War of the States*. What Davis called the 'demon of centralisation, absolutism and despotism' which is 'well-known by the friends of constitutional liberty' has modern parallels in the Europe Union, with national and regional sovereignty being subverted to unelected central committees. Interestingly Lincoln had said that if he could win the Civil War without freeing the slaves, he would have. Lincoln's main reason for pursuing this course of action 'was not to free the slaves, but to cause discomfiture to the South in the Civil War.' (Brian Walden, BBC TV, 13 January 1998). The distinction of Jefferson Davis being pro-slavery and Lincoln being anti-slavery was a useful myth to help centralise power in Washington.

DAVIS, WILLIAM MORRIS (1850-1934) A Welsh-American physical geographer from the Welsh heartland of Philadelphia, he developed the concept of the regular cycle of erosion, and has been called the most influential geomorphologist of all time.

DEE, JOHN (1527-1608) At Cefn Pawl near Beguildy was born Ieuan Ddu, John Dee, Black Jack, who became Elizabeth I's tutor, a man respected at court who was also a noted mathematician, astronomer, geographer and astrologer. 'John Dee' was however better known back in Powys as a magician and practitioner of the Black Arts than as a court adviser to Queen Elizabeth. Dee was a foundation fellow of Trinity College Cambridge in 1546, and moved to Louvain (Leuven) in modern-day Belgium because science and mathematics were better established there. There he mixed with great minds such as Mercator, Ortelius and Gemma Phrysus. He had lectured at Paris when he was twenty-three and returned to London to be taken into the heart of Elizabeth's court. 'An astounding polymath... the lectures of this twenty-three-year-old at Paris were a sensation; he was to be courted by princes all over Europe'. He had returned to England with navigational devices like the balestila (cross-staff), and was taken up personally by the Queen, the retinue of the Earl of Leicester and the Sidneys, being at the heart of the Elizabethan Renaissance. A brilliant mathematician like Robert Recorde of Pembrokeshire before him, he published an augmentation of Recorde's *Grounde of Arts*, a mathematical textbook which ran to

twenty-six editions by 1662, and wrote his own seminal *Preface* to the English edition of Euclid, which has been called a 'landmark in mathematical thought.'

Dee claimed descent from Rhodri Mawr, and invented the term *The British Empire* for Queen Elizabeth to prove her right to North America which had been 'discovered' by the Welsh prince MADOG ap Owain Gwynedd. This 'established' the Brythonic Celts, or the British, as the founders of her 'British' empire. 'With his remarkable library at Mortlake, (Dee) became the thinker behind most of the ventures of the English in their search for the North-East and North-West Passages to Cathay, pouring out treatises, maps, instructions, in his characteristic blend of technology, science, imperialism, speculation, fantasy and the occult' (*Welsh Wizard and British Empire*, Gwyn Alf Williams). He was imprisoned by Queen Mary for allegedly trying to 'enchant' her, and a London mob tragically sacked his fabulous library in 1583 as they thought it the den of a black magician. He is said to have been the model for both Shakespeare's white *Prospero* and Marlowe's black *Faust*. The original 'Black Jack' Dee was considered 'the Magus of his Age.'

DEGANWY, BATTLE OF, 1245 Following the death of Gruffydd ap Llywelyn in trying to escape from the Tower of London in 1244, his brother Dafydd switched to Gruffydd's policy for an independent Wales. Henry III had reneged on his promise to allow Dafydd to succeed his father Llywelyn I as Prince of Wales. Dafydd had taken Mold Castle and Flintshire back into the Princedom of Gwynedd, and in August Henry III marched an army to Deganwy. The English army was subject to guerrilla attacks all the way. A letter from the English camp reads '(they) crossed the river and like greedy and needy men, indulged in plunder, and spread fire and rapine through the country on the other side of the water, and amongst other profane proceedings, they irreverently pillaged a convent of the Cistercians, called Aberconwy, of all its property, and even of the chalices and books, and burnt all the buildings belonging to it.' Dafydd held off from pitched battle, and both armies were starving, when an Irish ship ran aground below Deganwy Castle, which was being rebuilt by Henry. Dafydd's men fell on the ship to get its food and drink, and then fired it. There was a series of inconclusive skirmishes around Deganwy to try and halt the castle's building, and one day the English lost 100 men. Next day the English returned to Deganwy with the bloody heads of Welsh villagers who had been killed in reprisal. In response, the Welsh hung all their captives and threw them in the Conwy River. Fighting continued across North Wales until a truce was agreed. Henry returned to England, in preparation for another offensive in 1246. However, Dafydd's unexpected and unfortunate death in that year meant that nephew Llywelyn ap Gruffydd succeeded to the princedom of Gwynedd, after several battles for power against his kinsmen.

DEGANWY CASTLE The twin peaks here were the home of the court of Maelgwn Gwynedd, the patron of saints Cybi and Seiriol, but who was one of the sixth-century kings reviled by Gildas. In 822 The *Annals Cambriae* state that the fort was destroyed by Ceolwulf of Mercia and his Saxon army. Robert of Rhuddlan built the first castle here around 1080, but no traces remain, and the Welsh built the next castle, described by Giraldus Cambrensis as a 'noble structure'. *The Chronicle of Ystrad Fflur* records in 1211 'In this year Llewellyn ab Iorwerth led frequent attacks against the Saxons, harassing them cruelly. And because of that, John, king of England, gathered a mighty host and made for Gwynedd, planning to dispossess Llywelyn and destroy him utterly. And so the king came as far as Chester and to the castle of Deganwy. And there the host suffered lack of food to such an extent that an egg was sold for a penny half-penny; and they found the flesh of their horses as good as the best dishes. And because of that the king, having lost many of his men, returned in shame to England without having fulfilled aught of his mission. And he returned again in August and with him a host which was greater and fiercer.'

John's forces had destroyed the castle and Llywelyn the Great took possession again in 1212 and rebuilt it from 1213. His sons demolished it on his death, to prevent the English under Henry III from using it, following the scorched earth policy practised before by King John.

However, under Henry III it was again rebuilt (against the will of Dafydd ap Llywelyn) from 1245 to 1254 but never completed. In 1245 there was a running battle there between the armies of Dafydd and Henry. A letter from Deganwy states that in 1245 English raiding parties from the castle returned with Welsh heads. In 1257, Henry III invaded Wales and relieved Llywelyn ap Gruffydd's siege of the castle, but was forced to retreat back to England after making a truce. In 1263-64, Llywelyn captured it after a long siege and again demolished it. However, Edward I camped there in 1283 and realised that the maritime site of Conwy would be a far easier site to defend. Thus he built his great castle there, abandoning Deganwy. Some of its stone was said to be used in the building of Conwy.

DEHEUBARTH Deheubarth emerged in the early tenth century as a consolidated kingdom covering Dyfed, Ceredigion and Ystrad Tywi. Gwynedd, Powys and Deheubarth made up the three main kingdoms of Wales, the latter generally comprising Seisylliwg and Dyfed, with minor kingdoms in Gwent and Morgannwg (Glamorgan). Wales was unified under RHODRI MAWR (844-878), who was King of Gwynedd, Dyfed, Seisylliwg and all Wales. His son Anarawd (878-916) succeeded him. HYWEL DDA was also King of Gwynedd and forced Brycheiniog into a sub-kingdom of Deheubarth in 920.

DEHEUBARTH, KINGS AND PRINCES OF
Hywel Dda the Good 920-950 (from 942 also King of Gwynedd and Seisylliwg)
Rhodri ap Hywel 950-953 (joint ruler, not including Gwynedd)
Edwin ap Hywel 950-954 (joint ruler, not including Gwynedd)
Owain ap Hywel 950-987 (as above, as the kingdom was divided between three brothers)
Maredudd ab Owain 987-999 – Deheubarth was under the dominion of Gwynedd until 1033
Cynan ap Hywel 999-1005
Edwin ab Einion 1005-1018
Cadell ab Einion 005-1018
Llywelyn ap Seisyll 1018-1023
Rhydderch ab Iestyn 1023-1033 – usurper
Hywel ab Edwin 1033
Maredudd ab Edwin 1033-1035
(Under the dominion of Gwynedd 1039-1042)
Hywel ab Edwin (again) 1042-44
(Death of last king of Brycheiniog, 1045, his kingdom is divided between his sons)
Gruffydd ap Llywelyn 1044-1047
Gruffydd ab Rhydderch 1047-1055
Gruffydd ap Llywelyn (again, 1055-1063 under dominion of Gwynedd)
Maredudd ab Owain 1063-1072
Rhys ab Owain 1072-1078 under Gwynedd
Rhys ap Tewdwr 1078-1093
(Under Norman Rule 1093-1135)
Princes of Deheubarth –
Gruffydd ap Rhys 1135-1137 ruled a portion of Deheubarth with Norman permission
Anarawd ap Gruffydd 1137-1143
Cadell ap Gruffydd 1143-1153
Maredudd ap Gruffydd 1153-1155
The Lord Rhys ap Gruffydd 1155-1197
Gruffydd ap Rhys 1197-1202 ruled jointly for some time with his brother Maelgwn, who then disputed the succession
1216-1234 Rhys (Grug) ap Rhys
1234-1271 Maredudd ap Rhys Grug
Owain ap Gruffydd 1202-1236 – the last independent Prince of South Wales

1236 Norman and Gwynedd domination
1234-1244 Rhys ap Mechyll, son of Rhys the Hoarse ruled part of Deheubarth
1244-1271 Maredudd ap Rhys, brother of Rhys ap Mechyll, as above
1271 -1283 Rhys ap Maredudd ruled a portion of Deheubarth.
After 1201, the descendants of Gruffydd ap Rhys ruled as Lords of the Cantref Mawr only.

DEINIOL THE BLESSED, SAINT (d.c. 550) A hermit who lived in Pembrokeshire, he founded and became Bishop of Bangor on the Menai Straits, and probably assisted his father Dunawd Fawr in the establishment of the great monastery at Bangor-is-Coed outside Chester. Many places are named after him across Wales, and some like Llanddeiniol in Gwent have been renamed. It is now called Itton. Deiniol fled the Yellow Plague in 547 and went to Brittany, being remembered in at least five ancient churches there. He was buried on 'the Isle of 20,000 Saints', Ynys Enlli (Bardsey).

DENBIGH H.M. Stanley was born in a cottage near the castle gate, and the County Hall is sixteenth century. The town walls are well preserved, the best in Wales after those at Conwy. The ruins of Denbigh Friary, a Carmelite foundation, are near St Hilary's Tower.

DENBIGH CASTLE The stone figure above the gatehouse is said to be Edward I, who built the castle from 1282. There had been a Welsh castle on the site, belonging to Dafydd, the brother of Llywelyn the Last. The new town, or bastide, was settled by English immigrants, and the Welsh were compulsorily expelled from their homes. The Welsh attacked the unfinished castle in 1294, but it was completed later. It lies on the summit of Caledfryn Hill, having the most elaborate 'keep-gatehouse' in Wales, and defended by three towers. The fortified town walls are over a mile long, and the Burgess Gate is one of the finest medieval town gatehouses in Europe. Parliamentarians under Major-General Thomas Mytton took the town and spent months besieging the castle before it fell in 1646. After six months of siege, Colonel William Salesbury ('Old Blue Stockings') had sent a message to the king informing him that his men were starving, and Charles I responded allowing him to surrender with honour. Denbigh Castle and town walls are the largest, strongest and best-preserved fortifications of all the northern Borderlands fortresses.

DENBIGHSHIRE, SIR DDINBYCH Denbighshire is one of thirteen traditional counties of Wales, created by the Laws in Wales Acts of 1535-1542, taken from areas formerly included in the Marches. Cantrefi were taken from Powys Fadog and Gwynedd-is-Conwy to include Cynllaith, Nanheudwy, Maelor Gymraeg, Iâl, Duffryn Clwyd, Rhufoniog and Rhos. The administrative county was abolished in 1974, with the majority becoming part of the new county of Clwyd, but Llanrwst and five rural parishes were included in Gwynedd. Denbighshire was recreated in 1996, covering a substantially different area. It includes the boroughs of Wrexham, Denbigh, Ruthin and the urban district of Colwyn Bay.

DEUDRATH CASTLE This is mentioned by Gerald of Wales in 1188 as being unusual, because it was a Welsh castle made of stone, and is near Portmeirion. Heavily restored, it is now a hotel.

DEVAUDEN, BATTLE OF, 743 The Welsh were slaughtered here by the Saxon kings Ethelbald and Cuthred. Ffawydden (Beech Tree), is the origin of the Gwent village's name.

DEVOLUTION In the 1979 referendum, 58.3% of the electorate voted, with 11.8% for devolution and 46.5% against. In 1997 only 50.7% of the electorate voted, with 559,419 in favour and 552,698 against, a majority of just 6,721. The first Assembly elections were then held in May 1999. Of the 60 seats, Labour won 28, Plaid Cymru 17, Conservatives 9 and Liberal Democrats 6, and a minority Labour Government took control of the Welsh Assembly. In 2003, Labour took 30 seats, with Plaid Cymru 12, Conservatives 11, Liberal Democrats 6 and 1 Independent.

In 2007 the results were Labour 26, Plaid Cymru 15, Conservatives 12, Liberal Democrats 6 and 1 Independent. In 2009 Rhodri Morgan (Labour) serves as First Minister in coalition government with Plaid Cymru.

DIC ABERDARON (1780-1843) Richard Robert Jones was known as 'Dic Aberdaron'. Uneducated, he learned fifteen languages, and travelled the countryside wearing a hare-skin hat, a ram's horn tied around his neck, and a cat at his side. It was said he could summon demons in the shape of piglets, which he called 'Cornelius' Cats'. Reapers at Methlem farm near Aberdaron could not cut a field of thistles, but Dic's 'cats' stripped the field in minutes. He is buried in St Asaf.

DILLWYN, AMY ELIZABETH (1845-1935) Growing up at Sketty Hall, Swansea, her father was Lewis Llewellyn Dillwyn, industrialist and MP for Swansea. She wrote novels and articles for *The Spectator*, and took over her father's company on his death. However, his estate which included the Llansamlet Spelter Works was £100,000 in debt. Her legacy was placed in Chancery so she could not receive any money before the creditors were paid. Aged forty-seven, she was expected to file for bankruptcy and make hundreds of men unemployed. However, in 1892 she took over the company's management, increased productivity, took no profits or wages and started paying off the massive debt. In 1893 she had to sell all the contents of her beloved Hendrefoilan Mansion to pay off some creditors. She lived in cheap lodgings, looking after all the accounts and finally cleared the debts in 1897. She was at last given the deeds to the works, and in 1902 *The Western Mail* called her 'one of the most remarkable women of the age.'

DILLWYN-LLEWELYN, SIR JOHN (1810-1882) Dillwyn-Llewelyn of Penlle'rgaer was a considerable scientist, also becoming a FRS. In 1841 he invented an 'electro-galvanic apparatus' to propel his boat around his private lake, and worked with Professor Wheatstone to develop the telegraph. They also proved that electric currents passed through sea-water in experiments at Mumbles. He collaborated with Claudets on Daguerreotypes, and helped Henry Fox Talbot, the inventor of the modern process of photography. (Fox Talbot himself was brought up in Penrice Castle in Glamorgan.) Dillwyn-Llewelyn was also an outstanding botanist.

DINAS BRÂN (FORTRESS OF THE CROW) CASTLE Overlooking Llangollen, and built by the princes of Powys Fadog, there are almost sheer drops to the north, and it is surrounded by the ramparts of a hillfort. There is a Welsh-built D-tower, as at Ewloe, and its defenders burnt and abandoned it when faced by Edward I's army in 1277.

DINAS EMRYS HILLFORT This rocky hill has three ramparts, the inner one of which may date from post-Roman times. It may be the Dark Age fort of Emrys Wledig, Ambrosius, who fought Vortigern. Later, Emrys became synonymous with Merlin. Nennius' legend of the battle between the Red Dragon of the Roman-Celts and the White Dragon of the Saxons, with the pool inside the mountain, is thought to be placed here. Recently an underground lake was found in the hill. There is also the base of a square tower, possibly twelfth century or built by Llywelyn the Great in the thirteenth century, and a circular platform from the ninth century or earlier.

DINAS POWYS CASTLE This is an ancient site, with occupation though the Iron Age, Roman, and Dark Ages, and seems to have been the site of a prince's court in the times of Arthur. A timber castle was built in the eleventh century, but it is not known if it is of Welsh or Norman origin. The existing stone castle was probably built by the Normans in the early twelfth century.

DINEFWR, BATTLE OF In 1282, Llywelyn II's forces defeated an English army.

DINEFWR CASTLE In *The Chronicle of Ystrad Fflur*, in 1146 'Cadell ap Gruffydd overcame by force the castle of Dinefwr which Earl Gilbert had built. And soon after that he took the castles of Carmarthen and Llansteffan.' In a strong defensive position on a hill overlooking Llandeilo and the Tywi Valley, it became the main castle of The Lord Rhys of Deheubarth. In civil war between his sons Gruffydd, Maelgwn and Rhys Grug, the castle changed hands. Llywelyn the Great in 1216 forced the brothers to share Deheubarth under the sovereignty of Gwynedd, but in the meantime, the Marcher Lords had taken advantage and pushed further into Wales. Edward I took the castle, and it was later besieged by Glyndŵr after he had taken Carmarthen.

DINEFWR COUNTRY PARK – PARC GWLEDIG DINEFWR The gardens were said to have inspired Capability Brown, and they include a famous herd of ancient White Park Cattle. Newton House was built in 1660 and has been restored as an eighteenth-century manor house, and the remains of a large Roman garrison site have been discovered there.

DINGESTOW, BATTLE OF, 1182 In 1179, Ranulf de Poer, Sheriff of Abergafenni, assassinated Cadwallon and took Cymaron Castle, with the approval of Henry II. The castle lay on the river Aran, between Llanbister and Llangynllo in Radnorshire. It seems that Ranulf may have been 'the ogre of Abergafenni' instead of William de Braose. The Welsh later narrowly escaped killing de Poer at Abergafenni in an attack. In 1182 he began building the castle at Dingestow, and was attacked by Hywel ap Iorwerth and the 'men of Gwent', being killed along with nine of his knights. He was almost decapitated by a sword stroke, but a priest arrived just before his death to forgive him his sins. William de Braose was almost killed in the same battle, having fallen into a trench. Maelgwn and the other sons of Cadwallon, the prices of Maelienydd, immediately took over Dingestow castle, and also Cymaron and other Norman castles in Radnorshire to re-establish their territory. It was a disastrous defeat for the Normans, as a large part of Powys was regained by the Welsh as a result of this battle.

DINGESTOW CASTLE Outside Monmouth, it secured the way from Monmouth and Raglan into South Wales, guarding the crossing over the River Trothi. The later stone castle site is west of the church, and was destroyed by Hywel ap Iorwerth during its construction in 1182. He was avenging the murder in 1175 of Seisyllt ap Dyfnwal at Abergafenni Castle by William de Braose.

DINHAM (DINAN) CASTLE The neglected remains of the thirteenth-century castle of the Lords of Llanfair Discoed are just north of Caerwent. Unfortunately, many other sites in Wales are in a similar state of non-preservation.

DIN LLIGWY HUT GROUP This is a wonderful defensive complex of stone houses in a stone enclosure in Anglesey, with rows of iron-working hearths, and near a Neolithic cairn and a medieval church.

DISESTABLISHMENT OF THE CHURCH The Liberation Society was formed in 1844 with the objective of disestablishing the Anglican Church in Wales. By the 1860's all nonconformist churches, led by Thomas Gee and HENRY RICHARD were campaigning, and bills failed to get Parliamentary approval until 1914. After a delay caused by the Great War, the bill came into force in Wales in 1920. One of the outcomes of the campaigning was one of the longest words in the English language, antidisestablishmentarianism.

DOGS The ancient, crinkle-haired red and white Welsh Hound, which is still used by some Welsh hunts, may be descended from the foxhounds at the courts of the Welsh princes. A large hound, it has been known for over 1,000 years. Welsh dog breeds include the Corgi, beloved by the English Royal Family since George VI had one in 1936. This 'dwarf-dog' (from 'cor' plus the

mutated 'ci') was bred to be close to the ground, and nip the ankles of the cattle it was herding rather than leap up and bite their flanks. It is one of the oldest breeds in the world, dating from Neolithic times. The popular Pembrokeshire variety has hardly any tail. The much rarer Cardiganshire Corgi has legs so short that its stomach almost touches the ground, and a long tail. They were used by drovers to drive cattle to market. Other breeds include the Welsh Setter, the Sealyham, the red and white Welsh Springer Spaniel (a sporting dog with its own world-wide web site), the Welsh Terrier (used for fox-hunting in North Wales) and the Welsh Collie. The Welsh Terrier Club of America was founded in 1900, with an annual show competition for these black and tan dogs. A Welsh Terrier won the Champion of Champions accolade at Crufts in 1998. The Sealyham Terrier, a particularly snappy little dog, was bred to hunt otters near Haverfordwest in 1890 by Captain John Owen, and is increasingly rare. The Welsh Sheepdog has a red and white variety that is particularly attractive, and some have been brought back to Wales from Patagonia to strengthen the breed.

A Welsh Collie called Taffy lived for almost twenty-eight years, dying in 1980, so Wales in 1996 held the record for both Europe's oldest living man, dog and sheep. The typical Welsh sheepdog is probably a type of Border Collie – it wins sheep trials everywhere, is faithful, hardworking and to the Welsh, the best dog in the world. The annual sheepdog trials at Bala are the oldest established anywhere, first staged in 1873. The author has seen photographs of a beautiful Welsh sheepdog called the Blue Cambrian, but is unsure if the breed still exists. Arthur Hammett, a ninety-four year-old farmer in St Athan, Glamorgan, had a scraggy pale bluish-grey sheepdog he called a 'Welsh Blue', similar to the Blue Cambrian, but the breed now seems to be extinct. Although over 300 pedigree breeds are recognised across the world, each belongs to a distinct group bred for a purpose, and genetic testing has given us the oldest breed in each group. There are thus only 10 generic breeds from which all types of dog descend, of which two are Welsh. All designated breeds of 'terrier' descend from the Welsh Terrier, which existed prior to 1500. All 'herding' dogs (sheepdogs, collies etc.) descend from either the Canaan Dog of Israel (from 2,200 BCE) or the Welsh Corgi (from 1,500 BCE).

DOLAUCOTHI GOLD MINES These were mined extensively from the Iron Age and were possibly the main reason for the Romans coming to Britain. It is the author's belief that much Irish gold also came from raids upon Wales, rather than from gold deposits in Ireland. (A recent television documentary could not trace the provenance of Irish gold torcs to Irish mines, ignoring the fact that the Irish attacked Wales for hundreds of years). Dolaucothi was the only gold mine in Britain during the Roman occupation, and gold (along with silver) went by pack mule to be shipped to the Imperial Mint at Lyons. Over half a million tons of rock was shifted, and visitors can see Roman aqueducts and enter the mines on guided tours. The remnants of barracks and a bathhouse are on the site, and the Romans left here in 390 CE. Experts believe that most of the gold was stripped out before the Romans arrived.

DOLBADARN CASTLE Outside Llanberis, and above Llyn Padarn it is a Welsh castle built by Llywelyn the Great before 1230. Owain Goch, the younger brother of Llywelyn the Last was imprisoned here by Llywelyn for twenty years. Dafydd, another brother, tried to hold it in the 1282-83 war, but it was taken by the Earl of Pembroke in 1282. It appears that Glyndŵr took it and held prisoners like Reginald de Grey here.

DOLBENMAEN CASTLE Near Porthmadog, this was a royal seat until Llywelyn the Great moved his court to Cricieth.

DOLFORWYN CASTLE This was built between 1273 and 1277 by Llywelyn the Last, safeguarding his territory from the Norman lordship of Montgomery. Dinas Brân, another 'Welsh' castle, has a similar plan of layout. Edward I wrote to him in 1173 forbidding him to build it, but Llywelyn replied that he did not require the king's permission to build in his

own principality. Roger Mortimer besieged and took it in 1277, and razed the local settlement. Stone cannon balls at the castle probably date from its capture and the use of siege engines. In 1276, King Edward had sent three armies into Wales. One regained Powys from Gruffydd ap Gwenwynwyn, the Earl of Hereford took Brycheiniog., and Roger Mortimer took Cydewain, Ceri and Gwerthrynion. Mortimer founded a new settlement at nearby Newtown in 1279. The castle was in ruins by 1398.

DOLGELLAU The nearby Coed-y-Brenin (Wood of the King) goldmines were worked until the 1930's, with wedding rings for the Royal Family being made from its gold. Dolgellau may mean 'Meadow of the Slaves', denoting the slave labour that the Romans used in the mine. A popular resort for Snowdonia, a path leads to the top of Cader Idris. To the east is the highest road in England and Wales, 'Bwlch y Groes' (Pass of the Cross'), 1790 feet high.

DOLPHYN, COLYN (fl. 1450) This Breton pirate in 1449 captured Henry, son of Lord Stradling of St Donat's Castle. After his father paid a large ransom, Henry was released, but four years later he managed to lure Dolphyn onto the rocks, by a false light in a new watchtower he built at St Donat's. Stradling handed him over to the local people. The terrorised people of Llanilltud Fawr (Llantwit Major) were said to have buried the Breton up to his neck in nearby Tresilian Bay, and calmly watched as the incoming tide washed over the infamous villain. Dolphyn's effigy was burnt annually for many years at Llanilltud Fawr.

DOLWYDDELAN CASTLE Traditionally the birthplace of Llewelyn the Great, it covers two routes into Snowdonia, including the Vale of Conwy. Its capture, possibly through treachery, on 18 January 1283, enabled Edward I to end the Welsh campaign that had seen the murder of Llywelyn the Last in the previous year.

DOMEN LAS ROMAN FORT Now vanished, but a Norman fort was placed on its site, near Pennal. Glyndŵr is said to issued orders from the castle on his visit to Pennal Church in 1406.

DRISCOLL, 'PEERLESS' JIM (1880-1925) Driscoll became featherweight champion of the world in 1909. He lost only 3 out of 71 fights, and fought Abe Atell in America, the world featherweight champion, but Atell would only agree to it being a non-championship 10-round bout. Driscoll won all 10 rounds, Nat Fleisher commenting that in his opinion Driscoll was the now champion of the world. Driscoll was offered a return fight for the World Championship, but had promised the nuns of Nazareth House Orphanage in Cardiff to take part in their annual charity show, and returned to Wales. Driscoll next fought FREDDY WELSH in a bitter match and was disqualified and served in the Great War. He died in 1924, his funeral procession watched by 100,000 Welshmen, the largest funeral ever in Wales. The first 100 in the procession were 100 orphans from Nazareth House, whose nuns went on to tend Driscoll's grave for years. His exploits inspired Percy Jones from the Rhondda to win a world title.

DRUIDS Celtic social hierarchy was headed by the Druids, masters of ritual, legend and astronomy, with attendant poets, seers and warriors. The Druids were the link between the people and around 4,000 gods. Druids also appear to have acted as judges and doctors, receiving twenty years of oral instruction before they were admitted to the order. This priesthood practised a naturalistic religion, with focus on sacred groves and springs. The word 'druid' derives from an ancient word 'drus' meaning oak tree ('derw' is the Welsh for oak). The Roman Pliny recorded the rite where mistletoe was cut from the sacred oak tree with a golden sickle, in his *Natural History XIV*. Because mistletoe rarely grows on oaks, this obviously called for a special ceremonial occasion:

They choose groves of oak for the sake of the tree alone, and they never perform any sacred rite unless they have a branch of it. They think that everything that grows on it has been sent from heaven by the god himself. Mistletoe, however, is rarely found on the oak, and when it is, is gathered with a great deal of ceremony... if possible on the sixth day of the moon.

The most important place for British druids was a wooden shrine, or sacred grove, on the holy island of Anglesey, known to the Romans as Mona, and to the Welsh as Môn. This island seems to have been important across Europe as the holiest site for all Celts, and this is possibly why the Romans were so focused upon destroying it. Tacitus described the attack on this last stronghold in 60 CE: 'The enemy lined the shore in a dense armed mass. Among them were black-robed women with dishevelled hair like The Furies, brandishing torches. Close by stood Druids, raising their hands to heaven and screaming dreadful curses. This weird spectacle awed the Roman soldiers into a kind of paralysis. They stood still – and presented themselves as a target. But then they urged each other (and were urged by the general) not to fear a horde of fanatical women. Onwards pressed their standards, and they bore down their opponents, enveloping them in the flames of their own torches. Suetonius garrisoned the conquered island. The groves devoted to Mona's barbarous superstitions he demolished. For it was their religion to drench their altars in the blood of prisoners and consult their gods by means of human entrails.' (*Annals XIV, 30*)

The druids acted as arbiters in disputes, and had freedom to move anywhere, as they were sacred. As they represented the cohesive driving force behind Celtic power, the Romans knew that they had to destroy the order and its sacred shrines. Perhaps Roman literature was sensationalist propaganda – the divination by entrails scenario does not seem to fit with the druidic role of educating bards and minstrels. However, druidic laws forbade them to commit their knowledge to writing, so we mainly have Roman sources to rely upon. Julius Caesar made it evident that Gaelic Druids had massive political and judiciary power, officiating at sacrifices, teaching philosophy and religion, and settling all disputes. Only responsible to the Archdruid, they did not have to pay taxes or undertake military service. They instructed the children of the upper classes, so reinforcing their hold upon society. It also seems that they believed in reincarnation, the spirit passing to another life.

Julius Caesar reported the importance of British Druidism to their Celtic counter-parts across the continent of Europe – 'The druids officiate at the worship of the gods, regulate public and private sacrifices, and give rulings on all religious questions. Large numbers of young men flock to them for instruction, and they are held in great honour by the people. They act as judges in practically all disputes, whether between tribes or individuals; when any crime is committed, or a murder takes place, or a dispute arises about an inheritance or a boundary, it is they who adjudicate the matter and appoint the compensation to be paid and received by the parties concerned... All the druids are under one head, whom they hold in the highest respect...The Druidic doctrine is believed to have been found existing in Britain and thence imported into Gaul; even today those who want to make a profound study of it generally go to Britain for the purpose. The Druids are exempt from military service and do not pay taxes like other citizens. These important privileges are naturally attractive: many present themselves at their own accord to become students of druidism, and others are sent by their parents and relatives. It is said that these pupils have to memorise a great number of verses – so many, that some of them spend twenty years at their studies... A lesson they take particular pains to inculcate is that the soul does not perish, but after death passes from one body to another; they think that this is the best incentive to bravery, because it teaches men to disregard the terrors of death. They also hold long discussion about the heavenly bodies and their movements, the size of the universe and of the earth, the physical constitution of the world, and the power and properties of the gods; and they instruct the young men in all these subjects.' (in S.A. Handford's 1951 translation). Druids not only advised their kings and nobles, but also helped villagers with fortune-telling, and telling them the best time to plant crops. They placated the gods of nature by throwing valuables and

animals into wells and lakes. Many Celtic treasures have been found this way, and the custom of bending and throwing swords and daggers into water survived in Wales until the nineteenth century, when bent pins were still cast into holy wells. In 1868, in Cevennes in France, animals and valuables were still being offered up to a lake in an ancient Celtic festival.

DRYSLWYN CASTLE Overlooking the River Tywi and near Dinefwr Castle, it was possibly built by The Lord Rhys (d. 1197), but is first mentioned in 1246 in *Annales Cambriae*. A Welsh rather than Norman castle, RHYS AP MAREDUDD seems to have received the castle from the crown for his loyalty in the 1282-83 war, and he extensively rebuilt it. Rhys held out here in 1287 against the forces of Edward I, and escaped before its capture. It surrendered to Glyndŵr in 1403, and was later slighted by the English to prevent its use in any further war.

DUNRAVEN CASTLE The Welsh name was Dindryfan (triangular fortress) and on its headland is an Iron Age hillfort with hut sites and pillow mounds. This was claimed to be the principal residence of the ancient Princes of Siluria and of Brân ap Llyr and his son Caradoc ap Brân – also known as Caractacus. A nearby farm is called Cae Caradoc (Caradoc's field.) In the twelfth century, Arnold le Boteler (later Butler) received the land from Maurice de Londres and built the first stone building here. The rent was three golden chalices of wine, hence the name of the nearby Three Golden Cups pub. Ownership of the castle passed from the Butlers to the Vaughans and then the Wyndhams who rebuilt Dunraven Castle in 1803 as a castellated manor overlooking Southerndown beach. It was used as a convalescent home during the Second World War and in 1962 was dynamited by the absentee Earl of Dunraven to escape punitive taxes.

DUNRAVEN HILLFORT This cliff-edged promontory fort, with two giant ramparts, is one in a string along the Glamorgan coastline, including the Bulwarks near Porthceri and Summerhouses near Boverton. The headland upon which it stands, overlooking the beautiful beach at Southerndown, is Trwyn y Wrach (The Nose of the Witch).

DWYNWEN, SAINT – FIFTH-SIXTH CENTURY Feasted on 25 January, she was the youngest daughter of Brychan Brycheiniog, King of Brecon, and her name is remembered at Llanddwyn and Porthddwyn. Her day is the Welsh equivalent of St Valentine's Day, with Dwynwen cards being sold commercially. DAFYDD AP GWILYM called her 'beautiful as the tears of frost.' There is also a Cave of Dwynwen at Tresilian Cove in Glamorgan. St Dwynwen led a pure life after an unrequited love affair, at Llanddwyn Island near Newborough Warren, Anglesey. There are the remains of an abbey and some stone crosses commemorating the saint, and the well on the island was famous for telling whether lovers would stay faithful. The handkerchief of the faithful lover will float on the surface, while that of the faithless lover will be attacked by a sacred eel. Fresh wheaten bread must be cast in the well to wake the eel, before the handkerchief is spread on the surface of the water. The well is sometimes covered by high tides. The following description is by William Williams of Llandygai, from 1807: 'The place was much resorted to formerly and continued in repute to our days. There was a spring of clear Water, now choked up by the sands, at which an old woman from Newborough always attended and prognosticated the lover's success from the movement of some small eels which waved out of the sides of the well, on spreading a suitor's handkerchief on the surface of the water. I remember an old woman saying that when she was a girl, she consulted the woman of this well about her destiny with respect to her husband. On spreading her handkerchief, out popped an eel from the North side of the well: then the woman told her that her husband would be a stranger from the south part of Caernarvonshire. Sometime after it happened that three brothers came from that part and settled in the neighbourhood where the young woman was: one of whom made his addresses to her, and in a little time married her. This is the substance of the story as far as I remember it. This couple were my mother and father.'

DYER, JOHN (1699-1757) He wrote *Grongar Hill*, and Wordsworth addressed a sonnet to this 'Bard of the Fleece, whose skilful genius made/The work a living landscape fair and bright.' Dyer had given up law to become an itinerant painter, and *Grongar Hill* was inspired by the Tywi valley around his home at Aberglasney. He published *The Ruins of Rome* in 1750, and became ordained in 1751, publishing his longest work, *The Fleece* in 1757.

DYFNOG'S WELL, SAINT At Llanrhaeadr-yng-Nghinmeirch, this was one of the most renowned holy wells, able to cure skin diseases, dumbness, deafness and smallpox. In Georgian times, a marble 'bathing-tank' was installed, which can still be seen.

DYFRIG, SAINT (c. 465-c. 546) The son of Peibio and Eurddil, his first establishment was at Archenfield. According to Geoffrey of Monmouth there were 200 philosophers at his college in Caerleon. He was associated with Caerwent and seems to have been bishop of Llandaf, being succeeded there by St Illtud. As Bishop Dubricius, he was known as 'Dubric the High Saint, Chief of the Church in Britain.' St Dyfrig died on the Isle of Saints, Bardsey Island, and his remains were moved to Llandaf Cathedral in 1120 by Bishop Urban.

DYRHAM, BATTLE OF, 577 (DEORHAM) About 450, the Celtic King Vortigern was in the middle of internal strife in Britain, and asked the Saxons to come to his aid. They came and assisted him, but stayed, pushing Vortigern into what is now Wales. A fluctuating border between Celtic tribes and Saxons advancing from the West was solidified in the sixth century by two great battles at Dyrham and Chester. In 577 the three British/Celtic kings, Conmail, Condidan and Farinmail, were beaten at the Battle of Dyrham, forming a wedge between the Britons of the south-west of England and the rest of the British tribes. The south-west tribes were slowly pushed back westward and became the Cornish, with a similar language to those of Brittany and Wales. This defeat to the West Saxons, north of Bath, not only led to the Welsh being cut off from their countrymen in Domnonia (the West Country), but also enabled the Saxon push up into Wales through the Severn Valley and also into Somerset and Devon. Around this time the Saxons occupied Gloucester (Glevum), Cirencester (Corinium) and Bath (Aquae Sulis), expelling the Romano-British. It may be that the descendants of the kings of Pengwern (Shrewsbury) having been defeated by Saxons, moved to found another dynasty based upon Glastonbury, and the battle was between these forces and the Saxons. This may be why the battle is not recorded in the *Annales Cambriae*.

DYSERTH CASTLE After the death of Llywelyn the Great, Henry III began a castle building programme across Wales, strengthening Rhuddlan and Deganwy and beginning this castle near Rhuddlan in 1245. However, along with Deganwy, it was attacked by the Welsh in the year of its building, and was destroyed by Llywelyn the Last in 1263.

EAST ORCHARD (NORCHÊTE) CASTLE Two famous orchards at St Athan, constructed from 1377 to c.1400, were guarded by West Orchard Castle, now in ruins and said to have been sacked by Glyndŵr, and East Orchard Castle, overlooking the Thaw Valley. More of a fortified manor house than a castle, East Orchard was destroyed by Llywelyn Bren. There are the remains of a dovecote, chapel and substantial house, and it was the seat of the Berkerolles. A medieval pack bridge lies below it. Castleton Farm, across the Rills Valley from East Orchard, was also a small castle.

EBBW VALE Formerly a centre for steel and coal, it lies in the Ebbw Valley, and the steel and tinplate works used to stretch for two and a half miles. There is a monument to its great MP Aneurin Bevan, in his birthplace of Tredegar, just two miles away.

EDGCOTE, THE BATTLE OF, 1469 The Earl of Warwick and the Duke of Clarence started a rebellion against the Yorkist King Edward IV. William Herbert, Earl of Pembroke, led 10,000

Welshmen to join the Earl of Devon's 6,000 Yorkist troops at Banbury, but after an argument, the Earl of Devon withdrew his forces. The loyalist Welsh army skirmished with the larger Lancastrian rebel army of Sir John Conyers. Herbert then drew up his troops on high ground on Danes Moor, and waited for the Earl of Devon, with the main body of archers, to join him. When he saw that Devon was not going to arrive, he abandoned his position and charged into Conyer's army, aware that Clapham's army of another 6,000 Lancastrians was in the area. Just as the battle seemed to have been won, Clapham's men arrived on Herbert's left flank, and the hopelessly outnumbered and exhausted Welsh army fell back with 5,000 men being slaughtered. William Herbert and his brother Richard were summarily executed. Humphrey Stafford, Earl of Devon, never joined the battle but was captured and executed at Bridgwater a few weeks later.

EDGEHILL, BATTLE OF, 1642 Charles I left his Shrewsbury headquarters and travelled to Wrexham, calling for the men of Flint and Denbigh to rally to his banner. His nephew Prince Rupert joined him at Shrewsbury, with an army gathered from across North Wales. In the south, the Royalist Marquess of Hertford raised an army, and took Cardiff Castle from the Earl of Pembroke. Charles' army of 24,000 men was mainly composed of Welsh foot soldiers, ill-trained volunteers, while his officers and cavalry were mainly English gentlemen. The king's army marched on London, but were intercepted by the Earl of Essex at Edgehill in Warwickshire. Prince Rupert's cavalry successfully charged but were dispersed over a wide area, while the well-drilled Roundheads were giving the poorly-armed Welsh army severe punishment. At least 1,000 died on the field. This was the first, and inconclusive, battle of the English Civil War, which would have been won by Charles but for the indiscipline of his cavalry. Another 1,500 Welsh soldiers were killed at Tewkesbury, and 2,000 at Hereford later that year. At another battle, at Naseby, at least 100 Welsh women, camp followers of their husbands, were killed or had their noses slit by Parliamentarians after the Royalist defeat. The Roundheads believed they were spies as they could not speak English.

EDNYFED FYCHAN AP CYNWRIG (d. 1246) He fought against Ranulph de Blondeville, Fourth Earl of Chester, when King John sent an army to dispossess Llywelyn ap Gruffydd. The legend is that Ednyfed cut off the heads of three English lords in battle and carried them to Llywelyn, who commanded him to change his family coat of arms to three severed heads (similar to that of Brochwel the Fanged). In 1216, Edynfed became 'distain' (the Welsh equivalent of seneschal or chief minister) of Gwynedd, and was known as the Chief Justice, Lord of Cricieth and the Lord of Bryn Ffanigl. He helped negotiate the Peace of Worcester in 1218 and represented Llywelyn in a meeting with King Henry III in 1232. He may have been on a Crusade around 1235. On Llywelyn the Great's death in 1240, Ednyfed continued as seneschal in the service of Llywelyn's son, Dafydd ap Llywelyn, until his own death in 1246. One of Ednyfed's sons had been captured and executed by the English in the war of 1245. Ednyfed was buried in his own chapel, now Llandrillo Church, where his tombstone may be seen. Ednyfed was a descendant of Machudd ap Cynan (see FIFTEEN NOBLE TRIBES), and the ancestor of OWEN TUDOR and therefore the Tudor Dynasty. Two of his sons served as seneschals to Llywelyn II.

EDNYFED'S CASTLE Ednyfed Fychan was the chief advisor to Llywelyn the Great and it appears that his castle is a small motte near Bryn Euryn Iron Age and Dark Age fort. Llys Euryn is a deserted fifteenth-century mansion nearby, built for Robin ap Gruffydd Goch.

EDUCATION ROBERT RECORDE of Tenby (1510-1589), the son of Thomas Recorde of Tenby and Rose Jones of Machynlleth, went to All Souls College. His invention of the 'equals' sign (=) revolutionised algebra, and his mathematical works were translated and read all over Europe. Possibly the most learned Welshman was EDWARD LHUYD (1660-1709), from Glanfred, near Llandre (Llanfihangel Genau'r-glyn). The first noted taxonomist of zoology, he transformed Oxford's Ashmolean Museum, and also revised the 1695 edition of Camden's

Encyclopaedia Britannica. ROBERT OWEN founded the first infant school in Britain, in New Lanark, and Kurt Hahn (the founder of Gordonstoun and Salem schools) set up the first United World College in St Donat's Castle, on the Glamorgan coast. Jesus College, Oxford's first Protestant foundation, was founded in 1571 by Dr Hugh Price of Brecon, mainly for the needs of Welshmen, and its first Principal was Dr David Lewis from Abergavenny (died 1584). It became even more strongly identified with Welsh education after its re-endowment by Leoline (formerly Llewelyn) Jenkins of Cowbridge, Y Bontfaen, in 1685. Traditionally, the sons of the gentry were sent to England to study until the monastic school at Abergwili was removed to Christ College, Brecon, and was granted a royal licence in 1541. The reason given was that the 'people of Carmarthenshire knew no English'. Among the new Tudor Grammar Schools set up were those at Cowbridge, Margam, Ruthin, Caerleon, Bangor, Llanrwst, Presteigne, Carmarthen, Wrexham and Beaumaris, and 'they exercised a strong Anglicising influence'. Haberdashers School in Monmouth was also granted a licence to educate.

The religious revivals of the eighteenth century used BISHOP MORGAN's wonderfully pure Bible translation and kept the language alive. The dark side of Nonconformism was its hatred of enjoyment – dance, drink and association with the opposite sex. It altered the Welsh psyche from extrovert and carefree to a zealous and pious fear of God. However, all meetings were in Welsh, as were the group discussions that followed. There was a boom in religious books printed in Welsh. The 1846 Report told the English government what it wanted to know, that the Welsh were uncouth, illiterate peasants because of their language. The Report had the exact opposite effect of what was intended, in Wales. Welsh thrived, with evening educational classes being held after chapel and work on Sundays. Wales had a grammar school system that took the brightest working-class children, before England. Despite the official Welsh language restriction in schools, the Welsh people had saved enough money from their pathetic wages to build the University of Wales at Aberystwyth in 1871. GRIFFITH JONES had started the 'circulating schools' around 1737, giving the Welsh opportunities for literacy – by the time he died in 1757, it was estimated that 160,000 people had learned to read, out of an estimated population of 480,000 (in 1750). This percentage of literate Welsh people was probably higher than any other European nation of the time, despite the grinding poverty. The Miners' Institutes of the nineteenth century assisted this literacy, with their wonderful library collections. One has been shifted, stone by stone, to the Museum of Welsh Life at St Ffagan's. The major contribution that Griffith Jones made was to save the life of the Welsh language – he taught the nation to read, and imbued it with a sound knowledge of Bishop Morgan's wonderful Welsh translation of the Bible. Teaching was the traditional route away from the mines and steelworks for many Welsh children – not the traditions of engineering or medicine of the Scot. David Rhys Davies (1835-1928) features in *The Guinness Book of Records*, for having taught as a pupil teacher, teacher and finally headmaster for a total of seventy-six years in Wales.

EDWARDS, GARETH OWEN (1947-) There is a case for any of the side of the 'Golden Age' of Welsh rugby to be included in this book, but Gareth Edwards is probably the most famous. In 1996 *Rugby World* polled 200 coaches, managers, players and writers across the globe, and Edwards was voted the 'greatest rugby player of all time'. Also in the top ten were Gerald Davies, Barry John and J.P.R. Williams, all members of the same 'golden' team of the 1960's-1970's. A similar poll in 1999 had the same result, over twenty years after his last match. From Gwaen-cae-Gurwen, he captained Wales 13 times, and also won 3 'Grand Slams', 4 Triple Crowns and 5 International Championships, playing in all the tests on the successful British Lions tours of New Zealand in 1971 and South Africa in 1974. He won 10 Lions caps. He told the author recently 'You had to win for Wales. You couldn't go home otherwise.' In his first Triple Crown win against England, Wales scored 7 tries, a drop goal, 3 conversions and 2 penalties against 3 penalties. With today's scoring of 5 points for a try instead of 3, Wales would have won 50-9.

The last game of the invincible All-Blacks tour in January 1973 saw Wales come up against, and be beaten by, the Barbarians. Wales should have beaten them, but Andy Haden and Frank

Oliver cheated a line-out penalty to scrape home by 3 penalties (9 points) to 2 unconverted tries (8 points). They had practised the move in the dressing room before the match, as recounted in his biography by their captain Graham Mourie, as Wales was the only team they feared. At the end of that tour, Welshmen made up the bulk of the Baa-Baas team and were determined not to let 'the cheats' return home unbeaten. The Baa-Baas won 23-11 in a scintillating performance, with Welshmen magically carving out the possibly the most famous try in history from under their own posts, despite the New Zealander Bryan Williams trying to decapitate J.P.R. Williams. CLIFF MORGAN was the commentator: 'Kirkpatrick to Williams. This is great stuff. Phil Bennett covering, chased by Alistair Scown. Brilliant, oh that's brilliant. (Bennett had jinked under his own posts to avoid the onrushing All-Blacks). John Williams, Bryan Williams (flinging his arm across J.P.R.'s throat, but the referee played advantage), Pullin, John Dawes, great dummy, David, the halfway line. Brilliant by Quinnell, this is Gareth Edwards, a dramatic start, what a score! Oh that fellow Edwards.' Edwards had been left well back by the speed of the move, at the very beginning of the match, having just chased back to try to help Bennett out of trouble. He saw the situation developing, and chased the game. Quinnell's pass was intended for Welshman John Bevan on the wing, who could have been bundled into touch, but Edwards intercepted it on the burst and just made it to the line, praying that his hamstrings would hold up. The sole Englishman in the move was John Pullin, the six Welshmen being Bennett, John (JPR) Williams, Dawes, Tommy David, Derek Quinnell and Edwards.

EISTEDDFODAU Eisteddfodau is the plural of Eisteddfod. There are traditions of an eisteddfod at Ystum Llwydiarth held by Taliesin in 517, of one under Maelgwn Gwynedd on the banks of the Conwy River in 540, and of 'Y Bardd Glas' held by Geraint in the ninth century, when 'cynghanedd' was established as a verse component. However, the first authenticated eisteddfod was held in Cardigan Castle by The Lord Rhys, in 1176. The present form of eisteddfod is an early nineteenth-century recreation, thanks to Iolo Morgannwg. The medieval 'meeting of the bards' called the Eisteddfod was revived, as a means of attracting patronage for Welsh cultural activity. At first competitions were confined to the traditional poetry composition (the strict Welsh form known as cynghanedd) and harp playing, but today choirs, bands, acting, recitation, fiction writing and painting can also be included. The 1176 date gives Wales the right to claim the oldest European festival, one with both poetic and political overtones.

Thomas Pennant described the eisteddfod of Lord Rhys: 'In 1176, the Lord Rhys, prince of South Wales, made a great feast at Christmas, on account of the finishing of his new castle at Aberteifi (Cardigan), of which he proclaimed notice through all Britain a year and a day before; great was the resort of strangers, who were nobly entertained, so that none departed unsatisfied. Among deeds of arms, and variety of spectacles, Rhys invited all the bards of Wales, and provided chairs for them, which were placed in his hall, where they sat and disputed and sang, to show their skill in their respective faculties: after which he bestowed great rewards and rich gifts on the victors. The bards of North Wales won the prizes; but the minstrels of Rhys's household excelled in their faculty. On this occasion the Brawdwr Llys, or judge of the court, an officer fifth in rank, declared aloud the victor, and received from the bard, for his fee, a mighty drinking-horn, made of the horn of an ox, a golden ring, and the cushion on which he sat in his chair of dignity.' Among the rivals for the bardic crown were Owain Cyfeiliog, Prince of Powys, and Hywel ap Owain Gwynedd, whose poems survive today. Hywel's more famous brother was Prince Madoc, the legendary discoverer of America.

The most important of the early eisteddfodau was at Carmarthen in 1451, where men from Flint won all three main prizes, for poetry, singing and the harp. It was here that Dafydd ap Edmwnd first laid down the rules for 'strict metres' of poetry. Henry VIII commissioned eisteddfodau, as did Elizabeth I – the Tudors remembered their Welsh roots. Queen Elizabeth 1, knowledgeable of her Tudor-Welsh heritage, had made the Eisteddfod into a test for bards, to sort out the real poets from the rest. At the 1568 Eisteddfod commissioned by Elizabeth, the prizes were small silver models – a harp for the harpist, a crwth for the fiddler, a chair for the poet and a tongue

for the best singer. The 6in high harp has survived in the possession of the Mostyn family. The Owain Glyndŵr Hotel in Corwen was originally a monastery, then a coaching inn, dating from at least 1329. There are claims that here was held the first Eisteddfod to which the general public were admitted, in 1789. More information would be welcome on this story. Sloping floors and ancient beams make this a wonderful stop for a few nights (and a few beers).

In 1858, the Llangollen Eisteddfod, the first 'modern' eisteddfod, lasted four days, and it was the first to which crowds were brought in excursion trains. *The Telegraph* reported the Eisteddfod as 'a national debauch of sentimentality', and *The Times* called it 'simply foolish interference with the natural progress of civilisation and prosperity – it is a monstrous folly to encourage the Welsh in a loving fondness for their old language.' This was at the time when children heard speaking Welsh in school were being beaten, and forced to wear the 'Welsh Not', so organisation and participation in the event was extremely courageous. To celebrate poetry, literacy and past achievement was 'uncivilised', according to the London press. There are many eisteddfodau in Wales, from schools to villages, one of the largest and best being at Pontrhydfendigaid in mid-May. A remarkable event happened in 1957, when Paul Robeson, the black American singer and champion of human rights, had been invited to attend the Welsh Miners' Eisteddfod. He was denied his passport because of the Communist witch-hunt of Senator Joe McCarthy, so a telephone link-up was made and recorded. The record opens with a message from the miners' president, the late Will Paynter, and is followed by a reply by Robeson, who then sings several songs and ends his performance with a message to the eisteddfod. The Treorchy Male Voice Choir then sings *Y Delyn Aur* and the link-up ends with the audience singing *We'll Keep A Welcome*. This historic recording was on sale at the 1996 Miner's Eisteddfod at Bridgend, and the story shows the Welsh attitude to right-wing extremism. It may well be that Wales is the only country whose national festival is devoted solely to the arts – another first for culture in this old country. However, late in the nineteenth century *The Times* wrote in response to a polite letter by Matthew Arnold: 'An Eisteddfod is one of the most mischievous and selfish pieces of sentimentalism which could possibly be perpetrated... Not only the energy and power, but the intelligence and music of Europe have come mainly from Teutonic sources... The sooner all Welsh specialities disappear from the face of the Earth the better.' (Quoted in A.L Rowse *Matthew Arnold as Cornishman*, in '*The Welsh Review*' 1945).

ELAN VALLEY The nine-mile long Elan Valley lake lands were the first of Mid-Wales reservoirs, built between 1892 and 1903 to supply Birmingham and the English midlands, over seventy miles away. The lakes form the basis of a 45,000 acre estate of open mountains, rivers and woodlands.

ELEN LLUYDDOG – FOURTH CENTURY Feasted on 22 May and 25 August, this daughter of Eudaf of Ewyas is also known as *Elen of the Hosts* and as *Helen of Caernarfon*. She is the Celtic Patron Saint of Travellers, predating St Christopher. She married Magnus Clemens Maximus (Macsen Wledig) and went with him when he led his British legions to become Emperor of Gaul, Britain and Spain from 383. She returned to Wales after his death with her sons, two of whom, Cystennin and Peblig, became saints.

ELFAEL, BATTLE OF, 1179 & THE MORTIMERS During 1173 and 1174 Hugh Mortimer's son Roger was prominent in crushing the Henry the Young King's rebellion in England and Wales. Henry the Young King was co-regent with his father Henry II, but pre-deceased him. However Mortimer fell foul of the king on 22 September 1179 when he murdered the Welsh King Cadwallon ap Madog in the neighbouring principality of Elfael. Cadwallon's court poet, Cynddelw, recorded the Cadwallon's death in Elfael writing:

...Taken today! Tis this that maddens me –
For his distracting loss I smart with pain.
Defending Elfael, when, in Autumn, he
Drenched with his blood his country's gory soil,

None greeted him with deferential gift;
They came to greet him, but they spared him not;
Fell back each coward then, till he was slain,
Rushed on each hero then, till he was felt;
Head over heels the stumbling chieftains fell,
While kin from kin sought succour every one.
While lived the country's high-escorted king,
Of gain and wealth they found the daily use,
High-trotting steeds, tall flanked and grey were theirs
A wolf was he, the root of manly strength,
In fight his valiant sword-strokes, wolf-like, fell...
His lance has memories of mourning left,
And crimson gashes oozing out with gore.
The fiery prince has left behind him sons,
Themselves would leave blood-tricklings from their foes.
Three whelps of leaders bold to thrust the spear,
In fray of lances eager eagles three.
Privy to conflicts three, and sword-cuts dire...
Three native hawks, high-famed, of purest breed,
Stout youths, who wash their cheeks from stain of war.
Since now, by stroke of battle-axe cut down,
Our princely lion-monarch is laid low...

After Roger Mortimer's men had killed Cadwallon with a battle-axe, Henry moved against him for his murder of a royal client. Roger was arrested while his men were hunted down, either being forced into outlawry, or if captured executed. Roger Mortimer spent the next two years incarcerated in Winchester castle. Mortimer was released after the disastrous battle of Dingestow in 1182, and returned to Wigmore. In 1195 Roger Mortimer led the royal sponsored invasion of Rhwng Gwy a Hafren (the region between the Wye and the Severn) and rebuilt Cymaron Castle, only to be defeated by Prince Rhys ap Gruffydd the next year at the Battle of Radnor.

ELIOT, GEORGE (1819-1880) Mary Ann Evans, daughter of a Welsh land agent, was 'George Eliot', who *wrote Adam Bede, The Mill on the Floss, Silas Marner, Daniel Deronda* and the towering masterpiece *Middlemarch*. She was first published with a male name, as it was highly unlikely that any publisher would accept a woman writer. Her work was full of intense compassionate intelligence, and she made a major contribution to the development of the novel. With the publication of *Daniel Deronda*, she was named 'the greatest living English novelist', and D.H. Lawrence credits her with being the first person to put real action and narrative into novels.

ELISEG'S PILLAR Near Llangollen, it was raised in the early 800's and at one time was over 20ft high. It probably gives its name to Valle Crucis (the Valley of the Cross) Abbey, and the skeleton of a very tall man was found there. It was raised by Cyngen, the last independent King of Powys, in memory of his great-grandfather King Eliseg, who 'recovered the land from the English with fire and sword.' Eliseg is claimed as a direct descendant of King Vortigern (Gwrtheyrn), who was blessed by St Germanus, and of the Emperor Magnus Maximum (Macsen Wledig). Eliseg seems to be a mistake for Elise by the carver, and the dots indicate lost words in the inscription when it was copied by Edward Lhuyd in the 1690's – he referred to it as Guinevere's Cross:

† Concenn son of Catell, Catell son of Brochmail, Brochmail son of Eliseg, Eliseg son of Guoillauc.
† And that Concenn, great-grandson of Eliseg, erected this stone for his great-grandfather Eliseg.

† The same Eliseg, who joined together the inheritance of Powys... throughout nine (years?) out of the power of the Angles with his sword and with fire.

† Whosoever shall read this hand-inscribed stone, let him give a blessing on the soul of Eliseg.

† This is that Concenn who captured with his hand eleven hundred acres which used to belong to his kingdom of Powys... and which... the mountain (the column is broken here and lines lost).

... the monarchy... Maximus... of Britain... Concenn, Pascent, Maun, Annan.

† Britu son of Vortigern, whom Germanus blessed, and whom Sevira bore to him, daughter of Maximus the king, who killed the king of the Romans.

† Conmarch painted this writing at the request of king Concenn.

† The blessing of the Lord be upon Concenn and upon his entire household, and upon the entire region of Powys until the Day of Judgement.

ELIZABETH TUDOR, QUEEN (1533-1603) The Virgin Queen is accepted as England's greatest monarch, who oversaw the flowering of culture and England developing an empire. The granddaughter of Henry Tudor, Henry VII, her forty-five-year reign, the 'Elizabethan Age' was possibly the most glorious in England's history. There were persistent rumours that Sir Francis Bacon was the illegitimate offspring of a union with the Earl of Leicester. Any marriage would have destabilised the realm, and by the time she was secure from internal and external enemies, she was too old to bear children. Elizabeth I was called a 'red-haired Welsh harridan' by the English historian A.L. Rowse, and under her rule, thirteen of the sixteen bishops appointed to Welsh sees were Welsh – the exact opposite of Norman-Plantagenet policy. Under her, Welshmen at court flourished. There are traditions that she stayed at Bodidris Hall with Leicester, and had a child at nearby World's End.

ELLIS, T.E. (1859-1899) Tom Ellis went to Bala Grammar School and became a leader of CYMRU FYDD. Shortly after leaving Oxford University, he became Liberal MP for Merionethshire in 1888. The Liberal Party was favoured by the Welsh for its support of Nonconformism. Becoming an unofficial spokesman for Welsh matters, he called in 1890 for a separate Welsh legislative assembly. Co-operating with Lloyd George in the cause of Welsh independence, he played a prominent role for the disestablishment of the Anglican Church in Wales.

ELVIS, SAINT The author's *The Book of Welsh Saints* attracted world-wide media attention because of the entry on St Ailbe, leading to articles, letters, and TV and radio publicity from Japan to Australia. 'Elvis was Welsh' was a popular headline. There was the expected academic scorn, but the hypothesis brought far more international publicity to Wales that the Welsh Tourist Board with its dismal multi-million pound campaigns of lonely backpackers – 'the Marlboro Man' approach to wasting the taxpayers' money. The bare facts are that the Welsh Saint Ailbe (d. 527-531) was also known as Ailfyw, Elfyw, Elouis, Elfeis, Eiliw and Elvis, and was feasted upon 12 and 13 September and 27 February. Danhadlwen (Banhadlen) was the sister of Non (St David's mother). The daughter of Cynyr of Caer Gawch and Anna ferch Vortimer, she married Dirdan of Brittany. Their son was Ailbe, who became one of the greatest figures in the Irish Church. Ailbe was the cousin of David, and other cousins included the saints Cybi and Sadyrnin. One source states that, as St Eloius, he was confessor and bishop at Menevia, the diocese including Pembrokeshire. He evangelised southern Ireland, founding the see of Imlech (Emly in Tipperary). A church near St David's, called Llanailfyw or St Elfeis, was dedicated to him. St Elvis Farm and the remains of St Elvis Church and monastery are on this site in Pembroke near the Preseli Hills. Baring-Gould states that Ailbe 'is known in Wales as Ailfyw or Elfyw, who founded a church now a ruin, called St Elvis, in Welsh Llanailfyw, or Llanelfyw, near St David's, consequently near where lived his aunt, St Non.' St Elvis remained in Menevia until David was born, and according to Welsh tradition baptised and fostered him, before going

to Ireland to evangelise. A farmhouse nearby is now a private house and was named Vagwr Eilw (Elvis' Enclosure, mutated from 'Magwyr'). There is an ambiguous *Saying of the Wise* that seems to propose the tolerance and understanding of homosexuality:

Hast thou heard the saying of Elvyw,
A man wise without a peer?
"Let every sex go to where it belongs".

St Elvis Parish is the smallest in Great Britain, and the title Rector of St Elvis was superior to that of the incumbent of the nearby vicar of St Teilo's in Solva. The name St Elvis has appeared on maps since at least the sixteenth century. On the site are the 5,000 year-old St Elvis Cromlech, a huge burial chamber with two tombs, and a few yards away the foundations of a square tower, possibly a lookout post or storage barn for the monks on this site. The remains of the church and monastery are large, and unusually situated north-south, covered with blackthorn. Following down the valley, there is St Elvis Holy Well, which was still pumping out 360 gallons an hour during the great 1976 drought, and had to be used to water the cattle at that time. This holy well is near St Elvis Farm, where a barn was built in the early twentieth century from the dressed stones of St Elvis Church. The last marriages took place in St Elvis Church in the 1860's and are recorded in the Haverfordwest Archives. The site, where the Preseli Hills sweep down to the sea, is just two fields inland, but well hidden from Irish and Viking pirates. St Elvis Rocks, off the mouth of the picturesque Solva Harbour, are now known as Green Scar, Black Scar and The Mare. The name 'Elvis' as a place-name is only found here in all of Europe.

Two very important ley lines meet here, one going to Stonehenge, and the site is littered with graves. The farmer has said that often in building sheds etc., he has seen 'chalk-marks' in the soil, which when touched powder into dust, i.e. ancient bones. The holy well was not recorded by Francis Jones, but local tradition is that St David was baptised by his cousin St Elvis on this site, with water from the well, in the font at St Elvis Church. This font is now in St Teilo's in Solva. St David's Cathedral is just a few miles away. A cross-marked sixth-century pillar, formerly a gatepost, was taken to St Teilo's Church, but its partner post was 'lost' in 1959. Even more intriguing, and of massive historical importance, is a square stone, with the simple face of a man carved into it. It is thought that National Trust employees used it to repair a field-bank. There are extremely few Dark Age facial representations among the ancient stones of Wales, and a non-intrusive survey may well find it. It was formerly in the centre of the ruined church and had holes bored into its top and bottom as sockets to allow it to act as a door, perhaps to a relic, which may make it unique. There is no record of this stone except in the memory of the farmer and his son who own the land, which is why it is being recorded here. As regards Mr Presley, his maternal side derived through seven generations of Mansells, a well-known Welsh surname. The first Presley who settled in America was a David (a Welsh name) Presley, and through the Presleys we have Elvis' father Vernon Elvis Presley (two Welsh Christian names and possibly a corruption of Preseli). His mother was Gladys Love Smith, whose mother was a Mansell and she has the Welsh saint's Christian name of Gladys. Elvis' dead twin brother was Jesse Garon – Garon is a Welsh name, deriving from St Caron. Elvis Aron Presley has the Christian names of two Welsh saints. Thus all his nuclear family unusually have Welsh Christian names, two of which, Elvis and Garon are extremely rare. Regardless of the Elvis Presley provenance, the sixth-century site of the cromlech, ruined monastery and holy well at St Elvis is symptomatic of hundreds of others across Wales. It is unknown and uncared for, whereas in other countries it would be a place of education, tourism and pilgrimage.

EMBLEMS Upon St David's Day, 1 March, the daffodil or leek is worn by Welsh people everywhere to announce their Welshness. They are also prominent during Eisteddfodau and at rugby internationals, especially massive homemade leeks. According to the Wales Tourist Board: 'On the evidence of Shakespeare, the leek was the recognised emblem of his day, and there is written evidence that it became the Welsh emblem considerably earlier. Entries in the

household accounts of the Tudor kings include payments for leeks worn by the household guards on St David's Day. According to one legend, the leek is linked to St David because he ordered his soldiers to wear them on their helmets when they fought a victorious battle against the pagan Saxons in a field full of leeks. It was more likely, however, that the leek was linked with the vegan St David and adopted as a national symbol because of its importance to the national diet in days of old, particularly in Lent.' St David's own emblem is a dove, and his increasingly popular flag is a gold cross on a black background. The leek is a 'cennin', and the daffodil a 'cennin Pedr' or Peter's leek. Perhaps people took 'pedr' to be interchangeable in the past, because the daffodil became an emblem after the leek, but it is difficult to attribute the reason for its adoption as a symbol. Some put it down to St David being a vegetarian, who ate leeks, or that leeks were a staple item in the Welsh diet. The Welsh crest of three white feathers and the motto 'Ich Dien' were adopted by the Black Prince at the Battle of Creçy, copied from the decorations of the blind King of Bohemia, who died in a cavalry charge which was wiped out by Welsh archers. The crest has been that of the Prince of Wales since the fourteenth century, and is on the Welsh international rugby shirt.

Although the flags of the princes of Gwynedd were red and gold dragons, it seems that their soldiers wore green and white, as an 'englyn' of Llywelyn I's time states that 'There is a host in Rhosfair, there is drinking, there are golden bells. There is my lord Llywelyn and tall warriors follow him; a thousand, a host in green and white.' Green and white may come from the colours of the leek, and these are also the colours which the Black Prince's Welsh troops wore at Crecy in 1346, a hundred years after Llywelyn. D.L. Evans commented that they were 'the first troops to appear on a continental battlefield in national uniform'. Henry Tudor, Earl of Richmond, placed his red dragon on a field of green and white when he marched to Bosworth Field to found the Tudor dynasty.

EMERGENCE OF INDEPENDENT WALES 400-1070 From the leaving of the legions and the refusal of Rome to assist in fighting off barbarian invasions, Britain came under the control of High King (Vortigern), a Romano-Welsh noble. He tried to pit invaders against each other, and seems to have invited Cunedda from Scotland to Gwynedd to repel the incursions of the Irish. He also allowed the Saxons to establish themselves to beat off the Picts. However, by the 490's the Saxons were establishing their own kingdoms across Britain, pushing the native Britons into the West Country, Cumbria, Strathclyde and Wales. Recent DNA sampling has proved that there was either mass displacement, or extermination, of the Britons left in what is now England. By the battles of Dyrham (577) and Chester (616), Wales (Cymru) was cut off from its kinsmen (cymbrogi) and the nation of Wales effectively dates from this period, becoming the rump of what was the British nation, still speaking the British language. There had been constant attacks from the Saxons, Danes, Picts and Scots, forcing alliances among native Welsh princes to prevent their permanence in Wales. Around 780 Offa's Dyke was built, formalising the border between the Saxons and Wales. Rhodri Mawr of Gwynedd (d. 877) consolidated the nation to fight off the Vikings, but these Danes managed to over-run England, which became a Danish kingdom. Hywel Dda (d. 950), the grandson of Rhodri, further helped define the nation of Wales. Gruffydd ap Cynan controlled almost all of Wales, but was killed in 1063, being hunted by the Saxons of Harold, Earl of Wessex, who himself died at Hastings in 1066. From then on the battle to keep British Wales as an independent nation was against the French-Normans.

EMIGRATION Possibly the best example of the hold that Wales has on its people is the rate of emigration in the nineteenth century. Twenty-six times as high a proportion emigrated from Ireland, due mainly to the terrible Potato Famine, but also the proportion was four times greater from England and seven times as many from Scotland. Most Welsh leave only as far as England to work, and then a very substantial proportion return, many to retire. 140,000 jobs disappeared from South Wales mining between 1921 and 1936, and Welshmen had to traverse the world to feed their families, but many returned. The feeling of *'Hiraeth'* is wonderfully summed up by R.J.

Barker in his 1936 *'Christ in the Valley of Unemployment:* 'I preached at Nanticoke, a Pennsylvanian mining town, and three parts of the congregation were made up of Welsh men and women who had heard me preach in South Wales in the previous seven or eight years. I went to see one old miner, a native of the Rhondda. He had lost his sight as a result of working in the mine... I can still see that pathetic figure standing at his door as I went down the road after bidding him farewell. His last words to me were "Weep not for the dead! Weep for the living, who will never see their native land again."...'

ENTERTAINERS Music and poetry are the mainsprings of Welsh entertainment, from the days of the bards and travelling harpists through to male voice choirs and more recently poets and rock groups. In Welsh legend, the inventor of vocal music was said to be Gwyddon Ganhebon. Carlo Rizzi, Musical Director of the Welsh National Opera, believes with George Bernard Shaw that 'the Welsh are the Italians in the rain'. He feels like that because 'when the Welsh are making music they give back to a flow of emotions which are rare to find in other places'. The Welsh National Symphony Orchestra has an international reputation, and Cardiff annually hosts the fabulous *Singer of the World* competition, giving up-and-coming opera singers from across the globe their chance for international recognition. Dame Adelina Patti, the internationally famous nineteenth-century opera singer was the highest paid entertainer in the world. Her home, Craig-y-Nos Castle is a huge 'sham' castle with its own theatre and a beautiful ornamental park on the River Tawe. It is being renovated by a group led by the soprano, Dame Gwyneth Jones. Among the galaxy of other leading international opera singers are Geraint Evans, Rebecca Evans, Start Burrows, Dennis O'Neill, Della Jones, Anne Evans, Jason Howard, Margaret Price, Anne Williams-King and Bryn Terfel. The latter, a bass-baritone, gave an unforgettable appearance singing *Rule Britannia* at *The Last Night of The Proms* in the Royal Albert Hall. Festooned in Welsh colours and flags, and clutching a huge red dragon, he sang a verse in Welsh, and is destined to be one of the lasting greats of international music. Margaret Price, born in 1941, started her career with the Welsh National Opera, and has appeared at Covent Garden, La Scala, and the Paris Opera. Now settled in Munich, she often performs with the Bavarian State Opera.

Alun Hoddinott of Bargoed and William Mathias of Whitland have been leading classical composers in modern Europe. Ralph Vaughan Williams is called an 'English' composer in every encyclopaedia, but is of Welsh stock. Moving on to popular music, Ivor Davies of Cardiff, Ivor Novello (1893-1951), not only wrote songs, but was an actor-manager, taking the romantic lead in his musicals such as *Glamorous Night* (1925), *The Dancing Years* (1939), and *Gay's The Word* (1951). He also wrote the operettas *Careless Rapture* and *King's Rhapsody*. He was the leading British silent movie star and a matinee idol through the 1920's. Novello's songs have survived as classics of musical theatre. Thomas Jones Woodward ('Tom Jones'), from Treforest, signed the largest contract in British television in 1968, receiving an estimated £9,000,000 for eighty-five shows spread over five years. *It's Not Unusual* and *What's New Pussycat* were probably his best-known hits. Shirley Bassey, from Cardiff, is another internationally renowned singer, perhaps best known for the James Bond film themes *Goldfinger, Moonraker* and *Diamonds are Forever*. Both Bassey and Jones are 'transatlantic' entertainers of international fame. Other entertainers include the singer Dorothy Squires, plus the old music-hall star from Cardiff, 'Two-Ton' Tessie O'Shea, Rolf Harris (the Australian all-rounder with Cardiff parents), the former 'Goon' Harry Secombe and comedians Griff Rhys-Jones, Paul Whitehouse, Lee Evans and the unforgettable Tommy Cooper. It is also thought that the brilliant Harold Clayton Lloyd, the American film comedian who died in 1971, had Welsh parentage.

EPYNT (EPPYNT) Driving from Brecon via Upper Chapel to Builth, one passes through these marvellous uplands, now closed off to the public and used for military training. Fifty-four mainly Welsh-speaking families were forced off their hill farms forever in 1940 by compulsory purchase.

ERDDIG CASTLE In the park of the later mansion, this motte and bailey occupies a strong position on a steep-sided promontory, overlooking the junction of two streams. Its ramparts are adapted from a prehistoric hillfort, and incorporate a section of Wat's Dyke. It was originally called 'the Castle of Wrexham' when it was built around 1090, at a time when the Normans expected to be easily able to push into Wales.

ERDDIG HALL Near Wrecsam, it is a fine seventeenth-century mansion in 1,900 acres, restored by the National Trust to show what life was like on a wealthy landowner's estate, 300 years ago.

ETHNIC CLEANSING Dr Mark Thomas and a team at University College, London, studied Englishmen from towns mentioned in the Domesday Book of 1086. They discovered their genes were almost identical with those of people in the Netherlands, where Anglo-Saxon invasions are thought to have originated. (The Y-chromosome is passed down from father to son). The genetic similarity ends at Offa's Dyke, with Welshmen being similar to Celtic Iberians. Dr Thomas stated 'It appears England is made up of an ethnic cleansing event from people coming across from the continent after the Romans left.' This may be the reason why so few remains of the Welsh language are found in English place-names or the English language. The original British were pushed into Wales, and the genetic barrier of Offa's Dyke exists to this day.

EURGAIN, SAINT – FIRST – SECOND CENTURY This 'virgin foundress of Wales' has a feast date of 30 June, and as one of Caradog's daughters in Rome, brought Christianity back to Wales, founding Cor-Eurgain, Caer Worgan at Llanilltud Fawr. The monastery was burnt in 322 by Irish pirates and rebuilt as Cor Tewdws. Caer Worgan was a few hundred yards north of Cor Tewdws (which is still marked on old maps), so may be the huge fifteen-room Roman villa site at Caer Mead. There is evidence of forty-one Christian burials in the Dark Ages on this site, possibly following a recorded attack by Goidels, Irish pagans.

EVANS, WILLIAM JOHN 'BILL' (1929-1980) & JAZZ PIANISTS His father Harry Evans emigrated to Philadelphia, and Bill was born in New Jersey, becoming probably the greatest jazz pianist of the 1960's and 1970's. Extremely influential, his intense style of playing can be seen in numerous You-Tube videos. He developed impressionistic and modal harmony. Another superb jazz pianist was Cardiff's Alec Templeton (1909-1963). Blind from birth, he moved to the USA in 1936, having his own radio and TV shows, and his compositions were recorded by such illuminati as Benny Goodman. Dillwyn Owen Paton 'Dill' Jones was born in Newcastle Emlyn in 1923, and emigrated to the USA in 1961 to be able to play with jazz greats such as Gene Krupa. Also a prolific composer, Dill Jones died of throat cancer in New York in 1984 and was admitted posthumously to the Gorsedd of Bards, cited as 'one of the leading jazz pianists in the world'.

EVANS, CARADOG (1878-1945) Born David Evans, from Llanfihangel-yr-Arth, he wrote short stories exposing the greed and hypocrisy of chapel-going West Walians. He was vilified for his play *Taffy* which hit out at the narrowness of nonconformist bigots.

EVANS, CATHERINE ALICE (1881-1975) Born in Neath, Pennsylvania (a strongly Welsh settlement), she was a noted microbiologist. Her research into bacterial contamination of milk led to the recognition of the dangers of unpasteurised milk. Until her research was published in 1918, brucellosis in humans and cattle was thought of as two different diseases. She was thereby responsible for the introduction of pasteurised milk. Human undulant fever, and Malta fever, caused by unpasteurised milk, were endemic across the world, being misdiagnosed in the USA as influenza, typhoid, malaria and other diseases, and had killed millions. She was told by her sceptical bosses and colleagues (all men) to stop her research, but carried on in secret, and her findings were initially greeted with scepticism. Both cattle and human diseases were now classified as brucellosis, from which she herself suffered for twenty years, the result of her experimentation. In 1928, for this and

for other work, she was made the first female President of the Society of American Bacteriologists.

EVANS, GERAINT, CBE (1922-1992) From Cilfynydd, he developed into what the New York Times described as 'a great actor in the British tradition, as well as a great singer in the Italian one.' A superb baritone, the Milanese watching him at La Scala thought he was a Sicilian because of his pure Italian diction. A perfectionist and admired by his colleagues, he appeared on all the world's great opera stages for forty years.

EVANS, GWYNFOR (1912–1990) Born in Barri, he was President of Plaid Cymru – The Party of Wales, for thirty-six years (1945-1981) until his death. A pacifist Christian and trained solicitor, he was the first Plaid Cymru MP to be elected, with a stunning victory at Carmarthen in 1966. He had campaigned strongly to save TRYWERIN from its dam in 1963, and the loss of the 100% Welsh-speaking community of Capel Celyn. Evans threatened to go on hunger strike in 1980 if Margaret Thatcher did not agree to the Welsh-language TV channel that she had promised. He foresaw that the survival of the language now depended upon television, a lesson only now being learned in Eire. While demonstrations and graffiti erupted all over Wales, Gwynfor had a 'last photograph' taken with his family. The government caved in and made funds available for Welsh-language television broadcasting. S4C (Sianel Pedwar Cymraeg), has its Welsh commentaries upon rugby matches, football matches, its own news reports and programming and its own 'soap', *Pobol y Cwm (People of the Valley)*. This was the first 'daily soap' series on television in Europe, and helped Evans achieve his aim of bringing the Welsh language back into people's homes. Evans followed in Saunders Lewis's pacifist traditions of Plaid Cymru, refusing to serve in World War Two, which earned him opprobrium in his home town of Barri. His father, who owned the department store Dan Evans, bought Gwynfor a farm in Carmarthen, so he had an occupation which did not require him to subvert his principles of non-violence.

EVANS, JOHN (1770-1799) 'The man who opened up America' was from Waunfawr in Gwynedd. In 1792 he explored the Missouri Valley for the first time, looking for Prince MADOC's Mandan Indians. The Welshman's maps were later sent by the Welsh-American Thomas JEFFERSON to aid the LEWIS and Clark Expedition, enabling it to find a route to the Pacific. His maps were also used by Jefferson to effect the *Louisiana Purchase*. The Spanish, who had been ceded Louisiana by the French, used Evans for the expedition to find the Mandans as they thought he could speak their language, and could convince them to become part of the Spanish Empire. The plan was to drive Spanish possessions up from Mexico and Louisiana and take over the central plains of America and then the Pacific Coast, before the Americans did. Evans entered the service of Spain and Jacques Clamorgan and reached the Mandans, enduring a terrible winter with them, and held the Mandans for Spain against the Canadians, thus helping to fix the current American-Canadian border. Evans travelled 1,800 miles in sixty-eight days, returning and dying in mysterious circumstances in New Orleans, possibly being killed, after saying tersely that there were no Welsh people between the latitudes of thirty and forty. However, it may be that he was told to say this, as a Welsh/British presence from 1170 in America would solidify England's claim to the Americas. Spain wished to have a legitimate claim to America, and for the British to have been there since 1170 would have not been helpful. A Welshman later claimed that Evans never returned to Philadelphia (the Welsh centre in America) as 'he had lied about the Indians'. A postscript to this letter of 1803, written just four years after his death, states that Evans 'when heavily in strong liquor bragged to his friends in St Louis that the Welsh Indians would keep their secret to their graves because he had been handsomely paid to keep quiet on the subject. He added that in a few more years there would be no more trace of any Welsh ancestry or language as time and disease would eventually remove all traces.'

EVANS, OLIVER (1755-1859) With Welsh parents, he was born in Newport, Delaware, becoming an engineer who developed high-pressure steam engines and machines powered by them. Joining a flourmill owned by his two brothers, he built machines using water power to drive conveyors and escalators. By his work, one operator could control all the mill's processes,

making Evans a pioneer of production-line techniques. Moving on to Philadelphia, he built over fifty stationary steam engines, and invented a steam dredger that could move on both land and water.

EVANS, WILLIAM DAVIES (1792-1872) From St Dogmael's, he was captain of a postal packet steamer when he invented, in 1924, the chess game opening known universally as *The Evans Gambit*. He also was the inventor of the tri-coloured light for shipping. Research into the Evans Gambit, spearheaded by World Champion Garry Kasparov, has shown that (1) Black has no clear path to equality, and (2) the practical problems facing Black are such that the *Evans* is now a fully viable weapon in the hands of today's Grandmasters. The basic intention behind the move is to give up a white pawn in order to secure a strong centre and bear down on Black's weak point, with a series of aggressive hammer blows. The Evans gambit has been played for over a hundred years, and it has not been refuted yet. The opening has been successfully played by Morphy, Chigorin, Fischer, Kasparov, Timman, Shirov, Short and Morozevich.

EVEREST, SIR GEORGE (1790-1866) Mount Everest was so named in 1865 after Sir George Everest of Gwernvale near Crickhowell, the former Surveyor-General of India. His name was pronounced to rhyme with 'cleave-rest'. Before Everest started mapping 'the Great Indian Arc of the Meridian' (in the *Great Trigonometrical Survey of India*), it was thought that Tenerife had the world's tallest mountain, and that the Himalayas were active volcanoes. One of Everest's measuring instruments, 'the Great Theodolite' weighed half a ton and needed two teams of twelve porters working in relays to transport it through jungles and over mountains. A 30ft stand had to be used for another instrument. It was so susceptible to vibration that survey members had to squat motionless while measurements were taken.

EWENNI PRIORY Under two miles from Bridgend, its walls cover five acres and it is one of the finest examples of a Norman defensive church, with impressive walls and a 1300 gatehouse. It was founded in 1141 by Maurice de Londres as a cell of the Benedictine abbey of Gloucester. In 2008, eighteen burials dating from the fourth century were found in the Priory, indicating its antiquity as a holy site before the Normans.

EWLOE CASTLE Outside Hawarden, Llywelyn the Last captured it in 1257 and rebuilt it, according to the Chester Plea Rolls of 1311. He had reconquered the surrounding district of Tegeingl (northern Flintshire) and 'built a castle in the corner of the wood' only eight miles from the Norman stronghold of Chester. A decade later, the English formally recognised Llywelyn as ruler of all Wales. The so-called 'Welsh Tower' may have been built in 1210 by Llywelyn the Great. In the remaining woodland of the great Forest of Ewloe, this D-shaped keep is typical of many Welsh castles such as Castell-y-Bere. It is the oldest surviving stone castle in the Welsh northern borderlands, and the most complete and unaltered of all the Welsh-built castles.

EXPLORERS There is a remarkable quartet of Welshmen who flourished around the end of the sixteenth century. The almost unknown Martin Llewellyn (*c.*1565-1634) was the first British cartographer, who spent his last thirty-five years as the steward of St Bart's Hospital. Only in 1975 were rediscovered the sixteen charts drawn by Llewellyn, covering the area from the Far East, including New Guinea and Japan, to the Cape of Good Hope. The charts are over fifty years earlier than any other known British map-maker, and each are around 3ft by 2ft, in black ink and four colours. It appears that he was a survivor of the two-year trading expedition from 1597-1599 by the Dutch Cornelis de Houtman, and Llewellyn's son stated that the maps were 'drawn in his own hand and according to his own observations'. The Oriental volume of his *The English Pilot*, thought to be the first English chart of the eastern seas, was not published until a century later. From 1612-1613, Sir Thomas Button (1577-1634) of Dyffryn House, near Cardiff, led an expedition looking for Henry Hudson. In his attempts to discover a North-West Passage to

Asia, he explored Hudson Bay, where Button Island is named after him, and is called 'The First White Man in Manitoba'. Button proved that there was no elusive 'North-West' Passage from Hudson Bay to the Pacific Ocean. He named New Wales, Nelson River and Button's Bay. He later suppressed Irish pirates attacking British shipping. Admiral Sir Robert Mansell (1573-1656) of Margam also explored north-west routes to Asia, and Mansell Island is named after him. A close friend of James I, he led an expedition against the corsairs of Algeria in 1620, releasing forty English merchant captains. His days as Treasurer of the Navy (1604-1618) were notable mainly for the increase in his private fortune. Mansell also ran a famous glassware shop in London, and is known for the quote:

An optimist is one who makes opportunities of his difficulties;
A pessimist is one who makes difficulties of his opportunities.

In 1631-32, Thomas James (c.1593-1635) of Abergavenny charted Hudson Bay, again searching for the elusive passage, and James Bay recalls his efforts. He also named Cape Henrietta Maria and wintered at Charlton Island exploring the coast. A 1633 account of his voyage has been suggested (along with Captain Shelvocke's 1719 voyage) as the inspiration for *The Rime of the Ancient Mariner*. Sir William Edward Parry (1790-1855) was in command of five expeditions to the Arctic. In 1818 he volunteered for the Ross Arctic expedition, and commanded the *Alexander*. He took the *Hecla* to search for the North-West Passage in 1819, and in 1821-23 spent another two seasons in the Arctic, in the *Fury*. He took the *Fury* and *Hecla* to the Arctic again in 1823-25. In his last expedition in the *Hecla*, he tried to reach the North Pole on sledges from Spitzbergen in 1827, reaching further North than anyone had done before. Only unexpected ice conditions prevented his success, decades before the Pole was reached. He became a rear admiral and Hydrographer of the Navy. His grandson Sir John Franklin Parry (1863-1926) also became an admiral, and Navy Hydrographer and surveyed the coasts of Borneo and China. In 1909, Sir T.W.E. David of Saint Ffagans led the Shackleton Antarctic Expedition's team, the first to locate and reach the magnetic South Pole, just 100 miles from the true South Pole. One of Captain Scott's ill-fated team to die with him was Petty-Officer Edgar Evans from Rhossili, Gower, where there is an evocative memorial. Dr Dafydd Rhys Williams, whose family comes from Bargoed, sent Welsh messages to the BBC television programme *Wales Today* in April 1998. On the space shuttle *Columbia*, he also took a Welsh flag and Gareth Edwards' 50th rugby international cap, which orbited the earth at twenty-five times the speed of sound.

FALKIRK, BATTLE OF, 1298 William Wallace was defeated owing to the destructive power of the Welsh archers in Edward I's army. They had argued with English troops on the way north, and King Edward killed eighty of them, prompting a threat to desert to Wallace's men. 10,500 of Edward's 12,500 infantrymen were Welsh, and the battle was the first that proved the superiority of the longbow, the speciality of the men of Glamorgan and Gwent. 10,000 Scots were killed, mainly by the murderous volleys of arrows. In the battle, Robert the Bruce took his army away from the field, possibly because a deal with Edward had been made. Wallace's fate was thus sealed by the treachery of a later Scottish hero. (The 'Scottish' Bruce changed sides several times, and had a Norman father and a Welsh mother). Wallace was known as 'Wallensis', the Welshman, as his part of Scotland, Strathclyde, was still referred to as the home of the Welsh in Scotland, and referred to by Scottish kings as their 'Welsh subjects,' still speaking the British language. Many Welshmen were fighting for Edward as Wales had been desolated during the War of Llywelyn the Last, and it was their only source of income and survival.

FALKLANDS WAR Only two Victoria Crosses were won in the Falklands Campaign. Welshman Colonel Herbert ('H') Jones (1940-1982), commanding 2 Para, won one posthumously in 1982, having led his troops to capture an Argentine machine-gun emplacement.

FARR, TOMMY (1914-1986) Born in the Rhondda he worked in the pits, but from the age of twelve, on leaving school, also made money in the boxing booths. In a sequence of eighteen undefeated fights as a professional, he beat two former World Light-Heavyweight Champions and Max Baer, the former World Heavyweight Champion. In 1937, as British and Empire Champion, he fought the great Joe Louis, for the World Heavyweight Championship. Aged only twenty-three, in New York, Farr took the fight in every round to Louis, willed on by hundreds of thousands in Wales listening to radios. He lost on points, but many of the 36,000 American crowd disputed the decision, booing for five minutes after the result was announced, and he became a celebrity in America. He served in the War and retired from boxing, but because of money problems returned to fight in 1950. He had not fought for eleven years but gained the British Championship. In 1953, aged almost thirty-nine, Farr fought Don Cockell for the British Heavyweight Championship. He was stopped in the seventh round, but took the microphone after the result was announced, and sang the Welsh National Anthem.

FASHIONS There is a movement to wear the modern Welsh cilt, a development of the 'brycan'. The brycan was a length of hard-wearing wool, two yards by six, which served as the Celt's dress by day and blanket by night. When hunting or in active pursuits, the brycan was belted at the waist to kilt (tuck) up the folds – the resulting skirt falling to the knees was the kilt in its embryonic form. In February, 1961, Kenfig Hill Rugby Club announced that they would adopt the cilt for social occasions, and it is becoming popular wear for weddings. Welsh costume, with the tall 'stove-pipe' hat for women, is an adaptation of eighteenth- century peasant dress. Traditional colours of women's woollen shawls and skirts varied between areas, but were usually a mixture of black, brown, white and red. The colour depending on the availability of local dyes. Men wore plain woollen breeches and waistcoats, with heavy black shoes. Llanuwchllyn, near Bala, was the last place where the national costume, of tall beaver hat and a scarlet cloak, was regularly worn by ladies going to market and religious services. William Coxe, in his 1801 *An Historical Tour in Monmouthshire*, tells us of a typical scene in Pontypool market – ' It was a pleasing amusement to mix in these crowded meetings, to observe the frank and simple manners of the hardy mountaineers, and endeavour, in asking the price of their provisions, to extort a Saxon word from this British progeny. The women were mostly wrapped in long cloth coats of a dark blue or brown colour; all of them wore mob caps neatly plaited over their forehead and ears, and tied above the chin; several had also round felt hats like those worn by the men, or large chip hats covered with black silk, and fastened under the chin. This head-dress gives an arch and lively air to the younger part of the sex, and is not unbecoming.'

There is a clog-maker in the Welsh National Folk Museum at St Ffagans. Itinerant clog-sole makers used to roam the sycamore woods in Wales, sending soles in vast numbers to the clog factories of Northern England. In Wales, each village once had its clog-maker, shaping the thick wooden soles and cutting the leather uppers to make long-lasting footwear for the villagers. LAURA ASHLEY was Welsh and her British factory was at Carno, Powys. However, now all the fashionable garments in her international chain of shops are manufactured outside the UK, in the Far East, and the company is foreign-owned. David and Elizabeth Emmanuel, the designers of Lady Diana Spencer's wedding dress were Welsh, as was MARY QUANT, who changed the face of world-wide fashion with her 1960's mini-skirts. Tommy Nutter was another famous Welsh designer of men's suits and shirts in the 1960's through to his death in 1992. Jeff Banks, the designer, is from Glamorgan. Julien MacDonald from Merthyr claims he is a 'style dictator', was spotted by Karl Lagerfeld and was British Designer of the Year in 2001.

FEAST DAYS OF THE EARLY SAINTS These are some of the most important of the saints known to have been feasted across Wales. There are over 900 saints from the Age of Saints detailed in the author's *'The Book of Welsh Saints'* and *'The Welsh Almanac'*:

Date	Saint	Also known as	Flourished
Jan 1	Medwyn	Medwin	C7th
Jan 13	Elian	Eilian	C6th
Jan 15	Lleudadd	lLeudad	C6th
Jan 23	Ellyw	Elli	C6th
Jan 25	Dwynwen	(*Wales' Valentine*)	c. 460
Jan 29	Gildas	Badonicus	c. 500-c. 570
Jan 31	Aidan	Madog, Maidoc, Aidus	C6th
Jan 31	Melangell		Died c. 590
Feb 1	Ffraid	Brigid	c.450-c. 525
Feb 3 (Feb 1)	Abbot Seiriol		C6th
Feb 9	Bishop Teilo		died 580
Feb 13	Dyfnog		C7th
Mar 1	Bishop Dewi	David, *Patron Saint of Wales*	c. 520-588
Mar 3	Abbot Gwynno		
Mar 5 (Mar 2)	Non	Dewi's mother	C5th-C6th
Mar 17	Patrick, Padrig	*Patron Saint of Ireland*	
Mar 27	King Gwynlliw	Woolo	died c.500
Apr 5	Derfel	Derfel Gadarn	C6th
Apr 7	Abbot Brynach		C5th-C6th
Apr 15	Bishop Padarn	Paternus	C5th-C6th
Apr 20 or 21	Abbot Beuno		died 642
Apr 27	Cynidir	Enoder	C6th
May 1	Briog	Brieuc (Britanny), Briavael, Brioc	C5th
May 5	Bishop Asaff	Asaph	C5th-C6th
May 16	Carannog		C5th
May 21	Collen		C7th
May 28	Abbess Melangell		
Jun 4	Pedrog		C6th
Jun 16	Curig	Kirik (Brittany)	fl550
Jun 20	Arfan	Aaron	exec. c.305
Jun 20	Julius		exec. c.305
Jun 20	Govan		C6th
Jul 2	Bishop Euddogwy	Oudoceus	died c.615
Jul 3	Abbot Peblig	Publicius	C5th
Jul 17	Cynllo		Fl.550
Jul 28	Bishop Samson		c.490-c.565
Aug 23 and Dec 5	Stinan	Justinian	C6th
Aug 23	Tudful	Tydfil	Died c. 480
Sep 7	Abbot Dunawd	Donat	C6th
Sep 11	Bishop Deiniol		C6th
Sep 21	Mabon		C6th
Sep 25 and Jan 24	Catwg	Cadoc, Cadog, form of Cadfael	c. 497-c.577
Oct 8	Cain	Keyne	C5th-C6th
Oct 9	Abbot Cynog		
Nov 1	Aelhaern	Elhaearn	C7th
Nov 1	Cadfan		C5th-C6th
Nov 3	Clydog Ruler of Ewyas, (Herefordshire), Welsh until 1536		
Fl.500,			martyred
Nov 3	Abbess Gwenfrewi	Winifrede	C7th
Nov 5 (6,7,8)	Abbot Cybi		C6th

Nov 6	Abbot Illtud		C5th-C6th
Nov 12	Abbot Tysilio		C7th
Nov 14	Bishop Dyfrig	Dubricius, Dyfan	Fl.475
Nov 15	Bishop Malo	Maclovius	died c. 640
Nov 22	Bishop Paulinus	Pol (Brittany)	died c. 505
Nov 27 (and 7)	Cyngar		C6th
Dec 12 (Feb 23)	Ffinian		C6th
Dec 8	Bishop Cynidr		C6th
Dec 26 (Dec 30)	Bishop Tathan	Tatheus	C5th

FESTIVALS AND SHOWS For details of over fifty arts festivals, from jazz to classical music, children's events or drama, please write to 'Festivals of Wales', Red House, Newtown SY16 3LE, or telephone 01686 626442.

Cwlwm Celtaidd, *The Celtic Festival of Wales* at Porthcawl, with dozens of international acts – see cwlwmceltaidd.com, the weekend nearest St David's Day, 1 March;

Hay Festival of Literature – usually in the last week of May/early June, this attracts top writers to the Book Capital of Europe;

Cricieth Festival in mid-June, featuring Celtic music, art and theatre;

Gregynog Festival – a week at the end of June, music with major performers at Gregynog Hall near Newtown;

Cardiff Singer of the World competition is a massive, week-long televised festival of music and song, with international opera singers and potential stars;

Royal Welsh Agricultural Show – at Builth Wells around the third week in July, a memorable experience;

Llangollen International Music Eisteddfod, is the second week in July – see Eisteddfod entry;

Gwyl Werin y Cnapan – A massively popular Celtic music and folk festival, second weekend in July, in Ffostrasol near Newcastle Emlyn. Unlike the National Eisteddfod, it has a beer tent;

Cardiff Street Festival, last week in July, first week in August – includes the Butetown Carnival and a party/rock concert down Cardiff Bay;

Vale of Glamorgan Festival – for a week in early August, modern classical music;

Royal National Eisteddfod – first week in August – see Eisteddfod entry;

Brecon Jazz – early August, attracts major talents from all over the world to one of Europe's major music events – there are financial problems in 2009;

Pontardawe Music Festival – in late August, with ceilidhs, folk music and traditional dancing;

Llandrindod Wells Victorian Festival – a week towards the end of August, where everyone dresses in Victorian costume and we return to the life of a century ago;

Machynlleth Festival – around the same time as Llandrindod Wells – a mainly classical and chamber music event, with a "pop" fringe and guided walks;

Excalibur Celtic Festival, in Swansea and the Gower area, including sports competitions and music events, in the first two weeks in September;

Cardiff Festival – late September, early October. This is one of the UK's largest themed festivals, with music, the arts, drama, literature and opera events;

Swansea Festival of Music and Arts – similar to Cardiff's festival, in October. The 50th anniversary took place over three weeks in October 1998;

Llanwrtyd Wells runs all sorts of festivals, including Drovers' Runs;

New Quay on the Dyfed coast has a marvellous New Year's Eve Festival, where nearly everyone in the town dresses in fancy dress to usher in the New Year, dancing in the streets after pub-crawling the evening away.

FIFTEEN TRIBES OF WALES Also called the *Royal and Noble Tribes of Wales*, these families were said to have inherited their importance from pre-Roman times. It seems that they governed

areas of Wales before the development of Gwynedd, Powys and Deheubarth as Princedoms. Whether there were fifteen nobles tribes of which five were 'royal', or fifteen noble tribes and five distinct royal tribes is a matter of debate. Other British tribes existed outside Wales, in Lothian, Dumbarton, Rheged and Dumnonia for instance, but the following are generally accepted as the Welsh tribes:

The Five Royal Tribes:

House of Cunedda Wledig of Gododdin, who became the traditional rulers of Gwynedd, and through Merfyn Frych founded the Houses of Aberffraw, Mathrafal and Dinefwr;

House of Gwerthyrnion – the descendants of the marriage of Vortigern and Sereva, the daughter of Emperor Macsen Wledig – Magnus Maximus;

House of Dyfed – possibly from the Celtic tribe of the Demetae;

House of Morgannwg – possibly from the Celtic Silures;

House of Gwent – believed to come from the hereditary Magistrates of Gloucester, the descendants of the sons of Caradog/Caractacus.

The Fifteen Noble Tribes. These are descended from:

Hwfa (Awfa) ap Cynddelw of Presaddfed, Anglesey, Lord of Llysllifon, steward to Owain Gwynedd;

Llywarch ap Bran, Lord of Cwmmwd Menai, who lived at Porthamel Uchaf, Anglesey around 1137. His wife was a daughter of Gronw ap Owain ap Edwin of Tegeingl, and was the sister of the queen of Owain Gwynedd. Llywarch was, like Hwfa, steward to Owain Gwynedd;

Gweirydd ap Rhys Goch – his house dates from the beginning of the twelfth century and he lived at Talybdion, Anglesey, being an ancestor of the Wynn Family of Bodewryd, Anglesey;

Cilmin Troed-du (the black foot) *c.*830, the son of Cadrod ap Gwiriad, who was the brother of Merfyn Frych, from whom the Salusbury family claimed descent;

Collwyn ap Tango, Lord of Eifionydd, Ardudwy and part of the Llŷn;

Nefydd Hardd (the handsome) of Nant Conwy, but who also lived at Crygnant, Llanrwst. Bishop William Morgan (1545-1604), translator of the Bible into Welsh, was descended from this line;

Maelog Crwm (the hunchback), Lord of Llech Wedd Isaf & Creuddyn, Caernarfonshire, *c.* 1175, said to be a descendant of Helig ap Glannawg;

Marchudd ap Cynan, Lord of Abergele resided at Bryn Ffanigle *c.* 846. He was an ancestor of Ednyfed Fychan and Henry Tudor;

Hedd Molwynog, Lord of Llanfair Talhaiarn, Dyffryn Elwy and Nant Aled, who lived at Is Dullas and Uwch Aled, Denbighshire in the last half of the twelfth century;

Braint Hir, Lord of Is Dullas, who lived *c.* 850;

Marchweithian, Lord of Isaled in Denbighshire was an ancestor of Rhys Fawr ap Maredudd, the standard bearer of Henry Tudor at Bosworth Field in 1485;

Edwin ap Gronwy, Lord of Tegeingl. His mother was Ethelfrida, the daughter of Edwin, Earl of Mercia, a descendant of Alfred the Great. Edwin married Ewerydd, the sister of Bleddyn Prince of Powys. Their three sons were Owain, Uchdryd & Hywel. Edwin was killed in 1073 and buried at Northop;

Ednywain Bendew (the strong-skulled) lived at Llys-y-Coed, Cilcain, Flintshire;

Efnydd Gwerngwy, Lord of the VII townships in Dyffryn Clwyd, the father in law of Maredudd ap Bleddyn, Prince of Powys and an ancestor of Owain Glyndŵr;

Ednowain ap Bradwen, Lord of Tal-y-Bont and possibly Meirionydd.

FISHGUARD, INVASION OF, 1797 The last invasion of British soil was a Franco-Irish force at Carreg Wastad Point, near Fishguard. A forty-seven year old cobbler, Jemima Nicholas (*c.* 1750-1832, 'The Welsh Heroine') single-handedly captured fourteen French soldiers. The French surrendered in The Royal Oak Inn in the centre of Fishguard, which still retains mementoes of the time. In recognition of Jemima's bravery, the government awarded her a handsome pension of £50 a year, which she drew until her death aged eighty-two. In Harri Webb's *Women of Fishguard,* the final verse reads:

I'll make the proclamation
Though conqueror I am,
You can conquer all creation
But you'll never conquer MAM.

When the first of four French warships was spotted from the now-ruined fort overlooking Fishguard Bay, a single shot was fired from one of the cannons that still are in position. The fort only had three live rounds, so it fired a blank, but the shot persuaded the captains to withdraw to Carreg Wastad, a steep headland. There disembarked the 1,400 strong 'Legion Noire', 'The Black Legion', mainly made up of convicts. Captain Thomas Knox, the English commander of the part-time local militia, The Fishguard Fencibles, was attending a ball at Tregwynt, just six miles away, when he heard of the landing. He, with all the guests, took to their horses and carriages and set off in haste for the relative safety of Haverfordwest. The drunken French invaders looted their way inland, desecrating Llanwnda Church. At Bristgarn Farm, a grandfather clock still has bullet holes in it, made by a Frenchman when he was startled by the clock's sudden chiming. Lord Cawdor's defensive force was outnumbered three to one, but accepted the surrender of the invaders at the Royal Oak Inn, in Fishguard. It is said that the French had misjudged the strength of the defending forces as they mistook Welsh women in their red cloaks and tall black hats as 'Redcoat' soldiers. Fishguard is the only Battle Honour earned on British soil, awarded in 1853 to The Pembrokeshire Yeomanry in recognition of the defeat of the French Landing. The most interesting and long-lasting effect of this invasion was the run it caused on the Bank of England. Investors panicked and wanted to recover their gold sovereigns from the Bank, which was forced, for the first time, to issue paper bank notes, to the value of £1 and £2. It seems symbolic that the printing of all the UK's money is now carried out in Wales at The Royal Mint in Llantrisant.

FLAG – THE OLDEST NATIONAL FLAG IN THE WORLD The Welsh national flag is not featured on the Union Flag (Union Jack) of the United Kingdom, which superimposes the blue and white saltire of St Andrew, and the red and white crosses of St Patrick and St George. The British flag thus features representation from Northern Ireland, England, and Scotland, but none from Wales. The Welsh Flag consists of two horizontal stripes, white over green, with a large red dragon passant. Green and white are the traditional Welsh colours, worn by the Welsh bowmen at the Battle of Creçy. The Red Dragon, one of the most ancient badges in the world, was brought to Britain by the Romans, who had copied it from the Parthians, and it was later used by both British and Saxon kings. Traditionally it was King Arthur's flag, and it was definitely the standard of Cadwaladr, from whom the Tudors were descended. Owain Glyndŵr adopted the red dragon of Cadwaladr as his standard and the national flag of Wales. The word 'draig' or dragon was used in Welsh poetry to symbolise a warrior or leader. Pendragon, as in Uther Pendragon, meant a head, or chief, leader. A legend dates from the eighth century about a fight between a Red Dragon ('Y Ddraig Goch') representing Wales and a White Dragon representing England, foretelling the triumph of the red dragon. The red dragon of the Celts was the Welsh flag and symbol against the Saxons for 600 years after the Romans left Britain.

The White Dragon of the Saxons was last seen in battle against the Normans at Hastings in 1066. 'Y Ddraig Goch', 'the red dragon', was widely accepted as the oldest flag in the world at the International Conference of Flag Makers in South Africa in 1987, according to the President of the Flag Institute. Flagmaker Robin Ashburner made the point before the year 2000 that it is the only flag to have remained unchanged in the last 1,000 years – 'the Welsh will be the only people to enter the next millennium with the same flag as they entered the current one'. (Denmark also claims the oldest flag, dating from 1219, but the 'father of flag science', or vexillology, Dr Whitney Smith of Massachusetts, supports the Welsh flag. The dragon came from China via the Romans, and when the Western Roman Empire was set up, the dragon symbol was used by the local chiefs in Britain. It was the Welsh symbol long before Offa built the dyke between the Saxon and Welsh

kingdoms. The Welshman Henry Tudor invaded England, through Wales, to end the Wars of the Roses. With the 'Red Dragon of Cadwaladr' as his standard, his smaller army defeated and killed the last Plantagenet King Richard III, at Bosworth Field. Henry used as his livery colours green and white, and on these colours his retainers painted the red dragon. When Henry became Henry VII of England in 1485, he decreed that from henceforth the Red Dragon should be the official flag of Wales. Henry even set up the official herald's position of Rouge Dragon Pursuivant to protect the flag. For a time the Dragon coexisted on the English Crown's royal crest with the Lion, but was replaced by the Unicorn of the Scottish Stuarts on the accession of James I in 1603. Thus neither the Welsh flag nor the Welsh emblems of daffodil and leek appear in a united British context.

There does not seem to be a Red Rose of Lancashire during the Wars of the Roses, and the White Rose of Yorkshire was one of Edward IV's badges. It seems to have been Henry Tudor's idea to amalgamate the two colours, red for Wales and white for England into the Tudor Rose when he ended the wars and married Elizabeth of York. Henry VII balanced his Greyhound emblem of the Duke of Richmond and Lancaster, against the Red Dragon of Wales and Cadwaladr on the Tudor royal arms. To him the dragon showed his 'Trojan' descent and gave his kingship a legitimacy distinct from the houses of Lancaster and York. Henry VIII and Edward VI had a red dragon on their shield, but Mary and Elizabeth had a gold dragon, and James I on his accession in 1603 substituted the unicorn for the dragon. The Four Lions Royal Standard of Wales derives from the four lions passive, in red and gold quarters, of Llewelyn II of Gwynedd. It was adopted by Owain Glyndŵr but with the four lions rampant, to symbolise that Wales would no longer be passive against English sovereignty. Owain Glyndŵr's personal flag was the golden dragon, 'baner y ddraig aur', on a red background, which he raised on Twt Hill outside Caernarfon on 2 November 1401. The Flag of St David, a gold cross on a black background, is gaining in popularity across Wales, much like the black and white stripes of the Finistere flag are becoming more prevalent in the Breton-speaking part of north-west France. Nothing more illustrates the ignorance of politicians than the wish of the South African Peter Hain, when Secretary of State for Wales, to 'rebrand' Wales by altering the oldest flag in the world. He stated 'Wales is about the Manic Street Preachers and Catatonia rather than women in shawls, leeks, daffodils and rain-sodden valleys... The dragon is very prickly-looking and old-fashioned. Wales lacks self-confidence and this process will help us address that.' The Welsh Office's favoured device to replace the dragon at the time was the Red Kite. Hain later had to resign his ministerial office after a funding scandal in an attempt for self-advancement in a bid to become Deputy Leader of the Labour Party. It is both absurd and sad when a South African and his coterie of sycophantic civil servants attempt to alter the oldest flag in the world, name-checking a couple of rock groups in order to achieve some sort of 'street credibility'. Welsh people have massive pride in their flag. Writing this, I have just returned from the sad funeral of my best friend, who died unexpectedly in Brittany in May 2009. He was cremated in Quimper with the Welsh flag over his coffin and the Welsh National Anthem being played.

FLAT HOLM (YNYS ECHNI) In the Bristol Channel, Flat Holm is a Welsh island, used by Viking raiders and as a cholera hospital in the past. From Lavernock Point on the nearby mainland, was transmitted the first conversation heard by radio waves. Marconi had stationed his assistant, George Kemp, on Flat Holm three miles away. The first words were, unsurprisingly, 'Are you ready?' The eighth biggest Welsh island, it measures ninety-five acres, and daily boat trips run from Cardiff, subject to weather conditions. It is a SSSI, like thirteen other Welsh islands. Steep Holm (Ynys Ronech), the near neighbour to Flat Holm, is English, and it was said that the knights who murdered St Thomas a Becket fled there to hide, and are buried either there or on Flat Holm.

FLEMINGS These were settled by Henry I in south Pembrokeshire to reinforce the Norman settlements there. *The Chronicle of Ystrad Fflur* notes in 1108 'In this year a folk of strange origins and customs, with nothing known of where they had been concealed in the island for many years before that, were sent by king Henry to Dyfed. And they occupied the whole cantref called Rhos and drove away the inhabitants from the land. And that folk had come from Flanders.'

FLINT CASTLE It was the first of the 'Iron Ring' of castles intended to crush Llywelyn ap Gruffydd and Welsh independence. Erected by Edward I around 1277-1283, it was slighted by Parliamentarians in 1647 after a three-month siege. Like Caernarfon, Conwy, Harlech and Beaumaris, it is a masterpiece of James of St George, the foremost castle builder in Europe. It is unusual because its strongest tower, or donjon, is only linked to the rest of the castle by a drawbridge. The River Dee used to run between the two buildings, so the design was contrived to protect supply ships. It may have been called 'Flint' to symbolise that it was the striking point for Edward's conquest of Wales. Over 3,000 diggers, woodcutters, carpenters and masons worked on the castle and the fortified town, or bastide. The castle cost around £7,000, or around £90,000,000 in today's terms. In 1282 it was besieged by Dafydd, the brother of Llywelyn the Last, and another attempt in 1294 was more successful. The Norman constable of the castle in 1294 burnt the castle and its bastide to prevent their use by the Welsh. The castle was then repaired. Flint Castle (wrongly) features in history, attributed by Shakespeare as the place where King Richard II was captured by Bolingbroke, who became Henry IV. The walls of the Great Tower are 23 feet thick, possibly a world record.

FLINTSHIRE Flintshire is the smallest of the thirteen historic counties, and is mostly based around the Wales north-east coast. The county also had a large detached county enclave, English Maelor, until the late twentieth century. The administrative county of Flintshire was abolished in 1974 to become part of the new county of Clwyd. The original county had been formed in 1284 after the Statute of Rhuddlan, and included the Lordships of Hope, Mostyn, Hawarden and Mold. The county's castles include Flint, Hawarden, Rhuddlan and Ewloe.

FLOWERS While the native Welsh daffodil has been the national flower from time immemorial, *'the world's rarest flower'* was found in Wales in 2000, clinging to a rock face in Snowdonia. The yellow perennial Snowdonia Hawkweed was thought extinct in 1950, but botanists found a single example on the Cwm Idwal nature reserve 1,600 feet up. Its inaccessibility meant that wild goats could not reach it, and seeds have been taken to ensure its survival. The tiny yellow Radnor Lily, once prevalent all over Britain 12,000 years ago, was only discovered in 1975. A survivor from the end of the last Ice Age, it is only found in a secret place in mid-Wales, and of the three surviving near Kington in 2002, one was eaten by an animal. More than 1,500 trees were recently felled to allow their survival. In Victorian times, the leek was not considered glamorous enough to be the Welsh national emblem and the daffodil, whose flowering coincides with the Welsh patron saint's holiday, became a replacement. There are two varieties unique to Wales. The small and delicate Welsh Daffodil, or Lenten Lily, can be seen at Coed y Bwl Wood, at Castle-upon-Alun, south-east of Bridgend. The Tenby Daffodil is a little larger and has grown wild for centuries on the coast of Wales, its early blooms being once rushed to London to be sold at Covent Garden. Tenby Daffodils are not only found in South Pembrokeshire, but also in Carmarthenshire and part of Ceredigion. Both daffodil species have suffered declines as a result of property development on land where they once thrived. The Welsh Daffodil is more widespread, but still scarce. In West Wales wild pink primroses are often seen.

FOEL DRIGARN HILLFORT Over 220 houses have been excavated on this massive site on the summit of Moel Drigarn in the Preseli Hills. *'Drigarn'* refers to the three superb Bronze Age cairns (three cairns) at the centre of the site. A moel is a bare hill. The Celtic respect for the dead is shown by the fact that the Iron Age hillfort builders left the cairns alone. Finds from the site can be seen in Tenby Museum.

FONMON (FWNMWN) CASTLE Built in the Vale of Glamorgan by the St Johns in the early thirteenth century, it has been lived in since that time, with only one change of family. In 1656, Colonel Philip Jones took it over, and the Boothbys who now live there are his descendants.

FOOD 'If you want at all times to be merry, eat saffron in meat and drink, and you will never be sad. But beware of eating too much, lest you should die of excessive joy' - *The Physicians of Myddfai* (based upon natural remedies from the thirteenth century, printed in 1861). Because of the climate, oats were the staple diet of Welsh people in the past, with 'cistiau styffylog' (great wooden 'oatmeal chests') being important items of furniture in most houses. There were many varieties of oatmeal dishes served with milk or buttermilk, such as 'bwdram', 'picws mali', 'llymru', 'siot', 'sycan blawd' and 'brywes'. In the 1890's, the typical diet of a hill farmer had remained the same for centuries, with bruised oatmeal cake and buttermilk to start the day, bread and butter and tea, and bacon and potatoes for dinner. There was 'sycan blawd' (steeped oatmeal, boiled and served with fresh milk) for tea, and oatmeal porridge, or bread and cheese and buttermilk for supper. 'Bara-llaeth' was a mixture of hot milk and bread, sometimes thickened with egg. 'Stwnsh rhidans' is still a popular mash of swede and potato. Cardiganshire's staple dish was its version of the famous Welsh 'cawl', a broth of vegetables and bacon, reheated and added to daily. Potatoes also were added, to fit with the 'bwyd llwy' ('spoon food') tradition of Welsh eating, where meat was of less importance (being less affordable) than dairy produce. Cawl itself dates from prehistory, formerly a mutton broth with any available vegetables thrown in, and a winter favourite for all Welsh mothers to give their families in pre-central heating days. Neck of Welsh lamb is browned and then brought to the boil in lamb stock, and any available vegetables, such as peas, broad beans, leek, carrot, onion, turnip and parsnip are added. The dish is seasoned, covered and left to cool for up to three hours. Cauliflower florets and shredded lettuce can be added twenty minutes before the end of cooking time, and the dish is served with crusty bread. Welsh lamb is used in many dishes, often minted or flavoured with thyme. In days gone by, the cawl cauldron was just topped up on a daily basis, and reheated for weeks on end. Cawl is still popular in the winter all over Wales, and 'lobscaws' was a derivant of cawl made with any leftovers from meals. This was the staple diet of the poor Welsh families who flooded into Liverpool from North Wales, looking for work in the nineteenth century. From this we have the slang for a Liverpudlian - a 'scouser'. 'Lobscouse' was the popular name on sailing ships for the broth that was served from the galley.

Rather like Eire, Wales is experiencing a renaissance in food. Its country hotels (that rely upon tourism rather than commercial trade), have to build up local trade and reputation, and pull in repeat tourist business just to survive. Many restaurants, pubs and hotels belong to the 'Blas o Gymru' ('Taste of Wales') scheme to encourage Welsh cooking. The best-known cheese in Wales is Caerphilly (Caerffili), a soft, crumbly and slightly tart white cheese which used to be very popular down the pit when Wales had legions of coal miners. This farmhouse cheese was cheap, as it was made from skimmed milk only, and fed to farm workers. When mixed with beer (and sometimes mustard) and toasted on bread, it makes the traditional Welsh Rarebit. The story is that the real name of this should be 'Welsh Rabbit'. In past centuries, many of the staff serving in the rich mansions of England were Welsh. While the lords and ladies upstairs were eating rabbit, the servants downstairs were making do with cheese on toast, 'Welsh rabbit'. The Welsh always had a passion for toasted cheese, 'caws pobi', which became a national dish back in Tudor times. Flavoured cream cheeses, such as those with marigolds, were popular as treats in Tudor and Stuart times, and a creamy 'Normandy-type' cheese was made in the eighteenth century, known as Newport Cheese. Sage cheese was made using sage and spinach juice. Cheese is now being made again in Caerphilly. 'Y Fenni' is a marvellous cheddar-type cheese, flavoured with beer and mustard seeds. Unpasteurised cheeses such as Llangloffan (red, and garlic-flavoured) are also very popular, despite the former attempts of the EU to close down not only all non-standardised food producers, but to prevent the use of non-pasteurised cheese. (At least one Stilton cheese-maker in England went out of business, while the French cheese producers totally ignored the edict.) Caerfai near St David's makes organic traditional Caerffili, with one variety having leeks and garlic added. Cwm Tawe offers a pecorino-type cheese made from ewes' milk, and Llanboidy offer a cheese with laverbread. Pen-y-Bont makes four-pound wheels of goats' cheese. From Teifi Farmhouse Cheese, there is a superb and mature unpasteurised nettle cheese.

Probably the most evocative South Wales meal ingredient is laver, a local lettuce-type seaweed

- laver bread ('bara lawr') is a mixture of laver and oatmeal, fried preferably in bacon fat, to make a delicious starter, or served as part of a traditional breakfast with pork sausage, egg and bacon. Local cockles, mussels, king and queen scallops, lobster and leeks appear in many Welsh restaurant dishes, along with locally caught fresh salmon, superb sewin (sea trout) and other trout. 'Glamorgan Sausages' are a superb vegetarian combination of spices and local cheese. Eggs are beaten with mustard, parsley, thyme and seasoning, and are added to a cheese and breadcrumb mixture. 'Sausages' are rolled, dipped into beaten egg, and fried in oil until golden brown. Another lovely old speciality is 'Anglesey Eggs', 'Wyau Ynys Môn'. A vegetarian variant of 'Scotch Eggs', they feature leeks, mashed potatoes, butter, eggs, cheese, milk, breadcrumbs and nutmeg. 'Bara brith' has always been popular, bread with dried fruit (softened overnight in hot tea) in it, to accompany afternoon tea. 'Welshcakes', 'Pice ar y Maen', are small flat pancakes of sugared dough, and just about every Welsh mother always had some on hand. Until the 1950's, most households had one of the heavy, flat, iron bakestones used for cooking them. 'Lardy Cake' is also popular, a very moist and heavy fruit bread, delicious with a hot drink. A Glamorgan speciality is 'teisen lap', a long 'cut and come again' cake made with currants and nutmeg.

According to *The Guinness Book of Records*, Bernard Lavery of Llanharry at one time held no less than fifteen World and five UK records for growing fruit and vegetables, including the world records for a cabbage (124 lbs), marrow (108 lbs), courgette (65 lbs), celery (46 lbs), cucumber (20 lbs) and parsnip (171in). His British records were for pumpkin (710 lbs), squash (504 lbs), watermelon (36 lbs), melon (18 lbs) and carrot (11 lbs). Wales is an excellent place for mushrooming with its clean air and fresh climate – the world record for a total fungi spore count was established near Cardiff in 1971, with 161,037 spores to the cubic metre.

FOOTBALL When Cardiff City won the FA Cup against Arsenal in 1927 (courtesy of a Welsh goalkeeper in the Arsenal team making a dreadful mistake) it was the only time the FA Cup left England. In 1925, Cardiff had lost the final 1-0 to Sheffield United. In 1968 they reached the semi-finals of the European Cup-Winners' Cup, losing to SV Hamburg. In 2008 Cardiff City lost to Portsmouth in the FA Cup Final, 1-0. Cardiff at the time were £30 million in debt, so had sold many of their star players, relying on local youngsters, two foreign players and players bought cheaply. Portsmouth, in the higher Premiership division was packed with ten expensive foreign international players, because of its multi-millionaire foreign owner. (Including substitutions, each team fielded fourteen players). Cardiff had 52% possession and were disallowed a goal. Portsmouth got a scrambled goal owing to a goalkeeping error. Cardiff had more possession, committed just 9 fouls and received no yellow cards. Portsmouth committed no less than 22 fouls and received 3 yellow cards for serious offences. If we count a yellow card as being worth two normal fouls, the foul count would be 9 by Cardiff and 25 by Portsmouth. Portsmouth's debts and loans in 2009 were £115 million, and a 19 October 2008 *Sunday Times* article revealed that the club received 'a joint share of at least £34 million from allegedly illegal arms deals that fuelled a brutal war in Africa'... 'including 170,000 landmines' in Angola. Welcome to the business of professional football. The team that borrows four times as much, is foreign-owned, uses five times as many foreign players and commits around three times as many fouls, wins. This is not xenophobia. Not that Cardiff City supporters are sore losers, of course. No single football reporter picked up on the match statistics, or that fact that Cardiff players were chopped down whenever they developed an attack by 'more professional' Premiership players. From 2009, Cardiff City have moved to a new ground, sharing it with Cardiff Blues rugby club.

The most expensive football player in history was Bryn Jones of Arsenal, who cost £14,000 in 1939. Unfortunately the war years coincided with his playing career. The youngest Welsh cap was the remarkable Ryan Giggs of Manchester United, aged seventeen. Wales in fact has had a remarkable number of world-class forwards, including Giggs, BILLY MEREDITH (Manchester City, Manchester United), Wyn 'The Leap' Davies (Manchester United, Manchester City, Newcastle), Trevor Ford (Aston Villa and PSV Eindhoven), Ivor Allchurch (Swansea and Newcastle), JOHN CHARLES (Leeds, Juventus and Roma), Gerry Hitchens (Arsenal, Cardiff and Torino), John

Toshack (Liverpool and Sporting Lisbon), Mark Hughes (Barcelona and Manchester United), Ian Rush (Juventus and Liverpool) and Dean Saunders (Aston Villa, Liverpool, Nottingham Forest and Galatsaray). In October 1986, Juventus set the British transfer record when they paid £3.2 million for Ian Rush, hoping for a repeat of the service that John Charles gave them. In 1984, Rush had won the European Golden Boot Award on scoring 32 goals in the 1983/84 season. Another Liverpool player was voted one of the best twenty-two players in the 1998 World Cup. Michael Owen was born in Hawarden, Flint, and could have played for Wales, but unlike Ian Rush and Ryan Giggs, chose the greater glamour of the English national team.

TREVOR FORD, a two-footed centre-forward, scored a hat-trick for Swansea in the 1950's against Aston Villa, who quickly bought him. He scored 59 goals in just three seasons before moving on to Sunderland for a record £30,000 transfer fee, then to PSV Eindhoven and Cardiff. Called 'the first modern centre-forward', he scored 177 goals in 259 games for Swansea. Another Swansea player, the 'golden boy' of Welsh football, Ivor Allchurch played his first game for them in 1949 and achieved 69 Welsh caps. Another two-footed player, he was the most respected footballer of his generation, known as 'the Prince', and 'the prince of inside-forwards'. He made 450 league appearances for Swansea. Two more famous Welsh forwards starred in the Tottenham Hotspur league and cup double side of 1961, operating on the wings, Cliff Jones and Terry Medwin. Cliff Jones' father Ivor also played for Wales, as had his uncle Bryn, mentioned above as the most expensive footballer in the world. Cliff Jones played 59 times for Wales, and played for Spurs for ten years, scoring 176 goals. He had cost the club a British record fee for a winger of £35,000. The only international player of note that has not been a forward is the former Everton goalkeeper, Neville Southall, with over eighty Welsh caps, an intriguing character who refused to celebrate victories with his clubmates, preferring to return home to his wife and children. John Toshack is another interesting character. Having won every honour in the game with a great Liverpool team, he became manager of Swansea, and took them from the Fourth Division to the First Division in three years, briefly being top of the Football League. The legendary Liverpool manager, Bill Shankly, called Toshack 'manager of the century' for this feat in taking a small Welsh town above the likes of Manchester United, Tottenham Hotspur and Liverpool. A fluent Spanish-speaker, he then took Real Sociedad from being a perennial struggler to being one of the top clubs in Spain. After four years, he was invited to become the coach of Real Madrid in 1988, and won the League with them. After another spell at Real Sociedad, and as manager of Wales, he moved to be coach of Deportivo La Coruña, challenging Barcelona and Real Madrid for the title again. He is now again the manager of the Wales team.

FORD, TREVOR (1923-2003) Swansea's Trevor Ford began his career as a full back before converting to centre forward, and played 38 times for Wales, scoring 23 goals. World War Two interfered with his career, and in 1945-46 he joined Swansea Town. He did not play for the full season but scored 41 of their 90 goals, and played for Wales. In 1946-47, after playing just 16 games and scoring 9 goals, he was transferred to Aston Villa for £9,500. In 1950, Ford was transferred to Sunderland and scored 58 goals in three seasons. At a £30,000 transfer fee, he became the world's most expensive footballer. He moved to Cardiff City in 1953 in another £30,000 transfer deal, and his transfer fees now totalled £70,000, making him the world's costliest player. Ford also played for Eindhoven, and gained a reputation as a hard player, although he was never cautioned or sent off in his career. He scored 177 Football League goals in 348 league appearances.

FORDEN GAER ROMAN FORT Near Montgomery, Levobrinta was built in the mid-second century, and remodelled in the third and fourth centuries.

FOUNDER SAINTS OF BRITTANY The most important saints in Brittany are the seven Founding Saints – St Malo, St Brieuc (Briog), St Samson of Dol, St Patern (Padarn, or Paternus), St Tugdual (Tudwal), St Pol Aurelian and St Corentin. Of these only St Corentin was not Welsh, being Cornish-Welsh). Most were taught at Llancarfan and Llanilltud Fawr monasteries. The

saints Malo, Samson, Padarn, Pol and Brioc were directly associated with Arthur/Armel as his kinsmen.

FRIDD FALDWYN HILLFORT With multiple banks and ditches, this Iron Age hill fort (translated as Maldwyn's Sheep Pasture) overlooks the Severn Valley, on the outskirts of Montgomery, which reminds us that the original name of Montgomery was Trefaldwyn (Maldwyn's Town).

FROST, BILL (1850-1935) – THE FIRST MAN TO FLY Bill Frost of Saundersfoot seems to have been the first man to fly, having patented a craft which was a cross between an airship and a glider in 1894. He stayed in the air for ten seconds, covering 500-600 yards until the undercarriage caught in a tree in 1896. His family and neighbours claimed that if he had cleared the tree he would have crossed the valley. (Orville Wright's 'first' flight in 1903, seven years later, lasted only twelve seconds.) Frost's flying machine was destroyed in a gale. He described himself as 'the pioneer of air travel'. Upon 26 July 1998, *The Sunday Times* carried a long feature *Welsh airman beat Wrights to the skies.* Andrew Alderson wrote that a Welsh carpenter, Bill Frost, flew in summer 1896... 'Until now, history has credited the Wright brothers with conquering the skies. But new evidence suggests that their famous flight was not the first. Seven years before them, Frost is said to have set off in a "flying machine" from a field in Pembrokeshire and stayed in the air for ten seconds. Newly discovered documents reveal that Frost, from Saundersfoot, Pembrokeshire, applied to register a patent for his invention – a cross between an airship and a glider – in 1894. It was approved the following year and detailed how the invention was propelled upwards by two reversible fans. Once in the air, the wings spread and are tilted forward 'causing the machine to move, as a bird, onward and downward.' A fan is used to help the aircraft 'soar upward', while the steering is done by a rudder at both ends.

Crucially, locals in the Welsh seaside resort insist that the aircraft was built and flown within a year of the patent being approved. Yesterday experts on both sides of the Atlantic believed that the name of William Frost, not the Wright Brothers, deserves pride of place in aviation record books as the first pioneer of manned, sustained and powered flight. Historians, descendants and a former neighbour of Frost are convinced that only his modesty – in failing to acclaim his role or having a photograph of the flight – meant his achievements went unacclaimed. Roscoe Howells, the historian and writer, used to be a neighbour of Frost in Saundersfoot and heard an account of the flight from the inventor himself. 'He became airborne, so he said, and I would never believe that Bill Frost was a liar or romancer,' said Howells. 'His flying machine took off, but the undercarriage caught in the top of a tree and it came down into a field. If he hadn't caught it in the tree, he would have been right over the valley over Saundersfoot and it would have been death or glory.' Nina Ormonde, Frost's great-great-granddaughter, said: 'Our family has always known that he was the first to fly, he flew for 500 to 600 yards. But Bill gave up on it and there is no point in our revelling in the glory because it was his achievement.' Frost's flying machine was 3ft long and made of bamboo, canvas and mire mesh, with hydrogen-filled pouches to attain 'neutral buoyancy'.

Alderson describes Bill Frost as a carpenter and builder on the nearby Hean Castle estate, who was a deacon of the chapel and founded the local male voice choir. 'His determination to fly his aircraft after the initial flight was defeated by bad luck and lack of money. Although he repaired his machine after hitting the tree, it was later ripped from its moorings and damaged by gales, apparently in the autumn of 1896. He later travelled to London and tried to get funding from the government's war department. According to Frost's descendants, he received several approaches from foreign governments for the rights to his patent, but refused on the grounds of patriotism. The revelations about Frost's design and flight have been uncovered by Jill Waters, a producer, and Patrick French, a presenter, for Radio 4's *Flying Starts*, to be broadcast on Saturday... The Wright Brothers had the benefit of independent witnesses, log books full of technical data and, most important, photographic evidence,' said French. 'Yet there are compelling reasons for

thinking that the first person to fly was Bill Frost.' In an interview given in 1932, three years before his death, Frost described himself as 'the pioneer of air travel'. Then aged eighty-five and blind, he spoke of his lack of funding after the War Department dismissed his efforts, arguing 'the nation does not intend to adopt aerial navigation as a means of warfare'.

FROST, JOHN (1784-1877) A Welsh speaker, he was elected Mayor of Newport in 1836. He was the one of the leaders of the CHARTIST march of 7,000 men which advanced upon Newport on 3 November 1839, in support of people's democratic rights. At least twenty-four men were shot dead by English troops firing from the Westgate Hotel. With other leaders, Frost was sentenced to be hung, drawn and quartered in a show-trial resulting from what Michael Foot called 'the biggest class-war clash of the century.' His sentence was commuted to hard labour in Tasmania for life. In 1854 he was released, and then pardoned in 1856, returning to be honoured in Newport. Frost said 'By the struggle of these men, we now enjoy five of the six demands of the People's Charter covenants in our constitution. I do hope that one day the last of these will be included, whereby we can at least get rid of a third of the House of Commons every year, by vote.' With the 2009 MP expenses scandal, it is a pity that we cannot get rid of all of the House of Commons immediately and in perpetuity, replacing it with people who believe in honour, ethics and principle above greed.

FYRNWY, BATTLE OF THE, 1400 At the start of the war of independence, Owain Glyndŵr's small force rampaged around northeast Wales for eight days from 18 September 1400, during which time the English settlements of Ruthin, Denbigh, Rhuddlan, Flint, Hawarden and Holt were attacked and destroyed, but the castles were left intact. Having left the town of Oswestry in flames on 22 September, Owain had advanced south with the intention of doing the same to Welshpool. However, to the west of his intended target he decided to camp on the banks of the river Vyrnwy (Fyrnwy) for a short while before advancing on the town. It was while he and his men lay at rest that the encampment was attacked by forces from Shropshire, Staffordshire and Warwickshire, under the command of Hugh Burnell. It was a bloody conflict with the river running red with blood, and Glyndŵr's force was scattered. Owain and a small band of followers took to the hills. The date given by Burnell for the battle is on the Feast of St Matthew, which could be 20 or 21 September, but Glyndŵr burnt Oswestry on 22 September and burnt Welshpool of 23 September. The Tudor brothers at the same time coordinated an attack in north-west Wales. Thus it is probably true that the account of the 'Battle of Fyrnwy' was a falsification, although it has gone into the history books. If Owain had been defeated, the following events make no sense. By 26 September, Henry IV had to assemble 13,000 troops at Shrewsbury. While there he executed eight alleged rebels, and then headed into Wales to attack Glyndŵr on 28 September. However, Henry had retreated back to Shrewsbury by 15 October. It seems that Burnell was engaged in propaganda for his own glory. There seem to be no Welsh accounts of the battle/skirmish, and Burnell's version that he prevented Glyndŵr sacking Welshpool is obviously wrong. The castle of Welshpool, now known as Powis Castle, was obviously too strong to be attacked without siege engines and a well-provisioned army, which it why the town was burned and the castle avoided. History is not set in stone – it constantly has to be re-addressed upon the basis of common sense rather than repetition.

GAER, Y (GOLLARS) HILLFORT Overlooking the River Ebbw in Newport, this large Silurian site has multiple enclosures.

GARDENS Owned by The National Trust, Gardd Bodnant (Bodnant Garden), overlooking the River Conwy and Snowdonia, is one of the finest gardens in Europe, with 100 acres of magnificent trees, shrubs and flowers. The beautiful Dyffryn Gardens, near Cardiff, are Grade I listed and designed by Thomas Mawson around the Grade II* Dyffryn House. There are twelve Champion Trees (the tallest or largest of their species in Britain, and there is a Pompeiian

Garden, a Theatre Garden, a Fernery, a Physic Garden and Panel Garden amongst the grounds. Some of its fine collection of Japanese acers have been moved to the National Botanic Garden of Wales. Gardd Powys (Powis Garden) has formal and informal gardens in the grounds of Powis Castle. This National Trust property was originally built by the Welsh princes of Powys, the Gwenwynwyn lineage, who anglicised the name to de la Pole, Powell and Herbert. Many of the collection of Indian treasures of 'Clive of India' are displayed there. These are probably the most famous of Wales' great gardens. A *Guide to the Historic Parks and Gardens of Wales* is available from The Welsh Historic Gardens Trust, Ty Leri, Talybont, Ceredigion, SY24 5ER, and a fascinating tour of Wales could be based on its booklet of tourist attractions. Featured are Clough Williams-Ellis' Portmeirion, Humphrey Repton's Plas Newydd, Gwydir Castle, Bodelwyddan Castle, Erddig Hall, Chirk Castle, Nanteos Mansion, Llanerchaeron, Stackpole, Margam Abbey and Tredegar Park.

GARFIELD, JAMES ABRAM (1831-1881) The second President of the United States to be assassinated, just 100 days into office, he boasted of his Welsh ancestry. An extremely competent and respected politician, Garfield, 'the last of the log cabin Presidents', lingered for six weeks after being shot twice by an insane lawyer. A former Union general in the Civil War, he could speak fluent German and could write Greek with one hand while writing Latin with the other. (A more recent President could hardly speak recognizable English.)

GARDENER, HELEN HAMILTON (1853-1925) Born in Virginia as Alice Chenoweth Day, she had Welsh parents, and was an American writer, reformer and feminist. Helen Gardener was her pen name. She fought for the rights of women to attend high school and college training, and promoted child protection. She had carefully refuted a leading neurologist's work that a female's brain was inferior to that of a male, in *Sex in Brain*, and became a leading suffragette. She was appointed by Woodrow Wilson in 1920 to be the first woman member of the US Civil Service Commission, the highest federal position ever held by a woman. The position was 'unsolicited as recognition of her ability and was unanimously confirmed.'

GARMON, SAINT Bishop Germanus of Auxerre came to Wales in 429 to combat the teachings of Pelagius, and won the 'Alleluia Battle' against pagan Picts and Saxons. Inside the churchyard of Llanarmon Dyffryn Ceiriog (the holy place of St Garmon in the Vale of Ceiriog) is the grassy mound known as Tomen Garmon (the Mound of St Germanus).

GARN BODUAN HILLFORT On the Llŷn Peninsula, a promontory hill fort with three lines of defences, freshwater springs, and the remains of 170 round huts, it lies atop a steep hill. It was probably used again after the Romans left.

GARN FADRYN HILLFORT In the centre of the Llŷn Peninsula, on a craggy hill, the ramparts surround the hilltop, with an inner defence wall protecting its stone huts.

GARNGOCH, BATTLE OF, 1136 On the Gower Peninsula, a memorial near Fforestfach marks the site of where Prince Hywel ap Maredudd of Brycheiniog defeated an Anglo-Norman army on New Year's Day. That so much blood was spilt is reflected in the name of the common, Garn Goch, Red Cairn.

GARTH CELYN - THE PALACE OF THE PRINCES OF WALES The remains of a medieval llys, the home of the two Llywelyns is on Garth Celyn, a promontory of land above the shores of Abergwyngregyn on the edge of the Menai Strait. The 'Garth' headland overlooks the ancient walkway across the Lavan Sands to the Isle of Anglesey. This walkway was the route used in the Roman invasions of Anglesey in 59 CE and 78 CE. Celyn ap Caw, brother of the sixth-century historian Gildas, established his base inside the Roman bank and ditch enclosure.

The site has remains dating back to the Neolithic period, and above it lies an Iron Age fort, Maes Gaer. The Royal Commission for Ancient Monuments called it 'the most important site to be discovered in Wales in the 20th century'. The 'Tŷ Hir', converted into an Elizabethan manor house, has an undercroft and dates back to *c*.1195. Joan, daughter of King John, wife of Llywelyn Fawr died here in 1237; Prince Dafydd ap Llywelyn in 1246; and Eleanor de Montfort on 19 June 1282, giving birth to a daughter Gwenllian ferch Llywelyn. It was the main home and court of the Princes of Gwynedd in the thirteenth century, effectively the capital of independent Wales during this period prior to the English conquest in 1283. From Garth Celyn, Llywelyn the Last issued his declaration of the *Rights of the Welsh to be an Independent Nation*. Not until recently was the provenance of the building understood, although the circular tower has always been known as Twr Llywelyn (Llywelyn's Tower). The tower is said to contain secret stairways, hidden rooms, hollow walls and tunnels. On the other side of the building is 'Llywelyn's Chapel'. Llywelyn the Last's brother Dafydd was captured near here in 1283, gravely wounded, and hung, drawn and quartered, ending the reign of the Princes of Gwynedd. CADW and the Gwynedd Archaeological Trust as yet seem not to understand the importance of the court.

GARTH MAELWG, BATTLE OF, 720 Arthfael fought the Saxons at this battle. He was later killed fighting them near Cardiff in Glamorgan, and was buried at Roath in Cardiff. Three massive cairns, named the Beacons, are supposed to mark the burial place of those slaughtered on Mynydd Garth Maelwg in Breconshire, and a slope is called Rhiw Saeson, Saxon Hill. However, there is also an ancient healing well called Garth Maelwg, between Llantrisant and Llanharan, and this could also be the site of the battle.

GATEHOLM Gateholm, Goat Island, can be reached at low tide from Marloes sands, and has a Romano-British village of hut circles in its twenty acres.

GELLIGAER MILITARY STATION This Roman fort north of Cardiff was abandoned around 120 CE, and smaller fort built which was abandoned in the second century.

GELERT Near Beddgelert (the Grave of Gelert) a monument supposedly marks the burial-place of Gelert, the hound left by Llywelyn to guard his child. The poor dog, covered with blood, was killed by Llywelyn before he realized that Gelert had killed a wolf to save the child. The story was invented by the eighteenth- century innkeeper David Pritchard to attract tourists to this beautiful spot, where the River Glaslyn cuts through the Snowdon Mountains. Pritchard is now reputed to haunt room 29 in the Goat Hotel. Gelert's Grave is a cairn in the field next to the church, but, in the words of Israel Zangwill:

Pass on, O tender-hearted. Dry your eyes.
Not here a greyhound, but a landlord, lies.

GENERAL STRIKE 1926 Britain was paralysed from 3 May 1926, by a strike started by the miners in dispute over the proposals of the Samuel Commission. They were backed by transport and other workers. On 12 May, the Trades Union Congress announced the end of the strike, as Baldwin's Government had offered better terms. The Miners' Union rejected the terms and stayed on strike until 19 November, when it finally ended in Wales. Miners' families were starving and they returned accepting the terms and conditions of the pit-owners, worse than those offered in the previous May.

GEOFFREY OF MONMOUTH (*c*. 1100-1155) The Latin publications of this clergyman gave us much information upon early British history and developed the popularity of Arthur. He was made Bishop of St Asaf in 1152. His earliest work was *The Prophecies of Merlin*, written before 1135. Geoffrey presented a series of narratives as the work of the Merlin who, until Geoffrey's

book came out, was known as Myrddin. It is thought that he altered the name to Merlin from Merdinus/Myrddin as it was too similar to the French 'merde', meaning excrement. It was the first work about this legendary prophet in a language other than Welsh, and for some time paralleled the later popularity of the *Nostradamus* prophecies. Geoffrey's next work was *Historia Regum Britanniae (History of the Kings of Britain),* dating from the first settlement by Brutus, the descendant of the Trojan Aeneas, to the death of Cadwaladr in the seventh century. Geoffrey includes Julius Caesar's two invasions, information on the kings Lear (Leir) and Cymbeline (Cunobelinus), and a narrative of Arthur's life. He claimed to have translated it from an ancient book written in Welsh, but much is based on Nennius' *Historia Brittanorum* and Gildas' *De Excidio Britanniae.* Geoffrey is the originator of the Arthurian canon, rather than Chrétien de Troyes. His *Vita Merlini*, the retelling of the Welsh Myrddin legend, was possibly written between 1149 and 1151, after his *Historia.*

GEORGE REX (1765-1839) – THE TRUE KING OF ENGLAND (1820-1839) In 1997 Kenneth Griffiths made a documentary for BBC TV, after discovering previously impounded documents. These prove that George III, when Prince of Wales, secretly married a Quaker, Hannah Lightfoot. They were actually married twice, first at Kew Chapel on 17 April 1759, and then at their secret home in London. The witnesses at Kew included the Prime Minister William Pitt. In 1866 a series of documents was produced at Chancery Court in London, which were believed to be the genuine marriage certificates. The record of the second marriage reads: 'May 27, 1759. This is to certify that the marriage of these parties, George, Prince of Wales, and Hannah Lightfoot was duly solemnised this day, according to the rites and ceremonies of the Church of England'. According to a handwriting expert in 1866, the documents and signatures were genuine. The Lord Chancellor confiscated the certificates, which Kenneth Griffiths rediscovered, and they are now available in the Public Records Office. The eldest of the three children born from this marriage was named George Rex, who was given a Royal Warrant and sailed to Cape Town when a young boy. In Cape Town he fell in love with a coloured slave, whom he subsequently freed and had children with. It was generally thought that George Rex had been sent to the colony to save the monarchy from a scandal. George Rex was adamant all his children were illegitimate, and refused to marry. The last words of George III to his son were rumoured to have been: 'You must never marry. There must be no legitimate heirs'.

George Rex was visited often by all the Governors of the Cape of Good Hope – the Second Earl of Caledon, Lord Charles Somerset and General Sir Galbraith Lowry Cole, and was buried in Knysna where his grave can still be visited today. Thus the official royal representative in South Africa had regular appointments with George Rex. A Buckingham Palace spokesman said: 'We are not commenting on the film, and we are not getting involved in it.' George III later had an unhappy (and bigamous) marriage to Princess Charlotte of Mecklenbug-Strelitz in 1761, and on the king's death in 1820 George Rex had the legitimate claim to the throne. George Rex's sister Sarah married Dr James Dalton of Carmarthen. Her daughter Charlotte Augustine Caroline Dalton died in 1832, and her other daughter Caroline married Daniel Prydderch, Mayor of Carmarthen. The daughter of Daniel and Caroline was Margaret Augusta Prydderch. Margaret Prydderch's and Charlotte Dalton's graves were recently found in the crypt of St Peter's, Carmarthen. A magnificent organ was made for George III for the Royal Chapel of St George's, Windsor, but instead he strangely gave it to Carmarthen, possibly as a thanksgiving for covering up his illegitimate heirs to the throne.

GILBERN This Welsh car manufacturer built exciting and progressive fibreglass sports saloons and estates, and there is a flourishing owners' club. The Gilbern Genie was popular, and the classic Gilbern Invader features in Jeremy Clarkson's book featuring the fifty 'hottest' cars ever made.

GILDAS, SAINT (c. 498-c. 570 OR 583) THE FIRST BRITISH HISTORIAN Abbot Gildas Badonicus, 'the second Apostle of Ireland' wrote '*De Excidio et Conquesta Britanniae (Concerning the*

Ruin of Britain) in 540. He drew lessons from the Roman occupation of Britain and denounced the five British 'tyrants' Constantinus of Domnonia (the West Country), Aurelius Caninus, Vortipor of Dyfed, Cuneglas of North Wales and his most despised, Maelgwn Gwynedd (Magloconus). Gildas had been taught by Illtud at Llanilltud Fawr, where he possibly wrote this denunciation. Another candidate for the place of writing is the Island of Steep Holm, Ronech, or in Brittany. Gildas took monks from St David's and Llancarfan to revitalise Irish Christianity. Probably because of his attacks on the British rulers, he went to Brittany for security, only returning to Britain when he heard that Arthur had killed his brother Huail ap Caw. According to Breton tradition he ended his days there, at his great monastery of Gildas de Rhuys. There are many other dedications to him there. Wick, formerly Y Wig Fawr (The Great Wood) near Llantwit Major, was originally named Llanildas after this remarkable saint. One of his surviving letters tells us of arrogant men that 'death has entered through the windows of their pride.' Certainly arrogant bankers and financiers, who recently brought the world to the brink of ruin, should contemplate the nature of a pride that uses greed as a substitute for lack of knowledge, intelligence, common sense and decision-making skills. Overpaid inept and immoral men should read Gildas at length and reflect on their sins. Here endeth the lesson.

GIRALDUS CAMBRENSIS, GERALD THE WELSHMAN (*c.* 1146-1223) Gerald of Wales was educated at St David's, Gloucester and Paris, becoming archdeacon of Brecon and the favourite to be Bishop of St David's in 1176. He was elected by the Welsh canons, but Henry II imposed an Englishman instead to the bishopric. Giraldus returned to France, and then accompanied Prince John to Ireland in 1185 when he wrote *Expugnatio Hibernica* and *Topographica Hibernica*. In 1188 he travelled with Archbishop Baldwin around Wales to recruit for the Crusade. Baldwin's pleas produced little effect, until he prompted Gerald to take up the preaching. At Haverford, Gerald moved the crowd to tears, speaking in Latin and French, and no less than two hundred joined the standard of the cross. It was remarked afterwards that if Gerald had only discoursed in Welsh not a single listener would have failed to join the Crusade. Giraldus described the journey in *Itinerarium Cambriae*, and in 1194 completed *Descriptio Cambriae*. The *Itinerary of Wales* takes us on a tour of one month in the south, and only eight days in the north. He tells us of a priest who, in his boyhood, paid a visit to fairy-land, and learnt the language, which was similar to Greek. He then gives us examples in the words for 'salt' and 'water', adding the equivalents in Welsh, English, Irish, German and French. This passage prompted the description of Gerald as 'the father of comparative philology.' When he reaches Cardiff, we incidentally learn that Henry II understood English, but could not speak it. Gerald was offered the bishoprics of Llandaff and Bangor, and of Ferns and Leighlin in Ireland, but refused, holding out for his rightful office of St David's. In 1198, on the death of its bishop, the king and Archbishop of Canterbury again vetoed his appointment, and he appealed to Rome, travelling there three times in five years. He has left us other works, and valuable descriptions of the times.

GLAMORGAN CANAL A wonderful piece of engineering, with fifty-two locks bringing coal from Merthyr to Cardiff. Parts still exist, but regrettably most has been filled in, in the late twentieth century.

GLAMORGANSHIRE, SIR FORGANNWG Glamorgan or Glamorganshire (Morgannwg) is one of thirteen historic counties, and was earlier a medieval kingdom or principality. It contains the two largest Welsh cities – Cardiff and Swansea. In 1974 it was divided into the counties of West Glamorgan, Mid Glamorgan and South Glamorgan. Glamorgan is the most populous and industrialised county in Wales. To the north are the industrialised valleys, and to the west of Cardiff, the new county of the Vale of Glamorgan which includes Barri, Penarth and Bridgend. It was founded as an independent kingdom named Morgannwg after a founding king called Morgan, possibly a son or descendant of Arthur. It was at times united with the neighbouring kingdoms of Gwent and Ergyng. Because of its wealth, location and geography,

Morgannwg was the second region of Wales, after Gwent, to be overrun by the Normans and hence is densely packed with the remains of castles.

GLASBURY-ON-WYE, BATTLE OF, 1056 Gruffydd ap Llywelyn defeated the invading army of Leofgar, Bishop of Hereford, near Hay-on-Wye. Leofgar was a Norman, and his force was made up of Saxons and Norman mercenaries. Later, the Saxon earls Harold and Leofric, with Bishop Aldred, effected a reconciliation between Gruffydd and Leofgar.

GLYNDŴR – OWAIN AP GRUFFYDD – LORD OF GLYNDRFRDWY (*c.* 1353- *c.* 1415)
Upon 16 September 2000, Glyndŵr's Day, Welsh patriots celebrated 600 years since a company of nobles gathered in his manor at Glyndyfrdwy to proclaim Owain Glyndŵr as Prince of Wales. Glyndŵr not only lit up Wales with a united war against overwhelming odds, but also his mysterious disappearance from history left an unbeaten feeling in Welsh hearts. He was the last 'Mab Darogan', 'Son of Prophecy' for the Welsh bards, before Henry Tewdwr (Tudur, or Tudor) took the English crown in 1485 from the last of the Angevins, Richard Plantagenet. Glyndŵr could trace his heritage back to Rhodri Mawr, who was head of the royal houses of Gwynedd, Powys and Deheubarth. He was born around 1353, and some say he was educated at Oxford. It is known that he studied for seven years at the Inns of Court in Westminster. Later he became squire to the Earl of Arundel and Henry Bolingbroke, later Henry IV. Fluent in Latin, English, French and Welsh, he served King Richard II in his 1385 Scottish campaign. He also may have fought on the Continent for the English King, but records are incomplete. Aged around forty-five, after a life of service to the crown, it appears that he returned to Wales to retire to his great family estates at Glyndyfrdwy (the Dee Valley, between Llangollen and Corwen), and at Cynllaith on the other side of the Berwyn Hills. But just four years later, in 1402, the English had burnt down both the manor houses at Sycharth and Glyndyfrdwy, of this fifty-year-old nobleman. King Richard II's abduction and murder by Henry Bolingbroke ruined Glyndŵr's idyllic existence after just one year of retirement. His income from his estates was around £200 a year, but in 1399 Reginald Grey, Lord of Ruthin, stole some of his Glyndyfrdwy lands. Glyndŵr was legally trained, and decided to fight Grey with a lawsuit in the English Parliament. A proud and loyal man, of royal blood, his case was dismissed with the comment 'What care we for barefoot Welsh dogs!' Glyndŵr returned to Wales, fuming, and Lord Grey decided that a frontal assault on Glyndŵr was unlikely to succeed. He therefore arranged a meeting to discuss Glyndŵr's grievances. Glyndŵr agreed, but knowing the Marcher Lord's record of previous treachery, asked for only a small band of men to accompany Grey. Lord Grey agreed, and arrived to open discussions at Sycharth. Luckily, Iolo Goch, the famous bard and a neighbour of Glyndŵr, was told of a much larger band of Lord Grey's horsemen, hidden in the woods outside the house, waiting for the signal to attack. Iolo Goch entertained the host, and singing in Welsh alerted Glyndŵr to the threat. Owain made an excuse and fled his beloved Sycharth to his other estate, further west at Glyndyfrdwy, just before Grey's troops charged out of the woods.

On 16 September 1400, Glyndŵr took the 'Red Dragon' of Cadwaladr and Wales as his standard. Aged almost fifty, he was proclaimed Prince of Wales, by Welsh nobles at Caer Drewyn, who had flocked to join him at nearby Glyndyfrdwy. Students from Oxford and Cambridge, labourers, noblemen and friars came to support him, resenting English wrongs. After Owain Lawgoch's assassination in 1378 on the orders of the English crown, the Royal House of Gwynedd was virtually extinct. Glyndŵr was then 'un pen ar Gymru', the only head of Wales, as he was the direct descendant and link between the dynasties of Powys and Deheubarth. Glyndŵr symbolically adopted Owain Lawgoch's heraldic device of the four red lions of Gwynedd. He altered the lions of Gwynedd from 'passant' to 'rampant' on his flag. As his ambassador later told the French king, Glyndŵr was the 'rightful' heir of Lawgoch, and of the princes of Gwynedd and Wales. Owain Glyndŵr united Wales both politically and symbolically.

HOUSE OF POWYS	HOUSE OF DEHEUBARTH
Bleddyn ap Cynfyn d.1075	Rhys ap Tudur d.1093
Maredudd d.1132	Gruffydd d.1137
Madog d.1160	The Lord Rhys d.1197
Gruffydd Maelor d.1191	Gruffydd d.1201
Madog d.1236	Owain d.1235
Gruffydd Maelor d.1269	Maredudd d.1265
Gruffydd Fychan d.1289	Owain d.1275
Madog d.1304	Llywelyn d.1308
Gruffydd d.1343?	Thomas d.1343
Gruffydd Fychan d.1370	Elen (also House of Gwynedd)
	Owain Glyn Dwr

On 18 September, Glyndŵr's small, poorly armed force rode into Lord Grey's base of Ruthin, looted the fair and fired the town. No-one was killed, but fourteen rebels were captured and hanged. Glyndŵr's band soon learned about fast-moving warfare. By 24 September, they had fired and looted Denbigh, Flint, Hawarden, Rhuddlan, Oswestry and Welshpool. On 25 September, Henry IV arrived in Shrewsbury with his army, and dismembered Goronwy ap Tudur, an Anglesey nobleman, sending his limbs along the Welsh borders to Chester, Hereford, Ludlow and Bristol, as an example to those thinking of supporting Glyndŵr. Glyndŵr was now in hiding when his aggrieved cousins, Goronwy ap Tudur's kinsmen on Anglesey, Gwilym and Rhys Tudur, started another rebellion. Near Beaumaris, at Rhos Fawr, the Tudur army was defeated but managed to melt away before it was destroyed. Henry IV then destroyed Llanfaes Abbey, as its Franciscan monks had supported the Welsh rebels. Henry marched to the coast at Mawddwy and returned to Shrewsbury. The small Welsh army watched him all the way, not strong enough to face the Plantagenet force. All Glyndŵr's lands given to the Earl of Somerset, John Beaufort, and it looked as if the war was over at the end of the year 1400. The Marcher Lords were now allowed to take any Welsh land that they could, either by force of arms or subterfuge. On top of this, in 1401, the English Parliament passed laws that no Welsh person could hold official office, nor marry any English person. The Welsh could not live in England, and had to pay for the damage caused by the 1400 rebellions. This racial purity enforcement enraged the Welsh of all classes.

Glyndŵr returned to Glyndyfrdwy, isolated with few supporters, as Gwynedd had accepted the royal pardon. Other noble Welsh families sent envoys to King Henry, complaining about the brutality and taxes of the Marcher Lords, but refrained from supporting Glyndŵr. The situation looked impossible until the Tudur brothers once more emerged from hiding in their Anglesey stronghold. While the garrison of Conwy Castle was at church outside the walls, on Good Friday 1401, Tudur's men posed as labourers, gained access to the castle and killed the two gatekeepers. Gwilym and Rhys Tudur, with a band of just forty men, fired the town and took control of Conwy Castle. Henry Percy, nicknamed Hotspur, controlled North Wales, and needed to get them out of the castle. After weeks of negotiations, the Welsh were starving. Both sides agreed to a sad compromise. The Tudurs were guaranteed free passage back to Anglesey and a pardon upon the giving up of some of their force. Gwilym selected them in their sleep – they were later drawn, hanged, disembowelled and quartered, their remains being salted and then scattered about Wales as a warning against further rebellion. Many Welshmen now started returning from England to Wales, and were backed by supporters of King Richard (by now murdered) with donations to the Welsh cause. A man called William Clark had his tongue pulled out for daring to speak against Henry IV, then his hand was also cut off for writing against him, and then was beheaded. By May 1401, another small band of men had joined Glyndŵr, and he had an inconclusive engagement with Hotspur near Cader Idris. He was forced to move south to the slopes of Pumlumon and raised his standard again where Nant-y-Moch reservoir now corrupts the land. With around 400 men only, he rode down to loot and burn Llandrindod Wells, New

Radnor, Abbey Cwmhir and Montgomery. Welshpool resisted and Glyndŵr returned with the remains of his little band (just 120 men, according to Gruffydd Hiraethog), to the safety of the Pumlumon (Plynlimon) foothills and caves. Unknown to him, an army of 1,500 Flemings from the settlements in southwest Wales – the 'Englishry' south of the Preseli Hills – was marching to exterminate this threat to their livelihoods. They surrounded him and charged downhill at Glyndŵr's trapped army at Hyddgen on the Pumlumon foothills. Glyndŵr's army knew that they either died there and then, or would be slowly disembowelled if captured. The incentive was enough, and they halted and reversed the Flemings' charge. News spread all over Wales that the Welsh had won a real battle at last.

Hotspur, disillusioned by a lack of support from Henry in Wales, now took his North Wales peace-keeping army back to Northumberland. This was Glyndŵr's opportunity to traverse all Wales, hitting Marcher Lord possessions and those of their sympathisers. These years are described by Sir John Wynn in his *History of the Gwydir Family* – 'beginning in Anno 1400, continued fifteen years which brought such a desolation, that green grass grew on the market place in Llanrwst... and the deer fled in the churchyard'. Another source tells us: 'In 1400 Owain Glyndŵr came to Glamorgan and won the castle of Cardiff and many more. He also demolished the castles of Penlline, Landough, Flemingston, Dunraven of the Butlers, Tal-y-Fan, Llanbleddian, Llanquian, Malefant and that of Penmark. And many of the people joined him of one accord, and they laid waste the fences and gave the lands in common to all. They took away from the powerful and rich, and distributed the plunder among the weak and poor. Many of the higher orders and chieftains were obliged to flee to England'. The king saw that Wales was turning to Glyndŵr, and that his Marcher Lords could not control any parts of the country. In October 1401, Henry marched to Bangor in North-East Wales, then West to Caernarfon in Gwynedd, then South, looting the abbey at Ystrad Fflur (Strata Florida) near Aberystwyth. Henry carried on to Llandovery, butchering any Welshman he caught, while Glyndŵr's men picked off his outriders and made constant assaults on his baggage train. At Llandovery, Henry publicly tortured to death and disembowelled LLYWELYN AP GRUFFYDD FYCHAN for refusing to betray Glyndŵr's whereabouts.

While his supporting bands harried the King's army, Glyndŵr unsuccessfully attacked Caernarfon and Harlech castles. Facing a professional army with mere volunteers, and holding no castles of consequence, Glyndŵr made overtures to the Scots, Irish and French for desperately needed assistance against their mutual 'mortal enemies, the Saxons.' He even asked Hotspur to try to arrange a peace with Henry IV. The usurper king was inclined to agree, but Lord Grey hated Glyndŵr, and Lord Somerset wanted more Welsh estates, so they agreed to use peace talks as a device to capture Glyndŵr. Fortunately, Hotspur, an honourable Northerner, refused to be part of this treacherous charade. 1402 started off well for Owain Glyndŵr. On 31 January, he appeared before Ruthin Castle, challenging Grey to fight. Grey was captured, trussed up and carried away to be imprisoned in Dolbadarn Castle. Perhaps Glyndŵr should have killed the man who was the cause of all his troubles, but he immediately ransomed him for £10,000. Some money was raised immediately, and Grey's son was given in surety for the rest. Raising this ransom effectively ruined Grey, who signed an agreement never again to attack the man he had made an outlaw. Soon after, Glyndŵr survived an assassination attempt by his cousin, Hywel Sele of Nannau, probably on the orders of King Henry. An arrow was deflected by the armour under his jerkin, and Hywel Sele was killed and placed in a hollow oak tree. Throughout the rest of the year, Glyndŵr ravaged North Wales (leaving alone Hotspur's estates in Denbigh), and then moved against Powys, controlled by the great Marcher Earls, the Mortimers.

On St Alban's Day, 22 June, at the Battle of Pilleth (near Knighton), Edmund Mortimer's English knights and Herefordshire levies charged uphill at Glyndŵr's army. However, Mortimer's Welsh archers poured volley after volley of deadly arrows into the English charge, apparently in an unrehearsed expression of support for Glyndŵr. (Much of western Herefordshire, Worcestershire, Cheshire, Gloucester and Shropshire was still Welsh-speaking at this time). Up to 2,000 of Mortimer's troops were killed on the slopes. Rhys Gethin, Rhys the Fierce, had drawn up his men

hidden behind the top of the hill, so Mortimer had underestimated the Welsh force of 4,000, as well as having been unable to control his Welsh archers. Mortimer was captured in the battle, but Henry IV accused him of treason and would not ransom him. Hotspur, Mortimer's brother-in-law, was incensed that a villain like Lord Grey could be ransomed, whereas Henry had set his mind against the innocent Mortimer. Mortimer joined Glyndŵr's forces. Glyndŵr at last had freedom to do whatever he wanted – he attacked and burnt Abergafenni and Cardiff, and the ruins of his sacking of the Bishop's Palace at Llandaf in Cardiff can still be seen. He besieged Caernarfon, Cricieth and Harlech castles. This forced Henry IV to totally ignore his Scottish problems and to assemble three armies, totalling a massive 100,000 men, on the Welsh borders. The bards had been singing of Glyndŵr's supernatural powers, and during Henry's advance into Wales, appalling weather conditions forced all three armies to return to England by the end of September. It was thought at the time that Glyndŵr could command the elements, and well as possessing a magic 'raven's stone' that made him invisible – even the English troops ascribed magical properties to this guerrilla partisan. This is referred to in Shakespeare's *Henry IV Part 1:*

Three times hath Henry Bolingbroke made head
Against my power. Thrice from the banks of the Wye
And sandy-bottomed Severn have I sent
Him bootless home, and weather-beaten back.

A 1402 entry in *Annales Henrici Quarti*, the English recording of the times, reads that Glyndŵr 'almost destroyed the King and his armies, by magic as it was thought, for from the time they entered Wales to the time they left, never did a gentle air breathe on them, but throughout whole days and nights, rain mixed with snow and hail afflicted them with cold beyond endurance.' In 1402, Edmund Mortimer married Owain Glyndŵr's daughter, Catrin. Mortimer's nephew, the young Earl of March, had a far better claim to the English throne than Henry IV, and no doubt Glyndŵr was hoping that Henry Bolingbroke would be killed and Wales made safe with an English king as an ally. His big problem was that Hotspur captured the Scots leader, the Earl of Douglas, at the battle of Homildon, securing England's northern border. With his Scottish problems solved, this allowed Henry IV to plan to finally subdue Wales. Glyndŵr, on his part, wanted complete control of Wales before Henry struck. In 1403, Owain Glyndŵr kept up his blockade of the northern Welsh castles, while attacking Brecon and Dinefwr and trying to displace the Flemings from Pembrokeshire. Glyndŵr's able lieutenants were the three Rhys's; Rhys Gethin (the Fierce), Rhys Ddu (the Black), and Rhys ap Llywelyn. The latter had real reason to hate the invading English – it was his father, Llywelyn ap Gruffydd Fychan, who had been slowly killed in front of Henry IV at Llandovery in the dark days of 1401, for refusing to lead him to Glyndŵr. Later in 1403, a Welsh army was beaten at Laugharne by Lord Thomas Carew. Glyndŵr also sadly learned of the deliberate demolition of his manors and estates at Sycharth and Glyndyfrdwy by the Prince of Wales, Henry of Monmouth, who later won undying fame at Agincourt.

Hotspur, meanwhile, wanted to ransom the Earl of Douglas, but Henry demanded Douglas as a prisoner to secure the ransom. Coupling this insult with the argument over Edmund Mortimer's ransom, Hotspur allied with Edmund Mortimer, Douglas and Glyndŵr to form an army near Chester. At the bloody Battle of Shrewsbury, Hotspur was killed, despite the havoc wrought by his Chester archers. This tragedy happened before he could link up with Glyndŵr. Henry marched through South Wales to Carmarthen, but as in Henry's previous invasion, Glyndŵr would not risk a pitched battle. The king returned to England and within a week Glyndŵr had taken Cardiff, Caerphilly, Newport, Usk and Caerleon. Some French troops were assisting Glyndŵr by now, and his army had grown to at least 10,000 men-at-arms. By 1404, Owain Glyndŵr's main focus was the taking of the seemingly impregnable *'Iron Ring'* of castles in North Wales. He won over the starving Harlech garrison by pardons or bribes when it had only sixteen men left. The great castles of Cricieth and Aberystwyth then fell, and at Machynlleth, in The Parliament House, Owain Glyndŵr held his first Parliament. Envoys came from France and Spain, and an ambassador was sent to

France. Dafydd ap Llywelyn ap Hywel, Davy Gam ('squint-eyed' or 'lame') tried to assassinate Glyndŵr here for Henry IV, and was surprisingly imprisoned rather than cut to pieces. (Davy Gam later was knighted by Henry V as he lay dying at Agincourt). Another Welsh Parliament was held in Dolgellau in 1404. Glyndŵr's small southern army once again pillaged Herefordshire, but the Earl of Warwick was said to have captured the Welsh standard at Campstone Hill near Grosmont Castle. The English pursued the defeated troops, which regrouped and beat Warwick at Craig-y-Dorth, three miles from Monmouth, and chased them back into the fortified town. Glyndŵr was now awaiting a French invasion fleet of sixty vessels under the Count of March, who never landed. Glyndŵr returned to his court at Harlech. In Anglesey, Owain's forces were now beaten at the battle of Rhosmeirch, and also lost Beaumaris Castle. In 1405, Rhys Gethin attacked Grosmont Castle in Monmouthshire, but was defeated. Glyndŵr now sent his almost identical brother, Tudur, and his son Gruffydd to restore the situation by attacking Usk Castle where Prince Henry had established himself. In the battle of Pwll Melyn, two miles away, Tudur and Abbot John ap Hywel of Llantarnam were killed. Gruffydd ab Owain Glyndŵr died later in the Tower of London. Three hundred Welsh prisoners were beheaded in front of the citizens of Usk, as an example to the Welsh insurgents.

After the Welsh defeats at Grosmont and Usk, Henry now offered a pardon to those who renounced the rebellion, and thereby regained full control of southeast Wales. He then gathered an army of 40,000 at Hereford to advance into mid and North Wales. Another English force took Beaumaris and control of Anglesey in the far North. At this time, Archbishop Scrope of York led a rebellion in the North of England. Henry was forced to divert his forces to Shipton Moor where he beat back the Northern rebels. This gave Glyndŵr some breathing space, and he gathered 10,000 men in Pembrokeshire to wait for an invasion fleet of 140 French ships. Around 5,000 Frenchmen arrived at Milford, joined with Glyndŵr and sacked the English/Fleming town of Haverfordwest, but could not take the castle. They next looted Carmarthen and then took over Glamorgan, leaving Glyndŵr back in control of most of Wales. In August 1405, he moved on to attack England, its first invasion since 1066. Henry raced to Worcester to face the threat of Glyndŵr, who was camped on Woodbury Hill. There were some skirmishes, but Glyndŵr had no lines of supply, so he retreated back to Wales, following a scorched earth policy. Henry's starving army was forced to call off the pursuit, freezing as the bitter winter took hold. Again, the terrible weather was blamed upon Glyndŵr's supernatural powers. This had been Henry's fifth invasion of Wales, and still Glyndŵr seemed untouchable. 1406 began with a treaty between the dead Hotspur's remaining Percy family of Northumberland, Earl Mortimer and Glyndŵr. This 'Tripartite Indenture' divided England and Wales between the three Houses, with Glyndŵr possessing Wales and gaining a 'buffer zone' on its borders. At his second Machynlleth Parliament, Glyndŵr wrote to Charles VI of France, asking for recognition, support and a 'Holy Crusade' against Henry for pillaging abbeys and killing clergymen. In turn, Glyndŵr promised the recognition by St David's of the French-based Pope Benedict XIII. (Welsh Parliaments were also held in Pennal, Harlech and Dolgellau). Glyndŵr also asked Papal permission to place two universities, one each in North and South Wales, to build a future for his country. This letter was signed 'Owain by the Grace of God, Prince of Wales', and is in the French National Archives.

However, Henry IV was wasting away through syphilis or leprosy, which enabled his son Henry, the 'English' Prince of Wales to take control of the Welsh campaigns. He beat a Welsh army, killing yet another of Glyndŵr's sons in March, and retook South Wales, fining the landowners heavily to support his thrust into North Wales. North Wales, being fought over for five years, had neither financial nor manpower reserves to support Glyndŵr, but he still held around two thirds of Wales, and major castles at Aberystwyth and Harlech. From this time, he almost disappears from history except for bardic references of him roaming the country. In 1407, Prince Henry besieged Aberystwyth Castle with seven cannon. One, 'The King's Gun' weighed four and a half tons. Rhys Ddu held out and Henry returned to England. Glyndŵr reinforced the castle, while England unfortunately signed a peace treaty with France. In this year, Owain's great ally, Louis of Orleans, had been murdered in mysterious circumstances in Paris.

1408 saw another blow for Glyndŵr. His ally, the old Earl of Northumberland, Hotspur's father, was killed at the Battle of Braham Moor by Prince Henry's forces. The Prince then re-entered Wales, bombarded Aberystwyth into submission, and by 1409 had also taken Harlech, Glyndŵr's last bastion, capturing Glyndŵr's wife and family. Edmund Mortimer, the former enemy who had become his son-in-law in captivity, died in Harlech, fighting for Glyndŵr. The last gasp of Glyndŵr's revolt occurred near Welshpool Castle when a raiding party under Phillip Scudamore, Rhys Tudur and Rhys Ddu was beaten and the leaders captured. After the usual revolting, slow, barbarous executions, Scudamore's head was placed on a spike at Shrewsbury, Rhys ap Tudur's at London, and Rhys Ddu's at Chester. This disgusting ritual torture was never practised by the Welsh when they captured prisoners, but Normans and Plantagenets believed that payment to the church would get them to heaven, whatever their sins. In 1413, the Plantagenet Prince Henry of Wales succeeded as Henry V, and in 1415 offered a pardon to Glyndŵr and any of his men. In 1416, he tried again, through Glyndŵr's remaining son Maredudd, who eventually accepted a pardon in 1421. It thus appears that Glyndŵr was still alive a few years after his last recorded sighting. Gruffydd Young, in the Council of Constance in France, was still working for Owain Glyndŵr in 1415, stating that Wales was a nation that should have a vote in ending the papal schism. Glyndŵr would have been around sixty-five years old at this time, having spent his last fifteen years in constant warfare against the English crown. Glyndŵr's greatest problem had been that he was up against the greatest soldier of his age, Harry of Monmouth, the future Henry V, who within a few years was to win at Agincourt with Welsh archers, and be recognised as the future King of France. Henry cut his teeth against a massively under-resourced Glyndŵr, who had no incomes to pay his troops and relied on volunteers against a vastly superior professional force. However, Owain could still point to a life where he set up his own law-courts and chancery, tried to form the first Welsh universities, summoned parliaments, sent envoys to foreign courts and nominated bishops. However, this battle between the 'Welsh' Prince of Wales and the 'French-Plantagenet' Prince of Wales could have only one ending.

Repressive laws were enacted after the rebellion to stop any future threat from Wales to the English crown. No-one with Welsh parents could buy land near the Marcher towns, own weapons, become citizens of any towns or hold any offices. In lawsuits involving a Welshman and an Englishman, the Englishman decided the verdict and the sentence. Gatherings of Welsh people were forbidden, and an Englishman marrying a Welsh woman became legally Welsh, forfeiting all his rights of citizenship. No Welshman could be a juror. These and many more impositions, on top of the already harsh regime of the Statute of Rhuddlan of 1282, ensured Henry Tudor great popular support in his move to gain the crown of England in 1485. The best summary of Glyndŵr is by the noted English historian, G.M. Trevelyan: 'this wonderful man, an attractive and unique figure in a period of debased and selfish politics'. The French historian, Henri Martin, calls Glyndŵr a man of courage and genius. And J.E. Lloyd puts Glyndŵr into his proper perspective in the Welsh national psyche: 'Throughout Wales, his name is the symbol for the vigorous resistance of the Welsh spirit to tyranny and alien rule and the assertion of a national character which finds its fitting expression in the Welsh language... For the Welshmen of all subsequent ages, Glyndŵr has been a national hero, the first, indeed, in the country's history to command the willing support alike of north and south, east and west, Gwynedd and Powys, Deheubarth and Morgannwg. He may with propriety be called the father of modern Welsh nationalism.' These two decades of fighting against overwhelming odds, of reclaiming Cymru from the Normans, are neglected in all British history books. This British hero has been excised from the history of Britain even more effectively than William Wallace was. The single battle that revived the hopes of independence again, and established Welsh nationalism forever, was at Hyddgen in the foothills of Pumlumon. There are plans to despoil this wonderful place, one of the last wildernesses left in Wales with hundreds of wind turbines. Wales, a much smaller country, with no assets left except tourism opportunities, has possibly ten times the density of wind turbines that England has, despite Wales presently producing over twice the electricity it needs.

GLYNDŴR, CATRIN (1380?-1413) One of Owain Glyndŵr's daughters, she fell in love with his captive Edmund Mortimer, who was captured in battle at Pilleth, and by 1402 they were married. The Glyndŵr family homes at Sycharth and Glyndyfrdwy had been burned by the English, and with their children, she and Edmund moved to the great Harlech Castle, which Glyndŵr's forces had captured. Aberystwyth Castle was besieged from 1407, falling in 1408, and the English brought their siege engines to Harlech. Edmund Mortimer died during the siege in a freezing winter, possibly of starvation, and Harlech was bombarded into submission by 1409. Llywelyn ap Madog ap Llywelyn, the castle's commander had been killed, and the defenders had no supplies or armaments left. Catrin, her three children including Lionel, a claimant to the English and Welsh thrones, her mother Marged and the rest of Owain's family were taken to the Tower. Catrin heard that her father's three greatest lieutenants, Rhys Tudur, Rhys Ddu and Phillip Scudamore had been captured near Welshpool, and had been hung, drawn and quartered, their limbs scattered for display around the kingdom. Their heads were spiked on display at London, Shrewsbury and Chester. After four long years in captivity it was noted that Catrin and two of her children were dead, and they were buried at St Swithin's Church in the City of London. If the plan of Glyndŵr, Percy and Mortimer had been achieved, Edmund Mortimer would have been King of England and Catrin his queen. Lionel Mortimer had more of a claim to the throne that Henry V and could not be allowed to live, so his death in the Tower is unrecorded. A 14-ton block of Welsh bluestone, commemorating Catrin, was unveiled at St Swithin's by Isabel Monnington-Taylor, a descendant of Glyndŵr, in 2001.

GLYNDYFRDWY CASTLE The motte can be seen from the main road near Corwen, and overlooks the Dee. The CADW plaque at the site *reads* 'Near this spot at his manor of Glyndyfrdwy, Owain Glyn Dwr proclaimed himself Prince of Wales on 16 September 1400, so beginning his fourteen year rebellion against English rule.' CADW's civil servants and bosses presumably do not know the difference between a War of Independence against a continuing foreign invasion by barbarians, and a 'rebellion' which generally means a protest against legal authority. This hill, known locally as Owain Glyndŵr's Mount, is actually the remains of the twelfth-century castle motte built to command the route through the Dee Valley. Like the motte nearby at Sycharth, it may have continued in use until the late fourteenth century, but Owain's manor is likely to have been the square moated area below it, and across the field. This would have been defended by a water-filled moat, palisade and gate.

GLYWYSING & GWENT There two kingdoms in southeast Wales were unified briefly under Morgan ab Owain, Morgan Hen (the Old, 930-974) in the name of Morgannwg (Glamorgan), but were broken up on his death:

Kings of Glywysing
Owain ap Morgan 974-c. 983
Owain's brothers c. 983-c. 990
Rhys ab Owain c. 990-c. 1000 jointly with his brothers
Hywel ab Owain c. 990-c. 1043
Iestyn ab Owain c. 990-c. 1015
Rhydderch ap Iestyn c. 1015-1033
Gruffydd ap Rhydderch 1033-1055
Cadwgan ap Meurig of Gwent 1055-1074 who reunited both kingdoms
Kings of Gwent
Nowy ap Gwriad c. 950-c. 970
Arthfael ap Nowy c. 970-983
Rhodri ap Elisedd 983-c. 1015
Edwyn ap Gwriad 1015-1045
1045-1055 Meurig ap Hywel ab Owain of Glywysing, who ruled jointly with his son Cadwgan

1045-1074 Cadwgan ap Meurig, who ruled jointly for some time with Caradog of Gwent
1063-1081 Caradog ap Gruffydd ap Rhydderch of Gwent
1081-1091 Iestyn ap Gwrgan(t) the last King of Morgannwg, which became the Norman lordship of Glamorgan.

GOATS An old Welsh song *Oes Gafr Eto* about coloured goats has made generations of children (and adults) collapse with laughter as it becomes quicker and quicker, and more and more difficult, to call out the colours of the goats. There are still a few feral herds in the wilds of Snowdonia, and a colony of around seventy wild Kashmiri goats has lived on the Great Orme since Victorian times. The mascot of the Royal Welch Fusiliers is a Kashmiri billy-goat, usually called Taffy. The regimental mascot of the Royal Regiment of Wales is also a goat. During the Crimean War, Private Gwilym Jenkins was on night watch, guarding a herd of cattle destined as food for the troops. He had for company a small goat kid, and fell asleep. The kid's bleating woke him up and alerted him to a sneak attack by the Russians. Jenkins sounded the alarm and the regiment was alert to fight off the attack. The goat, and its successors, have led regimental processions ever since, with the official rank and title of Lance-Corporal Gwilym Jenkins, familiarly nicknamed 'Shenkin'.

GOLD Romans mined in Wales for copper, lead, iron and gold, but possibly the main reason for their invasion of Britain was to access Welsh gold. Gold-mining in Dolaucothi, near Pumsaint, is of world importance in the history of prehistoric and Roman technology, and two major aqueducts represent the highest and lowest of nine hydraulic systems. The Celts first found gold here, and the Romans further exploited the site by open cast and gallery workings. It was the most technologically advanced mining site in Europe. A seven-mile aqueduct was channelled along the hillsides to bring water from the rivers Cothi and Annell. The water was stored in tanks cut into the rocks, from which it was sluiced to remove top soil, wash crushed ore and drive simple machinery. About a hundredweight of gold a week was extracted to send to the imperial mints at Lyons and Rome. Visitors to the site can see the strong-room where gold was stored, a cavalry station and the remains of a Romano-Celtic temple, and also go on an underground tour. It is the only place that we know the Romans mined gold in Britain, was one of the Empire's main sources of bullion. It was so important that they built a fort, where the Dolaucothi Arms Hotel now stands. Work stopped around the second century, until an Australian reopened some of the galleries in 1870, and they were worked again until 1939. Dolaucothi was the largest goldmine in the British Isles well before the Romans came, with evidence of Iron Age and Bronze Age technology, and it is thought that most of the gold was extracted before the Romans invaded Wales for its minerals. The National Trust's head of Archaeology, David Thackray, stated that 'this work shows Dolaucothi is a site as archaeologically significant as Stonehenge and Sutton Hoo, which are the National Trust's most important archaeological properties and which are World Heritage Sites.' There are ancient opencast workings there, and it is the only site in Wales marked upon Livy's map of the world. Beatrice Caouuet, leader of an international team of archaeologists, believes that the Romans built their largest network of leats and aqueducts in Britain at Dolaucothi to look for new lodes in the quartz there.

The wedding rings of the British royal family are traditionally made of Welsh gold, which commands a price premium to the public because of its rarity. Dolgellau became Wales' answer to the Klondike in the nineteenth century, when gold was found in the hills above Bontddu on the Mawddach Estuary. Earlier the Cistercian monks at Cymer Abbey on the Mawddach had found small gold deposits in the twelfth century, and the Romans also found evidence of gold in the area. About twenty small mines were working in the area until the onset of World War One. At the Welsh Gold Visitor Centre, near Dolgellau, you can chip away at rocks, but will usually only find iron pyrites, 'fool's gold'. This Gwynfynydd Mine, in Snowdonia National Park, reopened for underground mining from 1981 to 1998 and was the last mine still producing pure Welsh gold, just a few ounces a day. Welsh gold is more precious than platinum, because of

its rarity and difficulty of extraction. Two tons of ore produce just one ounce of gold. Ordinary gold costs £250 an ounce, platinum £650, and Welsh gold £750. It has a slight variation in colour to other gold. Near Pont Dolgefeiliau in Coed y Brenin, Ganllydd, are a nineteenth-century abandoned engine shed and old gold workings, next to the beautiful waterfalls of Pistyll Cain and Rhaeadr Mawddach. Coed y Brenin was the first forest to be deliberately laid out for mountain biking.

GOLDCLIFF On the Caldicot Levels near Newport, land reclaimed from the sea, the Goldcliff Stone records the work of legionaries building the sea wall. It reads: 'The Century of Statorius Maximus in the 1st Cohort (built) thirty-one & a half paces'. In 1113, Goldcliff Priory was founded, and the main drainage ditch nearby is still known as the Monksditch. Hidden in the laminated silts of the Severn estuary foreshore at Goldcliff are 8,000-year-old (Mesolithic) human footprints, recently shown in the TV documentary *Time Team*. It is now part of the extensive Newport Wetlands Reserve which opened in March 2000 as mitigation for the loss of the great Cardiff mudflats caused by the Cardiff Bay Barrage. Giraldus Cambrensis in 1188 described the small cliffs at 'Gouldclyff' as 'glittering with a wonderful brightness'. When the sun shines a bed of yellow mica reflects light to passing ships, giving Goldcliff its name.

GOLDEN MILE Samuel Lewis, in 1833, gives us the origin of the 'Golden Mile' off the A48 west of Cardiff, during the conquest of Glamorgan: 'Rhys ab Tewdwr, Prince of Dynevor, in the year 1080, invaded the territories of Iestyn ab Gwrgan of Glamorgan, and sacked his castles of Dinas-Powis, Llanilltyd, and Dindryvan; but he had no sooner withdrawn his troops than Iestyn retaliated by ravaging Carmarthenshire and Brecknockshire, where he obtained valuable booty. Eineon ab Collwyn, one of the leaders of an unsuccessful rebellion against Rhys, fled for refuge to the court of Iestyn, who entered into a negotiation with him, according to which Eineon was to receive the hand of Iestyn's daughter, and the lordship of Meisgwn, now called Miskin, if he could succeed in engaging for the service of the latter some of the Norman knights with whom he had formerly served abroad under William of Normandy. Eineon departed for London, and easily prevailed on Robert Fitz-Hamon, a near relative of the Conqueror, to come to Glamorgan, with such other knights as he should choose to engage under his command: on the arrival of these auxiliaries, consisting, besides Fitz-Hamon himself, of eleven knights and three thousand men at arms, Iestyn took the field, and commenced active hostilities against Rhys, whom he defeated, with the loss of nearly all his troops, on Hirwaun Wrgan, the extensive common before-mentioned, at the foot of a high mountain about two miles north of the present village of Aberdare, in this county, near the border of Brecknockshire. The Welsh Chronicle, contrary to the opinion of Mr Theophilus Jones and some other writers, states that Rhys fled from the field of battle to Glyn Rhondda, a sequestered valley some miles to the south, where he was taken by Iestyn and beheaded, from which circumstance the spot is said to have been since called Penrhys: his son Goronwy fell in the slaughter, and Conan, son of Goronwy, escaping with a few troops, was drowned, in his flight towards Carmarthen, in the lake of Crumlyn, now an extensive marsh, situated between Briton Ferry and Swansea. Iestyn rewarded his Norman auxiliaries conformably to his engagements, paying them in gold, on a common three miles west of Cardiff, which has ever since been called 'the Golden Mile'; and they marched towards the coast, with the view of embarking for England: but refusing to fulfil his promises to Eineon, the latter hastened in quest of the Norman commander, and, after stating the treacherous conduct of Iestyn, represented to him how easy it would be to obtain possession of the country for himself and his followers. Fitz-Hamon, with his knights, immediately retraced his steps, and was shortly joined by some of the native chieftains, who were exasperated at the tyrannical and unprincipled conduct of Iestyn, who was wholly unprepared to oppose so formidable a confederacy: he hastily collected what forces he could, and awaited the adverse troops on a common in the neighbourhood of Cardiff, where, after a short engagement, his army was totally defeated, and himself obliged to seek safety in flight. Thus was annihilated the British

kingdom of Glamorgan ; and the overthrow of Iestyn having left Fitz-Hamon entire master of the country, that leader proceeded to apportion it among his followers and some of the principal Welsh chieftains, reserving for himself the towns of Cardiff, Kenfig, and Cowbridge, with the surrounding domains.'

GOLF Dai Rees was the captain of the European team to beat the USA for the first time in The Ryder Cup in 1957, and Ian Woosnam was the world's leading golfer in the order of merit, after he won the American Masters' Tournament in 1991, and the World Match-Play Championship in 1987 and 1990. He also won the European Open in 1988. Wales also won the World Cup in 1987 (Woosnam and Llwelyn) and 1991 (Woosnam and Price).

GOODRICH CASTLE Although in Herefordshire, this is a typically strong castle of the Welsh Marches, dating from 1086 onwards. Overlooking the Wye, it saw action in the Civil War.

GOP CAIRN AND CAVES, TRELAWNYD This enormous cairn-mound in Flint is the second biggest artificial mound in Britain, after Silbury Hill near Avebury. 820ft above sea level, it still stands 46ft tall, and the limestone blocks were placed in the oval mound about 3,000 BCE. The Gop was formerly known as Kopraleni and Copperleiny, 'the hill summit of Leni'. However, it may mean 'Copa'r goleuni' meaning 'the summit of light' (reflected from the limestone) or 'the summit of Paulinus', referring to Suetonius Paulinus. Local tradition maintains that he defeated Boadicea here in 61 CE, and it is the sighting place of the ghosts of marching legionaries and Boadicea's chariot. Further down the hill are caves used by the people of the New Stone Age who built the cairn. Burials here date from 6000 BCE.

GOULD, A.J. ('MONKEY') (1864-1919) Newport-born, his nickname came from his childhood penchant for climbing trees. He played at centre and fullback for Newport for sixteen years, and was possibly the first fullback to run with the ball and score tries instead of kick it. He was Wales' most capped centre until Steve Fenwick in 1980, playing twice at full back and twenty-five times as centre. By 1896, aged twenty-three, Gould had played more first-class matches, scored more tries and dropped more goals than any other player on record. There are no records prior to 1886, but from 1887-1898 he scored 136 tries and 42 drop goals. No records are available for his penalty goals and conversions. He captained Wales several times, despite taking a year off to go to the West Indies in 1891. Five of his brothers also played for Newport, two also for Wales. His memorial bed in the Royal Gwent Hospital is inscribed 'To the memory of Arthur Gould – Greatest of Rugby Football Players.' He may invented the four three-quarters concept in rugby union, and the 1905-06 New Zealanders overcame all opposition except the Welsh team containing the legendary three-quarter line of Morgan, Nicholls, Gabe and Llwelyn. The All-Blacks, with three three-quarters, one half and two five-eights lost by try to nil and the game was revolutionised. Gould's funeral was the biggest seen in Wales until the death of David Lloyd-George.

GOVERNMENT OF WALES BILL, 2006 From May 2007, the Wales Assembly Government has been granted law-making powers in certain areas such as health and education, but not others such as security. The Bill elucidates the distinction between the legislature and the executive, making the First Minister a royal appointment instead of a delegate of the Assembly. The UK Government still can intervene on contentious areas such as water supply, and the bill does not go as far as the recommendations of the Richard Commission, which called for a bigger primary-law making body. The Wales Assembly Government still does not have the powers of its Scottish equivalent, because Scots have always held the major posts in recent Labour governments. The majority of the population do not know that 'Tony' Blair was born in Scotland and went to the most famous Scottish public school, Fettes. A third of the posts in Blair's first Cabinet were Scots, allowing Scottish concessions to be made: Anthony Charles Lynton Blair, Gordon Brown,

Alistair Darling, George Robertson, Donald Dewar, Derry Irvine, Gavin Strang and Robin Cook. With eight Welshmen in the Cabinet perhaps Wales might have had a little more influence in its own affairs.

GRACE DIEU ABBEY A Cistercian abbey built in 1226 by John, Lord of Monmouth, in 1233 it was despoiled by the Welsh as it was on their land, and then rebuilt elsewhere. Monks from Abbey Dore settled there. Edward III gave the monastery to the Hermitage of St Briavel, in the Forest of Dean, and it moved to the present site, its second move. This site was given in the Reformation by Henry VIII to Thomas Herbert and William Bretton. On its dissolution, there were only two monks. Some books state that the site is 'lost' but the last monastery was at 'Trody', on the right bank of the stream, west of Monmouth. This is on the Trothy Brook and probably in the lower meadows of Parc Grace-Dieu.

GRAIG LWYD AXE FACTORY, PENAMAENMAWR This 'grey rock' Neolithic stone axe factory on the North Wales coast is situated on an extinct volcano. The fine-grained volcanic stone mined there could be broken off, roughly shaped with a hammerstone and then polished on a grindstone similarly to flint. These axes have been found all over Britain, many with minimal signs of wear, indicating that they were highly prized, and probably ceremonial in many instances. They date from around 3000 BCE onwards.

GRANGER, PROFESSOR CLIVE (1934-) A world leader in econometrics, this was recognised by his Nobel Prize for Economics in 2003 (shared with the American Robert Engle). From Swansea, and now based in New Zealand, the body of work for which he won his Nobel Prize dates back to 1975.

GRASSHOLM, YNYS GWALES Ynys Gwales has the second largest colony in the world of gannets, 60,000 screaming dive bombers constantly vanishing into the seas. The island is owned by the Royal Society for Protection of Birds and was its very first sanctuary. Ronald Lockley had returned to Wales in the mid-1930's to take out a lease on Skokholm, and pioneered studies of the puffin, shearwater and stormy petrel. His work helped gain recognition for the need for the Pembrokeshire Coast and islands to become a National Park. The first bird observatory was established on the island by Lockley in 1933. Petrels and Shearwaters, like Puffins, live in burrows there, but only fly into them at night. Shags, Razorbills and Guillemots also breed on this twenty-two acre lump of basalt rock. Six miles off Grassholm is the Smalls Lighthouse, first built in 1776. In the vicious winter of 1800-1801, one of the two lighthouse keepers died. The survivor understandably did not want the decomposing body in either of the two small rooms. He therefore made a makeshift coffin and lashed it to the rails outside. It was all of three months before he could be relieved, by which time he was insane. After this, there were always three keepers in UK lighthouses. The present lighthouse was built in 1861, 126ft high, and assembled and shipped from Solva in pieces to the Smalls reef.

GRAVESTONES In St Andrews Church in Presteigne (Llanandras) is a gravestone marking the death in 1805 of Mary Morgan, a seventeen-year-old sentenced to death for the murder of a newborn illegitimate child. The jury included the child's father, and the unanimous verdict meant that the girl was executed before the arrival of a reprieve from London. The original gravestone accusing her of 'sin and shame' still stands, but the people of Presteigne put another gravestone facing it, engraved 'He that is without sin among you, let him first cast a stone at her', from the *Gospel of St John*. In the beautiful ruins of Strata Florida Abbey, near the resting place of the bard Dafydd ap Gwilym, is a Georgian tombstone to the amputated left leg of Henry Hughes, the rest of whom emigrated to America. Montgomery's churchyard contains 'The Robber's Grave'. John Davies was hanged in 1821 for sheep stealing. He was the bailiff on Oakfield Farm to a wealthy widow, but Thomas Pearce wanted to marry her, and Robert Parker coveted the farm.

They framed John Davies, and he protested his innocence. From the scaffold he cursed his accusers, predicting that for 100 years no grass would grow on his grave. Records show that the prophecy was true. Soon after Davies' death, Pearce became an alcoholic and died in a quarry explosion, and Parker died of a wasting disease. A man who planted a rose bush on the bare earth died soon after. On the gravestone of R. J. Lloyd Price in Bala is chiselled a 'thankyou' card to the racehorse Bendigo. It won the Cambridgeshire Stakes and restored much of Squire Price's fortune.

The 10-ton 1879 stone slab that covers the Vaynor grave of Robert Crawshay, the vicious owner of Merthyr Ironworks, pleads '*GOD FORGIVE ME*' – perhaps he realised the terrible suffering he inflicted on his workers. In the same graveyard is a sad epitaph to a rejected lover:

HERE LIES THE BODY OF GRUFFYDD SHON
COVERED HERE WITH EARTH AND STONE
YOU MAY SWEEP IT UP OR LEAVE IT ALONE,
IT WILL JUST BE THE SAME TO GRUFFYDD SHON

The marvellous Norman Ewenni Priory Church has a tablet to David William, the village blacksmith, who died in 1742:

My sledge and hammer lie decay'd
My bellows too have lost their wind
My fires extinct, my force allay'd
My vice is in the dust confin'd
My coal is spent, my iron's gone
My nails are drove, my work is done.

GREAT LITTLE TRAINS OF WALES Wales is famous for its narrow gauge steam railways, many built for transporting slate to the sea ports.

Talyllyn Railway – this runs from Tywyn to Abergynolwyn in Snowdonia. Passengers can alight at Dolgoch to see the Dolgoch Falls. This railway has operated continuously since its opening in 1865. This former quarry train runs seven miles on 27in gauge around the foothills of Cader Idris. It is the oldest narrow gauge railway in the world, and formerly carried slate to Tywyn. When it came to the end of its working life in 1951, a group of enthusiasts, including the author of the *Thomas the Tank Engine* stories, bought the railway and kept it going. It carried three quarter of a million passengers in 1995.

Ffestiniog Railway – the oldest small railway still running in Wales, it climbs thirteen miles through wonderful scenery from Porthmadog to the slate town of Blaenau Ffestiniog. On 23.5in gauge, it links two British Rail lines, and passes in a long tunnel through a mountain of slate. From 1832 the trains ran down to the coastal port by gravity, before being hauled back up to the slate quarries by horses. In October 1863, the *Princess* and *Mountaineer* locomotives entered service and were followed by the *Prince* and *Palmerston*. Also in 1863, the Board of Trade gave permission for passenger trains to run along the railway, the first on a narrow gauge in Britain. In 1870, some of the leading railway engineers of the time and the Imperial Russian Commission saw the first demonstration of the Fairlie double-engine *Little Wonder*, the forerunner of a new generation of Ffestiniog locomotives. The decline of the slate industry and World War Two led to the line closing in 1946, but the line was restored from 1954, and the railway carries over 300,000 passengers each year.

The Welsh Highland Railway – this has been restored for a short section from Porthmadog on 24in track, and stages exclusive *'Ivor the Engine'* days. The Millennium Commission gave a £4.3 million grant to help restore the service through the heart of Snowdonia, between Porthmadog and Caernarfon. The route will eventually be twenty-five miles of some of the most stunning scenery in Europe.

Snowdon Mountain Railway – from Llanberis to the summit of Snowdon, this is the only rack and pinion railway in Britain, on 27.5in gauge. Completed in 1896, the one in five climb takes the seventy-year-old engine and carriages about an hour. Its first engine came off its track, so the existing locomotives are known as Numbers 2, 3, 4 and 5.

Llanberis Lake Railway – a short 24in gauge section along Llyn Padarn has been restored, on what used to be the slate line to Port Dinorwig on the Menai Straits.

Bala Lake Railway – from Bala to Llanuwchllyn, following the lakeside for four miles on 24in gauge, on what used to be the Bala-Corwen line.

Fairbourne and Barmouth Steam Railway – along sand dunes to the mouth of the Mawddach with a connecting ferry to Barmouth, this has the narrowest of narrow gauges, at just over 12in. It was built as a horse-drawn tramway to carry building materials for the construction of Fairbourne, and steam was introduced in 1916. It is the last narrow-gauge boat train in Europe.

Brecon Mountain Railway – from Merthyr Tydfil up into the Beacons, almost four miles of 24in track on the bed of the former Brecon and Merthyr Railway.

The Welshpool to Llanfaircaereinion Light Railway Line – runs twelve miles, and was built in 1903 to enable local people to get their produce to Welshpool market. It descends nine miles to the River Banwy on 30in gauge.

Great Western Railway – from Llangollen along the Dee Valley, on standard 56.5in gauge, this runs through the gorge of the Dee, and is being extended along the old Barmouth-Ruabon line.

The Vale of Rheidol Railway – this has been taking passengers from Aberystwyth to the beauty spot of Devil's Bridge since the early 1900's. This is a superb twelve-mile run on 13.5in gauge.

The Teifi Valley Railway – runs a short distance near Newcastle Emlyn.

The Pontypool and Blaenafon Steam Railway – runs three quarters of a mile between two restored platforms, and the 110-year-old Crane Street Station at Pontypool has been moved and rebuilt, brick by brick.

Barry Island Railway – runs steam locos for two miles on parallel track to the main line.

GREAT REVIVAL 1904 Evan Roberts from Llwchwr (Loughor) was the inspiration of one of the world's greatest Protestant revivals, and within a few months over 100,000 people had been converted. It was probably the mainspring of Pentecostalism, and had a huge influence on the African American Church, sparking the Azusa Street Revival in 1906 in Los Angeles. It has been stated that around a quarter of the world's Christians (mainly Pentecostals and Charismatics) are Christians as a direct result of this 1904 revival.

GREAT UNREST 1908-1914 The term used for the years that saw the Cambrian Combine Strike, the Tonypandy Riot, disputes in the Cynon Valley, and riots in Llanelli during the railwaymen's strike and suffragette protests.

GRIFFITH, SAMUEL WALKER (1845-1920) He was born in Merthyr Tydful and studied at Sydney University. He served as Prime Minister and Chief Justice of Queensland, and had the major input into drafting Australia's Commonwealth Constitution in 1900. As the first Chief Justice of the succeeding High Court of Australia from 1900 to 1919, he had a major and lasting influence on the interpretation of law in the 'new' country. His place in Australian legal history parallels that of John Marshall in the United States of America.

GRIFFITH, D.W. (1875-1948) The father of the epic movie, David Lewelyn Wark Griffith – 'DW' – used to boast of his Welsh ancestry from Gruffydd ap Llywelyn, King of Wales. Born in Kentucky, a favourite domicile of expatriate Welshmen, he made hundreds of short films before his masterpieces *The Birth of a Nation* (1915) and *Intolerance* (1916). Other major films made between 1918 and 1922 were *Hearts of the World*, *Broken Blossoms* and *Orphans of the Storm*.

Hearts of the World broke new ground by showing war scenes actually filmed at the front in World War I. Griffith revolutionised cinema techniques, innovating the fade-in, fade-out, close-up and flashback. He has been called *'the pioneer of cinema'* and *'the father of film.'* Griffith co-founded United Artists with Charlie Chaplin, Douglas Fairbanks and Mary Pickford.

GRIFFITH, SIDNEY (1715?-1752) Known as 'Madam Griffith', she was prominent in the Methodist Revival, accompanying both HOWEL HARRIS and DANIEL ROWLAND, but failing to reconcile them. Her substantial fortune was expended on the *'Revival'*, including a huge contribution to help set up Harris's Trefeca commune. She regarded herself as the spiritual mother and the prophetess of the Welsh Methodist movement.

GRIFFITHS, ANN (1776-1805) She converted to Nonconformism in the Pendref Congregational Chapel in 1796. Ann wrote seventy hymns in her small farmstead, Dolwar Fach, at Dolanog near Llanfyllin. A hymn-writer, mystic and theologian, she died tragically early at the age of twenty-nine. Saunders Lewis called one of her hymns 'one of the greatest religious poems in any European language'. There is a memorial chapel in Dolanog, and she is buried in Llanfihangel-yng-Ngwynfa. One of her best-known verses, translated into English, is:

Make me as a tree planted, Oh! My God,
Sappy on the bank of the river of the waters of life:
Rooting widely, its leaves no longer withering,
Fruiting under the showers of a divine wound.

GRINGO REVOLUTIONARY – CAREL AP RHYS PRICE (1876-1955) After public school, Pryce he spent some time in a bank before going to South Africa to join the British South African Mounted Police, transferring to the Natal Light Horse, being decorated for his part in the Relief of Ladysmith. Service in the Imperial Light Horse and the South African Constabulary ended his ten years in conflicts in South Africa and he moved to Canada and signed up with the 6th Duke of Connaught's Own Rifles. Next, a penniless drifter in Los Angeles, Pryce eventually became generalissimo of the Magonista revolutionaries in Mexico, capturing Tijuana. After a trial in Los Angeles, he was a Hollywood film star before joining the Canadian Expeditionary Force in World War I, and transferring to the 38th (Welsh) Division as an artillery officer. Major Pryce was awarded the DSO, and after the war seemingly vanished for four years, quite possibly serving with the Black and Tans in Ireland, before resurfacing with many of their men in the Palestine Gendarmerie. John Humphries recounts his amazing adventures in *Gringo Revolutionary* (2005).

GROSMONT CASTLE This was probably founded by Earl William fitz Osbern in his invasion of South Wales in 1071, and he was killed in battle in that year. The present castle is mainly twelfth and thirteenth centuries, and its owner Payn fitz John was killed in 1137 fighting the Welsh.

GROSMONT, BATTLE OF, 1233 The castle's owner, Hubert de Burgh and Henry III were beaten at Grosmont by a combined Anglo-Welsh force. The Anglo-Welsh had laid siege to the castle, and were trapped between a relieving force from Hereford and the castle's defenders.

GROSMONT, BATTLE OF, 1405 Glyndŵr's forces under Rhys Gethin were defeated on 11 March, just before their next defeat at Pwll Melyn.

GROVE, SIR WILLIAM ROBERT (1811-1896) From Swansea, after studying law, he invented the Grove Voltaic Battery, the original 'fuel cell' in 1839. Appointed a FRS, he became Professor of the London Institution, writing *Correlation of Physical Forces*. In this, he anticipated the

General Theory of the Conservation of Energy. Returning to legal work, this remarkably rounded character became a High Court judge, dying in 1896. Instead of harmful gases, fuel cells produce water, and have been used with a new generation of 'hydrogen-powered' cars, backed by US Government funding. Its Energy Secretary, Spencer Abraham predicted that they would be on sale by 2020. Fuel cells are used by NASA to power onboard systems for its Apollo and Shuttle programmes, and Grove is known as 'the Father of the Fuel Cell.'

GRUFFYDD AP CYNAN (1055-1137) From Gruffydd ap Llywelyn ap Seisyllt's death in 1063, there was almost permanent fighting between the Welsh princes. The laws of 'Gavelkind' meant that kingdoms and princedoms were constantly being broken up between all male heirs, legitimate and illegitimate. Gruffydd ap Cynan, grandson of Iago of Gwynedd, landed in Anglesey to reclaim his lands from Trahaearn, in 1075. (His father had died fighting with Gruffydd ap Llywelyn against Harold of Wessex in 1063, when Gruffydd ap Cynan was just eight years old). He defeated Trahaearn at the Battle of Waederw and recovered Meirionydd as well as Gwynedd, but there was a revolt against him because of the conduct of his Irish mercenaries. Gruffydd tried to regain power again in 1076, but was forced off Anglesey. In 1081, he returned once more, allying himself with Rhys ap Tewdwr to try and heal the land after the depredations of the Earl of Chester and vicious Robert of Rhuddlan. The carnage in Wales only relented with the victory of Rhys ap Tewdwr (of the royal house of Deheubarth), and Gruffydd ap Cynan (of the royal house of Gwynedd) at the battle of Mynydd Carn in 1081, when Trahaearn was killed. William the Conqueror, on a pilgrimage to St David's in 1081, recognised Rhys ap Tewdwr's right to Deheubarth. However, in his attempts to gain the throne of Gwynedd, Gruffydd ap Cynan was captured by trickery by Hugh the Fat, Earl of Chester and held as a prisoner in chains at Chester for twelve years. Hugh the Fat had bribed Meirion Goch to bring Gruffydd to a meeting in 1082, where peace might be arranged between the Welsh and Normans.

In 1094, the Earl of Chester had ordered that Gruffydd be displayed in chains at Chester market place so the people could see the fall of the great Prince of Gwynedd. In the bustle of the market, Gruffydd was rescued by Cynwrig Hir. A blacksmith knocked his chains off and the small rescue party managed to escape to Aberdaron, and sail back across to Ireland. Gruffydd soon returned to Wales, with his fellow prince, Cadwgan ab Bleddyn. He ravaged parts of Shropshire and Cheshire, and defeated the Normans in the woods of Yspwys. William II (William Rufus) invaded Wales in 1095 to restore order, but the Welsh retreated to the hills, and William returned to England. In 1096, Gruffydd defeated Norman armies at Gelli Trafnant and Aber Llech. William led another fruitless invasion in 1097 against Gruffydd and Cadwgan. In 1098 the earls of Chester and Shrewsbury campaigned against Gruffydd and Cadwgan, and invaded Anglesey, but the Welsh lords fled to Ireland. Norman cruelty led to a fresh revolt, and just then the Scandinavians descended upon Anglesey. The earls were beaten on the banks of the Menai River by the force led by Magnus Barefoot, King of Norway, who personally killed Red Hugh, Earl of Shrewsbury. Gruffydd now moved to restore and consolidate his Gwynedd power base as the Normans retreated, reigning over Anglesey, Caernarfon and Meirionydd.

In 1114, King Henry I invaded with three forces; in South Wales under Strongbow; in North Wales under Alexander of Scotland, and an army under himself against Powys. Gruffydd submitted to Henry, and promised to give up GRUFFYDD AP RHYS, another patriotic leader, in order to keep the peace, who quickly fled to Aberdaron. A boat then took him to the safety of the great forest of Ystrad Tywi in Deheubarth. Gruffydd ap Rhys was the son of Rhys ap Tewdwr, the co-victor of Mynydd Carn. The *Chronicles* tell us that Gruffydd quietly sent a messenger to Pembroke Castle to warn Nest that her brother's life was in danger. Gruffydd ap Rhys later married GWENLLIAN ferch Gruffydd ap Cynan in Ystrad Tywi. Gruffydd ap Cynan ruled Gwynedd quietly until 1121, when he moved with King Henry quickly to take over Powys, which was riddled with internal disputes. He later took over Deheubarth. Gruffydd's sons Owain and Cadwaladr cemented his grip on most of Wales. Gruffydd now ruled over a peaceful Wales until his death in 1137. The work of some poets of his time is preserved in *The*

Black Book of Carmarthen, and the court poetry of his bard Meilyr survives. His biography was written just twenty years after his death, declaring Gwynedd to be the 'primus inter pares' ('first among equals') of Welsh kingdoms. Gruffydd was buried in Bangor Cathedral to the left of the high altar, and his son, the heroic poet-prince Owain Gwynedd succeeded peacefully. Gruffydd ap Cynan's daughter Gwenllian was executed by the Normans after the battle of Maes Gwenllian. Her son, The Lord Rhys, RHYS AP GRUFFYDD fought with OWAIN GWYNEDD against the Normans, and took over leadership of Welsh resistance upon his death. Thus Gruffydd's descendants carried on the fight for Wales for sixty years after his death, to the death of Rhys ap Gruffydd in 1197. Just thirteen years after this, Welsh leadership had passed to Llywelyn the Great, of the House of Gwynedd. In 1485, Gruffydd ap Cynan's descendant, Henry Tudor, became the first Welsh King of England.

GRUFFYDD AP LLYWELYN AP SEISYLL (1007-1063) Royal succession was important in Welsh history. Cunedda (*c.* 440 CE) established the main tree of descent, dividing Wales between his eight sons, whereby Meirion received Meirionydd, Ceredig had Ceredigion, etc. In line from Cunedda were Maelgwn Gwynedd (died 547), Cadwaladr ap Cadfan (defeated by Offa of Mercia in 634), Rhodri Mawr (who united Wales against the Norse invaders, and died in 878), Hywel Dda (who established the Laws, and died in 950), and Gruffydd ap Llywelyn. Maredudd ab Owain ap Hywel Dda briefly recreated the Kingdom of Wales from 986 to 989, after the schisms that followed his grandfather's death around 950. Later, Llywelyn ap Seisyll ruled Gwynedd from 1018 to 1023, and had defeated the Prince of Deheubarth to establish himself as King of Wales. Llywelyn's mother, Angharad, was a great-granddaughter of Hywel Dda. Llywelyn was killed in 1023, through the jealous treachery of Madog, Bishop of Bangor. Anarchy again restarted upon his death, with all the Welsh princes reasserting their independence. Llywelyn's son, Gruffydd ap Llywelyn, was also Maredudd ab Owain's grandson (on his mother, Angharad's side), with a major claim to the throne, but had to flee to France, where he stayed for sixteen years. *Brut y Tywysogion (The Chronicles of the Princes)* records that between 950 and 1100, twenty-eight Welsh princes met violent deaths and four were blinded. In a hundred years, nearly fifty Welsh rulers were tortured, incarcerated, murdered or slain in battle. Wales was racked by internal warfare and invasions by the Mercians until Gruffydd returned from France, and beat Earl Leofric (Lady Godiva's husband) at Rhyd y Groes (near Welshpool) on the Severn in 1038. In 1039, he killed Iago ab Idwal to regain Gwynedd and gain Powys. He ravaged Ceredigion and carried off the wife of its prince Hywel ab Edwin.

Gruffydd then gathered forces and won a battle at Pencader in 1041 to control Ceredigion, and won a battle at Newport in 1044 to gain southeast Wales, Gwent. Also in 1044, he killed Hywel ab Edwin at the battle of Carmarthen, when Hywel had allied with Danes to gain his revenge for the abduction of his wife. With control of South Wales, Gruffydd now turned aggressively on the Saxon invaders. In 1052 he crushed the Saxons and their Norman mercenaries near Leominster. He caused the death of Gruffydd ap Rhydderch, to gain Deheubarth in 1055. Gruffydd was now master of almost all of Wales. 1055 was an eventful year. Harold of Wessex, son of Earl Godwin, ensured that the Earldom of Mercia went to his brother. The deposed Earl, Leofric's son Aelfgar, allied with Gruffydd and Gruffydd married his daughter, Ealdgyth. The Mercian-Welsh allies burned Hereford, and Gruffydd took possession of Whitford, Hope, Presteigne, Radnor, Bangor-Is-Coed and Chirk, beating a small Saxon army. These lands, across Offa's Dyke, had been in Saxon possession for 300 years until the border stabilised. Bishop Leofgar of Hereford assembled a mixed force of Norman settlers and Saxon-English. He crossed the Dyke, but was killed by Gruffydd and his army was destroyed in 1056. Gruffydd had settled his court at Rhuddlan, an area heavily settled by Mercians, and in northeast Wales now reconquered large parts of the Earldom of Chester around Offa's Dyke, including much of Flintshire and Denbighshire.

In 1056-1057 Gruffydd drove Cadwgan ap Meurig out of Morgannwg, to control the last princedom. Gruffydd ap Llywelyn had become the only Welshman ever to rule over the whole of Wales. From 1057 until his death in 1063, all of Wales recognized his kingship. In the same year,

Aelfgar needed Gruffydd's help to regain Mercia again, and in alliance with the Viking Magnus Barefoot's fleet, they triumphed. However, Harold of Wessex, one of the greatest generals of the time, had been occupied defeating MacBeth in Scotland and uniting Wessex, Mercia, East Anglia and Northumberland, for eight years, before he unfortunately turned the Saxon war machine of the House of Godwinsson against Gruffydd. Gruffydd's brutality against rival Welsh families was well-known – he defended it as 'blunting the horns of the progeny of Wales so they do not wound their mother' (Walter Map's *De Nugis Curialum* of 1180). Thus, when Harold and his brother Tostig of Northumbria attacked Wales by land and sea, much support faded away and the other royal houses saw the opportunity to reclaim their princedoms of Deheubarth, Morgannwg, Powys and Gwynedd. It was winter, and Gruffydd's 'teulu', or bodyguard, had returned to their lands for the winter, not expecting any attack. Harold feinted to attack from Gloucester, and raided the South Wales coast with a fleet based in Bristol. Harold then made a long forced march with lightly armed troops to the north (similar to his superb march from the Battle of Stamford Bridge in Yorkshire to Hastings three years later). Most of Gruffydd's forces were separated from him, still in south Wales expecting an attack from Gloucester. He had been caught out by the fast-moving Saxons. Harold struck so rapidly at Rhuddlan, Gruffydd's seat of government, that Gruffydd only just escaped by sea. He was pressed back towards Snowdonia, and a reward of 300 cattle was offered for his head. He was killed by one of his own men, Cynan ap Iago, according to the *Ulster Chronicle* (his father Iago ab Idwal of Gwynedd had been killed by Gruffydd). The king's death on 5 August 1063 had been made possible by the treachery of Madog, the same Bishop of Bangor who had betrayed Gruffydd's father, Llywelyn, forty years earlier.

Gruffydd's head was carried to Harold, who married Gruffydd's widow Ealdgyth and made Gruffydd's brothers his regional commanders in Wales. Harold refused to pay the traitor Madog, and Madog's ship was sunk carrying him to exile in Ireland. Harold did not annexe any Welsh land, and in part because of this victory, he was elected King of England over the claims of Edward the Confessor's nephew. Soon the Saxon enemy was to be replaced by a far more powerful force – the Normans. The *Bruts*, the *Welsh Chronicles*, lamented Gruffydd as *the* 'head, shield and defender of the Britons... the man erstwhile thought invincible, the winner of countless spoils and immeasurable victories, endlessly rich in gold and silver and precious stones and purple apparel.' The *Anglo-Saxon Chronicle* recalls Gruffydd ap Llywelyn as 'King over all the Welsh race.' Harold went on to Hastings in 1066, and the Saxons of England were completely under the Norman yoke by 1070. However, Wales kept its independence against the Normans for two centuries, until the execution of Prince Dafydd in 1283, and the 1284 Statute of Rhuddlan. From then on, the Welsh were relatively subdued until the Glyndŵr rebellion gave independence again for a decade from 1400. Then, in 1485, the Welsh Tudors took over the English crown from the Plantagenets.

GRUFFYDD AP RHYS (d. 1137) Following the killing of his father Prince RHYS AP TEWDWR at BRECON in 1093, Deheubarth was taken over by the Normans, and young Gruffydd fled to safety in Ireland. He returned around 1113, and traveled around secretly raising followers. From 1116 he was strong enough to begin attacking a number of Norman castles and towns. However, his ambitious attack on Aberystwyth Castle was defeated, and he came to terms with Henry I, who allowed him to rule Cantref Mawr, a portion of his father's kingdom. unfortunately, local Norman lords did not recognize his suzerainty and he was again forced to flee to Ireland in 1127. In 1136 Gruffydd joined with his brother-in-law Owain Gwynedd and Cadwaladr, the sons of Gruffydd ap Cynan, in a rebellion against Norman rule. While he was away fighting in Gwynedd, his wife Gwenllian ferch Gruffydd raised an army but was defeated and executed at Kidwelly (Cydweli). Gruffydd ap Rhys, with Owain Gwynedd and Cadwaladr, gained a massive victory over the Normans at Crug Mawr in Cardiganshire later that year. In 1137 Gruffydd gained more ground in Dyfed, but died shortly afterwards. It seems he was deliberately poisoned, possibly by a Norman infiltrator. He had four sons by Gwenllian, Maredudd, Rhys,

Maelgwn and Morgan (who was executed with Gwenllian). Gruffydd also had two older sons by a previous marriage, Anarawd and Cadell, and at least two daughters, Gwladus and Nest. He was followed as Prince of Deheubarth by his eldest son, Anarawd. His sons, Cadell, Maredydd and RHYS AP GRUFFYDD (later known as The Lord Rhys.) all ruled Deheubarth in turn. Oddly, the *Oxford Companion to British History* (2002) calls GRUFFYDD AP RHYS 'the pretender to the throne of Deheubarth'.

GUEST, LADY CHARLOTTE (1812-1895) She married the ironmaster of Dowlais, Sir Josiah John Guest, the first MP for Merthyr Tudful. She helped in the welfare of his 12,000 workers, especially in the provision of schools and a clean water supply, but her main contribution to Wales is her translation of the *Mabinogion*, assisted by Thomas Price ('Carhuanawc'), published at Llandovery from 1838-1849. This brought the stories to a huge new audience, across Europe. She met Charles Babbage, inventor of the 'Analytical Engine', the world's first computer, and noted in her diaries 'He feels how much his invention is beyond the power of the age to appreciate, and this mortifies him more than it should do.' After her husband's death, she managed the Dowlais Works successfully and remarried. Her fabulous porcelain collection was bequeathed to the Victoria and Albert Museum. She had ten children in thirteen years, and the visiting schools she developed, with new teaching methods, have been called 'the most progressive in the industrial history not only of south Wales, but of the whole of Britain in the nineteenth century.'

GUILSFIELD HOARD, MONTGOMERYSHIRE This weapon hoard of over 100 objects largely comprises spearheads, spear-butts and scabbards for swords. Found near Crowther's Camp, it is one of the most important British hoards belonging to the late Bronze Age metalworking industry. Items can be seen in the National Museum of Wales.

GUTO NYTH BRÂN (1700-1737) Every New Year's Eve, there is a 6 km Race in Mountain Ash, with international athletes, to commemorate the eighteenth-century shepherd Guto Nyth Bran, who died after running twelve miles in fifty-three minutes. His death at the age of thirty-seven was attributed to being slapped on the back after winning the race. It was said that he could beat horses in races, keep up with hounds, and out-run a hare. A broken heart features on his gravestone in the churchyard of St Gwynno at Llanwynno, where most of the inscriptions outside the church are in Welsh. Most of those inside are in English.

GWAED ERW, BATTLE OF, 1075 In Gruffydd ap Llywelyn's first invasion of Wales, he defeated Trahaearn ap Caradog of Powys in Meirionnydd, after killing Cynwrig ap Rhiwallon, an ally of Trahaearn's who held Llŷn. Gwaed Erw means 'bloody acre' and it was fought in a 'narrow glen'.

GWENALLT (1899-1968) The Bardic name of David James Jones, imprisoned for being a conscientious objector in the Great War. He won the 'Chair' in 1926 and 1931, and his poems combine pacifism, socialism, Christianity and intense nationalism. Some of his later poems show his anger at the blackening of the valleys and the degradation of its workers.

GWENFREWI, SAINT (WINIFRED) (*c.* 615-660) Prince Caradog ab Alan, from Hawarden, tried to ravish her and she fled towards a church for sanctuary. Because he had been spurned, he cut off her head outside the church door. The earth then swallowed up Caradog. St BEUNO, her uncle, restored her head to her body, and she became a nun at Gwytherin in Denbighshire. St Winifred's Well at Holywell was once the most important in Britain, and has over 1,300 years of unbroken pilgrimage, the longest in Europe. (The site at Lourdes dates from only 1828). The remarkable stone shrine at Holywell was endowed by Henry VII's mother in 1490 and somehow escaped the destruction of the Reformation, possibly because she had been Henry

VIII's grandmother. Richard I (The Lionheart) and Henry V were patrons of the well, which became one of the greatest shrines in Christendom. It was visited by Henry V, Edward IV and Henry VII. St Winifred has two commemorative days in the Calendar of the Saints, 22 June for her martyrdom and 3 November for her second death. In 1138 her relics were moved from Gwytherin to Shrewsbury Abbey. According to *The Chronicle of Ystrad Fflur*, '... priests were forbidden to marry and the monks from Shrewsbury stole Gwenfrewi's bones.' This practice, like the removal of Dyfrig's remains from Bardsey Island to Llandaf Cathedral, was a particularly Norman practice. They wished to give their churches a holier aura and greater status. Ellis Peters, in her *Brother Cadfael* stories about the Welsh monk in Shrewsbury (Pengwern), sometimes uses this as a plot-line. People even attended the well during the Reformation, when pilgrimages were punishable by death, and the Catholic King James II came here to pray for a son and heir in 1686, the last royal pilgrimage in the British Isles. Since 1873 the well has been cared for by resident Jesuits. On the nearest Sunday to 22 July, pilgrims still come to see a relic, part of St Winifred's thumb bone, and enter the well three times to cure their ailments. This is perhaps a throwback to the Celtic rite of triple immersion, three being the holiest number for the Celts. (St Myllin, in the sixth century, was the first person in Britain to baptise by immersion in water). The spring had been used by the Romans, who used the waters to cure gout and rheumatism. The spring, although smaller than in earlier times, is the most copious in Great Britain, pouring from 2,000 to 3,000 gallons per minute.

GWENHWYFAR – SIXTH CENTURY Supposed to have been the name of each of the three wives of Arthur, it has been modernised to Guinevere. The earliest Welsh legends make her betrayal the cause of Arthur's last battle at Camlan, but the TRIADS blame a feud between her and her half-sister Gwenhwyfach. She is mentioned as Arthur's queen in *Culhwch and Olwen*, in the *Mabinogion*, and in Caradog's *Life of Gildas* King Melwas abducts her from Arthur's court and imprisons her for a year.

GWENLLIAN FERCH GRUFFYDD AP CYNAN (1098-1136) Sister of the great Owain Gwynedd and daughter of the warrior Gruffydd ap Cynan, King of Gwynedd, Gwenllian was born in 1098, when Wales was under unceasing attack from the Normans. Her brother Owain Gwynedd had succeeded his father in leading the Welsh defence against the Marcher Lords, and Gwenllian married Gruffydd ap Rhys ap Tewdwr and lived in Dinefwr, with her four sons, Morgan, Maelgwn, Mareddud and Rhys. On New Year's Day, 1136, her husband joined other Welsh forces in an attack upon the Norman invaders. Gruffydd ap Rhys went to North Wales, trying to gain assistance from Gwenllian's father, Gruffydd ap Cynan. Maurice de Londres, Lord of Cydweli (Kidwelly) attacked the Welsh in southwest Wales in his absence. Gwenllian led an army against two Norman forces, but her son Maelgwn was captured, and she was wounded and captured. Gwenllian and her other son Morgan were beheaded at Cydweli. On the express orders of de Londres, she was executed, and de Londres later founded Ewenni Priory, presumably assuming that he would go to Heaven. She left a four-year-old son, to be known as The Lord Rhys (Rhys ap Gruffydd), the grandson of Rhys ap Tewdwr who was slain by the Normans at Brycheiniog in 1093, and the nephew of the great Owain Gwynedd. Her daughter Nest married Ifor ap Meurig, the Welsh hero who scaled the walls of Cardiff Castle to kidnap Earl William and regain his stolen lands. At Caer Drewyn in 1165, twenty-nine years after her death, her brother Owain Gwynedd and her son The Lord Rhys faced Henry II's invasion army, which retreated in the face of the greatest army Wales had ever assembled. Dr Andrew Breeze in *Medieval Welsh Literature* believes that the author of *The Four Branches of the Mabinogion* was Gwenllian, around 1128, making her the first British woman author. The battlefield has still not been fully explored, and must be preserved as a heritage site.

GWENLLIAN FERCH LLYWELYN AP GRUFFYDD (1282-1337) Her mother Eleanor, the daughter of Simon de Montfort died in childbirth at GARTH CELYN. Six months later her father Llywelyn ap Gruffydd, 'the last Prince of Wales', was murdered after treachery near Builth Wells.

Edward I began building his 'Iron Ring' of castles surrounding and dominating Gwynedd, and the tiny orphan and her nurse were taken to England to ensure that the bloodline of the princes of Gwynedd would die out. Llywelyn's brother Dafydd was hung, drawn and quartered, a killing method devised by Edward I specifically for him. Dafydd's wife Elizabeth de Ferrer was imprisoned and never allowed to see their children again. Like Gwenllian, their daughter Gwladys was taken from the cradle, and imprisoned forever at Six Hills convent, dying in 1336, after fifty-three years in captivity. Of the sons of Prince Dafydd and Elizabeth de Ferrer, Gwenllian's cousins, Llywelyn ap Dafydd was five when imprisoned and died of malnutrition five years later. Owain ap Dafydd was still living twenty years later, and the king ordered then that his imprisonment should be made more secure, so he was locked up for the rest of his life. After thirty years in prison, a letter survives where he implores Edward II to be allowed to go and 'play' within the walls of the castle. He was then thirty-seven years old. He was known to be still alive in 1320, after almost forty years of incarceration. Edward I at first wanted to kill Llywelyn and Eleanor's baby Gwenllian, but was prevailed upon to spare her as she was his relative. She was only six months old when Llywelyn was murdered, and her mother had died giving birth to her. After her father's death, her uncle Dafydd had cared for her, so she was less than two years old when Edward wanted her killed. She was made a nun at Sempringham in Lincolnshire. The nuns noted her as Wencilian as they could not pronounce her name. In 1327, when Gwenllian was aged forty-five and well past child-bearing age, Edward III granted her a pension of £20 a year. She died unmourned on 7 June 1337, after fifty-four years in captivity, with no family, friends or visitors. Her cousin Gwladys had died in Six Hills nunnery the year before. The Gwenllian Society placed a plaque at Sempringham in 1993, commemorating this lost Princess of Wales. It was vandalised in 2000, the heavy Welsh slate capping being smashed. Repaired, it reads: 'Teyrnged i'r Dywysoges Gwenllian (1282-1357) Unig Blentyn y Tywysog Llywelyn ap Gruffydd Arglwydd Eryry, Tywysog Cymru – GWENLLIAN – A Tribute to the Princess Gwenllian (1282-1337) Only Child of Prince Llywelyn ap Gruffydd, Lord of Snowdonia, Prince of Wales.'

GWEUNYTWL, BATTLE OF, 1077 This battle saw Cadwgan's sons Llywelyn and Goronwy beaten again, as at CAMDDWR after they attacked Rhys ab Owain at the unidentified location of Gweunytwl (Gwaun y Twll means moor of the pit).

GWLADYS, SAINT – SIXTH CENTURY Feasted on 29 March along with her husband Prince Gwynlliw Filwr, a daughter of Brychan, she was courted by Arthur and was the mother of St Cadog and other saints. She used to bathe naked at Lady's Well (a corruption of Gwladys' Well), in what are now the grounds of Tredegar House, Newport.

GWRYCH CASTLE The Norman timber castle near Abergele was taken by The Lord Rhys, who rebuilt it in stone, but it was destroyed by Cromwell. In 1819 a Grade 1 listed building with 128 rooms and 19 embattled towers was erected by Lloyd Hesketh, the first Gothic folly to be built in Europe. His son Bamford extended the castle estate to 4,000 acres. It is now semi-derelict.

GWYDIR CASTLE Outside Llanrwst, it was destroyed during the Wars of the Roses in 1466. It was rebuilt around 1500 and became the home of a branch of the great Wynn family.

GWYN, NELL (1650-1691) An actress of Welsh parentage at Drury Lane, she caught King Charles II's attention and became his favourite mistress, giving birth to the first Duke of St Albans.

GWYN, RICHARD (1537-1584) In 1970 Richard Gwyn of Llanidloes, a Catholic poet and schoolteacher, was canonised. Four-hundred years earlier, he had refused to take the Oath of Supremacy, and to attend church in the reign of Elizabeth I. He was tortured and spent four years in jail.

Upon being heavily fined, and asked how he would pay, he smiled and said 'I have something towards it – sixpence'. The response to this jest was fairly humourless – he was sentenced to be

'drawn on a hurdle to the place of execution where he shall hang half-dead, and so be cut down alive, his members cast into the fire, his belly ripped open unto the breast, his head cut off, his bowels, liver, lungs, heart thrown likewise into the fire'. Gwyn responded 'what is all this? Is it any more than one death?' and he met his grisly end at Wrecsam in 1584. He is one of the 'forty martyrs of England and Wales'.

GWYNLLIW'S CATHEDRAL, SAINT, NEWPORT Anglicised to St Woolo's Cathedral, it stands on the site of St Gwynlliw's fifth to sixth-century cell and was begun by the Normans, with a superb decorated twelfth-century arch.

HALKYN MOUNTAIN, BATTLE OF, 1406 A night attack on Hywel Gwynedd's mountain stockade proved successful after heavy fighting, with Hywel Gwynedd being killed. This reverse for Glyndŵr in his War of Independence marked the beginning of the period of decline in his military fortunes.

HARLECH CASTLE Formerly on the coastline, this concentric castle stands 200 feet up on a cliff overlooking Cardigan Bay, and was captured by Owain Glyndŵr in his rebellion. Built on a spectacular site, it played a key role in Glyndŵr's national uprising in the fifteenth century, and he held a parliament there as well as in Machynlleth. Harlech is probably the most stirring of the World Heritage Listed castles in Wales, completed in 1290 and once painted a dazzling white. Harlech is a World Heritage Site, built by James of St George during Edward I's second campaign in Wales. Following the capture of Castell y Bere in 1283, around 1,000 men were used in its construction. It was besieged by Madog ap Llywelyn in his rebellion of 1294, and is associated with the tragic *Mabinogion* tale of Branwen, the daughter of Llyr.

HARLECH CASTLE, SIEGES OF, 1404 & 1407-09 In the Glyndŵr Liberation War, it fell after a prolonged siege to Owain Glyndŵr, who made it his main headquarters and court in 1404. A long siege under Henry of Monmouth with 1,000 men, which included the most terrible winter in living memory of 1408-09, led to the starvation of the garrison, and the death of Edmund Mortimer, the son-in-law of Glyndŵr. Glyndŵr's wife and daughters were incarcerated forever.

HARLECH CASTLE, SIEGE OF, 1460-1468 In the Wars of the Roses, Sir Dafydd ap Ieuan ap Einion held out for the Lancastrians for eight years to a Yorkist siege, inspiring the stirring song *Men of Harlech*. 'Black William of Raglan', Lord Herbert, eventually took the castle, but Dafydd had responded to his summons to surrender by saying 'Once I held a castle in France till all the old women of Cymru heard about it. Now I'll hold this castle till all the old women of France hear of it.' On the point of starvation, they marched out with flags flying and music playing, having surrendered on honourable terms. Only famine had forced surrender and Dafydd handed the castle to Lord Herbert and his brother Sir Richard Herbert. King Edward IV at first refused to honour the terms of the settlement but Sir Richard Herbert, out of respect for the bravery of the defenders, is said to have offered his own life in exchange for Dafydd's rather than see his promise broken. It was the last castle of King Edward IV to hold out against the Yorkist rebels, and one of its survivors was the twelve-year-old Lancastrian, Henry Tudor (later Henry VII). He was taken into captivity at Raglan. His uncle Jasper Tudor had escaped through the besieging forces, giving the Lancastrians one last hope of victory. Seventeen years later, Jasper and Henry ended the Wars of the Roses at Bosworth Field. These defenders were the *Men of Harlech* commemorated in the famous song.

HARLECH CASTLE, SIEGE OF, 1647 Harlech's fourth major siege was in the Civil War, when it was defended by Royalists under Colonel William Owen against the Parliamentarians. History repeated itself as it was the last Royalist castle to hold out, its fall ending the First Civil War in 1647.

HAROLD'S HOUSE These earthworks are immediately west of Portskewett church. A *Time Team* TV excavation in June 2007 found a medieval manor house with a fortified tower, probably on the site of a late Saxon royal hunting lodge, believed to have been built by King Harold around 1063 after his victory over the Welsh. The hunting lodge is recorded as being destroyed by the Welsh soon after it was built. Harold's House is also the site of early medieval welsh llys, or Prince's Court. There was a tidal inlet, now silted up. Dressed stone was recovered from the site, which proved to be the same size and style as used on St Mary's Church, which dates to the early 1100s.

HAROLD'S STONES The village of Trellech takes its name (*tri*=three, *llech*=flat stone) from the three tall Neolithic stones set in a field close to the Monmouth-to-Chepstow road, standing in a line 39ft long. There are three legends attached to them: they were placed by Harold to celebrate a victory of the Saxons over the British; they mark the spot on which three chieftains fell in battle with the Roman Harold; and the stones were flung or thrown from Ysgyryd Fawr (Skirrid mountain), fourteen miles away, by a mythical giant or by the magician Siôn Cent.

HARP, HORNPIPES AND CRWTH ('TELYN, PIBGORN A CHRWTH') The harp is the national musical instrument, and was traditionally used to accompany 'penillion' singing – a complex web of sound where the harp counters with a different melody to the singer. The words sung are a pattern of alliteration and rhyme, chosen from poems written in the ancient 'cynghanedd' form. This 'canu penillion' (singing of verses) or 'cerdd dant' (art of string) has existed for over a thousand years. Different types of harp used are the large Gothic harp, the Grecian (Orchestral) harp, the small harp and the very difficult Triple harp with three sets of strings. One can see harp makers exhibiting at the National Eisteddfod, and the annual festival, 'Gwyl Cerdd Dant', ensures the continuation of the old tradition. Until the sixteenth century, the harp ('y delyn') had the highest social status of any instrument in Welsh culture, but its close associations with dance made it offensive to puritanical Nonconformists by the eighteenth century. There was still a harpist employed at Llanover Court until his death in 1888. The massive concert pedal 'Welsh' Harp came over from Austria in the seventeenth century, ousting in popularity the authentic portable Welsh harp, that had been described by Giraldus Cambrensis in the twelfth century. Before the Nonconformist fever, the harp was often used with a 'pibgorn' (pipe) and 'crwth' (Celtic violin). There was also a primitive Welsh bagpipe, the 'pibacawd'. From over eight centuries ago, GIRALDUS CAMBRENSIS gives us the following description in his *The Journey Through Wales*:'Guests who arrive early in the day are entertained until nightfall by girls who play to them on the harp. In every house there are young women just waiting to play for you, and there is certainly no lack of harps. Here are two things worth remembering: the Irish are the most jealous people on earth, but the Welsh do not seem to know what jealousy is; and in every Welsh court or family the menfolk consider playing on the harp to be the greatest of all accomplishments.'

The Laws of Hywel Dda, codified around 940-950, specify that each master must employ a 'pencerdd' (chief musician) and give him a harp, pibgorn and crwth. The pibgorn and crwth traditionally accompanied dancing until the eighteenth century, when the harp and fiddle became the main accompaniment. The pibgorn was last commonly played by Anglesey shepherds in the early 1800's. The crwth was originally plucked like a lyre but from the eleventh century played with a bow (with some plucking). The last Welsh crwth player, or 'crowther', travelled through Anglesey in the eighteenth century, but Bob Evans of Cardiff now makes, plays, teaches and records the crwth. Crwths, pibgorns and harps can be seen at The Museum of Welsh Life in Saint Ffagans. A famous 1612 manuscript by Robert ap Huw notates traditional harp music, using five scales, and only recently has it been interpreted correctly – Wales' own Rosetta Stone. This is in the British Museum, and part had been copied from an earlier manuscript of the Elizabethan harpist, William Llewelyn. Arnold Dolmetsch has transcribed it, believing that it is 'the only source of knowledge of the polyphonic music of pre-Christian civilisations'. Gustave Rees, the American

author of *Music of the Middle Ages*, states that 'if the contents of the manuscript are as ancient as have been claimed, that fact would revolutionise both our notions concerning the development of music in medieval Europe, and the general belief that the concept of harmony as a system governing musical combinations from the vertical standpoint did not make itself felt with any radically great strength until the seventeenth century.' The older part of the manuscript contains the twenty-four measures of Welsh string music, mentioned in even older Welsh manuscripts, and formalised around 1110 in the reign of Gruffydd ap Cynan.

HARRIS, HOWELL (1714-1773) Known as 'the father of Methodism in Wales' and as 'the greatest Welshman of his age', he was at the core of the great Methodist movement, beginning his mission in north Wales, alongside Daniel Rowland and Howell Davies. A wonderful preacher, he deeply influenced religion in Wales. Coleg Trefeca holds the Howell Harris Museum.

HARRIS, ROBERT (1849-1919) Born in the Vale of Conwy, he was Canada's most influential portrait painter of the nineteenth century, his best-known picture being *The Fathers of the Confederation* of 1884, destroyed in a fire in the Parliament Buildings. Five thousand of his works are at the Confederation Centre of the Arts in Charlottetown, Prince Edward Island.

HATFIELD MOORS (HEATHFIELD), BATTLE OF, 634 King CADWALLON ap Cadfan defended Gwynedd against attack by Edwin of Northumbria at CEFN DIGALL in 625. With Penda of Mercia, he later attacked Edwin at Heathfield, possibly near Doncaster. Edwin was killed and Northumbria subdued. It is said that St David appeared to Cadwallon's troops, telling them to place leeks in their hats, so that they would know each other in battle. Cadwallon killed Osric, Edwin's son in the following year in battle at York.

HATTON, JULIA ANN (1764-1838) The sister of Sarah Siddons, she was too lame and squint-eyed to appear on stage, and married a bigamist called Curtis who deserted her. She tried to commit suicide in Westminster Abbey and then was accidentally shot in a brothel, before marrying William Hatton. In America she had success as a songwriter and librettist, and returned to Wales, becoming a successful novelist known as 'Ann of Swansea'.

HAVERFORDWEST This used to be an important trading port, as evidenced by the *Bristol Trader* pub on its old quayside. Nearby are the remains of the thirteenth-century Augustinian priory of St Mary and St Thomas, and of the mansion of Sir John Perrott (Perrot), the bastard son of Henry VIII. Growing up as a market town under the shadow of its castle, from 1545-1921 it was a county in its own right.

HAVERFORDWEST, BATTLE OF, 1405 With French assistance, this was won by Owain Glyndŵr before his invasion of England.

HAVERFORDWEST CASTLE Built in the mid-twelfth century by the Earl of Pembroke at the centre of 'Little England beyond Wales', it was never captured by Welsh forces. Llywelyn the Great defeated the Flemings and burned the town, but could not seize the castle in 1220, and it survived an attack by Glyndŵr's men in 1405. It surrendered to Cromwell's force after the battle of Colby Moor.

HAWARDEN CASTLE Near Hawarden House, and formerly the home of the Prime Minister W.E. Gladstone, it is on an Iron Age site, and has a strong round keep on a Norman motte built by Hugh the Wolf, Earl of Chester. Llywelyn the Last met Simon de Montfort's son Henry here, and was given the castle in the 1260's. However the English did not allow him to take possession so he took it by force in 1265, capturing its lord, Robert de Montalt, and destroying the castle. De Montalt was returned to power in 1267, on the promise not to refortify the site, but within ten

years the existing keep had been built. Its importance is demonstrated in that it was known as the 'gateway to Wales'. Alarmed by the rebuilding of the Castle, Llywelyn's brother Prince Dafydd ap Gruffydd attacked Hawarden from his nearby castle at Caergwrle (Hope). He staged a night siege in 1282, and took Hawarden Castle and its constable Roger Clifford and Payn de Gamage, slaying all the other defendants. Llywelyn felt the need to support his brother, who had previously been a supporter of Edward, and the great and fatal war of 1282-83 took place. Dafydd was executed in 1283, and the castle remained in English hands from that time. It was badly damaged in the Civil War when it surrendered to Parliamentary forces after changing hands three times.

HAWARDEN – ST DEINIOL'S LIBRARY Created and founded by William Ewart Gladstone, upon his death it became the nation's tribute to his life and work, and is the only residential library in Britain.

HAWARDEN WOOD, BATTLE OF, 1157 *The Chronicle of Ystrad Fflur* reads: 'In this year Henry II, king of England, led a mighty host to Chester, in order to subdue Gwynedd. And Owain, prince of Gwynedd, gathered a mighty host and encamped at Basingwerk and raised a ditch to give battle. And the sons of Owain encountered Henry in the wood at Hawarden and gave him a hard battle so that after many of his men had been slain, he escaped to the open country. And the king gathered his host and came as far as Rhuddlan and Owain harassed the king both by day and by night. While those things were happening the king's fleet approached Anglesey and plundered the churches of Mary and of Peter. But the saints did not let them get away for God took vengeance upon them. For on the following day the men of Anglesey fell on them; and the French, according to their usual custom, fled but only a few of them escaped back to their ships. And Henry, son of king Henry, was slain. And then the king made peace with Owain; and Cadwaladr received back his land. And the king returned to England.'

HAY-ON-WYE (Y GELLI GANDRYLL) Hay-on-Wye is the second-hand book capital of the world, owing to the efforts of RICHARD BOOTH, and hosts a yearly important International Book Festival. There are over twenty bookshops, including even the old cinema and Booth's Norman castle being used as stores.

HAY CASTLE The original castle was built on a motte near the parish church of St Mary's, but this large stone castle in the centre of town was built by the de Braoses. When her sons revolted, Isabella de Braose was starved to death by King John, who burnt Hay Castle and town in 1216. Llywelyn the Great also burnt the castle and town in 1231, and they were rebuilt by Henry III. In 1232 and 1237 the people of Hay were given grants to wall the town. It was taken by the army of Prince Edward in 1264 and by Simon de Montfort in 1265. Glyndŵr's men also attacked the town and castle, and the castle suffered further damage in the Wars of the Roses. The Duke of Buckingham remodelled the keep before his execution by Henry VIII in 1521. Much of the curtain wall was destroyed during the Civil War. Huge fires in 1910 and 1939 gutted the eastern and western wing respectively, but now the western wing is the home of Richard Booth and part is a bookshop.

HEAVENFIELD, BATTLE OF, 635 This took place near Hexham, near where the North Tyne River is crossed by Hadrian's Wall at Chesters Roman Fort. The Welsh-speaking North Country Britons were being driven west by Saxons in the sixth century. The Welsh had killed King Edwin of Northumbria's most powerful rulers in the Battle of Hatfield near Doncaster in 633, having formed an alliance with the Kingdom of Mercia. Edwin's successor was King Oswald (634-642), whose greatest enemies were the Welsh, led by CADWALLON of Gwynedd and the Mercians under Penda. In 635 Cadwallon brought north a huge army into Northumbria to fight Oswald. When the Welsh arrived in the north they were exhausted from their long journey, and Cadwallon was slain on the banks of the Rowley Burn.

HEDD WYN (1887-1917) The most famous modern bard, Hedd Wyn ('White Peace'), was the shepherd-poet Ellis Humphrey Evans from Trawsfynydd, who was killed at Passchendaele ('with a nosecap shell in the stomach') in the First World War. He had enlisted with the Royal Welsh Fusiliers at the age of thirty, early in 1917, and died on 31 July in the same year, just before he would have received the chief Bardic prize at the National Eisteddfod in Birkenhead. In September 1917, the winning poet was called to take the Bardic Chair for his strict metre poem *Yr Arwr (The Hero)*. Hedd Wyn could not reply to the summons, and the Chair was symbolically draped in black on the stage. The assembled Welsh wept openly, and the event is still referred to as 'The Black Eisteddfod'. The moving 1992 Welsh-language film commemorating the story was nominated for an Oscar. His birthplace is next to Trawsfynydd Lake, which provided the cooling waters for the appalling remains of a Nuclear Power Station, set in one of the most beautiful spots in Europe. Its life is finished, nuclear waste it stored next to it, and it may be decommissioned by 2096.

HELEDD, SAINT – SIXTH-SEVENTH CENTURY Llanhilleth is now dedicated to Illtud, but as originally called Llanhilledd Vorwyn (Hiledd the Virgin). She was the sister of Cynddylan, who died in battle against the Saxons at Pengwern (Shrewsbury), who then burnt his great palace on the site of the Roman town of Wroxeter. The great saga poem first written down in the ninth century, *Canu Heledd* (Song of Heledd) recalls the bloodshed and destruction, especially in the part *Cynddylan's Hall*. The poem was originally attributed to Llywarch Hen, as part of the *Red Book of Hergest*, but the intense emotions show mean that it may have been the work of Heledd, making her the first woman poet. She describes an eagle tearing Cynddylan's flesh open on the battlefield.

HELENA, SAINT (*c. 255-326 or 328*) Said to be the British wife of Constantius Chlorus and the mother of Constantine the Great (born 274), she was instrumental in his conversion to Christianity. Her father was said to be Coel ap Tegfan of Caer Collen (Harlech) and her mother Stradwan ferch Cadwan, the daughter of the King of North Wales. Her son Constantine is commemorated in the British Church.

HENRY VII (1457-1509) His grandfather Owen Tudor was executed by the Yorkists after the slaughter at Mortimer's Cross in 1461, and his father Edmund died in Yorkist imprisonment in Carmarthen three months before Henry's birth. After exile in Brittany, he returned with his uncle Jasper, and defeated Richard III at Bosworth in 1485 to end the Wars of the Roses and claim the throne for the Lancastrians. The Venetian emissary reported to Italy after Bosworth that 'the Welsh may now be said to have recovered their independence, for the wise and fortunate Henry VII is a Welshman', and Francis Bacon commented that the Welsh had 'thereby regained their freedom'. Henry married Elizabeth of York, who was a descendant of Llywelyn I. He halted two insurrections by the pretenders Lambert Simnel and Perkin Warbeck, and laid the basis of a stable monarchy, with an uneventful succession for his son Henry VIII.

HERBERTS, THE A famous family in the history of Wales, being Earls of Montgomery and Pembroke, they were patrons of Shakespeare. William Herbert was the first Welshman known to have addressed the House of Commons, and was an educational pioneer who wished to establish a Welsh college in the ruins of Tintern Abbey. Shakespeare's sonnets appear to be addressed to William Herbert (W.H.), as he was a great supporter of the arts in Elizabethan London. His kinsman Richard Herbert, buried in Montgomery Church, had two famous sons, the poet/cleric George Herbert, and the philosopher and diplomat Lord Herbert of Cherbury, who lived in Montgomery Castle.

HERBERT, GEORGE (1593-1633) Born in Montgomery, he was a devotional poet, and his

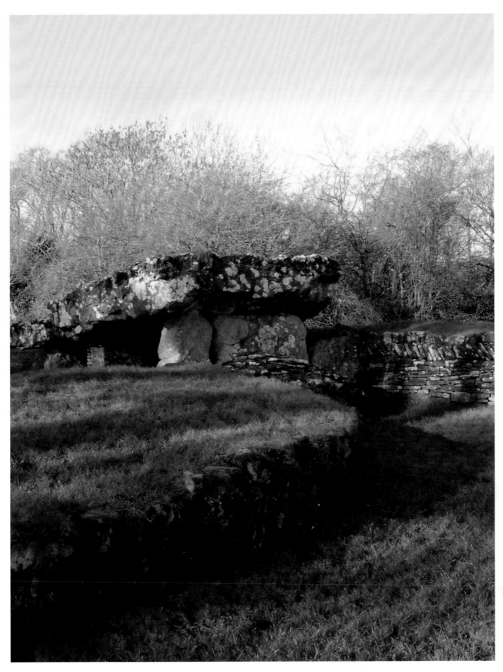

1. Tinkinswood Burial Cairn in the Vale of Glamorgan is around 6,000 years old, a millennium older than Stonehenge. Its capstone of around 46 tons is the heaviest in Britain, and it may represent the 'Earth Goddess'. The remaining mound behind the capstone measures 130ft by 60ft, and there are lines of stones leading away from it.

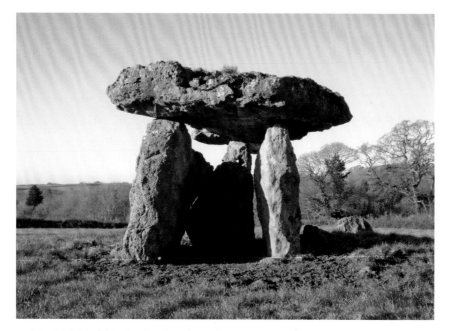

2. St Lythan's Neolithic chambered tomb was built around the same time as nearby Tinkinswood, in a place known as the 'Accursed Field' as nothing will grow there. Notice the hole in the end stone. There are several legends surrounding the cromlech, and there a mysterious raised circular wall next to it, with oak trees in the wall.

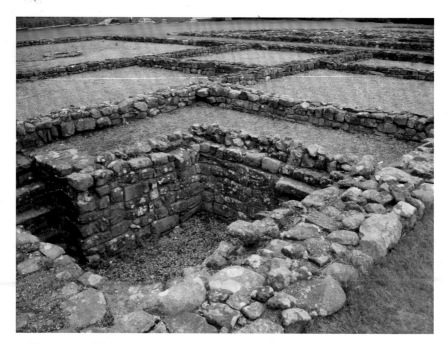

3. The remains of Segontium Roman Fort, Caernarfon, which held an auxiliary legion of up to 1,000 men. It was probably built around 77 CE, and occupied until 394 when the Romans left Britain. The Romans had previously massacred the druids on Anglesey, the European centre of Celtic druids, and built the fort to safeguard supplies of copper from the Great Orme and from Parys Mountain in Anglesey.

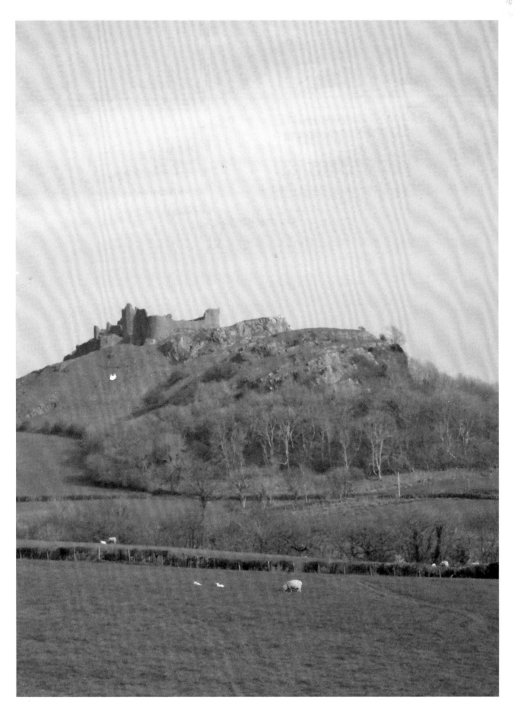

4. Castell Carreg Cennen, perhaps the most evocative of all Welsh castles, was originally built by the Lord Rhys, Prince of Deheubarth, and strengthened by Edward I. It is on a site associated with Urien Rheged, his son Owain and King Arthur. Much was demolished in 1462 during the Wars of the Roses.

5. Dolbadarn Castle was built by the Llywelyn the Great before 1230, and overlooks Lake Padarn. As early as the sixth century the site had been fortified to guard movement through the Llanberis Pass. It was held by the Welsh until Edward I's 1282 conquest, but taken by Owain Glyndŵr, who probably held his arch-enemy Lord Grey here in 1402.

6. Gateway to Caernarfon's Town Walls. The four castles of Beaumaris, Conwy, Caernarfon, Harlech and the attendant fortified towns at Conwy and Caernarfon are the finest examples of late thirteenth century and early fourteenth-century military architecture in Europe, and thus are a UNESCO World Heritage Site. Caernarfon's walls formed a 'bastide' or fortified settlement of English people.

7. Hay Castle – the home of the 'King of Hay', Richard Booth. Built by Maud de Breos in the twelfth century, it was taken and sacked several times before Edward II captured the Castle, but it was sacked again by Owain Glyndŵr in 1402, and by Welsh rebels in 1460. It has suffered from at least four major fires over the centuries.

8. Ancient stepping stones over the Ogŵr River, at Ogmore Castle. It was built soon after 1100 as the Normans took the south of Glamorgan, to guard a major ford. Ogmore was near the castles of Coity and Newcastle at Bridgend, forming the western face of the Norman advance.

9. In the Norman invasion of Brycheiniog, a motte and bailey was built, followed by a shell-keep in 1160 which the Welsh destroyed in 1233. Tretower Castle was rebuilt with this round tower inside the old shell-keep in 1240. By the fourteenth century the area was safe enough for Tretower Court to be built and lived in, near the castle.

10. Founded as early as 1070, Grosmont Castle is one of the 'Trilateral' of Gwent castles which also includes nearby Skenfrith Castle and the White Castle. The 'Three Castles' were fortified to form a single defensive unit protecting trade in the southern Welsh Marches.

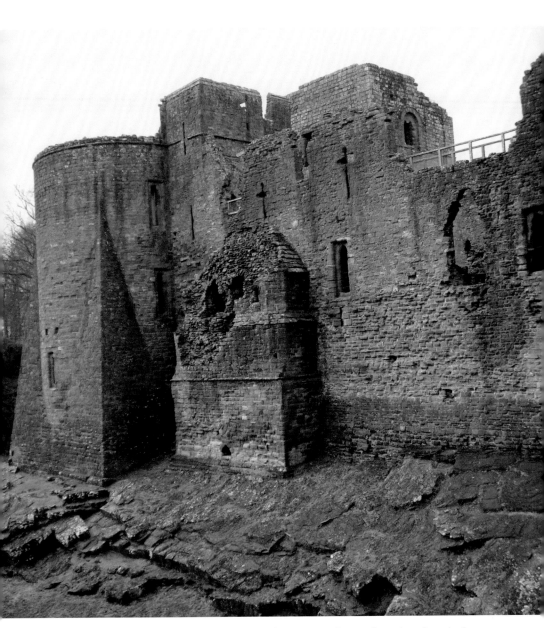

11. The Marcher Castle of Goodrich, showing rock-cut moat and square keep, dates from the first years of the Norman invasion of Wales. It stands on a spur overlooking the Wye Valley. As an impressive frontier fortress, it was fortified in stone in phases from 1160-1300.

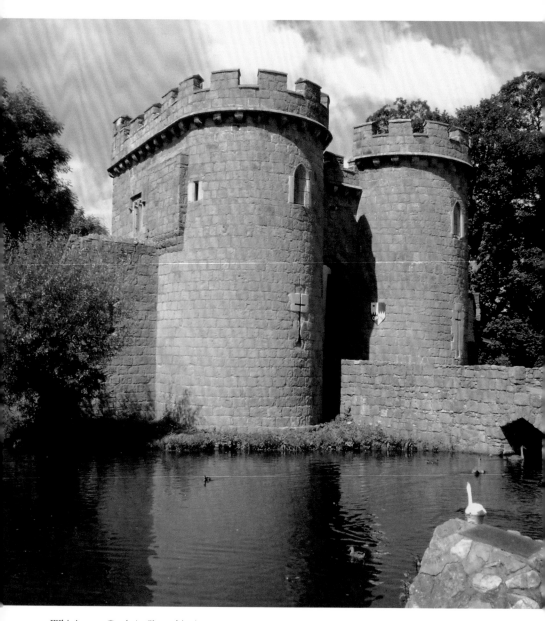

12. Whittington Castle in Shropshire is on an Iron Age site and was a court of the Princes of Powys. It is an unusual borderland castle in that it does not stand on high ground – its defences were ditches, spring-fed moats and marshy bogs. The present castle was built in 1221 but much has been destroyed.

13. Dating from the twelfth century, St Donat's Castle was restored by William Randolph Hearst among others, and is now home to Atlantic College. It is the longest continually inhabited castle in Wales, renowned for being haunted, and could be supplied by sea. George Bernard Shaw stated that it was what 'God would have built if he had had the money'.

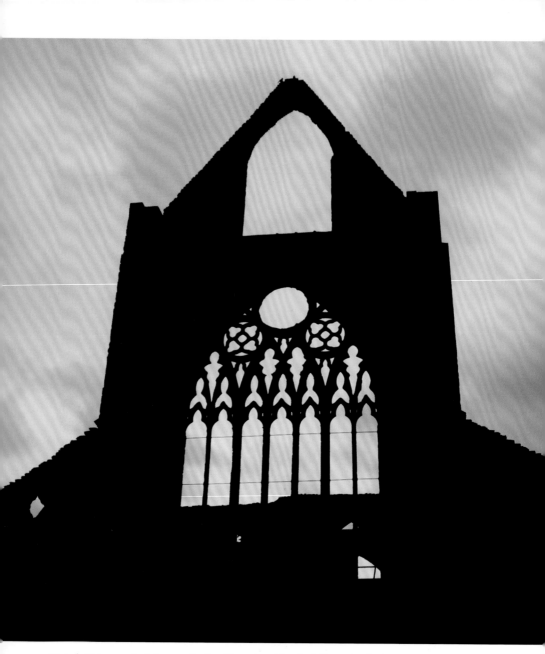

14. Tintern Abbey was built in 1131, the first Cistercian abbey in Wales and only the second in Britain. In the beautiful Wye Valley, it was never a rich foundation and when it was taken over by the Crown and destroyed in 1536, its only occupants were the abbot, twelve choir monks and thirty-five monastic servants.

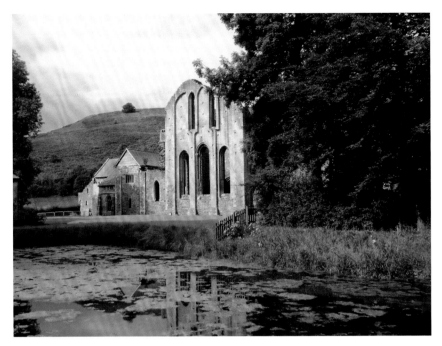

15. Valle Crucis Abbey, Abaty Glyn y Groes, near Llangollen, here viewed over its monastic fishponds, was named Valley of the Cross after the ninth-century Eliseg's Pillar nearby. In the seclusion of the Dee Valley, this Cistercian abbey was founded in 1201 by Madog ap Gruffudd Maelor, Prince of Powys Fadog,

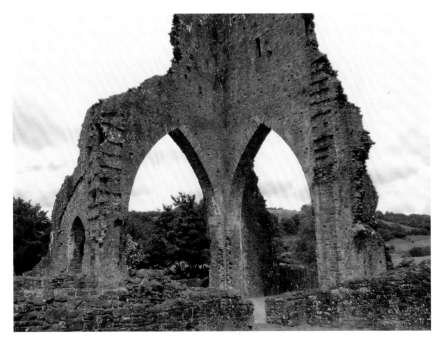

16. The Lord Rhys founded Talley (Tal-y-Llychau) Abbey for the Premonstratensian Order, the White Canons between 1184 and 1189. It stands at the head of the Talley Lakes, and its Welsh name means 'front of the lakes'. There is a nearby motte known as Talley Castle.

17. View from Pilleth Churchyard to fir trees where the dead of the Battle of Pilleth (1402) were buried. The white flowers are snowdrops. Edmund Mortimer's larger force advanced up the steep hill to meet Owain Glyndŵr's, but was heavily defeated, Mortimer being captured.

18. St Beuno's Church, Eglwys Beuno Sant, at Pistyll on the Llŷn is set in an oval Celtic churchyard, next to a monastic fishpond. it was an important centre for pilgrims on their way to Bardsey Island, Ynys Enlli, and Rupert Davies, the actor who played 'Maigret' is buried in the churchyard.

19. St Cewydd's church at Aberedw is near Llywelyn ap Gruffudd's Cave and the site of his murder. The site dates back 1,500 years, to Cewydd, the patron saint of rain. The legend that rain on his feast day of 15 July would lead to forty days rain, was transferred to the Saxon saint Swithun in 971.

20. St Gwynno's Churchyard at Llanwynno, a sixth-century foundation, which has a seventh-century ring-cross. Llanwynno (Llanworro) is the birthplace of the great runner Gruffydd Morgan, known as Guto Nyth Brân, who died in 1737 after being slapped on the back by an admirer after a race. There is a tombstone in the graveyard.

21. Medieval Dovecote inside twelfth-century monastic grange at Monknash, in the Vale of Glamorgan. There are fishponds and extensive remains, and the remarkable Plough and Harrow pub is built into one of the walls of the grange. The monks' medieval mill is hidden away in the nearby valley.

22. St Ilan was a sixth-century Celtic saint also remembered in Brittany, and his medieval Parish Church at Eglwysilan is where many of the dead from the Senghennydd Mining Disaster of 1913 are buried. 439 men and boys died in the explosion and most of their tombstones are in Welsh.

23. Medieval wooden partition wall at Cefn Caer, Pennal, where Owain Glyndŵr drafted the Pennal Letter for his ambassadors to take to Charles VI of France and Pope Benedict XIII. The pre-fifteenth-century hall house is on the site of a Roman fort overlooking Pennal.

24. The initial construction of Tretower Court may date to the early years of the fourteenth century but the castle was not entirely abandoned until later. From this central courtyard, one can identify four major phases of building, from around 1300 to the seventeenth century.

25. The hall at Tretower Court is in essence as remodelled by Sir Roger Vaughan from 1540 onwards, on a scale to match his position as the most prominent commoner in Wales. The house later became a farm, and uncared for, so much of its original medieval structure remains intact.

26. Owain Glyndŵr had captured his enemy Hywel Sele of Nannau in 1402 and was taking him to Dolgellau. At Llanelltyd Bridge over the Mawddach, his way was blocked by Sele's son-in-law, who lost sixty of his 200 followers.

27. View of the River Dee, Afon Dyfrdwy, from the bridge at Llangollen, steam train station on the right. One of the 'Seven Wonders of Wales', it was the first stone bridge over the Dee, originally built in 1345, and remodelled in Elizabethan times.

28. Aberglasney House has some of the finest gardens in Wales, and its 'nine green gardens' were eulogised by the poet Lewis Glyn Cothi in 1477. It was the home of the poet John Dyer, and the formerly 'lost' Cloistered Garden and parapet walkway is of international importance.

29. The Old Market Hall in Llanidloes is the only surviving timber-framed market hall in Wales, built between 1612 and 1622, but with some sixteenth-century timbers dating from its predecessor. It was once known as the Booth Hall from the market stalls or 'booths' which stood beneath and around it, and John Wesley preached here.

30. Chirk Castle Gates date from 1719, and are one of the finest pieces of ornamental ironwork in Wales, featuring the red hand of the Myddletons. The castle was built in the late thirteenth century by Roger Mortimer, and the Myddletons have lived here since 1595.

31. The Llangollen Chain Bridge has crossed the River Dee at Berwyn since 1814, linking the Llangollen Canal, Railway and A5 road from London to Holyhead. It was built by Exuperius Pickering to transport coal and slate to the new A5 and save himself the large toll to cross the Elizabethan Llangollen Bridge. The present bridge dates from 1929 and is to be restored.

32. This Llangollen Branch of the Shropshire Union Canal begins at Llangollen, runs through Ellesmere and merges with the Chester Canal in 1813. Its notable features include Telford's Poncysyllte Aqueduct over the River Dee and another aqueduct over the River Ceiriog at Chirk.

33. These restored quarrymen's cottages, quarry-master's house and chapel at Nant Gwrtheyrn, are now the Welsh Language and Heritage Centre. Choughs and seals are often seen here.

34. The eighteenth century disused Tŷ Uchaf farm in Nant Gwrtheyrn, near where King Gwrtheyrn (Vortigern) lived in the fifth century. He fled here having betrayed his fellow Britons to the Saxons in the fifth century. Castell Gwrtheyrn (Gwrtheyrn's Castle) used to be shown nearby on Ordnance Survey maps.

35. This old shop front on a slate-built house, adjoining the stream bridge at Pennal, shows how businesses had to diversify to survive in rural Wales.

36. Dewstow means the hamlet of St David, and its gardens were built in 1895 but buried after World War II and only rediscovered in 2000. Grade I listed, they contain many ponds and rills but also uniquely an artificial labyrinth of underground grottoes, tunnels and sunken ferneries.

37. Portmeirion Village was built by Clough Williams Ellis in two stages: from 1925 to 1939 and from 1954-76. The second period was typically Palladian in style, in contrast to the Arts and Crafts style of his earlier work. Several buildings were salvaged from demolition sites, and 'The Prisoner' TV series was famously filmed here.

38. The 16ft tall stainless steel sculpture near Llandovery Castle commemorates Llywelyn ap Gruffudd Fychan, and was unveiled in 2001, the 600th anniversary of his execution. Henry IV had forced Llywelyn into his service to find Owain Glyndŵr, but was led on a wild goose chase, as Llywelyn's two sons were serving Glyndŵr. Over a period of hours, Llywelyn was publicly disembowelled.

work is described by D.J. Enright as follows: 'the poems that make up *The Temple* are flawless and irresistible, and – for the tone of voice is immediately recognisable as his and his alone – unique. They are among the very finest we have in English; in them we hear a man pleading with God or arguing with him, or disputing with himself, but always talking to other men'. His aphorisms are also well known, such as 'he that lives in hope dances without music' and 'who aimeth at the sky shoots higher much than that he means a tree'. Some of Herbert's finest poems are better known as hymns, for example: *'Let all the world in ev'ry corner sing/ My God and King'*; and *'The God of love my shepherd is,/And he that doth me feed,/While He is mine, and I am His,/What can I want or need.'* His brother Edward, Lord Cherbury, was hailed as 'The Father of Deism' and also published poetry – perhaps his most evocative line is: *'Now that the April of your youth adorns/The garden of your face'*.

HERBERT, SIR WILLIAM (d. 1445) His real name was William ap Thomas ap Gwilym ap Jenkin, and as he had sided with the English against Owain Glyndŵr, he was given the tenancy of Raglan Castle for the rest of his life. He married the widow of Dafydd Gam, who had tried to kill Glyndŵr and had died at Agincourt. William Herbert led the Welsh archers at Agincourt. By his marriages he acquired wealth and land from two heiresses, and was knighted by Henry VI, an unusual honour for a Welshman. In 1432, he bought Raglan Castle, and became known as 'Y Marchog Glas o Went', 'The Blue Knight of Gwent.'

HERBERT, LORD WILLIAM (1423-1469) He anglicised his name (like his father above) from William ap William ap Thomas ap Gwilym to William Herbert, and as a prominent Yorkist fought in France and in Britain for Henry VI. Edward IV gave him the Lordship of Raglan in return for Herbert's help in his accessing the throne, and Herbert effectively controlled Wales for the Yorkists, enabling the king to put down rebellion across England. In 1468 he took Harlech Castle, narrowly avoiding taking the Lancastrian Jasper Tudor, but took Henry Tudor, a claimant to the throne, to be imprisoned at Raglan. Edward created William Earl of Pembroke for this act, and he had been awarded the Knight of the Garter in 1461. He and his brother Richard lost heroically and by treachery at the Battle of Banbury (EDGCOTE) and were summarily executed by the Earl of Warwick. The cream of the Welsh aristocracy died at this battle, the bard Guto'r Glyn proclaimed that 'my nation is destroyed, now that the earl is slain.' H.T. Evans called 'Black William' 'the first statesman of a new era, and the most redoubtable antagonist of the old.'

HERBERT, WILLIAM, EARL OF PEMBROKE (c. 1501-1570) In a *Sunday Times* 'Richest of the Rich' list, Herbert would be worth over £8 billion today. Exiled in France, he fought for the French with such bravery that the king wrote to Henry VIII about him. Herbert returned and married Anne Parr, the sister of Henry's sixth queen, Catherine. Herbert received Wiltshire estates, and on Henry's death became a Privy Councillor to Edward VI. Herbert stopped a Cornish attack on Exeter, and was a power broker in the struggle between the Duke of Somerset and the Earl of Warwick. He chose Warwick, was made Earl of Pembroke and took Somerset's Wiltshire estates. He supported Lady Jane Grey's succession to the throne, but somehow survived under Queen Mary, defending London in the Wyatt Rebellion. He was arrested when Elizabeth became queen, but managed to keep his freedom and estates. The present Earl of Pembroke was worth a mere £75 million in 2000.

HEREFORDSHIRE Like the other border counties of Gloucester, Worcester, Shropshire and Cheshire, pockets of Welsh speakers were in this county until the eighteenth century. The south and west of Hereford was known as Archenfield, a name derived from the Welsh kingdom of Ergyng, of which it was part. Ergyng in turn was probably derived from Ariconium, the Roman camp at Weston-under-Penyard. This was taken over by the Saxons around 800. It is still legal to shoot a Welshman in the city of Hereford, providing it is on a Sunday, one uses a longbow and it is within the Cathedral Close. You have been warned.

HEREFORD, BATTLE OF, 760 Resenting the fortification of Hereford by the Mercians, there was battle given, probably by the forces of Ithael of Glwysing's sons and King Nowy Hen of Brycheiniog against King Offa near Hereford. The British were defeated, but a temporary truce followed between the nations. Dyfnwal ap Tewdwr died in this battle, according to the *Welsh Annals*.

HEREFORD, BATTLE OF, 1055 Gruffydd ap Llywelyn, with Aelfgar, the disaffected son of Leofric of Mercia, burnt Hereford and took a large border area from the Mercians.

HEROES The Welsh hero par excellence is Owain Glyndŵr. Wales also has both the greatest pirate and greatest privateer that the world has known, Black Bart Roberts and Captain Henry Morgan. It seems strange that films are made about obscure characters from history, but none of these have figured in world-wide publicity. A film like Braveheart (about Scotland's William Wallace) would transform Wales' image across the globe. (Incidentally, Wallace was descended from Richard Wallensis 'the Welshman', a Strathclyde Briton, not a Scot, who lived at Richardston in Ayrshire in 1170. William was called Walys, or 'Welsh' up to his death in 1305. Richardston is modern Riccarton.)

HEROINES The Celtic Queen BUDDUG (Budigga, Boadicea) led her Celtic Iceni warriors against the Romans in the east of Britain. After King Prasutagus had died, he left his kingdom to two daughters with the Emperor of Rome as co-heir. This was the usual practice for a client-king of Rome. While the governor of Britain, Suetonius Paulinus, was fighting in Anglesey, the procurator, Decianus Catus took over the Iceni kingdom. Buddug protested, and was flogged and her daughters raped. The Iceni rose instantly, and destroyed Colchester. With the Trinovantes, the Iceni then almost annihilated the IX Legion on their march on London. Buddug took London and then St Albans (Verulanium). Tacitus recorded that 70,000 civilians and soldiers died in this wave of attacks. Paulinus hurried back with 10,000 hardened troops and overcame the Celts. Apart from the tales of Catrin o'r Berain, the two Gwenllians and Jemima Nicholas, other remarkable women feature strongly in Welsh history. Marged uwch Ifan was an Amazonian woman who lived near Llyn Padarn, and played the fiddle, made harps and built boats. She was also the local blacksmith, a well-known wrestler and a champion hunter. Pennant noted that 'At length, she gave her hand to the most effeminate of her admirers, as if predetermined to maintain the superiority which nature had bestowed on her.'

HILL FORTS Wales has the highest concentration of Iron Age hill forts in Britain, and probably Europe. Only the West Country, especially the Celtic stronghold of Cornwall, rivals it. One of the largest Iron Age hill forts in Wales is that of Garn Goch, near Llandeilo in the foothills of The Black Mountain, best approached from the village of Bethlehem, which itself is famous for its Christmas postmark service. Tre'r Ceiri Iron Age fort on the Llŷn Peninsula has around 150 dry-stone hut circles, 15ft thick, and up to 12ft high defensive ramparts. It is the largest Iron Age fort in northwest Europe. Din Lligwy on Anglesey is a small, well-preserved Romano-British settlement with a group of huts surrounded by a defensive wall. Nearby is a ruined Norman chapel. Carn Ingli Iron Age hill fort, upon the slopes above Newport, Dyfed is impressive. In legend, St Brynach communed with the angels here, and it is associated with the Celtic goddess Arianrhod. It is also on a ley line from Pen Dinas through Carreg y Gof (Rock of the Smiths) with its five Iron Age burial chambers. In Dyfed, Castell Henllys Iron Age Fort recreates the living conditions of two millennia ago on an ancient site. Nearby, Newport's Carreg Coetan Arthur capstone in Pembroke is supposed to mark Arthur's burial site (one of many in Wales). Twmbarlwm hill fort, north of Newport, Monmouthshire is the scene of a legend featuring a battle between the wasps and bees. The druids are also supposed to have had a court there, hurling the bodies of the guilty into the valley below it, which is still called Dyffryn y Gladdfa, the valley of the burial ground. Llanmelin hill fort, near Caerwent, may be the site of King Arthur's base – it was a tribal centre of the Celtic Silures, who were moved two miles away to Venta Silurum (Caerwent) by the Romans. It has a

remarkable horned earthwork entry system, and its proximity to Caerwent, Caerleon and its 'round table' of Arthurian legend lend the site some credence. Within a few miles are many other hillforts, Y Gaer (Tredegar Fort) and Stow Hill in Newport, Wilcrick Hill, Twmbarlwm and Lodge Hill in Caerleon being the most notable. A line from Llanmelin (possibly the site of Camelot) through Caerleon to Coed-y-Defaid fort (and Ffynon Oer) outside Bassaleg takes one to an area anciently known as Maes Arthur (Arthur's Field). The line then goes on to Coedkernyw, where the present church is on the site of one dating from the sixth century, founded by Glywys Cernyw, a son of Gwynlliw Filwr (the Warrior).

HIRAETH This is an almost untranslatable word meaning 'a deep, deep longing for home'. To some extent this is why Wales has retained its distinct identity despite being so close to England. Emigrants from Elihu Yale onwards return home when their work is done, on a far greater scale than the Irish or Scottish. Welsh communities of expatriates overseas, except in Patagonia, hardly exist. Some 430,000 Welshmen left in the 1930's Great Depression, but it appears a far higher proportion returned after the Second World War than did the Scots, Irish or English. The wonderful actor-director Kenneth Griffith was a man with a deep social conscience, as evidenced by his documentary on India's *Untouchables*. At seventy-three, he caught what he calls a 'whiff of mortality' travelling to Britain from India, and was 'suddenly overcome by an irresistible yearning to be home'. Although he had left Tenby aged thirteen, and had no family left there, he headed straight there and booked into a hotel overlooking North Beach. 'Griffith has recently found himself making the journey quite often, On one such visit, he was out walking along the North Cliff, admiring the view, when he was approached by a passer-by. Doubtless, the stranger was going to say "I know who you are. You're that actor fellow", he thought with resignation. Sure enough, the elderly man began, "I know who you are", but went on to say, "I can see your grandfather's features in your face". The actor's eyes fill with tears at the memory of that seafront meeting.' (Alan Road, *The Times Magazine*, 17 August 1996).

HIRBARTH, BATTLE OF, 980 Godfridr Haraldsson, brother of King Magnus of Man and Limerick, had taken Anglesey in 972. He allied with King Cystennin ab Iago of Gwynedd in his war against Hywel ab Ieuaf, who wanted the throne of Gwynedd. The Danish-Welsh force ravaged Anglesey and crossed pillage the Llŷn Peninsula. Hywel defeated them and Cystennin was killed.

HIRWAUN, BATTLE OF, 1093 This was supposed to be on Hirwaun Common, where there is now an industrial estate, and the name comes from Hirwaun Gwrgant, the long meadow (hir and gwaun) of Gwrgant. Iestyn ap Gwrgant, with Norman allies, probably fought Rhys ap Tewdwr here, and local names such as Maes y Gwaed (bloody field), Carn y Frwydr (battle cairn) and Gadlys (battle court) survive. After the battle, Rhys's head was supposed to have been taken to Penrhys monastery . Later, Fitz Osbern and his Normans turned against Iestyn ap Gwrgant, the last Prince of Glamorgan, and took his lands. Rhys ap Tewdwr was also supposed to have been killed near Brecon in battle.

HODDINOTT, ALUN (1929-2008) The composer was born in Bargoed, Glamorganshire. In 1951, he was appointed lecturer in music at the Welsh College of Music and Drama, becoming professor and head of department in 1967. Among his many awards were the John Edwards Memorial Award (he was the first recipient), the Arnold Bax Medal for composers and the CBE. Hoddinott achieved a mastery of composition that embraces almost every musical medium. In 2004, the BBC National Orchestra of Wales undertook a year-long season of Hoddinott's work to celebrate the composer's seventy-fifth birthday. In 2007 it was announced that the recording space and performance hall of the BBC National Orchestra of Wales, at Cardiff's Wales Millennium Centre, was to be named BBC Hoddinott Hall. Hoddinott's work has been performed all over the world by luminaries ranging from Sir Geraint Evans and Dame Gwyneth Lewis to Rostropovich

and John Ogdon. His life was paralleled by another great Welsh composer, William Mathias (1934-1992). From Whitland in Dyfed, he composed most of his work in Bangor, and one of his anthems was played at the wedding of Charles and Diana in 1981.

HOLT CASTLE It is also known as Chastellion or Castrum Leonis as it has a lion sculpture above its gateway. It was built on the banks of the Dee after the defeat of Llywelyn from 1282, by Earl John de Warrenne, in preference to repairing Castell Dinas Brân. A planned town was placed next to it for English settlers, and burned by Glyndŵr in 1400, but the castle was not taken. There was a detached water-gate on the River Dee, and a 'secret narrow-way' or emergency exit, and it defended a crucial ford over the river. It withstood nearly a year's siege in the Civil War, and except for Harlech, was the last Royalist stronghold to fall in Britain, in 1647.

HOLY ISLAND Off Western Anglesey is Holy Island, Ynys Gybi, with Trearddur Bay, connected by road and rail with the main island. Ynys Gybi is Wales' second largest island, at 28 sq miles and a SSSI.

HOLY WELLS St Non's Well, not far from the chapel of St Justinian, a sixth-century hermit, celebrates the mother of St David. David was in legend born on the slopes of St Non's Bay, and a ruined chapel marks the spot. St David's Cathedral is in a nearby sheltered hollow. St Winifrede's Well in Trefynnon (Holywell), Clwyd, has a shrine which has been a place of pilgrimage and healing since the seventh century, and is known as *'The Lourdes of Wales.'* Ffynon Asa, in the Halkyn Mountains at Newmarket, is Wales' second largest spring. The nearby Gop is the largest limestone cairn in Wales, eighty feet long and supposedly the grave of Queen Boadicea (Buddug). The well of Mair Saint, Holy Mary, at Penrhys between the two Rhondda valleys, was broken up in the Reformation, and is in a poor condition today, but once was almost as famous as St Winifrede's. St Cybi's Well, Ffynon Gybi, used to draw people to its healing waters at Llangybi, as in the eighteenth century a spa developed around it. Its two elaborate well-chambers were beneficial for *'scrofulous cases'*. Ffynnon Fair (Mary's Well) is at the foot of Grisiau Mair (Mary's Steps) where pilgrims used to take their last drink before undertaking the dangerous crossing from Porth Meudwy (Hermit's Entrance) to the holy island of Ynys Enlli (Bardsey). Barri Island featured a strange 'Roman Well', recently built over by a bar, and the spring of Patrisio in the Black Mountains was used by Father Isio, a Celtic hermit who was murdered by Saxons. At Llanfyllin near Welshpool, St Myllin established a church and holy well. He was the first person in Britain to baptise by immersion, in the sixth century, and the citizens of the town used the well for centuries to cure their ills. Penmon Priory has an ancient holy well, in Anglesey, and the nearby sixteenth-century dovecote could hold a thousand birds. *The Holy Wells of Wales*, by Francis Jones, lists 437 remaining holy wells, plus 125 wells with topographical names, 104 wells associated with lay names, 93 with adjectival names, 61 wells named after birds and animals, 32 with occupational names, and 25 named after trees. There are hundreds more 'lost' wells in Wales.

HOLY GRAIL One of the 'Thirteen Treasures' that Merlin had to guard was the Dysgl of Rhydderch, a sixth-century King of Strathclyde. It was a wide platter, where 'whatever food are wished for thereon was instantly obtained'. This was also a description of the drinking horn of King Brân the Blessed, in which one received 'all the drink and food that one desired'. Ceridwen's Cauldron contains all knowledge, and she gives birth to Taliesin. The Cauldron of Diwrnach would give the best cut of meat to a hero, but none to a coward. Brân also had a cauldron in which dead men could be revived. This 'Cauldron of the Celts' seems to be a precursor of the Grail, or cup of the Last Supper. The cup used by Jesus Christ at the Last Supper was supposed to have been brought by Joseph of Arimathea to Glastonbury, and from there to Ystrad-Fflur (Strata Florida Abbey). When Henry VIII dissolved the monasteries, the last seven monks are supposed to have taken the cup into the protection of the Powell family at Nanteos

near Aberystwyth, the descendants of Edwin ap Gronw, Lord of Tegeingl. A tradition says that the fragment of the wooden bowl remaining inspired Wagner to write *Parsifal*, and visitors are shown to the music room where Wagner worked on the opera. Fiona Mirylees, the last Powell heiress, placed the treasured 'cwpan' in a bank safe in Herefordshire, as the Powell family left Nanteos Mansion in the 1960's. The remaining ancient fragment is about 4in across, made of olive wood. So little is left, because supplicants used to wish to take a tiny splinter home with them. Nanteos Mansion has no less than three ghosts: an early Mrs Powell who appears as a grey lady with a candelabra when the head of the household is about to die; a lady who left her deathbed to hide her jewellery which has still not been found; and a ghostly horseman on the gravel drive at midnight.

HOPKINS, GERARD MANLEY (1844-1889) Of *Glory be to God for Dappled Things* fame, he tried to replicate 'cynghanedd' in the rhymes and rhythms of his poetry. Hopkins wanted his poetry burnt on his death, but it fortunately survived. The poems appear to have given a great impetus to the feelings and style of Dylan Thomas' work. A deeply religious man, Hopkins studied theology at St Beuno's in North Wales, where he also learned Welsh. *The Wreck of the Deutschland* and *Henry Purcell* are among the best-known works of this major poet. His poem about the kestrel, *The Windhover*, begins:

I caught this morning morning's minion, kingdom of/daylight's dauphin, dapple-dawn-drawn Falcon'. Pied Beauty tells us: 'Glory be to God for dappled things'... 'All things counter, original, spare, strange;/Whatever is fickle, freckled (who knows how?)/With swift, slow; sweet, sour; adazzle, dim;/He fathers-forth whose beauty is past change:/Praise him.

HORSE Horses were revered in Celtic literature, and the finest horse-trappings found in Britain were the Bronze Age hoard from Parc-y-Meirch (the ancient Horse Park) in Clwyd. The first surviving records of ponies and cobs in Wales date from 930. Hywel Dda's laws recognised five types of horse, the charger, hunter, hack, pack-horse and draft-horse. Wales is now famous world-wide for two types of horse – the lively Welsh mountain pony and the stocky Welsh Cob, which was established as a breed by the fifteenth century. Welsh mountain ponies are sold all over the world, with a record pony price of £22,050 being paid for a stallion, Coed Coch Bari, by an Australian in 1978. Basically, the recognised Welsh breeds are all types of pony, the smallest being the Welsh Mountain, up to twelve hands. The Welsh Pony is slightly larger, traditionally used as a riding pony by shepherds and farmers. The third type is stronger and thicker set, being recognised in the Middle Ages as a working farm horse. The Welsh cob is the largest type. Possibly the largest horse-fair in Europe is held every month at Llanybydder in Dyfed.

HUGHES, 'BILLY' (1862-1952) A Welsh migrant, William Morris Hughes, landed in Brisbane in 1884, aged twenty-two. 'Billy Hughes' became an organiser for the Australian Workers' Union after setting up a bookshop, and in 1894 was elected for the Labour Party to the New South Wales Parliament. Over seven years he campaigned for improved workers' conditions and old age pensions, and he persuaded the Labour party to adopt the full adult franchise in its electoral programme. He then stood for the First Federal Parliament, winning West Sidney in 1901. By 1903 he had qualified as a barrister, and after posts as Minister for External Affairs and Attorney-General became Prime Minister of Australia in 1915. He was given the Freedom of the City of Cardiff, and shared a platform with Lloyd-George to encourage conscription for the First World War. He lost the Premiership in 1923 at the age of sixty-one, but was Attorney-General and Minister for the Navy at the start of the Second World War. In 1952, still an MP, he died aged ninety. His parliamentary career spanned fifty-eight years, the Federation of Australia, two world wars, the Great Depression, and eight years as Prime Minister.

HUGHES, DAVID EDWARD, FRS (1831-1900) This musician, inventor, scientist and philosopher was the first man to transmit and receive radio waves. Born in Corwen, he invented the teleprinter (from 1855, this telegraph-typewriter was widely used). In 1878 he invented the microphone and the induction balance. In 1879, he held an experiment in Great Portland Street. At one end of the street he had a spark transmitter to generate electro-magnetic waves, and at the other a 'coherer', a piece of equipment to receive the waves. He had proposed the theory to Clark Maxwell, and this President and Secretary of the Royal Society witnessed the success of the experiment. A Welshman had proposed and demonstrated the first radio transmitter and receiver in the world, and thereby proved the existence of electro-magnetic radiation. The English committee was not impressed, however, and attributed the effects to Faraday induction, rather than electro-magnetic radiation. A polymath, from 1850-53, Hughes had been a Professor of Music at Bardston College, Kentucky, and he left a fortune to London hospitals. Ten years later, a German scientist named Hertz managed to transmit such radiation just from one side of his room to the other, not exactly the length of a London street, and was honoured with the unit of radio frequency, the Hertz, being named after him.

HUGHES, ELIZABETH PHILLIPS (1851-1925) Born in Carmarthen, she became the first President of the Cambridge Training College for Women Teachers. An advocate of mixed higher education, she was a ground-breaking educationalist. The training college evolved into Hughes Hall, the oldest graduate college in Cambridge.

HUGHES, JOHN (CEIRIOG) (1832-1837)

John Hughes, one of Wales's best-known poets, was born in Llanarmon Dyffryn Ceiriog, and wrote verses to some old Welsh melodies, including the haunting *Dafydd Y Garreg Wen* (David of the White Rock) and *Clochau Aberdyfi* (The Bells of Aberdyfi). His Bardic name was Ceiriog.

HUGHES, JOHN (1814-1889) The first steel mills were built in the Russia of the Tsars by John Hughes of Merthyr, who founded the town of Hughesovka. The Russians called it Yuzovska, renamed Stalino under the dictator, and since re-renamed Donetsk. A shipyard owner, engineer and designer from Merthyr, Hughes went to the Ukraine aged fifty-five to build a metal foundry with eight furnaces, and effectively began the modern Russian iron and steel industry. Hughes was a director of Millwall Engineering and Shipbuilding when he developed armour plating for 'iron-clads', wooden warships with iron shields. In 1864 Admiralty trials, his design was the most effective, and he was invited to Russia to plate the naval fortress at Kronstadt. His New Russia Company in the Ukraine had its own collieries to supply the blast furnaces, and his four sons took over the works on his death, employing up to 50,000 men and moving operations to St Petersburg. His grandchildren learnt Welsh in the 1890's in Russia, but the company was taken over in the Bolshevik Revolution. *Hughesovka: A Welsh Enterprise n Imperial Russia* (1952) by Susan Edwards, is an excellent summary of the enterprise and the family.

HUGHES, RICHARD ARTHUR (1900-1976) A poet, playwright, short story writer and novelist, he wrote *A High Wind in Jamaica* (called *The Innocent Voyage* in the USA) which achieved worldwide success. He wrote plays, verse and some wonderful novels like *The Fox in the Attic* and *The Wooden Shepherdess* before his death in 1976.

HUMPHREYS, LLEWELLYN MORRIS (1899-1965) Known variously as Murray the Hump, or Murray the Camel, his parents were from Carno. He became Al Capone's favourite sideman and was the man responsible for the 'mob' moving into legitimate business and thereby money-laundering. He was the architect of the famous St Valentine's Day Massacre in 1929 when Capone's men, dressed as policemen, wiped out seven of Bugsy Moran's rival gang. He succeeded Capone as 'Public Enemy No. 1' on Capone's death. With the repeal of prohibition, he set up gambling in Las Vegas. For one of his teenage daughter's birthday parties, Frank Sinatra came to sing for her.

HUNGARY The patriot Janos Arany wrote *A Walesi Bardok (The Massacre of the Welsh Bards)* in 1867, the famous Hungarian poem. After the death of Llywelyn the Last by treachery in 1282, King Edward I was said to have ordered the bards to celebrate his victory in song. Instead they chose death by singing of the killing of Welsh independence. This would have been entirely in character with this French-speaking King of England. There were restrictions placed upon the movement of bards by English kings, as the bards carried information in their songs and poems, in the absence of other media.

HWYL 'Hwyl' is a fervour, a passion, a feeling of invincibility, that the Celts had when they charged naked into battle against the Romans. 'Hwyl' can be experienced at international rugby matches, eisteddfodau, cymanfa ganu and at the remarkable times when dozens of Welsh choirs congregate to sing in The Royal Albert Hall. Tremendous 'hwyl' was also injected by the old nonconformist preachers, moving the parishioners nearly to tears. Very few of these old-timers still exist.

HYWEL AP CADELL AP RHODRI AP MERFYN FACH – HYWEL DDA – HYWEL THE GOOD OF DEHEUBARTH (890-950) In 918, it appears that Hywel ap Cadell ap Rhodri Mawr ruled Dyfed, and in 920 took over Seisyllwg when his brother Clydog died, so his lands covered the kingdom of Deheubarth, South-West Wales from the Dyfi to the Tawe. He made a pilgrimage to Rome in 928, and then from his power base in Deheubarth, this grandson of Rhodri Mawr added Powys and Gwynedd to his kingdom, to largely reunify Wales by 942. In *'Brut y Tywysogion'*, Hywel was described as *'the chief and most praiseworthy of all the Britons.'* The only Welsh king to earn the epithet 'Dda', 'the good', he peacefully unified much of Wales by inheritance, marriage, alliances, and diplomatic relations with Alfred the Great of Wessex. Upon the death of Idwal Foel of Gwynedd at the hands of the Saxons, Hywel drove out Idwal's sons and took over Gwynedd and Powys. He led no invasions into England, and coexisted peacefully with Aethelstan upon his succession after Alfred's death. It had helped that Alfred's chief advisor, Asser, was a former monk at St David's. Hywel understood the power of his larger neighbour, despite strong calls from the bards to ally against them. He had seen the death of Idwal and witnessed the final extinction of the Brythonic kingdom of Cornwall, and wished to keep Wales intact. Hywel Dda's quiet diplomacy helped give Wales another three centuries of independence against its larger neighbour.

The assembly called by Hywel in 930 at Y Hendy Gwyn (Whitland) was one of the first of its kind in Britain. In 942 the assembly finally established a legal code for all of Wales, *'Cyfraith Hywel'*, codifying the common laws of all the different kingdoms. This legislation was only destroyed in 1536 with the Act of Union with England, where laws based upon the right of the individual of any sex were replaced by laws based upon male dominance, property ownership and class structure solidification. Hywel's death in 949 or 950 saw the resumption of Viking attacks, and the laws of gavelkind meant that princes fought against princes with no national unity until the accession of Gruffydd ap Llewellyn in 1039. There were ninety years of murder and mayhem and internal power struggles against a background of Saxon, Mercian and Norse invasions. But the Laws lived for 600 years, and their ethos of human equality is slowly replacing the property-based spirit of English laws.

HYDDGEN, BATTLE OF, 1401 1,500 English soldiers and Flemish mercenaries marched from Pembrokeshire, on Henry IV's orders, to end the Glyndŵr War of Independence. They found Owain Glyndŵr with 120 followers on the slopes of Mynydd Hyddgen near Pumlumon Mountain. The Welsh were mounted, and skilled archers when on horseback. At least 200 of the English force were killed as it fled south. Two stones of quartz stand near the battlefield, called Cerrig Cyfamod Owain Glyndŵr (The Covenant Stones of Owain Glyndŵr), suggesting that here he resolved to his troops that there was no going back. The significance of this battle flashed through Wales and England. Welshmen left English universities to follow Glyndŵr, and there was an upsurge in his following across Wales. Welsh labourers in Shropshire and Hereford downed tools. Henry IV

heard the news on 26 May and summoned the men of fourteen counties to meet him at Worcester for a full-scale invasion of Wales. Glyndŵr wrote to the lords of West Wales 'After many years of captivity, the hour of freedom has now struck, and only cowardice and sloth can deprive the nation of the victory which is in sight.'

IFOR BACH (fl. 1158) A hero well known to Welsh children is 'Little Ifor'. Ifor ap Meurig, Lord of Senghennydd, attacked Cardiff Castle when Henry II was invading West Wales. In 1158, he scaled the walls of the considerable Norman motte which can still be seen inside the grounds of the castle. Ifor Bach captured Earl William of Gloucester, his wife and eldest son, and took them back towards Caerphilly, holding them until the Earl promised to give back the lands he had stolen from the Lordship of Senghennydd. This was an amazing feat, for Cardiff was a Norman bastide. Ifor and his small force had to scale the Roman walls, then get into the high keep, which still exists, and get out alive. There were one hundred and twenty men-of-arms and numerous archers stationed in the castle. Ifor's wife was Nest, a granddaughter of Rhys ap Tewdwr, and a sister of the Lord Rhys. Their great grandson, LLYWELYN BREN, was to be executed years later for trying to regain his birthright as Lord of Senghenydd.

ILLTUD, SAINT (c. 475-525 or 537) St Illtud was a Breton disciple of St Garmon, who became head of the most famous monastery in Britain, Llanilltud Fawr (Llantwit Major), after studying at Llancarfan. His pupils included St Samson of Dol (regarded as the patron saint of Brittany), St Cybi, Gildas the historian, and Maelgwn Gwynedd. Dewi Sant was probably educated here, also. Abbot Illtud died around 537, and is said to be the model for Sir Galahad in Arthurian romance. The Breton *Life of St Samson* calls him 'of all the Britons the most learned in the scriptures.' He was linked with Arthur as Illtud the Warrior, and a guardian of the Grail, and was feasted in Wales and Brittany.

INDUSTRIAL REVOLUTION Iron ore deposits in south-east and north-east Wales ensured rapid industrialisation after the 1770's, and from the early nineteenth century huge coal deposits were discovered, mainly in South Wales. Quarrying was also important, with slate in northwest Wales and limestone across Wales being extracted. Manganese, gold, silver, lead, uranium, copper and zinc have also been found in quantity across Wales. Wales was incredibly important in the early years of the Industrial Revolution across the developed world, e.g. Dowlais Ironworks in 1840 was the largest manufacturing concern in the world. In the mid-to-late nineteenth century, only the USA and the Ruhr rivalled South Wales as a region of pure industrial power, with its vast outputs of coal, iron, steel, zinc, copper and nickel. In the early nineteenth century, it is not hyperbole to say, that backed by its natural resources and mineral wealth, Wales had become the first industrial nation.

INNES, JAMES DICKSON (1887-1914) He was a superb landscape artist, much influenced by RICHARD WILSON and then AUGUSTUS JOHN. He seemed to be developing towards the Fauve (Matisse, Vlaminck, Derain, Rouault) movement before his tragic early death. With Augustus John, he rented a cottage in Snowdonia, and they contributed to the post-Impressionist movement.

IOLO MORGANWG (1747-1826) Unfairly traduced by some Welsh academics, to many he was the 'saviour of Welsh culture'. This editor of the *Myvyrian Archaeology* collected manuscripts, folk songs and traditions from across Wales. Born Edward Williams at Pennon near Llancarfan, He met the Prime Minister, William Pitt, and Dr Johnson, and was planning to seek the Mandan Indians with JOHN EVANS but ill health precluded the venture. He re-established the National Eisteddfod after a gap of centuries, and devised the Gorsedd ceremony and the Gorsedd of Bards. His voluminous papers were gathered by his son Taliesin and placed in the National Library of Wales. Iolo, more than anyone, sparked the revival of Welsh culture and

tradition. He is regularly traduced as a forger, but recent evidence strongly contradicts some of this criticism. Also modern writers tell us that Iolo was dazed by laudanum for all his life, not criticising Elizabeth Barratt Browning who was a greater user. Perhaps they do not realise that until the 1920's opium was prescribed as a medicine for asthma and other ailments. Iolo's so-called 'addiction' is not reflected in his voluminous writings and research which carried on until he was nearly eighty years old. Again, academics write what they have been told, neglecting the truth. A major re-assessment of his writings is needed, preferably not by academics. It is ironic that Iolo's motto was 'The Truth Against the World'.

IORWERTH AB OWEN (fl. 1175) *The Chronicles of the Princes* tell us of Iorwerth ab Owen, a descendant of the princes of Gwent, who controlled the lands around Caerleon. Rhys ap Gruffydd had given King Henry II free passage to cross Wales and invade Ireland in 1171. Henry took Caerleon from Iorwerth and installed a garrison. Iorwerth retook the ancient fort, and told the Normans to follow their king to Ireland. He then burnt the site so that the king would never want it again. In 1172, Henry returned, offering a pardon and the return of Iorwerth's lands. He invited Iorwerth to meet him for a peace treaty, and gave safe conducts for him and his sons. The Welsh leader was well aware of Henry's practice of blinding hostages, and sent just one son Owain, bearing gifts. Owain was killed, so Iorwerth crossed the Wye, attacking Gloucester, burning Hereford, and returned to Caerleon and rebuilt the town. His brother-in-law Seisyllt ap Dyfnwal captured Abergavenny Castle, and another kinsman Seisyllt ap Rhirid took the king's castle at Crickhowel (Crug Hywel), killing the garrison. In 1175, the Normans attacked suddenly and retook Caerleon from Iorwerth and his surviving son Hywel. However, The Lord Rhys arbitrated, and it was restored to Iorwerth soon after. Iorwerth was the only Welsh chieftain who escaped from the treachery of William de Braose, where Seisyllt ap Dyfnwal was murdered. He then forced the Norman Marcher Lord to flee from Abergafenni back to Brecon, trying to avenge this massacre of seventy unarmed Welsh noblemen. Iorwerth ab Owen, Lord of Caerleon, married Angharad, the daughter of Uthryd, who was Bishop of Llandaf from 1140-1148.

IRON AGE BUILDINGS In the Museum of Welsh Life, St Fagans, there are three roundhouses, roofed with straw and defended by a palisade and ditch. They are based on the remains of excavated buildings. The stone-walled house is based upon one at Conderton in Worcestershire. The first wattle-walled house as one enters the site is from Moel-y-Gaer hill fort in Flintshire. The large house, with its roof supported on posts, is from Moel-y-Gerddi in Gwynedd. There are working fires, firedogs and other utensils of the time in the huts, giving one an invaluable insight into Iron Age life.

IRON RING OF CASTLES This World Heritage Site of Harlech, Conwy, Caernarfon and Beaumaris castles, built by Master James of St George for Edward I to cut off Gwynedd, almost bankrupted the English crown. It was paid for by huge loans from foreign moneylenders, and the twelve-year programme (including other castles such as Aberystwyth, Cricieth and Rhuddlan) cost many times Edward's annual income. All the castles were accessible by sea, to enable supplies in times of siege, as the Welsh had no navy.

IRON & STEEL Nearly all the industrial heritage sites in Wales are in areas of real natural beauty, and many have blended into their backgrounds. Saundersfoot, a lovely little seaside resort, used to be a coal exporting port for the South Pembrokeshire coalfield, and in nearby Stepaside there are the remains of Grove Colliery and a nineteenth-century ironworks, slowly being cleared from the woodlands that enclosed them by the Stepaside Heritage Project. Dyfi Furnace is a well-preserved charcoal-fired blast furnace, with waterwheel, which was used for smelting iron between 1755 and the early nineteenth century. Near Pontneddfechan are abandoned gunpowder works and silica mines, in the woodland around the complex of waterfalls at Ystradfellte. A plaque on the wall of Tintern Abbey records the discovery and manufacture of brass, the alloy of zinc and

copper, by Cistercian monks in 1568. As the Abbey was dissolved in 1536 by Henry VIII, the provenance and proof of this claim needs further research. Blaenafon Ironworks opened in 1789, operating until 1900 and the remains, the best-preserved in Western Europe, are open to visitors. This historically important site includes a bank of blast furnaces, casting houses, water balance lift and workers' cottages, and is presently in the care of CADW (Welsh Historic Monuments). On the Forge site, a young Welshman called Sidney Gilchrist Thomas, with his cousin Percy Carlyle Gilchrist developed a new process of steel production in 1878. He used phosphoric ores, revolutionising steel manufacture by perfecting the 'Bessemer Process'. He sold the patent to a Scot called Andrew Carnegie, who then made millions of dollars in the USA and elsewhere from what is known today as 'The Carnegie Process'. Sidney Thomas' discovery vastly accelerated industrial expansion in Europe and America. Blaenafon is so internationally important in its archaeological remains that it has become a 'World Heritage Site'.

The round towers in Nantyglo were built to protect the ironmasters in case of the workers rebelling from their terrible conditions, pay and housing, with regular cholera epidemics. There are heritage walks around the area. The old Clydach Ironworks near Neath lie in a gorge of native beech woods, now a National Nature Reserve. Bersham Ironworks was important in the development of the iron industry. Here in 1775 a new method for horizontally boring-out cylinders was patented by John 'Iron-Mad' Wilkinson. The smooth circular bore enabled really accurate cannon to be manufactured for the American Civil and Napoleonic Wars. It also enabled the production of fine tolerance steam engine cylinders – James Watt was a customer – which speeded up the Industrial Revolution, with steam engines obsolescing water-powered production sites and replacing the horse and sail as methods of transport. Merthyr was known as the 'iron and steel capital of the world' during the Industrial Revolution, and South Wales was producing half of Britain's iron exports by 1827. In 1831, Merthyr Tydfil had the largest population in Wales, surpassing Cardiff, Swansea and Newport combined. Iron-masters such as Homfray, Guest, Hill, John Guest at Dowlais, and Richard Crawshay at Cyfartha controlled their mills with the proverbial 'rod of iron', and museums and Ynysfach Engine House recall these oppressive days. Thomas Carlyle wrote to his wife this description of Merthyr in 1850 'Ah me! 'Tis like a vision of Hell, and will never leave me, that of these poor creatures broiling in sweat and dirt, amid their furnaces, pits and rolling mills... The Town might be, and will be, one of the prettiest places in the world. It is one of the sootiest, squalidest and ugliest; all cinders and dust mounds and soot... Nobody thinks of gardening in such a locality – all devoted to metallic gambling.' As usual, Idris Davies had a verse for the effects of the Industrial Revolution, in *The Angry Summer*.

Great are the fires of Ebbw Vale,
And all the seas and heavens,
Great are the ships in Barry Dock
And great the golden forests,
Great are the shadows over the Rhondda
And the mansions built in the shires,
Great are the fortunes made in Gwalia
And the promontories of slag.

Antony Bacon's furnace at Cyfartha produced the rails for the earliest lines for Britain, America and Russia. Bacon retired in 1784, deeply worried by the fact that his works had supplied the iron for the guns that the Americans used in their War of Independence against England. Dowlais was the first plant in Britain to produce using the Bessemer process. All Merthyr's ironworks closed by the 1930's, Cyfartha having been the biggest foundry in Britain in 1800. Cyfartha had opened in 1765 and eventually closed in 1910. The other major ironworks at Merthyr, Dowlais, Penydarren and Plymouth, had opened in 1759, 1784 and 1763 respectively. Dowlais was the last to go, in 1936. All were owned by Englishmen, and the remains are evocative of a time when

Merthyr was the world centre of the Industrial Revolution. William Crawshay built Cyfartha Castle, overlooking Merthyr, as a symbol of his dominance, in 1825. His son Robert, closed the works in 1874 rather than give in to worker demands for decent wages and conditions. He kept them closed until his death in 1879, causing terrible hardships. On the huge stone slab covering his grave in nearby Vaynor, the inscription reads *'GOD FORGIVE ME'* - God may forgive, but the Welsh remember still.

IWAN, DAFYDD (1943-) From Upper Brynaman in Carmarthenshire, Dafydd Iwan Jones became the chairman of the Welsh Language Society from 1968-1971 and has campaigned for it ever since. He is now President of Plaid Cymru. He helped found Sain Records in 1969, the year of the Investiture of the Prince of Wales at Caernarfon, arousing controversy with his satirical song *Carlo (Charlie)* about Prince Charles. He has published over 200 songs, of which the most famous, *Yma o Hyd (Still Here)* refers to the survival of the Welsh people.

JEFFERSON, THOMAS (1743-1826) As third President after George Washington, the Welsh-American Thomas Jefferson negotiated and signed the Louisiana Purchase of French territories from Napoleon. For $15 million, the infant USA doubled in size - a cost of just 4 cents an acre. Jefferson used all his powers when he drafted the Declaration of Independence, imbued with the Welsh traditions of social equality... his original draft declares 'We hold these truths to be sacred and undeniable; that all men are created equal and independent, that from that equal creation they derive rights inherent and inalienable, among which are the preservation of life, and liberty, and the pursuit of happiness.' J. F. Kennedy, at a dinner honouring Nobel Prize winners said: 'I think this is the most extraordinary collection of talent, of human knowledge, that has ever gathered together at The White House - with the possible exception of when Thomas Jefferson dined alone.' This greatest and most unassuming American president composed his own epitaph - 'Here was buried Thomas Jefferson, Author of the Declaration of American Independence, of the Statute of Virginia for Religious Freedom, and Father of the University of Virginia'. Jefferson was extremely proud of his Virginian statute. It enshrined the separation of the church and state, as he believed in religious liberty - a politically-aligned religion would mean minority persecution. He believed that 'the care of human life and happiness... is the first and only legitimate object of good government'.

JENKINS, ROY (1920-2003) This miner's son and Labour MP was the Home Secretary who delivered 'the Permissive Society' between 1965 and 1967, with the legalisation of abortion and homosexuality. A successful Chancellor of the Exchequer, he was the first Briton to become President of the European Commission (1976-81). Together with three other leading Labour members, he formed the Social Democratic Party and dramatically won Glasgow Hillhead, a traditional Labour seat, in 1982. An adviser to Tony Blair, he was called 'the grandfather of New Labour', and was Chancellor of Oxford University when he died.

JOHN, AUGUSTUS (1878-1961) Augustus, and his sister Gwen, from Pembrokeshire, have many paintings in Welsh art galleries. Augustus John shocked even the Bohemian art world with his behaviour and promiscuity. A student at the Slade in the 1890's, he was invited to paint Queen Elizabeth, the wife of George VI, in 1937. He suggested that he stayed at a pub near Windsor Castle, where she would visit secretly for sittings, an offer she refused. In the 1940's he was offered a knighthood. His wife had died, and he was told by authorities that he must marry his long-time mistress Dorelia. He had lived and procreated with her for forty years, so he proposed - and she demurred, thus depriving him of his recognition. His portraits and paintings can be found in Stockholm, Washington, Sydney, Detroit and Dublin. For thirty years he had been the leading portrait painter of British society, hailed as 'the last of the Old Masters', but was a wild child until the end. Dylan Thomas' wife, Caitlin, was one of the many artists' models who found herself compromised in a relationship with him.

JOHN, GOSCOMBE (1860-1952) One of the most prominent Welsh sculptors, he is well-represented in Welsh galleries.

JOHN, GWEN (1876-1939) Regarded as a better painter by her famous brother Augustus, and born in Haverfordwest, she had an affair with Rodin, who was six years older than her father. She then lived a life of seclusion, producing some superb canvases.

JONES, DAVID (1895-1974) In 1937, David Jones wrote *In Parenthesis (seinnyesit e gledyf ym penn mameu)*. TS Eliot wrote that he was 'deeply moved' by the typescript and that it was 'a work of genius' in his introduction to it. Part poem, part book, it mingles Jones' cathartic experiences in the First World War with Arthurian legend, Welsh mythology and the Roman occupation of Britain. Eliot places Jones in the same literary representation as himself, Ezra Pound and James Joyce. Jones, a writer, painter, calligrapher and illustrator, was obsessed with the way technocracy has taken us away from faith and sacrament. The intensity of his inspiration from his historical roots is probably only rivalled by Arthur Machen and W.B. Yeats. According to the great poet W.H.Auden, David Jones' *The Anathemata* was 'very probably the finest long poem written in English this century'. Jones' considered meditation on the history and mythology of Celtic-Christian Britain was intelligent, ambitious and influenced T. S. Eliot's own work. Jones' *Epoch and Artist* is dedicated to Saunders Lewis, the Welsh Nationalist writer. All his writings show his alienation against the world of machines, existentialism, modernism and the analytical philosophy that eradicates metaphysics and the signposts of history. Jones was also a fine painter and calligrapher, influenced strongly by his friend Eric Gill. His delicate watercolour washes and elegant calligraphy took him away from the mainstream of British art, and a reassessment of this most multi-talented man is overdue. Kathleen Raine describes the 'Turneresque evanescence' of his painting *Manawyddan's Glass Door* in her wonderful appreciation of his writings, poetry and art in *David Jones and the Actually Loved and Known*. His luminous, visionary watercolours, redolent of Arthurian mysticism and the legends of *The Mabinogion*, can be seen in the Tate Gallery and many other museums.

JONES, DR DYFRIG (1940-1989) Dyfrig Jones gave, in the science lecture at the 1986 Abergwaun (Fishguard) Eisteddfod, *Voyager* data from Jupiter and Saturn, which vindicated his theory of planetary radiation. Born in Cribwn, Pembrokeshire, he explained his findings in Welsh. Honoured in America and amongst the worldwide space community, he was hardly known in Wales. In charge of the Space Plasma Physics Section of the British Antarctic Survey, he worked on myriametric plasma wave radiation.

JONES, DR ERNEST (1879-1958) He was a lifelong friend of Sigmund Freud's, and introduced psychoanalysis to the USA and Britain. With Jung, he organised the world's first psychiatric conference at Salzburg in 1909, with Freud as the lead speaker. Dr Jones learned German in order to more fully understand Freud's theories, and was instrumental in the furthering of Freud's work on neurosis. Jones helped organise Freud's relocation into England from Austria to escape the Nazis, and formulated the psychological concept of 'rationalisation' – describing excuses for things about which a person feels uncomfortable or guilty. Jones is remembered as the man who did more than anyone to popularise Freud's work.

JONES, GARETH RICHARD VAUGHAN (1905-1935) From Barri, this investigative journalist flew with Hitler on his private plane and warned the world about the dangers of Nazi Germany and Hitler's rise to power. In 1933 he wrote of the trip 'If this aeroplane should crash, the whole history of Europe would be changed.' Jones had been a Private Secretary for Foreign Affairs to Lloyd George. He also was the first foreign journalist to report on starvation in Stalin's Russia, after travelling through the Ukraine. Jones interviewed Lenin's widow, and his accounts were at extreme odds with those of the Russian sympathisers such as George Bernard Shaw and the Pulitzer Prize winning Walter Duranty of the *New York Times*. They echoed what the Communist Party told them, never

venturing out of Moscow to see the reality. Jones was in Inner Mongolia, checking upon reports that Japan was going to invade China, when he was killed by bullets in the back of the head, almost definitely by the Japanese secret service rather than by Chinese bandits. The NKVD – the Soviet Secret Police – was also suspected of shooting him three times in the head. Jones had also been travelling with a German with Nazi connections, who was spared. Gareth Jones, as well as exposing Stalin's *Five Year Plan* and its consequent 6-11 million deaths, predicted that World War II would begin in the Polish Corridor, that it would involve all Europe and that Japan would enter the war. The book *Gareth Jones: A Manchuoko Incident* (Dr Siriol Colley, 2001) is an inspirational account of a man whose accurate and unbiased reporting, if he had lived, could have stopped Word War II.

JONES, GEORGE (1811-1891) His parents John Jones and Barbara Davis left Llanwyddelan, Montgomeryshire for New York in 1801 and moved to Poultney, Vermont. Here, George was born, but he was orphaned aged 13. In 1841 he was offered a partnership in the *New York Tribune*, but refused. He stayed in the book and news business and became a successful banker, and in 1851 co-founded the *New York Times*. In 1862 he took over as editor, and became the major stockholder in 1876. As sole publisher, he was later responsible for the downfall of '*Boss Tweed*' from city office after a string of reports exposing corruption in the city.

JONES, GRIFFITH (1683-1761) 'The man who made Wales the most literate European nation' was born at Penboyr, Carmarthenshire, and began the 'circulating schools' movement in the 1730's. All the schoolmasters were personally trained by him. At his death, it was estimated that almost 200,000 people between the ages of six and seventy had been taught to read, out of a population estimated at 450,000 in 1750. Almost 3500 schools had been set up, and Wales was probably at this time the most literate country in the world, with William Morgan's Welsh Bible assisting the ability to read Welsh. The Welsh language may well have died out without the impetus and inspiration of Griffith Jones.

JONES, INIGO (1573-1652) Wales is about castles and churches, not great mansions and palaces. However, the great Inigo Jones (of Welsh parentage) has many houses and bridges attributed to him in Wales. He founded classical English architecture, designing the Queen's House at Greenwich, rebuilding the Banqueting Hall at Whitehall, and laying out Covent Garden and Lincoln's Inn Fields. He also designed two Danish royal palaces and worked with Ben Jonson, introducing the proscenium arch and movable scenery to the English stage. He was the greatest of the 'English' (sic) Renaissance architects.

JONES, LEWIS (1896-1939) From Clydach Vale, he was a political activist and a committed socialist novelist. In the 1926 General Strike he was imprisoned in Swansea for three months for his activities in the Nottinghamshire coalfield. He became Chairman of the Cambrian Lodge of the South Wales Miners' Federation, regularly in conflict with managers wishing to impose piecework. He resigned in 1929, refusing to work with non-unionised labour (whom he scorned as 'scabs'), and was unemployed for the rest of his life. Jones remained a political activist, but was sent home from Russia for remaining seated during a long standing ovation to Stalin. Jones led the 1932, 1934 and 1936 'Hunger Marches' from Wales to London. In 1936, he was elected as one of the two Communist members of the Glamorgan County Council. Jones died at the end of a day in which he had addressed over thirty meetings, in support of the Republican side in the Spanish Civil War. His novels *Cwmardy* (1937) and *We Live* (1939) are a grimly realistic description of life in a Welsh mining community, especially of the miners' struggle with their employers.

JONES, MARY (1784-1864) From Llanfihangel-y-Pennant, this sixteen-year-old girl walked barefoot over the mountains to Bala in 1800 to buy a Welsh *Bible* with all her precious life savings. This event inspired the formation of The Bible Society, whose London headquarters still treasures and displays her Bible. There is an inscription to her at Bryn-Crug Chapel.

JONES, MICHAEL DANIEL (1822-1899) Born in Llanuwchllyn, Merioneth, he was the father of the Welsh national movement, and to many was the greatest Welshman of the nineteenth century. He became Principal of Bala College, but his life work was the foundation and establishment of the Welsh colony of Patagonia. He was afraid that the proximity to England was destroying everything Welsh, and wanted to preserve Wales and Welshness forever. Jones was deeply concerned about the Anglicisation of Wales – his only solution to preserve Welsh heritage was to physically move the Welsh people. Jones founded the Patagonian Welsh colony, returned to Wales and set up the Bala-Bangor Theological College, constantly campaigning for Welsh causes. In his words, his Welsh-speaking colony would allow people to escape from the oppression of Tory landlords to a state where: '... a free farmer could tread on his own land and enjoy his own hearth, the song and the harp and true Welsh fellowship... There will be chapel, school and Parliament and the old language will be the medium of trade, of science, of education and of government. A strong and self-reliant nation will grow in a Welsh homeland.'

JONES, OWEN GLYNNE (1867-1899) This schoolmaster was killed on the Alps when his leading guide fell on him, but is recognised as 'the leading pioneer of rock-climbing in the British Isles, from the point of view of both technique and altitude.'

JONES, THOMAS (1742-1803) From Pencerrig, his mentor was Richard Wilson, and his series of paintings from Italy (1776-1783) have been called 'some of the most original and exhilarating landscape art produced by anyone, anywhere, in the eighteenth century' (Waldemar Januszczak, *Channel 5 TV*, 2003). There was a bicentenary exhibition in the National Museum of Wales in 2003.

JONES, TOM (1940-) Born Thomas Woodward, 'Jones the Voice' from Trefforest had a huge hit with *It's Not Unusual* in 1964, since when he has been a performer on the world stage. One of his songs, *Delilah* has been adopted by Welsh rugby crowds. He signed a contract to be the highest paid performer on British television in 1968, and regularly performs in the USA.

JONES, WILLIAM (1675-1749) From Llanfihangel tre'r Beirdd, Anglesey, Jones introduced the symbol for *pi* (the ratio of the circumference to the diameter of a circle) in 1706, adopted by Euler as the standard symbol in 1737. The mathematician was a friend of Dr Johnson, Edmund Halley and Isaac Newton, and was the father of the noted philologist Sir WILLIAM JONES. The name of his village denotes 'the holy place of St Michael in the place/town of the bards'.

JONES, SIR WILLIAM (1746-1794) This Welshman, serving as a judge in Calcutta, 'made the epoch-making discovery that the main languages of Europe are closely related to the principal languages of India. Jones saw the link between the classical Latin and Greek and ancient Sanskrit. It subsequently turned out that many modern Indian languages formed part of the same family as their counterparts in Europe, namely the Romance, Celtic, Germanic, Baltic and Slavonic groups' (*'Europe - A History'*, by Norman Davies). He was thus known as 'Oriental Jones' by his Welsh peers, for his pioneering studies in Sanskrit and Persian, and had a working knowledge of over thirty languages. He published his Persian Grammar aged only twenty-six, and learned Sanskrit as a Supreme Court judge in Bengal. Notable among his contemporaries as being utterly free of racial prejudice, he was the first linguist to discover that there was a linguistic 'family tree' that diversified into different, but related, languages.

JOSEPHSON, PROFESSOR BRIAN (1940-) One man who might turn out to be *'the most influential Welshman of all time'* is Cardiff's Brian Josephson, who specialised in Low Temperature Physics. He discovered what is now known as the *'Josephson effect'*, showing that an electrical current could flow between two superconductors (materials with no electrical resistance) even when an insulator was placed between them. This theory enabled him to design *'Josephson Junctions'*, which

possibly will become the basic component of hyper-powerful computers. These junctions have been applied to create extremely sensitive scientific instruments, capable of, for example measuring variations in the magnetic field living organisms. A Nobel Prize winner in Physics in 1973, his is still an unfamiliar name in Wales. He is now in charge of the Mind-Matter Unification Project of the Theory of Condensed Matter Group at the Cavendish Laboratory, Cambridge University.

KELLY, DAVID (1944-2003) From the Rhondda, Dr Kelly was a biological weapons expert. He allegedly committed suicide after exposing the falseness of the case for the UK going to war with Iraq, despite suicide being against his Bahá'í faith. Kelly was supposed to have killed himself by slitting a wrist, but there was no blood, nor fingerprints on the knife, and at the same time taking an 'overdose' of painkillers which was less than a third of a lethal dose. The Liberal Democrat MP Norman Baker wrote a persuasive book, *The Strange Death of David Kelly* stating that Kelly was killed before he could make more statements about the lies which led Britain into the Iraq War. Kelly had told a BBC reporter, Andrew Gilligan, that the Government had exaggerated its claims on Iraq's 'weapons of mass destruction', to justify declaring war. Kelly was unhappy with some of claims, especially the one that Iraq was capable of firing battlefield biological and chemical weapons within forty-five minutes of an order to use them. Kelly had visited Iraq thirty-seven times as a member of the United Nations team UNSCOM, and his success in uncovering Iraq's biological weapons programme led to his being nominated for the Nobel Peace Prize, a fact notably omitted by British media. The anodyne Hutton Report stated that Kelly had committed suicide. On the following day (28 January 2004), *The Independent* newspaper had just one word on its front page – 'WHITEWASH'. Not one 'weapon of mass destruction' was ever found in Iraq. Andrew Gilligan, the finest of all the BBC's investigative journalists, was forced to leave the BBC after an internal inquiry. He said: 'This report casts a chill over all journalism, not just the BBC's. It seeks to hold reporters, with all the difficulties they face, to a standard that it does not appear to demand of, for instance, Government dossiers.' Gilligan has never worked for the BBC since. Kelly had been asked what would happen if Iraq was invaded, and had replied, 'I will probably be found dead in the woods.' He was found beneath a tree in woodland.

KENFIG, CYNFFIG The 1,500 acres of dunes in the National Nature Reserve at Kenfig are home to 500 species of flowers, which is a third of the total number of British species. 95% of Britain's population of the Fen Orchid can be found here amongst the Burnet Roses, Sea Lavender and Sea Holly. A huge swathe of sand dunes, the largest complex in Britain, protected most of the South Wales coast in the past. The sands have been encroaching since the ninth century, covering Kenfig Village and its castle. The Normans built the castle and town around 1150, and by 1181 it was recorded that twenty-four ships lay in Kenfig's harbour. By 1281 there were 142 burgesses living there, but by 1485 the church, grange and castle had been virtually obliterated by sand dunes. Kenfig Medieval Borough is a scheduled monument of national importance – it has never been built upon or redeveloped, and is being slowly uncovered by archaeologists. The old 'Town Hall' occupies the upper room of a local inn, and is symbolic of a site that had parliamentary representation up to 1832. Kenfig Pool is home to many rare species of dragonfly, and the recently restored Sker House, which features in R.D. Blackmore's *The Maid of Sker* is a short distance away. Sker House was also famous for its ship-wreckers in centuries past.

KENFIG CASTLE Robert, Earl of Gloucester built this in the early twelfth century, and after constant Welsh attacks, it finally succumbed to drifting sand dunes after the thirteenth century.

KENFIG POOL & MEDIEVAL TOWN Kenfig Pool (Pwll Cynffig) is said to be the largest natural lake in South Wales, the centre of a fabulous eco-system of sand dunes leading to the sea, and the remains of a medieval borough lie next to it, under the sands.

KING OF BARDSEY ISLAND Farming and fishing supported a population of a hundred on Bardsey (Enlli) until 1925, when there was a mass emigration. Its leader, Love Pritchard, had been declared unfit for military service in World War I because he was too old. In a fit of pique, this acknowledged 'King' of Enlli declared the island a pacifist enclave. The title of King probably went back to the Middle Ages when the island was held by its Abbot. It was then taken over by an islander, who represented the islanders to their landlord, who was then Lord Newborough. The islanders were usually very late in paying their rents, despite which Lord Newborough had donated a crown to Love Pritchard. In response to the authorities' fears that the king and his Enlli subjects would side with the Kaiser, a boatload of police appeared, and took away everyone of military age. In 1925, the King of Enlli led a mass exodus of farmers and their families, leaving only half a dozen people behind. Wynford Vaughan Thomas recounted a visitor's recollection of a 1910 meeting with Love Pritchard at suppertime: 'His Majesty sat in his grandfather's chair eating supper which consisted entirely of crabs and beer. On one side of the chair was a collection of good-sized crabs among seaweed in a wooden pail; on the other side an equally big pail of beer. The King was smoking but every now and then he reached down into the left-hand pail, pulled out a crab, put it on the back of his left hand and brought his right fist down on it with a crash. He took out the insides of the crab, dropped them in the beer, and swallowed the lot with one gulp.'

KINNOCK, NEIL, BARON KINNOCK OF BEDWELLTY (1942-) One of only six Welsh Labour MP's who voted against devolution for Wales in the 1979 campaign, the Bedwellty MP became Leader of the Labour Party in 1983 and was widely expected to defeat Margaret Thatcher in the 1992 election. His triumphalist campaign led to a surprise defeat, after which he resigned as leader of the Labour Party. Thatcher's grateful government recommended him for a post as European Commissioner, which he occupied from 1995-2004. The main act he is remembered for in the EU is the sacking of Marta Andreasen in 2002. Kinnock insisted upon charges against the European Commission's former chief accountant. She had gone public with information that the EU's accounting procedures leave its massive budget open to fraud. She had said: 'The fundamental issue in this situation is that there is a lack of control in the €95bn entrusted to the European community.' She had previously complained several times internally, but no action was forthcoming. As of 2009, auditors are in their fifteenth year of refusing to sign off EU accounts because of institutionalised fraud. Anywhere else in the civilised world, if auditors refuse to pass just one year's accounts, there can be legal and criminal repercussions.

Leaving the EU after serving his two unelected terms, Kinnock became Chairman of the British Council in 2004. His son became head of its St Petersburg operation in the same year. His daughter works in the Policy Unit at 10 Downing Street for Gordon Brown. Kinnock's wife Glenys has been an MEP (Member of the European Parliament) since 1994. A former teacher, in 2006 she was criticised for attending a conference to discuss world poverty issues in Barbados. Always deeply critical of the House of Lords, Neil Kinnock had said he would never become a lord, but took his seat in it in 2005 as Baron Kinnock of Bedwellty. He was accused of hypocrisy by both socialist and conservative politicians and commentators. Neil Kinnock is also President of Cardiff University. He studied for a degree there, but to this day mystery surrounds whether he passed, failed it or retook it. In 2006 Kinnock was banned from driving for six months for two speeding offences in 2005 and 2006 on the M4 motorway. This took him to fifteen points on his driving licence, having already three speeding offences worth nine points within the previous three years. These five speeding offences in three years may be explained by his conversion to metrification during his lucrative years in Brussels. Earlier in 2006 Lord Kinnock had written an introduction to a report by the UK Metric Association, stating that that the continued use of miles in Britain was the 'most obvious example of the muddle of measurements units' in the country. He said in the report that imperial road signs 'contradict the image – and the reality – of our country as a modern, multicultural, dynamic place where the past is valued and respected and the future is approached with creativity and confidence.' According to Gwynfor Evans (*The*

Fight for Welsh Freedom, 2000), Kinnock said that 'between the mid-sixteenth century and the mid-eighteenth-century Wales had practically no history at all, and even before that it was the history of rural brigands who have been ennobled by being called princes.' The much-honoured 'Welshman' Neil Kinnock lives in London.

KNIFE-CLOTH-STONE This lovely old children's game can be played by any number of players, and comes down from the ancient Celts. It is now known as 'Scissors-Paper-Stone'. Put your right hand behind your back, and on the count of three bring it quickly in front of you with a pointing finger as a knife, a spread hand as a cloth, or a clenched fist as a stone. The knife (or two outstretched fingers for a scissors) will cut the cloth (or paper); the cloth will cover the stone, and the stone will break the knife. Score points on each round for the winner.

KNIGHT, PROFESSOR BERNARD, CBE (1931-) Starting life as a farm-worker, Cardiff's Bernard Knight intended to take a degree in agriculture, but then became a hospital laboratory technician before gaining entry to medical school. Qualifying in Cardiff in 1954, he spent a short time as a family doctor in a Welsh mining valley, then entered the Royal Army Medical Corps as a regular medical officer, serving for three years in Malaya during the terrorist Emergency. He served mainly as the pathologist in a small military hospital that he refers to as a MASH unit, for its similarity to the American TV series. Knight then became a forensic pathologist in the London Hospital, Whitechapel, and was appointed Professor of Forensic Pathology in the University of Wales in 1980, retiring in 1996. He has been involved in hundreds of homicide cases, for both prosecution and defence, including Fred and Rosemary West, Mary Bell and Vatican banker Roberto Calvi. Professor Knight was called to the Bar at Gray's Inn in 1967 and was made a CBE in 1993, for services to forensic medicine. Bernard Knight has been writing for over forty-five years, writing crime novels, historical novels, and many historical mysteries such as the noted '*Crowner John*' series about a medieval coroner, as well as biographies, medical and medico-legal textbooks, popular books on forensic medicine and on the history of medicine. A doctor, pathologist, barrister and writer, his awards include being a MD, BCh, MRCP, FRCPath, DMJ(Path), FHKCPath, FFFMRCP, FRSM(Hon), DM(Hon) and DSc(Hon). An unassuming inspiring polymath, Bernard Knight is still writing and deserves a KBE or lordship far more than most recent recipients (see KINNOCK above).

KNIGHTON Its Welsh name is Trefyclawdd, town on the dyke, and is an excellent centre for exploring Offa's Dyke. Many of the buildings are seventeenth century, including the Swan Hotel and other buildings in Town Clock Square.

KNIGHTON CASTLE There are two earthwork castles, and Llywelyn the Last captured the later one, destroying it in 1262.

KNUCKLAS (CNWCLAS) CASTLE Ralph Mortimer built castles at CEFNLLYS and Knucklas to consolidate the area of Maelienydd (Radnor) that he had seized. In 1260 the Welsh destroyed the settlement around Knucklas, ignoring the castle, and in 1262 Llywelyn the Last besieged Cefnllys and sent Owain ap Madoc to Knucklas, which surrendered on the sight of Owain's siege engines. The castle was dismantled, but garrisoned by Edmund Mortimer in 1282. It may be a Dark Age site, and legend states that Arthur married Gwenhwyfar here.

LADIES OF LLANGOLLEN Plas Newydd, a half-timbered Tudor-style house, was the home from 1778 of Lady Eleanor Butler (*c.*1745-1829) and Miss Sarah Ponsonby (1755-1831), two Anglo-Irish lesbians. They eloped from Waterford in Eire to a more hospitable atmosphere in Wales. The Duke of Wellington, Thomas de Quincey, Edmund Burke, Wordsworth and Sir Walter Scott visited them here. Their Gothic-style house is open to the public.

LAKES Its mountainous environment and regular rainfall has given Wales over 400 natural lakes, and caused fifty-seven dams and ninety reservoirs to be built, many supplying the English northwest and Midlands. The Snowdonia lakes have links with Arthurian legend. Bwlch y Saethau, (The Pass of the Arrows), was where the treacherous Mordred fought the King; the black boat that carried the dying Arthur away sailed across Llyn Llydaw to the Isle of Avalon, Bardsey Island; Merlin threw the crown jewels into the fishless lake, Llyn Cwmglas near Llanberis; and Sir Bedivere threw Excalibur into Llyn Ogwen or Llyn Llydaw. The beautiful Trawsfynydd Lake has the terrible scar of a derelict nuclear power station. A first-century Belgic Celtic feasting tankard was found in it. Made of yew staves, encased in bronze, it is complete, and the most beautifully ornate of only three found in Britain. Tal-y-Llyn, near Dolgellau, is a large natural lake under Tal-y-Llyn Pass, with the great bulk of Cader Idris brooding over it. In June 1963, on the slopes of Nant Cader just above Tal-y-Llyn Lake, two picnickers noticed some pieces of sheet bronze half-hidden under a great boulder. They were part of a tightly packed bundle of bronze sheets that had been hammered down for re-melting. The hoard has mounts for two shields, some plaques ornamented with double human figures which probably adorned shields, and other artefacts. The pieces date from around the time of Christ. Llyn Cau, below the summit of Cader Idris, supposedly bottomless, is said to contain a monster that seized a swimmer in the eighteenth century. Near Llanbedr, the small lake Llyn Cwm Bychan is near the Roman Steps, an ancient pack-horse route between Harlech and Bala. Llyn Clywedog, near Llanidloes, is yet another reservoir supplying the Midlands with water – its 237 feet dam is the tallest concrete dam in Britain, and the land was, as always, compulsorily purchased. Nant-y-Moch reservoir on the slopes of Plynlimon traps the headwaters of the River Rheidol, to provide power for the Rheidol hydroelectric scheme. Llyn Eiddwy in Dyfed features in the prophecy by Merlin – if it ever dries up, Carmarthen will suffer a catastrophic disaster.

LAKE VRYNWY Llyn Efernwy was built from 1877 to supply Liverpool's water, and the Welsh village of Llanwddyn, with its population of 450, was forcibly moved to new houses down the valley to accommodate its construction.

LAMPETER A University and market town on a main trade route, there has been a market here since 1284, and there is a horse fair each May. A college of the University of Wales is here, but is being merged with Trinity College, Carmarthen.

LAMPETER CASTLE The motte is in the university grounds. The castle was razed by the Welsh in the 1130's and never rebuilt.

LANCAUT, BATTLE OF (1645) The Beachley Passage was described in 1644 as 'the key to Wales', being of considerable strategic importance as a link between the King's forces in Wales and the Royalist west of England. In September 1644, Prince Rubert sent a force of 500 men to secure the passage, and they fortified a position across the Beachley Peninsula. A few days later Governor Massey took advantage of low water, when Royalist ships could not defend the peninsula, and took it for Parliament. In October, Royalists under Sir John Winter took it again, but were then defeated by Massey, losing fifty men, and with 220 prisoners being taken. In Spring 1645, Winter broke out of his house in Lydney and led a force to Lancaut, above Chepstow to try and fortify a crossing-point over the Wye. He was attacked at high water, with only twenty Royalists surviving out of a force of 180. Winter's successful escape after either the battle at Beachley or that at Lancaut gave rise to the tradition that he leapt his horse down the precipitous Lancaut Cliff, as a place named Winter's Leap.

LANDSKER This invisible line between the 'Welshry' of North Pembroke and the 'Englishry' of the south is marked by a line of mainly Norman castles stretching across the Preseli Hills. Stretching from Laugharne on the Carmarthenshire coast in the southeast, the line heads

northwest to St Bride's Bay, consolidated by around fifty castles either along or on either side of the line. The name means divide, from land and the Norse 'sker', literally a cut in the landscape, and there is still a language divide on the north of the line from Carmarthen Bay to St Bride's Bay in Pembroke.

LANGUAGE The Welsh word for Wales is Cymru. Y Cymry is the Welsh people. Cymro is a Welshman, and Cymraes a Welshwoman. Cymreig is the adjective for all things Welsh and Cymraeg means the Welsh language. Cymry, fellow-countrymen, gave the relic Celtic population in Cumbria their name. (Cymry derives from the Brythonic 'Combrogi', meaning fellow countrymen). The British being pushed back to the West of England and Wales by successive invaders thus called themselves a Celtic word, 'Cymry' to form a common bond. Romans Latinised Wales as Cambria. 'Sais', the Welsh for Saxon, has come to mean Englishman, and the English language is 'Saesneg'. 'Lloegr', the old Welsh name for England, came to be used in French and British literature as 'Logres', the realm of King Arthur. The Saxons that settled in Britain, pushing the Celtic Britons into the Western peripheries, adopted the collective name of 'Engle' or 'Engisc', which Latin writers termed 'Angli' ('Angles'). These English invader-settlers called the native British 'foreigners', 'wallas', 'wealh', 'wylisc' or 'walsci', and called the Welsh language 'weallas', which became known as Welsh. The name Wales is therefore Saxon. Thus the Welsh became unwanted 'foreigners', strangers in their own land at a very early date. The settling Germans, called the English in Britain, called the settled Celts alien, a habit that they kept up through the centuries as they conquered other, more exotic lands. Wales thus has a common root with 'Walloon' in Belgium, 'Wallachian' in Romania, 'Walachian' in Greece, 'Vlach' in Romania and 'Valais' in Switzerland – foreigners in one's own lands. French-speaking Walloons are known to the Flemish Belgians as 'Waalsch'. In German or High-Dutch, the world welsch means foreign, and to them, the Italians were the 'Welsch' or 'Walsch'. Slavs also call Latins 'Vlachy', 'Wallachs' or 'Wlochy'. In turn, these assorted Vlachs and Wallachians in the Balkans call themselves 'Romani', 'Rumeni' (Romanians) or 'Aromani' (Romans).

The Celtic-British province of 'Cerniw' was suffixed with the same root ('wal'), making 'Cornwall', the Welsh-speaking tip of the West Country. Cornish for Cornwall is 'Kernow'. Welsh settlers pushed from the West of England and Wales in the fifth and sixth centuries to settle the province of 'Cornouaille' in Western Brittany. Perhaps 'Wal' and 'Gaul' were the same word, with Wal being the shortened form of 'Gwal'? The Celtic root 'gal' means land of the Gauls or Gaels. Wales is 'Pays de Galles' in French, 'country of the Gauls'. Portugal, Galicia (in Spain and Poland), Galloway, Calais, Caledonia, Donegal, and Galatia all have the same origins. Whatever the etymology, Welsh is a term meaning foreigner, which is a fairly strong reason to refer to ourselves as Cymry, rather than Welsh. Taliesin and Aneirin were writing in Welsh around 600, and as John Davies writes in his *History of Wales* – 'This was a bold act for, throughout the territories that had been part of the Western Empire, the Latin of Rome was the sole written medium, and hardly any attempts were made to write Latin's daughter-languages, French, Spanish and Italian, until after 1000.' Unfortunately, the disappearance of paper from Europe and the expense of parchment means that most surviving Welsh from this period is in the form of marginalia on religious parchments. There was a cell containing Welsh manuscripts at the fort in Tenby around 880, but the only surviving literature consists of later copies. Welsh is spoken by possibly 12% of the population as a first language, with around 60% in some of its heartlands of North and West Wales. Compared to Erse (Irish) and Gaelic (Scots), it is surviving, partially because of the 1967 Welsh Language Act, and partially because of *S4C, Sianel Pedwar Cymraeg*. This Welsh television channel produces twenty-two hours of programmes a week, including the 'soap opera' set in the Valleys, *Pobol Y Cwm (People of the Valley)*. BBC's *Radio Cymru* also broadcasts in Welsh for twelve hours a day, and *Y Cymro* is a weekly newspaper in the Welsh language. The Welsh language is one of, if not the, oldest living language in Europe, belonging to the Celtic family of languages rather than the Germanic (Dutch, German) or Latin (French, Italian, Spanish) groups. Welsh comes from the Brythonic form of Celtic, which existed in Britain before the coming of the Angles,

Saxons and Jutes in the fourth and fifth centuries CE. Brythonic, or P-Celtic, gave us Welsh, Breton and the nearly extinct Cornish language. Goedelic, or Q-Celtic, is the origin of Scottish and Irish Gaelic and the extinct Manx language. (There is no Q in Welsh, and the form mac, of son of, in Scots and Irish Gaelic is replaced by map, or ap, in Welsh.)

Welsh has been used as a written language since 600 CE, 300 years before French and German were first written, and over 600 years since the first English (semi-recognisable to today's reader) occurred in Chaucer's *Canterbury Tales* and the like. What we would recognise as 'Modern English' only dates from nearer Shakespeare's time, around 1600. Apart from modern electronics terms, the only significant intruders to the Welsh language were borrowed from the Romans in the years leading up to 400 CE, e.g. 'porth' for door or gateway (porta) and 'ffenestr' for window (fenestra), which demonstrates the antiquity of the language. Around 1,000 words were derived from Latin, e.g. 'llyfr' (liber, book), 'pyscod' (piscis, fish), 'eglwys' (ecclesia, church), 'mur' (wall, murus), 'milltir' (mile, mille), 'cyllell' (knife, cultellus), 'melys' (sweet, or honey, mel), 'ceffyl' (horse, caballus), 'perygl' (danger, periculum) and 'pont' (pons, bridge). There are twenty-eight letters in the Welsh alphabet, with the following consonants being added to the English alphabet: ch (pronounced as in loch), dd (as the th in then), ff (as in off), ll (as in Loch Lomond, running the ch and L together), and th (as in teeth). The consonants j, k, v, x and z do not exist in Welsh, but k and z appear in Cornish and Breton. All consonants are pronounced 'hard' phonetically. Note that c is always hard, as in cat, never soft as in proceed, and that f is also hard, as in of, not off. Also g is like the g in garden, not George, and h is always pronounced as in hat, not left silent as in honest. The vowels are a (as in hat), e (as in bet), i (either pronounced as in hit or like the e in me), o (usually as in hot), u (pronounced ee), w (pronounced oo, either as in book, or room), and y (either pronounced as the u in understand or as ea as in tea).

LANGUAGE SURVIVAL The Act of Union with England of 1536 stated that 'No person or persons that use the Welsh speech or language shall have or enjoy any manor, office or fees within the realm of England, Wales or other of the king's dominions upon forfeiting the same offices or fees unless he or they use and exercise the speech or language of English'. This Act of Henry VIII, son of the Welsh King Henry VII, also stated that English was to be the only language used in the courts of Wales, causing vast areas of land to be taken from monoglot Welshmen by English litigants. This was yet another step by England to rid itself of the oldest and once dominant native language of Britain, following the laws from the Statute of Rhuddlan in 1282 and those passed in the early fifteenth century during and after the Glyndŵr Rising. For a period after 1549, English was the language used in church services, all law and administration, and its mastery was the only method for a Welshman to rise in life. As Gwynfor Evans said, it was the English language that made Englishmen out of the Brythons, Angles, Saxons, Danes and Normans that made up their nation. From 1536 until today it has been used to try and make the Welsh Brythons into Englishmen.

The turning-point in the survival of the Welsh language was the translation of *The Bible* into Welsh. The preacher William Morgan ministered in Llanrhaeadr-ym-Mochnant, and by 1588 had completed the translation, with three other clergymen, working over twenty-five years. His most able assistant was the brilliant Bishop Richard Davies of Abergwili. One of Morgan's precursors in religious translation, William Salesbury (Salebury, Salusbury), was said to be a former privateer, a profession at which the Welsh have gained some international renown over the centuries. Bishop Morgan said that 'Religion, if it is not taught in the mother tongue, will lie hidden and unknown'. Queen Elizabeth's Privy Council decreed that a copy should be placed in every Welsh church. '*Y Beibl*' standardised the different types of prose and dialects of the time into the Welsh of today. *The Bible* moved the people towards a standardised national language based on the speech of the North and North-west of Wales, but there are still four recognizable dialects: y Wyndodeg (Venedotian) of the north-west; y Bowyseg (Powysian) of north-east and mid-Wales; y Ddyfydeg (Demetian) from the south-west; and Gwenhwyseg (Gwent and Morgannwg) in the southeast. Today's dialects interestingly coincide with today's major and oldest bishoprics,

which themselves are based on the old Welsh princedoms, which were themselves founded from the ruling Celtic tribes in the area. Thus the dialects date back 2,000 years. In 1621, John Davies wrote 'It is a matter of astonishment that a handful of the remaining Britons, in so confined a corner, despite the oppression of the English and the Normans, have for so many centuries kept not only the name or their ancestors but also their own original language to this very day, without any change of importance, and without corruption' (*'Antiquae Linguae Britannicae'*).

Building on the Welsh Bible was Griffith Jones (1683-1761), Rector of Llandowror, Carmarthenshire. His circulating schools made Wales the most highly literate country in Europe. By 1757, with a third of the population being able to read, the main reading was the family Bible. Emphasis upon the importance of the Bible and reading has been a major factor in keeping the language alive. One problem in the survival of Welsh was the appointment of Englishmen to Welsh bishoprics and clericships, with Welsh being excluded from church services, to which Lewis Morris referred in a letter in 1764 'What can you expect from Bishops or any other officers ignorant of a Language which they get their living by, and which they ought to Cultivate, instead of proudly despising. If an Indian acted thus, we would be apt to call him Barbarous. But a Scot or Saxon is above Correction'. This was written to Evan Evans, a Welsh poet-curate who could not obtain a living in Wales, only a curacy under an absentee English rector. In 1766, a seventy-year old, ailing English monoglot was given the living of Trefdraeth and Llangwyfan in Anglesey. Only five of his 500 parishioners spoke any English. In 1768, the churchwardens brought a case of unfitness against him on the grounds that he spoke no Welsh. In 1773, Canterbury decided in favour of the wardens, but the English rector kept the job. The argument used by the rector's counsel in court should be read by all Welshmen: 'Wales is a conquered country, it is proper to introduce the English language, and it is the duty of the bishops to endeavour to promote the English, in order to introduce the language... It has always been the policy of the legislature to introduce the English language into Wales... The English language is, by act of Parliament, to be used in all courts of judicature in Wales, and an English Bible to be kept in all the churches in Wales that by comparison with that of the Welsh, they may the sooner attain to the knowledge of English'.

In 1846, an inspection was carried out of the Welsh-speaking Nonconformist schools, by three monolingual English barristers and seven Anglican assistants. Their report became known as *Brad y Llyfrau Gleision (The Treason of the Blue Books)*, as it called standards deplorable, blaming the Welsh tongue as 'the language of slavery'. (The reports had blue covers). The barristers proclaimed that the Welsh language condemned the Welsh to intellectual backwardness, encouraged depraved sexual habits, and had produced 'no Welsh literature worthy of the name'. As well as criticising the dirtiness, laziness, ignorance, superstition, promiscuity and immorality of the Welsh, it lamented the effects of the Nonconformist religion and stated 'The Welsh language is a vast drawback to Wales and a manifold barrier to the moral progress and commercial prosperity of the people. It is not easy to over-estimate its evil effects.' English papers then reported that the Welsh were settling down into savage barbarism, with the habits of animals. *Chambers Edinburgh Journal* of 1849 stated that the use of the Celtic tongue was a 'national discredit.' In 1852, the Inspector of Schools announced that it was 'socially and politically desirable that the language be erased'. English-only Board Schools were imposed to hasten the decline of Welsh. By 1847, only 3 out of 1,657 day schools in Wales taught any Welsh. By 1899, Welsh was being examined in only 15 out 1,852 elementary schools. The effects were dramatic, and it looked as if the language could never recover from this official onslaught. In 1801 Meirionydd (Merioneth) was totally Welsh-speaking, closely followed by Gwynedd. By 1881, just 12% of the population spoke only Welsh. By the same year, only Anglesey had significant strength in Welsh speakers, where for 40% it was their sole language. The process of Anglicisation had been quickly accelerated by the WELSH NOT, which had been hung around the necks of Welsh speakers in many schools for half a century.

This *1847 Report* had stated that Welsh was a 'peasant tongue, and anyone caught speaking Welsh were to be severely punished'. The 'Welsh Not' was a ban upon the speaking of Welsh

in schools, and was carried out with some vehemence, in yet another attempt to exterminate the language. A wooden placard had to be worn around the neck, passed on to anyone heard speaking Welsh, with the last child at the end of the day being thrashed by the teacher. This piece of wood on a leather strap was called a 'cribban', and Irish and Breton children had their languages thrashed out of them in a similar manner. In other Welsh schools, a stick was passed on to the same effect. In others, the child was fined half-a-penny, a massive sum for poor parents. At the same time the prominent Welsh industrialist, David Davies was saying that Welsh was a second-rate language – 'If you wish to continue to eat barely bread and lie on straw mattresses, then keep on shouting "Bydded i'r Gymraeg fyw am byth" (May the Welsh language live forever, the chorus of the National Anthem). But if you want to eat white bread and roast beef you must learn English!' The English poet and schools inspector, Matthew Arnold, declared in 1855 that the British regions must become homogeneous... 'Sooner or later the difference of language between Wales and England will probably be effaced'... an event which is (yet again) 'socially and politically desirable'. In 1865 *The Times* called the language 'the curse of Wales...the sooner all Welsh specialities vanish off the face of the earth the better'. In years to come, older people used to boast of how many times they had been caned for wearing the 'Welsh Not' at the end of the day. Next, the 1870 Education Act made the English school system compulsory in Wales. Many children refused to speak English, so learned nothing at school, for instance Sir Owen M. Edwards, a distinguished educationalist of the early 1900's, who would have remained semi-literate but for the Welsh-speaking Sunday schools. In 1871 a number of people led by the Liberal MP, Osborne Morgan, petitioned the Lord Chancellor to appoint just one Welsh-speaking judge, as the majority of Welsh people spoke mainly Welsh, and there were substantial monoglot communities. The Lord Chancellor replied that 'there is a statute of Henry VIII which absolutely requires that legal proceedings in Wales shall be conducted in English, legal proceedings had been in English for 300 years, and, moreover, the Welsh language is dying out... probably the best thing that can happen for Wales is that the Welsh tongue should follow the Cornish language into the limbo of dead languages.' The nineteenth century saw the major decline of the Welsh language, partly because of the Welsh Not and partly because of massive immigration into the industrial south and northeast. At the start of the nineteenth century, 70% of the people spoke only Welsh, 10% spoke Welsh and English, and 30% spoke only English. By the end of that century, only half the population could speak Welsh.

The first Welsh Language Society was formed in 1885 by Dan Isaac Davies with the support of HENRY RICHARD, to promote the use of the Welsh language in education, but ended with Isaac's death in 1887. A rallying call, broadcast by Saunders Lewis in 1962 led to the founding in 1963 of *Cymdeithas yr Iaith Gymraeg*, the *Society for the Welsh Language*. By various methods of civil disobedience, it forced the English Parliament to pass the Welsh Language Act in 1967, giving equal status to the Welsh language for the first time since 1536. As recently as 1965, a Mr Brewer-Spinks tried to enforce an 'English Only' language rule at his factory at Blaenau Ffestiniog. Three staff resigned, and he only rescinded the rule after a meeting with The Secretary of State for Wales. In 1970, Dafydd Iwan, the Welsh folk singer and nationalist, was imprisoned for refusing to pay a fine for defacing English road signs. Twenty-one Welsh magistrates paid his fine to release him. Later, Gwynfor Evans' intended hunger strike forced the English government to give Wales its own Welsh-language media and help the survival of the language. Until recently, the Welsh National Rugby Team always called its line-out ball throw-in in Welsh – usually some alpha-numeric code is needed to disguise where the hooker is throwing the ball. The Royal Welsh Fusiliers in the recent Bosnia peace-keeping mission also communicated in Welsh over the radio, thereby preventing interception of messages. However, even as late as November 1996, *The Times* was still criticising minority languages in a leader article, this time the use of the Irish language, which drew a speedy response from Gerry Adams in its 'letters' column. In the more Anglicised parts of Wales, there is still a strong feeling against the use of the language. A letter in *The South Wales Echo* (9 October 1996), from a Mrs Keenan reads... 'Although born and educated in Wales, I spent many years in England. It was disconcerting to discover that we are perceived as a backward

nation, clinging to an esoteric tongue, and spending our leisure time watching rugby. Are there no local politicians with the courage to influence a referendum on the language issue? Let's be rid of the signs, the bilingual correspondence and the teaching of this useless language in schools'.

The percentage of people speaking Welsh dropped from 54.4% in 1891 to only 18.7% in 1991. According to the 1992 Welsh Office survey, 70% of the Welsh-speaking households they surveyed were childless. The last monoglot Welsh speakers – this author's maternal grandmother had extremely poor English – seemed to have died out in the mid-twentieth century. Now, a third of the people living in Wales were born outside the country – a greater proportion than possibly any other nation in the world. Of the eight 'new' Welsh counties, the largest were Dyfed, Powys and Gwynedd, with 27.8%, 24.4% and 18.6% respectively of the area of Wales, making up over 60% of Welsh land. The percentage of the population who speak Welsh in these areas is high – 61%, 20% and 44%. Dyfed's figure would be far higher, if it was not for the English settlements, retirement bungalows and holiday weekend homes of South Pembrokeshire, the 'Englishry' south of the Landsker. Gwynedd is solidly Welsh except for the Aberconwy holiday home area with 36% – many people from the northwest and midlands of England retire in Conwy's more congenial surroundings. Other incomers, unemployed, move to Wales to escape inner-city squalor and oppressive council estates. However, Gwynedd's Dwyfor was the last district in Britain to abolish Sunday closing of public houses, and has over a 75% Welsh-speaking population. Powys has been under threat since the war with non-Welsh people moving into the old counties of Brecon, Montgomery and Radnorshire. Certain other areas have a high proportion of Welsh speakers, e.g. the Lliw Valley in West Glamorgan with 37% and Glyndŵr in Clwyd with 40% (Owain Glyndŵr's homeland). There are conflicting claims upon how many people speak Welsh, dependent upon the agenda of the research, but it is probably about 600,000 of a 3,000,000 population, i.e. under a third of the 2,000,000 Welsh people living in Wales. However, the figure probably drops to a maximum of 100,000 of people who use it as their first language, not just at home but in shops, pubs, petrol stations and the like. Possibly 3% of the population are able to use the language in most everyday affairs outside work, so unlike the Welsh Language Board – which equates an understanding of Welsh with the survival of the language, not the full use of the language when shopping, asking for postage stamps etc. – this author believes that the language is still gravely threatened.

The main danger has been the mobility of people in modern times, especially into the main Welsh-speaking areas. For instance, in the 1991 Census, only 67% of Gwynedd's population was born in Wales. For Powys it was only 61%, and for Dyfed 75%. In the non-Welsh 'industrialised' counties of Gwent, Mid-Glamorgan, South-Glamorgan, and West-Glamorgan, the Welsh native birth statistics are much higher, at 82%, 89%, 78% and 87%. This is the main pressure on the language, as more and more people come to this relatively safe, inexpensive and unspoilt area of the United Kingdom to retire. The proportion of Wales' inhabitants aged over sixty has trended as follows:

%	1871	1901	1931	1961	1981	1991	2001
aged over 60	8	7	11	18	21	23	23

As we have seen with Welsh folk dance, it hung on by a thread in the memory of one old woman. There are now similar fears for the language. According to a 1997 report by *Cymdeithas yr Iaith Gymraeg*, only twenty-one villages and towns could be classified as Welsh-speaking by 2001. This report takes 75% of Welsh speakers as meaning a Welsh community. Most of such communities are clustered at the end of the Llŷn peninsula beyond Porthmadog, and in Caernarfon and Blaenau Ffestiniog, with Llangefni the only Welsh-speaking community in Anglesey. The report blames English immigration, attracted to rural Wales by house prices which remain low while those in England rise rapidly. Even the strongholds of the Princes of Gwynedd are now threatened, and there is disagreement with the quango known as The Welsh Language Board, which believes that the language is 'safe', because of the number of new learners in South-East

Wales. However, a critical report has pointed out that 'if it is to survive, the Welsh language must keep its community base, its foothold as a community language. Otherwise we would go the way of the Irish, with lots of speakers on paper, but which does not exist as a community language except in a very few areas'... 'The Welsh language will not survive unless there is an environment where people can communicate through Welsh, can live their lives through Welsh, rather than as individual Welsh speakers'. For Welsh to survive as a generally spoken language, it will be a massive struggle. In the 1991 census, 62% of Anglesey residents said they were fluent in Welsh. In 2000 a survey of 1,000 islanders found only 54.2%, because of inward migration from England and elsewhere. According to a 2000 survey, the top ten places in Wales where visitors are most likely to hear the Welsh language spoken are Bala, Llanrwst, Caernarfon, Porthmadog, Pwllheli, Carmarthen, Llandeilo, Gwendraeth, Tregaron and Lampeter.

LANOVER, LADY (LLANOFER) (1802-1896) Born Augusta Waddington, she married Benjamin Hall, Lord Lanover, and for her unstinting work for Wales became known as 'Gwenynen Gwent' (the Bee of Gwent). By 1834, she had learned Welsh so well that she won a prize for an essay on the Welsh language in the Cardiff Eisteddfod. Only Welsh was allowed to be spoken in her house, and she was responsible for a revival of interest in traditional Welsh dress and folk dancing. She had a personal harpist and her reputation grew to the point where she was called 'The Living Patron Saint of Wales.' With CHARLOTTE GUEST, her work led to the Welsh Revival of 1835-45 and the foundation of the National Eisteddfod, the Welsh Manuscripts Society and the Society of Cymmrodorion.

LATIN The Roman occupation influenced the Welsh language, giving us pont - bridge, llyfr - book, ffenestr - window, cyllel - knife and many other words. However, the language of Welsh law, as it predated the coming of the Romans, seems to have been unaffected except for tyst - witness.

LAUGHARNE, BATTLE OF, (1403) Having taken Carmarthen, on his march through Wales, Owain Glyndŵr halted his army outside Laugharne, on 10 July. Laugharne and its castle were defended by the renowned Lord Thomas Carew. Glyndŵr had the premonition of a trap, and at dawn on the eleventh sent just 800 men to reconnoitre a possible escape route to the north. The column was cut to pieces, and Glyndŵr moved his main force on rather than be delayed in a major battle. Henry Percy had declared against the king at Chester on 10 July, and Glyndŵr's intention was to quickly link up and help Percy against Henry IV. However, this delay meant that he was too late and Percy was killed at Shrewsbury.

LAUGHARNE (TALACHARN) CASTLE Overlooking the Tâf estuary, it was taken by The Lord Rhys in 1189 after the death of Henry II. It was later taken and destroyed by Llywelyn the Great, and again taken and burnt by the Welsh in 1257. In 1575, it was given by Elizabeth I to Sir John Perrot who converted it into a Tudor mansion. In the 1930's and 40's Richard Hughes, writer of *A High Wind in Jamaica* lived in the castle, at the same time that Dylan Thomas was writing in the nearby boathouse. It is now open to the public.

LAUGHARNE CASTLE, SIEGE OF 1644 It was captured by Royalists and then by Parliamentarians in the Civil War. The Royalist Colonel Gerard left a force of 200 under Lieutenant-Colonel Russell here, but Rowland Laugharne with 2,000 men and artillery besieged it, and took the town. After two days of bombardments the castle wall was breached and the outer ward taken. Russell surrendered the next day.

LAWRENCE OF ARABIA (1888-1935) T.E. Lawrence, of '*Seven Pillars of Wisdom*' fame, was born at Tremadog (at what is now Snowdon Lodge), and only his birth there qualified him for a scholarship at Jesus College, Oxford's 'Welsh' college.

LAWS Codified across Wales by Hywel Dda in 942, Welsh Law gave precedence to the woman's claim in any rape case; marriage was an agreement, not a holy sacrament, and divorce was allowed by common consent, with an equal share of land and possessions; illegitimate children had the same rights as legitimate children; and there was equal division of the land between all children upon the death of parents. This last law contributed to the strife among Princedoms and Kingdoms – everyone had a claim somewhere, and most tried to rebuild what their parents had – the Normans were clever at playing off one heir against another and gaining in the long run. Under Hywel's Laws, farming was a communal affair (reminiscent of Robert Owen 800 years later), and a man did not have unrestricted control over his wife as a possession, unlike all the other 'civilised' European countries. Both inside the Celtic Church, as well as outside, there was a tradition in Wales that women had a real social status – a woman's rights to property under *Cyfraith Hywel* were not granted in English law until 1870 and 1882. A woman also had a right to compensation if her husband hit her without any cause. In English law, the woman was the property of the husband, a chattel (until the twentieth century), whereas a divorced Welshwoman received half the property under Hywel's laws until English law took precedence in the sixteenth century. It is typical of the Laws that the queen had special privileges – there is no mention of a queen in early English, Irish or Germanic laws.

Doctors in Welsh law were liable for the death of patients unless the family had agreed to the course of treatment. Contracts were stronger than legislation, in civil disputes. In criminal proceedings, recompense by the offending family network, and reconciliation, took precedence over revenge. The laws tried to achieve social harmony, with none of the English elements of public whipping, trial by fire or boiling water, torturing, gibbeting, burning of witches or disembowelling being known in independent Wales. The rate of execution in 'primitive' twelfth-century Wales was proportionately less than a quarter than that endured under modern English law in the nineteenth century. As late as 1839 we can see that the sentence given to the leading Welsh Chartists was that they should be 'hung, drawn and quartered' – the punishment for asking for democracy. For theft in Wales there was no punishment whatsoever if the purpose was to stay alive – up to the late eighteenth century, children were hung in England for stealing a lamb. Children were of equal status in Wales – the law of Gavelkind meant shared inheritance amongst all children – a civilised and socially unique method of preventing massing of power and lands. Even more advanced was the law that illegitimate children received all the rights, including inheritance, of family offspring – *'Cyfraith Hywel'* states that the youngest son has equal rights to the oldest, and also that 'the sin of the father and his wrongdoing should not be set against the son's right to his patrimony', so illegitimate children had equal rights. A boy came of age at fourteen, free of parental control, and a father could be chastised for hitting him after this age. A girl came of age at twelve, and like the boy could decide whether she wished to stay in the father's household. She could never be forced into marriage, nor be arbitrarily divorced. Rhiannon, in the *Mabinogion* story of Pwyll, Prince of Powys, refuses to marry, saying 'every woman is to go the way she willeth, freely.' Professor Dafydd Jenkins has noted that aspects of Hywel's laws, that were superseded by English law in 1536, are being reintroduced as enlightened reforms in the 1990's, such as reparation to the victims of crime. Compensation of the victim was more important than punishment of the offender. For damage unwittingly done, redress had to be made. Even for murder, the Welsh state was active in seeking compensation for the victim's family, to remove the need for vengeance and feud. Obviously, the far-extended Welsh family-clans exerted pressure on their members to toe the line, as if any of them offended, all had to pay something. All the checks and balances were in place under this system to make society enforce its own social code.

Unlike most societies, there were no differences in morality requirements for the sexes – a Welsh woman could heavily fine her husband on an increasing scale for adultery, and also divorce him for it. A woman could even divorce her husband for 'stinking breath'. She had property rights not given under English law until the Married Woman's Property Act of 1870 which allowed women to keep earnings or property gained after marriage. The Married Woman's Property Act of 1882 allowed women to retain what they had at the time of marriage. In France

and the rest of Britain, wife-beating was a recognised right of the husband – in Wales there had to be a definite, very serious offence, and then the punishment was limited to just three strokes of a rod. The Welsh have possibly been the most civilised race in the world in their attitudes towards women from the Dark Ages of the fifth century to the present day. The Laws were fair to all men and women – violence to the person was averted at all costs, and responsibility shared by the offenders' relatives, which made for social order. The twin elements that define a nation are its language and legislation – the English government in 1536 wiped out a humane system of laws based on social responsibility and replaced it with one based upon class, property, prestige, repression and violence. It almost wiped out the language by similar methods.

There is a tradition that the tribal laws and customs were codified by Dyfnwal Moelmud long before Hywel, but the earliest manuscripts date from the twelfth and thirteenth centuries, extracts made by practising lawyers, the earliest from the time of Llywelyn the Great. There were slight differences between North, West and South Wales, known as the Venetian, Demetian and Gwentian Codes, and they stayed in force in entirety until Edward I's Statute of Rhuddlan in 1283, with many provisions remaining until the period of the Tudors in the sixteenth century. Many Welsh laws and traditions are noted in the ancient '*Triads*', expressions where objects are grouped in threes. Some of these sayings may date back to the time of the Druids, who committed the old laws to memory. Triads are found in the oldest Welsh manuscripts such as the *Mabinogion*, bardic poems, the twelfth-century *Black Book of Carmarthen*, ancient versions of the Welsh Laws, and the fourteenth-century *Red Book of Hergest*. Examples are:

Three things a man experiences through litigation: expense, care and trouble.
Three things which cannot be hidden: love, hatred and pride.
Three things not easily restrained are the flow of a torrent, the flight of an arrow, and the tongue of a fool.
Three things a good liar must have: a good memory, a bold face, and a fool to listen.
Three things that will take a good man unawares: sleep, sin and old age.
The strength of a bard is his muse, that of a judge is his patience, that of a lawmaker his patriotism.

The amazing fact that the laws were written in Welsh as well as Latin helped ensure that the language thrived. To keep a culture, history, laws, literature, religion, language and community must intertwine and be respected. These Welsh laws, first written down over a thousand years ago, according to Saunders Lewis fashioned: 'lively forms of the mind of every poet and writer in Wales until the sixteenth century, and also directly influenced the shape and style of Welsh prose. This implies that the language had already reached a philosophical maturity unequalled in its period. It meant that it had a flexibility and positiveness which are the signs of centuries of culture. This means that there is a long period of development behind the prose of the Cyfreithiau (Laws).' Over a hundred years ago, Ferdinand von Walter of Bonn wrote in '*Das Alte Wales*' – 'From this point of view, the Welsh outdistance all other people in the Middle Ages... In Wales justice and right blossomed, founded on the laws of Hywel Dda, into a perfection of beauty unlike anything found among other people in the Middle Ages.'

From the Laws, we find that Welsh kings had a servant called a 'Foot-Holder'. This anti-stress kit consisted of a man holding the king's feet in his lap, from the moment the king sat down to eat in the evening, until he went to bed. At this time, the king had no power, as he was no longer king while his feet were off his kingdom. He could therefore relax, and not have to make any decisions, while his power passed to the 'Foot-Holder'. The 'Foot-Holder' could now grant pardons to criminals, arbitrate in disputes and the like, while the king drank quietly to oblivion and threw chicken drumsticks at the cook.

LEAD Mid-Wales used to have several lead mines, and production peaked in the seventeenth and eighteenth centuries, leaving behind some intriguing industrial archaeological sites. The Romans

worked lead for its silver content and for pewter, and at Llanymynych, Powys, it is said that the slaves never left the underground caverns. Cwm Ystwyth closed in 1916, so the site is fairly well-preserved, miles from anywhere. In the 1830's large increases in lead prices resulted in a boom, and Llanidloes' Van Mines became the richest in Britain. Lead was found by chance there in 1862, just two miles from the River Severn for easy transport, and by the 1870's a £5 initial capital share was worth £100. However, by 1878 the world price had fallen, and by 1880 all the richest lodes were worked out. The remains are still impressive, with the ore washing troughs, shaft chimneys and waterwheel still in evidence near the mounds of grey waste and Van Pool. Near Ffrwd Fawr waterfall, the little village of Dylife once was populated by thousands of workers at a lead mine almost as rich as Van. Started before Van, production reached 10,000 tons per annum in the nineteenth century, and there was a 50ft waterwheel to drain the lower levels of the mine. The downturn in lead prices was even more disastrous than at Van, because lead had to be taken by packhorse many miles to Derwenlas. Sion-y-Gof, John the Smith, at these mines, suspected his wife of adultery and murdered her. For an alibi, he also murdered his daughter, threw both bodies down a disused shaft and said that they had left him. When the bodies were found, he was tried and sentenced to death. His body was to be gibbeted in an iron cage. As the only ironworker in the village, he had to make his own cage, and he was hung on Pen-y-Grocbren, The Hill of the Gallows. His body hung from the gallows in the iron gibbet cage until he rotted away, the gallows collapsed and the whole was buried with wind-blown soil. The story was thought of as a local myth, until in 1938. The cage was unearthed, and the discoloured skull in its gruesome iron-piece is now in the Museum of Welsh Life at St Fagans, Cardiff. Bryntail lead mines, near Llyn Clywedog, are also evocative ruins from the last century. Near Llyn Brianne, Rhandirmwyn means 'district of minerals' and this gorgeous countryside covers what was once one of Europe's largest lead mines. Minera Lead Mines near Wrexham have been restored to show visitors their 1820's hey-day. Bwlchgwyn in Clwyd owes its existence to the lead mines worked during the 1840's (on the sites of previous Roman workings), and in Nant-y-Ffrith Valley are footpaths and the Milestones Geological Museum of North Wales. It is said the Welsh lead was used in the pipes of Pompeii and Herculaneum and the pewter dishes of Rome.

LEADERS From the Kings of Ceredigion and Ystrad Tywi, Gwynedd, Powys, Gwent and Morgannwg, and Dyfed, one leader emerged to control Wales. Descended in direct line from the Kings of Gwynedd and Powys, RHODRI FAWR of Powys (Rhodri the Great), married Angharad of the royal lineage of Ceredigion and Ystrad Tawe and united the nation. The great Houses of Gwynedd, Deheubarth and Powys emerged to be the focal points of resistance against fresh waves of invasion. HYWEL DDA of Deheubarth (Hywel the Good), Rhodri's grandson, codified the ancient laws of Wales. One of Hywel's descendants, GRUFFYDD AP LLYWELYN, was the only Welshman to unite all of Wales and throw the Saxons back over Offa's Dyke, but was killed in battle by Harold Godwinsson of Wessex, the future King Harold (of Hastings and 1066 fame). OWAIN GWYNEDD of the House of Gwynedd, a descendent of Hywel, briefly reunited Wales after years of anarchy. Owain's nephew, The Lord Rhys, RHYS AP GRUFFYDD of the House of Deheubarth, whose mother was Gwenllian of the House of Gwynedd, took control, before LLYWELYN FAWR (Llywelyn the Great of Gwynedd) rose to dominance. Llywelyn Ein Llyw Olaf (Llywellyn Our Last Prince, of Gwynedd), Llywelyn Fawr's grandson was the last Prince of Wales to be acknowledged by the English. The heroic OWAIN GLYNDŴR, with descent from the Houses of Powys, Deheubarth and Gwynedd, was the last man who united most of Wales, and invaded England. OWAIN LLAWGOCH, the last direct descendant of the House of Gwynedd, was a leader in exile. HENRY TUDOR became the first of the Tudor dynasty of British kings, Henry VII. Welsh heroes generally have a history of fighting superior external forces and constant internal ones. The Celts are ultra-parochial and still tribal. They do not like being governed by anyone, but will rally against a common cause. We saw it against Rome, and the Irish, Vikings, Saxons, Normans and Plantagenets. We see it today. To Cardiff rugby supporters, the traditional enemy has always been Newport, just seven miles

away. To Swansea, it is Llanelli, again close by. However, when it comes to choosing the national team, there are cries from Cardiff and Newport that there are not enough East Wales players in the team, but to Swansea and Llanelli there are not enough West Wales players. When it comes to playing England, all differences are suspended for the afternoon, and the nation holds its breath and prays for a Welsh victory.

LEOMINSTER, BATTLE OF, 1052 In a crushing victory near this town, Gruffydd ap Llywelyn defeated the Saxons and their Norman mercenaries, thereby holding the Welsh borders intact for another decade.

LEONOWENS, ANNA HARRIETT (1831-1914) Leonowens (née Edwards) was the tutor to the children of King Mogkut (Rama IV) who needed a new English teacher for his wives and sixty-four children. Her books *The English Governess at the Siamese Court* and its sequel *The Romance of the Harem* were best-sellers and remade as *The King and I*. In her story, she wrote: 'the Romans had not stamped the love of freedom out of our Welsh hearts, nor could the English do that in the centuries that followed.' She had sailed to Bombay aged fifteen to join her mother and stepfather. She married but her husband died early, leaving her with three infants, when she saw the advertisement to be the Governess to the children of King Rama IV. Her sister Eliza's eldest daughter married a Eurasian named Pratt, and their youngest son William took the stage name of Boris Karloff.

LEVELS Wales has regained some land from the sea in the Gwent (Caldicot) Levels and Wentloog (Gwynlliwg) Levels, which make up the most extensive ancient fenland in Wales. The Wentloog Levels are protected from the massive tidal differences in the Bristol Channel by Peterstone Great Wharf, a huge bank of earth. 'Reens' (straightened drainage ditches) cover this marshland between the mouths of the Taff and Usk rivers. When a high spring tide allies with a strong southwesterly wind, the sea can still come over the bank. The 1606-7 floods claimed hundred of lives here, and the depth of the flood is marked by a plaque on the side of St Bride's Church at Wentloog. Nash and Goldcliff churches also have plaques recording the 1607 flood levels. These marshes were reclaimed by the Roman II Legion, probably using slave labour. They also have strong Arthurian connections, but seem to be doomed by urban planners over the next twenty years. East of the Usk, the Caldicot Levels are marshland silt lying on top of peat, and changes in water levels have led to tilting buildings, for example Whitson Church. Much of the drainage here dates from medieval and probably Roman times. This unique ecological system, an 'Outstanding Historic Landscape' of SSSI's, reedbeds, bulrushes and marsh birds is threatened by new housing, industry and twenty miles of a new toll motorway. It is one of the largest ancient grazing and reen drainage sites in Britain.

LEWIS, ALUN (1915-1944) Born in Aberdare, he died of gunshot wounds in Burma, during the Second World War. It seems he slipped after washing and shaving, accidentally shooting himself in the head with his revolver. His poems *In Hospital : Poona I, In Hospital : Poona II, Song (on seeing dead bodies floating off the Cape), Sacco Writes to His Son,* and *The Sentry* were all read by Dylan Thomas on BBC Radio. Like Edward Thomas, the war took him away too early, at the age of just twenty-nine years. His poems have a recurring theme of isolation and death, and he was indebted to Edward Thomas, to whom he dedicated one of his best poems. Some critics believe that he was the greatest of the Second World War poets.

LEWIS, DAVID (1616-1679) David Lewis, rector of Cwm near the Skirrid Mountain, ministered secretly to Catholics in Wales for thirty years, and was known as 'Tad y Tlodion', 'Father of the Poor'. He was arrested with seven other priests by the fanatical Protestant, John Arnold MP. After painful interrogation, he was prosecuted for papacy by Arnold, who was closely related to the judge at the trial. In 1679 at Usk, Lewis was found guilty, hanged, cut down barely alive, disembowelled, dismembered and beheaded. He was canonised by Pope Paul VI three centuries later.

LEWIS, REV H. ELFED (1860-1953) He is probably the best-known recent Welsh hymn writer, born at Cynwyl Elfed.

LEWIS, GILBERT NEWTON (1875-1946) The American-Welshman 'probably did more to advance chemical theory this century than any other chemist' (*Chambers Biographical Dictionary*) with his pioneering work in transferring ideas from physics into chemistry. This theoretical chemist first set out the electronic theory of valency.

LEWIS, GWYNETH (1959-) She was appointed the National Poet of Wales in 2005, the equivalent of England's Poet Laureate, and Cardiff's wonderful bronze and slate Millennium Centre was opened in November 2004 with her 6ft tall words creating glass windows into the building. The words read:

> CREU GWIR IN THESE STONES
> FEL GWYDR HORIZONS
> O FFWRNAIS AWEN SING

The translation of 'Creu Gwir fel Gwydr o Ffwrnais Awen' is 'Creating truth like glass from inspiration's furnace'. She writes on her website: 'I wanted the words to reflect the architecture of the building. Its copper dome reminded me of the furnaces from Wales's industrial heritage and also Ceridwen's cauldron, from which the early poet Taliesin received his inspiration (awen). Awen suggests both poetic inspiration and the general creative vision by which people and societies form their aspirations. The windows out of which the words are made suggest to me an ideal of poetry: that it should be clear enough to let light in and out of a building, offering enough a distinctively local view of the world; it should speak a truth which is transparent, beautifully crafted but also fragile and, therefore, doubly precious.' For the English language 'In these Stones Horizons Sing', Lewis goes on to say: 'It was important to me that the English words on the building should not simply be a translation of the Welsh, that they should have their own message. The strata of the slate frontage of the WMC reminded me of the horizons just beyond Penarth Head. The sea has, traditionally, been for Cardiff the means by which the Welsh export their best to the world and the route by which the world comes to Cardiff. The stones inside the theatre literally sing with opera, musicals and orchestral music, and I wanted to convey the sense of an international space created by the art of music.'

LLECH-Y-CRAU, BATTLE OF, 1088 Rhys ap Tewdwr had been forced from his kingdom of Deheubarth by the sons of Bleddyn Cynffin, assisted by Normans. He returned with a fleet and defeated the invaders, killing two of Bleddyn's sons, Madog and Rhiryd. Llech-y-Crau may be Llechryd on the River Teifi.

LEWIS, SIR THOMAS LEWIS (1881-1945) A noted cardiologist and clinical scientist, he was the first man to master the electrocardiogram and fought hard for funding for research into clinical science.

LEWIS, MERIWETHER, & THE LEWIS AND CLARK EXPEDITION 1803-1806 President Jefferson's friend and protégé, a fellow-Welshman called Meriwether Lewis (1774-1809), opened up the American West, with fellow explorer William Clark. Lewis commanded and completed the first overland expedition to the Pacific Coast and back. The President had specially chosen Lewis for the task, and told Congress that he expected Lewis and Clark to discover a 'mountain of salt', 180 miles long and forty-five miles wide (around the size of Wales). They made contact with new Indian tribes, and found 'new species' such as prairie dogs, horned lizards, coyotes, bighorns, sage grouse, porcupines, jack rabbits, trumpeter swans, steelhead salmon trout, mule deer and

pronghorn antelopes. 122 animals new to science were discovered, along with 170 new types of plant. Over two years, four months and ten days they took to reach the Pacific Coast and return, the expedition encountered over forty Indian tribes, including the Oto, Missouri Osage, Yankton Sioux, Omaha, Teton Sioux, Arikaras, Mandans, Hidatsas, Flatheads, Nez Pierce, Shoshoni, Warapams, Chinooks, Clatsops, Walla Walla, Crow, and the tribe feared most by all the other Indians, the Blackfeet. Lewis followed the Missouri to its source, crossed the unknown Rockies (aided by an Indian woman, Sacajawea) and followed the Columbia River to Pacific Ocean, returning overland to St Louis from 1804-1806. He had designed a collapsible canoe, *The Experiment*, to transport equipment around rapids. At Lemhi Pass in Idaho, Lewis had become the first white man to cross the Continental Divide, and he named the Missouri River canyon in Montana, *The Gates of the Mountains*. Americans can now follow his trail, stopping at isolated campsites. According to his biographer, S.E. Ambrose, in *Undaunted Courage*, Meriwether Lewis was 'the first great American celebrity after the Revolutionary War – a superstar in today's terms.' Jefferson rewarded Lewis with the governorship of the huge new territories acquired by the Louisiana Purchase, but it looks like Lewis had acquired syphilis, drank to obsession, drifted into debt and committed suicide in Tennessee in 1809, aged just thirty-five. Controversy now rages as to whether he was murdered. The main account of his death comes from an innkeeper, Mrs Grinder, who recounts hearing two shots, then finding Lewis with bullet wounds in his head and chest, using a razor, 'busily engaged in cutting himself from head to foot'. Lewis was almost certainly robbed and killed, rather than committing suicide.

LEWIS, SAUNDERS (1893-1985) He was a playwright, literary critic, pacifist, novelist and poet, and a writer in Welsh with a reputation across Europe. He was twice nominated for the Nobel Prize for Literature, and to some he was the greatest figure in Welsh literature in the twentieth century. His poems have been compared to those of Yeats and Eliot. A founder of Plaid Cymru, from 1926 he was its President. In 1936, along with two friends he set fire to a hangar on the RAF bombing range at Penberth on the Llŷn Peninsula. The three men turned themselves in the next day. Lewis stated from the dock of the court that: 'What I was teaching the young people of Wales in the halls of the university was not a dead literature, something chiefly of interest to antiquarians, but a living literature of the Welsh people. This literature is therefore able to make demands of me as a man as well as a teacher... It is plain historical fact that, from the fifth century on, Llŷn has been Welsh, of the Welsh, and that as long as Llŷn remained un-Anglicised, Welsh life and culture were secure. If once the forces of Anglicisation are securely established behind as well in front of the mountains of Snowdonia, the day when the Welsh language will be crushed between the iron jaws of these pincers cannot long be delayed. For Wales the preservation of the Llŷn Peninsula from this Anglicisation is a matter of life or death.' The Welsh jury acquitted the three defendants. The Government was shocked and had the three retried away from Wales, in London with an English jury, where they were given nine-month prison sentences. Lewis lost his job as a university lecturer. The actual legality of a British Government turning over the rational verdict of a trial jury seems in doubt.

Lewis said that 'to acquiesce in the death of a language which was the heritage of our forefathers for 1500 years, is to despise man. Woe betide the society that despises man.' The Welsh former Prime Minister, David Lloyd-George, railed against the injustice of it all – 'They yield when faced by Hitler and Mussolini, but they attack the smallest country in the kingdom which they misgovern. This is a cowardly way of showing their strength through violence... This is the first government that has tried to put Wales on trial at the Old Bailey... I should like to be there, and I should like to be forty years younger.' Saunders Lewis was asked if he wanted to see a bloody revolution, and answered 'So long as it is Welsh blood and not English blood.' He died in 1985, a poet-philosopher-nationalist-pacifist, still without much honour in his own land – the majority of Welsh youngsters have never heard of the man, who did more than anyone since Bishop William Morgan to keep the Welsh language alive. Saunders Lewis was shamefully blacklisted by the University of Wales for his nationalism – not until 1951,

fifteen years later, was he accepted back into academia, at Cardiff University.

LHUYD, EDWARD (1660-1709) From Glanfred, near Llandre (Llanfihangel Genau'r-glyn) he was the first noted taxonomist of zoology, transformed Oxford's Ashmolean Museum, and also revised the 1695 edition of Camden's *Encyclopaedia Britannica.*

LIGHTHOUSE The 140-year-old Whiteford Point Lighthouse in the Burry Estuary is a listed building, and Britain's only surviving iron-clad offshore lighthouse.

LINCOLN, BATTLE OF, 1141 A third of the army of the Earls of Gloucester and Chester were Welshmen, led by Maredudd and Cadwgan, the sons of Madog ab Idnerth of Maelienydd (Radnorshire). They resented the Mortimers of Wigmore pushing into their lands, and were on the side of Empress Matilda during the anarchy of the struggles between Stephen and Matilda. King Stephen's opposing army counted the Earls of York, Richmond, Norfolk, Southampton, Surrey and Worcester. The Welsh contingent, armed only with knives and spears, were overwhelmed by the armoured knights of the Earl of York, but their Marcher Lord allies managed to capture King Stephen. In 1142, Cadwgan and his brother Hywel were killed by Helias Say, the pro-Stephen Lord of Clun. Their uncle Hoeddlyw was killed also in that year, fighting in Montgomery. Maredudd ap Cawdgan was killed in 1146 by Hugh Mortimer. Hugh Mortimer was defeated by King Stephen's forces in 1148, and Madog ab Idnerth's two surviving sons Cadwallon and Einion Clud regained Maelienydd and Elfael respectively.

LITERATURE The earliest extant poem in Welsh is *Y Gododdin* by Aneirin, probably written in Strathclyde in Scotland and describing a Celtic war party's defeat at the Battle of Cattraeth. This author doubts that the battle was at the traditional inland site of Catterick in Yorkshire, as the name is more likely to be derived from cad = battle, traeth = beach. Gildas, the sixth-century historian, studied at Llanilltud Fawr (Llantwit Major), died in 570 and was the first writer of history in Britain. His *De Excidio et Conquestu Britanniae* shows the resistance of fifth and sixth-century Britons against the Anglo-Saxons. The superb illuminated manuscript, *The Book of Teilo*. with Welsh annotations in its margins, was stolen from Llandaff Cathedral and renamed *The Gospel of St Chad.* This important part of Welsh heritage now is shown off in pomp in Lichfield Cathedral in England, and claimed as an English manuscript, despite the contemporary Welsh writing in its marginalia denoting sixth and seventh-century land grants by Welsh princes. Nennius lived around 830 and was a pupil of Elfodd, Bishop of Bangor. His *Historia Britannorum* gives us information upon the fabled Arthur, who as *'dux bellorum'* after the death of Hengist led the Britons against the Saxons in twelve battles. Nennius drew strongly upon Gildas' work. In the ninth-century Asser's *De Vita et Rebus Gestis Alfredi* gives us the story of Alfred burning the cakes. A monk of St David's, Asser joined King Alfred's household in 885, and studied with him for six months a year, until his death as Bishop of Sherbourne in 910. He also wrote a chronicle of history from 849 to 887.

From around 930, *Armes Prydain* is a great poem of lament, asking for an alliance between Brittany, Wales and the Norsemen of Dublin to throw the hated Saxons out of the British Isles. Hywel Dda is castigated for his accommodating stance towards Athelstan of Wessex, in this *Prophecy of Britain. Annales Cambriae* is a set of tenth-century Welsh annals, giving extra information upon Arthur and his times, including the Battle of Badon in 518 and the fatal Battle of Camlan in 539 where both Arthur and Mordred were killed. Written about 960, the pedigrees of the Welsh royal families in this document are invaluable for understanding early Welsh history. Jacques Chevalier stated 'Wales was the only country in Europe in the tenth and eleventh centuries which had a national literature, apart from an imperial one in Latin. The people of Wales were the most civilised and intelligent of the age.' Around 1050 to 1150, the stories known as *The Mabinogion* were first written down, possibly by Gwenllian, as they are remarkable in their female view of events. Four Welsh documents (*The Four Ancient Books of Wales*) are truly outstanding

pieces of mediaeval literature, of international importance. They were all written down using far older material:

The Black Book of Carmarthen, dating from the mid-twelfth century;

The Book of Aneirin, written in the late thirteenth century;

The Book of Taliesin, from the fourteenth century; and

The Red Book of Hergest, also fourteenth century.

In *The Red Book* are to be found Welsh translations of *British Chronicles*, the famous *Triads*, ancient poems of Llywarch Hen, and the priceless *Mabinogi* stories. The oldest surviving manuscript in Welsh, *Llyfr Du Caerfyrddin* (*The Black Book of Carmarthen*) dates from around 1250. About fifty years later, in the scriptorium at Ystrad Fflur (Strata Florida Abbey), *Llawysgrif Hendregadredd*, the collection of mediaeval Welsh poetry was collected. The Breton Geoffrey of Monmouth 'established' a lineage for Britain dating from the Trojans, and created the Arthurian basis for future romances. Born around 1090, Geoffrey was schooled in Monmouth's priory. At Oxford, he was entrusted with translating an ancient manuscript from the original British language into Latin. From this and other sources he compiled his *History of the British Kings* (*c.* 1135), which refers to Cymbeline and Lear, the departing Romans and the flourishing of Arthur in the Dark Ages. This *Historia Regum Britanniae* became an instant success across Europe. Its translation into French ensured the mythology of Arthur spread across the continent. He traced British ancestry from Cadwaladr in 689 back to Brutus, the great-grandson of Aeneas of Troy, 1,900 years of history, and described the Anglo-Saxon invasions of Britain. Probably an Archdeacon of Llandaf, he moved to St Asaf in 1152 and died in 1155. According to him, London was founded by the Trojans as New Troy, Troynovant, which accounted for the Celtic tribe of Trinovantes in the South-East of England.

Walter Map (1140-1210), a border Welshman who became Archdeacon of Oxford, was highly regarded. Chaucer refers to his *Courtiers' Trifles* (*De Nugis Curialum*) in the *Canterbury Tales*. Map also wrote *Lancelot*, but only fractions of his writings survive. Giraldus Cambrensis (Gerald de Barri, Gerald of Wales, 1146-1223) has left valuable works, and also desperately tried to ensure the independence of the Church of Wales against the supremacy of England. Born in Manorbier Castle, a son of Nest (the 'Helen of Wales'), Gerald was rejected twice for the Archbishopric of St David's, once by Henry II and once by the Archbishop of Canterbury. He appealed to Rome, was outlawed and fled abroad to be held at Chatillon. Later pardoned, this Archdeacon of Brecon wrote important works on Ireland and Wales. His *Itinerarium Cambriae (Voyage through Wales)* is a fascinating and sympathetic view of Wales and its people in medieval times. The *Brut y Tywysogion (Chronicle of the Princes)* of 1256 is probably the best sourcebook for Welsh history, linking the Llywelyns back to Cunedda, and detailing battles and genealogies.

In 1536, the Act of Union with England forbade the use of Welsh for official purposes, but only a decade later the first book printed in Welsh (in London) was written by Sir John Price (John Prys) of Brecon, *Yn y Llyfr Hwn*. Just a year later, William Salesbury published his *Dictionary in English and Welsh* in 1547. The Act of Uniformity, 1549, declared that all acts of public worship had to be in English. Yet Salesbury published his *Kynniver Llth a Ban* in 1551, a translation of the main text of the Prayer Book. The indomitable Salesbury published another book in 1556 on *How to Pronounce the Letters of the British Tongue (Now Commonly Called Welsh)*. In 1567, he translated the *New Testament* into Welsh, and in the same year Gruffydd Robert published a book on Welsh grammar from his exile in Milan. The year of the Armada, 1588, saw the publication of Bishop William Morgan's masterful translation of the *Bible* into Welsh. With Salesbury's earlier *New Testament*, this saved the language more than any other influence. It was not until 1942 that the Welsh language was allowed to be used in court proceedings, and not until 1967 that Welsh appeared upon official forms, but Welsh still had no official status as a language. In 1993 its status was improved by a new Welsh Language Act.

Kate Roberts (1891-1985) has been the most distinguished writer in Welsh in the twentieth century. Born near Caernarfon, she has been called 'the Welsh Chekhov'. Emlyn Williams (1905-1987), the playwright, novelist and actor, wrote the psychological thriller *Night Must Fall* in 1933,

and often played the lead in his own plays. Alun Richards, born in 1929 at Pontypridd, has been a leading playwright, novelist and short story writer. Bernice Rubens was the first woman to win the Booker Prize, in 1970, and Alice Thomas-Ellis is a well-known novelist, but Wales is best known for its poetic rather than its prose tradition. David Hughes won the WH Smith Literary Award in 1988 with *The Pork Butcher*, filmed as *Souvenir* in 1989. Many fine writers are of Welsh descent – Jerome K. Jerome (who based the character of Harris in *Three Men in a Boat* on George Evan Jenkins), Charles Kingsley (*The Water Babies, Hereward the Wake*), George Meredith and Mary Webb (nee Meredith) spring to mind. Also of Welsh origin, Harriet Beecher Stowe's *Uncle Tom's Cabin* was a sensational worldwide success as the first anti-slavery novel. In the nineteenth century, Matthew Arnold put the Celtic contribution to English literature in its rightful place... 'while we owe to the Anglo-Saxon the more practical qualities that have built up the British Empire, we have inherited from the Celtic side that poetic vision which has made English literature the most brilliant since the Greek' (*The Study of Celtic Literature*).

LITTLE ENGLAND BEYOND WALES South Pembrokeshire, south of the Landsker crossing the Preseli Hills, was known as this because the Flemings and English who settled here after the Norman Conquest of England. They gave their villages English names, and built a line of castles to keep the Welsh out.

LL This is a consonant, so places in Wales that begin with Ll, such as Llandudno, should be spelt LLandudno. However, normal practice has been followed in this book.

LLAN Many places with this prefix, meaning 'religious enclosure', are associated with very early Christian settlements, containing a church dedicated to a Celtic saint. Unfortunately, many of these churches were rebuilt and renamed by the Normans in the eleventh and twelfth centuries. Churches named after St Michael (Llanfihangel) or St Mary (Llanfair) are often on the sites of earlier foundations. There are over 600 churches in Wales (and just over its present border) still dedicated to the original saints. A monastic settlement was traditionally surrounded by an earth wall or rampart and a ditch – the area enclosed was known as a 'llan', and the name in later times became associated with a church. Thus Llanbadarn was founded by St Padarn, Llanilltud Fawr by St Illtud, etc. Llanilltud monastery was a centre of learning, perhaps as early as the first century, as Cor Eurgain, founded by Caradoc's daughter and her Roman husband on their return from the imprisonment of Caradog (the hero Caractacus of the Silures) in Rome. In the sixth century, Illtud seems to have taken over the great monastery to train missionaries. Bologna claims to be the oldest European centre of learning, but Llanilltud Fawr (Llantwit Major) has a far longer history. Llanilltud Fawr made an immense contribution to Christian history, but equally intriguing is Llancarfan, a few miles away, where seven small streams meet. Originally called Nant Carfan, it is the Carbani Vallis mentioned in the ancient *Book of Llandaf*, and was the seat of a famous Celtic monastery back in the sixth century. The church is dedicated to St Catwg (Cadoc). Catwg was born *c.* 500 in Monmouthshire, possibly educated at Caerwent, and founded the monastery in 535. The monk Caradoc of Llancarfan was referred to by Geoffrey of Monmouth as his contemporary, and it has also been claimed that he wrote *Brut y Tywysogion (Chronicles of the Princes)*. In Llancarfan's hidden valley there are many wells, some of which were claimed to have healing powers, and overlooking it is the large hill-fort known as Castle Ditches. Nearby Llanfeithyn Farm is said to have been the site of Catwg's monastery, where Dyfrig (Dubricius) was taught, and his name is attached to Dyfrig's Well. Also taught there were St Baruwg (Baruc – buried in the old chapel on Barri Island), and St Finnian of Clonnard. Llanfeithyn also had a chapel dedicated to St Meuthin (probably the same saint as Tathan) and it became a grange attached to Margam Abbey in the twelfth century. Nearby, the ancient building at Garnllwyd, now a farmhouse, is also said to have been a monastic site, and hundred of human bones have been found in an adjacent field. These three monastic sites are within a mile of each other, and only four miles from Llanilltud Fawr. Geophysical surveys could probably recover Celtic crosses from the ground on these sites.

LLANBADARN FAWR Just outside Aberystwyth, the fifth of the ancient bishoprics, Llanbadarn Fawr, has never achieved cathedral status, although it was founded in the sixth century. With a thirteenth-century castle, Llanbadarn is said to have minted its own coins, and was a major centre during Owain Glyndŵr's rising. The National Library of Wales was founded in 1907, and in 1963 Cymdeithas yr Iaeth (The Welsh Language Society), was founded here.

LLANBLEIDDAN (LLANBLEDDIAN) CASTLE On a hill opposite the hillfort of Caer Dynnaf, just outside Cowbridge, it was built by Gilbert de Clare in 1307 and uncompleted at his death at Bannockburn in 1314. Also known as St Quentin's Castle, it was sacked by Llywelyn Bren.

LLANDAF CATHEDRAL Eglwys Gadeiriol Llandaf (Llandaff Cathedral), on the Taf, just north of Cardiff, was founded by St Dyfrig (Dubricius) in the sixth century, and probably contains his tomb and that of St Teilo (who is also credited with founding the see). Dyfrig is also said to have established his first monastery on Ynys Enlli (Bardsey Island), where three pilgrimages were regarded as the equivalent of one to Rome. In 1120 Bishop Urban of Llandaf brought Dyfrig's remains back to Llandaf to improve the prestige of his bishopric. Llandaf has claims to be the oldest bishopric with a continuous history in Britain, as a religious settlement seems to have been there very quickly after the establishment of Christianity. The Norman Bishop Urban had re-dedicated the cathedral to St Peter, but Giraldus Cambrensis later referred to it as the church of St Teilo. Owain Glyndŵr destroyed the neighbouring Bishop's Palace, and the cathedral was hit by a German aerial mine in the Second World War. However, Llandaf has been restored, with a superb sculpture by Jacob Epstein of *Our Lord in Glory* spanning the nave. There is work by Dante Gabriel Rossetti inside, and the Llandaf Cathedral Choir School dates back to the ninth century, possibly the oldest in Europe. There is a lovely walk alongside the River Taf to Cardiff Castle from the Cathedral. The Llandaff Charters (The Book of Llandaff, Liber Landavensis) were written around 1125 and record land grants from the sixth century to the ninth century.

LLANDEGAI, BATTLE OF, 1648 The Royalists under Sir John Owen of Eifionydd were defeated by the Parliamentarian colonels Twistleton and Carter, upon Owen's capture.

LLANDEILO On a commanding position above the River Tywi, this ancient market town was founded by St Teilo and known as Llandeilo Fawr, with a monastery and scriptorium. Only recently has it been discovered that Llandeilo was an important Roman site with two forts and a settlement, and excavations have been made around Newton House in Dinefwr Park.

LLANDEILO, BATTLE OF, 1213 Rhys Grug (the Hoarse), the fourth son of The Lord Rhys, destroyed the town but was then defeated by an English army led by Falkes of Breaute. King John had sent the English force to aid Rhys and Owain, the grandsons of The Lord Rhys. Rhys Grug was forced to seek his brother Maelgwn's protection in Ceredigion. It is unsure if there was a separate battle at Talley at this time.

LLANDEILO, BATTLE OF, 17 JUNE 1282 When Edward I took his army to the north to subdue Llywelyn II, Gilbert de Clare, Earl of Gloucester, took a separate force to subdue south Wales. He lost five knights, possibly at Caledfwlch (also the name for Arthur's sword), but the Welsh were defeated.

LLANDEILO, BATTLE OF, 1316 The town and castle were badly damaged by fire during the Welsh revolt by Llywelyn Bren in 1316. Newton at Dinefwr and Llandeilo Castle were later put to the torch in July 1403 during Owain Glyndŵr 's march through the Tywi Valley.

LLANDOUGH CROSS OF IRBIC When a Roman villa was being excavated prior to being built on, the site of St Dochdwy's lost monastery was found, with at least 800 burials from the fourth century onwards, making it the largest Celtic Christian burial site found in Britain. The tenth-century Cross of Irbic is in the churchyard, and the carving on the Sutton Stone shaft is of an interlacing pattern, with the base including a carving of a horseman, and two human faces on the sides.

LLANDOVERY (LLANYMDDYFRI) CASTLE Near the river and the centre but hidden from general view, the castle was begun in 1116. Shortly after, Gruffydd ap Rhys destroyed the outer bailey but could not take the tower. In 1158, the Welsh took it from Walter Clifford, and over the next decades ownership alternated between the Normans and various of The Lord Rhys's sons. From 1262 to 1276, it was in the hands of Rhys ap Gruffydd. In 1277 Edward I took it, and it was in English hands except for a few months in 1282 when it was taken by Llywelyn the Last on 4 July. It was strengthened from 1283, and resisted Glyndŵr's forces. There is a statue of Llywelyn ap Gruffydd Fychan. The castle was slighted by Parliamentarians.

LLANDOVERY ROMAN FORT A medieval church stands in the corner of this fort, and from it one can see the Roman road leading to Pumsaint.

LLANDOW AIR DISASTER 16 MARCH 1950 Between Cowbridge and Llanilltud Fawr, *Vale of Glamorgan*. Possibly due to pilot error, an Avro Tudor airliner with seventy-eight passengers and five crew crashed near Llandow Aerodrome on the return trip from seeing Wales play Ireland at rugby. Eighty people died, including six men who played for Llanharan Rugby Club, and three who played for Abercarn. It was the greatest loss of life in an air disaster at that time.

LLANDRINDOD WELLS Sulphur wells and bubbling saline rills were responsible for the growth of this spa from Victorian times, and there also are many substantial Edwardian buildings. This most famous spa town in Wales was created almost from scratch in the 1850's,. A famous Victorian Festival, where all the locals dress up in Victorian costume, is held for one week every August. Up to 80,000 visitors a year used to use the wells, and advertisements of the day claimed that 'saline, sulphur, magnesian and chalybeate waters are very efficacious in the treatment of gout, rheumatism, anaemia, neurasthenia, dyspepsia, diabetes and liver affections'. A chalybeate spring still spouts out of a public drinking fountain in Rock Park Gardens. In the Pump House Tea Rooms at the Rock Park Spa, one could choose from draught saline, sulphur or magnesium water.

LLANDUDNO Wales' largest seaside resort is a long beach and promenade between the Great Orme and Little Orme headlands. It was the brainchild of Edward Mostyn and Owen Williams, who from 1824 began transforming a mining and fishing village. St Tudno's Church stands on the Great Orme, and a cable car takes one to the top of the peninsula.

LLANELLI From being a centre for coal mining, it became one of the largest tin-plating centres in the world from the 1850's, known as 'Tinopolis'. For obscure reasons its people are known as 'Turks', by the 'Jacks' (people of Swansea). Its rugby team, the 'Scarlets', recently played their last match before leaving their world-famous ground at Stradey Park for a new venue, Parc y Scarlets, an unfortunate mongrel of a name.

LLANELLI RIOT 1911 The period of 'The Great Unrest' amongst an impoverished and over-worked people saw major disturbances in the Cynon Valley, a riot among seamen in Cardiff Docks in 1911, and the Llanelli Riot. When a crowd harassed the occupying soldiers, two young Llanelli men were shot and killed. It was just two days after the start of the National Railway Strike of 1911, which ended on the night of the killings. The 2.30 train from Cardiff to Milford Haven had been

stopped by a crowd, and the First Battalion of the Worcester Regiment had been called in to disperse the rioters. The troops were ordered to fire at the people, but Private Harold Spiers, a Welshman, refused to do so upon unarmed civilians. John Francis was hit in the throat, and Ben Hanbury in the hand. John John and Leonard Wurzel were killed. This occurred while no-one was threatening the troops, and was the last time that workers in Britain were shot and killed by the army in an industrial dispute. Following this, ninety-six trucks were destroyed, shops were damaged and four people accidentally killed in an explosion. On the same day and following, there was disorder in Tredegar, Bargoed and across the coalfield. Thousands lined the streets of Llanelli for the funerals of the six who died. Spiers had been arrested for refusing to fire into the crowd, but escaped from his guards, and was re-arrested two weeks later in New Radnor. He was charged and tried for desertion, but two days later there was a report in *The South Wales Daily News*, stating: 'We are officially requested to deny the statement made by Private Spiers on his arrest'... 'Spiers was never ordered to fire by the Officer in Charge. It is extremely doubtful whether he was amongst the troops on the Railway at all, and he was not under arrest at the time he deserted'. According to recently released Public Records Office papers, these lies were concocted by Winston Churchill, then Home Secretary, who did not wish to make Spiers into an imprisoned working class hero. Churchill was already hated throughout South Wales for sending the troops into Tonypandy in 1910, and was an ambitious politician. In a Parliamentary reply in December 1911, a War Office official firmly denied that any soldier in Llanelli had refused to fire, but stated that Spiers had been imprisoned for two weeks for going absent without leave. Also in December 1911, Spiers bought himself out of the army, but enlisted again in 1914 and fought throughout the First World War.

LLANERCHAERON ESTATE This eighteenth-century 'time capsule' in Ceredigion shows how country gentlefolk lived 200 years ago. The mansion was designed by John Nash, and the elegant house, walled gardens, original kitchens, laundry, brewery and cheese parlour can all be visited.

LLANFAIR PG Llanfairpwllgwyngyll ('St Mary's Church by the pool of white hazel trees') in Anglesey, was renamed by the local bard John Evans (Y Bardd Cocos, 1827-1895) as: Llanf airpwllgwyngyllgogerychwyrndrobwllllantisiliogogogoch (as above, but adding 'near the rapid whirlpool, by the red cave of the Church of Saint Tysilio'). Local tradesmen used it to publicise the village in the nineteenth century. British Rail used the concocted name when it reopened the railway station in 1973. Llanfair PG has another claim to fame in that Britain's first Women's Institute was established here in 1915.
Not to be outdone, The Fairbourne Steam Railway at Barmouth has also invented a 'more commercial' station name for a station board which is 64 feet long, of: Gorsafawddacha'idraigo danheddogledddollonpenrhynareurdraethceredigion ('The Mawddach Station with its dragons' teeth on the Northerly Penrhyn Drive on the golden beach of Cardigan Bay' – the dragons' teeth are the remains of Second World War concrete defences).

LLANFOR ROMAN CAMP Near Bala, it encompassed a supply depot, watchtower and marching camp.

LLANGAMARCH WELLS This spa town on the River Irfon, attracted David Lloyd George and foreign heads of government to its barium wells. Barium chloride allegedly helped cure heart disease, gout and rheumatism. The spring is in the grounds of the Lake Hotel, formerly known as the Pump House Hotel. Nearby Cefn-Brith was the home of John Penri (Penry), who was hung, drawn and quartered aged thirty-four in 1593 for his pamphlets denouncing absenteeism and immorality in the clergy. He left his four children all that he possessed, a Bible each.

LLANGOLLEN Founded by St Collen, its bridge over the tumultuous River Dee dates from

around 1500 and was considered one of the 'Seven Wonders of Wales'. At nearby Berwyn the Chain Bridge was built over the Dee by Exuperius Pickering to take coal to Corwen and Bala. Plas Newydd was the home of the Ladies of Llangollen and Valle Crucis Abbey, Eliseg's Pillar and Dinas Brân Castle are nearby.

LLANGOLLEN, BATTLE OF, 1132 Near Llangollen, this was where Gwynedd's advance was checked by the men of Powys, and Cadwallon ap Gruffydd ap Cynan, the brother of Owain Gwynedd, was killed.

LLANGOLLEN INTERNATIONAL MUSIC FESTIVAL In 1955, a young unknown called Luciano Pavarotti sang with his father's choir from Modena, at the Llangollen International Music Festival. It is said that his hearing Tito Gobbi sing at Llangollen, combined with the acclaim and the award of first prize, were the spurs that made him decide to make singing his professional career. In July 1995, he returned to give a free, and triumphal, performance, ending the night in tears in front a rapturous audience. Local ladies had made flower displays for the stage, only to learn that Pavarotti was allergic to flower pollen. Shortly before the performance, they had to pinch off all the pollen-bearing anthers, and spent £150 upon hair lacquer, to spray on the flowers and prevent any pollen interfering with the maestro's performance. He enjoyed the dessert so much at the post-concert banquet at the Bryn Hywel Hotel, that he secretly had another four sent up to his bedroom. Started by Harold Tudor in 1947 in an attempt to bring peoples together after six years of war, Llangollen Festival is the best place to see scores of national costumes and enjoy the most varied dancing and singing in Europe, probably in the world. Over 12,000 international participants come as folk singers, choirs, dancers, groups and instrumentalists, with 150,000 visitors descending on this town of just 4,000 people, making it a marvellous cosmopolitan affair. The European Centre for Traditional and Regional Cultures (ECTARC) is based in Llangollen, with performances and displays featuring the cultures of all the EU states.

LLANGOLLEN CANAL With magnificent scenery, it passes over the River Dee via the spectacular Pontcysyllte Aqueduct, 120ft high and over 1.000ft long. Built between 1795 and 1805 by Thomas Telford, the aqueduct and canal have become a World Heritage Site. It joins the Shropshire Canal after going through the 460 feet Chirk Tunnel and passing over the 70ft-high Chirk Aqueduct.

LLANGORS Llangors Lake, Llyn Syfaddan in Breconshire is said to be the largest natural lake in South Wales. Nearby is the sixth-century church dedicated to St Paulinus (St David's tutor) and a Viking burial stone. The legend that the lake covers a lost city, can probably be attributed to the fact that a small artificial island in the lake is the only known Welsh site of a crannog, a defensible fort used by lake dwellers.

LLANGORSE, BATTLE OF, 916 Llangors has links with royal and episcopal estates from about the seventh century. Both historical and archaeological evidence suggests that the crannog towards the northern side of the lake was a residence of the kings of Brycheiniog in the eighth-tenth centuries. *The Anglo-Saxon Chronicle* records that in 916, Lady Aethelflaed sent an army into Wales, three days after the murder of abbot Ecgberht and his companions. The army stormed Brecenanmere ('Brecon mere') and captured the king's wife and thirty-three other members of the court. The attack on the mere almost certainly refers to the destruction of the royal crannog and the capture of the wife of King Tewdwr ab Elised, King of Brycheiniog. *The Book of Llandaff* records the grant of Llan-gors to the church of Llandaff by the king of Brycheiniog in the seventh century. High quality textiles from the period have been excavated in the silt on the site, and there are signs of it having been fired a millennium ago, so *The Anglo-Saxon Chronicle* is probably correct.

LLANIDLOES Founded by St Idloes in the seventh century next to the River Severn, the town began to expand after the Norman Conquest of Britain in 1066, when a motte and bailey castle was constructed on the site where the Mount Inn now stands. In 1280 Llanidloes obtained its first Charter, granted by Edward I, and this was followed in 1344 by a Charter making the town a self-governing borough. This status was retained until 1974. The layout of wide streets formed in the shape of a cross originated at this time. The Old Market Hall, the only half-timbered hall of its kind in Wales still in its original position, was constructed on the centre of the cross early in the 1600s. Llanidloes was renowned for the quality of its wool in the sixteenth century, and its flannel during the eighteenth and nineteenth centuries. Flannel may be one of the very few Welsh words to pass into the English language.

LLANIDLOES, BATTLE OF, 1162 Hywel ap Ieuaf of Talgarth, Lord of Arwystli, was defeated by Owain ap Gruffydd (Owain Gwynedd) after he had taken Tafolwern Castle.

LLANIDLOES CHARTIST RIOTS 1839 There was a huge depression in the flannel industry, which assisted the movement for political reform in the 1830s. At the end of April 1839, circumstances led to a riot that effectively overthrew the constituted authority of the town's officials for five days, until troops could be mustered to 'restore order'. Llanidloes remained an occupied town for a whole year, whilst a number of trials saw sentences of transportation and imprisonment imposed on over 100 people.

LLANILLTUD FAWR (LLANTWIT MAJOR) St Illtud's sixth-century monastery was said to be based upon that founded by Eurgain in the first century, and then re-endowed by Tewdws. Many saints were taught there including David and Patrick, and it has claims to the world's first university, certainly Britain's first university. Remains of the monastery are north of Illtud's medieval church. Nearby Boverton was said to be the birthplace of Arthur.

LLANILLTUD FAWR ROMAN VILLA At Cae'r Mead or Caer Mead, just north of the town, lies this remarkable site, hardly known even to local people. Skeletons have been found here, some seemingly killed in battle, and there are superb mosaics, dated to about 320 CE. It was lived in from about 150 to 350, and its 'double-courtyard' construction is extremely rare in Britain. Excavated in the nineteenth century, it has been covered by earth ever since. In the next field is a ploughed-out tumulus and a gold Celtic torc was found here.

LLANLLYR ABBEY This Cistercian nunnery was founded by The Lord Rhys around 1180, as a daughter-house to Strata Florida, and despoiled by the monks of Strata Florida after his death. In 1284 it was granted 40 marks compensation for the damage done during Edward I's conquest of Wales. Little remains except fishponds, since it was stripped after the Reformation. It was in the parish of Llanfihangel Ystrad in Ceredigion, and one of only two Cistercian nunneries in Wales, along with Llanllugan in Montgomery.

LLANMELIN WOOD HILLFORT This impressive site seems to have been the tribal centre of the Silures, near Caerwent, and Roman pottery has been found there. It has been associated with Camelot by some authors.

LLANSANTFFRAID-YM-MECHAIN ROMAN COMPLEX A settlement and supply base in Powys.

LLANSTEFFAN CASTLE Near Carmarthen, the castle was first erected in the twelfth century on an Iron Age site. After Cadell ap Gruffydd had taken Dinefwr, Carmarthen and Llansteffan in 1136, Llansteffan was given to his brother Maredudd: 'soon after that a multitude of French and Flemings laid siege to Llansteffan. And Maredudd ap Gruffydd, to whom the castle had

been entrusted, rose superior to his age: for a boy though he was in age, he showed nonetheless the action of a man so that his enemies were slain or put to flight.' In 1146, it was taken by the princes of Deheubarth, and held until 1158. It was retaken in 1189 by The Lord Rhys, but fell to Henry II. Llywelyn the Great captured and burned it the castle 1215, and it was also burned by Llywelyn the Last in 1257 after the English defeat at Coed Lathen. Glyndŵr took the castle, and Jasper Tudor later made it into a great residence in the late fifteenth century.

LLANTARNAM ABBEY Five miles west of Newport, the abbey was founded Lord Hywel ab Iorwerth of Caerleon in 1579, and later colonised by Cistercian monks from Strata Florida. Its abbot died fighting for Owain Glyndŵr. Dissolved in 1536, it was made into a country home by the Catholic William Morgan in 1553, and the Great Hall rebuilt in the 1830's. The sisters of St Joseph of Annecy bought it in 1946 as the centre for their order in the UK and Ireland.

LLANTHONY, BATTLE OF, 1136 Richard de Clare held the lordship of Ceredigion, and the Welsh had won battles at CARN GOCH and CRUG MAWR in his lordship. He crossed the Welsh border in April, heading for Ceredigion with a small force. De Clare was ambushed and killed by Iorwerth ab Owain and his brother Morgan, grandsons of the penultimate Prince of Gwent, Caradog ap Gruffydd. The fight took place in a woody area called *'the ill-way of Coed Grano'*, near Llanthony Abbey.

LLANTHONY PRIORY & ST DAVID'S CHURCH This is a beautiful ruined Norman priory in the mysterious Vale of Ewyas, with a pub/hotel built into its tower. It was recognised as an Augustinian priory by 1118, but the Welsh had forced its desertion by 1135. The de Lacys brought canons from Gloucester and built the present priory between 1180 and 1230. It suffered during the Glyndŵr War of 1400-1415. Rhiw Pyscod is a footpath from Llangorse Lake to bring fish, still alive and wrapped in rushes, to the monks. Rhiw Cwrw is another path leading to the abbey, bringing beer from Abbey Dore. (Rhiw means hill, pyscod means fish and cwrw is beer.) Adjacent to the priory, St David's Church predates it, on a Celtic foundation, but the present church dates from 1109. It has thick defensive walls and small windows, and the altar is sited to face the sun on 1 March, St David's Day. Llanthony is a corruption of Llan Honddu, itself an abbreviation of Llan-Ddewi-Nant Honddu – the holy foundation of David on the Honddu Stream.

LLANTILIO CROSSENNI, BATTLE OF, *c. 577* King Iddon ap Ynyr Gwent was losing to the Saxon invaders who had chased the survivors of the Battle of Dyrham into Wales. St Teilo's prayers swayed the battle and the Saxons were defeated. Iddon gave the land where the battle was fought to St Teilo, where he built St Teilo's church.

LLANTRISANT CASTLE Richard de Clare built this in 1250 to control the area of Meisgyn (Miskin), but not much more than a tower survives.

LLANWRTYD WELLS This claims to be the smallest town in Britain. Its well was documented in the fourteenth century as 'Ffynnon Drewllwyd' or 'Droellwyd' ('Smelly Spring'), as its overpowering smell is due to its having the highest sulphur content in Britain. The spring was rediscovered in 1732 when the local vicar saw a frog come out of it, and realised that it must be safe to drink. The Reverend Theophilus Evans then announced his cure of the 'grievous scurvy', and encouraged people to come and take the waters, because the presence of healthy frogs meant that the water was pure. However, not until the Victoria Wells were exploited by piping the water in 1897 (thereby removing the frogs), did the range of magnesium, saline and chalybeate treatments become popular. Locals claim that they 'invented' pony-trekking in the 1950's. The town stages offbeat events such as the annual 'Man versus Horse' Race over a hilly twenty-two-mile course every June. Beginning in 1980, cyclists were also allowed to compete in from 1985. In

2004 a man beat the horse for the first time, winning £25,000 (The prize was £1,000 in year one, rising to £25,000 in this twenty-fifth year of the race). Llanwrtyd Wells also holds a Mountain Bike Festival including Bog-Leaping (August), the World Bog Snorkelling Championships (also in August), the Welsh International Four-Day Walk (September), The Drover's Walk in late-June following the old routes with a drover's inn reopened for the day, the Welsh International Four-Day Cycle Race (October) and the Mid-Wales Beer Festival (November).

LLAWGOCH, OWAIN, LAWGOCH (1330?-1378) Owain ap Thomas ap Rhodri was known in Wales as Owain Lawgoch (Llaw Goch = Red Hand), and on the continent as Yvain de Galles. (He was nicknamed 'bloody hand' because of his presence on battlefields across Europe). Owain was the grandson of Llywelyn II's brother Rhodri, and the sole heir of the Princes of Gwynedd. Born about 1330 on his father's estate at Tatsfield in Surrey, his father warned him that the family might be targeted as the last in the line of Gwynedd, and encouraged Owain to flee England. In 1350 Owain bound himself to the service to the King Philip VI of France, and became his protégé. Owain now constantly proclaimed himself the true heir of Aberffraw (the court on Anglesey of the Princes of Gwynedd), and only de Guesclin features more highly in French literature as an enemy of the English at this time. Described by Edward Owen as 'possibly the greatest military genius that Wales has produced', he crossed back to England in 1365 to claim his Tatsfield inheritance (his father had been executed in 1363), but was unsuccessful and forced to return to France in 1366. His lands in England and Wales were confiscated in 1369. Many Welshmen followed him, including Ieuan Wyn, who took over Owain's company of soldiers after his death. Owain still features in the folk literature of Brittany, France, Switzerland, Lombardy and the Channel Islands. 'Owen of Wales' had been brought up at the court of King Philip VI of France, and became one of the most noted warriors of the fourteenth century. Described as 'high-spirited, haughty, bold and bellicose' (Barbara Tuchman, '*A Distant Mirror*'), he had fought heroically against the English at Poitiers in 1356, somehow surviving against all the odds. Owain campaigned in the Lombard Wars of the 1360's, for and against the Dukes of Bar in Lorraine, and with the great Bertrand du Guesclin in the campaigns of the 1370's. In 1366, he had led the Compagnons de Galles (Company of Welshmen) to fight Pedro the Cruel in Spain.

An Anglesey man, Gruffydd Sais was executed, and his lands confiscated by the crown in 1369 for contacting 'Owain Lawgoch, enemy and traitor', and in the same year Charles V gave Owain a fleet to sail to Wales from Harfleur. It was repulsed by storms. The French King now gave Owain 300,000 francs, another fleet and 4,000 men to win back his land. Owain proclaimed that he owned Wales 'through the power of my succession, through my lineage, and through my rights as the descendant of my forefathers, the kings of that country'. Taking Guernsey from the English, Owain captured the legendary Captal de Buch, the Black Prince's comrade, hero of Poitiers and one of England's greatest soldiers. Owain had taken a Franco-Castilian landing party to the Channel Islands, and overpowered him at night. Such was the Captal's reputation that King Charles V kept him in prison in the Temple in Paris without the privilege of ransom. Both King Edward of England and delegations of French nobles repeatedly asked Charles to ransom him if he promised not to take up arms against France, but the King refused and the noble Captal sank into depression He refused food and drink and died in 1376. Owain prepared to invade Wales after his seizure of Guernsey, but sadly a message came from the French king to instead help the Spanish attack the English-occupied La Rochelle in 1372. Owain responded and fought again against the English. Owain never had another chance to return to Wales. In 1375, he took part in the successful siege of Saveur-le-Comte in Normandy, where for the first time cannon had been used really successfully to break the English defences. He then took a contract from the great Baron de Coucy to lead 400 men at a fee of 400 francs per month, (with 100 francs per month going to his assistant, Owain ap Rhys). Any town or fortress taken was to be yielded to De Coucy. The capture of Duke Leopold of Austria was to be worth 10,000 francs to Owain, who attracted 100 Teutonic knights from Prussia to his banner. With The Treaty of Bruges, English knights also came to offer their services under the leadership of Owain. Probably

around 10,000 soldiers eventually formed an army for De Coucy and Owain. The knights wore pointed helmets and cowl-like hoods on heavy cloaks, and their hoods called 'gugler' (from the Swiss-German for cowl or point) gave their names to the 'The Gugler War'.

The companies making up the army plundered Alsace, and took ransom of 3,000 florins not to attack Strasbourg as Leopold retreated, ordering the destruction of all resources in his wake. Leopold withdrew across the Rhine, relying on the Swiss to stave off the attack, although the Swiss hated the Hapsburgs almost as much as they hated the Guglers. The invaders were allowed entrance to Basle, but their forces became increasingly scattered as they sought loot in the wake of Leopold's depredations. Near Lucerne, a company of Guglers was surrounded by the Swiss and routed. On Christmas night, a company of Bretons was ambushed by citizens of Berne, city of the emblem of the bear. On the next night, the Swiss attacked the Abbey of Fraubrunnen, where Owain was quartered, setting fire to the Abbey and slaughtering the sleeping 'English'. Owain swung his sword 'with savage rage' but was forced to flee, leaving 800 Guglers dead at the Abbey. Ballads tell of how the Bernese fought '40,000 lances with their pointed hats', how 'Duke Yfo (Owain) of Wales came with his golden helm' and how when Duke Yfo came to Fraubrunnen, 'The Bear roared "You shall not escape me! I will slay, stab and burn you!" In England and France the widows all cried "Alas and woe!" Against Berne no-one shall march evermore!'

The following details are fully recounted in 'Froissart's Chronicles'. In 1378, Owain was conducting the siege of the castle of Mortagne-sur-Mer in the Gironde on the Atlantic coast. As usual, early in the morning, he sat on a tree stump, having his hair combed by a new squire, while he surveyed the scene of siege. His new Scots manservant, James Lambe, had been taken into service as he had brought news of 'how all the country of Wales would gladly have him to be their lord'. But with no-one around, Lambe speared Owain in the back, and escaped to Mortagne – the English king had paid £20 for the assassination of the person with the greatest claim to the Principality of Wales, the last of the line of Rhodri Fawr. Norman and Angevin policy had always been to kill Welsh male heirs and put females of the lineage into remote English monasteries, as we can see in the case of Llywelyn the Last (Llywelyn Olaf). Owain Lawgoch was only second in valour to Bertrand du Guesclin in Europe through these years, a mercenary operating away from home compared to a national hero. His is an amazing story, yet he is unknown to 99% of Welshmen. His importance to King Edward III of England is shown in a payment of 100 francs and in the Issue Roll of the Exchequer dated 4 December 1378: 'To John Lamb, an esquire from Scotland, because he lately killed Owynn de Gales, a rebel and enemy of the King in France... By writ of privy seal, & c., £20.' However, with Owain Lawgoch's death, the prior claim to the heritage of Llywelyn the Great and Llewelyn the Last passed on eventually to another Owain, Glyndŵr, another 'Mab Darogan' ('Son of Prophecy') of the Welsh bards. When Owain Glyndŵr, in 1404, requested French help against England, he reinforced his case by referring to Owain Lawgoch's great service to the French crown. It seems that some of Llawgoch's battle-hardened veterans returned to Wales to fight for Glyndŵr. It is rumoured that they brought his heart back to Wales, which was buried in Llandybie Church. It may be that Owain had a son, as a minor chevalier named Eduart d'Yvain was noted towards the end of Owain's life. If so, the heirs to the House of Gwynedd may be alive in France. A monument has been erected in 2003 to Llawgoch by Cymdeithas Yvain de Galles, at Mortagne-sur-Mer.

LLAWHADEN CASTLE East of Haverfordwest, it was a palace of the Bishops of St David's, fortified in stone after a siege by The Lord Rhys.

LLEWELLYN, RICHARD (1906-1983) His book *How Green Was My Valley* was a moving account of coal-valley life, made into the famous film by John Ford. Born Richard David Vivian Llewellyn Loyd at St David's, he was a film director before writing a series of novels between 1939 and his death in 1983. His Anglophobe father refused to register his birth, instead insisting

that it was written in the family Bible in true Welsh fashion, but the Bible was destroyed by a V2 bomb in 1944. When he joined the Welsh Guards, Richard Llewellyn gave two dates of birth of 1905 and 1906, but his widow believes he was born in 1907. He changed the David to Dafydd in later life.

LLOYD GEORGE, DAVID (1863-1945) The Liberal Party surged into power in Wales with its opposition to landlords, and anti-establishment policies, and by the turn of the twentieth century was virtually in total control. The Liberal David Lloyd George had grown up in Llanystumdwy, near Cricieth, and Welsh was his first language. He introduced Old Age Pensions (1908) and National Health Insurance (1911) when Chancellor of the Exchequer from 1908-1915. Previously as Minister for the Board of Trade (1905-1908) he was responsible for the passing of three important acts involving merchant shipping, the production census and patents. The rejection of his budget by The House of Lords in 1909-1910 led to Parliamentary reform and a lessening of the nobility's power. A radical Welsh nationalist and a pacifist, he compared the Boers, in their fight against the Empire, to the Welsh. He only moved away from pacifism with the invasion of Belgium by Germany in 1914.

After being Minister of Munitions, then Minister of War in 1915-1916, he became coalition Prime Minister from 1916 until his General Election defeat in 1922. By his forceful policy he was, as Adolf Hitler later said, 'the man who won the war'. One of the 'Big Three' at the peace negotiations (with Woodrow Wilson and Georges Clemenceau), he was shown to be a brilliant diplomat. His defeat in 1922 was mainly due to his ceding of 'The Irish Free State' – the modern day Eire was given its independence by him, against strong opposition by the Conservatives in his government. Lloyd George is also notable in world history for approving the Balfour Declaration, promising the Jews a national state in Palestine. Thus Wales has had a world statesman who has changed the face of the twentieth century. On Lloyd George's death, Winston Churchill told the House of Commons: 'He was the greatest Welshman which that unconquerable race has produced since the age of the Tudors. Much of his work abides, some of it will grow in the future, and those who come after us will find the pillars of his life's toil upstanding, massive and indestructible.'

LLOYD, EDWARD (d. 1713) In February 1688, '*The London Gazette*' mentioned the Tower Street coffeehouse, which Edward Lloyd from Wales had started. Soon after, Lloyd began issuing a weekly bulletin, the forerunner of '*Lloyd's List*', giving news about shipping and business. His coffeehouse quickly became a meeting house and information service for all those interested in shipping insurance and commerce. It grew into the world's largest insurance association, Lloyd's, moving to the Royal Exchange, and issuing its first standard policy in 1774. Lloyd's still provides the point of contact between syndicates of 'names' (members who supply the capital), and firms of underwriters who share the cover on policies issued. From Lloyd's coffee house, there have evolved Lloyd's of London, Lloyd's List and Lloyd's Register.

LLOYD, GENERAL HENRY HUMPHREY EVANS (1729-1783) Henry Lloyd of Gwynedd left home aged eleven to fight for the French in the War of the Austrian Succession (1740-48). He then fought for the Austrians, and then the Brunswickians in the Seven Years War (1756-1763). He was a general in the Russian army during the Russo-Turkish Wars (1768-1674) and commanded forces against Sweden and the Turks, writing a seminal military textbook used in military academies across Europe. He also wrote an influential account of Frederick the Great's campaigns, which was used by Antoine de Jomini and Scharnhorst. A recent book by P.J. Speelman is entitled *Henry Lloyd and the Military Enlightenment of Eighteenth Century Europe*. Lloyd received a massive pension of £500 a year from the British Government, but his record of service in the British army remains hidden. His *A Political and Military Rhapsody on the Invasion and Decline of Great Britain and Ireland* (1779) was suppressed by the British Government, and is a theoretical defence of Britain following a French invasion from Brest to Plymouth.

LLOYD GEORGE, MEGAN (1902-1966) The youngest daughter of David Lloyd George, she stood as MP for Anglesey in 1928. She was making a speech on agriculture, when a Welsh-speaking farmer heckled her, saying that she knew nothing, not even how many ribs there were on a pig. Megan calmly asked him to come up on the podium where she would count them. She was elected Liberal MP for Anglesey and was its MP for twenty-two years, the first Welsh female in the House of Commons. A feminist and radical, she fought for equal pay for women in the Second World War and for a Parliament for Wales, becoming President of its campaign. Losing Anglesey to Cledwyn Hughes in 1951, Attlee wanted her to join Labour, which she did in 1955, winning Carmarthen in 1956 and being its MP until her death from cancer.

LLYN BRENIG SACRED LANDSCAPE On Mynydd Hiraethog are the remains of constructions from the Bronze Age people (*c.* 2,000 BCE – *c.* 1,500 BCE) who lived in the drowned valley of the reservoir of Llyn Brenig. An archaeological trail leads through some of the sites, such as a reconstructed platform mound, Maen Cleddau (the Stone of the Swords), a reconstructed ring mound, and Boncyn Arian (the Hillock of Silver). This latter burial mound has been grave-robbed, probably because of its name.

LLYN Y FAN FACH Llyn Y Fan Fach, near Llanddeusant, in The Black Mountain, carries its legend of 'The Lady of the Lake'. She rose from its waters and married a local farmer, and had sons with magical healing powers. After the farmer struck her three times, she returned to the lake.

LLYN FAWR There may be a crannog to be excavated in Llyn Fawr in Northern Glamorgan – here was found the 2,500-year-old Celtic hoard of two great bronze cauldrons, an iron sickle and a massive sword, unique in Britain in its resemblance to Hallstatt weapons.

LLYN TEGID – BALA LAKE This is the largest natural lake in Wales, being four miles long. A fish said to be unique to Bala and a couple of smaller Gwynedd lakes, a relic of the ice age, is the gwyniad. This white fish of the salmon species hides in the deep waters and allegedly has never been caught by a rod and line, but is sometimes found washed up on the shoreline. Tegid Foel and his wife, the Celtic corn goddess Ceridwen, in legend lived on an island in the middle of the lake – this may be a reference to a crannog.

LLYWELYN AP GRUFFYDD FYCHAN *c.* 1335 – 9 October 1401 Following the defeat at Hyddgen by Owain Glyndŵr, Henry IV amassed a huge army at Worcester and marched into Llandovery. There he forced a Caeo landowner, to help him find Glyndŵr's base. Two of this Llywelyn ap Gruffydd Fychan's sons were fighting for Glyndŵr, and he thus led Henry's army on a wild goose chase for weeks through Deheubarth, allowing Glyndŵr's forces to slip away into the mountain fastnesses of Gwynedd. When Henry IV realised he had been misled, he dragged Llywelyn through the streets, then sat in the castle gatehouse to watch him being hanged until half-dead. He then supervised his ritual torture and slow disembowelling, which took several hours before he died and was dismembered. Llywelyn was sixty-seven years old. His body parts were salted for preservation and then distributed through Wales to be nailed up as a display of English power. Henry IV had no right to the English crown, taking it by treachery and murder. In October 2001, a wonderful stainless steel statue of the patriot was unveiled at Llandovery.

LLYWELYN BREN (d. 1318) Llywelyn Bren, Lord of Senghenydd and Miskin (Meisgyn), was a cultured, dignified nobleman, who led a rebellion with his five sons against the cruelty of Lord Payne de Turberville of Coity Castle, the Norman Lord of Morgannwg. Hugh Despenser had appointed Payne de Turberville of Coity Castle to be Custodian of Glamorgan. Turberville advocated the expulsion of Welshmen from his Glamorgan lordship. Sir William Berkerolles of East Orchard Castle was Despenser's sub-lord, given full powers over the estates of Llywelyn

Bren. This had been done to evict Bren from his rightful possessions across Glamorgan. The Normans found it far easier to subdue these flatter and richer southern parts of Wales, where reinforcements from the sea were available during their slow and uneven conquest. However, Berkerolles owed Llywelyn Bren his life, as Llywelyn had previously protected him in a Welsh attack, where thirteen Norman soldiers on Berkerolles' bodyguard were killed. Bren's estates had been wrongfully taken by the local Norman lords while he and his two sons were imprisoned in the Tower of London. Llywelyn appeared before the King and barons at Lincoln Parliament on 28 January 1316 because he had tried to restore Glamorgan to the Welsh. Llywelyn received a full pardon on 17 June 1317 and returned to recover his estates. He rode to his base of Castell Coch, which the Normans had taken, and they refused to hand it over. Gathering around 1,000 supporters, Llywelyn scaled the castle walls and started a second revolt. He destroyed the castles at Sully, Barry, Old Beaupre, Kenfig, West Orchard and possibly East Orchard at St Athan. Thousands of Welshmen then attacked the more powerful castles at Cardiff, Caerleon and Llantrisant, but Llywelyn made the grave mistake of trying to besiege the enormously powerful Caerphilly Castle for nine weeks.

King Edward II sent two armies against him and Llywelyn Bren was cornered near Ystradfellte. To save his followers, he surrendered knowing his fate, saying 'It is better for one man to die than for a whole population to be killed by the sword.' He knew that Edward needed his men to fight against the Scots, so he had ensured their safety. In 1318 he endured the usual drawn-out death by hanging and disembowelling that was regarded as just punishment. There is no known record of Welshmen torturing or killing prisoners in this way. Hugh Despenser, the new Lord of Glamorgan, had insisted on this disgusting execution of this rightful heir to most of Glamorgan. It appears that when Llywelyn surrendered to the Earl of Hereford, he was released. Despenser then captured him, killed him, and took over the rest of Glamorgan and some of Gwent. Llywelyn Bren had been dragged through the streets and executed at Cardiff Castle by the order of Despenser to Berkerolles, whose life Bren had previously saved. Llywelyn was executed, according to Despenser on the orders of King Edward II, but Despenser had received no such authority from the King. He wanted Llywelyn Bren out of the way, and had made Berkerolles execute him to distance himself from the unlawful event. According to Rice Merrick in 1566, Hugh Despenser was later executed near the Black Tower of Cardiff Castle, and is said to be buried in the adjoining Greyfriars Monastery ruins, alongside Llywelyn Bren. The full charge against Despenser reads 'That he did wrongfully adjudge Llywelyn Bren, causing him to be beheaded, drawn and quartered to the discredit of the King and contrary to the laws and dignity of the Crown'. Roger Mortimer wanted Despenser 'to suffer a death every bit as horrible as his killing of Llywelyn Bren in 1317.' However, it appears that he was executed at Hereford rather than at Cardiff and his limbs dispersed to Bristol, Newcastle, York and Dover, with his head going to London to be spiked.

Bren's widow had attacked the castles of Cardiff, Caerffili and St Quentin's after Llywelyn's death. Berkerolles was judged innocent in the tragic affair, and kept his castle at East Orchard. According to Ian Mortimer, in his biography of Roger Mortimer, 'People were starving to death... in Wales the plight of the people was just as extreme. But there they found a leader who not only inspired them; he inspired his enemies as well. His name was Llywelyn Bren.' Norman kings and their lords were almost universally illiterate French-speakers. Llywelyn Bren ap Rhys ap Gruffydd ap Ifor Bach read Latin, Welsh, English and French, and had his library confiscated after his murder.

LLYWELYN THE GREAT – LLYWELYN AP IORWERTH AB OWAIN GWYNEDD – LLYWELYN FAWR – LLYWELYN I 1173-1240
Dolbadarn Castle was built by Llywelyn's father, Iorwerth, around 1170, and it was there (or Nant Conwy) that Llywelyn was born in 1173. He never claimed the title of Prince of Wales, but was content to be overlord of Wales, being recognised as Prince of Gwynedd or Prince of Aberffraw, and Lord of Snowdon. His grandfather

was the great Owain Gwynedd. Professor T. Tout has called Llywelyn 'certainly the greatest of the native rulers of Wales... If other Welsh kings were equally warlike, the son of Iorwerth was certainly the most politic of them... While never forgetting his position as champion of the Welsh race, he used with consummate skill the differences and rivalries of the English... Under him the Welsh race, tongue and traditions began a new lease of life.' Llywelyn gained possession of part of Gwynedd in 1194, when Richard I, The Lionheart, was King of England. Aged just twenty-two, Llywelyn had defeated his uncle Dafydd at the battle of Aberconwy. On the death of his cousin Gruffydd in 1200, Llywelyn gained the rest of Gwynedd. Llywelyn wished to push out from his Gwynedd power base, to take over the kingdoms of Deheubarth (after the death of The Lord Rhys), and Powys. To help his plans, Llywelyn first allied with King John, who became King in 1199, and he married John's daughter, Joan in 1205. Equally, John wished to limit the ambitious Gwenwynwyn of Powys.

Powys was traditionally the weakest of the three major princedoms of Gwynedd, Deheubarth and Powys, squeezed between the other Welsh houses and the English Marcher Barons. Llywelyn over-ran Powys while King John captured Gwenwynwyn at Shrewsbury. Llywelyn also pushed Gwenwynwyn's ally, Maelgwyn, out of Northern Ceredigion. Llywelyn then took the Marcher Earl of Chester's castles at Deganwy, Rhuddlan, Holywell and Mold. From this position of control of North Wales, Llywelyn ap Iorwerth could then assist John on his invasion of Scotland in 1209. However, by 1210, King John now saw Llywelyn as an over-powerful enemy, and allied with Gwenwynwyn and Maelgwn to invade Wales. Llywelyn, deserted by other Welsh nobles, fell back towards his mountain base of Gwynedd, trying a scorched earth policy to starve John's army. However, he eventually was forced to sign an ignominious peace treaty that just left him his original lands of Gwynedd. The lesser Welsh rulers at first preferred an absentee overlord rather than a native Welsh ruler, but the situation changed when they saw King John build castles near Aberystwyth, near Conwy and in Powys. This new threat of subjugation reunited the Welsh under Llywelyn in 1212, and John's castles were attacked and taken. Pope Innocent III gave his blessing to the Welsh, and King Philip of France invited Llywelyn to ally with him against the English. True to form, John hung his Welsh hostages, including Maelgwyn's seven-year-old son. By 1215, Llywelyn had captured many Norman castles and was in control of Pengwern (Shrewsbury), returning it to Welsh hands. Llywelyn joined the English barons at Runnymede, and his power was one of the major factors that persuaded John to sign the *Magna Carta* in that year.

At Llywelyn's Parliament at Aberdyfi in 1216, he adjudicated on claims from rival Welsh princes for the division of Welsh territories under his overlordship, and his decisions were universally accepted. This was probably Wales' 'first Parliament'. By 1218, Llywelyn had taken Cardigan, Cilgerran, Cydweli, Llansteffan and Carmarthen castles, and was threatening the Marcher Lords' castles of Swansea, Haverfordwest and Brecon. King John had died in 1216, and in 1218 Llywelyn's pre-eminence in Wales was recognised by the new English king Henry III, at The Treaty of Worcester. However, William, Marcher Earl of Pembroke, seized the castles of Carmarthen and Cardigan in 1223, as the English barons moved in concert to push Llywelyn back to Gwynedd. Hubert de Burgh, Justiciar of England, pushed into Powys, but was decisively beaten by Llywelyn at Ceri in 1228. Hubert then consolidated his hold on Marcher Lordships, and by 1231, Llywelyn was forced to go on the offensive, pushing down to South Wales and burning Brecon and Neath. Pembroke and Abergavenny were also taken. Henry III invaded Wales to support Hubert, and was lucky to escape with his life when Llywelyn launched a night attack on Grosmont Castle. By the Peace of Middle in 1234, Llywelyn was once more recognised by the English as pre-eminent in Wales, calling himself Prince of Aberffraw and Lord of Snowdonia.

Now at this height of his powers, *Annales Cambriae* records 'The Welsh returned joyfully to their homes, but the French (i.e. the Norman-English), driven out of all their holds, wandered hither and thither like birds in melancholy wise'. Llywelyn had been very much helped in his dealings with the English through his marriage to Joan, the daughter of King John, and spent

his later years building up the prosperity of Wales. Llywelyn helped religious foundations, and supported a great flowering of Welsh literature. The earliest known text of '*The Mabinogion*' was written down, and the imaginative brilliance of the bards can still be read today. They praised the strength and peace their lord had brought Wales against the 'French' king and his Norman barons. Dafydd Benfras wrote that Llywelyn was 'his country's strongest shield', Einion ab Gwgan hailed him as 'the joy of armies... the emperor and sovereign of sea and land', and Llywarch ap Llywelyn wrote 'Happy was the mother who bore thee, Who are wise and noble.'

Aged sixty-eight, this great lord of Snowdon died as a monk at Aberconwy Abbey in 1240, worn out and crippled. Llywelyn ap Iorwerth ab Owain Gwynedd had inspired a revision of the *Laws of Hywel Dda*, reorganized the administrative machinery of Wales, maintained cordial relations with the Pope and the English Church, and brought peace and prosperity to a united Wales. He had also ensured that Henry III recognised his son by Joan, Dafydd, as rightful heir. His remarkable diplomatic and military skills were celebrated by all the Welsh poets of the times. '*Annales Cambriae*' refers to his death: 'Thus died that great Achilles the Second, the lord Llywelyn whose deeds I am unworthy to recount. For with lance and shield did he tame his foes; he kept peace for the men of religion; to the needy he gave food and raiment. With a warlike chain he extended his boundaries; he showed justice to all... and by meet bonds of fear or love bound all men to him.'

However, Gruffydd, Dafydd's elder brother, was still imprisoned in the White Tower in London. He died on St David's Day, 1244, trying to escape on a rope of knotted sheets. In 1245 Henry III reneged on his promises to Llywelyn and again invaded Wales, but was defeated by Dafydd in the only significant battle at Deganwy, and retreated back to England. Upon the tragically early death of Dafydd ap Llywelyn Fawr in 1246, a new power struggle took place to control Wales, only to be resolved by Llywelyn the Last. Mystery surrounds Dafydd II's death. It may be that he was poisoned on Henry's orders. Years later, Llywelyn's great stone sarcophagus was removed from Aberconwy Abbey, as King Edward I symbolically built his castle over the site. It went to the Gwydir Chapel in the Church of St Grwst in Llanrwst. The present Chapel is said to have been designed by Inigo Jones. However, Llywelyn's bones were not allowed to be taken away, and left under the new castle of Conwy. His bard, Dafydd Benfras, wrote this moving lament at his death:

Where run the white rolling waves
Where meets the sea the mighty river,
In cruel tombs at Aberconwy
God has caused their dire concealment from us,
The red-speared warriors,
Their nation's illustrious son.

LLYWELYN THE LAST - LLYWELYN AP GRUFFYDD AP LLYWELYN FAWR - Y LLYW OLAF - LLYWELYN II *c*. 1225-1282 Welsh custom of 'gavelkind' meant that Llywelyn the Great's kingdom had to be divided among all his four male heirs, although Llywelyn had tried desperately for all the kingdoms to be united under his son Dafydd. Within a month of Llywelyn's death, in 1240, King Henry III moved against Dafydd, invading and reneging on his agreement, forcing him to surrender many of his father's gains. Dafydd yielded his elder brother, Gruffydd as a prisoner. Incarcerated in the Tower of London, Gruffydd died trying to escape, four years later. King Henry's treachery meant that Norman Marcher lords took Welsh territories, Gruffydd ap Gwenwynwyn took his realm back, and the king claimed the territories of Tegeingl, Carmarthen, Cardigan and Cydweli. Llywelyn's father, Gruffydd, has a particularly tragic history – he was the illegitimate son of Llywelyn the Great, and was imprisoned as a hostage by King John from 1211-1215 after John defeated Llywelyn in battle. Then Llywelyn the Great saw Gruffydd as a problem for Dafydd's succession and locked him up in Deganwy castle from 1228-1234. From 1239 to 1241 both Gruffydd and his son Owain Goch were held by

Dafydd in Cricieth Castle. Finally, after Dafydd's defeat by Henry III, poor Gruffydd was to spend his last three years in the Tower of London. So Gruffydd ap Llywelyn Fawr ap Iorwerth was imprisoned by King John for four years, by his father Llywelyn the Great for six years, by his step-brother Dafydd II for two years, and then by King Henry III for three years, when he died trying to escape. From 1211 to 1244 Gruffydd spent fifteen of thirty-three years imprisoned. This sad history affected his son, Llywelyn ap Gruffydd, in his view of Norman-Welsh relations, for the rest of his life.

Gruffydd's tragic death sparked the Welsh to react to Henry's overlordship. Assisted by Gruffydd's vengeful son, Llywelyn, Dafydd allied with all but two of the other Welsh princes (Powys and Gwynllwg). They attacked the Norman lands and regained the important border castle of Mold. Dafydd appealed to Pope Innocent IV for help, offering Wales as a vassalship in return for protection against the Norman-English. He called himself 'Prince of Wales', the first person to use that title. Henry III assembled an army at Chester and beat the Welsh on the banks of the river Conwy, slaughtering all the Welsh prisoners. An English army was recalled from Ireland to lay waste to Anglesey. Dafydd kept fighting from his Gwynedd fastnesses, and forced Henry to withdraw. One of the great tragedies of Welsh history is Dafydd's premature death in 1246, possibly from poisoning. Henry claimed all of Dafydd's land, because he had been promised it if Dafydd died childless. A Norman army now pushed up through the South, conquering Ceredigion, Meirionnydd and Deganwy. The leaderless men of Gwynedd immediately accepted Llywelyn and his eldest brother Owain Goch as rulers of Gwynedd. (Owain had been imprisoned in the Tower of London with their father, Gruffydd). However, after three years of warfare, the brothers had reached a point where the starving population could no longer support an armed force, and sued for an armistice. In April 1247 they were confirmed as lords of Gwynedd uwch Conwy (that part of Gwynedd west of the Conwy River and north of the Dyfi) and the status of Gwynedd was reduced to an English vassalship, conforming to the matters of status of an English lordship. In this year, Matthew Paris recorded that 'Wales had been pulled down to nothing'.

In 1256, *Brut y Tywysogion* records that 'The gentlefolk of Wales, despoiled of their liberty and their rights, came to Llywelyn ap Gruffydd and revealed to him with tears their grievous bondage to the English; and they made known to him that they preferred to be slain for their liberty than to suffer themselves to be unrighteously trampled on by foreigners.' By 1255, Llywelyn ap Gruffydd ap Llywelyn Fawr had won back total control of Gwynedd. He had defeated and imprisoned his two brothers Owain and Dafydd at Bryn Derwen. Poor Owain Goch was incarcerated in Dolbadarn Castle for twenty years to ensure stability, but Dafydd escaped to England. ('Red Owen' thus spent twenty-three years incarcerated, eight more than his father). Llywelyn now pushed out all over Wales, beating back Henry III's army, while the men of Deheubarth beat royal forces near Llandeilo in 1257. The ruling houses of Powys, Glamorgan and Deheubarth acknowledged Llywelyn as their lord in 1258, as he had not only pushed the Normans out of Gwynedd, but also out of most of Wales. Until 1262 there was a fragile truce, but Llywelyn went back on the attack to gain more of Wales, first from Roger Mortimer, and then part of the lordships of Brecon and Abergavenny. In 1264, he allied with Simon de Montfort, who was now in control of England after defeating the king at Lewes. By the Pipton Agreement, de Montfort recognised Llywelyn, on behalf of the crown, as Prince of Wales and overlord of the other great men of Wales.

The English chronicler Matthew Paris wrote that 'the North Welsh and the South Welsh were wholly knit together, as they had never been before', and praised the courage and vigour of Llywelyn, saying 'Is it not better, then, at once to die (in battle) and go to God than to live (in slavery)?' Later, King Henry III was forced, by The Treaty of Montgomery in 1267, to recognize Llywelyn as Prince of Wales, who in return recognised the suzerainty of the English crown. Llywelyn now had more control and influence in Wales than any prince since the Norman Conquest of England. However, where his relations with the devious Henry had always been poor, he was soon to come up against a new king of England who simply resented Llywelyn's

very existence. When Edward I succeeded to the English crown, Llywelyn, fearing the normal Norman-French treachery, did not attend the coronation. His father had died in London. Llywelyn also refused to pay tribute to Edward I, and built a new castle and town, Dolforwyn, against Edward's wishes. Llywelyn had sent a letter to Edward in 1272, stating that 'according to every just principle we should enjoy our Welsh laws and custom like other nations of the king's empire, and in our own language.' Llywelyn was declared a rebel in 1274, and Edward invaded. Edward and his barons used violence to provoke rebellions all over Wales which were brutally crushed, while he pursued and harried Llywelyn, even forcing him to move, starving, from his mountain stronghold of Gwynedd.

In 1277, Edward had an amazing number of 15,600 troops in Wales, and Llywelyn was humiliated with the Treaty of Aberconwy when he sued for peace. He was stripped of his overlordship granted at the Treaty of Montgomery. In 1278, King Edward felt secure enough to release Elinor de Montfort, the betrothed daughter of the great Simon de Montfort, from prison. He then attended her wedding to Llywelyn in Worcester Cathedral. (Years previously, Elinor had been captured with her brother, on her way to marry Llywelyn – the Plantagenets feared a dynasty that would be more popular than theirs). However, after a peaceful interlude, Llywelyn's wayward brother Dafydd attacked Hawarden (Penarlag) Castle and burnt Flint in 1282, sparking off another war. Ruthin, Hope and Dinas Brân were quickly taken. Llywelyn had the choice of assisting his brother, who had been disloyal to him before, or supporting him. He fatefully chose the latter option, agreed at a Welsh 'senedd' ('senate') at Denbigh. Days before, Elinor had died on the birth of their first child, Gwenllian. Llandovery and Aberystwyth were soon taken by Llywelyn as the revolt spread.

King Edward now assembled 10,000 soldiers at Rhuddlan, including 1,000 Welsh archers. Navies with archers moved to the Dee and from Bristol. Other armies advanced under the Marcher Lords. The war first went well for the Welsh. The Earl of Gloucester was defeated by Llywelyn near Llandeilo, a force in Anglesey was smashed, and Edward was forced back from Conwy to winter in Rhuddlan. However, more English reinforcements, including 1,500 cavalry and Gascon crossbowmen arrived. In 1282, a Welsh detachment of eighteen men was entrapped at Cilmeri, near Llanfair-ym-Muallt (Builth Wells). At this place on 11 December, Llywelyn was killed. His nearby leaderless army was then annihilated, possibly by Welsh bowmen in English pay. (There were no known survivors of an estimated Welsh force of 3,000 men, and no known Anglo/French casualties – it seems that the Welsh army surrendered on hearing of Llyweleyn's death, and was massacred to a man). Llywelyn's head was cut off and sent to Edward at Conwy Castle, and later paraded through London with a crown of ivy, before being stuck up on the Tower of London. His coronet was offered up to the shrine of Edward the Confessor at Westminster Abbey. The 'Croes Naid' of his ancestors, believed to be a fragment of the 'True Cross', and perhaps the Welsh equivalent of Scotland's Stone of Scone, was taken to Windsor Castle and vanished during the English Civil War.

There is no understanding of how Llywelyn came to be so far detached from his main forces in his Gwynedd stronghold. Edward had offered him exile and an English earldom in return for unconditional surrender. With his small band, Llywelyn had been waiting for someone at Irfon Bridge, but longbowmen suddenly appeared and cut them to bits. Llywelyn escaped, only to be speared by Stephen de Frankton, before he could reach his main forces. Archbishop Pecham of Canterbury had been negotiating between Llywelyn and Edward on the terms of an end to the war, and the documentation still exists. According to Pecham's later letters, a document was found on Llywelyn inviting him to go to the Irfon Bridge, sent by the Marcher Lords. The *Dunstable Chronicle* states that Llywelyn was invited by the sons of Roger Mortimer to meet him, and they ambushed and killed his small band of retainers. This document disappeared, as did a copy sent by the Archbishop to the Chancellor. Relevant letters from Pecham's correspondence around this date have also disappeared. It is certain that Llywelyn was killed by Norman treachery – *'the treachery on the bridge'* is a recurrent theme in Welsh literature, and for centuries the inhabitants of Builth were known as traitors in Wales. ('Bradwyr Buallt', 'Builth Traitors' became a common

term of abuse). Also according to Archbishop Pecham, de Francton's spear did not kill him, and Llywelyn lived on for hours, asking repeatedly for a priest, while his army was being slaughtered a couple of miles away. He was refused one, while his captors waited for the Marcher Lord Edward Mortimer to come to the scene. According to *The Waverley Chronicle*, he executed Llywelyn on the spot. Probably Mortimer also took possession of the letter in Llywelyn's pocket at this same time. It may have been that de Franckton was given a large farmstead at Frampton, just north of Llanilltud Fawr, in the now 'safe' Vale of Glamorgan, in return for keeping quiet.

There is an intriguing entry in *Brut Tywysogion* for 1282 – 'and then there was effected the betrayal of Llywelyn in the belfry at Bangor by his own men.' There is evidence, on the basis of rewards given by the king, that Madog ap Cynfran, Archbishop of Môn (who took the place of Bishop Arian in his absence) and Adda ap Ynyr may have been plotting against Llywelyn, luring him south to the ambush set by the Mortimers. The same entry records that 'he left Dafydd, his brother, guarding Gwynedd; and he himself and his host went to gain possession of Powys and Builth. And he gained possession as far as Llanganten. And thereupon he sent his men and his steward to receive the homage of the men of Brycheiniog, and the prince was left with but a few men with him. And then Roger Mortimer and Gruffydd ap Gwenwynwyn, and with them the king's host, came upon them without warning; and then Llywelyn and his foremost men were slain on the day of Damascus the Pope, a fortnight to the day from Christmas day; and that was a Friday.' Roger le Strange had succeeded Roger Mortimer in command of the royal forces near Builth, and won the 'battle' of Orewin Bridge. He was married to Hawyse, the sister of Gruffydd ap Gwenwynwyn, who collaborated with the Mortimers and was present at Llywelyn's death. Gruffydd ap Gwenwynwyn was given lands in 1283 as his reward for opposing Llywelyn, and had been the only prince in Wales not to swear fealty to Llywelyn. Powys Wenwynwyn was the only area of Wales to become part of the March without conquest.

The plaque on his roadside granite monument at Cilmeri simply proclaims 'Llywelyn ein Llyw Olaf' – 'Llywelyn Our Last Leader'. His mutilated body probably lies in the atmospheric remains of the Cistercian Abbey Cwmhir, (Abaty Cwm Hir) which had a 242ft nave, the longest in Britain after York, Durham and Winchester Cathedrals. In 1282, Gruffydd ab yr Ynad Coch's magnificent elegy to Llywelyn tells us:

> Great torrents of wind and rain shake the whole land,
> The oak trees crash together in a wild fury,
> The sun is dark in the sky,
> And the stars are fallen from their courses,...
> Do you not see the stars fallen?
> Do you not believe in God, simple men?
> Do you not see that the world has ended?
> A sigh to you, God, for the sea to come over the land!
> What is left to us that we should stay?

Upon Llywelyn's death, his brother Owain Goch was imprisoned and died that year, and his brother Dafydd was later captured and horribly executed. Their children were imprisoned for their rest of their lives, in an attempt to extirpate the House of Gwynedd. However, one brother, Rhodri, was living in England and his grandson became Owain Llawgoch. In 1183, a clerk in Edward I's service wrote from Orvieto: 'Glory to God in the highest, peace on earth to men of good will, a triumph to the English, victory to King Edward, honour to the Church, rejoicing in the Christian faith... and to the Welsh everlasting extermination.'

LLYN CERRIG BACH A great find of Celtic treasure was made in Llyn Cerrig Bach, Anglesey, of bronze and iron artefacts from the second century BCE to the first century CE. This hoard, with its chariot-fittings, horse-harnesses, swords, shield bosses, spearheads, trumpet, cauldrons, sickle and manacles for slaves or prisoners of war, may be a relic of the Druids' last stand,

described by Tacitus. Perhaps the ritual abandonment happened on the eve of the Roman destruction of the Druids. These intriguing finds can be seen in the National Museum of Wales. This, the largest hoard of Iron Age objects found in Wales, was found during the construction of a runway in 1942, as a peat bog was dredged. The first find pulled up by a harrow was an iron chain. It was so strong that it was used to pull a tractor out of the mud, before its true nature was ascertained – a slave-gang chain of iron with neck shackles. Another hundred and fifty Iron Age objects were found, all thrown into the waters as offerings to gods. The iron swords were bent, making it impossible for them to be used again.

LOCAL GOVERNMENT From 1888, the administrative counties of Wales were based upon the thirteen traditional counties of Anglesey (Ynys Môn), Brecknockshire (Breconshire, Sir Frycheiniog), Cardiganshire (Sir Geredigion), Carmarthenshire (Sir Gaerfyrddin), Caernarvonshire (Sir Gaernarfon), Denbighshire (Sir Ddinbych), Flintshire (Sir y Fflint), Glamorgan (Sir Forgannwg), Merionethshire (Sir Feirionydd), Monmouthshire (Sir Fynwy), Montgomeryshire (Sir Drefaldwyn), Pembrokeshire (Sir Benfro) and Radnorshire (Sir Faesyfed). There were also four independent county boroughs at Cardiff, Swansea, Newport and Merthyr Tydfil. In 1974, these traditional '13 counties' and the four independent county boroughs were amalgamated into eight new 'two-tier' counties: Clwyd, Dyfed, Powys, Gwent, Gwynedd, Mid-Glamorgan, South Glamorgan and West Glamorgan. These counties were divided into thirty-seven local government districts, further divided into communities. Clwyd was composed of Alyn and Deeside, Colwyn, Delyn, Glyndŵr, Rhuddlan and Wrexham. Dyfed was made up of Carmarthen, Ceredigion, Dinefwr, Llanelli, Preseli and South Pembroke. Gwent comprised Blaenau Gwent, Islwyn, Monmouth, Newport and Torfaen. Gwynedd was made up of Aberconwy, Arfon, Dwyfor, Meirionydd and Anglesey. Powys comprised Brecon, Montgomery and Radnor. Mid-Glamorgan was Cynon Valley, Ogwr, Merthyr Tydfil, Rhondda, Rhymney Valley and Taff-Ely. South Glamorgan was Cardiff and the Vale of Glamorgan. West Glamorgan was Lliw Valley, Neath, Port Talbot and Swansea. Councils at all three levels were subject to election. In 1994, the Local Government (Wales) Act replaced the eight counties and thirty-seven district councils with eleven counties and eleven county boroughs. Powys retained its name, and took on southern Clwyd. The 'new' counties are Carmarthenshire, Flintshire, Ceredigion, Pembrokeshire, Monmouthshire, Anglesey, Cardiff, Swansea, Powys, Denbighshire and Gwynedd. The new county boroughs are Blaenau Gwent, Bridgend, Caerffili, Conwy, Merthyr Tydfil, Neath Port Talbot, Newport, Rhondda Cynon Taff, Vale of Glamorgan, Wrexham, and Torfaen. Some time in the not so distant future the administration of local government in Wales will alter again, giving opportunities for new empires with more people doing less work in new offices with new facilities and worse service. And it will be altered again. And again.

LOUGHOR (LLWCHWR) CASTLE In 1151, this Norman castle outside Swansea was attacked and burned by the Welsh, but rebuilt in stone.

LOUGHOR ROMAN FORT On a strategically vital River Loughor crossing, Leucarum was abandoned in the second century but probably reused in the third to fourth century.

LOWE, HAROLD (1882-1944) Fifth Officer Harold Lowe was called 'the true hero of the *Titanic*' and was played by fellow-Welshman Ioan Gruffydd in the film. Aged just fourteen, Lowe left his home in Barmouth and joined the merchant navy, joining the White Star company in 1911. On the fateful night he was asleep in his cabin, before shouting and running footsteps alerted him to the danger. He fired his gun to calm the crowds and organised the loading of the lifeboats for women and children to be saved. Only then did he take charge of lifeboat no. 14 and rowed away from the sinking vessel. He had courageously argued with Bruce Ismay, the head of the White Star Shipping Line, as he lowered one boat. However, unlike any

of the other officers, Officer Lowe decided to return to the ship. He dispersed the occupants of his lifeboat among the other boats, and rowed back towards the sinking ship, managing to rescue four people still alive in the water. Officer Lowe also rescued passengers stranded on a sinking inflatable lifeboat, ensuring that everyone alive reached the safety of the *Carpathia*, a passing ship. At the inquest in New York, he criticised the crew's efforts to save passengers. Ismay was one of the survivors, branded a coward for the rest of his life. Upon his return to his Barmouth home, 1,300 people attended a reception held in Lowe's honour. He was presented with a commemorative gold watch, with the inscription 'Presented to Harold Godfrey Lowe, fifth officer R.M.S. *Titanic* by his friends in Barmouth and elsewhere in recognition and appreciation of his gallant services at the foundering of the *Titanic* fifteenth April 1912.'

LUDLOW CASTLE In Shropshire, this was the administrative centre of the Welsh Marches, and Henry VII's eldest son Arthur, who was brought up to be Welsh-speaking, died here. History was changed by the marriage of his younger son Henry VIII to Arthur's widow, Catherine of Aragon, and their subsequent divorce.

MABINOGION This treasury of Welsh mythology consists of folk tales from the eleventh century and earlier, which were preserved by monks writing *The White Book of Rhydderch* around 1300-1325, and *The Red Book of Hergest c.* 1400. These books are the source of much of the legend surrounding King Arthur, and the collection was first translated in full into English by Lady Charlotte Guest, published between 1838 and 1849. Lady CHARLOTTE GUEST divided the tales into three volumes: the *Four Branches of the Mabinogi*, the *Four Independent Native Tales* and *The Three Romances*, and added the story of Taliesin from another old manuscript. These stories are 'among the finest flowerings of Celtic genius and, taken together, a masterpiece of mediaeval European literature' according to Professor Gwyn Jones in his introduction to the Everyman edition. *The Four Branches* are the *Mabinogi* proper, the stories of *Pwyll'*, *Branwen*, *Manawyddan* and *Math*. There are two short stories, *The Dream of Macsen Wledig*, and the legend of *Lludd and Llefelys*. The other two stories are the incomparable *Culhwch and Olwen*, the earliest Arthurian tale in Welsh, and the romantic *Dream of Rhonabwy*. The three Arthurian romances are *The Lady of the Fountain, Peredur* and *Geraint Son of Erbin*. *The Dream of Macsen Wledig* commemorates the time of Magnus Maximus, the fifth-century Roman leader of Britain (Dux Britannorum) who took the British garrison with him to campaign across and gain most of the Western Empire of Rome. He was eventually defeated by Theodosius. According to professors Gwyn Jones and Thomas Jones, the author *'created a miniature masterpiece.* He achieved the effect of illumination and extension of time and space which lies beyond the reach of all save the world's greatest writers.' There is a theory that *The Four Branches* were written by Gwenllian ferch Gruffydd, the Welsh heroine killed by the Normans outside Cydweli, making her the earliest known woman writer in Britain (save for five Anglo-Saxon nuns whose letters are preserved).

MAC Mudiad Amddiffyn Cymru (the Movement for the Defence of Wales) attacked water pipelines and government buildings in the most concerted campaign of violent direct action in Wales since Owain Glyndŵr 's uprising in 1400. It culminated in the death of two insurgents in 1969 when attempting to plant a bomb on a railway line, hours before the royal train taking Prince Charles to Caernarfon for the investiture was due to pass. The story is recounted in John Humphries' 2008 book *Freedom Fighters: Wales's Forgotten 'War' 1963-1993.* John Jenkins was jailed for ten years in 1970 for directing a campaign of sabotage which came close to persuading Prime Minister Wilson to cancel Charles' Investiture. Starting with events in Tryweryn in 1963, twenty acts of sabotage would be attributed by the police and security services to MAC. The failure of the security services to crack the conspiracy was because MAC was organised as a collection of independent cells. The same cell system was eventually adopted by the IRA after Owain Williams, jailed for his part in sabotaging Tryweryn, jumped bail and fled to Ireland.

Humphries believes that the remnants of MAC driven underground after Jenkins's arrest re-emerged 10 years later as Meibion Glyndŵr (Sons of Glyndŵr) targeting holiday homes in Wales. During a decade of arson attacks, more than 200 properties were burned down.

MACHEN, ARTHUR (1843-1947) Arthur Jones-Machen, from Caerleon, was hailed by Sir Arthur Conan Doyle as a 'genius', and John Betjeman stated that Machen's work changed his life. By 1894 Jones-Machen had translated the *Memoirs of Jacques Casanova* into twelve volumes of 5,000 pages, and the translation has been reprinted seventeen times. Oscar Wilde had encouraged him to move into fiction, and his first major work, *The Great God Pan* scandalised Victorian society. It was published by John Lane at the Bodley Head, also in 1894. Oscar Wilde congratulated him on 'un grand succes', and the book, a sensational Gothic novel that mixed together horror, sex and the supernatural and horror was soon reprinted. His next major novel, his masterpiece, was set in Caerleon and London, tracing a boy's search for beauty through literature and dreaming, finally ending in a drug-induced depraved tragedy. *The Hill of Dreams* was called 'the most beautiful book in the world' by the American aesthete Carl Van Vechten in 1922, but was also named as 'the most decadent book in all of English literature' by the French critic Madeleine Cazamian in 1935. It was said to be a work 'worthy to stand upon the shelf beside Poe and De Quincey.' It is the book's 'prose poetry that distinguishes the book most of all from its contemporaries, giving it a potency and imperishability that most of the serious and acclaimed novels of the day, dealing also with the theme of the individual's spiritual pilgrimage, do not have.' 'He also wrote the story acclaimed as the greatest weird story ever written, *The White People*; and those vignettes collected as *Ornaments in Jade*, which are certainly among the finest prose poems ever written.' Machen also made a scholarly case for the search for the Holy Grail being a remembrance of the lost liturgy of the Celtic church.

His influence was massive – a *Spectator* article (29 October 1988) traced lines of descent of his thought through Alistair Crowley and the 'Golden Dawn' movement to L. Ron Hubbard and Scientology, to the Hippy Movement and the revival of interest in ley lines and magical stones, and to the Neo-Romantic art of Ceri Richards and Graham Sutherland. Many authors, including masters of the modern horror genre like Stephen King and Clive Barker acknowledge their debt to Machen, and he earned the respect and praise of such major literary figures as T.S. Eliot, D.H. Lawrence, Henry Miller, Jorge Luis Borges, H.G Wells, Oscar Wilde, W.B Yeats, Siegfried Sassoon, George Moore and John Betjeman. Machen is periodically revived as a master of imaginative writing. An interesting aside on Machen's career is that he tried to boost morale and spread his supernatural beliefs, by propagating the 'Angel of Mons' story in the *London Evening News* in August 1914. British soldiers had seen weird figures in the sky on their retreat from Mons in World War I. Machen suggested that it was Saint George leading Henry V's archers from Agincourt. His bowmen were 'replaced' in popular retelling and modern mythology by an angel, or flock of angels.

MACHEN CASTLE, CASTELL MEREDYDD In 1236 Gilbert, Earl of Pembroke, took this castle from Morgan ap Hywel by treachery, and fortified it, but gave it back 'for fear of the lord Llywelyn'. East of Caerphilly, it was used as a retreat by Morgan ap Hywel after he had lost his main stronghold of Caerleon to the Normans. Morgan probably built the round tower keep, but the bailey and curtain wall appears to have been constructed by Gilbert Marshall in 1236. In 1248, the castle passed to Morgan's grandson Maredudd from whom its Welsh name is derived, and it was later held by the de Clares.

MACSEN WLEDIG Magnus Maximus (the fabled Macsen Wledig in the *Mabinogion*) had left Britain in 383 CE to try to gain the Imperial crown. He took the British legions with him, eventually dying in battle in 388 against Theodosius. The Princes of Powys, as shown on the standing stone ELISEG'S PILLAR, traced their royal lineage and legitimacy back to Macsen Wledig.

MADOC (1134 – *c*. 11) In 1170, three ships and 300 men were said to have left the islands of Ynys Fadog in the mouth of the River Glaslyn. A memorial plaque marks the point of departure in Llandrillo-yn-Rhos (Rhos-on-Sea), near Colwyn Bay. Legend says that America was discovered by the expedition's leader, Prince Madoc, son of the heroic Prince Owain Gwynedd, and that there was a tribe of Welsh-speaking Indians, the Madogwys or Mandans. Sources describe Prince Madoc's Welshmen moving up from Alabama, fighting the Iroquois in Ohio, and the remnants heading west where they were discovered in the Revolution (as the Mandan Indians) in North Dakota. In Welsh mythology, Madoc's ship, the *Gwennan Go*rn still haunts the coast off Abergele. He picked up his brother at Lundy Island on the way to America, and returned several years later with a small crew. The others had been left to start a colony in this fabulous new land. Prince Madoc then sailed again to America with ten ships filled with men and women. The fact that there are traditions associated with Alabama and Georgia, as well as North Dakota, may mean that the two parties never met up. A French trader from St Louis in 1792 had come across a tribe of Indians in the Upper Missouri, the Mandans, and had described them as 'white, like Europeans'. Jacques Clamorgan organised a Spanish expedition to find these 'White Padoukas'. Clamorgan operated from St Louis, and led The Missouri Company for Spain, trying to open up the unexplored American interior, win control of the fur trade, and reach the Pacific before the British and Americans.

The artist George Catlin painted some of these 'Welsh-speaking' Mandans before the tribe was decimated by the new white man's illness of smallpox in 1838. Scholars claimed that many of their customs, and their use of coracles for catching fish, 'proved' their Welsh ancestry. Professor Gwyn Williams also recounts that 'Mandan girls were celebrated for their good looks and amiability and were said to be more adept than most. They chattered endlessly even when making love – a fact which one later observer cited as further proof of their Welsh descent!' Madoc's story is recounted in Hakluyt's *Voyage*s (1582) and Lloyd and Powell's *Cambria* (1584). John Dee, the Welsh 'magus of his age' claimed America for Queen Elizabeth I on the basis of this tale, which was developed by Southey in his long poem *Mado*c in 1805. Robert Southey's *Madoc* is based on Montezuma's statement to Cortez, that a white leader 'from the east' brought an American tribe south into Mexico. At Fort Morgan, Mobile, Alabama a plaque was erected by The Daughters of the American Revolution 'In Memory of Prince Madoc who landed on the shores of Mobile Bay in 1170 and left behind, with the Indians, the Welsh language'. Tom McRae (*The Inditer*, on the Internet) looked with his uncle for two 'stone cauldrons' on Mobile Bay recently. His uncle had seen them as a child, when they were known as 'Viking Tarpots'. Very early ships carried stone pots for ballast and storing food. When they landed, the cauldrons were used to boil resin from pine trees, to make pitch and 'caulk' the hulls of their ships. There are also references to Prince Madoc in relation to an ancient stone wall in Fort Mountain State Park, near Chatsworth, Georgia.

Madoc ab Owain Gwynedd was possibly born in Dolwyddelan Castle, and was smuggled to Ireland as a boy by his mother Brenda, daughter of the Lord of Carno in mid-Wales. Later in favour at his father's court, he married Annesta, a maid of honour. According to legend, in the next three years he travelled to Ireland, Cornwall and Brittany, and in 1163 represented his father as emissary to the Lord of Lundy Island. In 1169, Owain Gwynedd died, and there was the likelihood of civil war between his many sons for the succession. Madoc and his brother Einion had three ships built, the flagship of the little fleet being the *Gwennon Gorn*. Wood was felled from the great forest of Nant Gwynant in Caernarfonshire, and Viking practice was followed in the construction. The old stories state that stag horn nails were used instead of iron as they would not rot, and that he could use the lodestone to navigate safely. The hulls were covered, like coracles, with cow hides tanned on oak bark. The ships were built at Abergele and they sailed from Rhos-on-Sea. Madoc settled some of the company in America, and returned for his brother Rhiryd, Lord of Clochran in Ireland, as promised. Another band of settlers then left via Lundy, Rhiryd sailing in the *Pedr Sant* (Saint Peter). An old stone found on Lundy Island was said to read 'It is an established

fact known far and wide, that Madoc ventured far out into the Western Ocean never to return'. According to legends, Madoc went back to Wales a third time to bring more settlers, but never came back. It may be that the bands of settlers never met, because one story then takes the settlers heading up north-west and becoming the Mandan Indians, and another relates to white settlers heading down to Mexico and Aztec territories. Hernando Cortez, who captured Mexico, may have mentioned Madoc's settlers. Montezuma, the King of Mexico, in his treaty with Cortez, stated that his light-skinned people came from a little island in the north. The buccaneering explorers Walter Raleigh and John Hawkins also mention Madoc in their writings.

On Columbus' return from his discovery of America, he stated that the people honoured a white man called *Matec*, and he wrote on his chart of the Gulf of Mexico 'these are Welsh waters'. He also referred to one stretch of sea near the Sargasso as 'Mar di Cambrio' (the Sea of Wales). For years, the early Spanish settlers in Nova Hispaña (Florida) searched for the 'gente blanco' (white people) who had reached America before them. One 1519 Spanish map labels Mobile Bay as 'Tierra de los Gales' (Land of the Welsh). The Italian historian Peter Martyr (1459-1525) wrote about white Indians with brown hair, and said that Indians in Guatemala and Virginia revered 'Matec'. The Dutch writer Hornius argued in 1652 that America had been peopled by many races, with the Welsh as a major component. The stone forts around Mobile Bay cannot be explained by the Indians. The largest unexplained fort is on top of Fort Mountain in northwest Georgia, near the headwaters of the Coosa River whose waters flow into Mobile Bay. A major boost to the Madoc legend was the return to Wales, after a missionary tour, of the Reverend Morgan Jones in 1669. He stated that he and some companions were captured by Indians who threatened to kill them. Jones turned to his fellow missionaries and told them, in Welsh, to prepare themselves for death. The Indians heard and understood him, welcomed the missionaries as cousins and set them free. The explorer George Rogers Clark was told by Chief *Tobacco's Son* of the Shawnee Indians that white men had been killed at a battle, in the thirteenth century, on the Falls of the Ohio, near Louisville Kentucky. The defeated colony moved on upriver along the Ohio, Missouri and Mississippi rivers. John Sevier, the founder of Tennessee, noted the old stone hill-forts from Mobile to Kentucky and Tennessee. Ancient Roman coins were found in these forts. He questioned Oconosta, who had been a Cherokee chief for sixty years, in 1782. Oconosta related the story of the white Indians escaping from hostility with local tribes, moving from the Carolinas down the Tennessee River into the Ohio River, then up the Mississippi and Missouri. Oconasta related that 'they are no more White people; they are now all become Indians, and look like other red people of the country.' 'He had heard his grandfather and father say they were a people called Welsh, and that they had crossed the Great Water and landed first near the mouth of the Alabama River near Mobile and had been driven up to the heads of the waters until they arrived at Highwassee River.' The explorer-painter George Catlin thought that the Mandans were the lost Welsh tribe, as their women were fair-complexioned, with hazel, blue or grey eyes. Some of the men had beards, unlike other Indian tribes. They did not use canoes like neighbouring Indians, but round boats like coracles. Catlin also said that some of their words were identical to Welsh, and he discovered this before he found out about the Madoc story.

The Mandans, unlike other Indians, knew how to ride horses with bridles and saddles. Their lodges had once been oblong, rather than the circular ones favoured by native Indians. It was a matrilinear society, based upon agriculture, like the old Welsh society. Some beehive lodges are reminiscent of the styles used by Celts, as seen in the few Glamorganshire pigsties remaining. The Mandans had box-beds with skin curtains – box-beds with curtains were popular in Wales until 1800. Their rounded 'bull boats', made of skins and wickerwork, were almost identical to the Welsh coracles that have been used for the last two millennia. Anthropologists place their arrival on the Missouri at between 900 and 1400, the right timeframe for Madoc's small band. The Mandans' legends said that they came from 'lower down' the Missouri. A string of strange stone 'forts' run down from their Heart River and Knife River territories down to Mobile Bay, on the Gulf of Mexico. Indians did not build forts, but Madoc was born in a castle. Upriver from the Falls, at the mouth

of Fourteen Mile Creek, a stone fortress once stood. In 1874, State Geologist E. T. Cox described this walled fortification on the 'Devil's Backbone' and drew a map of a pear-shaped enclosure. His assistant stated that a great deal of skill was necessary to build the walls without mortar. (The unique stone fortress was dismantled to build the Big Four Railroad Bridge. In 1898, a helmet and shield were found in Louisville, but were stolen. In 1799, six skeletons were unearthed in Jeffersonville, but have been lost.) The neighbouring Hidatsa tribe called the Mandans 'Gulf-people' because of their origins in the Gulf. These occurrences helped cement the connections between Madoc's settlers moving from Mobile and the Mandan tribe.

One of the first explorers to find the tribe, the French explorer La Verendrye in 1739, wrote: 'The fortifications are not characteristic of the Indians... Most of the women do not have the Indian features... The tribe is mixed white and black. The women are fairly good-looking, especially the light coloured ones; many of them have blonde or fair hair.' Many descriptions referred to the preponderance of brown and red hair, and blue eyes amongst the Mandans, and they were known as the 'white Indians' even by other Indian tribes. At least two of the Lewis and Clark party of 1803-106, Sergeant Ordway and Private Whitehouse, believed that they would find Prince Madoc's fair-skinned Indian descendants, still in possession of Welsh treasure. They met light-skinned Indians in The Flatlands of Montana, speaking a strange 'gurgling kind of language spoken much through the throat', and Whitehouse was 'sure of it' that they were the lost Welsh tribe. The Mandans were almost wiped out by smallpox in 1781 when half the tribe died, and then in 1837 it again decimated them to just a few dozen survivors. These were enslaved by the Arikaras, and now no Mandan-speakers survive. The remnants live on the Fort Berthold reservation in the heart of the USA, and their ceremonial grounds have been covered by the Garrison Reservoir (so there is definitely something in common with Wales). The Mandans worship 'the Lone Man', a white man who started the tribe, and his shrine is 'The Ark of the Lone Man', a holy canoe. Mandan cosmology also centres of a great flood – Madoc's lands in Wales bordered Cantre'r Gwaelod, the 'lowland hundreds' lost to the sea. The late Gwyn Alf Williams, with his hatred of imperialism, was dismissive of Madoc in his 1979 book *Madoc: the Making of a Myth*, but one can only reiterate the final lines of his book, where he met a surviving Mandan, Ralph Little Owl: 'They came at last, those moments we had half-hoped for, half-feared, when a chill ran through us which was not the wind. Ronald Little Owl rehearsed the Mandan prophecies which had all come true, including one that old wolves would make the Missouri run backwards (as they have done). The last one, however, he would not tell us – "it would not be polite". The language? "When I die, the Mandan language will have gone." And the Lone Man? He bent his Asiatic face into the television lights and said, "The Lone Man was the founder of our people. He was a white man who brought our people in his big canoe across a great water and landed them on the Gulf of Mexico." '

A recent book by Dana Olson refers to the fact that a colony of Welshmen is mentioned in *Walum Olum*, the chronological history of the Delaware Indians...'That the country north of the Falls of the Ohio and adjacent to the river was inhabited by a strange people many years before the first recorded visit of a white man, there can be no doubt. The relics of a former race are scattered throughout this territory, and the many skeletons found buried along the river banks of the river below Jeffersonville are indisputable evidence that a strange people once flourished here.' According to Olson, there is 'additional and convincing proof that Prince Madoc founded the first recorded settlement in America and established in what is now Clark County, Indiana, the longest surviving colony (1170-1837) before widespread immigration brought other white men to this country.'

MADOG AP LLYWELYN (d. 1295) In 1294, a Welsh national rising was planned as Edward I was to sail to France. The leaders were Morgan in Morgannwg, Cynan in Brycheiniog, Maelgwn in Ceredigion and Madog ap Llywelyn in Gwynedd. Madog was the son of Llywelyn ap Maredudd, the last of the lords of Meirionydd, and a direct descendant of Owain Gwynedd. On 30 September, Caernarfon Castle was captured by Madog, killing the castellan, and there

were coordinated attacks on the royal castles at Aberystwyth, Denbigh, Castell y Bere, Cricieth, Harlech, Cardigan and Builth. The Sheriff of Anglesey was killed, and an army under Lord de Lacey was crushed in the Vale of Clwyd, with large parts of the country returning to the Welsh. Cardigan Castle was taken, and in Ceredigion, Glamorgan and Brecon, many castles and manors were sacked. Madog now pronounced himself Prince of Wales, twelve years after Prince Dafydd of Wales had been executed. Unfortunately, prevailing winds meant that Edward had not sailed to France as expected, and his levies were mustered in Shrewsbury on 30 September. He told his Marcher Lords to pacify their lands, and they gathered other armies at Chester, Montgomery and Gloucester. Edward brought his French invasion force up to Conwy, and then moved to Bangor, but lost his baggage train in an ambush and was forced to return and shelter in Conwy Castle. Madog now moved south away from the main royal army, looking for support from Powys, when he was attacked by the Earl of Warwick at Maes Madog, near Caereinion in 1295. Warwick had used the king's funds to hire Glamorgan and Gwent longbowmen, who decimated Madog's small army, mainly composed of North Wales spearmen. Madog had drawn them up in a traditional 'porcupine formation' but they were showered with arrows from the Welsh archers and beaten badly. Five days later, the King's forces came on the remnants of the exhausted Welsh army and slaughtered 500 of them in a night attack. Madog escaped, surrendered to John de Havering in August, and was taken to London but his fate is unknown. However, one source says that Morgan and Cynan were eventually caught and executed using the normal barbaric Angevin methods.

MADOG AP MAREDUDD AP BLEDDYN AP CYNFYN (d. 1160) He succeeded his father, as the last King of all of Powys in 1132. Alongside Owain Gwynedd's brother Cadwaladr he led a large army of Welshmen at the Battle of Lincoln in 1141, supporting the Earl of Chester. In 1149 he took Oswestry back from William Fitz Alan's Normans, but was under pressure from Owain Gwynedd, although Madog had married Owain's sister, Susanna. Madog was forced into an alliance with Ranulf of Chester but was defeated by Owain at Coleshill in 1150. Owain confiscated his lands in Iâl (Yale near Wrecsam), but in 1157 Henry II helped Madog regain most of his lands, and he returned Oswestry to Fitz Alan. Madog was buried in 1160 at St Tysilio's Church in Meifod. Shortly after his son Llywelyn was killed, and Powys was divided. Owain Cyfeiliog, Madog's nephew took most of southern Powys, which became known as Powys Wenwynwyn after Cyfeiliog's son Gwenwynwyn. The northern part was taken over by Owain Gwynedd, and became known as Powys Fadog. The ancient Kingdom of Powys had ended after hundreds of years.

MAELGWN GWYNEDD (d.c. 547) Cadwallon's Lawhir's son, he consolidated North Wales around 540, opposed Ida the Flamebearer of Bernicia, and also fought Saxon armies. Called Maelgwn Hir (the tall), he was also referred to sometimes as 'Island Dragon' for he controlled Anglesey. He gave land at Holyhead to St Cybi, and supposedly gave land to St Deiniol to start the monastery at Bangor which became a cathedral. There is a folk tale that he and the other chiefs should meet in Cardigan Bay and sit on their thrones, waiting for the fast tide of the river Dyfi to come in. The greatest chief would be he who held his place the longest. Maelgwn had a special wooden chair made, which floated, and proved he was the greatest prince of North Wales. The sands of the mouth of the river Dyfi have always been called Traeth Maelgwn. The bard Taliesin described Maelgwn's terrible death from the Yellow Plague of 547. He took refuge in a church near his castle at Deganwy, but fearing enemies had to see if any were approaching – 'and Maelgwn Gwynedd beheld the Yellow Plague through the keyhole of the door, and forthwith died.' Maelgwn may have fought against King Arthur, succeeding him as Pendragon.

MAELOR The Maelor was formerly a cantref of the kingdom of Powys, focused on the monastic centre of Bangor is Coed, divided from the rest of Wales by Offa's Dyke, but reclaimed by Wales during the reign of Stephen. Around 1202, the region was first divided into two halves, separated

by the River Dee, the east part becoming known as Maelor Saesneg (English-speaking Maelor). The western area remained Welsh and became known as the Maelor Gymraeg. Maelor Saesneg (English Maelor) was often referred to as 'Flintshire Detached' on old maps. Welsh Maelor corresponds approximately to the later parishes of Wrecsam, Bersham, Erbistock, Marchwiel, and Ruabon in Denbighshire. Both halves are now in the county borough of Wrecsam.

MAENAN ABBEY Cistercian monks were moved here, near Llanrwst, from Aberconwy (Conwy) to enable Edward I to build a castle on Llywelyn I's resting place. A hotel is now on the site.

MAES COGWY, BATTLE OF, 642 King Oswallt (Oswald) of Northumbria was defeated by Penda's Mercian army, in revenge for his ally King Cadwallon of Gwynedd, whom Oswallt had killed at Heavenfield in 634. The Battle of Maserfield or Maes Cogwy was fought on 5 August, and ended in Oswallt's death and dismemberment. The location of the battle is traditionally identified at Oswestry (Oswald's Tree) in Shropshire, which was then in the kingdom of Powys. Oswallt was in the territory of his enemies, which would suggest he was on the offensive. The battle stopped Northumbrian expansion south of the Humber, and left Penda of Mercia in charge of the Midlands of England, as his brother Eowa was slain at Maes Cogwy. Powysians under Cynddylan ap Cyndrwyn from Pengwern (Shrewsbury) participated in the battle. They must have allied with Oswallt, because after this battle against Mercia, the region around Pengwern was sacked, its royal family slaughtered and large areas of Powys' eastern borderlands were annexed by Mercia. These events were remembered in two Welsh poems which told of the desolation of Princess Heledd (*Canu Heledd*) on hearing of the death of her brother, King Cynddylan, the king of Pengwern (*Marwnad Cynddylan*). It may be that the Powysian palace based in Wroxeter Roman city was first burned by the Mercians, and the men of Powys fought for Oswallt shortly after.

MAESDU, BATTLE OF, 1098 Also known as the Battle of Deganwy, this 'black field' outside Llandudno is now a golf course. A Norwegian/Viking force was defeated here.

MAES GARMON, BATTLE OF, 429 Near Mold, this was 'the Alleluiah Battle' - when the Britons defeated a combined raiding party of Picts and Saxons. The tradition is that the heathens were ambushed, not by weapons, but by the Britons banging their shields and shouting 'Alleluiah' at the top of their voices many times. The foe fled in panic, many of them drowning in the River Alun. It was reputedly a bloodless encounter on the Welsh side. Another site for the battle may be in the area around Carrog, off the Corwen to Llangollen road.

MAES MAEN CYMRO, THE BATTLE OF, 1118 Hywel ap Ithel of Rhos and Rhufeiniog defeated the sons of Owain ab Edwin of Dyffryn Clwyd outside Ruthin. However, Hywel died of his wounds six weeks later. This enabled the sons of Gruffydd ap Cynan to annexe Hywel's lands for Gwynedd.

MAGIC Mystical Wales is represented in its literature and in the Myrddin stories - Myrddin (Merlin) predates his inclusion in the Arthurian Cycle of stories. Generations of the Harrieses of Cwrt y Cadno near Llanpumsaint, were revered as having magical powers. In the sixteenth century, one is supposed to have split a nearby megalith in two. In the eighteenth century, thunder in the Cothi Valley signified to locals that a Harries was consulting his chained and padlocked book of magic. Dr John Harries was the most famous member of the family. The local conjuror, or 'cosuriwr', or 'dyn hysbys' (wise man), was consulted by people up to the nineteenth century for investment advice or sickness remedies, often involving a large toad. One of these sorcerer-witch doctors was Huw Lloyd of Cynfal Fawr near Ffestiniog, who regularly met the Devil' on a rock in the Cynfal Gorge, known as Huw Llwyd's Pulpit. John Harries and

Huw Lloyd were the type of 'wise men' linked with black magic and medicine. Another type of recognised 'dyn hysbys' was a renowned cleric such as Edmwnd Prys – possibly identified as such because of his great learning. The third category of 'cosuriwr' were those who had 'inherited the gift' by belonging to a certain family. A well-known Llangurig family of wise men included Evan Griffiths of Pant-y-Benni, and Edward Davies of Y Fagwr Fawr, Ponterwyd. Learning from their families and from books, they treated sick animals, and people came from all over Wales to receive a charm to protect their livestock. This took the form of a prayer written in a mixture of Welsh, Latin and English, the mystical 'abracadabra' symbol and the zodiac signs. The prayer was corked into a bottle ('potel y din hysbys'), with the warning never to uncork it, and placed in the animals' barn. Some such bottles still remain in Welsh farmhouses, and there are examples in the Museum of Welsh Life and the National Library of Wales. Sometimes the evil spirit who troubled the farm was human, such as the local landowner or a troublesome neighbour, and protective charms were bought and bottled.

Mari Berllan Piter lived near Aberaeron, and her tumble-down cottage, Perllan Piter, is now covered by her orchard (perllan). It is called 'The Witch's Cottage' and it is said that it is impossible to photograph it. She could change herself into a hare (sacred to the Celts, and protected by Saint Melangell) to escape from angry neighbours, who blamed her if any thing went wrong. Local farmers gave her gifts of flour and potatoes in return for not cursing their animals. When Dic y Felin, the local miller, refused to grind her wheat into flour, she made the mill-wheel reverse direction. When a young girl stole an apple from the witch's orchard, Mari put a spell on her that made her walk backwards all the way home. Mari died in 1896 and is buried in Llanbadarn Trefeglwys churchyard. The twin brother of Henry Vaughan, Thomas Vaughan (1621-1666) was also educated at Jesus College and became a 'natural magician' of repute, publishing several hermetic and alchemic treatises. He was involved in Rosicrucianism, and wrote *Magia Adamica; or the Antiquity of Magic* in 1650. He had been a student of Henricus Agrippa, the occult writer described as an astrologer by Rabelais.

MAGNA CARTA 1215 Llywelyn I had aided the English barons against King John. In return his rights and those of the Welsh were recognised by John. Three relevant clauses in the treaty were: 'If we have dismissed or removed Welshmen from lands or liberties, or other things, without the legal judgment of their peers in England or in Wales, they shall be immediately restored to them; and if a dispute arise over this, then let it be decided in the marches by the judgment of their peers; for the tenements in England according to the law of England, for tenements in Wales according to the law of Wales, and for tenements in the marches according to the law of the marches. Welshmen shall do the same to us and ours'... 'Further, for all those possessions from which any Welshman has, without the lawful judgment of his peers, been dismissed or removed by King Henry our father, or King Richard our brother, and which we retain in our hand (or which are possessed by others, and which we ought to warrant), we will have respite until the usual term of crusaders; excepting those things about which a plea has been raised or an inquest made by our order before we took the cross; but as soon as we return (or if perchance we desist from our expedition), we will immediately grant full justice in accordance with the laws of the Welsh and in relation to the foresaid regions.'... 'We will immediately give up the son of Llywelyn and all the hostages of Wales, and the charters delivered to us as security for the peace'. After the treaty, Llywelyn started to exert his power in South Wales, destroying Norman castles and taking the royal castles of Cardigan and Carmarthen. In 1216 at Aberdyfi, all the other Welsh princes acknowledged him as their overlord. In 1218 by the Treaty of Worcester the English crown recognised his position, and he ruled Wales in relative peace until his death.

MAID OF CEFN IDDFA *The Maid of Cefn Iddfa* is a lovely tune, and the mansion of Cefn Iddfa in Llangynwyd is now in ruins. The song is dedicated to Ann Thomas (1704-1727), the daughter of the mansion, who was said to be made to marry a local solicitor, Anthony Maddocks. Her true love, Wil Hopcyn, left the district in grief, and wrote the beautiful song *Bugeilio Gwenith Gwyn* (*Shepherding the White Wheat*) to show his love for her. He returned when she was mortally ill, and

she died in his arms. He is buried next to her in Llangynwyd churchyard.

MAID OF SKER A similar tale to the above, Elizabeth Williams (*c.* 1747-1776) of the great Sker House, Porthcawl, fell in love with the house's harper, Thomas Evans. Her father made her marry an English industrialist, Thomas Kirkhouse, and she died of a broken heart. R.D. Blackmore, the author of Lorna Doone, used to stay in the house, and wrote the unrelated novel, *The Maid of Sker.*

MAN OF THE MILLENNIUM A *Sunday Times* poll in 1999 of 100 world leaders, artists and scientists such as Boris Yeltsin, Bill Clinton and Andrei Sakharov asked them to propose the most significant figures of the last 1,000 years. The top ten were Gutenberg, followed by Shakespeare, Caxton, da Vinci, Faraday, Owain Glyndŵr, Isaac Newton, Lincoln and Galileo. (The most significant figures of the last century were Churchill, Mandela, Fleming, Whittle, Einstein, Crick and Watson, Keynes, Bill Gates, Stalin and Tim Berners-Lee). Glyndŵr's appearance in seventh place, above Lincoln, Churchill etc., and the highest placed military leader and nationalist, is amazing for someone who is hardly recorded in English history. It demonstrates that objective knowledge of a history of Britain is more easily gained by people not using English history books.

MANNAN, BATTLE OF, 987 King Maredudd ab Owain of South Wales had killed King Cadwallon of Gwynedd in battle, and Cadwallon's brother, Hywel ab Ieuaf asked Godfridr Haraldsson, the conqueror of Anglesey, to help him regain Gwynedd. There was an overwhelming victory when Maredudd lost a thousand men, and another two thousand were imprisoned. Maredudd retreated to Ceredigion and Dyfed and paid a penny a man to ransom his troops.

MANORBIER CASTLE Giraldus Cambrensis was born here, overlooking a beach near Tenby, and parts were built in the twelfth century by Gerald's father, William de Barri. The Great Hall dates from the 1140's and may be the oldest stone building surviving intact in any West Wales castle. The castle was slighted by Parliamentarians in 1645.

MARCHES After beating Harold of Wessex at the battle of Hastings in 1066, William the Conqueror saw the need to quickly subjugate the rest of Saxon England. To keep Wales in check, he appointed three powerful barons to hold the Welsh border against any invasion. He knew that the Welsh originally occupied England and had been pushed back by successive invasions of Saxons, Mercians, Angles, Danes, Jutes and the like. To hold the region east of Offa's Dyke, he appointed Hugh the Wolf (Hugh Lupus), also known as Hugh the Fat, as Earl of Chester. He was responsible for stopping any approaches from Gwynedd. Further south, he made Roger of Montgomery Earl of Shrewsbury, to stop the Princes of Powys penetrating up the Severn Valley. William Fitz Osbern was made Earl of Hereford to stop the Princes of Deheubarth, Glamorgan and Gwent from entering England. Below Hereford, the Norman lords Lacy, Ballon and Fitzhamon infiltrated along the Gwent/Glamorgan plains. The main Marcher castles were built in the three great centres of Chester, Shrewsbury and Hereford, and along the border at Bridgnorth, Huntington, Longtown, Whittington, Chirk, Hopton, Powis, Stokesay, Montgomery, Wigmore, Croft, Painscastle, Ludlow, Grosmont, Skenfrith, White Castle, Clun, Clifford, Clyro, Hay-on-Wye, Pembridge, Goodrich, Clearwell, Monmouth, St Briavel's and Chepstow. (At the same time, the Marshalls as Earls of Pembroke consolidated their hold on southern Pembroke). The importance of Wales is shown by the fact that over 200 years after the Norman Conquest of England, much of Wales was still independent. In Edward I's reign, at the time of Llywelyn II's death in 1282, there were only ten earls in England. Of these, seven were Marcher Lords.

Thus had been created the 'Marche', the mark or boundary that separated England from Wales. These Norman nobles had the right to do anything they wished in relation to their

Welsh neighbours. They had 'carte blanche' to take any land in Wales by any means possible, by lying, cheating, torture and war. The initial three earldoms were made 'Counties Palatinate' and their 'Marcher Lords' were promised that any Welsh land they took they could keep. They administered their own laws and taxes, and used a system of subsidiary Lords Marcher to invade Wales. It took seventy years to subjugate most of South Wales, compared to three years to occupy all of England. Not until 1420 did Wales finally succumb, after the Owain Glyndŵr rebellion. However, the territories of these lords were of increasing interest to the English crown, which slowly tightened its grip on the barons. With the Welsh Tudor dynasty, England and Wales combined legally, and the days of these robber barons ended.

MARGAM ABBEY On a Celtic monastic site, the Earl of Gloucester endowed the Cistercian abbey here, which became the largest and wealthiest in Wales in the twelfth century. The remains are in the grounds of Margam Abbey Park.

MARGAM ABBEY PARK In 1787, Margam Orangery was built, still the biggest in the world at 330ft long. Margam Park was designed in 1830 by Thomas Hopper, the architect of Penrhyn Castle. One of the owners of this Margam estate, Christopher Rice Mansel Talbot, sailed his luxury yacht *Lynx* as the first ship through the Suez Canal in 1869. In fifty-nine years as the Member of Parliament representing Glamorgan, he only was known to speak once in the House of Commons, to ask another MP to close his window because he was 'sitting in a draught'.

MARGAM STONES MUSEUM The Great Cross of Cynfelyn is one of the important Celtic wheel-crosses in this museum, next to Margam Abbey Park.

MARKETING Scotland spends four times as much as Wales upon marketing its country to overseas visitors. As a result, only 3% of visitors to the British Isles come to Wales, and Wales' share of the overseas tourist 'spend' is only 2%, as many are passing through on their way to Ireland. The Wales Tourist Board, responsible for the marketing of Wales, has been integrated into the Welsh Assembly Government from 2006. It will be almost impossible to market Wales as a tourist destination if the density of wind farms, already among the highest in Europe, and ten times as dense as in England, is increased.

MARKS, HOWARD (1945-) Howard Marks, one of Balliol College's more famous alumni, has made his mark in history. Apart from being featured in various 'mugshot' disguises all over the cover of a Super Furry Animals album, he is famous for having had forty-three aliases, smoking twenty joints of cannabis a day for over forty years, and for smuggling over 100 tons of cannabis. From his early days as a child in Pyle near Bridgend, to an American state penitentiary, his autobiography *Mr Nice* is a dazzling dive into the world of MI6, the CIA, DEA (Drug Enforcement Agency), IRA, Mafia and P.J. Proby. He was only captured and imprisoned in America after a plea-bargain from the large and late Lord Moynihan, who had an almost equally strange life.

MARSHALL, JOHN (1755-1835) 'The Father of American Constitutional law', was of Welsh stock. After serving in the army in the War of Independence, he was a congressional representative and then Chief Justice from 1801-1835. He established the doctrine of judicial review, placed the Supreme Court in a position of independence and power, and his decisions are the standard authority of constitutional law.

MATHEMATICS Robert Recorde of Tenby invented the equals sign =, in 1550, and is commemorated in the parish church. He died a bankrupt, despite his book of algebra going into twenty-six editions in his lifetime. In 1706, William Jones of Llanfihangel Tre'r Beirdd, Anglesey, was the first person to use the symbol pi to denote the ratio of the circumference of a circle to its diameter.

MATHRAFAL CASTLE This was one of the three royal seats of Wales, the capital of the House of Powys (Gwynedd and Deheubarth were based at Aberffraw and Dinefwr). The site may have shifted from an earlier one on a hill less than a mile away. The motte was probably built by Owain Cyfeiliog (*c.*1170) or by Robert de Vieuxpoint (*c.*1210) but Llywelyn ab Iorwerth (the Great) destroyed Mathrafal in 1212. Prince Gwenwynwyn of Powys had transferred his court to Welshpool earlier that year.

MATTHEWS, DEATH RAY (1880-1941) In Mynydd-y-Gwair, in the hills north of Swansea, Harry Grindell Matthews supposedly worked on a secret weapon, a death ray, from 1934. He claimed that it could kill rats from a distance of 64ft. Of course, he became known as '*Death Ray*' Matthews. He also 'invented' a device that could stop magnetos working, and demonstrated it by stopping a moving motorcycle. He claimed that it could be used for 'downing aeroplanes' or stopping an enemy's transport from operating. He had previously experimented in light-controlled boats, radiotelephony from moving cars, sky projectors and in talking movies. In 1912, he demonstrated his radiotelephone, or 'aerophone', the world's first portable phone, to Queen Mary. An inventor and pioneer of talking films, he failed to persuade the British film moguls that 'talkies' were the future for the industry. He also invented a working 'sky-projector', projecting pictures onto clouds. A biographer has stated that the reclusive inventor was also working on rockets, submarine detection and interplanetary travel, and that strange guests would suddenly arrive and disappear by private plane. It is rumoured that Goebbels visited him to see if he could ignite gunpowder at a distance using electromagnetism. 'Death Ray' died of a heart attack in 1941, seemingly after destroying all his papers (or his research could have been burned by someone else). Matthews left behind a mysterious legacy. Some said that he was shot in the Tower of London for developing war weapons for Germany, and on his death the national press wrote about his laboratory in the mountain mists. A 1997 HTV programme, *Home Ground*, featured the strange story of a German Telefunken radio transmitter from the Second World War, set up for Morse Code use only. Capable of enough power to cover Europe, it was discovered in the basement of Telephone House, Swansea, having been impounded during the war. There were rumours of a German spy transmitting over a three-day period before his arrest, and a major Luftwaffe blitz killed 347 people in Swansea during three nights in February 1941. The first wave of attacks knocked out the anti-aircraft guns operations room, and German pilots commented upon Swansea's lack of defences. Could 'Death-Ray' have been this German spy? Could his 'destroyed' papers resurface in the National Records Office or secret service files, after more than the usual sixty years' restriction under the Official Secrets Act?

MAYFAIR The most expensive real estate in Europe was once owned by a Welsh family. Mary Davies inherited the manor of Ebury (including Mayfair and Belgravia), but unfortunately chose not to marry into this author's family, but instead chose a minor Cheshire landowner, Sir Thomas Grosvenor, a descendant of William the Conqueror's huntsman, Hugh Lupus. Buckingham Palace was built on Grosvenor land, and the present Grosvenor incumbent, the Duke of Westminster, was once the richest man in England. He recently made the national newspapers in connection with many visits to prostitutes.

MEAD This is alcohol made from honey and water. The ancient Greeks elevated mead to a 'food of the gods', and Norsemen celebrated weddings for a whole lunar month – hence the word 'honeymoon'. However, the Welsh monasteries found that the honey flavours of the drink were too strong, and diluted the honey with fruit juices. (Honey was used to ferment drinks in these times because there was no sugar available). The Laws of Hywel Dda gave permission for court stewards to have a daily ration of mead, and laid down rules for its production. A mead aperitif is made from apples, honey and sometimes quince in our sister-nation, Brittany, where it is known as 'chouchen' or hydromel. Cider is very popular in Brittany, and an apple eau de vie called lambig is also a speciality. Mead was so strong and popular that the Church tried to

persuade people to turn to ale, which had replaced it as the popular drink by the eighteenth century. By the middle of the nineteenth century, mead was very much a minority drink in Wales, but is usually used as the toast drink, at recreations of medieval banquets in stately homes and castles. Meads such as metheglyn, hyppocras, pyment and cyser, combining honey with spices and fruit, are sometimes sold at the Royal Welsh Show. Metheglyn is spiced with cloves, ginger, rosemary, hyssop and thyme. Under the Tudor Dynasty, mead became the most popular alcoholic drink in England. Elizabeth I had the finest metheglyn, sent annually to her from Anglesey. However, from the seventeenth century, sugar was imported from the West Indies, replacing honey as a sweetener, and mead declined in the face of cheaper competition from ale, gin and rum. The following quotation was found in *Yr Haul*, the magazine of the Church in Wales, in July 1932; 'Getting drunk on mead meant a dreadful drunkenness, damaging to the body, people getting so drunk that they could not sober up for many days. In addition to this, its effect on the body's equilibrium was very different from the effect of getting drunk on beer. A man who gets drunk drinking beer leans forward, and such a drunkard moves forward, but mead would make one lean backwards, and a drunkard drunk on mead would be impelled 'backwards' despite all efforts to move forwards.'

MECHAIN, BATTLE OF, 1069 Maredudd and Ithel, the surviving sons of Gruffydd ap Llywelyn, were killed in battle against their uncles Bleddyn ap Cynffin and his brother Rhiwallon. Rhiwallon was also killed in this Montgomeryshire battle, leaving Bleddyn as the sole ruler of Gwynedd and Powys until his death in 1075.

MELANGELL, ABBESS (*c.* 570-641) She protected a hare from Prince Brochwael's huntsmen, at Pennant Melangell. Brochwael granted perpetual protection to hares in the lands he granted her to create a convent, and they were known as 'Melangell's little lambs'. Her twelfth-century coffin-shrine there is a unique survival in the British Isles, being supported on pillars.

MEN OF HARLECH The march of the *Men of Harlech* (*Rhyfelgyrch Gwŷr Harlech*), written in 1468, celebrates the heroic ending of an eight-year siege in the (English) Wars of the Roses. *Men of Harlech* was one of the songs with which the Welshmen at Rorke's Drift in the Zulu Wars responded to the Zulu impi war chants.

MEREDITH, WILLIAM HENRY (BILLY) (1874-1958) In Football, the oldest international in the world was from Chirk, who played right wing for Manchester City, Manchester United, and Wales. At twelve years old Meredith was working in Black Park Colliery. The conditions marked him for life, and he decided to become a professional footballer, signing for Ardwick (Manchester City) for a £5 fee. He made his debut while still working down the pit. He scored twice on his home debut and quickly became the favourite player of the supporters. One Friday after working he took the 2.00 am train on Saturday morning to Newcastle, arriving at 11.00, played a match and was back home at 10.30 pm to go to work the next day. This moustachioed lynchpin of the City team took them to promotion and in the next year became their captain. His trademark was that he chewed a toothpick while playing. As captain, he took Manchester City to the Cup Final, scored the winner, and took the FA Cup to Manchester for the first time. He had started to become nationally famous, on a maximum wage of £4 a week. Meredith was then bought by the newly promoted Manchester United, and has a place of honour in their football museum. As Bobby Charlton stated, Billy Meredith was their 'earliest star'. Football at this time was a 'hard man's game', with heavy boots and ball and little protection from fouls, but Meredith missed hardly any matches as United won the League in 1908. In his position of authority in the game, he chaired the first meeting of the Professional Footballers' Association – and led a strike for better conditions. Meredith was the last player to return to play after the strike ended.

He was Manchester United's key player when they won the FA Cup in 1909, and he became

soccer's first media personality, with personal appearances and product endorsements – he was football's first 'superstar' in any country in the world. Meredith returned to Manchester City for the final three years of a glittering career. He played against England aged almost forty-six, in 1920, in an international career spanning a record 26 years. This was his forty-eighth and last international, Wales beating England in London. He was also in the team for Wales' first ever victory against England, and was selected 71 consecutive times for his country from the age of twenty-one, but only played 46 times because Manchester City often stopped him playing. Meredith played for thirty years in the English First Division and hardly missed a game until he was well into his fifties. He would have set more records, but for the First World War and the suspension of football, when he was in his prime aged twenty-six to thirty. Obsessed with training and fitness, he scored nearly 500 goals from his position of outside-right, and was a sporting celebrity in his seventies. However, he died in 1958 aged eighty-three, and is buried in an unmarked grave in Manchester. The great winger Stanley Matthews was compared to him, but Meredith could also score goals – he said Matthews 'would never have made the grade in my day'.

MERIONETHSHIRE, MEIRIONYDD (Sîr Feirionydd) is one of the thirteen historic counties of Wales. It was formed of the cantrefi of Meirionydd, the Ardudwy commote of Dunoding, Penllyn and Dinmael. Its main towns are Bala, Barmouth, Blaenau Ffestiniog, Corwen, Dolgellau, Ffestiniog and Tywyn. The former administrative county of Merioneth, created under the Local Government Act of 1888, was abolished in 1974, most of the shire become the Meirionydd district of the new county of Gwynedd. The county is the most mountainous in Wales, containing a large part of the Snowdonia National Park, and has a high proportion of Welsh speakers.

MERLIN, MYRDDIN – FIFTH-SIXTH CENTURY Myrddin Emrys, after whom Caerfyrddin (Carmarthen) was named, is the Merlin of Arthurian legend. Merlin's Oak, a leafless stump held up by iron struts, stood in the centre of Caerfyrddin until 1958 when it was removed to assist more carbon and lead pollution by modern traffic. Merlin had prophesied that Carmarthen would fall with the death of the tree, so it had been carefully preserved: 'Llanllwch has been, Carmarthen shall sink, Abergwili will stand', and 'Carmarthen, you shall have a cold morning; Earth will swallow you, water in your place'. Councillors voted to uproot it, along with 1,500 years of legend. Another of Merlin's prophecies was that a bull would go to the top of St Peter's Church in Carmarthen, and a calf was found at the top centuries later. The most famous wizard in the world, he was in Welsh folk tales long before the Arthurian cycle in which he appeared as Arthur's councillor, and foresaw the hero's downfall. He became known as Merlin because the Latinized form of Myrddin would have been Merdinus, linked to the Latin for dung, Merdus (or the French 'merde'). Myrddin was also a poet and a prophet, forecasting that one day the Welsh would once again take over the land of Britain and drive the Saxons out. This shows remarkable foresight – the east side of the British Isles is dropping into the sea at three to four times the rate of that of the west side. In future millennia, England will have disappeared and Wales and its Cornish and Cumbrian cousins will once again rule this island.

As a youth, Merlin was linked with Vortigern, King of Britain, who could not build a tower on DINAS EMRYS. Merlin informed him that there was a problem because two dragons guarded an underwater lake. Recent archaeological excavation showed an underground pool. These red and white dragons were symbolic of the British against Saxon fight for Britain. In legend, Merlin next advised Ambrosius Aurelius, the conqueror of Vortigern, to bring back the Giant's Ring of sacred stones from Ireland and erect Stonehenge. After the death of Ambrosius, his successor Uther Pendragon became besotted with Eigyr (Igraine), wife of Gorlois, so Merlin shape-shifted Uther into Gorlois and she conceived Arthur. Welsh traditions say that Merlin lies in chains in a cave under Bryn Myrddin, Carmarthen, or in a cave near Dinefwr castle, or buried on Bardsey Island, where he took the 'Thirteen Treasures of Britain'. He is also thought to have been imprisoned in a lake in Brittany.

There were probably two Myrddins, one being Myrddin Wyllt, a Celtic wizard who lived in the Scottish woods at the time of Vortigern, going mad after the battle of Arturet, near Caerlaverock. Myrddin Emrys from Carmarthen probably lived at the time of Arthur. The Breton link with Merlin and Arthur is interesting. There is a scenic tour in the 'Purple Country' of Broceliande, with fifty-six miles of roads criss-crossing ancient sites and megaliths. The 'Barenton Spring' is where Merlin first met Vivian the Enchantress. 'Merlin's Tomb' is an old passage grave where he was imprisoned by Vivian. Also in the forest, the lake known as the 'Fairies' Mirror' is supposed to be used by Vivian to hold Merlin. Morgana le Fay imprisoned Arthur's unfaithful knights in 'The Valley of No Return' nearby. Comper Castle's lake is said to have been the home of Vivian, who brought up Lancelot under its waters, and the castle has a permanent Arthurian exhibition. Nearby Paimpont Abbey celebrates the Welsh missionaries, contemporary with Arthur, who became bishops in Brittany.

Merlin left behind a set of prophecies for the next millennium after his death. GEOFFREY OF MONMOUTH recounts his life and prophesies. Thomas Heywood's 1812 book *The Life of Merlin* links Merlin's prophecies through all the events in British history, for example the Gunpowder Plot:

To conspire to kill the King,
To raise Rebellion,
To alter Religion,
To subvert the State,
To procure invasion by Strangers.

At the end of Merlin's 'Vita' are the following lines:
Normans depart and cease to bear weapons through our native realm with your cruel soldiery. There is nothing left with which to feed your greed for you have consumed everything that nature has produced in her happy fertility. Christ, aid thy people restrain the lions and give to the country quiet peace and the cessation of wars.

MERTHYR RISING 1831 The Great Depression of 1829 led to massive unemployment and wage cuts, making the working classes even more indebted to their masters. William Crawshay had lowered wages at his Merthyr iron foundries, there was a crisis among tradesmen and shopkeepers, and the Debtor's Court was confiscating workers' property to pay off debts. Thomas Llywelyn, a miner, demanded compensation and led a demonstration that released prisoners and marched on Aberdare. At the same time in nearby Hirwaun, when the Debtors' Court had seized the truck of Lewis Lewis, miners, ironworkers and tradesmen joined the political radicals – they had had enough. The Merthyr Rising had begin. Hungry iron and coal workers took over the town for five days, and paraded under a sheet daubed symbolically with the blood of a lamb and a calf. The 'red flag' was raised on Hirwaun Common on 31 May 1831. On its staff was impaled a loaf of bread, showing the needs of the marchers. This was probably the first time that the 'red flag' of revolution was raised in Britain. (It may the first time anywhere in the world). A 10,000-strong crowd battled with soldiers at the Castle Inn on 3 June 1831, and up to two dozen men, women and children died in the fighting. Unemployment and reduced wages had fomented the unrest, and the workers burnt court records and their employers' property. The tyrannical ironmasters Crawshay and Guest were locked up in the Castle Inn, defended by Scottish soldiers, who opened fire on the mob. The Argyll and Sutherland Highlanders were reinforced by the Glamorgan Yeomanry, but the supporting Swansea Yeomanry were forced back to Neath. Major Richards called out the equivalent of the Home Guard, the Llantrisant Cavalry, to rescue the regular soldiers, who sustained no losses.

Lewis Lewis, the truck owner whose loss sparked off the initial revolt, was sentenced to death, commuted to exile for life. A twenty-three-year-old collier, Dic Penderyn (Richard Lewis) was accused of riotous assault and a 'felonious' attack upon Private Don Black of the 93rd Highland Regiment. Dic Penderyn was hung at Cardiff Gaol on 31 July 1831, his last words being 'Arglwydd,

dyma gamwedd' ('Oh God, what an injustice'), as an example 'pour les autres'. Other defendants were transported to Australia. Forty years later, an immigrant from Merthyr, Iuean Evans, confessed on his deathbed in the USA that it was he that wounded the soldier, not Richard Lewis. The carter who took Penderyn's body back to be buried in Aberafan asked to be, and is, buried next to Dic Penderyn in the churchyard of St Mary's there. The Merthyr Rising was described by John Davies as 'the most ferocious and bloody event in the history of industrialised Britain.' Gwyn Williams pointed out that 'these defeats inflicted on regular and militia troops by armed rioters have no parallel in recent British history.' Publicity was suppressed – after all, the starving Welsh working class did not matter in the grand scheme of things. In June 1831, a Mrs Arbuthnot noted in her diary: 'There has been a great riot in Wales and the soldiers have killed twenty-four people. When two or three were killed at Manchester, it was called the Peterloo Massacre and the newspapers for weeks wrote it up as the most outrageous and wicked proceeding ever heard of. But that was in Tory times; now this Welsh riot is scarcely mentioned.' Gwyn Williams commented that 'bodies were being buried secretly all over north Glamorgan... widows did not dare claim poor relief.' The Dic Penderyn Society organises an annual meeting of remembrance at the graveside of Richard Lewis and outside Cardiff Market, where Cardiff Gaol once stood.

MERTHYR TYDFUL (TYDFIL) Iron was worked here from the sixteenth century, but with the Industrial Revolution Merthyr became one of the world's greatest iron-making centres, called 'the iron capital of the world', and was the largest town in Wales by 1801. By the 1840's the Guest Ironworks at Dowlais, first built in 1759, had became the biggest manufacturer in the world with 5,000 workers. However, within a hundred years the South Wales ports of Cardiff, Swansea, Barry and Cardiff had overtaken Merthyr in size and economic prosperity. Cyfartha Castle is a monument to the fortunes made by its ironmasters such as Guest, Crawshay, Bacon, Hill and Homfrey. Richard Trevithick ran the first steam engine in the world here in 1804, from Penydarren Ironworks to Abercynon in 1804. Three sons of a local solicitor named Berry became the media barons Lord Buckland, Lord Camrose and Lord Kemsley. In 1870, Merthyr grocer William Gould unveiled the world's first secret ballot box, now displayed in Cyfartha Castle. Keir Hardie was always associated with Merthyr. As an Independent Labour MP, after an explosion at a colliery in Pontypridd in 1894 which killed 251 miners, he asked that a message of condolence to the relatives of the victims be added, to an address of congratulations on the birth of a royal heir (the future Edward VIII). His request was refused and Hardie made a speech attacking the monarchy, resulting in uproar in the House of Commons. In 1895 he lost his Parliamentary seat, but in 1900 formed the Labour Party. In that year he was elected as the junior MP for the dual constituency of Merthyr Tydfil and Aberdare, which he would represent for the remainder of his life. Only one other Labour MP was elected that year, but the party continued to grow, winning power in 1924. In 1922 Merthyr controversially elected R.C. Wallhead as its MP. He had been imprisoned as a conscientious objector in World War I. In 1927, the town elected Mary Ann Rowlands as Mayor, before women had achieved equal voting rights.

The above facts are among many in a Merthyr Council publication of 2005's centenary celebration, *100 Interesting Facts you might not have known about Merthyr Tydfil*. Very, very strangely, it omits any mention whatsoever of Stephen Owen ('SO') Davies (1886-1972). Born in 1886 in Abercwmboi he started working in the coal mines at eleven years of age, and later became the South Wales Miners' Federation (SWMF) Miners' Agent (1918-1934) and a member of the SWMF Executive Committee (1924 -1930). He eventually (1924-1933) became the Vice-President of the SWMF. In 1934 he became Labour MP for Merthyr Tydfil. 'SO' was MP for Merthyr continuously until his death in 1972, for the Labour Party from 1934 to 1970, and the Independent Labour Party 1970-1972. In 1970 the local Labour Party had decided he was too old to stand again. He was eighty-four at the time, but opponents spread rumours that he was actually closer to 90. 'S.O.' refused to retire and decided to stand as an independent, when Labour chose union official Tal Lloyd as the official candidate to defend Labour's 17,000 majority. S.O. Davies romped home as an Independent by 7,400 votes, despite all the attempts of party apparatchiks. The Merthyr

voters had once more voted for a rebel. It appears that thirty-two years after his death, the Labour machine in Merthyr had still not forgiven this great and incorruptible servant of the town.

MEURIG AP TEWDRIG AP TEITHFALLT This King of Morgannwg took over the land before his father TEWDRIG was martyred in 470. Often Welsh kings and princes handed their territories over to a single son before they died, to avoid their lands being divided equally between their children by 'gavelkind'. Meurig's kingdom encompassed Hereford, Worcester, Glamorgan and Gwent, with Brecon probably being a vassal kingdom. Thus Meurig controlled the lands of the Celtic tribe, the Silures. He helped found Llancarfan and Llandaff monasteries. Meurig seems to have been the pendragon or dux bellorum, the leader of the British in their constant battles against the encroaching pagan Saxons and Picts. His sons were ARTHUR, Idnert, Frioc and Comerg. His daughters all married the sons of the King of Brittany, Emyr Llydaw (Budic II). Thus Anna married Prince Amwn Ddu of Llydaw, Afrella married Prince Umbrafael and Gwenonwy married Gwyndaf Hen. This partially accounts for Arthur's prominence in Breton history.

MIDDLE AGES 1300-1536 From *c.* 1320, environmental changes led to a decrease in the population, which would not return to the level of 1300 for another 250 years. The BLACK DEATH and plague (1348/49, 1361 and 1369) meant that there arose a demand for free labourers, as so many bondmen (taeogion) had died. There were far fewer freemen (boneddigion), and also there was a change to the English system of inheritance based upon that of England, where the eldest son inherited everything. This meant that Wales started to see larger estates bequeathed. Wales still suffered under unequal laws and taxes, which helped stimulate the war of liberation under Owain Glyndŵr (1400-1415). The Glyndŵr War is now seen as central to the Welsh identity and nationhood, but it was not for another generation that the country began to recover, and the Welsh gentry began to co-operate with the English authorities.

MILFORD HAVEN, ABERDAUGLEDDAU Described by Nelson as one of the finest natural harbours in the world, Henry II invaded Ireland from here and Henry VII landed from France to overcome Richard III. The town was founded in 1719 by William Hamilton, the husband of Nelson's mistress Emma. The size of the estuary has attracted oil terminals and tankers. Its Welsh name, Aberdaugleddau, means that it is at the mouth of where the two Cleddau rivers meet.

MILITARY HISTORY Welsh military history falls into distinct phases -
1. The arrival of the new wave of Celts around 600 BCE – other waves of Celts had arrived previously;
2. The Roman Occupation from 78 CE to around 390 CE;
3. The Dark Ages until *c.* 600 CE, which saw the rise of Christianity ('The Age of the Saints' in Wales, but The Dark Ages across the rest of Europe). This was the time of the Celts fighting against the Picts and Irish invaders, and the time of the fabled Arthur;
4. The Welsh Kingdoms fighting and uniting under Rhodri Mawr, Hywel Dda, and Gruffydd ap Llywelyn against the Vikings, Irish and Anglo-Saxons until 1066;
5. The fight against the Normans by the Welsh Princes including Owain Gwynedd and the two Llywelyns until the 1282 Statute of Rhuddlan;
6. Plantagenet oppression, with the Glyndŵr Rebellion of 1400-1415, until 1485;
7. The Wars of the Roses, and the taking of the English throne by the Welsh Tudor (Tudur, Tewdwr) dynasty at the Battle of Bosworth Field in 1485;
8. The English Civil War period.

MILLER, WILLIAM HALLOWES (1801-1880) From Velindre near Llandovery, he was the founder of atomic crystallography, and as a young man was appointed to the life Chair of Mineralogy at Cambridge. Miller was Professor from 1832 until 1870. Succeeded by another young Welshman, they held the chair for an astonishing ninety-four years between them. *Miller Indices* are a

symbolic vector representation of an atomic plane in a crystal lattice, and are used to describe planes and directions in a crystal. The mineral Millerite is named after him.

MINERALS Wales is being systematically quarried for granite and road-building materials. Geologically, it has been blessed with minerals of value, which has often been of little benefit to the Welsh people. In no less than six types of mineral production and technology, Wales was once the world leader – coal, copper, gold, slate, tin and iron-working. It was also important in silver and lead-mining. Wales is a wonderful place to study and explore industrial archaeology. Many major sites are either heritage centres, or surrounded by natural woodlands and wildlife. One, Blaenafon, has become a World Heritage Site, and Pontcysyllte has recently joined it. Of course, the owners of the minerals were mainly English (except for a few coal pits owned by David Davies), and all the wealth has been stripped out of Wales with minimal input, unless one counts the restoration of Cardiff Castle and Castell Coch by the (Scottish) Marquis of Bute. There are twelve classifications of the periods of rock formations that make up the world, in order of oldest to youngest being: the Pre-Cambrian, Cambrian, Ordovician, Silurian, Devonian, Carboniferous, Permian, Triassic, Jurassic, Cretaceous, Tertiary and Quaternary. The oldest two refer to Wales, the next two to South and North Wales Celtic tribes, and the fifth to our British cousins across the Bristol Channel. As well as stone being extracted across Wales, scarring landscapes, the massive extraction of sand from the Bristol Channel has meant huge losses of sand from South Wales beaches in this author's lifetime. As well as minerals, valleys have been compulsorily dammed for water to be taken to England, and mountains covered with foreign trees which acidify the soil forever. Thus the land, seas and waters have been exploited, leaving only the wind, which is also being harnessed by foreign wind farms for use in England. Wales already produces more than twice the electricity it needs. It is a very small country, and despoliation of landscape and resources has a much greater effect compared to that in larger nations. However, as long as the Welsh Assembly Government does exactly what Westminster orders it to do, and Westminster does exactly what Brussels and Strasbourg orders it to do, there is no hope for any democratic debate upon the landscape of Wales.

MOEL ARTHUR HILLFORT At Nannerch, and near Offa's Dyke, a well-defended site with inward ramparts defending the entrance.

MOEL Y CLODDIAU HILLFORT Near Moel Arthur, and also known as Pen y Cloddiau, this Flintshire hillfort in the Clwydian Hills is one of the largest in Wales. Moel means '(the top of) a bare hill', and Cloddiau means 'banks'.

MOEL FENLLI HILLFORT Near Rhuthun (Ruthin) and the two previous hillforts, it is the highest of the hillforts in the Clwydian Hills, with strong northern defences and inturned banks defending its entrance.

MOELFRE, BATTLE OF, 1157 This was a sea battle (also called Tal Moelfre), outside Moelfre Harbour, between the men of Anglesey and Henry II's fleet, which was heading to Rhuddlan to support him. Owain Gwynedd's sons had defeated Henry at Coles Hill, and Henry's men had been looting churches in Anglesey when attacked. The battle continued into the harbour. Henry's half-brother, leading the fleet, was killed. The battle was celebrated by Gwalchmai, Owain Gwynedd's court poet.

MOEL TŶ UCHAF STONE CIRCLE On the western edge of the Berwyn Mountains, 1,263 feet above sea level, there remain forty-one stones in this 'kerb-circle'. It seems to have been an astronomical site, but in its centre was a stone-lined 'cist' grave. Nearby is a platform cairn, other grave sites, Bwrdd Arthur (Arthur's Table) and the prehistoric 'Ring of Tyfos'. Moel Tŷ Uchaf lies on the ancient track known as Ffordd Saeson (Saxons' Road) which links the Dee and Ceiriog valleys.

MOEL Y DON, BATTLE OF, 1282 Luke de Tany and Roger Clifford, having subdued Anglesey, crossed the Menai Straits against the king's orders. Their force was made up of 40 lances, 300 men-at-arms and up to 2,000 foot-soldiers and it was comprehensively defeated. Tany and Clifford were killed.

MOEL Y GAER HILLFORT On the top of Halkyn Mountain, near Mold, it commands views across the Clwydian Hills with its chain of hillforts, and across the Dee Estuary to Lancashire. Caches of slingstones have been found there.

MOEL Y GAER HILLFORT Surmounting Llantysilio Mountain, it can be accessed from Horseshoe Pass.

MOLD This market town is the administrative capital of Clwyd, and is surrounded by burial mounds. The Welsh-language novelist Daniel Owen (1836-1895) was born here.

MOLD, BATTLE OF, 1199 With the death of Owain Gwynedd in 1170, the Normans had made constant fresh attempts to take over North Wales. Llywelyn the Great, by 1199, had gained the loyalty of most of the nobles of eastern Gwynedd, and planned a campaign to reduce the Norman incursions from their castles situated on the border. When the winter began, he set out to attack the powerful border fortress of Mold, seventy-five miles from his base at Dolwyddelan. His chosen route was over the mountains, and men and horses slipped in the snow and ice, falling off narrow pathways to their deaths. Llywelyn had hoped to take Mold castle by surprise, but the garrison fended off his initial attack. Therefore, while one section of his men kept up the attempt to break in at the original position, his reserves, having manoeuvred into position undercover of woodland, attacked simultaneously two new positions of the castle's defences. Successful entry soon caused the Anglo/Norman garrison to surrender. Determined to reduce the use of Mold as a staging post for any further advances by Normans, Llywelyn ordered it to be burnt. The smoke was seen from Chester twenty miles away to the east. Llywelyn now began incursions into western Gwynedd, and one after another local leaders were brought under control. By Christmas 1199 he had achieved his goal of being Prince of all of Gwynedd.

MOLD CASTLE The Norman motte and bailey may date from 1140, and it was taken by the Welsh in 1146. Henry II recovered it in 1167. Owain Gwynedd captured it in 1170, the year of his death. Llywelyn I burnt it in 1199.

MOLD GOLD CAPE This is one of Britain's most famous ancient artifacts. Alongside the Caergwrle Bowl, it is one of the most important European Bronze Age finds, being discovered in 1833. Workmen were digging for stone in a mound at Bryn yr Ellyllon (Hill of the Sceptre), near Mold, when they uncovered a stone lined burial chamber. The cape was crushed, and was further damaged as it was shared out between the finders. Initially, the cape was dated to the Dark Ages, as it was seen as too ornate to be dated before the Romans, and its style was obviously not Roman. In the late nineteenth century, academics realized that the Bronze Age came before the Iron Age, and the Cape was dated to the earlier period, probably dating from 1950-1550 BCE. Recent research indicates that it may have been designed for a woman, and the grave goods, especially amber beads, also point to its owner being female. There are a number of important finds from the Bronze Age in northeast Wales: the Caergwrle Bowl (a shale, tin and gold bowl, the design of which forms a boat), the Westminster Torc (a twisted gold neck ornament), the Rossett Hoard (a socketed axe and pieces of a gold bracelet and two pieces of a knife), the Burton Hoard (a hoard containing a unique collection of bronze palstave axes and gold jewellery of great craftsmanship) and the Acton Hoard (a collection of bronze axes that point to a strong bronze working tradition in this area).

MONEY The earliest form of money in Britain was sword blades, and the earliest Celtic coins were pure gold imitations of Phillip II of Macedon's saters, around 125 BCE. Later, silver and potin (copper and tin) coins were minted. The Romans introduced their own coinage, but 'after the fall of Rome, Britain showed the unique spectacle of being the only Roman province to withdraw completely from using coined money for nearly 200 years' (G. Davies, *A History of Money*, University of Wales Press, 1994). Wales lagged behind the rest of the UK in readopting coins, using cattle (capital, chattels and cattle have a common root in linguistic development). The Welsh word 'da' means good as an adjective, but goods or cattle when used as a noun. Fortunately, while fighting off the Anglo-Saxon threat, the Celts were spared the Danish method of enforcing poll tax in Ireland and parts of England. Non-payers there had their noses slit, hence the expression 'to pay through the nose'. Coins were struck for Hwyel Dda in the tenth century and possibly for Llywelyn the Great. Llywelyn ap Cadwgan had coins struck at the mint of William Rufus in Rhydygors in Carmarthen. They were impressed 'Llywelyn ap Cadwgan Rex', in the last decade of the twelfth century. The Swan public house in Llanilltud Fawr was supposed to have been a mint for the last Welsh princes of Glamorgan (Morgannwg), and 'Mint Field' is the name of an adjacent house. Llanbadarn was also said to have minted coins for Welsh princes. Recent evidence suggests that there was a mint in Cardiff in 1080, one at Llantwit Major and perhaps also one at St David's. The Royal Mint is situated in Llantrisant, and has its origins back in 287 CE, making it the world's oldest company, according to *The Guinness Book of Records*. It produces money for over fifty countries.

MONMOUTH This is the only town with a fortified gateway on a bridge in Britain. 'Monmow Bridge' over the River Mynwy is thirteenth century and once possessed a portcullis and a rampart for sentries. Only three such stone gated bridges survive in Europe. King Henry V, 'Harry of Monmouth' of Agincourt glory, who finally ended Glyndŵr's dreams of an independent Wales, was born here, and his statue is on the wall of the eighteenth-century Shire Hall. There was also a Roman fort here, named Blestium. The nearby Naval Temple on top of the Kymin was built in 1800, to commemorate British admirals.

MONMOUTH CASTLE It was used to control the Welsh between the Severn and Wye river valleys. The castle was largely destroyed in the English Civil War, when it changed hands three times. Therefore only part of the Great Tower and Hall remains. In 1673 the Duke of Beaufort built Great Castle House on the castle site, using its materials.

MONMOUTHSHIRE AND BRECON CANAL Built in 1812, it follows the Usk Valley for thirty-three miles through beautiful scenery. There are only six locks, of which five are in one flight, a tunnel and an aqueduct. More than twenty miles are on one level, the longest in Britain.

MONMOUTHSHIRE Monmouthshire (Sir Fynwy) is one of thirteen historic counties of Wales, covering southeast Wales, and was formed from the Welsh Marches by the Laws in Wales Act of 1535. The county was traditionally divided into six hundreds, or cantrefi: Abergafenni, Caldicot, Raglan, Skenfrith, Usk and Wentloog. In 1891, Newport was granted county borough status, and there was one municipal borough, Monmouth. The administrative county of Monmouthshire was abolished in 1974, most of it becoming the new county of Gwent. Because Monmouthshire was a Marcher territory, it was not until 1974 that the legal definition of Wales would include Monmouthshire.

MONROE, PRESIDENT JAMES (1758-1831) Of Welsh descent, the Secretary of State under Madison, and also Secretary of War, he was President from 1816 to 1825. In the 1820 election, he would have been elected unanimously, but one vote was cast against him so that Washington would remain the only US President elected unopposed.

MONTGOMERY (TREFALDWYN) With a population of just 1,000, this Georgian gem of a town used to be the smallest borough in England and Wales.

MONTGOMERY, BATTLE OF, 1644 This was the largest battle of the Civil War in Wales, fought to gain control of the town and castle of Montgomery, as it controlled access to mid-Wales. The castle was held for the King by Lord Herbert of Chirbury, and after a Parliamentary force under Sir Thomas Myddleton occupied the town, Herbert surrendered the castle to him in September. Soon, Sir Michael Ernley had gathered together a Royalist force, which managed to surprise the Parliamentarians, who were divided, with 500 infantry remaining under siege in the castle, and Myddleton escaping to Shrewsbury, where he raised a force of 3,000 men, to return to Montgomery. The Royalists meanwhile, had increased their force to around 4,000-5,000 men. The two sides met on 17 September 1644, probably close to the River Camlad. The Royalists had the best of the initial fighting, but the better-disciplined Parliamentarians were able to regroup, and secured Parliament's control of the castle. Two thousand Royalists were killed or captured.

MONTGOMERY CASTLE This was built by Henry III to control the approaches to Central Wales in his campaign against Llywelyn the Great. It was constructed between 1224 and 1251, and survived an attack by Llywelyn in 1228. In 1231 he attacked again but only succeeded in burning the town, and Dafydd ap Llywelyn unsuccessfully besieged it in 1245. Town walls were built in 1279-1280, and more buildings were added to the castle after the defeat of Llywelyn the Last in 1282. The Herberts were forced to surrender it to Parliamentarians in the Civil War, when much was demolished, including their mansion in its grounds.

MONTGOMERY, TREATY OF, 1267 Henry III ratified the claim of Llywelyn ap Gruffydd, Llywelyn II to the title of Prince of Wales.

MONTGOMERYSHIRE Montgomeryshire in Welsh is known as the shire of the place of Maldwyn, Sir Drefaldwyn, and is one of thirteen historic counties, being roughly the kingdom of Powys Wenwynwyn. Its English name comes from one of William I's counsellors, Roger de Montgomerie, who became the First Earl of Shrewsbury. Montgomery is the county town, sharing administrative functions with the larger Machynlleth. Its cantrefi included Cyfeiliog Arwystli, Mawddwy, Mochnant, Deuddwy, Ystrad Marchell and Gorddwr, and its lordships included Cedewain and Mechain. Its main towns include Llanfyllin, Newtown and Welshpool.

MORGAN, CLIFF (1930-) He joined Cardiff Rugby Club straight from school in 1949, and won 29 Welsh caps as outside-half between 1951 and 1958. In 1952 he won a Grand Slam, and in 1953 was in the side which famously beat New Zealand. Morgan toured with the British Lions and was for many years the most exciting rugby player in the British Isles. He became a noted BBC broadcaster after his retirement from the game.

MORGAN, GODFREY CHARLES, LORD TREDEGAR (1831-1913) Present at the Charge of The Light Brigade, he was created first Viscount Tredegar in 1905, having become the second Baron Tredegar in 1875 upon the death of his father. However, he was unmarried and the direct line of Morgans died with him. He was MP for Brecon from 1858-1875. Of more than passing interest is his horse, Sir Briggs. He is buried in the cedar garden of Tredegar House. The inscription reads: 'In Memory of Sir Briggs: Favourite charger. He carried his master the Hon. Godfrey Morgan, Captain Seventeenth Lancers boldly and well at the Battle of Alma, in the first line of the Light Cavalry Charge at Balaclava and the battle of Inkerman, 1854. He died at Tredegar Park February sixth 1874. Aged twenty-eight years'. Sir Briggs was bought in 1851, the same year he won the hunt steeple chase at Cambridge, and he also won at Cowbridge races with Godfrey Morgan riding him. At Balaclava Sir Briggs carried Morgan through the fateful Charge of the Light Brigade. The exact number taking part in the charge is controversial, between 661

and 673, and only 195 men came back to the English lines. Sir Briggs received a sabre cut to the forehead. Sir Briggs also saw action in charges at Inkerman. Godfrey Morgan became sick and returned to Constantinople. Sir Briggs remained in the Crimea with Godfrey's brother, Frederick Morgan, and was used as his staff horse. In the same year that Sebastopol fell, Sir Briggs won the military steeplechase at Sebastopol. In 1855 Sir Briggs returned to Tredegar House, where he was finally buried. Forget *Sea Biscuit* – if any horse deserves a film, it is Sir Briggs.

MORGAN, ELAINE (1920-) A respected novelist and playwright from Pontypridd, she resented the sexist Desmond Morris hypothesis in *The Naked Ape* that women had developed breasts purely to attract men. She went on to develop her theories in *The Aquatic Ape, The Scars of Evolution, The Descent of the Child* and *The Aquatic Ape Hypothesis*. She believes, unlike most biologists and paleoanthropologists, that mankind spent between 1-2 million years of its evolutionary life in water. Fat only occurs in two types of mammal, hibernating or aquatic. Unlike the apes, human infants are born fat and become fatter, as they had no need to live in trees. We have skin adapted for water, rather than layers of fur, human babies can swim from birth, and there appears to be no one who can disprove this remarkable woman's theories. Her research since this time, especially *The Aquatic Ape Hypothesis*, makes a compelling case for a total revision of evolutionary theory. Many anthropologists at last agree that life evolved in the seas rather than on the African savannah. Her husband Morien Morgan was a hero of the Spanish Civil War.

MORGAN, ADMIRAL SIR HENRY (1635-1688) 'Privateering' was the practice of the state commissioning privately-owned ships to attack enemy merchant ships. It was far cheaper than trying to run a navy. Privateering came into its own with the sea-dog captains of the Elizabethan Age, men such as Drake, Hawkins, Frobisher and Raleigh. Legally sanctioned, it was fundamentally different from piracy, which preyed on all shipping, in that it focused upon enemy ships only. The Crown often sold privateering licences in return for a cut of the spoils. Many of the privateers who fought the Spaniards in the seventeenth century became known as buccaneers, from the French '*boucaniers*', meaning sun-dryers of meat. The most famous and successful of all the buccaneers and privateers was a Welshman, Henry Morgan. He was a cousin of the Morgans that owned Tredegar Park outside Newport. He was born the son of a gentleman farmer, probably in Llanrhymni Hall or nearby Penkarne. Morgan set sail from Bristol at the age of twenty, with the Penn-Venables Expedition which failed to take Hispaniola. In 1655 Jamaica was seized from Spain to serve as a base for freebooting French, Dutch and British privateers to operate against Spanish America. He sailed out of Jamaica, and was so successful that within two years his share of the booty enabled him to buy his own ship. Aged just twenty-nine, he now used Jamaica as his base, and from here he harassed the Spanish on the American mainland, and built up an enormous treasure trove. When the Spanish started attacking British ships off Cuba, the Governor of Jamaica asked Morgan to return and scatter the Spanish fleet. Morgan was then made Admiral of the Jamaican fleet of ten ships and 500 men, because of his courage and success.

Well documented is Morgan's sacking of Puerto Principe (now Camaguey in Cuba) in 1668. In the same year, he looted and ransacked the largest city in Cuba, Porto Bello, and Maracaibo in Venezuela. His actions are too numerous to recount here, but he plundered a quarter of a million pieces of gold and silver coins, jewellery, silks, spices, munitions, weapons and slaves. Captain Morgan acquired a reputation that attracted seafarers from all over the West Indies to join his flag. Morgan was put in charge of thirty-five ships and 2,000 men. Aged just thirty-five, he decided to try and break the power of Spain in the West Indies by attacking Panama, the richest town in the Americas. Meanwhile, Britain and Spain had negotiated peace in London and orders were despatched to him to call off any attacks on Spanish colonies. Morgan ignored the orders, reached the mainland in 1670, and marched across the Isthmus of Panama towards the city. In the course of this devastating raid, Morgan and his men succumbed to the heat and

disease as they hacked their way through the jungle. By the time he reached Panama, in January 1671, Morgan had fewer than 800 of his original 2,000 men left, but he attacked the defending Spaniards with such venom that they fled the city.

The Spanish put a price on Morgan's head, and as the raid had occurred in peace-time, he was arrested and extradited to London in 1672. Charles II had endured the Great Plague, the Great Fire of London and the Dutch fleet had sailed up the Medway and sunk his fleet. Charles' position was in jeopardy and there was no way that he could execute Britain's greatest hero, known as 'the sword of England', and keep his throne. King Charles II knighted Morgan and sent him back to Jamaica as Lieutenant Governor of the island, where Morgan died, a successful planter, at the age of fifty-two in 1688. The English translation publishers of Exquemelin's contemporary book, *The Buccaneers of America* were sued by Morgan for calling him a 'pirate', and questioning his upbringing, in 1685. This was the first ever recorded case of damages being paid and apologies being made for libel. The greatest and most successful privateer of all time, Morgan is also one of Britain's most successful generals. This author has translated Exquemelin as *The Illustrated Pirate Diaries: A Remarkable Eye-witness Account of Captain Morgan and the Buccaneers*, and has also written *Admiral Sir Henry Morgan: The Greatest Buccaneer of Them All*, pointing to the fact that Morgan was one of the greatest generals in history. He invaded inland Spanish possessions on six occasions, defeating greater forces each time.

MORGAN, JOHN PIERPOINT (1837-1913) This eminent banker single-handedly saved the USA from bankruptcy on at least two occasions, and was 'the most powerful man in America.' He founded GE (General Electric), IMM (International Mercantile Marine, which built the *Titanic*, and ATT. He sat on the boards of dozens of companies and left his great art collection to the Metropolitan Museum of Fine Art. Morgan had built his father's firm into most influential private banking house in the USA. After the 1893 financial panic, Morgan formed a syndicate to float a dollar bond issue for President Grover Cleveland, to finance an increased gold reserve. This stabilised the American economy. His bank financed the development of the railroad system to open up America. He set up US Steel Corporation in 1901, then the largest corporation in the world, and International Harvester in 1902. Morgan controlled large chunks of the economy, including the Equitable Life Assurance Society. In 1988, Bill Gates' worth was around $51 billion owing to his Microsoft shares. However, Morgan controlled a percentage of American GDP many times greater than that of Gates. Peter Drucker calculated that Morgan alone had been able to finance all of America's private and public capital investments for four months. In 1998 it would have required the wealth of the top sixty American billionaires combined. Morgan was the driving force behind making America the world leader in production, its multinational corporations, and its railroad, financial, shipping, telephone, steel and electrical industries.

MORGAN, LEWIS HENRY (1818-1881) Marx and Engels were heavily influenced by the Welshmen Robert Owen and Richard Price, but Morgan was hailed by them as giving independent confirmation of their materialist theory of history. His *Ancient Society*, a treatise upon the origins of the institutions of government and property, had followed pioneering studies on the North-American Indians from 1851-69. Morgan also appears to be the first author to argue that animals possess powers of rational thought.

MORGAN, GENERAL SIR THOMAS He was the uncle of Sir HENRY MORGAN and was a Parliamentarian general in the English Civil War. His brother Edward was a Royalist General. This was probably to preserve the family's Llanrumney (Llanrhymni) estate from confiscation, whichever side won. General Sir Thomas Morgan was greatly favoured by Cromwell, a veteran of the Thirty Years War and an expert in sieges and cavalry tactics. After Richard Cromwell was deposed, there was a stalemate between Lilburne's Parliamentarians who wanted a republic and General Monck who wished Charles II to return from exile. Both factions courted Thomas

Morgan to join them. Morgan's cavalry support for Monck was the decisive act in restoring the monarchy. Henry Morgan's other uncle, Sir Edward, was famed as the 'Heer van Lanrumny' in the Thirty Years War, and went into exile with Charles II. He was rewarded with the Governorship of Jamaica, where his daughter Elizabeth met and married her cousin Henry.

MORGAN, BISHOP WILLIAM (1545-1604) Born at Penmachno, Nant Conwy, his place of birth is open to the public. Vicar of Llanrhaeadr-ym-Mochnant and Llanarmon, he spent twenty years translating the Bible into Welsh. An Act of Parliament had been passed in 1563 allowing the translation of the Bible and the Book of Common Prayer because the 'English tongue is not understood' by most people in Wales. His *Welsh Bible* was published in 1588, and he was made Bishop of Llandaf and then Bishop of St Asaf. The translation not only ensured the survival of the language, but also Meic Stephens commented that 'The Bible of 1688 was as influential in keeping alive the idea of an independent Wales as the defeat of the Armada was in maintaining England's independence.'

MORGAN, WILLIAM, FRS (1750-1833) A medical doctor and schoolmaster, he was probably the first man to produce X-Rays when he passed electricity through an almost airless tube. RICHARD PRICE had been instrumental in securing the appointment of his nephew William Morgan, who rapidly succeeded to the post of Actuary at the Equitable Society, and by whose industry the Society was raised to unparalleled prosperity in over fifty years of service. At his uncle's instigation, Morgan conducted the first ever valuation in 1776, and wrote an early book entitled: *The Doctrine of Annuities and Assurances on Lives and Survivorships* in 1779. The importance of this paper was the understanding that the premiums charged for any assurance cover must be calculated with reference to statistical experience. Morgan used a hypothetical table for his paper, in which, of eighty-six births, there was one death every year until the age of eighty-six. Morgan's work also enabled the Equitable to be the first office to pay a bonus on a policy, and he is regarded as 'The Father of Actuarial Science'. Morgan advised Scottish Widows how to set up an office, and Morgan's son and grandson were also actuaries.

MORGRAIG CASTLE Lost until 1895, this lies on Cefn Onn ridge above Cardiff, a five-towered thirteenth-century castle. Lying between Welsh Senghennydd and English Glamorgan, there has been discussion as to whether it is a Welsh or Norman castle. It was possibly built by the de Clares, because of the existence of Sutton stone from a quarry in the Vale of Glamorgan, which Welsh builders may not have been able to access at that time.

MORLAIS CASTLE Near Merthyr, in an Iron Age fort above the Taff Gorge are the remains of a large castle of Gilbert de Clare, Earl of Gloucester. The land was claimed by Humphrey de Bohun, Earl of Hereford and war broke out between them in 1290. They were both fined by Edward I who had to march from North Wales to intervene. It was taken by Madog ap Llywelyn in 1294 and never fully completed.

MORMONS The Mormon Tabernacle Choir was formed by 249 Welsh Mormon immigrants, in 1848 in Salt Lake City.

MORRIS, SIR LEWIS (1833-1907) From Carmarthen, he wrote verse and drama, largely drawing on incidents in Welsh history and mythology, as in *The Epic of Hades*. Morris campaigned tirelessly for a national university in Wales.

MORTIMER'S CROSS, BATTLE OF, 1461 Owen Tudor, the husband of Catherine of Valois, was executed in the market-place at Hereford after this Lancastrian defeat. Two of his sons were Jasper, Earl of Pembroke, and Edmund, Earl of Richmond. Edmund's posthumous son was Henry VII, helped to the throne by his uncle Jasper.

MUSEUM OF WELSH LIFE Just outside Cardiff is the Museum of Welsh Life at St Fagan's Castle. This has been an example for the rest of the world to follow since its inception in 1946. Chapels, a cockpit, a toll-house, ancient farmhouses, a working woollen mill, farm workers' cottages etc. from all over Wales have been rescued and restored with original furniture. Even a Miners' Institute has been moved there and reinstated – a former heart of learning where colliers could gain access to thousands of that precious commodity, books, for a penny a week. My mother, from Mid-Wales, remembers the (working) smithy as a girl, and more especially the Tannery. It was situated well outside Trefeglwys in Montgomery because of its terrible smell, when guard dog faeces were used in the leather curing process. Craftsmen like potters, coopers and wood-turners can be seen working at the museum.

MUSIC *Ar Hyd Y Nos (All Through The Night), Hiraeth, Calon Lan, Bugeilio'r Gwenith Gwyn, The Maid of Cefn Iddfa, Sospan Fach, Llwyn Onn (The Ash Grove), Clychau Aberdyfi (The Bells of Aberdyfi), Codiad yr Hedydd (The Rising of the Lark), Y Deryn Pur (The Dove), Y Fwyalchen (The Blackbird), Syr Harri Ddu (Black Sir Harry). Dafydd y Garreg Wen (David of the White Rock), Nos Galan (New Year's Eve), Pantyfedwen, Men of Harlech, Cwm Rhondda (Guide Me O Thou Great Jehovah), The Maid of Cefn Iddfa, Myfanwy* and *Cartref* are all Welsh songs that are known across the country and in every choir's repertoire. Some, like *Men of Harlech*, are over five hundred years old. The ninety-year-old Welsh Folk-Song Society, Cymdeithas Alawon Gwerin Cymru, is based in Aberystwyth and collects and preserves old Welsh songs.

MUTATIONS The modern words mum and dad seem to come from the Welsh 'mam' and 'tad', where the 'tad' is soft-mutated to 'dad'. Mutations are probably the major area of difficulty in learning the Welsh language – often initial consonants change, for instance Cardiff is 'Caerdydd' in Welsh, and 'in' is 'yn'. However, 'in Cardiff' is not 'yn Caerdydd' but instead 'yng Nghaerdydd'. 'To Cardiff' in Welsh is not 'i Caerdydd' but 'i Gaerdydd'. 'And Cardiff' is not 'a Caerdydd' but 'a Chaerdydd'. Only some initial consonants change, for instance the initial letters c, p and t are subject to soft, nasal and spirate/aspirate mutations, whereas b, d and g are subject to just soft and nasal mutations and the consonants of ll, m and rh only soft-mutate. Very, very few words of the ancient British language are found in the English language, itself an amalgam of French and German. Apart from mum and dad, as noted, there are very few words such as cuckoo (from cyw, cyw), flannel and gammy (from the Welsh cam), which is one of the reasons why Welsh is such a special language. One of the ubiquitous reality TV shows dealing with relocation to the countryside was presented in November 2008 by an Englishman, who himself had relocated to Wales some years back, for a better quality of life. He took prospective purchasers from Manchester to a house near Llanfyllin, during which he pronounced the 'fyllin' component as 'filling' without the g. Thus he mispronounced the f, y and ll – three successive consonants. Compounding the mistake, for someone who lives in Wales, he proudly showed them the nearby 'St Fyllin's Well'. There is no St Fyllin, Fyllin being a soft mutation of Myllin, as explained below. For anyone learning Welsh, usually locals will correct you, although you can get by without knowing the rules for mutating words. The table below explains better:

Consonant	Word	Soft	Nasal	Spirant
c	Caerdydd			
Cardiff	Gaerdydd	Nghaerdydd	Chaerdydd	
p	pen			
head	ben	mhen	Phen	
t	tad			
father	dad	nhad	Thad	
b	bach			

small	fach	mach		
d	dyn			
man	ddyn	nyn		
g	glas			
blue/green	las	nglas		
ll	llawen			
merry	lawen			
m	mam			
mother	fam			
rh	rhyd			
ford	ryd			

MYDDFAI Myddfai near Llanddeusant was the home of the 'Physicians of Myddfai' in mediaeval times, a family which was celebrated throughout Wales for their cures, a curious inter-tangling of mythology and fact with the Lady of the Lake (of Llyn y Fan Fach). Rhiwallon and his three sons were physicians to Rhys Grug, Lord of Dinefwr, who died in 1234. Their folk remedies were recorded in mediaeval manuscripts dating from the thirteenth century, and collected and published in book form in 1861 (recently re-published). The last descendant of these physicians was said to be John Williams, doctor to Queen Victoria.

MYNYDD CARN, BATTLE OF, 1081 This was part of the dynastic struggle for control of the kingdoms of Gwynedd and Deheubarth. Gruffydd ap Cynan had tried to gain the kingdom of Gwynedd from Trahaearn ap Caradog in 1075, but had been beaten and forced to take refuge in Ireland. He returned with a force of Dublin Vikings and Irish in 1081, landing near St David's and meeting Rhys ap Tewdwr, King of Deheubarth. Rhys had recently been driven from power by Caradog ap Gruffydd of Glamorgan (Gwynlliwg), helped by Meilyr ap Rhiwallon of Powys and Trahaearn ap Caradog. Rhys and Gruffydd decided to combine forces to fight their rival princes. The battle occurred a day's march north of St David's. Caradog ap Gruffydd, King of Gwynlliwg, and Trahaearn ap Caradog, King of Gwynedd were killed by Gruffydd ap Cynan and Rhys ap Tewdwr, and they regained control of Gwynedd and Deheubarth respectively.

MYNYDD LLANGATTCOCK (LLANGATTWG), BATTLE OF, 728 Ethelbert of Mercia fought with Rhydderch (Molwynog) ap Idwal of Glamorgan and two huge cairns are supposed to be where the dead are buried. The remains of a warrior were found in one. The Mercians were chased back to the River Usk, where many were drowned.

NAMES Because of the relatively few numbers of Welsh Christian names and surnames, e.g. Jones (John, Johns), Evans (Evan, Bevan), Roberts (Robert, Probert), Davies (David, Davis), Howell (Howells, Powell), Williams (William) etc. It became usual for Welshmen to acquire nicknames. I heard of a docker who used to vanish after clocking in for work, until home time, when he mysteriously reappeared to clock off. He was known as 'Dai Man from Atlantis' after the TV series of the time. In some villages, there might be 'Jones the Milk', 'Jones the Butcher', 'Jones the Top Farm', 'Jones the Coal', and so on. The great entrepreneur David Davies was known as ' Davies Llandinam', 'Davies Top Sawyer', then 'Davies the Railway', and finally 'Davies the Ocean' as his career progressed. A much decorated war veteran was nicknamed 'Dai Alphabet' because of all the initials he was entitled to wear. I remember someone known as 'Dai Bananas', who was not thought to be very bright, and another man called 'Dai Barking' because he was, in the colloquialism, 'barking mad'. 'Emlyn Kremlin' was supposed to have been a Marxist agitator in Maerdy. A travel agent in one town was known as Evans 'There and Back', and the funeral director was Evans 'One-Way'. The

electrician was 'Electric Bill' and a plumber with one tooth was Dai 'Central Eating'. In Mumbles, a man was mentioned so often in the local newspaper that he was ironically called Mr X, and Richard Evans, who ran the Mermaid pub was known as 'Dick the Fish'. I knew a petty tyrant who rose from a clerk's job to a position of power, so became 'Dai Posh', as he spoke in a strangulated 'English' accent to disguise his Rhondda Valleys roots. The 'posh' was pronounced as 'poesh' to further accentuate his estrangement from reality, and the jocularity which his affectation occasioned.

Other descriptive names like Fechan or Fychan 'the Small', and Goch, 'the red-haired' were transmuted over time into Vaughan, and Gough or Gooch. The émigré painter, Josef Herman, said that he knew he was accepted by the mining community at Ystradgynlais when he was called 'Jo Fach', Little Joe. Some leading Welsh families took English names, for instance William ap William of Raglan Castle (Black William) was forced to take the name of Herbert by the English crown during The Wars of the Roses. Similarly the Lord Gruffydd ap Gwenwynwyn was forced to drop the ancient suffix of the Prince Gwenwynwyn of Powys, by Edward I. Edward not only made him renounce his royal titles, but made him accept the title Baron de la Pole, or forfeit all his estates around Powys Castle. Surnames that usually denote a Welsh ancestry are as follows. Ap Evan, son of Evan, often became Bevan with the language mutation before vowels (similarly ap Owen became Bowen etc.), and many other surnames are prefixed with p, for example ap Robert became Probert.

Typical surnames are: Adam/ Adams; Bevan, Bevin (son of Evan); Brangwyn; Cadwallader/ Cadwaladr; Caradoc/ Craddock; Cecil (from the Welsh Seisyllt, in turn from the Roman Sextilius); Cethin – Gethin (from the Welsh for 'fierce'); Charles; Clwyd (the region of Wales); David/ Davids/ Davis/ Davies/ Dafydd (perhaps from the Princedom of Dyfed); Dee – from du, black; Edward/ Edwards – supposedly from Iorwerth; Emyr; Evans/Evan – Bevan; Eynon, Einion – Beynon (possibly from Justinian); Gough, Gooch – from coch/ goch, red-haired; Griffith/ Griffiths – from Gruffydd; Gwilliam; Gwynne/Wynn – from gwyn/wyn 'white' or from the Princedom of Gwynedd; Gwynedd; Harry – Parry, Barry – from Harri; Herbert; Henry – Penri; Hopkin/ Hopkins – an old Flemish settler diminutive; Howel/ Howells/ Hywel – Powell; Hughes/ Huw – Pugh/ Puw/ Pew; Iestyn – from Justinian; Humphreys/ Humphries; Ifan, Ifans; James; Jenkin/ Jenkins – from Siencyn; Jones/ John/ Johns – from Latin Ioannes, which became Ieuan, Ifan, Evan; Llywelyn, Llywelyn, Lewelyn; Lewis; Lloyd/ Loyd and Floyd from Llwyd 'grey'; Madoc/ Maddocks; Map, Mapp = 'son'; Mathew/ Matthew/ Matthews; Medwyn/ Medwin – Bedwin, from Edwin; Meredith (from Maredudd); Meurig/ Merrick; Morgan/ Morgans – from the princedom of Morgannwg; Morris/ Morus – from Meurig, Latin Mauricius; Nash; Owen/ Owens – Bowen; Parry (ap Harri); Phillips/Philip; Powys – the princedom; Powell (ap Hywel); Price, Pryce, Price – ap Rhys; Pritchard (ap Richard); Probert (ap Robert); Protheroe; Pugh/ Puw (ap Huw); Rhydderch – Pritchard; Rhys/ Rees/ Reese/ Reece/ Rice – Preece/ Price; Richard/ Richards – Pritchard; Robert/ Roberts – Probert; Rosser – Prosser; Rowlands; Samuel/Samuels; Thomas/Tomos; Traherne/Treharne; Tudor/Tewdwr – from Celtic Teutorigos, Teutoris; Vaughan/ Fychan/ Vernon – from the diminutive y fechan of bach 'small' = the small one; Vivian/ Vyvyan; Watkins/ Watcyn/ Gwatkin– from the diminutive Flemish; Williams – Gwilliam; Yale/ Iâl – from the region around Wrexham; Yorath (from Iorwerth). The telephone directory for the small towns of Gaiman, Trelew and Port Madryn in Patagonia demonstrate the small number of Welsh surnames – there are: 108 Jones, 85 Williams, 42 Pugh, 40 Roberts, 38 Hughes, 31 Thomas, 22 Evans, 14 Owen, 13 Lloyd, 13 Lewis, 11 Price, 8 Griffiths and 5 Davies.

NARBERTH CASTLE Narberth is mentioned in the *Mabinogion*, and on a hill in the town. In 1116, *The Chronicle of Ystrad Fflur* notes: 'Gruffydd ap Rhys took the castle near Arberth and burned it. Many young hotheads gravitated to him and they carried off many spoils. And he burnt a castle in Gower and slew many within. And Owain ap Cadwgan was slain.' Narberth later belonged to the Mortimers, but it was forfeited to the Crown during the Glyndŵr War, as Edmund Mortimer had sided with him, and was held against Glyndŵr 's men. Its castellan, Thomas Carew, was allowed to keep the castle and its lordship as his reward, but it later reverted to the Mortimers.

NASH, 'BEAU' (1674-1761) Richard (Beau) Nash was born in Swansea in 1674, educated at Carmarthen (Caerfyrddin) Grammar School and Jesus College, Oxford. He supported himself in London as a gambler. Nash then moved to Bath in 1705 and established The Assembly Rooms, drawing up a polished code of etiquette and dress for society, and chiding The Prince of Wales upon occasions. As Master of Ceremonies, this dandy dictated society manners, bolstered by his income from the gaming rooms. Nash conducted public balls on a magnificent scale, with nobility flocking to 'take the waters' by day and to be entertained at night. The Gambling Laws of 1740-45 deprived Beau Nash of his source of income, but from 1758 until his death in 1761 the Corporation of Bath gave him an allowance of 10 guineas a month in recognition of his services in building up Bath as a spa resort. By his fashion leadership, his influence on manners and improvements in streets and building, he made Bath 'the' fashionable holiday centre of its day. *Blackwood's Magazine* in 1844 noted that he was 'a man of singular success in his frivolous style, made for a master of ceremonies, the model of all sovereigns of drinking places, absurd and ingenious, silly and shrew, avaricious and extravagant. He created Bath; he taught decency to "bucks", civility to card players, care to prodigals, and caution to Irishmen! Bath has never seen his like again.' Oliver Goldsmith claimed that 'the whole kingdom became more refined by lessons originally derived from him... (he was) the first who diffused a desire for society and an easiness of address among a whole people.'

NASH, JOHN (1752-1835) John Nash, of Haverfordwest, lived in Carmarthen from 1784-1796, designing several local houses, before he designed the wonderful Bath terraces and crescents, and the wonderfully oriental Prince Regent's Pavilion at Brighton. He laid out Regent's Park, Trafalgar Square, St James Park, Carlton House Terrace and Regent Street. He redesigned Buckingham Palace and Marble Arch and designed Nelson's Column. One of the greatest town planners, his 1779 patent for improvements to the piers and arches of bridges led the way for the introduction of steel girders in building. The beautiful house he designed in Llanerchaeron, near Aberaeron, is now a National Trust property. He is known as 'the architect of the Regency' and as 'the man who changed the face of London.'

NATIONAL ANTHEM *Mae Hen Wlad fy Nhadau* (*The Land of My Fathers*), was written by the weaver Evan James and his son James in Pontypridd in 1856, and a Goscombe John statue commemorates them near the famous Edwards Bridge. It is unusual for a national anthem in that it does not call for wars and destruction against other nations. The Welsh want no military domination overseas, no recognition of racial superiority, just survival, 'parhau'. It symbolises 'Hiraeth', the love of a country with no denigration of other parts of the world. The anthem's main thrust is 'O bydded yr hen iaith barhau' ('Oh let the old language survive'), and it was written at a time when its English masters were trying to exterminate Welsh as a language. Wales has a national psyche of defensive consciousness – it has never in over two millennia been an aggressive nation except in defence of its remaining lands. The remaining verses all end with the same plea for language survival:

Mae hen wlad fy nhadau yn annwyl I mi,
Gwlad beirdd a chantorion enwogion o fri;
Ei gwrol ryfelwyr, gwladgarwyr tra mad,
Dros ryddid collasant eu gwaed.
Gwlad, gwlad, pleidiol wyf i'm gwlad;
Tra mor yn fur i'r bur hoff bau
O bydded i'r hen iaith barhau
The old land of my fathers is dear to me,
Land of poets and singers, famous men of renown;
Its brave warriors, fine patriots,
Gave their blood for freedom.
My country, my country, I am devoted to my country,
While the sea is a wall to the pure loved land
O may the old language survive.

NATIONAL ASSEMBLY Officially opened in 1999 on Cardiff Bay, the National Assembly consists of sixty Assembly Members, elected every four years. forty are elected in constituencies using the first-past-the-post system, and the other twenty are elected to represent the five regions of Wales. The Assembly is a devolved body allocating UK Government funds, with powers that include health, education, economic development, planning and culture. The new Senedd building fronting on to Cardiff Bay was completed in 2006, joined to Crickhowell House.

NATIONAL BOTANIC GARDEN OF WALES On the site and grounds of Myddleton Hall, near Llanarthne, this has been parkland since the early 1600's, and in 1789 Joseph Paxton built a water park here. A centre for botanical research, the central glass-house and double-walled gardens are remarkable. A superb day out, (less crowded and more picturesque than the Eden Project in Cornwall), it is near ABERGLASNEY Hall.

NATIONALISM 'The present Nationalist Movement is largely the creation of ex-servicemen who saw, during the War, the incongruity of fighting for the freedom of nations abroad, while their own was still in bondage'. (Gwynfor Evans, 1945). One of the reasons that there are nationalists in Wales is the denial of its history. In 1953, the Principal Garter King of Arms, George Bellew of the College of Heraldry, stated categorically that Wales could never have a national flag as 'it had never been a kingdom'. This view was upheld by the Assistant Secretary of State, Sir Austin Strutt, and still prevails among social commentators and writers today. Wales was a kingdom hundreds of years before the English had to search Europe for petty German princes and princesses from areas the size of the Isle of Wight to become their rulers. The present German 'dynasty' has less right to a 'royal' flag representing Britain than virtually anyone walking the streets of Newcastle or Liverpool. This is a major reason for the 'rewriting of history' in Britain by Hanoverian and Victorian scholars. Welsh kings and princes were directly descended from Cunedda, around 400 CE. This was why the Normans from William the Bastard onwards, Plantagenets and the House of Lancaster were so keen to exterminate the bloodline, killing off family prisoners and assassinating the last Prince of Gwynedd, Owain Llaw Goch (Owain Lawgoch) in France in 1378. Wales is a nation, despite a level of inward immigration unparalleled elsewhere, and will still be when England divides into regions autonomous from London.

NATIONAL PARKS Wales has three National Parks, five Areas of Outstanding Natural Beauty, and hundreds of nature reserves. The Forestry Commission owns vast chunks of Wales – fortunately more recent policy has allowed the planting of some deciduous trees that leaven the dark green slabs of conifer cash crops disfiguring our mountains and valleys. 7% of Wales is now also covered with bracken. Caterpillars in Finistère, Brittany, demolish fresh young bracken fronds. With a similar climate to ours, there must be an ecological answer to the problem.
National Parks:
1. Brecon Beacons. This mountain range of 519 sq miles was designated in 1957, and covers parts of 4 counties, Mid-Glamorgan, Powys, Gwent and Dyfed. Unfortunately, some is used for military training, and not accessible.
2. Pembrokeshire Coast National Park. 225 sq miles was designated in 1952, the only coastal national park in England and Wales. Unfortunately, some is used for military training, and not accessible.
3. Snowdonia National Park. 838 sq miles in Gwynedd was designated in 1951.
Wales also has fifty National Nature Reserves, nineteen local nature reserves, and ten important Nature Reserves run by the RSPB (Royal Society for Protection of Birds). A further eight Special Protection Areas for wild birds are specified under an EC Directive. Wales also has no less than seven wetlands of international importance, and almost 900 sites of Special Scientific Interest.

NATIONAL TRUST The first piece of land bought by the National Trust is Britain was the viewpoint of Dinas Oleu near Barmouth. There are now dozens of properties and places being

conserved by the National Trust or CADW in Wales. National Trust properties include Penrhyn Castle, Plas Newydd, Powis Castle, Erddig, Conwy Suspension Bridge, Chirk Castle, Erddig, Aberconwy House, Bodnant Garden, Tenby Tudor Merchant's House, Llanerchaeron, Dinefwr Park, Colby Woodland Garden, Aberdulais Falls, Segontium Roman Fort, Plas yn Rhiw, Tŷ Mawr, Tŷ'n y Coed Uchaf, Aberdulais Falls and Dolaucothi Gold Mines.

NEATH The Roman fort of Nidum was abandoned in 120 CE. There is a central market, and the Gnoll Estate features remarkable water features.

NEATH ABBEY Founded by Richard de Granville in 1130 as a Savignac monastery, it became a Cistercian foundation in 1147, and there is a superb thirteenth century dormitory undercroft. It was turned into a factory during the Industrial Revolution.

NEATH CASTLE The site was chosen to guard a river crossing, and the first ringwork was built by Robert, Earl of Gloucester in the twelfth century. It was probably destroyed by Llywelyn the Great in 1231, but rebuilt. It was also attacked when owned by Hugh Despenser, and rebuilt again in the fourteenth century.

NENNIUS (d. 809) *'The Historian of the Britons'* had access to lost fifth and sixth-century materials for his Latin *'Historia Brittanorum'*. Of his list of twenty-eight cities in Britain, sixteen are in Wales and the West, and he also mentions Arthur and acknowledges his debt to GILDAS. Nennius describes the terrible pagan Saxon incursions into British territory, and the attacks by the Scots and Irish upon Welsh Christian foundations and princes.

NEOLITHIC & BRONZE AGES 24,000 BCE-800 BCE In the years from 1400 BCE, climate cooling meant that the high homesteads were abandoned. Wales saw the development of bronze and gold ornaments, and the manufacture of bronze axes and tools. Dinorben hillfort is the earliest dated in Wales, from about 1000 BCE, and over 600 other hillforts have been identified in Wales from the Bronze through the Iron Ages. There was some harvesting, indicated by the presence of grain mills, but from the evidence of bones, it appears that animal husbandry was the main source of food.

NEST, PRINCESS (*c.* 1080-*c.* 1145) Known as the 'Helen of Wales', she was daughter of the King of Deheubarth, RHYS AP TEWDWR, killed at BRECON in 1293. The sister of GRUFFYDD AP RHYS, who married the tragic GWENLLIAN, she was placed as a ward of the court of William II and was seduced by his son, later to become Henry I. Their first son was the first of the line of Fitzhenrys, and was made Duke of Gloucester. A beautiful woman, known as Helen of Wales, Henry arranged her marriage of his friend Gerald of Windsor, Earl of Pembroke, in a diplomatic effort to keep peace in Wales. Of their three sons, David Fitzgerald became Archbishop of St David's, and Maurice and William fought unsuccessfully to gain extra lands in Wales. Thwarted, they led the Norman invasion of Ireland, Maurice being granted Kildare by the king. Owain, the son of Prince Cadwgan of Ceredigion and Powys, saw Nest at an eisteddfod at his father's Cardigan Castle. He fell in love with her and broke into Cilgerran Castle in 1109, firing it and escaping with Nest. Cadwgan was told to restore Nest to the Earl of Pembroke, but Owain refused. Owain fled twice to Ireland before his father Cadwgan died through Norman treachery in 1111. Henry feared the growing power of his Norman barons, and now favoured Owain, who in 1115 fought for him in Normandy, being knighted. Owain was fighting for the king in South Wales in 1116, but was ambushed and killed by the vengeful Earl Gerald of Windsor and a band of Flemings. Nest returned to Gerald, but he died shortly after at Carew Castle. Nest now married Stephen, the Constable of Cardigan Castle, and their son Robert Fitzstephen was one of the conquerors of Ireland with his half-brother Maurice Fitzgerald. Nest now married the Sheriff of Pembroke, having another son. The great families of Fitzhenry, Fitzstephen, Carew, Fitzroy and Barry are all descended from Nest. She was reputed to

have had seventeen children by husbands and lovers including another one by Henry I from when he visited Wales in 1114. No less than seven of her offspring were known as 'the race of Nesta' and led the Norman Conquest of Ireland from 1169. Nest's grandson was Giraldus Cambrensis, Gerald of Wales.

NEVERN CASTLE (CASTELL NANHYFER) The original Welsh castle was taken by Robert FitzMartin in the twelfth century, but it was captured by The Lord Rhys in 1191, and given to his son Maelgwyn. The FitzMartins went on to build the castle at Newport, in Pembrokeshire. In 1194 The Lord Rhys was briefly imprisoned at Nevern by his sons Hywel Sais and Maelgwyn, but later released by Hywel. In turn, The Lord Rhys imprisoned two other rebellious sons and held them in Ystrad Meurig. In 1195 Hywel Sais destroyed the castle to stop it falling into English hands, and recently a broken board for Nine Men's Morris was found during excavations, adding to evidence suggesting that the castle had been hastily abandoned.

NEWBOROUGH (NIWBWRCH) In Gwynedd, the village dates from the uprooting of the Llanfaes population for Edward I to build Beaumaris Castle. Up until the 1920's the village was mainly involved in weaving baskets, mats and ropes from the marram grass upon the massive sand-dune complex of Newborough Warren. Now a National Nature Reserve, the six hundred acres are home to Soay Sheep, red squirrels and goldcrests. The renowned bird artist Charles Tunnicliffe lived here from 1945 until his death in 1979.

NEWCASTLE In Bridgend, and guarding a crossing on the River Ogmore (Ogŵr), the castle was the furthest western possession of Robert FitzHamon, dating from around 1106. Henry II expanded it in the 1180's.

NEWCASTLE EMLYN CASTLE In a loop overlooking the Teifi, it was possibly founded by Maredudd ap Rhys in 1240, and then held by his son Rhys ap Maredudd from 1287. It changed hands three times between Rhys and the king until Rhys was defeated and killed. In 1403 it was taken by Owain Glyndŵr's forces, and Sir Rhys ap Thomas owned it in 1500. Rowland Laugharne's Roundheads were beaten off by Gerard's Cavaliers in the siege of 1645, but after the eventual Royalist defeat, the Parliamentarians returned to destroy the castle.

NEWPORT The old borough of Newport grew rapidly with the onset of the Industrial Revolution, as its docks expanded. It has two large deepwater docks and one of the largest sea locks in the country. The museum contains relics from CAERWENT (Venta Silurum) and the magnificent Tredegar House is on its western outskirts. Newport's Welsh name is Casnewydd-ar-Wysg, (New Castle on Usk). St Woolo's (St Gwynlliw's) Cathedral is on Stow Hill, down which the Chartists marched to the Westgate Hotel. The huge Celtic Manor Hotel overlooks the M4 outside Newport, the brainchild of billionaire local man Terry Matthews, and its golf course hosts the Ryder Cup in 2010.

NEWPORT, BATTLE OF, 1044 Gruffydd ap Llywelyn defeated local princes to control southeast Wales, and with his defeat of Hywel at Aber Tywi later that year, added South Wales to his North Wales possessions, effectively uniting Wales.

NEWPORT CASTLE (Monmouthshire) On the west bank of the Usk in the centre of the city, it was built between 1327 and 1386, replacing the motte and bailey on Stow Hill. It was later owned by the Duke of Buckingham and Jasper Tudor.

NEWPORT TRANSPORTER BRIDGE (1906) One of only seven still in use in the world, it carries cars and passengers across the Usk in a carriage suspended from a trolley. Grade I listed, it was opened by Godfrey Morgan, but services were suspended in 2007.

NEWPORT (TREFDRAETH) CASTLE (Pembrokeshire) Built by William FitzMartin when The Lord Rhys ejected him from Nevern (Nanhyfer) Castle, it lies near the beach (trefdraeth means place of the beach), and was twice destroyed by the Welsh in the thirteenth century. The castle was rebuilt and is now a private home.

NEW RADNOR CASTLE This is a moated site near the church, and Philip de Braose built the first castle here around 1095, which was destroyed by the Welsh in 1196, 1216, 1231 and 1262. Edward Mortimer rebuilt it after Llywelyn's death in 1282, but it was taken by Glyndŵr in 1403. In 1845, dozens of headless skeletons and a separate pile of skulls were found when foundations were being dug for a new church. This seems to denote prisoners being beheaded after one of the battles. Prince Charles stayed here in 1642, but it was later dismantled by Parliamentarians. There was a siege, as evidenced by cannon balls on the site. There is also a fortified site at Old Radnor, next to the small masonry castle known as Castle Thimble.

NEWTOWN The Welsh market town of Cedewain was renamed Newtown in 1279 when it was granted a market charter by Edward I, and lies in a loop of the Severn. Robert Owen's birthplace in the town is now a museum.

NEWTOWN CASTLE This was founded by the Mortimers, on land returned to Llywelyn the Last by the Treaty of Montgomery in 1267, to help prevent his claiming his rightful lands. When the Mortimers took Llywelyn's Dolforwyn Castle and town just four miles away in 1277, Newtown started to gain in importance as the administrative centre of the region of Cedewain.

NEW YEAR New Year's Day in the Gwaun Valley, near Fishguard, is celebrated upon 13 January. For 1,500 years Europe followed the Julian Calendar with each year lasting 365.25 days, and this odd quarter was accounted for by having an extra day every four years, each 'leap year'. As the actual year is slightly longer, the Julian Calendar meant that by the sixteenth century, an extra eleven days had accumulated on top of the astronomical calendar. Pope Gregory 'dropped' the eleven days, made a minor adjustment in leap years, and altered New Year from 25 March to 1 January. Protestant England eventually moved to the Catholic reckoning in 1752, following the example of the rest of Europe. However, the Treasury kept the 'Old New Year' of 25 March, adding the eleven days to compensate for the adoption of the Gregorian Calendar, making 5 April the start of our financial year. The Russian Orthodox Church still uses the Julian Calendar, so Christmas there is on 7 January, as the drift is now thirteen, not eleven days. (Thus Cwm Gwaun celebrates on 13 January). The extra two days are because 1800 and 1900 are leap years in the Julian Calendar, but not in the Gregorian. In the UK the fiscal tax year, which governs liability to personal income tax and capital gains tax, runs from 6 April to 5 April. This is because the New Year traditionally fell on 25 March (Lady Day). When Britain converted from the Julian to the Gregorian Calendar in 1752, the Government and landlords were unwilling to miss out on eleven days of taxes and rents, so the 1752-53 tax year was extended by eleven days. As a result of all this, our two main holidays of the year – Christmas and New Year's Day, are now only 7 days apart.

NITHSDALE, LADY (*c.* 1655-1749) Lady Winifred Herbert, youngest daughter of William Herbert, first Marquis of Powys, married the Earl of Nithsdale in Paris in 1699. She and her family had followed the Catholic James II into exile. The Earl was captured at Preston in the abortive pro-Stuart rising in 1715, imprisoned in the Tower of London and sentenced to death. Winifred made the terrible journey through snow from Scotland, riding a horse from Newcastle to London, and was allowed to visit her husband. She pleaded in French to King George I (who could speak no English but understood a little French), who pointedly ignored her. Lady Winifred took her lodgings-keeper, Mrs Mills to see her husband, and hid clothes on

her body so the Earl could dress as Mrs Mills. She left the cell weeping, clutching at 'Mrs Mills' who was hiding 'her' face, seemingly distraught. Winfred and the Earl escaped, and George I was incandescent with anger at being fooled. They hid in her lodgings outside the Tower for a few days, as the search fanned out from London. Then the Earl of Nithsdale was hidden (unknowingly) at the house of the Venetian Ambassador, before he escaped to Paris when the hunt had died down. Winifred joined him, and in Rome he piled up massive debts. The brown cloak used in the escape is now in the possession of the Duchess of Norfolk, who represents the Nithsdales in the female line.

NON, SAINT – FIFTH-SIXTH CENTURY St David's mother, she is also feasted in Brittany and Cornwall. St Non's Well, near her chapel at St David's, in legend sprang into being when she gave birth.

NONCONFORMISM The Toleration Act of 1689 allowed religious freedom, which had been fuelled by a rapid rise in literacy in Wales. In 1671, the Welsh Trust had been set up to assist levels of literacy and to help the destitute. After a short time, it was superseded by the Society for the Promotion of Christian Knowledge (SPCK), but most of its teaching was in English to first language Welsh speakers. Thus GRIFFITH JONES set up the *'circulating schools'* with the help of Madam Bevan, for teaching in the Welsh language. After Jones' death in 1761, the schools continued, and Catherine the Great sent a commission to study their success, in 1764. The remarkable increase in literacy caused by these schools paved the way for the great Methodist Revival of the later eighteenth century. Its three major figures were HOWEL HARRIS (1714-73), Daniel Rowland (1713-90) and WILLIAM WILLIAMS 'Pantycelyn' (1717-91) All three were hugely influenced by the work of Griffith Jones and his Sunday Schools. Harris and Rowland met in 1737 and decided to merge their evangelising energies and activities, and the date of the Methodist Revival really starts at this time. The tendency towards Calvinism and the growth of Nonconformity, in particular Methodism, became after the 1730's an expression of nationalism. Eventually 80% of the Welsh became Nonconformist.

A second wave of preachers and leaders occurred with the Industrial Revolution, including Thomas Charles of Bala (1755-1814) and Christmas Evans (1766-1838), 'the Bunyan of Wales'. The massive increase in Nonconformist denominations saw a surge of chapel-building across Wales in the nineteenth century, with a chapel being built on average every eight days. In today's more secular times, hundreds of chapels have been abandoned, destroyed or converted. There were fifteen major Methodist revivals, the last 'great' one in 1859, before the greatest of them all. It was led by, and personified by, a twenty-six-year-old ex-miner from Loughor, named EVAN ROBERTS. In 1804, he had a religious experience and took the message across Wales. Thousands of meeting occurred, and Roberts preached at about 200 meetings. David Lloyd George stated that the revival was 'rocking Welsh life like an earthquake.' More chapels were built, and although the revival had almost blown itself out by 1905, with Roberts mentally and physically exhausted, the founders of the Apostolic Church were inspired by Roberts' work. Chapels had become the focus of Welsh culture, politics and education.

NORMAN CONQUEST Normandy consolidated its conquest of England in the eleventh century by slowly pushing out into Wales, Scotland and Ireland. In later years, this new nation-state of England and its neighbours came to control the greatest empire the world has ever seen, including North America, the Indian sub-Continent, Australia and huge chunks of Africa. To these colonies, England gave a form of democracy in return for economic benefit. Having conquered Saxon England with considerable ease after a fortuitous victory at Hastings, William the Bastard (later known as the Conqueror) gave lands on England's border with Wales to Marcher Lords. This was to secure his border, and to allow expansion. Not until 1283, over 200 years later, did England gain control of Wales, compared to three years to completely subdue England. Even then, there was fighting, culminating in Glyndŵr's War of Liberation from 1400

to 1415. Wales was Norman-England's first colony, with the hold on power being consolidated by motte and baileys and later stone castles, and settlements in bastides, walled towns. (Also Flemings were planted throughout South and South-West Wales). There are thirty-four towns with remains of medieval walls in Wales. Edward I established bastides in North Wales to complement his 'Iron Ring' of castles around Gwynedd. He financed these great walls from Crown sources, and massive foreign loans, not as usual from taxes on goods coming into the town (murage grants). Conwy's walls (1284 to 1287) form part of a larger defence plan, the main element being the great castle. The settlement was flanked by the river or a great ditch, and had twenty-one towers and three double-towered gates. The walls of Caernarfon are also nearly intact. Other walls built by Edward in North Wales were linked to the castles at Flint, Rhuddlan II, Beaumaris, Cricieth, Harlech, Y Bere and Aberystwyth. There were also planted walled towns in North Wales at Overton, Holt, Ruthin, Denbigh, New Mostyn, Rhuddlan, Caerwys, Deganwy, Newborough, Bala, Llanfyllin, Welshpool, Dolforwyn, Newtown, New Montgomery, Caersws and Llanidloes.

NOVELLO, IVOR (1893-1951) Ivor Novello was the toast of the West End in the beginning of the twentieth century, and his *Keep the Home Fires Burning* became almost an anthem of the troops suffering in Europe. He had crash landed twice in World War I while serving in the Royal Naval Air Service, and then entertained the troops on the Western Front. Born David Ivor Davies in Cardiff, he was a naturally gifted star of stage and screen, also writing songs, operettas, musicals, plays and films. He was variously described as having 'the most beautiful profile in the world', and as 'the last great romantic' 'the British Adonis' and 'the Valentino of England'. As well as a string of hit musicals and films, he wrote songs such as *We'll Gather Lilacs* and *Dreamboat*. He died of coronary thrombosis just four hours after playing the lead in his greatest musical, *King's Rhapsody* at London's Palace Theatre. His biographer Peter Noble called him 'the great Welshman who brought more happiness to more people through his many gifts than possibly any other man in our century.' The annual Ivor Novello Awards were created after his death to celebrate the best British music and songwriters.

OFFA'S DYKE King Offa of Mercia seems to have continued the initiative of WAT'S DYKE when he created a larger earthwork, now known as Offa's Dyke (Clawdd Offa). John Davies wrote of Cyril Fox's study of Offa's Dyke: 'In the planning of it, there was a degree of consultation with the kings of Powys and Gwent. On the Long Mountain near Trelystant, the dyke veers to the east, leaving the fertile slops in the hands of the Welsh; near Rhiwabod, it was designed to ensure that Cadell ap Brochwel retained possession of the Fortress of Penygadden.' And for Gwent, Offa had the dyke built 'on the eastern crest of the gorge, clearly with the intention of recognizing that the river Wye and its traffic belonged to the kingdom of Gwent'. From Prestatyn on the North Coast, to Chepstow on the South Coast, the 168-mile Offa's Dyke Path attracts walkers from all over Europe. Offa, the eighth-century Saxon King of Mercia, built it to serve as a border, and the present bank and ditch still serves as much of the present border. As well as a political barrier, it may have been a customs barrier for trade and cattle, because there are some notable places where it is missing. Near Knighton (Tref y Clawdd, or Town of the Dyke), the height of the bank to the bottom of the ditch is even now around 16ft to 20ft. The width of the ditch is 16ft, the ditch being on the Welsh side of the raised dyke. John Davies has called the dyke 'perhaps the most striking man-made boundary in the whole of Western Europe.' In effect, it solidified the border between Wales and the Saxons/Mercians, with the notable exception of Herefordshire, much of which stayed 'Welsh' for another eight hundred years. This national border, much of which the Dyke marks, could be the oldest in Europe, older than that between Spain and Portugal, or France and Germany. In the past, a Welshman caught east of Offa's Dyke had an ear cut off. There have been some recent attempts to attribute the dyke as 'the Wall of Severus' built 'from sea to sea', by the emperor who died in York in 211.

OGHAM, OGAM This was the ancient alphabet of the Celts, in use from *c.* 300 to the seventh century. On ancient stones, the number and position of straight and slanted lines carved into the edges give us characters in Ogham script, common in Ireland and Wales. As some of the Welsh stones were also inscribed in Latin, we now know the Ogham alphabet and can translate many of these standing stones. Blocks of wood were also carved, and Irish sagas tell us of huge libraries of Ogham texts recorded on bark. The system was named after the Celtic god of eloquence, Ogma or Oghma, and the Celts regarded ability with words greater than physical prowess.

OGMORE CASTLE Along the western frontier of early Norman control, it guards a ford across the Ogŵr, where ancient stepping-stones still allow one to cross. William de Londres built the first castle here in 1116, including a ditch that filled up at high tide. Maurice de Londres built the large tower in 1126. Its history is unrecorded, but a remarkable stone from the sixth century was found here, inscribed 'Be it known to all that Artmail gave this estate to God and Glywys and Nertat and his daughter.' This may be a grant of land from King Arthur.

OLD KINGDOMS & COUNTIES The Kingdom of Gwynedd, that area roughly now the Snowdonia National Park and the Island of Anglesey, with its capital at Aberffraw, was the key to Welsh independence. Repeatedly, the frontiers were pushed back to this inhospitable and mountainous northwest corner of Wales. Without the prolonged resistance of Gwynedd, Wales would hardly exist as a separate entity from England. To the east of Gwynedd lay the Kingdom of Powys, and southwest were the smaller kingdoms of Ceredigion (Cardigan), Dyfed (Pembroke) and Ystrad Tywi. These latter three were occasionally unified as Deheubarth, e.g. under The Lord Rhys. In the mid-south were Brycheiniog (Brecon) and Buallt (Builth), and below them Morgannwg (Glamorgan) and Gwent (Monmouthshire). Parts of Herefordshire, Worcestershire and Shropshire, the border counties, were Welsh-speaking until a couple of hundred years ago. Monmouthshire used to pass between England and Wales as an administrative county, and part of Flintshire was detached from Wales and surrounded by English administrative areas. However, the traditional 'Thirteen Counties of Wales' were reorganised in 1976 to form eight new administrative units. In the northeast, Flint and Denbigh became Clwyd. In the southeast, Monmouthshire was renamed Gwent. Glamorgan in the south was split into three new counties, East, Mid and South Glamorgan. Radnor and Brecon in mid-Wales formed Powys. Pembroke, Ceredigion and Carmarthen in the southwest and west now formed Dyfed. The northwest counties of Meirionnydd, Caernarfon and Anglesey reverted to being called Gwynedd. In general, most administration now, except for the densely populated Glamorgan, has reverted to the previous thirteen counties and the four major towns of Cardiff, Newport, Swansea and Wrecsam. Oddly, every single reorganisation for the sake of efficiency in the public sector has resulted in more public sector jobs.

OLDEST LIFE FORM Wales has the oldest rocks in Britain, and in Harlech in 1964, the oldest surviving life form in the world was found, the organism Kakabekia Barghoorniana, which has been in existence for 2,000 million years. As this remarkable occurrence seems unknown, the author retrieved the following information from *The Natural History Reader in Evolution.* Sanford Siegel, a University of Hawaii botanist, examined the micro-organisms of a sample of soil he had gathered near the wall of Harlech Castle: 'When he cultured that soil sample... the medium triggered the growth of microscopic clusters of star-shaped bodies attached to slender stalks. Each body, about 5 micrometers (0.0002in) in diameter, closely resembled pictures Siegel had seen of a recently discovered fossil micro-organism. But as far as he knew, no living specimens of this organism had ever been described. With the help of the fossil's discoverer, Elso Barghoorn of Harvard University, Siegel was able to establish, in a strange sequence of paleobotanical events, that he had found a living relative of an organism first described as a fossil. Barghoorn had made his own discovery while gathering specimens of ancient rocks in a search for primitive organisms. One specimen of chert, or flintlike rock, from Kakabek in Ontario, Canada, contained

peculiar umbrellalike forms that seemed regular enough in physical appearance and structure to be considered microorganisms, rather than a pattern that had developed as the rock formed. Barghoorn named these microorganisms Kakabekia umbrellata, meaning umbrella-like form from Kakabek. Since the rocks in which Barghoorn's forms appeared dated from the middle Precambrian period, about two billion years ago, the microorganisms were among the oldest of all plantlike fossils. Siegel's discovery of a living relative of Barghoorn's fossils established a remarkable thread of biological history. Siegel named his creature Kakabekia barghoorniana in honour of his colleague'. Not a lot of people know that.

OLDEST PUBS IN WALES At Llanfihangel Crucorney in Gwent, the Skirrid Mountain Inn is a stone inn with a marvellous past. It was known as the Milebrook alehouse in 1100. Around two-hundred people were hung here up to the seventeenth century, and the beam above the foot of the stairs was the original scaffold. The first execution, recorded in 1110, tells us that James Crowther was given nine months imprisonment for robberies with violence, and that his brother John was hung for stealing a sheep. (It should be noted that this was Norman Marches law, not Welsh law, operating here at this time – there are parallels with today's laws where property takes precedence over people). Scorch and drag marks of the rope can still be seen on the beam, and the pub is probably the oldest in Wales, with beams that come from ships' timbers, mediaeval windows, and dining room panelling from a British man-o-war. Owain Glyndŵr's troops rallied in the inn's cobbled yard before marching on Pontrilas. There are flagstone floors, high settles, excellent good bar food including Glamorganshire (cheese) sausages, and draught Founders Ale. Skirrid is derived from *ysgyryd* (a shiver), and legend says that in the hour of darkness after the Crucifixion the mountain shuddered and shivered before splitting into two into Ysgyryd Fawr and Ysgyryd Fach (Big Shiver and Little Shiver). Other rivals for the title of Wales' oldest pub are the thatched Blue Anchor at East Aberthaw in the Vale of Glamorgan (in Aberddawen, selling beer since 1380); the Groes Inn near Conwy (licensed in 1573); Tŷ Mawr at Gwyddelwern near Corwen; the Red Lion at Llanafan Fawr (near Builth Wells, selling beer since 1188 and visited by Giraldus Cambrensis), the Old House at Llangynwyd (near Maesteg, from 1154), and the thirteenth-century thatched Llindir Inn at Henllan.

OREWIN BRIDGE, BATTLE OF, 1282 This is traditionally the bridge over the Irfon where Llywelyn the Last's army was defeated after his murder in December 1282. However, there may have only been a minor skirmish, or indeed the Welsh may have surrendered on the news of the death of Llywelyn – and then been killed. There were no recorded English casualties, and no recorded survivors of the 3,000 followers of Llywelyn. In the words of Anthony Edwards: 'After the defeat of Llywelyn ap Gruffydd in 1282, King Edward carried out a systematic slaughter of the Welsh in many parts of Wales, probably to reduce the Welsh manpower. For instance, the 3,000 footsoldiers, the leaderless remnants of Llywelyn's army, were put to death between Llanganten and Builth, and while King Edward was at Rhuddlan very many Welsh, including priests, were put to death, bringing on him the reproof of the archbishop of Canterbury.' The sons of Owain ap Maredudd of Elfael were escheated in December 1282. In legal terms, an 'escheat' is to take the estates of the dead. A Chancery Rolls document of 24 November 1284, dates the dispossession to December 1282 or shortly after. Llywelyn was murdered upon December eleventh. It thus appears that the Welsh lords of Elfael and their followers may have been executed at Orewin Bridge. Edwards believes that the 3,000 footmen and 160 horsemen were executed in cold blood where Builth golf course is today. This is also the time of 'the massacre of the bards' – traditionally when Welsh bards, the purveyors of news and records, were purged across Wales.

ORME'S HEAD, BATTLE OF, 856 Rhodri Mawr killed the Viking leader Horm (aka Gorm), on Anglesey, and Orme's Head at Llandudno seems to be named after Horm. Two poems by Sedius Scotus, written at the court of Charles the Bald, King of the Western Franks, celebrate

this important victory over the Danish threat to Europe, and Rhodri was also lauded at Charlemagne's court.

OSWESTRY (CROESOSWALLT) This former Welsh-speaking market town, just over the border in Shropshire, was officially made English by Henry VIII's Act of Union in 1535. Seen on the seventeenth- century Llwyd Hall is a double-headed eagle, given by the Holy Roman Emperor for service by the Llwyds (Lloyds) during the Crusades.

OSWESTRY HILLFORT This may be the site of Cynddylan of Powys's court, rather than Wroxeter, which was burnt by the Saxons. It also may be the site of Caradog's last battle against the Romans. Known as Old Oswestry, this massive Iron Age hillfort was also called Caer Ogyrfan, supposedly after the father of Arthur's Guinevere (Gwenhwyfar).

OSCARS Ray Milland (Reginald Truscott-Jones) of Neath won Best Actor for playing an alcoholic writer in *The Lost Weekend* (1945). (He also received a citation from the Alcoholics Anonymous Unwed Mothers of America). Hugh Griffith of Anglesey was nominated twice for Best Supporting Actor, once for *Tom Jones* (1964), and receiving the award for *Ben Hur* (1959). Sir Anthony Hopkins won the Best Actor award in 1992 for his performance as Hannibal Lecter in *The Silence of the Lambs*. He was also nominated as Best Actor for *The Remains of the Day* (1994) and *Nixon* (1996). Hopkins was nominated for Best Supporting Actor for *Amistad* in 1998. Jack Howells of Abertysswg won an Oscar in 1963 for his documentary *Dylan Thomas*. Richard Burton was nominated for Best Supporting Actor for *My Cousin Rachel* (1952) and for Best Actor for *The Robe* (1953), *Becket* (1964), *The Spy Who Came In From The Cold* (1965), *Who's Afraid of Virginia Woolf* (1966), *Anne of The Thousand Days* (1969) and *Equus* (1977). Tessie O'Shea (see below) received an Oscar nomination for *The Russians are Coming; The Russians are Coming* in 1966.

O'SHEA, TESSIE (1914-1995) From Cardiff's Riverside, she first appeared on stage at the age of six and was in variety for the rest of her life. One of the last survivors of the music hall, some will remember her versions of *Hold Your Hand Out, You Naughty Boy* and *Nobody Loves a Fairy When She's 40*. In the latter song, 'Two-Ton Tessie' used to prefix 'fat' before 'fairy'. She topped the bill at the London Palladium in 1940 with Max Miller, and aged fifty-one won a prestigious *Tony* award on Broadway.

OUTWARD BOUND The International Outward Bound Movement was founded in Aberdyfi in 1941.

OWAIN GWYNEDD – OWAIN AP GRUFFYDD AP CYNAN (1109-1170) *The History of Gruffydd ap Cynan* was written in the thirteenth century, 150 years after his death. Born around 1055, his family was exiled at the Irish court, and he married the daughter of the King of Dublin. He invaded Wales in 1075, beating Trahaern of Gwynedd. Trahaern won a second battle, and Gruffydd turned to piracy for six years. In 1081, with a fellow-prince, Rhys ap Tewdwr, he set out from St David's and killed Trahaern at the battle of Mynydd Carn. Rhys took control of Deheubarth, but Gruffydd was imprisoned in chains by the Normans. After his rescue, and Rhys' death in the Battle of Brycheiniog against the Normans in 1093, Gruffydd at last took control of Gwynedd and Deheubarth. King William II, William Rufus, invaded but was repulsed. The Marcher Lords attacked with revolting cruelty, but were forced back to their border fortresses. In 1099, King Henry I attacked Wales. Gruffydd, by diplomacy, evaded battle, and kept quiet until his peaceful death in 1137 at the age of eighty-two. He was ruler of most of Wales, and Bangor Cathedral holds a tomb believed to be his – the earliest tomb of a Welsh prince.

During the 200 years of battles with the Normans and Plantagenets, three political entities in Wales remained fairly stable and relatively independent, the princedoms of Powys, Deheubarth

and Gwynedd. Gruffydd's son Owain extended Gruffydd's possessions over Offa's Dyke into England, and down into the other two princedoms. This ensured the predominance of the Princes of Gwynedd, Rhodri Mawr's descendants, in the continuing Welsh fight for independence. Owain ap Gruffydd thus became known as Owain Gwynedd. (Owain's grandson was Llywelyn ap Iorwerth, Llywelyn the Great, whose own grandson was Llywelyn ap Gruffydd, Llywelyn Olaf.) Owain's reign saw the strongest Norman attacks on Wales so far – his whole reign had to be focused upon protecting Wales from the Marcher Lords. Gwalchmai, his pencerdd ('chief household bard') wrote in *The Triumphs of Owain:*

Owain's praise demands my song
Owain swift and Owain strong;
Fairest flower of Rhodri's stem,
Gwynedd's shield and Britain's gem...
Lord of every regal art
Liberal hand and open heart...
Dauntless on his native sands
The dragon-son of Mona stands

From his accession to the crown of Gwynedd in 1137, Owain Gwynedd was faced with major problems from his brother Cadawaladr, and Owain's sons Hywel Hir and Cynan defeated Cdwaladr and forced him to flee to Ireland. In 1145, in the seventh year of his reign, Owain lost his favourite son Rhun and fell into a long period of grieving. However, his sons Hywel Hir and Cynan took the mighty Norman fortress of Mold (Wyddgrug) and razed it to the ground, restoring his spirits. In 1149 Madoc ap Maredudd, Prince of Powys, joined with the Norman Earl of Chester to gain lands off Owain.

In 1156 Owain's brother Cadwaladr was again causing trouble. With Madoc ap Maredudd of Powys, Cadwaladr stirred the King Henry to invade Wales, to exterminate this over-powerful neighbour. Henry II's first campaign against Owain ended in a truce in 1157. Owain, with his sons Dafydd and Cynan, had waited for Henry's army in the woods at Coed Eulo (Cennadlog) near Basingwerk, on the Dee estuary. They almost took Henry prisoner, and the Earl of Essex threw down the Royal Standard and escaped through the woods at COLES HILL. Their army was slaughtered in a battle in the woods of Consyllt. Knights from Henry's fleet ravaged Anglesey, where one of the King's sons was killed, while Henry waited for reinforcements at Rhuddlan. With the 1157 truce, Owain gave King Henry his sons and other hostages, promising not to attack England, and allowed the King to keep the land around Rhuddlan. In 1160, with the death of Madoc ap Maredudd, Owain attacked Powys and extended his influence in the east. In 1166, the Council of Woodstock tried to make the Welsh princes vassals, and there was an uprising led by Owain, and his nephew Rhys ap Gruffydd (The Lord Rhys). A monk of St David's wrote 'All the Welsh of Gwynedd, Deheubarth and Powys with one accord cast off the Norman yoke.'

Henry then tried again to subjugate Wales, but failed, and Owain's son Dafydd captured the important King's castles of Basingwerk and Rhuddlan in 1166 and 1167. Henry recaptured them, and set up to invade from a base in Shrewsbury. With his brother Cadwaladr now with him, and The Lord Rhys, Owain called his forces to Corwen. Henry moved through the damp Berwyn Mountains, cutting a road through the heavy forests to keep away Welsh archers and raiding parties. Even today the road is called 'Ffordd y Saeson', ('The English Road'). Welsh guerrilla attacks and bad weather defeated the Normans, and they retreated back to the shelter of Shrewsbury (Pengwern). One violent attack by the Welsh guerrilla forces took place at a place now called 'Adwy'r Beddau' (The Pass of the Graves). King Henry, in his rage, killed all his prisoners. He also had four important hostages – Rhys and Cadwaladr, two sons of Owain Gwynedd, and Cynwrig and Maredudd, two sons of The Lord Rhys of Deheubarth. 'He blinded them – "and this the King did with his own hand" ' according to *The Chronicles*. The children had been held by the English since the 1157 truce, ten years earlier, as surety against Owain invading England, but

Henry had invaded Wales, so they should not have been harmed. Few Welsh people know of this terrible event – it is uniformly omitted in British history books, much like the British invention of concentration camps in the Boer War. Twenty-two hostages in all were blinded, and Owain was asked to burn English churches to retaliate, but he said that Henry 'had made an enemy of God Himself, who can avenge the injury to Himself and to us at the same time.' One wonders what would have been written, if the Welsh had ever done this to English princes. As Cicero stated, 'To know nothing of what happened before you is to remain forever a child'.

In 1168, diplomatic relations were established between 'the bulwark of all Wales' Owain Gwynedd and King Louis VII of France, to King Henry's impotent fury. When Owain died in 1170, after thirty-three years as Prince of Gwynedd, he was hailed as 'the king and sovereign and prince and defender and pacifier of all the Welsh after many dangers by sea and land, after innumerable spoils and victories in war... after collecting together into Gwynedd, his own country, those who had been before scattered into various countries by the Normans, after building in his time many churches and consecrating them to God'.

His chronicler states also that his kingdom 'shone with lime-washed churches like the firmament with stars'. He was also known as Owain Fawr, 'Owain the Great', and repulsed the invasion by Henry II so easily that no other Plantagenet king attempted to subjugate all of Wales until years after Owain's death. Owain had encouraged monasticism, especially in Gwynedd, but he died excommunicated because he refused to divorce his wife, who was his cousin. Archbishop Baldwin of Canterbury, when he visited Bangor Cathedral in 1188, thus spitefully ordered Owain's bones to be moved from the Cathedral to the churchyard. Madog, a son of Owain Gwynedd, was credited as being the Welshman who discovered America. The Lord Rhys was Owain's nephew. Rhys was the son of Gwenllian, Owain Gwynedd's sister, and she was executed by the Normans when Rhys was just four years old. Rhys ap Gruffydd, Prince of Deheubarth, now took the mantle of chief defender of Wales against the invading Normans.

OWEN, DAFYDD (1712-1741) Wales' most famous harpist was born at Y Garreg Wen farmhouse near Borth-y-Gest in Gwynedd. He used to play the harp at nosweithiau llawen ('happy evenings', informal gatherings for music and songs). Carrying his harp home one night from Plas-y-Borth, he lay down and slept, to be woken by the sound of a skylark, whereupon he composed the famous *Codiad yr Ehedydd* (*The Rising of the Lark*). On his deathbed, aged only twenty-nine, he woke and described a dream to his mother where he had been listening to a beautiful song, accompanied by two white doves. He noted the song down, and asked his mother to sing it at his funeral. This was the haunting *Dafydd y Garreg Wen* (*David of the White Rock*), the favourite piece of music of Carlo Rizzi. Dafydd's family and friends sang the tune all the way of the funeral procession from his farmhouse to Ynys Cynhaearn Church.

OWEN, SIR HUGH (1804-1881) A Methodist philanthropist, he was one of the original promoters of the foundation of the University College of Wales at Aberystwyth. His famous *Letter to the Welsh People* of 1843 called for the Welsh people to take action, to further the cause of education and thereby raise the prosperity of the nation.

OWEN, ROBERT (1771-1858) In 1771, Trenewydd (Newtown) in mid-Wales produced a man who changed society across the world with his thoughts and actions. Karl Marx and Freidrich Engels both paid generous tribute to him in the development of their theories. Engels wrote that 'every social movement, every real advance in England on behalf of the workers links itself on to the name of Robert Owen.' When Robert Owen took over the cotton mills in New Lanark in Scotland, in 1800, he improved housing and sanitation, provided medical supervision, set up a co-operative shop and established the first infant school in Great Britain. Owen also founded an Institute for the Formation of Character and a model welfare state for New Lanark.

His example was largely responsible for bringing about The Factory Acts of 1819, forcing through this first law limiting the hours of work for women and children. However, disappointed

at the slow rate of reform in England, Owen emigrated to America in 1821 to set up another model community. From 1817 Owen had proposed that 'villages of co-operation', self-supporting communities run on socialist lines, should be founded, to ultimately replace private ownership. He took these ideas on co-operative living to set up the community of New Harmony, Indiana, between 1824 and 1828, before he handed the project over to his sons and returned to Britain. The USA community failed without his inspiring idealism, but he carried on encouraging the fledgling trade union movement and co-operative societies. In 1833 he formed the Grand National Consolidated Trades Union. From 1834, Owen led the opposition against the deportation of The Tolpuddle Martyrs, a group of Dorset farm labourers, who had stopped working in a cry for higher living wages. Because of his criticisms of the organised religion of the day, where clerical positions were granted as favours, he lost any support from those in power, whose families benefited from the system.

He wrote about the barbaric nature of unrestrained capitalism in *Revolution in Mind and Practice* – the glories of Thatcherite free trade, where Nike, Adidas and Reebok sportswear were until very recently made in totalitarian regimes using semi-slave labour, spring to mind today. Owen wanted political reform, a utopian socialist system, with a transformation of the social order. All people were equal, so there should be no class system, and individuals should not compete but co-operate, thereby eliminating poverty. Robert Owen was a fore-runner of the co-operative movement, a great inspirer of the trades union movement, and possibly the modern world's first socialist. Those that followed his teachings, who called themselves Owenites, gradually changed their name to Socialists, the first recorded use of the term. Owen is a Welshman of international stature, who is hardly acclaimed in his own land, but his socialism is a thread that runs through Welsh history from the *Laws of Hywel Dda* in the tenth century, to the election of the first Labour MP in Britain in 1910, to the whole-hearted support for the Miners' Strike in 1984, to the permanent state of left-wing support in Wales. (Unfortunately, there are no credible left-wing parties remaining since Blair and Brown adopted right-wing Thatcherite policies, when rebranding Labour as 'New Labour'.)

As the pioneer of co-operation between workers and consumers, his understanding of the 'value chain' and wealth creation has not been equalled until the works of Michael Porter in recent years. The over-riding problem in Western society is that political leaders are insulated from the communities they represent – they are always several orders of magnitude richer than the common man, and do not understand the basic nature of wealth creation. Wealth comes from something being dug out of the ground, altered and transported, with value being added along the route. Every service is parasitic upon this process. It seems that Mrs Thatcher never realised that marrying a millionaire was not an option for most of society. In April 1840, an editorial in *The Cambrian* referred to Robert Owen: The discontent of the lower and working classes has assumed a new form which threatens to become far more mischievous than mere political agitation, however fiercely carried on. We allude to the institution and spread of Socialism. Under pretence of improving the condition of the poor, Socialism is endeavouring, permanently, to poison their happiness, by depraving their morals, and depriving them of all those consolations flowing from the principles of religion. It is of little use to show that Mr Owen is a lunatic.'

Incidentally, a theme in this book is that the Welsh are terrible self-publicists. In *The Witch Doctors* a 1997 'global business book award winner', we have reference to Robert Owen as 'a Scottish mill-owner who thought there was money to be made by treating workers as if they were human beings (he would not employ any child under ten years old). Owen thus has been deemed to be "the pioneer of personnel management" (quote from Urwick and Breech, quoted in Clutterbuck and Crainer)... Peter Drucker's enthusiasm for the well-being of workers led Rosabeth Moss Kantner to compare him to Robert Owen, the nineteenth-century Scotsman who ordered his factory managers to show the same due care to their vital human machines as they did to the new iron and steel which they so lovingly burnished.' So there we have it, the leading edge authors of *The Witch Doctors*, with other eminent management writers, all claim Owen to be 'Scottish'. No wonder no-one knows about Wales on the world stage. Just some

of the epithets applied to Robert Owen are 'the Founder of Socialism', 'the Founder of Infant Schools', and 'the Most Popular Man in Europe'. His son, Robert Dale Owen, was prominent in the abolitionist movement in the USA, writing *The Policy of Emancipation* and *The Wrong Slavery*. Robert Dale Owen became a Congressman and Ambassador to India, but (like his father) returned to Newtown and died in 1858. 'Hiraeth' is a strong emotion. A memorial museum is now in the house where his father was born.

OWEN, WILFRED (1893-1918) An Anglo-Welsh poet tragically extinguished in the Great War was Wilfred Owen, from Plas Wilmot near Oswestry on the Welsh border. Concussed at the Somme, he later was awarded the MC, and was killed just a week before the Armistice. One of his poems contains the lines:

Red lips are not so red
As the stained stones
Kissed by the English dead

Only five of his poems had been published while he was alive, but Siegfried Sassoon had met him in War Hospital, and collected the rest for publication in 1920. Owen's bleakly realistic poems were chosen by Benjamin Britten for his *War Requiem*.

OXWICH CASTLE Sir Rice Mansel converted an existing castle on the Gower Peninsula to a superb manor-house from 1520 onwards. When the Mansels moved their family seat to Margam, it fell into disrepair.

OYSTERMOUTH, YSTUMLLWYNARTH, CASTLE Overlooking Mumbles, on the Gower Peninsula, it was built by William de Londres in the early twelfth-century. The Welsh burnt the castle in 1116 and 1215. It was visited by Edward I in 1284, and owned by the de Braoses. In the graveyard of the village Thomas Bowdler (1754-1825) is buried, the man who expurgated ('bowdlerised') Shakespeare. The original Welsh name means 'the river bend of the grove of the bear' – and Oystermouth is an approximation of attempting to say Ystumllwynarth in English. Oyster in Welsh is either wystrysen or llymarch.

PAINSCASTLE CASTLE, & THE BATTLE OF PAINSCASTLE 1198 On a Roman site near Hay-on-Wye, it may have been built by Pain FitzJohn. He was killed by Madog ab Idnerth in July 1137, with the castle being captured and destroyed. Painscastle was then rebuilt and destroyed again. Maud de Braose is said to have defeated a Welsh attack here in 1195. The Lord Rhys besieged it, and perhaps took it in 1196 (he died the next year). In 1198, Trahaearn, the cousin of Prince Gwenwynwyn of Powys, was tied to a horse, dragged through Brecon, and executed by the Normans. Gwenwynwyn attacked Painscastle in retaliation in July 1198. However, without siege engines he was defeated. Gwenwynwyn had brought with him most of the princes of Wales, and many of them fell in subsequent disastrous battle when the Justiciar, Geoffrey Fitz Peter, routed Gwenwynwyn in August. After this battle, both Llywelyn I and Llywelyn II avoided pitched battles whenever possible. Their spearmen were no match for Norman knights on horseback. According to English sources the Welsh losses at Painscastle were 3,000 men against just three Normans. King John took the castle in 1208, but it was captured by Gwallter ab Einion Clud in 1215, who later submitted to John and was made Lord of Elfael. In 1222, it belonged to Llywelyn the Great but was destroyed, and rebuilt in 1231 by Henry III. In 1265, the stone castle was taken and destroyed by the Welsh, and then rebuilt again. The Beauchamps garrisoned Painscastle during the Glyndŵr campaign in 1401. Just one small castle out of hundreds in Wales, it has a history of at least six sieges and two battles, but this impressive motte and large ditch is largely forgotten like the others.

PAINSCASTLE, BATTLE OF, 1196 Lady Matilda St Valery, wife of William Braose (d.1211) of Radnor and Brecon, advanced on Painscastle where she 'slaughtered the Welsh'. She then proceeded to refortify Painscastle much to the annoyance of Prince Rhys ap Gruffydd of Deheubarth. In 1196 The Lord Rhys came here, fighting for his kinsmen in Elfael, and defeated the Marchers at the Battle of Radnor, before besieging Painscastle. There are conflicting reports as to whether he took the castle. *The Chronicle of Ystrad Fflur* records: 'Rhys ap Gruffydd gathered up a mighty host, and he fell on Carmarthen and destroyed it and burned it to the ground. And he took and burned the castles of Colwyn and Radnor. And Roger de Mortimer and Hugh de Sai gathered a mighty host against him. And Rhys armed himself like a lion with a strong hand and a daring heart, and attacked his enemies and drove them to flight. And forthwith Rhys took Painscastle in Elfael.'

PANTYFEDWEN On 2 October 1996, the Reverend William Rhys Nicholas died, aged eighty-two. Rhys Nicholas was honoured as a superb poet, and also assisted in the publication of Welsh poetry at the Gomerian Press and John Penry Press. An *S4C* TV programme in 1995 was devoted to his Welsh-language hymns. His most well-known hymn, *Pantyfedwen*, won the 1967 Pantyfedwen Eisteddfod near Lampeter, which was sponsored by the London Welsh millionaire, David James. In 1968 a competition to write a tune for the hymn was won by the Liverpool Welsh composer, Eddie Evans. By the end of the 1970's, this beautiful hymn-tune had become 'a second national anthem', sung at festivals, weddings, funerals and chapel services.

PARRY, DR JOSEPH (1841-1903) Dr Joseph Parry was born in the now preserved terrace of skilled ironworkers' cottages, Chapel Row, in Merthyr. He wrote some of Wales' favourite tunes, including the lovely *Myfanwy*, and the magical *Aberystwyth*, which are beloved by all Welsh male voice choirs.

PARRY-THOMAS, J.G. (1884-1927) From Wrexham, he became the chief engineer at Leyland Motors and designed the Leyland 8, which was intended to compete with Rolls-Royce. Parry-Thomas also became a professional racing driver at Brooklands. He set a new world motor speed record twice at Pendine Sands in 1926 to beat the record held by Henry Segrave. He had bought the car from the estate of the dead Count Zborowski and modified it, calling it *Babs*. Malcolm Campbell surpassed his record by 3 mph with a speed of 175 mph in 1927, so Parry-Thomas tried to retake the record. The car used an exposed chain to link the engine to the right-hand drive wheel, and the high engine cover forced him to drive with his head tilted to the side. At around 180 mph, the chain snapped and Parry-Thomas was decapitated. *Babs* was buried in the sand, but exhumed in 1969 and restored by Owen Wyn Owen.

PATAGONIA In South America, the existence of the Welsh-speaking colony in Patagonia stopped Chile claiming vast expanses of land from Argentina, in 1865. 153 Welsh emigrants had boarded the sailing ship *Mimosa* and landed at Port Madryn there in that same year, trekking forty miles to find a settlement near the Chubut River. Two decades later, in 1885, some Welsh families crossed 400 miles of desert to establish another settlement in Cwm Hyfryd at the foot of the Andes. Y Wladfa ('The Colony'), founded by the reformist preacher MICHAEL D. JONES, was to be a radical colony where Nonconformism and the Welsh language were to dominate. The Argentine government was anxious to control this vast unpopulated territory, in which it was still in dispute with Chile, so had granted land for the establishment of a Welsh state, protected by the military. For ten years after 1865, this Welsh state was completely self-governing, with its own constitution written in Welsh. The immigrants owned their own land and farmed their own farms – there was to be no capitalist state with its hated landlord system. Females were given the vote – the first democracy in the world to show egalitarianism. This author can find no earlier reference to female equality in voting. This was fifty years before British suffragettes even started to try to change the British system. All boys and girls aged eighteen could also vote, over a century

before they could in Britain. Voting was by secret ballot and all people were eligible – two more democratic innovations. The language of Parliament and the law was Welsh, and only Welsh school books were used. Back home, the use of Welsh was forbidden in schools. 'Y Wladfa' (Gwladfa means colony or settlement) was 'the first example of a practical democracy in South America', and the first example of a practical, egalitarian, non-discriminatory democracy in the world. (People often forget that the Greeks had slaves).

There were massive problems in the settlement at first, until the native Teheulche Indians and their chief taught the Welsh to catch guanaco and rhea, from the prairies. Also, the Indians would exchange meat for bread, going from house to house saying 'poco bara' - Spanish for 'a little' and Welsh for 'bread'. This was a 'green colony' whereby both sides gained. The Welsh taught the Indians to break in horses, and they in turn showed the Welsh how to use bolas to catch animals. By controlling the waters in the Camwy Valley, the settlers at last began to prosper. Unlike unsuccessful Spanish settlers before them, they had very few problems with the native Indians, who still empathise with the Welsh. When two Welshmen were killed in the Chubut River uplands in 1883, Lewis Jones, the leader of the colony, refused to believe it. He told the messenger 'But John, the Indians are our friends. They'd never kill a Welshman.' It transpired that an Argentine patrol had trespassed on Indian land, and the Welsh were tragically mistaken for the Indians' Spanish-Argentine enemies, who treated the Indians like vermin. The bodies had their sexual organs stuffed into their mouths.

Butch Cassidy and the Sundance Kid in Patagonia were alleged to have formed a gang comprised of Welshmen, and Cassidy's old farm is still ranched. Their best friend was a Welshman called Daniel Gibbons, who helped them purchase horses. A son of Michael D. Jones, a grocer called Llwyd ap Iwan, was supposed to have been killed by the gang in 1909, in Arroyo Pescado in Northern Patagonia. However, it appears to have been a couple of renegade drifters from the USA that carried out this act. It was this pair, named William Wilson and Robert Evans, who were also killed in the shoot-out with the Argentine military at Rio Pico, not the famous American outlaws. The Bolivia deaths were the fiction of a screenwriter. Butch, Sundance and Etta appear to have spent their time peaceably – they had no need of money at first – and were assisted by the Welsh to settle in Patagonia. Butch Cassidy bought 12,000 acres near Cholila in 1901, and the following year Sundance and his 'wife', Etta Place arrived. However, in 1907 one of their gauchos saw Butch's picture in a Buenos Aires paper, although he could not read, and told everyone around him that this was his 'boss'. A couple of days later, Sheriff Perry (of Pinkerton's Detective Agency), heard the story and made his way down to Patagonia from the capital. The gaucho had also showed the outlaws the picture in the newspaper, and they escaped with Etta Place over the Andes into Chile, just two days before Pinkerton's detectives arrived on the scene. According to his sister, Butch died in the 1930's in Washington State, and Etta Place seems to have died in Denver some time after 1924.

The colony grew to 3,000 people by the time Welsh immigration halted in 1912. Interestingly, the Welsh code of law established by the settlers was the first legal structure in Argentina, and its 'influence in modern-day Argentinian law can still be seen'. Around four-hundred people are currently learning Welsh in Patagonia, helping the language to survive, and there are teacher exchanges with Wales to double this figure. However, only 5,000 still speak the language regularly, most of them in their later years. The success of the colony attracted immigrants from Spain and Italy in the first decades of the twentieth century, and the Welsh influence is declining steadily. The Eisteddfod Fawr is still held in Chubut, financially supported by the Argentinean government. It gives around a £300,000 a year to support eisteddfodau in Chubut, Gaiman, Trefelin and Trelew, in recognition of the service performed by the early settlers. Gaiman is the 'most' Welsh town in Patagonia, with signs on the road approaching 'Visit Tŷ Llwyd, the Welsh Tea House', 'Stop at Tŷ Gwyn' and 'Come to Tŷ Te Caerdydd'. In Tŷ Te Caerdydd, a costumed group from the local school sometimes dances, and the traditional Welsh tea is served by Welsh-speaking, Welsh-costumed staff. Bruce Chatwin's curious travelogue, *In Patagonia*, gives some flavour of the place, with characters like Alun Powell, Caradog Williams, Hubert Lloyd-Jones, Mrs Cledwyn Hughes and Gwynneth Morgan.

In the 1920's, President Fontana was the first President of Argentina to visit the region. On horseback – there were no roads or trains – the official party could not cross the river into Trelew. A tall, strong, red-haired Welsh youngster called Gough offered to help, and lifted Fontana up and carried him across the raging river, to the town reception. A couple of years later the boy was in the ranks of conscripts in the main square in Buenos Aires, waiting for the president to address all those required to carry out their National Service in the military. The president stepped out onto the square, surrounded by his generals and bodyguard, when a Welsh voice rang out loud and clear – 'Hey, I know you!' Gough broke ranks and started striding towards the Presidente, waving his arms. A hundred guns trained on him before President Fontana broke into a smile and shouted to his guard that this big red-haired youth was indeed not dangerous, and was known to him.

PATRICK, SAINT, PADRIG (c. 389-461) Saint Patrick (Padrig), Ireland's patron saint and 'the Apostle of Ireland', was thought to have been born in Pembrokeshire in 389, and was carried off by pagan Irish raiders (Goidels) in 406, becoming Bishop of Armagh in 432, consecrated by St Garmon at Auxerre. Recent evidence seems to point to his birth in Banwen near Neath or Pedair Onen near Cowbridge. Other sources say that he was captured at the monastic college of Caer Worgan at Llanilltud Fawr, where he was known as Maenwyn (Tall White Rock). The sixth-century St Patrick's Chapel lies under the sands of Whitesand Bay in Pembroke, two miles from St David's and next to Tŷ Gwyn, 'the cradle of Christianity' and 'the earliest Mission College in Britain.' It seems strange that the 'most famous Irishman in the world' was in fact a Welshman. Wales is the only country in the UK to have its native patron saint. Other Welsh saints claimed as 'Irish' include Patrick's brother Senanus or Sennan, his sisters Darerca and Lupida, and the saints Ailbe, Mel, Mechu and Muinis. Many Irish saints were instructed at Llancarfan and Llanilltud Fawr and Welsh saints evangelised Ireland. Unlike St David of Wales, Patrick has never been officially canonised by the Catholic Church.

PAVILAND, THE RED LADY OF Decades before Darwin, this was the first instance of the scientific recovery of fossil human remains in the world, from Goat's Hole Cave at Paviland on the Gower Peninsula. Found by Professor William Buckland in 1823, he correctly identified the skeleton as male, but the ochre-stained bones became a *'painted lady'* in the national press, thought to have 'serviced' Roman soldiers. Perhaps the epithet 'painted lady' or indeed 'scarlet woman' comes from this misattribution of a 29,000-year-old man as a 1,800-year-old prostitute. Buckland was a devout Christian who believed that man evolved on earth only a few thousand years ago. He could not accept the evidence of flint artefacts, nearby bones of Ice Age animals such as Woolly Rhino and Mammoth and the ritual burial of the 'ochred man', as being before the time when man first officially existed according to biblical scholars. New dating techniques show that he died 29,000 years ago. 'Paviland man' was a person of some importance, his robes dyed with red ochre which stained his bones, and buried with fifty rods made of mammoth ivory, ivory bracelets and perforated sea shells. The earliest modern humans in Europe were named Cro-Magnon Man after an 1868 discovery in France, but 'Pavilandian Man' was the original discovery, in 1823. This is the site of the earliest ceremonial burial known in the world, and the discovery has led to the theory that human burial could have originated in Europe, specifically in Wales. At the time of his burial, the cave was far inland, not on the coast.

PEACE UNION This was founded through the hard work of Joseph Tregelles Price, a humanitarian Quaker who tried desperately to save the doomed Dic Penderyn. Its first secretary was Evan Rees of Montgomeryshire, author of *Sketches of Horrors of War*. He was followed as secretary by HENRY RICHARD and the secretaries for the first 100 years were all Welsh. The Peace Union was the forerunner of the League of Nations, which in turn changed into The United Nations.

PELAGIUS (MORGAN) (c. 354-c. 420/440) This Christian almost destroyed the infant

Catholic Church. Said to be a native of Llanrhaeadr and a lay monk at Bangor-is-Coed, he had a pure vision of Christianity which emphasised the individual's direct contract with God, without the intermediary of a powerful and money-making church bureaucracy. Following the example of Christ was the way to Heaven, not praying for salvation or paying for indulgences. His teachings were initially accepted by many bishops, who were later expelled from the church. He fled Rome to escape the Visigoth invasion, and his British follower Celestine was condemned for accepting Pelagius' heresy. Pelagius went to North Africa, meeting Augustine and ended his days in Palestine, being condemned for heresy in 417. Augustine famously declared that there was no salvation outside the church, but Pelagius believed that mankind did not need this intermediary. If one sinned, one broke one's contract with God and went to Hell. If one led a blameless life, following the teachings of Jesus, one went to Heaven. It was as simple as that – it was up to man to make his way to Heaven, not the Roman church. *The Catholic Encyclopaedia* honestly states that 'the greatest error into which he and the rest of the Pelagians fell, was that they did not submit to the doctrinal decisions of the Church.'

His teachings helped make possible the rise of Luther and the non-Roman Christian churches, and it was feared at one time that 'the Pelagian Heresy' would destroy the infant Catholic Church. Pelagianism was an honest approach to the Christian religion that would have starved the early Roman church of funds and power, and its last refuge was in Britain. Pelagianism was extirpated in Greece by 431, but was still followed in Gaul in 429. Pelagius' *Commentary of St Paul* was in use in Ireland in the fifth century, but its last outpost seems to have been Wales, as St David at the Synod of Brefi in 547 preached against it, an act that helped tremendously in his later canonisation. Pelagius' name was a Greek translation of the Celtic Morgan ('sea-born'). His European friends called him Brito, as he hailed from the Celtic Church of the Britons. Settling in Rome about 400, he wrote *On the Trinity*, *On Testimonies* and *On the Pauline Epistles*. His doctrines were examined and he was accused of heresy before the Synod of Jerusalem in 415. His heresy was that he did not believe in Original Sin or predestination, but in free will and in man's innate capacity to do good. His impeachment failed, so the Catholic authorities tried again at the Synod of Carthage in 416. Pope Zosimus manipulated his banishment from Rome in 418, but Pelagianism has often returned to plague the church authorities, particularly with Arminius and Jansen in the seventeenth century. Pelagius was the first real critic of the Greek Orthodoxy of these times, and his contemporary St Augustine of Hippo was forced into formulating a repudiation of Pelagius. However, Bishop Honoratus of Arles tried to reconcile Pelagius and Augustine. With another Briton, Celestius (Celestine), also later excommunicated, Pelagius believed 'si necessitas est, peccatum non est; si voluntatis, vitiari potest' –'if there be need, there is no sin; but if the will is there, then sinning is possible'. Pelagius was condemned by that hater of the socialist Celtic church, the Venerable Bede, for his 'noxious and abominable teaching'. It is worth noting again that Bede rejoiced in the slaughter of Welsh monks at Bangor-is-Coed, because they wished to stay with a more Christian form of a people's religion, rather than one based upon the power of force and Rome. It is extremely important that people understand the Pelagian message, and re-examine the treatment of Cathars, and the reasons for the Crusades. If Pelagius' teachings had been followed, the world would be an extremely different place, with far less war and misery over the centuries.

From a website by Lewis Loflin, entitled *Why Pelagius Was Right*, we read:

Pelagius and his Christianity are more in line with the teachings of Jesus while those of Augustine are derived from a Gnostic cult known as Manacheism, a form of Mesopotamian Gnosticism. Augustine would define the Original Sin for the Latin Church but Pelagius saw through this appalling nonsense. (Gnosticism claims all creation and flesh are corrupt and even sex within marriage was evil.) Like Arius who tried to bring the Christian church in line with Bible, Pelagius too would try to bring the church back to the moral teachings of Jesus. Both lost. The whole argument is over the question of original sin, a concept invented by Paul and later expanded by St Augustine in the West. Due to the politics of

Augustine, Pelagius was convicted of heresy in the West, but was cleared by the Eastern Churches while Augustine himself was rejected later on.

Pelagius was accused along with his disciple, Coelestius of the following beliefs:

Adam was created liable to death, and would have died, whether he had sinned or not;

The sin of Adam hurt himself only and not the human race;

Infants at their birth are in the same state as Adam before the fall;

Neither by the death nor fall of Adam does the whole race of man die, nor by the resurrection of Christ rise again;

The Law introduces men into the kingdom of heaven, just in the same way as the Gospel does.

Even before the coming of Christ there were some men sinless.

Thus he claimed one could achieve grace through one's own free will without the church, its priests, and all its trappings. Many early Christians believed that following Jesus' example and living life as He taught was the way to salvation, but this left nothing for the church to do and so this was declared heresy.

PEMBROKE The town was in decline until 1814, when the Royal Navy Dockyards in Milford Haven were closed and moved to Pembroke Dock, two miles from Pembroke. St Mary's and St Michael churches both date from the thirteenth century, and Monkton Priory Church is on a sixth-century site. Sections of the town wall still remain.

PEMBROKE CASTLE One of the very few castles that never fell to the Welsh, it was founded by Roger de Montgomery in 1093 on a site capable of being supplied from the sea. Gilbert Strongbow, Earl of Pembroke later owned the castle, building the Great Keep, and in 1457 Henry Tudor was born here. In the Civil War, it was besieged by the Parliamentarians and damaged, but still remains a massive and wonderful building, despite Cromwell blowing up the barbican and the fronts of all the towers.

PEMBROKE DOCK, DOCK PENFRO Formerly called Paterchurch, in 1814 the Royal Naval Dockyards were built there, and five royal yachts and 263 warships were built here. The dockyards closed in 1926, and in 1943 it was home to the largest operational base for flying boats (mainly Sunderlands) in the world, guarding the Western Approaches. In 1940, a Junkers 88 penetrated the defences, bombing oil tanks at Pennar. This was the greatest fire in Britain since the Great Fire of London, taking eighteen days to put out.

PEMBROKESHIRE Penfro (Sir Benfro) is a maritime county, and its historic county town is Haverfordwest (Hwllfordd). It was a County Palatine in 1138, under Gilbert de Clare, First Earl of Pembroke. The main towns are Pembroke, Pembroke Dock, Milford Haven, Tenby, Fishguard, Saundersfoot, Narberth, Neyland and St David's. After the Local Government Act of 1972 folded Pembrokeshire into the super-county of Dyfed, its people requested that it became two separate districts, Preseli and South Pembrokeshire. These coincide exactly with the Welsh-speaking North (the Welshry) and the English-speaking South (the Englishry) on either side of the 800-year-old 'landsker' division across the Preseli Hills.

PEMBROKE, SIEGE OF, 1648 Rowland Laugharne and the remnants of his Royalist army fled back to Pembroke after their defeat at St Ffagans, but the Royalist rebellion had by now spread across Wales. Richard Bulkeley and Anglesey declared support for the king, Sir John Owen tried to take Denbigh Castle, Rice Powell took Tenby and Nicholas Kemeys took Chepstow Castle. Parliament now ordered Cromwell and five regiments to Wales to end the Second Civil War, which primarily was a Welsh affair. The Roundheads took back Chepstow and Tenby on their march across South Wales, but John Poyer and Rowland Laugharne still held out in Pembroke Castle. Cromwell's chaplain wrote: 'Pembroke castle was the strongest place that we ever saw...

We have had many difficulties in Wales... We have a desperate enemy.' Cromwell's cannon could not break the 20ft walls and his ladders could not reach 80ft, so he attempted to starve the rebels into surrendering. A local man betrayed the source of the castle's water supplies, which Cromwell cut off. After eight weeks, with no food or water left, Cromwell had secured larger cannon from Gloucester, and the defenders' powder had run out. The Royalists surrendered. Poyer, Powell and Laugharne were court-martialled and sentenced to death, but Thomas Fairfax decided that only one should die. The condemned refused to draw lots, so a young child was chosen to draw, and Poyer was shot in front of large crowds at Covent Garden in 1649.

PENARTH 'The Garden by the Sea' has a restored Victorian pier and esplanade, a flourishing marina with access by boat to Cardiff Bay, and the Turner House Museum, showing paintings from the National Museum of Wales. A walkway around the foot of the headland to link to Cardiff Bay is in progress.

PENCADER, BATTLE OF, 1041 Gruffydd ap Llywelyn defeated Welsh princes to take Ceredigion in his quest for Welsh unity. Among those defeated was Hywel ab Edwin, and Gruffydd carried off Hywel's wife after the battle. Hywel escaped to Ireland.

PENCADER CASTLE Only the motte remains, near Alltwalis in Carmathenshire. It was possibly built by Gilbert de Clare in 1145, but soon retaken by the Welsh. Henry II came to Pencader to receive homage from The Lord Rhys in 1162, and an old man told Henry that the Welsh language would survive until Judgement Day.

PENCELLI CASTLE Near Brecon, it may have been built by Bernard de Neumarche in the 1080's, and was held by the Baskervilles during the war of 1093-1099. It was seized from the Le Wafres by the de Braoses in 1215, regained by the Le Wafres, and lost to the Welsh in 1262. Retaken in 1273, the Mortimers built the gatehouse before it was in turn taken by the king in 1322. The Elizabethan Manor House there was built in 1583-84, becoming the home of the Herberts for 300 years, on the site of St Leonard's Chapel in the castle grounds. Its cellar was documented as a 'dungeon' and the shackles and chains were taken to the National Museum of Wales in Cardiff.

PENCOED CASTLE East of Newport, Monmouthshire, it was probably built around 1270 by Sir Richard de la More, and from 1306 by the de Kemeys. The Morgans of Tredegar turned it into a mansion and it is now derelict.

PEN DINAS HILLFORT On a promontory, it looks over Aberystwyth and covers two summits. The Wellington Monument, a pillar built in 1852, lies inside it.

PENDINE SANDS Malcolm Campbell set a world motor speed record of 146 mph here in 1924, and four more record-breaking runs were made here between 1924 and 1927, two by Campbell and two by PARRY-THOMAS. The seven-mile beach was also used for motorbike and car races. Records were set previously at Brooklands and Arpajon, and after the death of Parry-Thomas, Daytona and Bonneville in the USA became the major venues for record attempts.

PENHOW CASTLE East of Newport, Monmouthshire, this fortified manor house was probably founded by Roger de St Maur around 1130, when he took the lordship from a Welsh prince. In 1240, William St Maur (the name was later to become Seymour) agreed with his brother-in-law Gilbert Marshall, Earl of Pembroke, to take the nearby manor of Undy from the last prince of Gwent, Morgan ap Howell. Pencoed has been restored.

PENLLYN CASTLE Northwest of Cowbridge, this may be a Dark Age site, and features one of the first Norman keeps in Glamorgan. The keep is in the grounds of a fine 1790's manor, and

the site overlooks the main Roman road through South Wales. There are double-coffin-styles for the dead of Penllyn to be carried across fields two miles south to the church at Llanfrynach.

PEN LLYSTYN ROMAN FORT On the bank of the Afon Dwyfach, near Bryncir in Gwynedd, there was accommodation for 1,000 soldiers.

PENMARK CASTLE On the Waycock River in the Vale of Glamorgan, there was a timber castle in the twelfth century, and the stone remains date from the thirteenth century, but the moat has been filled in. There was action here in the Civil War.

PENMON PRIORY It is on the site of St Seiriol's sixth-century monastery, on the east coast of Anglesey, and St Seiriol's holy well still exists. During the twelfth century, under the patronage of Gruffydd ap Cynan and Owain Gwynedd, the abbey church was built, and became Augustinian in the reign of Llywelyn the Great. Two Celtic High Crosses and a smaller cross are inside the church. The dovecot nearby has space for 1,000 birds. There was a sister foundation on nearby Ynys Seiriol (Puffin Island).

PENNAL & CEFN CAER The original sixth-century Celtic church of St Tannwg and St Eithrias is now that of St Peter ad Vincula. Its only sister churches of 'Peter in Chains' are the Chapel Royal in the Tower of London and a church in Rome. There is a unique stained glass window of 'the green man.' The church includes Roman remains from the nearby fort at Cefn Caer, and its oval churchyard indicates a Celtic religious site. In 1406 it was Glyndŵr's Chapel Royal, and it was in Pennal that he assembled the princes of Wales in 1404, when he was crowned Prince of Wales. The Pennal Letter was a radical programme for Wales as an independent nation once again, and there is a copy in the church, as well as a painting of Glyndŵr's coronation. Cefn Caer is a superb pre-fifteenth century medieval Hall House on the outskirts of Pennal, near Machynlleth, built on the remnants of a first-century Roman fort. This unmodernised hall house was an important centre of bardic patronage and was used by Owain Glyndŵr as a base and a home whilst he was setting up his Parliament at Machynlleth. The Pennal Letter was probably written at Cefn Caer, and replicas of Glyndŵr's crown and sword are on display there.

PENNAL LETTER 1406 This was sent to Charles VI in Paris, pledging support for Pope Benedict XIII in Avignon rather than Pope Urban VII in Rome. In the letter, which railed against the 'usurper Henry of Lancaster' and the 'madness of the Saxon barbarian', Glyndŵr proposed that St David's should become an archdiocese independent of Canterbury, and incorporate the dioceses of Exeter, Bath, Hereford, Worcester, Coventry and Lichfield. In Wales, clerics would have to be competent in Welsh. The Pope was also asked to approve the foundation of two Welsh universities, one in the north and one in the south. This was to be the foundation of not just an independent, but of a progressive nation-state.

PENNANT, THOMAS (1726-1798) This scholar from Whitford near Holywell, who corresponded with the eminent Linnaeus and with Gilbert White of Selborne, kept fascinating diaries of his travels through Wales, Ireland and Scotland. *A Tour of Wales,* (1773-1776) is a fascinating assemblage of three volumes.

PENNARD CASTLE With a sheer drop on two sides, it stands on the cliffs at Three Cliffs Bay, on the Gower Peninsula, but was abandoned in the fourteenth century because of the encroachment of sand.

PENNSYLVANIA Welsh Quakers were the founding fathers of Pennsylvania in the late seventeenth century. The grandfather of William Penn was Tudor Pen-y-Mynydd, and his name had become anglicised. William Penn had promised these Quakers a Welsh-speaking colony, 'New Wales', 40,000 acres forming the so-called 'Welsh Barony'. A letter of Penn's in 1690 confirms this fact. However,

also in 1690 the Welsh Tract (Charter) took authority from the Welsh Quaker meetings, placing it in the hands of the colonial government. Penn wished to have the settlement named New Wales, not Pennsylvania, but the Welsh Admiral Sir Thomas Button had given that name to lands along the western shore of Hudson's Bay in 1612. (This remained so until New South Wales was named in 1788). Dr Thomas Wynne of Caerwys planned the layout of Pennsylvania itself, and his house, Wynnewood, still stands, the first stone-built house in the state. A trial at Bala in 1679, for non-payment of tithes to the church, had convinced many Welsh Quakers to emigrate, and they set up the settlements of Bangor, Narberth, Radnor, Berwyn, St Davids, Haverford, Bala-Cynwyd and Bryn Mawr in Pennsylvania. Large tracts of Pennsylvania today are still called Gwynedd, Uwchlyn, Llanerch, Merion, St Davids, North Wales, Treddyfryn and so on. The Welsh Society of Philadelphia, dating from 1729, is the oldest ethnic language society in the USA. Baptists from Swansea flocked to Swanzey, Connecticut, and an attempt was made to establish a 'Utopia' called New Cambria in Pennsylvania. Ohio also had very strong Welsh immigration. At Towamencin near Lansford in Pennsylvania is the Morgan Log House, over 300 years old. This is the oldest, unchanged colonial dwelling in America, built by Edward and Elizabeth Morgan, the grandparents of Daniel Boone. Boone (1735-1820) was one of many American Welshmen who moved to Kentucky via the Carolinas. From 1769, he lived in the forests as a frontiersman with his brother and was twice captured by Indians. From 1775-1778 he repelled Indian attacks on his stockade fort, around which Boonesboro has grown up.

PEN Y CRUG HILLFORT Near Y Gaer, the Roman camp outside Brecon, it is a superb large site, with the innermost rampart still standing 17ft high.

PENYDARREN ROMAN FORT In Merthyr Tudful, there was a bathhouse here.

PEN Y GAER HILLFORT At Llanbedr-y-Cennin, south of Conwy, there are two ramparts, and three ramparts elsewhere on the site, defending hut foundations. It is a special site because of its use of *'chevaux de frise'*, a complex of short, sharp standing stones facing any attackers. These slowed down any attack, and are the equivalent of 'dragons' teeth used in World War II against tanks.

PEN-Y-GAER ROMAN FORT Near Bwlch, Powys, it was abandoned around 120 CE.

PENRHYN CASTLE Outside Bangor, Penrhyn Castle was originally a medieval fortified manor house, founded by Ednyfed Fychan (d. 1246), the seneschal to Llewelyn the Great and his son Prince Dafydd of Gwynedd. In 1438, Ioan ap Gruffydd was granted a licence to crenellate, and he founded the stone castle and added a tower house. Between 1820 and 1845 the castle was redesigned by Thomas Hopper. A spiral staircase from the original property can still be seen, and a vaulted basement and other masonry were incorporated into the new structure. Hopper's clients were the Pennant family, who had made their fortune from Jamaican sugar and Welsh slate quarries. In 1859 Queen Victoria visited, and a one-ton slate bed was made for her. Queen Victoria was notable in that her girth measurement was greater than her height.

PENRHYN QUARRY STRIKES In 1896, dissatisfied with conditions and wages, the workers walked out of Bethesda slate quarry, and were locked out for eleven months, returning but having won no concessions. On 22 November 1900, 2,800 men again walked out of Lord Penryhn's quarry as they wanted union recognition, and remained locked out for three years. Four-hundred returned to work in June 1901, leading to local unrest, and the social community of Bethesda never fully recovered.

PENRICE CASTLE This derelict Norman castle is the largest on the Gower Peninsula, in ruins and on private land.

PENRY, JOHN (1563-1593) The first Welsh Puritan martyr was the Presbyterian John Penry from

near Llangamarch in Breconshire, executed in 1593. Educated at Cambridge and Oxford, his second book was secretly printed in 1588, the year of the Armada. He appealed to Parliament in it for Welsh-speaking preachers in 'my poor countrie of Wales'. He described the Welsh bishops of the established Church of England as 'excrements of Romish vomits', and pleaded for the sovereignty of the individual conscience. He was hung, drawn and quartered.

PENTRAETH, BATTLE OF, 1170 Upon Owain Gwynedd's death in 1170, his sons fell into dispute over the lordship of Gwynedd. Hywel ab Owain's half brothers Dafydd and Rhodri had forced him to flee to Ireland. Hywel raised an army in Ireland and returned the same year in an attempt to claim a share of the kingdom, but was defeated and killed at the Battle of Pentraeth on Anglesey, at Rhos-y-Gad (Battle Moor), or actually on the beach at Pentraeth where the River Nodwydd meets the sea. The seven sons of Hywel's foster-father, Cadifor, were killed while defending him in this battle, and were commemorated in verse:

> The sons of Cadifor, a noble band of brothers
> In the hollow above Pentraeth
> Were full of daring and of high purpose
> They were cut down beside their foster-brother.

Hywel was an excellent poet, and his best-known poem is probably *Gorhoffedd Hywel ab Owain Gwynedd* in which he praises his father's kingdom of Gwynedd, both for its natural beauties and its beautiful women. Other of his poems include the earliest known love poetry in the Welsh language. Many Welsh princes wrote poetry. Literacy was less well respected across the border in England.

PERROT, SIR JOHN (PERROTT) (1527-1592) One of history's intriguing elements was the failure of Henry VIII to have a son by Catherine of Aragon, the former wife of his brother Arthur. However, Henry did have an illegitimate son, Sir John Perrott, who was born in 1527. His mother was Mary Berkeley, a lady of the royal court and wife of Sir Thomas Perrott. Edward VI, Mary and Elizabeth I all acknowledged John Perrott as a half-brother. Sir John was one of the four knights who carried Elizabeth I's canopy at her coronation. He made vast wealth from his time as Vice-Admiral for West Wales, much from collusion with pirates, and built a great manor at Haroldston outside Haverfordwest, rebuilding Laugharne and Carew castles as manor houses. Elizabeth appointed him Lord President of Munster, to suppress a rebellion there, which he did within a year. He was Lord Deputy of Ireland from 1584 to 1588, but was arrested on a false charge of treason in 1591 and sentenced to death. Queen Elizabeth refused to sign the death warrant of her half-brother and planned to pardon him, but he died in the Tower of London.

PERSONAL NAMES Some of the author's favourite old Welsh Christian names for males are: Aelhaear, Aeron, Alawn, Aled, Anarawd, Andras, Aneirin, Arwel, Awen, Bedwyn, Berwyn, Bledri, Bleddyn, Brynmor, Cadfael, Cadwaladr, Carannog, Caron, Carwyn, Celn, Cennydd, Cian, Cledwyn, Colwyn, Cyffin, Cynan, Dafydd, Dilwyn, Dyfan, Dyfed, Dylan, Edern, Eifion, Elgan, Elis, Elwyn, Euros, Gareth, Geraint, Glyndŵr, Gruffydd, Gwilym, Gwyndaf, Gwynfor, Heddwyn, Hywel, Iestyn, Ieuan, Iolo, Iorwerth, Islwyn, Iwan, Lewys, Llywarch, Llywel, Llywelyn, Mabon, Macsen, Madog, Maelrys, Maldwyn, Maredudd, Medwyn, Meirion, Meurig, Meuryn, Mihangel, Orfran, Morgan, Morien, Morlais, Mostyn, Myrddin, Onllwyn, Owain, Powel, Prys, Rhodri, Rhydian, Rhys, Selwyn, Selyf, Tecwyn, Teifion, Tudur, Trahaearn, Tryfan.

For females, selected Christian names include: Aelwen, Aerona, Aeronwen, Alwen, Aneira, Angharda, Annest, Anona, Arianwen, Arwen, Betsan, Bethan, Bradwen, Branwen, Bronwen, Carwen, Carys, Catrin, Ceinlys, Ceinwen, Cerian, Ceridwen, Cerys, Daron, Dilwen, Dwynwen, Eiddwen, Eilwen, Eira, Eirawen, Eirlys, Eirwen, Elan, Elen, Eleri, Eluned, Elwen, Euron, Fflur, Gaenor, Gwenllian, Gwenonwy, Gwyneth, Heledd, Ilid, Ionwen, Luned, Lynwen, Llinos, Mair,

Mairwen, Manon, Marared, Marchell, Mared, Marged, Margiad, Medeni, Medwen, Megan, Meinwen, Meirian, Meirionwen, Melangell, Meleri, Menna, Mererid, Meriel, Meryl, Morwen, Morwenna, Mwynen, Myfanwy, Nerys, Nia, Non, Nonna, Olwen, Prydwen, Rhian, Rhiannon, Rhoslyn, Seren, Sian, Sioned, Siriol, Sulwen, Teleri.

PHILIPS, KATHERINE (1632-1664) She was 'Britain's first recognised female writer' and was also called 'the first of the English poetesses'. She wrote poems to Henry Vaughan and in praise of the Welsh language, being known to her contemporaries as 'the matchless Orinda.'

PHYSICIANS OF MYDDFAI Llyn y Fan Fach, in the mountains near Llanddeusaint, is known as the place where Myddfai of Blaen Sawdde farm met the *'lady of the lake'*. After Myddfai offered her three kinds of bread, the beautiful woman promised to marry him on the condition that he would never hit her three times without a cause. Her father gave the couple livestock, and they lived at Esgair Llaethdy farm and had three sons. However, Myddfai tapped her thoughtlessly on three occasions; when she did not want to attend a baptism, when she cried at a wedding and when she laughed at a funeral. She disappeared with all the animals, but reappeared to her sons on several occasions, at Llidiart y Meddgon (Physicians' Gate) and Pant y Meddygon (Physicians' Hollow). She taught them how to heal with herbs and plants, and her eldest son Rhiwallon became physician to Rhys Grug, Lord of Dinefwr. Rhiwallon's three sons were Rhys Grug's doctors when he died in 1234, and they founded a long line of physicians culminating in John Williams, Queen Victoria's eminent doctor. The places still exist, where the ancestors of this longest line of medical men in recorded history learned their profession. John Williams edited the thirteenth-century manuscript of the earliest folk remedies *The Physicians of Myddfai* and it was translated into English by John Pughe in 1861.

PICTON CASTLE In 1108, to strengthen his toehold in Pembrokeshire, Henry I settled Flemings around Haverfordwest. Around this time, Picton was founded, with a Flemish leader, Wizo, founding Wiston Castle, just three miles to the north. The castle passed through the Wogans to the Dwnns and then to the Phillipps. The castle was probably built by Sir John Wogan, Justiciar to Ireland from 1295-1308.

PICTON, SIR THOMAS (1758-1815) 'The Hero of Waterloo', from Poyston in Pembrokeshire, distinguished himself in battle at St Lucia in 1796, and was made Governor of Trinidad when it was taken in 1797. In 1809 he fought at Walcheren, and was made Governor of Flushing. He then took command of the 'Fighting 3rd' division under Wellington in the Peninsular War. His bravery at the terrible battles of Badajoz, Vittoria and Ciudad Rodrigo made him popular with his men and the British public. He also fought at Bussaco, Fuentes d'Onor, in the Pyrenees, Orthes and at Toulouse. He received the thanks of the House of Commons on seven occasions and retired with honour to Ferryside, aged fifty-six. Napoleon escaped from Elba, and Wellington recalled Picton to command the English Fifth Division. Picton's 'thin red line' held Quatre Bras in the face of murderous attacks, and he sustained grave gunshot wounds in his ribs and hip, which he and his valet concealed from his officers and Wellington. Two days later, Picton formed his division in a square and boldly led an unexpected charge with bayonets, at Waterloo. He was shot in the head. This manoeuvre effectively turned the battle in Wellington's favour. Picton had been in tremendous pain, with broken ribs from the earlier wound, and both hip and rip wounds were gangrenous. He may be the only Welshman buried in St Paul's Cathedral, and there is a monument to him in Carmarthen. He was loved by his men, leading from the front and serving forty-five years as a soldier.

PIERS Some have vanished, but there are fine survivors at Penarth, Colwyn Bay, Aberystwyth, Llandudno, Bangor, Mumbles and Beaumaris.

PIGS The Welsh Pig is claimed to be the oldest breed in history, and like other animals, is featured strongly in Celtic legend and place-names. Sixty years ago, this long-faced, floppy-eared white pig was one of the three most popular breeds in Britain, but in 2009 its numbers were down to just 377 breeding sows and 77 boars. It appears that the Welsh Black Pig has become extinct since the last war. One of the most popular terms for a child who gets a mucky face eating is still a 'mochyn ddu' (black/dirty pig), even in Anglicised areas of Wales.

PIGSTIES In south Wales there are around eighty remaining examples of circular pigsties, built of dry stone (with no mortar or cement), using corbelling and resembling early Irish Christian cells. Most are in Glamorgan and date from the late eighteenth and early nineteenth centuries. There is an example in the Museum of Welsh Life.

PIGWN ROMAN MARCHING CAMPS These are near Trecastle, with one built inside another, and a Roman road leads to Pigwn stone circle.

PILLETH, THE BATTLE OF (BRYN GLAS), 22 JUNE 1402 This was a national humiliation for the English, and the news of their casualties on St Alban's Day reached Rome within days. Near Presteigne, Sir Edmund Mortimer had led the English army of 2,000 to defeat Owain Glyndŵr, who had been proclaimed Prince of Wales by his fellow princes. Four redwood trees mark the site of a mass grave found in the late nineteenth century. It appears that Mortimer saw Pilleth Church burning, crossed a marsh and headed uphill through scrubland. The hill is not continuous, and it appears that Mortimer saw about 600 Welshmen on what he thought was the ridge, and headed towards them. As they approached the small force, the bulk of Glyndŵr's army, led by Rhys Gethin (the Fierce) appeared over the top of the hill, behind Glyndŵr's vanguard and began pouring arrows into Mortimer's army. Mortimer was on the lower slopes, with the marsh behind him. His own Welsh archers, seeing the Golden Dragon flags of Glyndŵr, turned on their English compatriots and Mortimer's force was crushed, he being captured and later joining Glyndŵr's forces. At least 1,100 of Mortimer's men were killed. After two years of war, this was the breakthrough by Glyndŵr's guerrillas, and led to another thirteen years of fighting.

PIOZZI, HESTER LYNCH (1741-1821) Proud of her ancestor Catrin o'r Berain on her father Sir John Salusbury's side, 'Mrs Thrale' was an educational prodigy. Soon after marrying the wealthy London brewer Henry Thrale, she was mixing with Sir Joshuah Reynolds, David Garrick, Oliver Goldsmith and the cream of London society, but is best known for her long friendship with Samuel Johnston, who idolised her. An author and belle-lettriste she later 'scandalously' but happily married an Italian music-master, Gabriele Piozzi, a man 'below her station' in polite society.

PIRATES Wales produced the most famous privateer in history, Sir HENRY MORGAN. It also produced a notable series of pirates, including the greatest and most curious them all, Black BART ROBERTS, whom *Newsweek* called the 'last and most lethal pirate', also known as 'The Black Pirate'. Daniel Defoe called his aspect 'black', as he had black hair and a dark complexion, and he was simply the most formidable pirate in history. To put piracy into context, the English Navy was a bitterly cruel organisation, and deserters were common. It had to 'press-gang' most of its unfortunate seamen from British ports. Conditions were not quite as bad in the merchant navy, but there was still a constant flow of dissatisfied seamen men willing to sail under the black (or red) flag of piracy. Bartholomew Roberts wrote of the motives for becoming a pirate: 'In an honest service there is thin rations, low wages, and hard labour; in this, plenty, satiety, pleasure and ease, liberty and power; and who would not balance creditor on this side, when all the hazard that is run for it, at worst, is only a sour look or two at choking (dying)? No, a merry life and a short one shall be my motto.' Apart from Bartholomew Roberts (1682-1722) and HOWEL DAVIS, Wales had some other major contributions to make to pirate history. JOHN

CALLICE was the most renowned Elizabethan pirate. Captain John Bowen (fl. 1701) operated between the Red Sea and Bengal, with headquarters in Madagascar. He retired to Mauritius with a vast fortune. His movement into piracy began with his capture by French pirates. Captain James also operated in these South Seas.

PLAID CYMRU During the National Eisteddfod in Pwlleli in 1925, representatives from Y Mudiad Cymreig (The Welsh Movement) and Byddin Ymreolwyr Cymru (The Army of the Welsh Home Rulers) met to join and form Plaid Cymru (The Welsh National Party). Saunders Lewis was a founder and later president, and the other five people present at the meeting were Lewis Valentine, H.R. Jones, Moses Gruffydd, D.E. Williams and Fred Jones. It followed the failure of Cymru Fydd and the huge advances made by Labour at the 1922 General Election. The party's main aim from 1930 was Dominion status for Wales. There was a great opportunity to take advantage of the militancy engendered by the Trywerin affair, but the Plaid leader Gwynfor Evans, like his predecessors, was a committed pacifist. It made electoral progress under Dafydd Wigley, but in this millennium seemingly has become moribund. Its deep commitment to windfarms, pylons and substations has alienated many members, especially those with an engineering, scientific, environmental or economics background.

PLAS NEWYDD The National Trust's Plas Newydd, on the banks of the Menai Strait, is an elegant eighteenth-century country house designed by James Wyatt, with Whistler's largest wall painting, and a military museum devoted to the battle of Waterloo.

POETRY The great French scholar Camille Julian confirmed that Celtic unity was 'in the domain of poets rather than statesmen'. Wales is a literary nation, with its background suffused by the Bardic poetic tradition – as Idris Davies says in *Psalm:*

Make us, O Lord, a people fit for poetry,
And grant us clear voices to praise all noble achievement...
Make us worthy of the golden chorus
That the sons of God have always yearned to sing.
Make us, O Lord, a people fit for poetry.

Poetry is at the heart of all Welsh culture and Wales has the oldest recorded poetry in any living Western language, from the cynfeirdd, first poets, Aneirin and Taliesin in The Dark Ages. The saga of Llywarch Hen, perhaps a fifth-century tragedy, tells of the King mourning the death of all his twenty-four sons in battle. Many of the oldest poems still exist, having passed down verbally through the centuries before being written in the eleventh and twelfth centuries. It was said that the old Celtic bards, or poets, had to train for twelve years to become a full bard, learning eighty long story-poems in the first six years. In the next three years they had to learn another ninety-five, and in the final three three another 175 heroic odes, each taking over an hour to retell. The oldest surviving poems use many mnemonics (aids to memory), stemming from this tradition of having to intimately know over 350 hours of poetry. The Welsh poetic tradition, going back 1,500 years, is almost matchless among living languages.

POITIERS, THE BATTLE OF 1356 In 1356, the 'Black' Prince of Wales found himself at Poitiers, near Tours, with an Anglo-Gascon army of 8,000 men. He faced King Jean's army of at least twice as many soldiers. The Prince played for time by negotiating, while his troops frantically set up defensive positions and palisades for his Welsh archers. Marshal Clermont advised blockading the English and starving them out, but his proposal was rejected. However, the only access to the English enemy was a narrow passage allowing only four men to ride through. The French flank was decimated by Welsh archers before they could approach the centre of the field. The French frontal attack was beaten back by arrows that fell so thick that they 'darkened the air'. Shooting from protected positions, protected by dismounted knights and foot soldiers, archers aimed at the unarmoured rumps of the retreating horses. Their fallen

riders were then knifed and piked to death. After repulsing three assaults in seven hours, the Black Prince and the Captal de Buch charged out and captured the French King. Several thousand of the French nobility had died, and the King, Constable, Marshalls, thirteen counts, five viscounts, twenty-one barons and 2,000 knights and men-at-arms were captured. On the Black Prince's side was Hywel ap Gruffydd, known as Hywel y Fwyall, or '*Hywel the Axe*'. His battle-axe was so feared that for many years after his death, a feast was served before it, then given out to the poor in honour of Hywel. Fighting for the French against the English was Owain Lawgoch, the heir to the Princes of Gwynedd, who somehow survived the slaughter, and later captured the famous Captal de Buch.

POLITICS As more people were allowed to vote in the years leading up to universal suffrage, the Welsh voted for the Liberal Party, for its stance supporting Nonconformism. However, the Labour Party has come to dominate Welsh politics. Merthyr, a town of grinding oppression from the ironmasters, had been the first town in Britain to elect a Socialist MP, with Keir Hardie in 1900. The swing from Liberals to Labour and the left is shown in the following table:

Welsh MP's	LAB	TORY	LIB	PLAID	OTHER
1900	1	6	26	-	1
1906	1	-	28	-	4
1910Jan	5	2	27	-	-
1910Dec	5	3	26	-	-
1918	10	3	2	-	20
1922	18	6	2	-	3
1923	19	4	11	-	1
1924	16	9	10	-	-
1929	25	1	9	-	-
1931	15	6	8	-	6
1935	18	6	2	-	9
1945	27	3	4	-	1
1951	27	5	3	-	1
1955	27	5	3	-	1
1959	27	6	2	-	1
1964	28	6	2	-	-
1966	32	3	1	-	-
1970	27	7	1		1
1974 Feb	24	8	2	2	-
1974 Oct	23	8	2	3	-
1979	22	11	1	2	-
1983	20	14	2	2	-
1987	24	8	3	3	-
1992	27	6	1	4	-
1997	33	-	1	4	-
2001	34	-	2	4	-
2005	29	3	4	3	1

In 1888, Keir Hardie (a Christian pacifist socialist who bitterly opposed the First World War) had made a pledge on Home Rule, and Devolution was 'pledge number 3' in Labour's General Election Manifesto in 1918. In 1924, Labour introduced its first devolution bill, but the bill was 'talked out'. In 1929, the pledge on devolution had dropped to last position out of 63 in Labour's General Election Manifesto, as the party realised that Wales and Scotland were easy votes for them. When Labour achieved power in 1945, it totally dropped its commitment to constitutional reform. Labour's proposals for a toothless Welsh Assembly in 1997 paralleled its

1978 Wales Bill, when the 1979 Referendum offered the same powerless assembly to the people. For seventeen years to 1997, Wales was ruled by a Conservative party that won just 39 seats out of 190 in 5 elections in Wales. The Tory Party now has only 3 seats in Wales, but Wales can still be treated like a colony by an English/Scottish-controlled parliament. The Secretary of State for Wales can push legislation through the House of Commons using the votes of English MP's, even if every Welsh politician is against it, such as a new nuclear power station, wind turbines on its mountains and hills, rivers diverted, valleys drowned, a new Severn Barrage or whatever. Measures that affect only Wales, and no other part of the UK at all, must be accepted with no power to change them at all. The Scottish Assembly was given legislative powers because of the predominance of Scots in the Cabinet at that time, including the two most powerful men, Tony Blair and Gordon Brown. If the House of Commons looks like not wishing measures to go through, the non-elected Privy Council can bypass it. A Privy Council quorum can be made up of four Counsellors and the Queen, and it recently blocked a High Court decision to allow the illegally displaced Chagos Islanders to return to their homelands. So much for British democracy.

PONTCYSYLLTE AQUEDUCT Near Llangollen, it was built by Telford between 1795 and 1805, and is one of the world's greatest engineering achievements. It was built to carry the Ellesmere Canal to link the coalmines of Denbighshire to the national canal system and the heartlands of the Industrial Revolution. The greatest of obstacles was the crossing of the Dee valley. With its 19 spans, 1007ft length and height of 127ft, it was the tallest aqueduct in the world for 200 years. The spectacular achievement was made possible by the pioneering use of cast iron. The height made it necessary to find ways of reducing weight of stonework in the piers. They were tapered and the top sections were built hollow. Only one man was killed in its construction, and according to the engineers, he was at fault. Now a World Heritage Site, it carried 10,000 canal boats and 25,000 pedestrians each year. When built, it was said that crossing it was the closest experience one could get to flying. The narrow-boats that use it weigh 12 tons, and its water is contained is a huge cast-iron trough. The sections were sealed and made watertight with Welsh flannel boiled in sugar, and bedded into mortar made of lime and ox-blood.

PONTYPOOL Superb Pont-y-pŵl Japan lacquer-ware was produced from the seventeenth to the nineteenth century, and the town grew with iron-working from Elizabethan times.

PONTYPRIDD The Ynysangharad chain works, founded along the Glamorgan Canal in 1816, made the huge anchor chains for the *Queen Elizabeth* and *Queen Mary*. The eighteenth-century 140ft single-span bridge was once the longest single-span bridge in the world, built by the self-taught William Edwards.

PORCELAIN Nantgarw and Swansea were centres for making high quality porcelain between 1815 and 1820, which because of its scarcity is extremely collectable. Individual pieces can fetch over £10,000.

PORT EYNON At Port Eynon, the headland has the remains of the great Salt House, a mansion destroyed by storms some 300 years ago, and a short walk takes one to the mysterious Culver Hole, a walled-up fissure in the cliffs possibly used for smuggling, and definitely as a mediaeval dovecote (a culver is a wood-pigeon).

PORTHAETHWY, BATTLE OF, 1194 Llywelyn ap Iorwerth defeated his uncle Rhodri ap Owain Gwynedd at Menai Bridge (Porthaethwy) on Anglesey, in his campaign to take over Gwynedd.

PORTHCAWL In 1831 its docks were built in response to demand from the coal trade, but

closed in 1906 and the town developed as a holiday resort, with fine beaches, a funfair, a huge caravan site at Trecco Bay and an excellent golf course.

POWELL, ANTHONY DYMOKE (1905-2000) Powell, who pronounced his name Pole, was proud to be able to trace his heritage back to The Lord Rhys. He is known for his epic 12-volume novel *A Dance to the Music of Time*. Another famous writer who was aware of his Welsh heritage was C.S. Lewis, of *Narnia Chronicles* fame. Equally, the poet Ted Hughes was of Welsh extraction, with a sister named Olwen.

POWIS CASTLE Outside Welshpool, it was a Norman castle at the heart of the kingdom of the princes of Powys. Now a National Trust property, it is a grand mansion and has been inhabited by the Powis family for over 500 years. The castle gardens, laid out in 1722, are especially fine.

POWYS, JOHN COWPER (1872-1963) In 1934, this novelist moved to Corwen for inspiration from the mountains, and wrote two of his finest works, *Owen Glendower* (1940) and *Porius* (1951) here. His first major novel had been *Wolf Solent* in 1929, which Herman Hesse called *a* 'cumbersome chunk of genius'. In 1955 he moved to Blaenau Ffestiniog, where he died in 1963. Henry Miller praised him fulsomely, as did Simone de Beauvoir and Elias Canetti. Powys wrote 'We Aboriginal Welsh People are the proudest people in the world. We are also the humblest'. A powerful but neglected novelist, his brothers Llewelyn and Theodore Francis also contributed to a notable literary outpouring from one family.

POWYS This kingdom emerged after the Roman withdrawal, based on the tribal lands of the Cornovii. Its first known king was Cadell Ddyrnllwg, *c.* 460. Its boundaries originally extended from Cambrian Mountains to include the the West Midlands of England, and included the Severn and Trent rivers. The region was organised into a Roman province, with the capital at Viroconium Cornoviorum, Wroxeter, the fourth largest Roman city in Britain. In the early Dark Ages, it was ruled by the Gwrtheyrnion dynasty, descended from the marriage of Vortigern (Gwrtheyrn) and Princess Sevira, the daughter of Magnus Maximus (Macsen Wledig). From the fifth to eighth centuries, Germans pressurised the West Midlands, eventually conquering it to form Mercia. Wales had been depopulated by a great plague in the mid-sixth century, but the English immigrants were less affected by because they had far less trading contact with the continent. It seems that at this time King Brochwel Ysythrog (the Fanged) moved the court of Powys west from Wroxeter (Caer Guricon) to Shrewsbury (Pengwern). In 616 Aethelfrith of Northumbria defeated Selyf of Powys at Chester, and Meifod became the new court and royal burial site. Powys now stabilised its borders with several victories against the Mercians, and the court moved to Mathrafal in the Powysian Hills by 717. The building of Offa's Dyke took Oswestry back into English possession, but over time the area between the dee and Conwy, the 'Perfeddwlad' came back to the princes of Powys. Powys was united with Gwynedd when King Merfyn Frych of Gwynedd married princess Nest, the sister of king Cyngen of Powys, the last representative of the Gwrtheyrnion dynasty. With Cyngen's death in 855, Rhodri Mawr of Gwynedd became King of Powys. His son Merfyn inherited Powys in 877. Maredudd ab Owain ap Hywel Dda was King of Deheubarth and Powys by 986, when he seized Gwynedd. Maredudd fought off English encroachment in Powys and increasing Viking raids in Gwynedd. Powys passed to his grandson Llewelyn ap Seisyll and his son Gruffydd united all of Wales. Upon the death of the The Lord Rhys of Deheubarth in 1197, the ruling power in Wales passed to the royal line of Powys, to Madog ap Maredudd, who is described in *The Dream of Rhonabwy* in the Mabinogion. From Madog, power passed to Owain Cyfeiliog, his nephew, a poet who consolidated Powys. Owain Cyfeiliog was excommunicated by Canterbury, but was buried in at Ystrad Marchell, the Cistercian Abbey he had founded. The violent Gwenwynwyn of Powys succeeded (he features in Walter Scott's novel *The Betrothed*), but he was decisively defeated.

Leadership of Wales now passed from Deheubarth and Powys back to the House of Gwynedd – to Llywelyn the Great. Mathrafal Castle remained the capital of the Princes of Powys until Gwenwynwyn moved to Welshpool in 1212. In 1267 both Powys Fadog and Powys Wenwynwyn paid homage to Llywelyn Gruffydd of Gwynedd as the Prince of Wales, but Gruffydd ap Gwenwynwyn, the lord of Powys Wenwynwyn, changed allegiance again in 1277 during the new English campaign against Llywelyn II. In the final campaign of Llywelyn the Last in 1282 the forces of Gruffydd ap Gwenwynwyn were instrumental in his downfall and the demise of Welsh independence, when with Hugo Le Strange and the Mortimers they lured Llywelyn into negotiations and killed him. After 1284 Welsh princely titles were abolished and Powys ceased to exist. It was incorporated into the new counties of Breconshire, Montgomeryshire, Radnorshire and parts of Denbighshire in 1974 to reform into the county of Powys.

PREECE, SIR WILLIAM HENRY (1834-1913) From Caernarfon, he was instructed by Michael Faraday, and became a pioneer of wireless telegraphy and telephony. Inspired by DAVID HUGHES, he improved railway signalling and introduced the first telephones to Great Britain, from the USA, as engineer-in-chief of the Post Office.

PRESIDENTS OF THE UNITED STATES OF AMERICA Wales gave the infant USA five of its first six presidents, John Quincy Adams, John Adams, Jefferson, Madison and Monroe. Three died on 4 July, Independence Day, Adams and Jefferson in the same year. (America has had thirteen Presidents with Welsh ancestry). In 1916, Charles Evans Hughes, the Welsh-speaking son of a Tredegar immigrant, was only just beaten by Woodrow Wilson for the Presidency (277 to 254 Electoral College votes, 9,129,606 to 8,538,221 popular votes). Charles Evans Hughes was Secretary of State and Chief Justice between 1921 and 1925, and 1931-1940 respectively. Joseph Davies helped shape American foreign relations, and Harry Lloyd Hopkins headed the New Deal projects under F. D. Roosevelt. As Roosevelt's closest confidante, Hopkins undertook special missions to Russia and Britain in World War II. In 1849, the unknown twelfth President of the USA was the American-Welshman David Rice Atchison, who served for one day pro-tempore between Presidents Polk and Taylor. Probably the most useful politician of all time, he never started a war, raised taxes, told lies or broke promises.

PRESTATYN In the eighteenth century a centre for lead-mining, it is now an established seaside holiday resort.

PRESTATYN CASTLE Henry II built the original castle in 1157, and it was expanded by Robert de Banastre in 1164, but destroyed by Owain Gwynedd in 1167. Banastre and his followers went to Lancashire. The Earls of Chester took over the castle.

PRESTATYN ROMAN FORT The XX Legion used this fort, and there are remains of a bath house and its aqueduct.

PRESTEIGNE Llanandras, the holy place of St Andras, it was once on the main coach route from London to Aberystwyth. Thirty of its buildings were once coaching inns.

PRICE, HENRY HABBERLEY (1899-1984) From Neath, this noted philosopher was Professor of Logic at Oxford, whose major works included *Perception* in 1932, *Thinking and Experience* (1953), *Belief* (1969) and *Essays in the Philosophy of Religion* (1972).

PRICE, RICHARD JOHN LLOYD (1843-1923) This squire of Rhiwlas near Bala, he inherited his estate aged seventeen, and founded the Bala Whisky Distillery in the 1860's. His entrepreneurial activities are recorded in an odd book of his called *Dogs Ancient and Modern and Walks in Wales*. Inside his book cover, Price advertised more of his enterprises, including:

'The Rhiwlas Game Meal; Rabbits for Profit and Rabbits for Powder; Welsh Whiskey; Rhiwlas Game Farm; and Fresh Laid Pheasants' Eggs'. A plaque he placed on a house in Bala reads 'Home-made House – All Bricks and Slates Produced in Rhiwlas Estate'. He also organised the first recorded sheepdog trial on 9 October 1873, where a plaque was erected to record the event near the field.

PRICE, DR RICHARD (1723-1791) One of the most influential and original Welshmen in history was Dr Richard Price of Llangeinor, a dissenting minister and radical who, with his friend Joseph Priestley helped found the Unitarian Society. He influenced Mary Wollstonecraft, who wrote the important *Vindication of the Rights of Women*. His *Review of the Principal Questions in Morals* put an element of realism into the philosophy of the day, and was possibly the greatest of his theological and ethical treatises. A close friend of Benjamin Franklin, Price supported the American Revolution, and *The Declaration of Independence* owes a great deal to his *Observations on the Nature of Civil Liberty*. This seminal work sold 60,000 copies and ran to twelve editions by the end of 1776. He argued that each community had the right to self-government, responsible only for carrying out their electors' wishes, and that denial of this responsibility constituted treason. How different to today, where MP's generally genuflect to their whips and party policy.

He also drew up the first budget of the new American nation, and his expertise on demography and actuarial matters influenced the financial policies of William Pitt and Shelburne. Unwavering in his support for the American colonies, despite English opprobrium, he refused an offer of American citizenship. Price was also a great supporter of the French Revolution. A Unitarian minister and moral philosopher, he argued against David Hume, believing that 'morality is a branch of necessary truth'. In 1776 he published '*Observations on the Nature of Civil Liberty*', which influenced the French Jacobins. He also provoked Burke's anger with his support for the French Revolution and the French 'ardour for liberty' (*A Discourse of the Love of Our Country* 1789), where he sermonised 'Tremble, all ye oppressors of the world... you cannot now keep the world in darkness'. Price also supported the American Revolution with several books. He was honoured in both these countries.

This 'Friend of the Universe, the Great Apostle of Liberty' was asked by the newly established American Congress, through his friend Benjamin Franklin, to accept American citizenship and to set up a financial system in the new republic. The Continental Congress sent him the following resolution 'In Congress 6 Octr 1778, Resolved, That the Honourable Benjamin Franklin, Arthur Lee, and John Adams Esqrs or any one of them, be directed forthwith to apply to Dr Price, and inform him, that it is the Desire of Congress to consider him as a Cityzen of the United States, and to receive his Assistance in regulating their Finances. That if he shall think it expedient to remove with his family to America and afford such Assistance, a generous Provision shall be made for requiting his Services.' Price influenced Marx and Engels. He also influenced William Pitt the Younger with his writings on The National Debt, and helped to set up the first scientific system for life insurance and pensions with his *Observations on Reversionary Payments* in 1771. Price had been admitted to The Royal Society in 1765 for his work on probability, and was a friend of Bayes, whose work he rescued from obscurity. This statistician, preacher and philosopher had a political influence upon radicals in both the Old and New Worlds. John Davies calls Price 'the most original thinker ever born in Wales'. He was officially mourned in Paris, when he died in 1791.

PRICE, REV THOMAS (1787-1848) Known by his Bardic name of Carnhuanawc, Price was criticised in the *Blue Books* enquiry for being too enthusiastic over the use of Welsh in the classroom, and spent his life campaigning for the language. Between 1836 and 1842 his *Hanes Cymru (History of Wales)* was published in fourteen parts. Price set up his own school in Felindre, Cmwdu in Breconshire so that Welsh could be used in the classroom, and assisted Lady Llanover with the translation of the *Mabinogion* into English. He greatly advanced the cause of collecting Welsh manuscripts, harp music and folk dances.

PRICE, WILLIAM (1800-1893) Llantrisant in Mid-Glamorgan has a superb hill fort, and provided the Black Prince's finest archers for The Hundred Years' War. However, its main claim to fame is its nineteenth century-doctor/druid, Dr William Price, who proselytised not just vegetarianism, nudity, and free love, but also the unhealthiness of socks, the potential dangers on the environment from rapid industrialisation, revolution, republicanism and radical politics. He refused to treat patients who would not give up smoking, and prescribed a vegetarian diet instead of pills. Born at Rudry, on 4 March 1800, he qualified as a doctor at the age of twenty-one. He was the first doctor to be elected by a group of factory workers as their own general practitioner, being paid a weekly deduction out of wages paid at the Pontypridd Chainworks. This was the precursor of the miners' medical societies, which were, in turn, the origin of the National Health Service.

A skilled surgeon, he attended Chartist rallies in a cart drawn by goats. He was forced to escape to France (in a frock) to live in 1839, after taking part in the terrible Chartist Riots in Newport, and returned seven years later. He held druidic ceremonies at the rocking stone near Pontypridd, which were considered satanic by the local Methodists. He did not approve of marriage as it 'reduced the fair sex to the condition of slavery' and lived openly 'in sin' with his young housekeeper. This precursor of the Hippy Movement had a son when he was eighty-three, and named him 'Iesu Grist'(Jesus Christ). When Iesu died, aged five months, in 1884, Dr Price cremated him on an open funeral pyre. Price was dressed in flowing druidical robes, and timed the event to take place as the locals were leaving their chapels.

The local population attacked him, rescuing the charred remains of the child, and the police arrested Price. The mob then went to find the mother, Price's young housekeeper, Gwenllian, but were deterred by Price's twelve large dogs. (Price did not believe in marriage as 'it turned women into slaves.') The doctor was acquitted after a sensational trial in Cardiff, and cremation was legalized in Britain as a result. Another infant was born, named 'Iarlles Morgannwg', the 'Countess of Glamorgan' and in one of his many lawsuits he called the child as assistant counsel to him. He issued medallions to commemorate his legal victory, and at the age of ninety had another son, once again called Iesu Grist. At the age of ninety-three, he died and was cremated in front of twenty thousand spectators at East Carlan Field, Llantrisant. This was the first legalised cremation (1893), and a ton of coal and three tons of wood were used to accomplish the mission. Price had organised the cremation himself, selling tickets to the people that later attended it. Llantrisant's pubs ran dry. Price, with a long flowing beard and hair past shoulder-length, habitually wore only the national colours of red, white and green. On his head was a red fox-skin pelt, with the front paws on his forehead and the tail hanging down his back. His cloak was white, his waistcoat scarlet, and he wore green trousers – the colours of Wales. He started building a druidic temple, in which the gatehouses are lived in today. One of the two round 'Druidic' towers he built in 1838 as gatehouses for his projected eight-storey Druidic Palace was recently on the market.

Dr Price's dying act was to order and drink a glass of champagne before he moved on to his next destination. Eat your heart out, Hollywood; no-one could make up a life like this. An anti-establishment campaigner for women's rights, socialist, doctor, rebel, Chartist, druid, hippy, vegetarian, environmentalist pioneer of cremation who foresaw the dangers of smoking two-hundred years ago. He had dreamed of 'a golden age' when Wales would once again be ruled by Druids. His birthplace, the Green Meadow Inn at Waterloo, near Newport, was in the news in 1996. Discovery Inns wished to demolish it, to put up thirteen boxes that pass for living dwellings these days. CADW, the historic monuments society in Wales, washed their hands of the matter, although the local community desperately wanted to save this historic site. The houses were built. Sic transit gloria mundi.

PRICHARD, DR JAMES COWLES (1786-1846) From Ross in Herefordshire, he argued for a single human species in his 1813 *Researches into the Physical History of Mankind*. Later, in 1831, he was the first to establish Celtic as an Indo-European language with close affinity to Sanskrit,

Greek, Latin and the Teutonic languages (*The Eastern Origin of the Celtic Nations*). He also wrote on Egyptian mythology and on the natural history of mankind.

PRINCE IN WALES Sir John Wynn (1628-1719), MP for Merionethshire, was such a prominent figure in Welsh life that he was nicknamed 'The Prince in Wales'. The Wynn family owned several mansions but the main home was at Wynnstay in Ruabon. The town was originally called Rhiwabon, and was near estates owned by John ap Ellis Eyton, who fought for Henry Tudor at Bosworth. His tomb can be seen in Ruabon Church. Knighted, Sir John altered the name of his estate to Watstay after Wat's Dyke. Watstay passed through marriage to the Evans family, and the daughter of Eyton Evans, Jane, married Sir John Wynn. They changed the estate name to Wynnstay. Sir John and Lady Jane Wynn died childless, and their huge estates went to Jane Thelwall, the great-granddaughter of the first Baronet, another Sir John Wynn. She was married to Sir William Williams, Second Baronet, and a condition of the will was that they added Wynn to their surname. The Williams family and the Wynn family had the two largest estates in North Wales. Thus the new line of Williams-Wynn, based at Wynnstay, owned most of North Wales, hence the number of pubs named Wynnstay as they were on the lands of the Wynnstay estate. As Wales' 'first commoners', the most famous member of the family became always known as the 'Prince in Wales', not the 'Prince of Wales', to distinguish them from the non-Welsh variety.

PRINCE OF WALES (1) Ystrad Fflur, Strata Florida Abbey, sees the annual celebration of 19 October 1238 which marked the voluntary unification of Wales where all the princes met there to swear allegiance to Llewelyn the Great and his son. In 1237, Llywelyn's wife Joan had died, and he had suffered a stroke, so he presented his son and heir Dafydd to all the other princes of Wales. Llywelyn had been recognized as overlord by King Henry III, and he wished to secure the succession before he retired as a monk to Aberconwy Abbey, where he died just two years later. The last native Prince of Wales, Llywelyn ap Gruffydd, was acknowledged as such in 1258 at a meeting with all the other Welsh princes. Only one, Gruffydd ap Gwenwynwyn, who was later involved in Llywelyn's death, would not swear fealty. After this meeting, Llywelyn made an addition to the titles of his grandfather, 'Prince of North Wales' and 'Prince of Aberffraw and Snowdon'. He was now known as Prince of Wales, but was killed in 1282. Edward I proclaimed his own son to be Prince of Wales in 1301. By the Statute of Rhuddlan in 1284, King Edward had declared all Welshmen subjects of the English Crown. The myth that Edward II was presented to the Welsh in 1284 as a baby in Caernarfon dates from 1584. This first Anglo-French Prince of Wales was invested at Lincoln when he was seventeen years old, not at Caernarfon. If his older brother Alphonso had survived, we would have seen a Prince Alphonso of Wales and a King Alphonso of England. Since this first investiture, all but one Princes of Wales have been French, 'English', German, and a mixture of all types of European nationalities except Welsh. The one exception was Prince Arthur, the Welsh-speaking son of Henry VII, Harri Tudor, who died early, with his younger brother becoming Henry VIII.

If we examine at the 'lineage' of minor German families that make up the present Prince of Wales, we can see his Welsh connections. His mother was a Saxe-Coburg-Gotha (the family renamed itself Windsor during the First World War against the Germans, for obvious reasons). Prince Charles' father was ostensibly a Battenburg (Phillip's uncle, Lord Mountbatten, similarly changed his name from Battenburg to Mountbatten, and wanted Prince Charles to take the surname Mountbatten-Windsor). However, the Duke of Edinburgh, Phillip Mountbatten's real surname is Schleswig-Holstein-Sonderburg-Glucksburg, not Mountbatten or even Battenburg. As far as history is concerned, Charles Windsor, 'Prince of Wales', is really Charles Saxe-Coburg-Gotha-Schleswig-Holstein-Sonderburg-Glucksburg, not Charles Windsor, if we amalgamate the real surnames of his mother and father.

PRINCE OF WALES (2) Dewi Wyn Thomas, a retired engineer in Rhuddlan, is of direct

descent from Owain Gwynedd, according to *The Mirror*, 17 June 1999. Owain Gwynedd's line by his first wife Gwladys ap Llywarch was exterminated by the incarceration of Gwenllian at Sempringham. However, the line of the princes of Gwynedd carried on through his second wife Christiana. Dewi stated 'The family lost all the wealth and treasures pretty soon after Edward I invaded Wales. The tyrant executed the last Prince of Wales, Llywelyn ap Gruffydd, in 1282 and set about slaughtering the family so there could be no heir. But he forgot all about another line of the family, which was started by the second marriage of an earlier king – my grandfather twenty-three times over, Owen (sic) Gwynedd. So the line of inheritance passed on through them, largely unknown, till it got to me. None of my early ancestors wanted to claim the title or any of the land in case the English found out and put their heads on skewers.'

PRINCES AND KINGS OF GWYNEDD The history of Gwynedd is the history of Welsh independence and language – its rocky crags, Anglesey with the royal court at Aberffraw and the Llŷn peninsula are the real heart of Wales. As much as we know of the royal lineage is shown below, with those with separate headings italicised:

Ruler	From	To
Cunedda	*c.* 400	450
Einion Wyn		
Cadwallon Llawhir ab Einion		
Maelgwn Hir ap Cadwallon		549
Rhun ap Maelgwn		
Beli ap Rhun		
Iago ap Beli		616
Cadfan ab Iago		c625
Cadwallon ap Cadfan		635
Idris ap Gueinoth	635	637
Cadafael ap Cynfedw		655
Cadwaladr ap Cadafael	655	664
Cadwaladr Fendigaed ap Cadwallon		682
Idwal ap Cadwaladr ap Cadwallon		
Rhodri Molynwog ab Idwal		754
Caradog ap Meirion		798
Cynan Dindaethwy ap Rhodri		
Molwynog	798	816
Hywel Farf-fehinog ap Caradog	798	825
Merfyn Frych ab Etthil ferch Cynan	825	844
Rhodri Fawr ap Merfyn Fach	844	878
Anarwd ap Rhodri	878	916
Idwal Foel ab Anarwd	916	942
Hywel Dda ap Cadell ap Rhodri	942	950
Iago ab Idwal Foel	950	979
Hywel ab Ieuaf ab Idwal Foel	979	985
Cadwallon ab Ieuaf ab Idwal Foel	985	986
Maredudd ab Owain ap Hywel Dda	986	999
Cynan ap Hywel ab Ieuaf	999	1004
Llywelyn ap Seisyll		1023
Iago ab Idwal ap Meurig ab Idwal Foel	1023	1039
Gruffydd ap Llewelyn ap Seisyll	1039	1063
Bleddyn ap Cynfyn	1063	1075
Trahaearn ap Caradog	1075	1081
Gruffydd ap Cynan ab Iago	1081	1137

Owain Gwynedd ap Gruffydd ap Cynan	1137	1170
Iorwerth Drwyndwn ab Owain, Cynan ab Owain,		
Dafydd ab Owain (Dafydd I), Maelgwyn ab Owain – sharing	1170	1195
Llywelyn Fawr ab Iorwerth (Llywelyn I)	1195	1240
Dafydd ap Llywelyn (Dafydd II)	1240	1246
Owain ap Gruffydd, Llywelyn ap Gruffydd – sharing	1246	1255
Llywelyn ap Gruffydd (Llywelyn II)	1255	1282
Dafydd ap Gruffydd (Dafydd III)	1282	1283

The last descendant of the House of Gwynedd, owing to the English attempts to kill off the family, was the grandson of Llywelyn ap Gruffydd's brother. Owain Lawgoch was regarded as a 'mab darogan' ('son of prophecy', or 'promised deliverer') by the Welsh, and styled himself as Prince of Wales. This Welsh hero spent much of his life outside Wales, fighting across Europe, until he was assassinated in 1378 on the orders of the English crown.

PRYCE, SIR JOHN In the eighteenth century, Sir John Pryce of Newtown passed into history as a man who loved his wife so much that he slept in bed with her embalmed body after she passed on. His second wife had to sleep on the other side of the bed from the corpse. When this second wife died, Sir John settled down at night between two embalmed women. The third Lady Pryce ordered that her predecessors be placed in the family tomb.

PRYCE, PROFESSOR DANIEL MERLIN (1902-1976) In September 1928, Alexander Fleming's assistant, Dr Merlin Pryce, lifted the cover of a staphylococcus culture plate and said 'That's funny'. Near the edge of the culture was a mould about 20mm in diameter with a smaller satellite attached to it. The details are too complicated to explore here, but interested readers should source the article *Merlin Pryce (1902-1976) and Penicillin: An Abiding Mystery* by Dr Emyr Wyn Jones and Professor R. Gareth Wyn Jones (try Googling it). Without Pryce's intervention, Fleming would not have discovered penicillin. Pryce kept his comments to himself, out of loyalty to Fleming, his native shyness, and perhaps because of an inferiority complex at that time, refusing to join the Freemasons and coming from a mining village, Troed-y-Rhiw, with a publican father. In 1956, Lady Fleming accused Pryce, then a Professor of Pathology 'Anyone would think that you had discovered the mould.' Pryce, by now more confident with another twenty-eight years at the top of his profession, quietly responded 'But I did.'

PRYCE-JONES, SIR PRYCE (1834-1920) Newtown saw the birth of the mail-order idea, started by Pryce-Jones in 1861 to sell Welsh linens. He used leaflets for people to order his wares, and the growth of the railways enabled him to start this retailing revolution. One of his more famous customers was Queen Victoria. In 1890 Victoria knighted him, and in that year he had more than 100,000 customers. By his death the business had expanded to 300,000 customers across the globe. His business base, the Royal Welsh Warehouse is still being used.

PUGHE, WILLIAM OWEN (1759-1835) This Welsh antiquarian and grammarian from Llanfihangel-y-Pennant pointed out links between the Welsh and Hebrew languages, and is best known for his *Welsh and English Dictionary* of 1803.

PUDDICOMBE, ANNE ADALISA (1836-1908) Born Anne Adalisa Evans in Newcastle Emlyn, at the age of sixty she changed her writing pseudonym to Allen Raine, and was a huge success as a romantic novelist. Her first book had been rejected by six publishers but after its title was changed from *Mifanwy* (sic) to *A Welsh Singer* and she had altered her name to Puddicombe, it was published and went on to sell 316,000 copies. She sold around 2,000,000 books, nearly all about the small corner of Cardiganshire which she knew so well.

PUFFIN ISLAND (YNYS SEIRIOL) Off Anglesey, its former names were Priestholm and Ynys Lannog, and there are monastic remains.

PUMSAINT ROMAN FORT Built in 120 CE but abandoned in 150, it guarded the gold mines at Dolaucothi.

PWLLGWDIG, BATTLE OF, 1078 A battle between Welsh princes, probably on Goodwick Moor, near Fishguard. Trahaearn ap Caradog of Powys defeated Rhys ab Owain and his brother Hywel. Rhys 'fled like a wounded stag before the hounds', according to *The Chronicle of Ystrad Fflur*. After the brothers' flight from the battle, they were killed by the forces of Trahaearn's ally, Caradog ap Gruffydd.

PWLLHELI The port was given by the Black Prince to Nigel de Loryng in 1349, along with neighbouring Nefyn. It developed from a market town in Victorian times to a seaside holiday resort on Cardigan Bay.

PWLL DYFACH, BATTLE OF 1042 Hywel ap Edwin ap Einion, King of Deheubarth defeated a Danish army which had been ravaging Dyfed.

PWLL MELYN, BATTLE OF 1405 A tragic battle in the War of Liberation, when Owain Glyndŵr's brother Tudor was killed. Also, Owain's eldest son Gruffydd taken prisoner by Lord Grey of Codnor, after a failed attempt to take Usk Castle. After the failure, the fleeing Welsh regrouped on Mynydd Pwll Melyn (Yellow Pool Mountain) but were routed and chased through Monkswood Forest. John ap Hywel, Bishop of Llantarnam Abbey, rallied seventy men on the riverbank, trying to buy time for others to escape, and was killed. Up to 1,500 Welshmen may have died. The English thought that they had slain Owain himself, as his brother Tudor was similar in appearance. Gruffydd was sent to Nottingham Castle and then the Tower of London where he died around 1412.

QUANT, MARY (1934-) Her father was from Merthyr Tydful and her mother from Cydweli, and she was evacuated from Kent in World War II to Tenby. In the 1960's Quant redefined female fashion across the world. As both a fashion designer and style icon, she invented the mini-skirt and brought new fabrics and materials into the production process. She was the 'queen of swinging London', and the *Sunday Times* placed the 'big three' in recent fashion as Dior, Chanel and Quant. Her shop made King's Road, Chelsea, the centre of the world fashion scene.

RACISM After the famous historian A.J.P. Taylor wrote his *History of England* he was asked in 1957 'What should be done about Ireland, Scotland and Wales in a history of England?' He answered 'Somehow I sorted it out: the lesser breeds were allowed in when they made a difference in English affairs.' A.A. Gill (b.1954), the Anglo-Indian-Scot *Sunday Times* columnist, referred to the Welsh thus: 'We all know that they are loquacious dissemblers, immoral liars, stunted, bigoted, dark, ugly, pugnacious little trolls' in his column in the 1980's. He was asked why he hated the Welsh and in *The Independent* stated 'The point is about the Welsh is that they're like mice; individually they're quite sweet, but all together they're a plague.' Even the Welsh sense of nationhood is mocked. The critic and journalist Simon Heffer (b. 1960) said in 2008 that 'there is no such thing as a Welsh nation... When I hear the term Welsh nationalism I laugh. I mean, it's like Essex Nationalism. This is not a nation.' Anne Robinson (b. 1944), an Anglo-Irish quiz show host, nominated Welsh people for inclusion in *Room 101*, in the TV programme of the same name – the fictional space in George Orwell's novel *1984* that contains everyone's greatest fear. She described Welsh people as 'irritating and annoying'. 'What are they for?' Robinson asked the show's presenter Paul Merton, 'They are always so pleased with themselves.' In 1993, in *The Evening Standard*, A.N. Wilson (b. 1950) wrote: 'The Welsh have never made any significant

contribution to any branch of knowledge, culture or entertainment. They have no architecture, no gastronomic tradition, no literature worthy of the name.' However, in 2000 he wrote: 'The Welsh are almost the only race left on the planet who are regularly insulted with impunity. Journalists lace their copy with anti-Welsh jibes and jokes, which, if applied to the Irish, would merit a bomb in the editor's office and, if written about the Jews, would close the newspaper down.' Mike Dickin of *Talk Radio* ended one show with the following words: 'The Welsh are a flawed people. If a Welshman mated with a pretty sheep there is a 1% chance of the result having some brains. If a Welshman mated with an ugly sheep there is no chance at all.' Racism is illegal, seemingly except when directed against the Celts of Ireland, Scotland and Wales. Perhaps the saddest comment is that Wilson and Heffer went to Oxford or Cambridge fairly recently, which should have given them the art of objective reasoning backed by some semblance of knowledge. A.A. Gill is dyslexic, which possibly explains his ignorance of the history of these isles.

RADIO In 1897, Marconi sent a radio signal from Lavernock Point, near Penarth, three miles to Flat Holm Island, first proving that radio could operate over water and therefore be used by ships.

RADNOR, BATTLE OF, 1196 Having taken Colwyn Castle (Colwent or Glan Edw), New Radnor Castle was besieged with catapults and siege engines, and then sacked by the Welsh under The Lord Rhys, before a relieving force under Roger Mortimer and the de Says arrived. The Norman army including forty knights was destroyed, and Hugh de Say killed. The site of the battle may have been where the remains of a rampart block the valley. It was a pitched battle, forced upon Rhys by the Norman army blocking his retreat, and the Welsh attacked first. Rhys was then forced to return to his territories as William de Braose had invaded and taken part of Cardigan, Rhys' main court along with Dinefwr.

RADNORSHIRE Radnorshire (Sir Faesyfed) is one of thirteen historic counties of Wales. It comprises central Powys, and its chief towns are Knighton, Llandrindod Wells, Llanelwedd, New Radnor, Presteigh and Rhayader.

RAGLAN CASTLE In Monmouthshire, the great Raglan Castle, built in 1432 by Sir William ap Thomas, is made of yellowish sandstone, and the later additions are in red sandstone. Thomas fought for Henry at Agincourt and became known as 'The Blue Knight of Gwent.' His son Sir William Herbert, Earl of Pembroke, then owned the castle and remodelled the walls. Herbert was killed at the Battle of Edgcote in 1469. Henry VII lived here as a prisoner, as a boy. The polygonal keep has a double drawbridge, unique in Britain. Henry, Earl of Raglan, poured all his fortune into the Royalist cause and held out in 1646 for the King Charles against the Roundheads. After three months Raglan was taken, mainly because Fairfax joined the siege with large cannon. Although Harlech Castle fought on, the fall of Raglan effectively marked the end of all Royalist hopes against Cromwell. The great 'Yellow Tower of Gwent' was partially demolished after the Civil War, and was so resilient to cannon that teams of workmen had to laboriously carry out the work with pickaxes from the roof until two of its six sides fell. The greatest library in Wales was destroyed here, and somehow some ornate carved Tudor panelling escaped the deliberate destruction. It was found advertised in a Sotheby's catalogue in 2005, and returned to the castle. It dates from the time of Henry VIII and had been used as a partition wall in a cowshed.

RAIL A plaque in Raglan Church commemorates the first practical steam engine, built by the Marquis of Worcester at Raglan Castle in 1663, and Wales has many notable 'firsts' regarding steam engines and railways. The first recorded steam locomotive drew wagons with men at Penydarren, Mid Glamorgan, on 22 February 1804. It was built by Richard Trevithick, and predated George Stephenson's Locomotion by twenty-one years. The engine pulled ten tons of iron and seventy passengers from Merthyr Tydfil to Quaker's Yard at around five miles per hour. However, Merthyr's ironmasters had invested so heavily in the Glamorgan Canal leading to Cardiff Docks, that they

had no wish to invest in a competitive technology. The world's oldest passenger railway opened in 1807 in Mumbles, Swansea, and operated until 1960. It was bought by a competitor, South Wales Transport, a local bus company and closed. Built by engineer Benjamin French, it ran along the front of Swansea Bay, from Swansea to Oystermouth. The railway made Mumbles famous in Victorian times. The first train was pulled by horses, then steam trains, then electric power.

According to *The Guinness Book of Records*, John Drayton of Newport, Gwent, gave British Rail 31,400 suggestions for improvement between 1924 and 1987, of which one in seven were adopted. 100 were accepted by London Transport. Britain's longest electric-powered Cliff Railway, at Aberystwyth, takes the visitor to the world's largest Camera Obscura, overlooking 1,000 sq miles of sea and landscapes, including twenty-six mountain peaks. In 1863, the Ffestiniog Railway, which still runs between Porthmadog and Blaenau Ffestiniog, took delivery of the world's first narrow-gauge steam locomotive for public services. Named *The Princess*, it is still in working condition. The highest station in Britain is at the top of Snowdon Mountain Railway, 3,493 feet above sea level, and it is the only rack-and-pinion railway in Britain. The summit of the Great Orme, Llandudno, can be reached by Britain's longest cable car (5,320 feet) or by a funicular railway built in 1877. From the top one can watch guillemots, kittiwakes and razorbills on the cliff ledges. British Rail operates 'The Heart of Wales' line, one of the finest scenic rides in Britain, which links Shrewsbury with Swansea. Of equal quality is the Cambrian Coast Railway northwards along Cardigan Bay from Aberystwyth. The Severn Tunnel made history in the 1880's as the first tunnel beneath an estuary, and at four-and-a-half miles was also the world's longest tunnel.

RAMSEY ISLAND Ynys Dewi, (David's Island), is linked in legend with St Justinian, and lies just off St David's Head. The fourth largest island in Wales, it has been a Royal Society for Protection of Birds sanctuary since 1992. Manx Shearwaters are repopulating the island, with the disappearance of the rats that took over their burrows, and choughs have always nested there. It has been farmed since mediaeval times.

REAL KING OF ENGLAND The pretender to the English throne is from the Stuart line, but there is an earlier descendant, of the Tudors. This author recently made a programme for RTE, '*Black Sheep*', which traced the line of Des Perrott, a Cork builder, from the line of Henry VIII via Henry's illegitimate son John Perrott. John Perrott's grandson was a noted Quaker, who was spared by the Inquisition of Limerick and also by Cromwell's Parliamentarians. Perrott went to the Vatican to try to persuade the Pope to change his religion and was imprisoned but spared, on account of his royal connections. Thus we have a Tudor claimant to the English throne, so his descendant King Des Perrott of Cork predates the Stuart pretender. There is another pretender, an Australian forklift driver descended from the Plantagenets. This is based upon the claim that Edward IV was illegitimate. This author prefers the claim of Des Perrot of Cork, who has promised him the Lordship of Glamorgan and the ownership of Cardiff Rugby Club and the Millennium Stadium, when his kingship is recognised.

REBECCA RIOTS 1839-1844 In rural West Wales, rioting took place against the hated toll gates and workhouses, simultaneously supporting the Chartist protests in industrial areas. This last peasant revolt in Britain began at the hamlet of Efailwen, with the destruction of the tollgate and burning of the tollhouse, in May 1839. Improvements to roads were necessary, and thus roads had been put in charge of 'road trusts'. These made their profits from large numbers of tollgates, set up along the roads. Local farmers were crippled by the charges, and could not afford to take their produce or herds to market. Local uprisings occurred, with groups of men dressed in skirts with blackened faces, demolishing turnpikes and toll gates. The leader was thought to be Thomas Rees, known as Twm Carnabwth, and their targets also included some of the hated workhouses in South West Wales. (Many tollhouses can still be seen, often hexagonal in shape, and converted to private houses).

These 'Daughters of Rebecca' were such a force that the government moved quickly to reduce

and make uniform the tolls. *Genesis* XXIV, 60 states 'And they blessed Rebekah and said to her "Thou are our sister, be thou the mother of thousands of millions, and let thy seed possess the gates of those which hate them" ' The leader of each band of night raiders was called Rebecca, and his followers 'daughters'. The imposition of tollgates had been the tipping point leading to violence. The mounted raiders were sick of heavy taxes, tithes to an alien church, high rents to English absentee landlords, the acceleration of enclosure of common land where they could once graze their animals, the English placemen who served as priests, landlords and judges, the price of bread and so on. Anglican clergymen were sent letters addressed to 'Ministers of the National Whore.'

A statement in *The Welshman* in 1843 expressed the feelings of the demonstrators:

> The people, the masses, to a man throughout the counties of Carmarthen, Cardigan and Pembroke are with me. O yes, they are all my children... Surely, say I, these are members of my family; these are the oppressed sons and daughters of Rebecca. The tollgates had finally tipped the balance from passive acceptance to action in 1839. Finding the official authorities helpless against the code of silence that protected them, the Maids of Rebecca extended their activities to encompass social justice. They made fathers pay for illegitimate children, or even marry the women involved. Unjust sentences were righted, men were made to go back to their wives, and a family Bible which had been seized for non-payment of tithes was returned.

Only when some ringleaders were transported to Australia for life (Shoni Sgubor Fawr, Dai'r Cantwr and Jac Tŷ-isha) did the dissent slowly fade away, but an 1844 Act of Parliament did reform the iniquitous toll road system.

Dai'r Cantwr (David the Singer) was born David Davies at Treguff near Llancarfan. A farm labourer and local preacher, he also taught people to sing and led the church choir. Tried at the Carmarthenshire Sessions with thirty-nine others, he was found guilty of destroying the gates at Spudder's Bridge. He was chained by each leg to another prisoner, moved to London and then went on a horrific seventeen-week journey to Tasmania. While in prison, he composed several songs, one of which was sold in village fairs all over Wales *Can Hiraeth y Bardd am ei Wlad* (*The Poet's Longing for his Country*). Also in prison he wrote 'The fame which might have been mine, I have forfeited, and no more will I see Llancarfan or the haunts of my youth.' He never returned to Wales. Gelli-Goch, near Machynlleth, is the birthplace of Hugh Williams (1796-1874). In Carmarthenshire, Williams was supposed to have been the mastermind behind Rebecca and her children. Openly sympathetic, as a solicitor he defended any protesters brought to court, without taking any fees. He compiled an anthology of radical verse, and addressed Working Men's Association and Chartist meetings, being watched constantly by the police.

RECORDE, ROBERT (1510-1558) He was a leading mathematician, the writer of the first English language texts on algebra and arithmetic, and incidentally invented the equals (=) sign, to 'avoid the tedious repetition of equals to'. His arithmetic book went into fifty editions and was notable in being innovative in two respects. It was written as a dialogue between a master and pupil to keep it interesting (shades of *Sophie's World*), and it used the device of pointing fingers (precursing Windows icons!). Recorde studied at Oxford, qualified as a Doctor of Medicine in Cambridge, was a doctor in London and in charge of mines in Ireland, but died bankrupt in prison because of a lawsuit taken out by the Duke of Pembroke. His memorial in Tenby reads:

In Memory of
ROBERT RECORDE
The Eminent Mathematician
Who Was Bron at Tenby, circa 1510.
To His Genius We Owe the Earliest
Important English Treatises on
Algebra, Arithmetic, Astronomy and Geometry;
He Also Invented the Sign of

Equality = Now Universally Accepted
By the Civilised World
ROBERTE RECORDE
Was Court Physician to
King Edward IV and Queen Mary
He Died in London
1558

RED-HAIRED ROBBERS OF MALLWYD In the sixteenth century a band called 'Gwylliaid Cochion Mawddwy' ('the Red-haired Robbers of Mallwyd') terrorised Mid-Wales, before many were caught and executed by Baron Lewis Owen. Around eighty were rounded up and condemned at a place where the house Collfryn ('Hill of Loss') stands. They were hung in 1554 two miles from Mallwyd on Rhos Goch ('Red', or 'Bloody Moor') and a mound, 'Boncyn-y-Gwylliad', is supposedly where they were buried en masse. A few weeks later, the baron was ambushed and murdered by surviving members at 'Llidiart-y-Barwn' ('the Baron's Gate') near Mallwyd. As well as Llidiart-y-Barwn, the nearby Brigands' Inn remembers these red-headed rogues. Local place names recalling the event abound, such as Mwynt y Gwylliad (where there is an old cemetery), Pont y Lladron ('Bridge of Thieves'), Sarn y Gwylliad (a causeway or ford), Ffynnon y Gwylliad (a well) and Ceunant y Gwylliad (a ravine). People with red hair in Meirionydd and Montgomery are still sometimes called 'red bandits'.

RED KITE Milvus Milvus, 'Barcud' in Welsh, the Red Kite, used to be common as a scavenger in London's streets in Shakespeare's time. By 1905, only five birds remained in Britain after centuries of persecution, in the Cambrian Mountains – a symbol of Welsh survival to many people. Now there are over 500 pairs and this majestic predator draws tourists to Wales – perhaps it should feature as the national bird, like America's Bald Eagle. By 1984 there were 33 breeding pairs and by 1995 there were 111, rearing 90 young successfully. In 2007 there were 471 breeding pairs in Wales, a remarkable success story.

REES, JOHN – JACK THE FIFER (1815-1893) John Humphries, in his marvellous *The Man from the Alamo* recounts the life of this unknown Chartist, who was sentenced to hanging, drawing and quartering in his absence. Born in Merthyr Tydfil, Rees emigrated to the USA, and when aged twenty served in the New Orleans Greys. He had probably worked as a child in the ironworks or coalmines, and as he was a good fife player may have been in the English army in his teens. He took part in the siege of San Antonio, fought at Coleto Creek and was one of only twenty-eight men who survived the Goliad Massacre when over 300 Texans were killed. He had escaped but was recaptured and released in 1836. He was back in Wales as a mason in Tredegar Ironworks in 1839, and became heavily involved in the Chartist Movement. It appears that he led the Chartist marchers down Stow Hill and may have fired the first shot at Newport's Westgate Hotel. Certainly Rees was armed with a pistol when he demanded the release of Chartist prisoners. Rees wrote an account of his escape after the riot, heading first for Newfoundland and then to Virginia. In 1846 he was serving with the Texas Rangers, being captured again by the Mexicans. Released, he joined the California Gold Rush, becoming an American citizen.

REFORMATION For Wales, the greatest indirect influence of Henry VIII leaving the Roman Catholic Church was the later translation of the *Bible* into Welsh, directly preserving the Welsh language. The Act of Supremacy was accepted by most Welsh clergy, who had to take an oath of loyalty to the Crown, which had become head of the church. Despite the Protestant Reformation across parts of Europe at this time, Henry never became a Protestant, instead enforcing his authority over that of the Pope in his kingdom. Monasteries and abbeys were closed and their wealth and lands taken by the Crown – thus the historical landscape of Wales is littered with the remains of scores of religious houses. However, there had been decline for some

time. The fifteen Cistercian houses in Wales had under 100 monks in total. Only around 250 monks, nuns and friars were left without a home or vocation, and most received a small pension, with some obtaining new livings. Some of the Benedictine houses remained as smaller parish churches. Much of the church lands in Wales ended up in the hands of a new class of landed gentry such as the Mansells who took Margam Abbey and its lands, while Sir John Williams took Abbey Cwm Hir, Sir John Price took Brecon Priory and the Raglans took Tintern Abbey. Lord Powis had bought Strata Marcella before the Dissolution of the Monasteries.

The Protestant Reformation gathered speed after Henry's death, except when Mary was queen, and some Welsh Catholics were executed, such as Bishop Robert Ferrar of St David's. One poet called Protestantism 'fydd Saeson', the faith of the Saxons (English) as it was also popular in Germany. Some Catholics, known as 'recusants' were fined for non-attendance of church (as Protestants had been under Mary). Pilgrimages, such as those to Penrhys, Holywell or St David's were banned, and religious icons across Wales were destroyed. In 1539, Henry VIII had first allowed the translation of the *Bible* from Latin into English, and Cranmer's *English Litany* appeared in 1544. In 1546, the first book in the Welsh language was Sir John Price of Brecon's *Yn y Lhyvyr Hwnn, (In This Book)* which included the *Creed, Lord's Prayer* and *Ten Commandments*. The preface urged the printing of Welsh religious texts. Elizabeth I, with an insecure past, was determined to make her position secure, and wished to promote a church which would receive wide popular support. With this in mind an act of 1563 required the provision of a Welsh Language *Bible* and *Prayer Book* Welsh dioceses and the diocese of Hereford (which at this time may still have had a majority of Welsh speakers). William Morgan's translation of the *Bible* into Welsh in 1588 enabled not only the language to prosper, but assisted the transformation of the Welsh into a Protestant nation. It allowed the message of the Reformation to be understood by the overwhelmingly monoglot population of Wales. People could now access Christianity directly rather than relying upon Catholic priests communicating through Latin, which thus made the state more secure.

RELIGION Mention has been made elsewhere of the fact that Wales was a Christian country, before Irish missionaries and St Augustine converted England. Augustine prophesied doom for the Welsh (in *The Anglo-Saxon Chronicle)* when he said that 'if the Welsh will not be at peace with us, they shall perish at the hands of the Saxons'. The nascent Roman-English church hated its Celtic Christian predecessor, and called upon all the powers of Rome to subdue it by any means. The Roman missionary to England, Saint Augustine had also previously condemned Welsh monks at the Synod of Chester for their refusal to bow to Rome. He wanted the Welsh to obey him as Archbishop of Canterbury and help him evangelise the English and drop some of the Church's customs. At the first meeting of the Welsh bishops with him, probably in Wiltshire in 602-603, he stated that 'The Brythons said they could not give up their customs without getting their people's consent.' The Welsh bishops had tended to a Christian people for hundreds of years after the Romans left, while the rest of Europe was heathen – as the Welsh saw it, they were the true keepers of Christianity, not this arrogant foreign priest, who threatened them with violence. Seven British bishops of the Celtic Church went to the second meeting with Augustine, around 603-604, with a large party of monks from the nearby monastery of Bangor-is-Coed. Bede told the tale of the bishops consulting a hermit before they met Augustine, as to whether they should follow this newcomer's ideas and authority. The hermit told them that they should follow Augustine 'if he is a man of God'. The bishops asked how they would know, and the hermit quoted the Gospel according to Saint Matthew: 'Shoulder my yoke and learn from me, for I am gentle and humble in heart'. If Augustine was gentle and humble, they should follow him as their Archbishop. If he was proud and severe, Christianity was not in him. They asked the hermit how to judge this, and he told the Celtic bishops to arrive late for the meeting. 'If he gets to his feet when you come to him, listen humbly to him, for he is the servant of God; but if he scorns you by remaining seated and not rising when you arrive, you being accompanied by a greater number than he is, then you must treat him with contempt.'

Augustine did not rise, the Welsh did not follow him or listen to any of his recommendations for changing the date of Easter from the traditional one, for changing their method of tonsure, etc. As Gwynfor Evans stated in *Land of My Fathers*, spiritual pride was seen as the worst sin by the socialist Celtic Church, and this arrogant Roman interloper threatened them with war. The Celtic Church remained intact until being largely broken up by the Normans 800 years later, and finally killed off by the Act of Union in 1536. The Venerable Bede stated that the Welsh had no desire to Christianise the pagan English, and added in 731 that 'It is to this day the fashion among the Britons (Welsh) to reckon the faith and religion of Englishmen as naught and to hold no more converse with them than with the heathen' (*Historia Ecclesiastica Gentis Anglorum*). He went on to claim that 'The Britons for the most part have a natural hatred for the English and uphold their own bad customs against the true Easter of the Catholic Church; however they are opposed by the power of God and man alike.' When he recorded the great Saxon victory by Aethelfrith at Chester in 613, he noted the English massacre of Welsh monks at Bangor-is-Coed for their sinful support of the Welsh King of Powys, Selyf. He recounted with some glee that 1,200 of the 2,100 monks were slaughtered by the pagan Aethelfrith. The Venerable Bede refers to what Welsh bards called 'The Massacre of the Saints', calling the Welsh 'treacherous men', and their army 'an atrocious militia'. This early rewrite of history shows the Venerable Bede's massive prejudice against men defending their own country against foreign attack – he was a German himself and preferred his German barbarian brothers to defeat Christians. He quotes the words of Aethelfrith when he urged his victorious soldiers to rampage through the great monastery, murdering the monks who were kneeling in prayer: 'If they call upon God against us they are fighting us as surely as those who bear arms'. The dictionary definition of 'venerable' is 'commanding respect by virtue of age, dignity, character, or position. Worthy of reverence, especially by religious or historical association', and in the Catholic Church the adjective refers to one who has reached the first stage of canonization.

RELIGIOUS LEADERS Hywel Harris (1714-1773) founded Welsh Calvinistic Methodism, and formed a Protestant monastery which he called his 'family' in Trefeca in 1752. Unfortunately, Harris's Calvinism was based on three important principles: God was supreme, only the pre-ordained would go to heaven, and man was utterly depraved. The Methodism which swept Wales almost killed off its culture, especially folk-dance, as all forms of enjoyment and closeness to the opposite sex were deemed sinful. Hugh Price Hughes (1847-1902) was a Welsh Wesleyan minister, born in Carmarthen. He founded *The Methodist Times* and combined Methodism with socialism. Griffith Jones in his lifetime was responsible for educating 160,000 Welsh children. William Williams of Pantycelyn, one of the greatest figures in Welsh literary history is mentioned elsewhere in this book. The present Archbishop of Canterbury is a Welsh-speaking Welshman, Rowan Williams.

RENAISSANCE There was a minor renaissance in the early fourteenth century, with Einion Offeriad writing his *Grammar* as a guide to poets, and with the flourishing of Dafydd ap Gwilym. In Elizabethan times, many leading members of the Welsh gentry flourished at court, and were high in legal, political, military and professional circles. The leading positions in the Welsh Church were filled by Welshmen for the first time in hundreds of years, and in 1571 Jesus College, Oxford was founded as a Welsh college. Welshmen such as John Dee and Cecil were important in forging the new 'British' rather than English identity, and the concept of a 'British' Empire. Sir Philip Sydney called the Welsh 'the true remnant of the ancient Britons' and praised the bards' role from Roman times. There was a revival in Wales of 'old penillion', the four-line stanzas recited to the harp. The old Bardic system of 24m was replaced by 'free metres', not using the intricate cynghanedd structure, and thus enabling the craft of poetry to be more widely practised. The growing wealth of the Welsh gentry enabled more and more to afford 'house bards' and there was an upsurge in the popularity and practice of poetry, assisted by the travelling bards. Edmund Prys (1543-1623) composed poems and psalms, and used free metres to urge fellow poets to

adopt humanism. Free metres were also used by William Cynwal, e.g. in his *O Blaid y Gwragedd* (*Defence of Women*). In prose, most literature was aimed at preaching the gospel, and used by both Catholics and Protestants. The most important preacher-poet was Rhys Pritchard of Llandovery (1579-1644). The verses in his *Canwyll y Cymru* (*The Welshman's Candle*) became the basis for many Welsh hymns. Stephen Hughes of Carmarthen wrote *Taith y Pererin*, a version of *A Pilgrim's Progress* in 1688, which to Welsh Nonconformists has been an important book for centuries. Between 1546 and 1660, 108 books were published in the Welsh language, miniscule in comparison with those published in English or French, but favourably comparable to just four in Scottish Gaelic and only eleven in Irish Gaelic. In general, the literature of Wales came to be dominated by Protestantism and Puritanism, an influence which lasted until the twentieth century.

REWRITING OF HISTORY To the sins of omission of early British/Welsh contributions to British history, we can trace a deliberate path of manipulation, distortion, suppression and destruction by Normans through to Hanoverians and Victorians, in a desperate attempt to gain legitimacy for conquering a nation. This sad strategy has been normal for all victorious countries – the Chinese in Tibet, the Australian settlers and Aborigines, the Indonesians and East Timor, the Spanish in South America, and so on and so on. Many Welsh standing stones have been broken up, taken away or covered over. Old treasure hoards, showing remarkable Celtic artistry, have been lost or melted down. Very little early writing remains, compared to Eire. (Comparably, Dublin Museum has a superb display of Celtic and medieval gold, whereas in Wales it was nearly all stolen and melted down). Much of what we know about the early saints, predating by hundreds of years the Roman Church of England, comes from the Breton '*Vitae*' (Lives of Saints). As the Normans took over the great monasteries at Llancarfan and Llanilltud Fawr (Llantwit Major), their treasures were taken to English abbeys, but their ancient libraries to The Tower of London. When Welsh princes were imprisoned in the Tower, they took their libraries with them, where the books stayed. All of this information from the Dark Ages onwards was destroyed by fire, supposedly by a monk called Ysgolan in 1300. Early non-Roman religion was suspect, tarred with the brush of Pelagianism (incidentally, this wonderful doctrine tells us that people could be Christian without giving money to the church, and unbaptised children could go to Heaven). These ancient Welsh books also conflicted with the view that Britain was heathen, before Rome and Augustine came to save its citizens. Of course, Viking raids such as those on St David's, Llancarfan and Llanilltud had damaged libraries, but much was recollected through the oral traditions and mnemonics that enabled the bards and monks to remember history. The next great threat was the Reformation, and the Dissolution of the Monasteries. These events, along with the burning of the great libraries at Raglan and St Donat's castles, have destroyed many Welsh sources. The one man who did more to put everything back together, Edward Williams of Flemingston (Iolo Morganwg), has been unfairly (and irrationally) savaged by academics.

Richard II (1367-1400) attempted to ban writing in Wales, and his deposer Henry Bolingbroke (Henry IV) had an Act of Parliament passed prohibiting the importation of all writing materials and equipment into Wales. Richard III saw the danger of the invention of the printing press, and prohibited its use in Wales. Even though a Welsh King, Henry VII, defeated Richard in 1485, it was not until 1694 that an Act of Parliament allowed printing presses to be set up in Wales. The Stuart and Hanoverian kings and queens related themselves back to Scottish origins, and had little interest in Welsh traditions and history, and even less in the language. When German George Hanover somehow became King of England in 1714, history changed in its teaching and emphasis. The *Bruts* and the twelfth-century *History of the Kings of Britain* were no longer used as source materials. The Stuarts were still trying to regain the throne, backed by two Scottish rebellions in 1715 and 1789. This new German dynasty had to be established in its rightful place to stop nationalist feelings flaring up in England. The 1789 French revolution reinforced this view, and the 'Bruts' disappeared into the backwaters of knowledge. The marriage of Queen Victoria of Hanover to Prince Albert of Saxe-Coburg and Gotha sparked a 'Saxon' revival,

with a cult growing up around King Alfred who led the Anglo-Saxons against the Vikings in the ninth century. (Incidentally, Alfred asked for Welsh scholars to set up what later became Oxford University, and insisted that the Welshman Asser, Bishop of St David's, moved to England to work with him as his advisor). The Victorians then suffixed Alfred 'the Great' and used his court's version of early British history *The Anglo-Saxon Chronicles*, rather than earlier or concurrent Welsh sources, for the early history of Britain. For instance, although Welsh sources identify King Arthur with Arthmael ap Meurig ap Tewdrig in southeast Wales, he is not mentioned in *The Anglo-Saxon Chronicles*, so real history was ignored. Britain and Wales were depicted as barbarian hell-holes before the Romans and Saxons came and unified England, and the Normans unified England and then Wales. Kings who were treacherous, devious illiterate murderers, from William the Bastard to Edward I and Richard 'the Lionheart' were made heroes of history. History became revisionist, ever moving away from historical fact, with each generation of historians regurgitating greater distortion.

After 'The Treachery of the Blue Books', Welsh teachers were replaced with English ones, and the disgusting *'Welsh Knot'* instituted in schools for children caught speaking Welsh. In 1866, Bishop William Stubbs wrote *'The Constitutional History of England'*, revolutionising the teaching of British history from the time of the 'noble' and civilising influence of the Romans, up to 1485. His Germanophile book was written to be the official curriculum for all schools – the history of Romans, Anglo-Saxons and Normans – not the history of the British people. Bishop Stubbs wrote, in his *Select Charters from the beginning to 1307* (Oxford 9th edition, published in 1951), the following piece of pre-Hitlerian dogma. The Welsh were a 'tolerated remnant': 'The English nation is of distinctly Teutonic or German origin. The Angles, Jutes and Saxons... Entered upon a land... whose inhabitants were enervated and demoralised by long dependence, wasted by successive pestilences, worn-out by the attacks of half-savage neighbours and by their own suicidal wars:.... This new race was the prime stock of our forefathers, sharing the primaeval German pride of purity of extraction... and strictly careful of the distinction between themselves and the tolerated remnant of their predecessors... It is unnecessary to suppose that any general intermixture either of Roman or British blood has affected this national identity... from the Briton and the Roman of the fifth century we have received nothing... The first traces, then, of our national history must be sought not in Britain but in Germany.' Stubbs' work is still the basis of what is taught (and unfortunately believed) today.

The above demonstrates the worthlessness of the British, i.e. Welsh people. They count for nothing in history, and their 'Age of Saints', fighting off the pagan Saxons was merely 'enervating'. Welsh history of 'The Age of the Saints' and King Arthur was wiped from the record and replaced by the so-called 'Dark Ages', not worthy of mention. British heroes are not great men like Owain Gwynedd and Llywelyn the Great, nor betrayed princes like Llywelyn the Last, nor intelligent warriors like Owain Glyndŵr, nor the fabulous Owain Llawgoch, so feared that the crown had to have him assassinated. Instead they are illiterate oafs, like the bloodthirsty homosexual Richard 'the Lionheart', the non-existent Robin Hood, and that illiterate butcher of the North, William the Conqueror. Holding out against the torturing, foreign Normans, Angevins and Plantagenets for hundreds of years is not worthy of attention. Wales has its own patron saint, the vegetarian ascetic David. The English had to find a Lebanese one, George and his mythical dragon. Wales had an organised and honest church at least 150 years before the English were Christianised. Welsh Christianity was far nearer to Christ's teachings than the Roman version. Wales had the most civilised laws in the world, while the rest of Europe based its laws upon repression, violence and dominance of class systems. Wales has an old language. England has a modern one. Wales has the oldest national flag in the world. England has a modern one. Wales had equality for women, whereas England suppressed women until recently. Wales set more store by music and poetry than aggression. England did not. Wales is a nation. England is becoming a set of regions. No-one asked why, if Stubbs' Romans were so wonderful, why society collapsed in England upon their leaving. No one asked why, if Stubbs' marvellous Saxons had such spirited purity, they were overwhelmed immediately by a small Norman force. No-one asked why the French

kings of England rejoiced in illiteracy. It took these Danish/Viking/French three to four years to overcome mighty Anglo-Saxon England, but from 1066 until around 1420 to finally subdue Wales. The Normans combined with fresh waves of Frenchmen and the original Anglo-Saxons, to present a far mightier force than ever faced England, against little Wales and its independent princedoms. However, this 'lesser breed' of A.J.P. Taylor survived and survives.

One can only care about the past, if one has knowledge of its reality. *The New Welsh Review*, summer 1997, carried two excellent articles upon the Celtic Church in Wales. The first, by Patrick Thomas, the Rector of Brechfa in Carmarthenshire, is titled *Not a Man of God*. It 'explains why not all Welsh Christians have been celebrating fourteen-hundredth anniversary of St Augustine's landing in Britain'. The second article is by Brian Davies, the curator of Pontypridd's Historical and Cultural Centre, *Archaeology and ideology, or how Wales was robbed of its early history*. The following is the conclusion of the article by Brian Davies: 'Only a few years later *The Times* in a reply to a polite letter from Matthew Arnold asserted that: An Eisteddfod is one of the most mischievous pieces of sentimentalism which could possibly be perpetrated... Not only the energy and power, but the intelligence and music of Europe have mainly come from Teutonic sources... The sooner all Welsh specialities disappear from the face of the Earth the better. This is a clear enough agenda, which will be familiar to many. What may not be fully appreciated is that, although most of the Welsh were Nonconformist by the nineteenth century, the early history of the Church in Wales was still a prime target for these Teutonic racists. For them it was an uncomfortable problem that the foundation of the Church of England can only be pushed back to 597AD when Augustine landed in Kent, while the major figures of the Welsh 'Age of the Saints' were active between half a century and a century earlier.

Christian civilisation in Britain had to be presented as an achievement of the English. The Welsh Church could only be allowed some vitality after the time of Alfred, the celebrated founder of the Saxon state. In order to create the 'Dark Ages' required by Saxon triumphalism the evidence of the continuous history of the Welsh Church back to Roman times, preceding the foundation of the 'national' Church of England by several centuries, had to be pushed to the margins of consciousness and if possible be literally buried. This of course was unacceptable to many of the Welsh clergy, and the story of the tensions within the Anglican church over matters of Welsh history is a book waiting to be written. It is unfortunate that present day mediaevalists do not normally study nineteenth-century history. If they did they would realise that the basic framework of interpretation of early British history which they still innocently use is not the product of calm, objective collection and assessment of data. It is a politically motivated construct; a falsification of history for the purposes of English nationalism. It is surely time for archaeologists and historians of post-Roman Wales to emancipate ourselves from these prejudices of nineteenth-century 'Saxon' nationalism. We need to write post-Imperialist history free of this Victorian master race theory. Then the superb surviving examples of early Welsh monumental art at Llanilltud Fawr, Margam, Coychurch and Merthyr Mawr in Glamorgan and a dozen other locations elsewhere in Wales may be re-interpreted in the light of the available evidence, and an unnecessary gap in Welsh history be filled.'

RHAYADER A market town in mid-Wales, on important routes from north to south, and from east to west Wales.

RHAYADER CASTLE, CASTELL GWRTHEYRNION It was built in 1177-1178 by The Lord Rhys, as a response to the murder of his son-in-law Einion Clud in an ambush by the Mortimers at Llawr Dderw in 1176, on his return from Rhys's great eisteddfod. The castle overlooks the River Wye. It was further strengthened by Rhys in 1194, protecting the borders of his kingdom of Deheubarth. Rhayader Castle fell to Maelgwn and Hywel, the sons of Cadwallon ap Madog of Maelienydd, and then to the English before Rhys retook it. It was lost again, to the Mortimers, and then retaken by the Welsh in 1202. It was also known as Castell Gwrtheyrnion, after the region.

RHODRI MAWR – RHODRI AP MERFYN FRYCH AP GWRIAD – RHODRI THE GREAT 820-878 Possibly because of the lasting Roman influence in Wales, and their much later adoption of Christianity, the Saxons and neighbouring Mercians were regarded as uncultured and aggressive pagans by the Welsh. The border was held against them, albeit with some fluidity. There were also constant Pictish attacks on the coastal areas of Wales. However, the next severe threat to Wales was that of the Norsemen, whose first recorded attack was in 850. Merfyn Frych spent his reign fighting against the Danes and Mercians, but managed to hand on his kingdom intact to Rhodri. Rhodri Mawr unified most of Wales to move it towards statehood, thanks in part to the need to fight this constant Viking threat. A descendant of Llywarch Hen, the warrior-bard, Rhodri had succeeded his father in 844, and it is notable that Wales achieved national unity under him, whereas England had to wait for statehood until the coronation of Edgar at Bath in 973. (So much for the critic Simon Heffer saying in 2008 that Wales 'had never been a nation'.) Rhodri was the only Welsh King to be called 'The Great' in his lifetime, and earned thanks from Charlemagne for his victories against the Viking threat, killing the Viking leader Horm, off Anglesey in 856. (Orme's Head at Llandudno may be named after Horm). In fact, Alfred and Charlemagne were the only other rulers to be bestowed with the title of 'Great' in this century. Nora Chadwick called Rhodri 'the greatest of all the kings of Wales'. (Llywelyn ab Iorwerth was only called 'the Great' after his death).

Until his death in battle in 878, Rhodri held Wales together, even making an alliance with King Alfred of Wessex against the Norsemen. He had assumed the throne of Gwynedd upon his father's death, taken control of Powys upon the death of his uncle Cyngen (on a pilgrimage to Rome) in 872, and ruled Seisyllwg from 872 when he married the sister of its last king. Now leader of nearly all Wales, his inherent hatred of Mercians led him to ally himself with the Danes against a Mercian invasion in 878, and he died in battle against them, protecting Powys from invasion. His son Gwriad fell at his side. His dominions were divided, with Anarawd becoming King of Gwynedd, Cadell King of Deheubarth, and Merfyn King of Powys. Three years later at the Battle of Conwy, the Welsh victory under Anarawd was known as 'Dial Rhodri' ('Rhodri's Revenge') – 'God's vengeance for the slaughter of Rhodri'. The practice of partible inheritance, *gavelkind*, meant that each of Rhodri's six sons had a part of Wales to control. Unusually for Welsh sons, they seemed to work well together, with the result that Rhodri's grandson, Hwyel Dda eventually came to rule Wales. The Viking raids carried on until 918, halting with the rule of Hywel Dda, and restarted on Hywel's death in 952, especially focusing upon Welsh monasteries. St David's Cathedral was sacked by them for the sixth time, as late as 1091.

RHONDDA The long and wooded Rhondda Fawr (Big) and Rhonda Fach (Small) valleys were altered forever by intensive coal mining in the nineteenth century, and the influx of population was accommodated by strings of terraced houses clinging along the steep sides of the valleys.

RHUDDLAN, THE BATTLE OF, 796 Offa was said to have died here. He may have been killed when the Mercians beat the Welsh here and took control of Tegeingl (Englefield), named after the Deceangli Celtic tribe. Offa was the first man to call himself *Rex Anglorum* (King of the Angles), and had also invaded Wales in 77 and 794.

RHUDDLAN, BATTLE OF, 1167 Also called the Battle of Twt Hill, Owain Gwynedd, his brother Cadwaladr and The Lord Rhys won here and took the castle before advancing on Prestatyn, where Owain razed the castle and town of Robert Banastre.

RHUDDLAN CASTLE There was a fort here, or nearby, constructed in 921 by Edward the Elder, the son of King Alfred. Before 1063, Rhuddlan was the royal seat of Gruffydd ap Llywelyn ap Seisyll, the High King of Wales, but in 1063 he was driven out by Earl Harold Godwinsson, who was later to be killed at Hastings. Robert of Rhuddlan built a castle here in 1073, on the site of Gruffydd's palace, as the Normans consolidated their hold on the Welsh Marches and pushed

towards Gwynedd. In 1277, Edward I accepted Llywelyn II's submission at Rhuddlan. At Rhuddlan Castle, in the 'ring of iron', Edward canalised the River Clwyd to enable it to be supplied from the sea, building it from 1277 to 1282, with James of St George taking charge of the works. Edward laid out a new town nearby and tried unsuccessfully to have the bishopric moved from St Asaf to Rhuddlan. The castle was attacked by Madog in 1294 and by Glyndŵr's followers in 1400, when the town was over-run, but the castle was not taken. A Royalist castle in the Civil War, it was slighted by Parliamentarians in 1648.

RHYD Y GROES, BATTLE OF, 1039 Gruffydd ap Llywelyn destroyed the forces of Leofric, Earl of Mercia (the husband of Lady Godiva) near Welshpool and pushed them back into Mercia. Rhyd-y-Groes is the vital ford on the Severn mentioned in *The Dream of Rhonabwy* in the *Mabinogion*.

RHYL A huge funfair and excellent beaches attract holidaymakers, it has had massive immigration since the war from Mancester and Birmingham. During this period, its Victorian elegance has faded, but there is massive regeneration taking place.

RHYMNI, BATTLE OF, 1072 Maredudd ab Owain ab Edwin had regained his dynasty's lands of Deheubarth, upon the death of Gruffydd ap Llywelyn. He fought the Norman incursions into Gwent, but came to an agreement not to resist and was rewarded by William I with lands in England. However, when the Normans pressed into Glamorgan, he met them in battle and was killed, to be succeeded by his son Rhys. According to *The Chronicle of Ystrad Fflur*, he 'was slain by the French and Caradog ap Gruffydd ap Rhydderch on the banks of the Rhymni.'

RHYS AP GRUFFYDD AP RHYS AP TEWDWR – YR ARGLWYDD RHYS – THE LORD RHYS 1132-1197 In 1136, GWENLLIAN led her army against the Normans at Cydweli. One son was killed, another imprisoned, and towards the end of the fighting, she was captured and executed. The battlefield is still called Maes Gwenllian, a mile from the castle, and a stone marks the place of her death. She left a four-year-old son, to be known as 'The Lord Rhys'. He was the grandson of Rhys ap Tewdwr who was slain by the Normans at Brycheiniog in 1093. His father was GRUFFYDD AP RHYS, who was named 'Gruffydd the Wanderer' from his days in hiding in the great forest of Ystrad Tywi. Gruffydd died soon after Gwenllian, so their remaining children were brought up by Gwenllian's brother OWAIN GWYNEDD. Rhys was born in 1132, and grew up in the shadow of his uncle Owain Gwynedd, but from Owain's death in 1170 until his own death in 1197 was the pre-eminent Welsh leader, based in the castle he built at Dryslwyn and his principal residences at Cardigan and Dinefwr. After Gruffydd's death in 1137, his remaining sons worked together to consolidate the princedom of Deheubarth (one son Morgan had been beheaded along with his mother, Gwenllian). However, Anarawd ap Gruffydd was assassinated by raiders from North Wales in 1143, Cadell ap Gruffydd was severely wounded by Normans from Tenby after reconquering Ceredigion, and Maredudd ap Gruffydd died in 1155, leaving only Rhys able to fight. Rhys burnt Cydweli Castle in 1159, to avenge his mother's execution, and thirty years later rebuilt it. However, from this time, there was heavy pressure from King Henry II until 1165. Cantref Bychan and Ceredigion were restored to their Norman lords, but Rhys successfully attacked Llandovery in 1162.

Gwenllian had operated out of the forests of Caio, retaking Welsh land until her death at Cydweli in 1136. Her efforts and death had served to build bonds between rival Welsh princes, rather like Jeanne d'Arc in France. In 1167, the Princes of Gwynedd, Powys and Deheubarth now united, putting aside their normal quarrels. Their army, led by The Lord Rhys and Owain Gwynedd, halted an invasion force at Caer Drewyn in the Berwyn Hills. The aggressors were made up of armies from England, Scotland, Flanders, Anjou, Gascony and Normandy, supported by a Danish fleet and financed by London merchants. The English could not believe the army that faced them, and slowly retreated. King Henry II personally blinded two of Rhys' hostage sons in revenge, along with two of Owain Gwynedd's sons. They were children at the time. They were taken hostage in a truce

made in which the Welsh promised not to invade England, so Rhys and Owain did not expect this action, as Henry had invaded Wales. (Henry II was a French-born, French-speaking 'English' king, the first of the Plantagenets, responsible for the murder of Becket.)

This victory brought home to the Welsh a need for a united front once more, and Rhys took over leadership of Wales upon his uncle Owain Gwynedd's death. Like Hywel Dda with the Saxons, he realised the necessity of friendship and accommodation with the Normans to preserve Welsh independence, and diplomatically befriended Henry II, despite his blinding his sons. He allowed Henry through Wales on his way to Ireland in 1171, and Henry in turn officially recognised Rhys as ruler of Deheubarth. Ceredigion and other territories were restored to the house of Deheubarth. On Henry's return, he appointed Rhys Justiciar of South Wales, in return for Rhys' support. This gave Rhys effective overlordship of most of South Wales including Glamorgan and Gwent. Rhys held the first Eisteddfod that can be authenticated in Cardigan in 1176 (where his father is also said to have held this great event), and twelve years later entertained Giraldus Cambrensis and Archbishop Baldwin of Canterbury. Also know as Rhys 'Mwyn Fawr' ('The Greatly Courteous'), The Lord Rhys established the Abbey of Ystrad Fflur (Strata Florida) in Ceredigion (Cardiganshire) in 1186.

After Henry II's death, Rhys gained more of Wales back from the Norman Marcher Lords, campaigning constantly. In 1196, the Normans of the East encroached on his territories, under Roger Mortimer and Hugh de Say. Rhys put them to flight, capturing Painscastle and burning Maes Hyfaidd. He died aged around sixty-five in 1197, hailed as the chieftain who did more than any to preserve South Wales from the Normans. He was also renowned as a patron of bards and monks, and was commemorated as 'the head, and the shield, and the strength of the south, and of all Cymru; and the hope and defence of all the tribes of the Britons'. One of Britain's greatest heroes, like his uncle Owain Gwynedd and his mother Gwenllian, he is unknown in British history books. The tomb effigy of The Lord Rhys is in St David's Cathedral, along with that of Giraldus Cambrensis. Rhys ap Gruffydd's effigy is the recumbent figure of a knight in the north presbytery. Strangely enough, just like Owain Gwynedd, he died in a state of excommunication, mainly because of a quarrel with Bishop Peter. However, the Celtic Church still buried him in a cathedral, like Owain Gwynedd, despite the wishes of Canterbury. *The Sunday Times* in 2000 placed Rhys 95th in their 'richest of the rich' list of the last millennium, with a fortune made from 'land and war' worth £4.5 billion. When he and Owain and Gwenllian begin appearing in British history books, we will begin restoring reality and fact to that branch of education, but it will not happen in this author's lifetime, if ever.

RHYS AP MAREDUDD (d. 1292) From 1271, Rhys had been prince of Cantref Mawr, part of Deheubarth. In 1287, he was wronged by the new Justiciar of South Wales, Robert de Tibetot. Rhys had been loyal to King Edward I in the 1282-83 War, and been given Dryslwyn Castle, but rebelled to take back his former royal home of Dinefwr Castle. He then overcame mighty Carreg Cennen Castle and Llandovery castles. He swept south through Carmarthen, then north to take Llanbadarn Castle. English armies totalling 20,000 men were sent to take him, and he was besieged in Dryslwyn Castle for three weeks by 12,000 of them, before continuing a running fight through Cardigan and Newcastle Emlyn. Driven to the hills, he was captured in 1292, and tortured and executed at York in the same barbarous manner as Dafydd, the brother of Llywelyn the Last.

RHYS AP TEWDWR (d. 1097) Rhys lost control of Deheubarth but regained it at the Battle of MYNYDD CARN. Until his death in 1097 he was prominent, along with Gruffydd ap Cynan, in resisting Norman advances into Wales. He was killed either near Brecon, or at Hirwaun near Aberdare.

RHYS, JEAN (1890-1979) Ella Gwendolen Rees Williams was born in Dominica and was a chorus girl in London and a volunteer cook in the First World War. She lived mainly in Paris, meeting Hemingway, Ford Madox Ford and Joyce, before returning to Britain. Her father was

a Welsh doctor and her mother a Creole. The radio broadcast in 1958 of her *Good Morning, Midnight* of 1939, and *Wide Sargasso Sea* of 1966 rekindled wide interest in her early novels such as *Voyage in the Dark* and *After Leaving Mr MacKenzie*.

RICHARD, HENRY (1812-1888) The pacifist Henry Richard of Tregaron (1812-1888), was known as Apostol Heddwch ('The Apostle of Peace') in Wales. A Congregational minister in London from 1835 to 1850, he became Secretary of the Peace Society (see Peace Union) in 1848. A nonconformist radical and a friend of Richard Cobden, he travelled widely in Europe, holding peace conferences and encouraging the use of arbitration in international disputes. Richard was elected MP for Merthyr Tydfil at the age of fifty-six, and thoroughly repudiated *The Blue Books* which maligned Welsh education. His first act in The House of Commons was to condemn those landlords who evicted their Welsh tenants for voting Liberal. As an MP, he was passionately interested in Welsh education, land reform, disestablishment of the Church of English in Wales, and the protection of the Welsh language. His interests led to his nickname as 'The Member for Wales'.

RICHARDS, HENRY BRINLEY (1819-1885) Richards was the composer of *God Bless The Prince of Wales* (the music used for the Australian National Anthem). He was regarded as the finest pianist in Britain, and befriended Chopin on a study trip to Paris.

RICHARDS, CERI (1903-1971) He celebrated life in his abstract paintings, especially in his Dylan Thomas Suite of prints, with bold colours and a reaffirmation of the springs of life. His semi-surrealist, Celtic-inspired works are timeless, and have many similarities to Graham Sutherland's Welsh-inspired works.

RIOTS A mixture of people, from all over Britain, had flocked for work to Merthyr, Wrexham, Swansea, Neath, Monmouthshire and the Rhondda Valleys in the Industrial Revolution. Faced with appalling working conditions, having to buy all their provisions at company-owned high-priced 'truck shops', and living at poverty levels in shanty towns, there was political upheaval – the awakenings of real and persistent social discontent. In 1793, hundreds of copper workers and miners marched to Swansea protesting about the high price of grain, cheese and butter, but were dispersed. Three Merthyr men were executed for rioting in 1801. After the 1815 Corn Laws that pushed bread to artificially high prices for the benefit of landed interests, the situation became worse. In the 1820's, fifty men from the Neath Abbey steelworks were sacked for trying to form a union, and *The Cambrian*, Wales' leading newspaper called their leaders 'gin-swilling degenerates'. The Calvinistic Methodists called union activity 'devilish', but by 1831 a Merthyr miner told the magistrate that 'My Lord, the union is so important to me that I would live on sixpence a week rather than give it up.' Serious violence broke out at Merthyr Tydfil in 1831. Troops were called in, and after two pitched battles, order was restored. In the brutal suppression, at least twenty-four men were killed, more victims than in the 'Peterloo Massacre' of fifteen Manchester weavers in 1819, but Welsh deaths did not receive anything like the same publicity or notoriety in history.

In a visit by the Queen to Aberystwyth University in May 1996, such was the feeling of many students that the official visit was cancelled upon police advice, the first time this has happened in her long reign, anywhere in the world. Older residents of the town were disgusted, as were the mayor and assorted local councillors. There is no royal palace in Wales, nor any real links with the German-Danish-Greek monarchy. A motion had been passed in the Aberystwyth Students' Union demanding an apology from the Queen for the past treatment of the Welsh language, and signs read 'Dim Croeso' - 'No Welcome'. Dafydd Pritchard, the poet crowned Bard at the 1996 Eisteddfod, sold framed verse at £15 each to help pay legal bills for the so-called Pantycelyn Five, students charged with public order offences for standing in front of the Queen's car. Part of the poem was also printed on £8 T-shirts sold in the cause by the Welsh language activists 'Cymdeithas yr Iaith'. The phrase used is 'twll tin y cwin, fel un cor yw eu gwaedd

dros egwyddor' – 'arseholes to the queen, as one choir is their cry for principle'. The only 'royal' residence in Wales since Garth Celyn in 1282 has been a three-bedroom farmhouse oddly named Llwynywormwood near Llandovery, bought by Prince Charles in 2006. It is not thought that he has ever stayed there.

ROBERTS, BLACK BART (1682-1722) To put piracy into context, the English Navy was a bitterly cruel organisation, and deserters were common. It had to 'press-gang' most of its unfortunate seamen from British ports. Conditions were not as bad in the merchant navy, but there was still a constant flow of dissatisfied seamen men willing to sail under the black (or red) flag of piracy. Bartholomew Roberts wrote of the motives for becoming a pirate: 'In an honest service there is thin rations, low wages, and hard labour; in this, plenty, satiety, pleasure and ease, liberty and power; and who would not balance creditor on this side, when all the hazard that is run for it, at worst, is only a sour look or two at choking (dying)? No, a merry life and a short one shall be my motto.' This 'Last and Most Lethal Pirate', Black Bart (Barti Ddu), captured over 400 ships between 1719 and 1722, bringing commerce in North America, the West Indies, West Africa and the whole Atlantic almost to a standstill. Born in 1682 at Little Newcastle near Haverfordwest, Bartholomew Roberts went to sea as boy and became a skilled navigator. We first hear of him as the thirty-seven-year-old third mate on the *Princess* galley, picking up slaves from the Gold Coast. He was captured by two pirate ships, captained by another Welshman, Hywel Davis, and given the choice of joining them, which he did, despairing of lack of any promotion because of his class. Black Bart's favourite oath was 'Damnation to him that ever lived to wear a halter!' He was known as 'pistol-proof', as he was expert in ship-handling, crew control, and the tactics of naval warfare. Within six weeks, Hywel Davis was dead in an ambush by the Portuguese, and Roberts was voted the new captain. Accepting, he said 'If I must be a pirate, it is better to be a commander than a common man'. He swiftly avenged Davis' death, then attacked a Portuguese fleet (although outnumbered forty-two merchant ships and two men-of-war to his single ship). Roberts escaped with the richest merchantman in the fleet – £50,000 in the currency of the day, and another captured ship.

He allowed no boys or women on his ships, was a teetotal tea-drinker, and the ship's band played hymns for Sunday services. No drinking or gambling was allowed on board on Sundays. The band also played Black Bart into battle – he dressed in red damasks and velvet from head to toe, with a three-cornered red hat with a huge scarlet plume, armed with cutlasses and pistols. His demeanour and scarlet dress were such that French traders called him Le Joli Rouge – the origin of the 'Jolly Roger'. It is also said that Black Bart's flag was the origin of the skull and crossbones – a skeleton with an hourglass. Suffering internal fights and terrible deprivations at times, he was feared by all sea-going vessels. Being annoyed at the persistent attempts of the governors of Barbados and Martinique to imprison and execute him, he designed a personal flag and plate for his cabin door, with 'ABH' (a Barbadian's head) and 'AMH' (a Martinican's head) illustrated on them. He later captured, and hung, the Governor of Martinique in October 1720 from his yardarm. Roberts' crew was drunk when he was finally ambushed by the Royal Navy. It seems that Roberts deliberately sought death. He was tired of trying to control a drunken, womanising rabble. Captain Ogle was knighted for his singular service in killing 'the great pirate Roberts', the only naval man honoured for service against the pirates. Ogle himself made a fortune, from illicitly purloining the plundered gold dust he found in Roberts' cabin.

Of the 254 pirates captured, fifteen died en-route to the Gold Coast, and four more in the slave hole there during the trial. Some musicians and 'forced men' were acquitted. 'The House of Lords', the hardest and longest-serving members of the crew, had followed Hywel Davis, and regarded themselves as the 'aristocracy' of the pirate profession, giving each other honorary 'lordships'. They were not contrite at their trial. Seventeen of Robert's crew were committed to prison in London, of whom thirteen died in transit. Of the fifty-two members of Roberts' crew hung on the Gold Coast, a third were from Wales, and a third from the West country. (After an apparent act of betrayal, Roberts would allow no Irish to serve with him). The oldest to be executed was forty-five, and the youngest just nineteen. The bodies of the eighteen worst

offenders, the members of the famous 'House of Lords', and Israel Hands (who had served with Blackbeard and features in *Treasure Island*), were dipped in tar, bound with metal strips and hung in chains from gibbets on three prominent hills overlooking the sea-lanes of the Gold Coast. The shock of the death of this most famous, brave and dreaded pirate helped end the so-called 'golden age' of piracy. This author wrote *'Black Bart Roberts: The Greatest Pirate of Them All'*, but has since discovered that Roberts was involved in piracy in the Indian Ocean before he served on slave ships.

ROBERTS, EVAN JOHN (1878-1950) Born in Loughor, Evan Roberts was the only son in a Calvinist Methodist home, who from the age of eleven to twenty-three worked in coalmines with his father. In 1904 he began studying for the Ministry at Newcastle Emlyn and an evangelistic sermon there led to a religious experience that gave Roberts belief in 'Baptism of the Spirit'. One night, after he had been praying about the failure of mainstream Christianity, his life was transformed when God came to him in his dreams. He later said: 'I found myself with unspeakable joy and awe in the very presence of the almighty God.... I was privileged to speak face-to-face with him as man speaks face-to-face with a friend.' In October, he began preaching to small meetings, although not yet qualified as a minister. The 'Four Points' of his message were: Confess all known sin; Deal with and get rid of anything 'doubtful' in your life; Be ready to obey the Holy Spirit instantly; and Confess Christ publicly. Soon he was attending thousands of people to his meetings, and became the charismatic leader of the Welsh Religious Revival of 1904-05. The Welsh-speaking working-class preacher was quiet, often reflective, and invited the audience to participate, to share their experience of the Holy Spirit. Roberts' meditative approach was a huge and welcome change, from the in-your-face, aggressive fire-and-brimstone preachers of the time. By 1906, Roberts had fallen victim to overwork caused by the pressure of his hundreds of appearances, and suffered a physical and emotional collapse. His style of preaching was to become a blueprint for the Pentecostal movement, which today has around 115 million followers worldwide.

ROBERTS, ISAAC, FRS (1829-1904) From Groes, Denbighshire, he solved the problem of Victorian astronomers taking photographs of deep space objects. These were too faint to be seen by telescopes, but could be seen on a photographic plate, as long as the exposure was long enough. However, the movement of the earth over a long time period made the image blurred. Roberts solved the problem by inventing a combination camera-telescope that gave a clear image. He thus took the first detailed pictures of the Andromeda Nebula, showing its unknown spiral structure, and built his own observatory in his garden. There have been many Welsh astronomers. Around the same time John Jones, a farm labourer from Bangor, taught himself to build and built a great reflector telescope to examine Mars. Known universally as 'Y Serynddwr' (The Astronomer), he was visited by, and used by Samuel Smiles as an example of self-help, and Smiles recounted how Jones had showed him the 'snowcap' of Mars. Jones taught himself English by comparing passages in Welsh and English Bibles, and also became proficient in Greek and Hebrew.

ROBERTS, KATE (1891-1985) The daughter of a quarryman from Rhosgadfan, Caernarfonshire, an eminent writer and journalist, she has been called 'the Welsh Chekhov', and was the twentieth century's most distinguished prose writer in Welsh. She wrote until her death aged 94, and her wonderful illustrations of Welsh life have captured the essence of twentieth-century rural Wales.

ROBERTS, RICHARD (1789-1864) He was a mechanical engineer and inventor, born in Carreghofa. Self-taught, he improved Maudsley's screw-cutting lathe and built one of the first metal-planing machines. He developed Crompton's 'spinning mule' and set up in business making self-acting spinning mules and railway locomotives, starting with the *Experiment* for the Liverpool and Manchester railway in 1833.

ROBERTS-JONES, IVOR (1913-1996) In 1973, he 'had created one of the grandest works of public sculpture in Britain. It was also probably the last commemoration of its kind'. *The Times* obituary of December fourteenth was referring to his brooding, indomitable, intense statue of Winston Churchill, commissioned to stand outside the Houses of Parliament. One of his best works is *Two Kings* at Harlech Castle, and he was publicly commissioned for statues of Viscount Slim, Viscount Alanbrooke and Augustus John.

ROBINSON, MARY DARBY (1758-1800) Her mother was Hesther Seys of Boverton Castle, Llanilltud Fawr, and aged twenty-one she was playing *Perdita*, which was to become her nickname, in *A Winter's Tale*. The Prince of Wales (later George IV), aged seventeen, was smitten with the twenty-one year-old and courted her. The scandal soon broke, but the affair lasted a year, and her poems influenced Coleridge.

ROCH CASTLE Built in the thirteenth century northeast of Haverfordwest, by Adam de Rupe as part of the chain of castles forming the Landsker, it was by the Civil War in the hands of the Walter family. It was taken by Parliamentarians, recaptured by the Royalists and retaken again. The daughter of Walter Lacy, who owned the castle at this time, was Lucy Walter, whose son by Charles II became the Duke of Monmouth. The rightful king of England, as Lucy had married Charles in secret, the Duke of Monmouth was executed by James II after the Monmouth Rebellion.

ROCK MUSIC In the 1960's/70's, Wales produced Amen Corner with Andy Fairweather-Low, Rockpile with Dave Edmunds, Racing Car, Man and Badfinger who all did well in the UK/US charts. In the 1980's, Rhyl's 'The Alarm', with the estimable Mike Peters, had many hits, as did Shaking Stevens, Bonnie Tyler and Scritti Politti. In the 1990's, the best British band was probably the Manic Street Preachers, and Gorki's Zygotic Mynci, Feeder, the Stereophonics, Catatonia and Super Furry Animals have also been internationally successful groups. In the 2000's Feeder and the Lost Prophets were popular. Geraint Jarman has pioneered rock music with Welsh lyrics, followed by Gorkis and the Super Furries. John Cale from Garnant was a founder of the Velvet Underground with Lou Reed. The female singer Duffy had the best-selling album of 2008.

ROCKS Wales has the oldest rock formations in Britain, the 650 million years old, Pre-Cambrian strata in three main areas. These ancient rocks are found at the tip of the Llŷn Peninsula, possibly the most 'Welsh' and unspoilt part of Wales; at St David's Head, the most holy part of Wales for Christians; and finally in large parts of Anglesey, the religious centre and holy island for the Celts and Druidism. The next oldest rocks, the volcanic Cambrian strata, form Snowdonia and the backbone of Merioneth and the Preseli Hills. The igneous Ordovician rocks in the Preselis are the famous mystical 'bluestones' that were transported to Stonehenge. Nearly all of Wales is composed of hard rock, over 200 million years old. The Paleozoic Era is divided into six periods: the Cambrian, Ordovician, Silurian, Devonian, Mississippian, Pennsylvanian and Permian. The Cambrian is named from the Latin word for Wales because rocks of this age were studied by early geologists in Wales. During the Cambrian period, we know most about its desert land areas, warm seas and rapid diversification of life. The Ordovician period is based on the Celtic tribe in Wales. Primitive fishes mark this period. The Silurian period is based on the Welsh Celtic tribe also. During the Silurian period jawed fishes roamed the oceans while invertebrate animals and plants colonized the land.

ROLLS, CHARLES STEWART (1878-1910) The Monmouth-born son of an MP, Charles Rolls had his first car at the age of nineteen, in 1896, when its speed was restricted by the need to have a man walking in front with a warning flag. It thus took him three days to drive home from his studies in Cambridge. From his days at Eton, he had been besotted with engineering, and had enrolled for a mechanical engineering degree at Trinity College. He was the first undergraduate

and the fourth person in Britain to possess a car. He told friends of his ambition to have a car associated with his name, so that 'in future it might be a household word just as much as Broadway or Steinway in connection with pianos.' (Unfortunately, the sale of Rolls-Royce and Bentley to Germany a hundred years later, leaves Britain with just one indigenous manufacturer, Morgan sports cars in Malvern on the Welsh borders. The Morgan family was originally Welsh).

Rolls invented a bicycle for four people, learned mechanical skills in the railway workshops at Crewe, obtained a third engineer's certificate so he could act as engineer on his father's yacht, and became an accomplished motor racing driver. After leaving Cambridge he opened his own car showroom in London, C.S. Rolls & Co., selling mainly French Panhards. In 1904, he met Henry Royce, and was so impressed by his two-cylinder car that he financed the production of Royce's cars, ordering nineteen to sell in London, wanting to be able 'to recommend and sell the best cars in the world'. In 1906, they formed Rolls-Royce Ltd., and their first car, the fabulous 6-cylinder Silver Ghost was available to the gentry. Royce was chief engineer, on a salary of £1,250 pa, and Rolls took £750 and 4% of the profits as the technical managing director. Rolls publicised the cars by racing them, setting a record between London and Monte Carlo. He earned the dislike of Queen Victoria because she thought cars scared horses. Living life at the maximum, and looking for fresh challenges, Rolls took up aviation, and became the first Briton to fly more than half-a-mile, and made the first non-stop flight to France and back. However, on 12 July 1910, he achieved another tragic first – he was the first British aviator to be killed in a plane crash. His Wright biplane broke up in an air display over Bournemouth, and the wreckage was towed away by a Rolls-Royce Silver Ghost.

ROMANS IN WALES In 55 BCE, Julius Caesar invaded Britain, and wrote in his *Gallic Wars* that 'All the Britons paint themselves with woad, which gives their skin a bluish colour and makes them look dreadful in battle.' His invasion was not successful however. Wales was never completely subdued by the Romans. Two of their three British legions were stationed on the borders, at Deva (Chester) and Isca Silurum (Caerleon). Isca was built, with Venta Silurum (Caerwent) to keep the Silures down, while Caerfyrddin (Carmarthen) was the heartland of the Demetae tribe. In 78 CE, Tacitus remarked that it was necessary to exterminate almost 'the entire race' of the Ordovices of mid-Wales and Gwynedd. While Caradog led a series of attacks by the Silures against the new Roman provinces in 47 and 48, Tacitus recorded that Scapula received the submission of the Deceangli of north-east Wales on the River Dee in 49, enabling him to pressurise the Silures. In the same year a fort was established at Gloucester, with others at Usk and Clyro. The Silures kept fighting after Caradog's capture, and defeated the Twentieth Legion in 53, at Caerfelin (Llanmelin Hillfort, their tribal capital near Caerleon). Nero threw in reinforcements from Rome, including the crack Second Augustan Legion. Scapula went home, broken after ten years of campaigning. In 57, Nero ordered that Anglesey, the chief centre of British discontent, be taken, and Tacitus describes the burning of the sacred Druidic groves. Tacitus complained that Rome had sent its best generals and legions to this extremity of empire: 'In Britain, after the capture of Caractacus, the Romans were repeatedly defeated and put to rout by the single tribe of the Silures alone... the race of the Silures are not to be changed by clemency or severity.'

The Iceni then rose under Buddug (Boadicea), preventing the Romans from finishing off the conquest of Wales. From 69-78 there was another great push against the Silures and the Ordovices, by Julius Frontinus, then Julius Agricola. After fighting Rome from 47, the Silures agreed peace by 75, as Caerleon was completed as a legionary centre. Three Roman legions were now situated on the Welsh borders, at Uriconium (Wroxeter), at Isca, and at Deva. With southeast Wales made secure by accommodating the Silures in Caerwent and giving them administrative powers, the Ordovices of Gwynedd and mid-Wales were almost slaughtered out of existence by Agricola by 84. There had been at least thirteen separate campaigns against Wales and its borders between 48 and 79, which explains the multiplicity of Roman villas, forts, fortlets, marching camps, roads and civil ruins dotted over much of Wales. Roman influences in Wales run from the language to places beginning

with Caer to the effects on surnames (Sextilius > Seisyllt > Cecil) and Christian Names (Justinus, Justinian to Iestyn). Magnus Maximus, the commander at Caernarfon, was accompanied by a Welsh bodyguard when he invaded the Continent in 381 to claim the Imperial Throne. He left the government of Wales in the hands of Romanised Welshmen, thereby Wales was the first Roman territory to attain peaceful self-government. Maximus was killed at Aquileia in 388, and is known in Welsh history as Macsen Wledig, a hero of the Welsh, from whom later princes claimed descent. One of the most famous Welsh medieval stories, *The Dream of Macsen Wledig*, refers to Segontium, the Roman fort of Caernarfon. Within a hundred years, around 510, the Emperor Honorius had no troops to spare for British garrisons, and the Welsh nation came into existence. After the final withdrawal of Rome, Britain later found itself divided into three areas; Gaelic/Goidelic Scotland, Germanic England and Brythonic Wales, Strathclyde and the West Country.

ROUND CAIRNS/ROUND BARROWS Some are Late Neolithic, with inhumations, but as the Bronze Age progressed, cremations were standard in these tombs. In the lowlands, the majority have been destroyed by ploughing, some in Glamorgan in this author's lifetime. Beaker burials, in the period interfacing the Neolithic and Bronze Ages, were more usually found inland. They could be up to 15ft high and up to 150ft in diameter, and there are about 2,000 known remaining examples across Wales. They sometimes occur on the tops of hills, and can be made of earth or an amalgam of materials.

ROWLANDS, GENERAL SIR HUGH, VC (1828-1909) Born near Llanrug, he served with the Welch Regiment before invading the Crimea as captain of the Grenadier Company. After the Battle of the Alma, he was severely wounded at Inkerman, where he became the first Welshman to win the Victoria Cross. He was at the siege of Sevastopol, and at the two attacks on the Redan. He was nominated for another VC for the first attack on the Redan, but regulations at the time made the award impossible. He won more honours, and when an officer was asked who had done most in the whole Crimean War, he answered that it was Rowlands. He was given a civic reception at Caernarfon and given command of the Welch Regiment, in 1865. In the Boer War, despite conflict with the incompetent commanders Bullers and Wood, Rowlands prevented Pretoria being taken.

ROWTON HEATH, BATTLE OF, 1645 Charles I took troops from South Wales, intending to join up with Montrose's forces in Scotland. He wished to sail from Chester to Ireland and then to Scotland, but Chester had been besieged, and it was the only port available to his forces. Hoping to relieve the siege, his Welsh forces entered Chester from its unguarded west side on 23 September. The plan was for Marmaduke Langdale's northern horse go to Rowton Heath on the southeast of the city to attack the besiegers in the rear, while Charles, his Welsh forces and the city's defenders sallied forward and trapped the Parliamentarians between two Royalist forces. However, Poyntz with 3,000 cavalry had been chasing Charles, and on 24 September took the field against Langdale. The besiegers helped Poyntz's forces as the battle approached deadlock, forcing Langdale's men to flee to Chester. In the general mêlée which ensued, Charles escaped being captured, but the Civil War was virtually over, as Montrose was defeated around the same time.

ROYAL NATIONAL EISTEDDFOD All proceedings are conducted in Welsh, the first language for 500,000 Welsh people, with a simultaneous translation service. There was always no alcohol available on the site, which rotates between North and South venues every year, and it is always commemorated by a permanent circle of standing stones. Alcohol has been only available in the 'youth tent' until recently. This is Wales' biggest single annual event, and the ceremonies are carried out by a Gorsedd of Bards, an association of people interested in Welsh arts and music. The two important ceremonies are the Chairing and the Crowning, when each winning poet in different styles is chaired or crowned in attendance by other poets or writers. 'The Chair'

is the symbol of authority. 'Eisteddfa' literally means 'seated session'. The Welsh for 'cathedral' is literally the 'church of the chair', 'Eglwys Gadeiriol'.

RUGBY LEAGUE In the past, Wales has often lost its best rugby union players to rugby league, for instance Maurice Richards of Cardiff (who memorably scored four tries in one match in rugby union against England), David Watkins and the legendary Billy Boston. Cardiff's Billy Boston was the second highest try scorer in the history of rugby league, who played 564 times for Wigan, and 31 times for Great Britain. Joining Wigan from Cardiff, he was chosen for the Great Britain team to tour Australia in 1954 after just five league matches. He scored 36 tries on the tour. Lewis Jones scored the most rugby league points in a season, for Leeds, in 1956/57, with 36 tries and 194 goals, totalling 496. David Watkins scored the most goals, 221, for Salford in 1972/73. The longest continuous career was of Augustus John (Gus) Risman, from Barry, who played his first game for Salford in 1929 and his last game for Batley in 1954. His son, Bev, went on to play for England at rugby union before turning to league. Jim Sullivan (1903-1977) left Cardiff Rugby Club aged seventeen to play for Wigan, and scored 6,022 points over twenty-five years of playing. He was the top points scorer on three British Lions tours, refusing to go on a fourth for personal reasons. Clive Sullivan (1943-1985) from Cardiff played for Hull and Hull Kingston Rovers, scoring 368 tries in 565 games and becoming the only black captain of the British Lions.

Probably the most remarkable rugby player in the history of league and union has been Blaina's David Watkins (born 1942), now Chairman of Newport Rugby Club. He is the only player to have captained Britain in both Rugby Union (the British Lions) and in Rugby League. He is also the only man to have captained Wales in Union and League. He was also captain of Newport rugby union club for four years, and of Salford rugby league club for seven years. Rivalling him is Jonathan Davies (born 1962), voted 'Man of Steel' in rugby league. From Trimsaran, Davies had only played 35 games for Neath at outside-half when he was selected to play against England in 1982, becoming Man of the Match. Wales won, Davies scoring a try and drop-goal. Next playing for Llanelli, he won 37 caps for Wales, then signed for Widnes rugby league team for a world record fee. In 1991 he had a season with Canterbury Bulldogs and in 1993 joined Warrington. In 1995, his wife Karen was diagnosed with cancer, and Davies returned to Wales for family support, and to play rugby union for Cardiff. In 1996, he was awarded an MBE and in 1997 his wife died. Davies is a Welsh speaker with his own Welsh language TV programme, and is also a TV commentator and pundit.

RUGBY UNION The 'national game', rugby union, saw a marked deterioration in standards and world rankings over the last decades, but recently the team has climbed back to fourth in the world rankings, only behind New Zealand, South Africa and Australia, and above all the European teams. In the 'golden age' of the 1970's, it seemed that Wales were playing magical rugby. Indeed, possibly the try of the century, that scored by the Barbarians against New Zealand, featured six Welsh internationals in a passing movement that covered the field. The dream halfback pairing of Barry John and Gareth Edwards was ended when 'King' John retired prematurely from the game. Edwards went on to make a record 53 consecutive appearances from 1967 to 1978, when he retired. A poll of 200 players, coaches, managers and writers across the globe, to find the greatest rugby player of all time, was published by *Rugby World* in October 1996. The highest Englishman, at twelfth, was Fran Cotton. Top was Gareth Edwards, (followed by Serge Blanco) and three other members of 'the golden team', Gerald Davies, Barry John and JPR Williams, are all in the top ten. Edwards won three Grand Slams, five successive Triple Crowns, captained Wales thirteen times and scored twenty tries. He went on three British Lions tours, including the successes in New Zealand in 1971 and South Africa in 1974.

The most famous rugby club side in the world, Cardiff, has beaten New Zealand, Australia, South Africa and Maori first XV's, as touring teams used to treat Cardiff as an international fixture – the club to beat. Australia have never beaten Cardiff in six attempts. Cardiff also introduced four

three-quarters into the game, as they could not decide who to drop in 1884 – until then rugby had been a game mainly for forwards. They persisted with the experiment in the 1884-85 season, but lost two games because the scoring system gave a single drop goal precedence over three tries! In 1885-86 Cardiff won 26 out of 27 games, losing only the last match of the season. They had invented the passing game – not one drop goal or penalty was scored all season and they scored 131 tries against 4. The Cardiff system of four backs was permanently adopted by the Welsh Rugby Union in 1888/89, and by the other Home Unions in 1893/94. The greatest rugby union club attendance was a Cardiff-Newport derby match in 1951, with 48,500 seeing Cardiff lose 8-3 at the Arms Park. Mike Ruddock easily won the Grand Slam in his first season as Wales' coach in 2004-2005, but left in strange circumstances shortly after. The 'smoke and mirrors' of the Welsh Rugby Union has successfully obscured what went on. The new Welsh rugby coach, Gareth Jenkins, intended his players to call their moves and lines-out in Welsh, as they used to, to prevent other teams deciphering their game plans. After a disastrous time under Jenkins, another new coach, new Zealander Warren Gatland won another Grand Slam in 2007-2008. In 2008, Shane Williams was voted by the International Rugby Board as international 'Player of the Year'.

The greatest Welsh try of all time has been voted as Ieuan Evans against Scotland in 1988, called by Bill MacLaren 'magic, magic all the way, not even Merlin the Magician could have done any better.' In 2002 the results were announced of the 'greatest Welsh team of all time': Fullback JPR Williams, Right Wing Gerald Davies, Outside Centre John Dawes, Inside Centre Bleddyn Williams, Left Wing JJ Williams, Fly Half Barry John, Scrum Half Gareth Edwards, Loose Head Prop Denzil Williams, Tight Head Prop Graham Price, Hooker Bryn Meredith, Locks Delme Thomas and Geoff Wheel, Blindside Dai Morris, Openside John Taylor, No. 8 Mervyn Davies. There have been so many superb rugby players from Wales, such as Gwyn Nicholls and Cliff Jones, that their contribution cannot be adequately assessed in this book.

The following table lists results of international test matches played against the teams that form the Six Nations Championship. Considering Wales has the smallest population, its record is excellent, especially against England and France.

Opponent	Played	Won	Lost	Drawn	Difference
England	118	53	53	12	-
Scotland	114	63	48	3	+15
Ireland	112	61	45	6	+15
France	85	43	39	3	+4
Italy	14	11	2	1	+9
TOTAL	443	231	187	25	+43

RUGBY UNION GRAND SLAMS BY WALES 1908 – beat England 28-18, Scotland 6-5, France 36-4, Ireland 11-5, 4 captains being A.F. Harding, G. Travers, E.T. Morgan and H. Winfield (1 game each);

1909 – beat England 8-0, Scotland 5-3, France 47-5, Ireland 18-5, captain W.J. Trew;

1911 – beat England 15-11, Scotland 32-10, France 15-0, Ireland 16-0, captain W.J. Trew (3 games), J.L. Williams (1 game);

1950 – beat England 11-5, Scotland 12-0, France 21-0, Ireland 6-3, captain J.A. Gwilliam;

1952 – beat England 8-6, Scotland 11-0, France 9-5, Ireland 14-3, captain J.A. Gwilliam;

1971 – beat England 22-6, Scotland 19-18, France -5, Ireland 23-9, captain John Dawes;

1976 – beat England 21-9, Scotland 28-6, France 19-13, Ireland 34-9, captain Mervyn Davies (Wales only used 16 players in both the 1971 and 1976 seasons);

1978 – beat England 9-6, Scotland 22-14, Ireland 20-16, France 16-7, captain Phil Bennett;

2005 – beat England 11-9, Scotland 46-22, Ireland 32-20, France 24-18, Italy 38-9, captain Gareth Thomas – the only time a Grand Slam has been won playing more games away from home;

2008 – beat England 26-19, Scotland 30-15, Ireland 16-12, France 29-12, Italy 47-8, captain Ryan Jones

- only two tries scored against Wales, a record in the 6 Nations;
Grand Slam Titles England 12, Wales 11, France 8, Scotland 3, Ireland 1
Triple Crown titles England 23, Wales 20, Scotland 10, Ireland 9

RUMNEY CASTLE, CARDIFF Overlooking the River Rhymni, it was attacked and abandoned around 1289, as evidenced by a coin hoard.

RUPERRA CASTLE Built in 1626 by Sir Thomas Morgan, Charles I stayed there after Naseby. It was rebuilt in 1785 and in 1875 Captain Godfrey Charles Morgan, Lord Tredegar, lived there. There was a disastrous fire in 1941 when troops were billeted in the mansion.

RUSSELL, BERTRAND (1872-1970) The third Earl Russell was born in Trellech, Monmouthshire, orphaned at three, and gained Firsts in moral sciences and maths at Cambridge. Made a FRS in 1908, between 1910 and 1913 he jointly authored with Alfred Whitehead the groundbreaking *Principia Mathematica*. His work on epistemology, logic and mathematics altered the course of English philosophy. He supported free trade, women's suffrage and was dismissed from Trinity College for opposing the First World War. He despised Stalinist Russia, and only abandoned pacifism in the face of Hitler's invasions. In the USA wrote the brilliant *History of Western Philosophy*. Russell founded the Campaign for Nuclear Disarmament (CND), and was imprisoned for anti-nuclear protests in 1961, aged eighty-nine. He spent his last years at home in Penrhyndeudrath. In 1949 he had received the Order of Merit and in 1950 the Nobel Prize for Literature. The author of over seventy books, 2,000 articles and 60,000 letters, he has been called 'the last important public intellectual in Britain', 'one of the two most important logicians of the 20th century', and 'the 20th century's most important liberal thinker, one of two or three of its major philosophers and a prophet for millions of the creative and rational life'.

RUTHIN, RHUTHUN Among its old houses is the fourteenth-sixteenth-century Nantclwyd House, and in the market square is Maen Huail, a stone where Arthur is said to have beheaded Huail (Hywel) ap Caw, the brother of Gildas.

RUTHIN CASTLE A hundred feet above the Clwyd Valley, it controls a river crossing, and the first known castle was given by Prince Dafydd ap Gruffydd to Edward I in 1277. A Welsh-built castle, it was originally known as Castell Coch yn yr Gwernfor (the red castle in the great marsh). Lord Reginald de Grey took it over, after Llewelyn ap Gruffydd's death in 1282, and used James of St George to further fortify the site. Glyndŵr captured Baron Reginald de Grey outside Ruthin Castle in 1402, and ransomed him for 10,000 marks (£6,666 pounds). In today's money that would be worth £40 million in a relative earnings index. Glyndŵr desperately needed money to finance his guerrilla war, and the huge ransom broke de Grey's power forever. Captain Sword led the castle's Royalist defenders in the Civil War, but in its second siege in 1646 the castle was surrendered when the attackers were ready to explode mines tunnelled in under its walls. (There was also another Ruthin Castle near Bridgend in Glamorgan, now a farmhouse, destroyed by Glyndŵr).

RUTHIN ROMAN FORT This was abandoned about 100 CE.

ST CLEAR'S, YSTRAD CYNGEN CASTLE This motte and bailey is at the junction of the Taf and Cynin rivers, but all stonework has been removed over the centuries. It was probably captured by The Lord Rhys in 1153, when known as Ystrad Cyngen. In 1188, a young Welshman was heading to St David's to join the Crusade, but was murdered by twelve English archers. The Englishmen had to go on Crusade as a penance. In 1189, The Lord Rhys captured the castle and gave it to his son Hywel Sais, but William de Braose took it back in 1195. In 1215 Llywelyn

the Great captured and destroyed it, but it was later in the hands of William Marshall, Earl of Pembroke. Glyndŵr's men attacked it in 1405. The settlement outside the castle was protected by a massive earthen bank and ditch.

ST CWYFAN'S ISLAND The Grade I listed church of St Cwyfan near Aberffraw, the court of the princes of Gwynedd, is now cut off by the tide for much of the day. (St Cwyfan is the forerunner of today's name Kevin, and the old Gaelic was Coengen). The church used to be on the mainland, but much of this northwest coast slid into the sea, and the church is half its former size. The legends of 'cantre'r gwaelod', the flooded lands, abound in this area.

ST CYBI'S WELL Just north of Llangybi Church, this is a sixth-century holy well with two well-chambers, and a cottage for its custodian. It was a place of pilgrimage, and cured warts, lameness, blindness, scrofula, scurvy and rheumatism. Until the eighteenth century, there was an ancient chest, Cyff Gybi, for offerings to the saint in the nearby church. Carn Pentyrch, an Iron Age hillfort, lies on the hill above the well.

ST DAVID'S CASTLE This is an earthwork built for the protection of the bishops of St David's, but not as well fortified as Llawhaden. William the Conqueror probably stayed here on his pilgrimage to St David's. It was superseded by the nearby Bishop's Palace.

ST DAVID'S CATHEDRAL In medieval times, only two pilgrimages to St David's equalled one to Rome, and William the Conqueror was allowed to pass peacefully through Wales on pilgrimage here. Edward I and his queen also made a pilgrimage to St David's. It is, along with the other Welsh bishoprics, one of the oldest Christian sites in Europe, and the present cathedral dates from 1176. The tomb of The Lord Rhys is here, along with those of Bishop Henry Gower and Edmund Tudor, the father of Henry VII. The Holy Well of St Non, the mother of David is nearby, and the ruined Bishop's Palace adjoins the cathedral. St David's, the smallest city in Britain, is the only city to lie entirely within a National Park.

ST DOGMAEL'S ABBEY There was a Celtic foundation before the order of Tiron was established here in 1115. From 1120, the monks followed the order of St Benedict and the remains date from the twelfth to fourteenth centuries.

ST DOGMAEL'S, LLANDUDOCH, BATTLE OF, 1091 Einion ap Cadifor ap Collwyn, his brother Llywelyn, their uncle Einion ap Collwyn and Gruffydd ap Maredudd (a direct descendant of Hywel Dda) conspired against Rhys ap Tewdwr, the Prince of South Wales. They took a force to St Dogmael's, his court, hoping to take the prince by surprise. However, Rhys was prepared, and Einion and his brother Llywelyn were killed in the battle. Gruffydd was beheaded as a traitor, and Einion ap Collwyn escaped to seek sanctuary with Rhys's enemy Iestyn ap Gwrgan, Prince of Glamorgan. This is also known as the Battle of Llandudoch, the Welsh name for St Dogmael's.

ST DONATS CASTLE & ARTS CENTRE A medieval castle near Llanilltud Fawr, it was owned by the Stradlings and later owned and restored by the newspaper magnate William Randolph Hearst (portrayed in film forever as 'Citizen Kane'). Dating from the twelfth century, it now houses Atlantic College, the first of the United World Colleges to be established. Within the castle grounds lies St Donat's Arts Centre, housed in a fourteenth-century tithe barn. In the valley under the castle is the medieval St Donat's Church with a fifteenth-century calvary, unusually non-vandalized during the Civil War. It was once named Llanwerydd, a Celtic foundation of St Gwerydd.

ST FAGAN'S, ST FFAGAN'S, BATTLE OF, 1648 Eight-thousand Royalists advanced on Cardiff, led by Rowland Laugharne, against three-thousand Roundheads led by Colonel Thomas

Horton. The Parliamentary forces were far better drilled and equipped, and after initially being beaten in a skirmish, Laugharne's men regrouped before attacking Horton at St Ffagans. Cromwell was known to be heading for Wales, which forced the action earlier than Laugharne wished. After a bloody battle, 3,000 Royalists were captured, many being sent to Barbados as slave labour. Half of the Royalist army managed to escape westwards to Pembroke, where Cromwell later defeated them. Seven-hundred Royalists were killed, supposedly sixty-five men from St Fagan's alone, whose widows had to bring in the corn in the following summer.

ST FAGAN'S CASTLE Lord Meurig ap Howell lost this land to Peter le Sore, who raised a ring work here in 1091. A thirteenth-century curtain wall remains, and the castle has developed over the centuries into a mansion, which lies within the superb Museum of Welsh Life. St Fagan's Well, in the castle grounds was said to cure epilepsy.

ST NON'S CHAPEL & HOLY WELL Overlooking the sea near St David's, this is traditionally the site of St David's birth, and dates from the sixth century. The holy well was always well attended on St Non's Day, 2 March, the day after St David's Day.

ST SEIRIOL'S WELL Dating from the sixth century, the Augustinian Penmon Priory was built next to it in the thirteenth century. Seiriol's cell site can still be seen near the well, and he was buried on nearby Ynys Seiriol, Priestholm. Seiriol was known as 'Seiriol the Pale' as he used to head west in the morning to meet St Cybi, and return east in the afternoon. St Cybi of Holyhead, travelling in the opposite direction, was known as 'Cybi the Tanned'.

SAINTS The first known Welsh saints, St Julius and St Arvan, were martyred at Caerleon in 305, and three Celtic bishops attended the Synod of Arles in 314 and the Council of Ariminium in 359. Celtic bishops were probably at the Council of Nicea in 325, and bishops from Britain were also signatories at Tours in 461, Vannes in 465, Orleans in 511 and Paris in 555. The Welsh *Triads* say that Caractacus and his father Brân, after seven years' captivity in first-century Rome, brought the religion to Wales, and there is a tradition that St Paul preached in Celtic Britain. St Clement's *Epistle to the Corinthians*, written around 95 CE, states that Paul had gone to 'the very limit of the West.' There are legends of Joseph of Arimathea across Wales and the West Country, of Jesus landing in Cornwall, and of his mother Mary dying in Wales. It seems that Christianity reached Wales in the first century, and then was possibly reinforced by waves of Christian Gauls escaping the Aurelian persecution of 177. The teaching of Pelagius became popular in Britain, and St Germanus (St Garmon) travelled from Auxerre in 429 and in 447 to preach against the doctrine. In this second visit he led the Celtic Britons against the invading Picts and Scots, defeating them with the battle cry of 'Alleluia'. Tradition has the battle placed at Maes Garmon near Mold in Flintshire. Monasticism in Wales dates from at least 420, with the first notable saints being Dyfrig (Dubricius) and Illtyd around the start of the sixth century. A second generation, who followed them around the middle of the century, were mainly taught by them, for instance Samson, Dewi/David, Gildas, Teilo, Catwg/Cadog, Cybi and Padarn. Many of these also set up their own holy settlements, for instance Llandeilo, Llangybi and Llanbadarn. Many churches dedicated to Welsh saints were renamed by Normans in the eleventh and twelfth centuries, as St John, St Mary (Mair = Llanfair, St Michael (Mihangell = Llanfihangell) etc. The prefix 'llan' generally denotes a fifth to seventh-century Celtic saint, male or female, as often the children of nobility who were given lands by their parents to establish a foundation. There are over a thousand known Welsh saints (see this author's *The Book of Welsh Saints*) who founded places of worship in the so-called 'Dark Ages'.

SALESBURY, WILLIAM (1520-1584) From Llansannan, and given the Holy Day of 10 September, in 1547 Salesbury published a dictionary to help the Welsh better understand English. He warned that Welsh had to be preserved by his generation, following the annexation of Wales

to England in 1543's Act of Union. An excellent scholar, his translation of the *New Testament* and *Book of Common Prayer* into Welsh (with Richard Davies, Bishop of St David's) helped the Welsh language before Morgan's translation of the Bible. He was known as 'the most learned Welshman of his day'.

SAMSON, SAINT (486?-565) He is counted among the seven founder saints of Brittany. Born in southern Wales, he died in Dol-de-Bretagne, in north Brittany. Samson was the son of Prince Amwn of Dyfed and Anna ferch Meurig of Gwent, who was said to be Arthur's sister. As part of the prophecy concerning his birth, his parents placed him under the care of Saint Illtud to become a monk. Samson later became abbot of Llantilltud. He was ordained a bishop by Dubricius, Dyfrig in 521. Samson is recorded as having been in attendance at a church Council in Paris held at some time between 556 and 573. He had been an abbot at several different monasteries before he was ordained bishop, and following his ordination, he traveled to Ireland, South Wales, Cornwall, the Channel Islands, and Brittany. In Cornwall he founded a monastery that was located at either South Hill or Golant, and in Brittany he founded the monastery of Dol. Samson also participated in Breton politics, successfully petitioning the Merovingian king Childebert I on behalf of Judual. He helped, along with St Armel, Prince Judual to defeat Marcus Conomorus and regain his kingdom in Brittany. Samson was buried, with his cousin Magloire, in the Cathedral of Dol. The primary source for his biography is the *Vita Sancti Samsonis*, written sometime between 610 and 820, but clearly based on earlier materials. Not only does it preserve such details about Samson such as his abstinence from alcohol, but valuable details about Celtic Christianity in Britain during Samson's time. A kinsman of Arthur, he was closely associated with St Armel in Brittany, who may be Arthur himself.

SARN HELEN ROMAN ROAD 'Sarn Helen', was the Roman road that crossed Wales from Moridunum (Carmarthen in the south) to Segontium (Caernarfon in the north). Sarn Helen means 'Helen's Causeway', but is possibly a corruption of 'Sarn Y Lleng', 'Causeway of the Legion'. Newer roads follow some of it, but parts of Sarn Helen are just as laid down by Roman slaves almost two thousand years ago. A 'new' Roman road appears to have been discovered west of Carmarthen, and the Roman network makes for some superb country walking. From 78 CE, Wales was effectively under Roman control until 390 CE. Several other Roman roads across Wales are known as Sarn Helen. The best preserved is near Ysradfellte and its marvellous waterfalls, and at Maen Madoc the cobbled surface and ditch is exposed, allowing one to see the construction.

SCIENTISTS The late Professor Phil Williams theorised that there were so many Welshmen in science, including John Meurig Thomas, President of the Royal Institution, because 'science was a field, unique in Britain, where ability was the only qualification for success. To get on in the Civil Service, the City, the Army, the Church, it was a pre-requisite to wear the right tie and speak with the right accent. But in science – and only in science the talented student from Wales could get right to the very top. And once a few Welshmen had made their mark, they served as role models for the next generation.' Williams remarked that at one meeting of the Space Physics Research Grants committee, six of the seventeen scientists were Welshmen, and another named Hughes, was the grandson of a Welsh teacher. In the same year, at an international conference on the ionosphere in Belgium, nearly every speaker was Welsh, although they were working in three different countries. Incidentally, *The Computus Fragment* is part of a manuscript on the stars written in Welsh by a monk at Llanbadarn around 940. Also Lewis Morris Rutherfurd, 1816-1892, who studied at Williams College Massachusetts, was the leading spectroscopist and astronomical photographer of his day, so it seems that the Welsh have always been star-gazers. A society of Welsh scientists, 'Y Gymdeithas Wyddonol Genedlaethol', is based in Aberystwyth. Wales' contribution to science has been greatly undervalued.

SCOTCH CATTLE Around the same time as the Rebecca Rioters in rural Wales, there arose in Monmouthshire the mysterious 'Scotch Cattle' raiders dressed in animal skins and women's clothes, with blackened faces. The leader of each group, the Tarw (Bull) wore horns on his head, and they would attack unpopular managers, unfair employers, strike-breakers and profiteers, and smash windows and furniture, around midnight. For fifteen years in the 1820's and 30's this secret society of separate 'herds' organised strikes, frightened blacklegs and employers but 'Scotch Law' held, whereby no-one was ever betrayed to the authorities. Dr D.J.V James, in *Rebecca's Children*, describes a typical visit to blacklegs, strike-breakers, or non-supporters of strikes... 'The leaders of the party were disguised by masks, handkerchiefs, and cattle skins; the remained had blackened faces, and wore women's clothes, 'their best clothes', or simple reversed jackets. They announced their arrival by blowing a horn, rattling chains, and making 'low' noises. At the home of their victim, the Cattle smashed the windows with stones or pickaxes and broke down the door. Once inside, it was a relatively easy matter to destroy the furniture and earthenware, and to set fire to clothes and curtaining. The inhabitant might be ill-treated or given a further warning; then the Cattle disappeared as quickly as they had arrived, leaving their glistening red mark on the open door.' The movement petered out in 1835, when a miner, Edward Morgan, was hanged in Monmouth for his part in a disturbance.

SECOND WORLD WAR 1939-1945 Over 200,000 people came to Wales to escape the bombing of England, including 50,000 children who were taken to the Rhondda Valley. However, an attack on Cardiff caused 165 deaths in January 1941. A month later, three nights of bombing in Swansea saw 230 deaths and the destruction of most of the city centre. Over 15,000 Welsh people lost their lives in the war. Mention must be made of the Welsh contribution to the Merchant Navy, with ports like Barri, Cardiff, Newport, Milford, Pembroke Dock and Swansea sustaining extensive casualties. Barri lost proportionately the highest number of men in the merchant navy of any port in Britain (see this author's *Welsh Sailors of the Second World War*).

SECRETARIES OF STATE FOR WALES This is the title of the head of the Welsh Office within the Parliamentary Cabinet. Secretaries have been: James Griffiths (Labour) 1964-66; Cledwyn Hughes (Lab) 1966-1968; George Thomas (Lab) 1968-1970; Peter Thomas (1970-1974); John Morris (Lab) 1974-1979; Nicholas Edwards (Conservative) 1979-1987; Peter Walker (Con) 1987-1990; David Hunt (Con); 1990-1993; John Redwood (Con) 1993-1995; David Hunt (Con) 1995; William Hague (Con) 1995-1997; Ron Davies (Lab) 1997-1998; Alun Michael (Lab) 1998-1999; Paul Murphy (Lab) 1999-2002; Peter Hain (Lab) 2002-2008; Paul Murphy (Lab) 2008-2009; Peter Hain (Lab) 2009-.

SEDITION From the *Glamorgan Calendar Rolls and Gaol Files* of 1625, we read: 'The Cardiff Grand Jury presented that Thomas William, of Colwinston, yeoman, uttered these treasonable and seditious Welsh words, namely: Mae dy vrenyn yn drewy ger bron Duw yn y bechod val ddoyt tithe William hoell; in English, "Thy king doth stincke before God in his sin as thou dost, William Howell." ' These criminal indictments, for libellous, slanderous and treasonable writing or speech, are important in that they give us virtually our only records of the different dialects of Welsh language.

SPENNYBRIDGE CASTLE, CASTELL RHYD-Y-BRIW Also known as Castell Ddu, Black Castle, it was probably built by Llywelyn the Last in 1262, and held by his ally Einion Sais from 1271.

SETTLEMENTS The antiquarian Camden noted 'Anglia Transwallania' - 'England Beyond Wales'. This part of Pembrokeshire south of the Preseli Hills was known as the 'Englishry', with a line of fortifications protecting it from the 'Welshry' in north Pembrokeshire. The place names north and south of this line are Welsh and English respectively, divided by the invisible line known as the 'Landsker'. From 1111, many Flemings were settled in Pembrokeshire by Henry I, to work the fish, wool and wine trades. Tenby became a Flemish stronghold, and many places

like Flemingston display old cottages with the distinctive massive 'Flemish chimneys'. Llangwm, another Flemish settlement near Haverfordwest, used to have a distinctive distrust of strangers, and was actively hostile. Jealous of their fishing rights in the Cleddau creeks, the villagers collected bass, mullet, herring and salmon from distinctive black-tarred boats, descendants of the smaller two thousand year-old coracles. The women used to row and walk miles to Milford, Haverfordwest and Pembroke markets with the fish and shellfish catches. St Florence, near Manorbier, was also settled by the Flemish. Similarly, Flemings were settled in the south of the Gower (Gŵyr) peninsula, and there is also an Englishry – Welshry border there. There were previously Viking settlements in Pembroke, with Norse place-names – Milford, Haverfordwest, Herbrandston, Hubberston, etc. The names of many Welsh islands have a Scandinavian origin, ending in holm (islet) or ey (island), e.g. Anglesey (Island of the Angles), Bardsey, Caldey, Skokholm, Grassholm, Flat Holm etc. Irish settlers in the northwest and southwest of Wales were generally driven out, or assimilated into the population. Also 'bastides' or fortified towns were set up from the thirteenth century, usually next to castles, for incomers to colonise Wales.

SEVERN BORE A 'bore' is a surge of tidal water up an estuary or river, caused by the funnelling of the rising tide into a narrowing mouth. The River Severn is the longest river in Britain, and meets some of the highest tides in the world where it opens out into the Bristol Channel. An extremely high tide, especially in spring, can be assisted by wind, and build up in height where it is resisted by the river current against it. It will eventually break through the river current, and the broken wave will surge for miles up the Severn, even uprooting trees on the banks. Every year people try to surf up the River Severn, on this 'Severn Bore', which can reach up to six feet high at narrows in the Severn. The ports of Newport on the Usk entry into the Channel, and Cardiff on the Taff, Rymni and Ely entry into the Channel, experience the highest tidal ranges of any port in the world, along with Avonmouth on the other side of the Bristol Channel.

SEVEN WONDERS OF WALES

> Pistyll Rhaeadr and Wrexham Steeple,
> Snowdon's Mountain, without its people,
> Overton yew trees, St Winifrede's Wells,
> Llangollen Bridge and Gresford's Bells.

The 'Seven Wonders' of the rhyme are all in north-east Wales and as follows:
1. Wrexham Steeple is on the Church of St Giles, a superbly decorated 136ft tower, completed in 1520. Endowed by Margaret Beaufort, Henry VII's mother, the Perpendicular tower has twenty-nine sculptures. The church's superb 1720 wrought-iron gates are by the Davies brothers of Bersham, who also made the gates at Chirk Castle. Elihu Yale, the founder of Yale University, is buried in the churchyard, and Parliamentary forces melted the organ pipes in the Civil War, to make bullets.
2. The bells are at Gresford Parish Church, Clwyd, which also has superb medieval stained glass and a fourteen-hundred year-old yew in its churchyard.
3. Pistyll Rhaeadr plunges 240ft near Llanrhaeadr ym Mochnant.
4. Snowdon, or Y Wyddfa Fawr, is the highest mountain in England and Wales. Many paths and trails run up its 3,560ft.
5. St Winifrede's Well at Holywell was visited by several English kings. From the thirteenth century until the Reformation, it was in the care of the Cistercian monks of nearby Basingwerk Abbey, which gained a healthy income from pilgrims.
6. There are twenty-one yew trees in the churchyard at St Mary's, Overton, some dating from the twelfth century. Overton was once an important borough with its own castle.
7. Llangollen's Trefor Bridge, named after John Trefor, Bishop of St Asaf, dates from 1354, rebuilt in the sixteenth century and later widened for modern traffic.

The following rather esoteric shortlist of thirty items in *The Western Mail* of April 2006 for a 'new' seven wonders of Wales features: Blaenau Ffestiniog slate mines; Britain's smallest house at Conwy; Caerffili Castle; the coracle; Dinorwig power station; Eisteddfodau; the Great Glasshouse at the National Botanic Garden of Wales; the Llangernyw Yew; the Mabinogion; Milford Haven waterway; the Millennium Stadium; the National Library of Wales; Patagonia; the Pembrokeshire islands; Pentre Ifan cromlech; Pistyll Rhaeadr; Pontcysyllte aqueduct; Portmeirion; the Red Lady of Paviland; Rhossili beach; Sarn Helen; the Second Severn Crossing; Snowdon; Tom Jones; Tower Colliery; the triple harp; Wales Millennium Centre; the Welsh Cob; the Welsh 'culinary team' and Welsh lamb.

SHEEP Wales has the highest density of sheep in the world, which has given rise to countless jokes. It has 15% of the EU's sheep, but only 1% of the population. Welshpool's Monday fair is the largest sheep auction in Europe. To fit with our Welsh Black Cattle, Welsh Black Cobs (horses), Welsh Black Fowl (a breed of chicken) and Welsh Black Pigs (now possibly extinct), there is obviously a 'Welsh Black Mountain Sheep', and the Llanwenog Sheep from West Wales has a strange tuft like that of a unicorn. Both can be seen at The Museum of Welsh Life at Saint Ffagans, near Cardiff. The oldest sheep in the world last lambed at the age of twenty-four and died just before her twenty-ninth birthday, near Aberystwyth in 1988. The UK sheep-shearing record of 625 ewes was set by N. Beynon of Gower at Carno, Powys in 1993. Other Welsh sheep breeds include the rare Dafad Rhiw on the Llŷn Peninsula, the Dafad Torddu, the Beulah Speck-Faced, the black-faced Clun Forest, the Welsh Mule, and the Badge-Faced (Black-Bellied) sheep. The rare Hill Radnor sheep were favoured in the eighteenth century to make fine woollens, and women travelled from village to village, knitting stockings to sell as they walked. There is also a flock of Hill Radnor at The Museum of Welsh Life. Our newly-shorn Welsh Mountain Sheep are not the prettiest sheep in the world, especially compared to another native breed, the speckle-faced Kerry Hill, but they are definitely the cleverest. If one watches them rolling over cattle grids, or wandering up back alleys in valley towns trying to open gates to get to a rubbish bin, or molesting one for food on the Brecon Beacons, it is easy to realise why grocers in the Valleys stopped displaying their goods outside their shops. I have been lucky enough to watch Welsh sheep teach their lambs how to roll over the cattle grids – this appears to be a habit that no other sheep in the world has mastered.

SHIRING OF WALES 1536 Following the conquest of Edward I in 1282-83, the Welsh princes' lands were divided into counties for English administration. Gwynedd became Anglesey, Caernarfon and Meirionnydd (Merioneth). Tegeingl (Englefield), previously part of Gwynedd, became, with the eastern part of Powys Fadog, the county of Flint. The heart of Deheubarth became Carmarthen and Cardigan. The Act of 1536 created seven new counties to add to these six. Smaller lordships were joined to the large lordships of Glamorgan, Brecon and Pembroke. Powys Wenwynwyn became Montgomery, and Maelienydd became Radnor. Denbigh and Monmouth were also consolidated to make the '13 Counties', which lasted until the later twentieth century before several reorganisations.

SHOW-JUMPING In the Helsinki Olympics, Sir Harry Llewellyn on Foxhunter won Britain's only Gold Medal in the Games, winning the Show Jumping Team event. Richard Meade won an individual gold in Munich in 1972, and team golds in Mexico and Munich. David Broome was World Show Jumping champion three times between 1961 and 1969.

SHREWSBURY (PENGWERN) This Shropshire market town was the headquarters of one of the great Marcher lords, the Earl of Shrewsbury, but as Pengwern used to be the capital of the princes of Powys, until conquered by Mercia.

SHREWSBURY, BATTLE OF, 1403 Henry Percy (Harry Hotspur) of Northumberland, a third

member of the Tripartite Alliance with Owain Glyndŵr and Edmund Mortimer, was defeated and killed by Henry IV, his body being displayed at Shrewsbury and then dismembered for display across Britain. Hotspur's head was spiked at York. This battle allowed Henry IV to devote his whole forces to defeating Glyndŵr. The Church of St Mary Magdalene was built on the battlefield in 1406 as a memorial to those who died, and features an effigy of Henry IV. It seems to be the only memorial chapel in Britain to be on the actual site of the battle it marks. It appears that Hotspur did not wait for his father's forces to join him in the action, and that Henry precipitated the action. Henry may have known that Owain Glyndŵr was heading across Wales to meet up with Hotspur, but had been delayed by events in southwest Wales and terrible weather. Glyndŵr had taken Dinefwr, Llandovery, Llandeilo and Carmarthen castles in just five days, but a Fleming army halted his progress for some time. It is said that Glyndŵr's vanguard arrived just in time to see the end of the fighting. It had been a bloody and close affair until Hotspur was killed. If the usurper Henry IV had been killed, and the Mortimers gained the throne, Wales would have received the English marcher counties back.

SIDDONS, SARAH (1755-1831) She was born in a tavern in Brecon's High Street, now renamed 'The Sarah Siddons', and came to the attention of the great actor-manager David Garrick. She became the most famous actress of her age, and as a tragic actress had no peers. At her last performance, in 1812 as Lady MacBeth, there was a massive black market in tickets, and she invented the 'hand-washing' gestures in the sleepwalking scene. The play could not be concluded at the end of this scene, as the audience was uncontrollable in its appreciation.

SILVER In 1637 a branch of the Tower Mint was set up in Aberystwyth, to coin locally mined silver. Near Cwm Einion (Artists' Valley, popular with artists in the nineteenth century), is Furnace, a historic metal-smelting site, dating from silver-smelting in the seventeenth century. Silver was also mined near Llanidloes in the seventeenth century. A mile west of Ponterwyd in Cardiganshire is the Llywernog Silver-Lead Mining Museum, where one can follow a trail through a site that operated from 1740 to 1914. There is a 'panning shed' and an extended underground tour. This mining of silver-rich lead ore was a major rural industry in mid-Wales for 2,000 years.

SIÔN CENT (fl. 1240) Some experts have identified the mysterious Siôn Cent with Owain Glyndŵr, when Glyndŵr disappeared from history. This reclusive poet and scholar was also said to have been vicar of Kentchurch in Hereford (still Welsh until 1536) and Grysmwnt (Grosmont) in Gwent. Many supernatural happenings were attributed to him – could this have been a smokescreen for Glyndŵr? He died at the age of 'at least one hundred and twenty', and his grave exists half in the chancel and half in the graveyard of his church, supposedly because of a pact with the Devil. He is also said to have magically built the bridge over the River Monmow that has always been named after him. Siôn Cent was a master of the 'Dychan' ('satire'), and his poems sermonise against vanity and love of worldly things – these few lines are from *Man's Vanity:*

> After wine, the beloved kinsman
> Will be put diligently into the earth
> And his kin will mourn him for a while
> As he is covered with a spade.
> Cruel tormentor, does the man not know,
> Grim task, that no border
> Supports his house there, awful abode,
> Except the earth alone?
> And gravel presses against the cheek.

SKENFRITH CASTLE, CASTELL YNYSGYNWRAIDD Near Abergafenni, it is one of the

'castles of the trilateral' along with Grosmont and White Castle. With those castles, it belonged to the king in 1160, and in 1187 Henry II instructed his engineers to rebuild it in stone. In 1219 Hubert de Burgh further fortified it, but in 1239 it was seized by Henry III, who lead-roofed it. Next to the River Monmow, it is an impressive site. The nearby medieval church has a wooden dovecot-topped tower and is next to the remains of a medieval quay. (Ynysgynwraidd, from which Skenfrith is derived, means an island that was formerly rooted, or full of roots.)

SKOKHOLM ISLAND Skokholm had Britain's first bird observatory in the seventeenth century, and rare Manx Shearwaters nest here, along with puffins, storm petrels, razorbills, guillemots and oystercatchers. The shearwater population of 195,000 pairs on Skomer and Skokholm is internationally important, as the world's largest colony of this burrow-nesting bird homes in to its burrows at night. Skokholm is 263 acres, Wales' seventh largest island, and a SSSI.

SKOMER ISLAND IRON AGE SITE The island is covered with remains of Iron Age round huts, field systems, field-clearance cairns and walled enclosures, dating from the first century BCE. Skomer has a Viking name, and is 722 acres of superb bird-watching territory. Wales' third largest island at 722 acres, it is home to the unique Skomer Vole and one of the most important seabird sites in Britain. The vole is almost tame and can be picked up, and the island is a SSSI.

SLATE The Romans used Welsh slate to roof Segontium in Anglesey, and Edward I used it extensively in his 'Iron Ring' of castles built to subdue the people of Gwynedd. During the Industrial Revolution, the English-owned Welsh slate quarries (like the English-owned coalmines and ironworks) were the world's largest producers. Slate dust, tuberculosis and long working hours made the miners' lives miserable – like colliers, they even had to buy their own candles from the quarry owners. In 1900 the workers in Lord Penrhyn's Bethesda quarry went on strike for minor concessions, and stayed out for three years, Britain's longest-ever industrial dispute at the time. All managerial jobs had been given to the English or Scots, with very few going to local Welshmen, who had to become highly anglicised to be promoted in the works. Welsh-speaking Welshmen did all the skilled work, grading and splitting the slate, but the management refused to recognise their union. Some men eventually returned to work, because of the grinding poverty, but newspapers published their names, pubs and shops refused to serve them or their families, they were refused entry to chapel and stoned by furious strikers' wives. Eventually the fabulously wealthy Lord Penrhyn, the former George Dawkins, who was spending the equivalent of millions of pounds on building Penrhyn Castle, took some men back on even less money. However, several hundred strikers were blacklisted and were refused work. The bitterness split the community into the 'bradwyr', traitors, who now attended Anglican churches, and the betrayed, who went to chapel. This quarry was methodically exploited from the end of the eighteenth century and developed into the largest and deepest (1,410 feet) quarry in the world, employing 3,500 men.

There is an astonishing transformation as you cross the heather-covered hills towards Blaenau Ffestiniog – slate spoil tips and slate houses with slate roofs and slate mountains take over – this is a terrific and thought-provoking visit. Blaenau Ffestiniog is still a real stronghold of the Welsh language, with a great sense of community spirit. Blaenau's Gloddfa Ganol is now the world's largest slate mine, with forty-two miles of tunnels. At the nearby Llechwedd Slate Caverns, one enters by electric train descending a steep 1:1.8 gradient to an underground lake, and there is an excellent mine tour and a heritage centre (wear warm clothes). The Chwarel Wynne Slate Mine in Glynceiriog, Clwyd, also offers guided tours through its eerie tunnels. In Gwynedd, the Dinorwig Slate Quarry near Llanberis was one of Wales' largest, employing over 3,000 men. Upon its closure in 1969, it was preserved as the Welsh Slate Museum, with a huge 50ft waterwheel. Corris also employed over 1,000 men producing slate in its heyday, with a narrow-gauge railway taking the slate to Machynlleth. The Corris Railway Museum tells the story of the railway and the past workings at Corris. Near Harlech, the Old Llanfair Slate Caverns are also open to the public. At the strange and atmospheric little harbour of Porthgain, which exported building stone, one can walk around

the cliff point to 'The Blue Lagoon' at Abereiddi, a harbour quarried from slate and filled by the sea. The old slate workings here have some remarkable rare fossils such as graptolites.

SNOOKER Ray Reardon was world champion six times between 1970 and 1978, Terry Griffiths won the title in 1979, and Mark Williams won in 2000 and 2003.

SNOWDONIA Eryri is the massive mountain complex of North-West Wales. Its name comes from '*eryr*', land of eagles. (In English, an 'eyrie' is an eagle's nesting place). Yr Wyddfa (Snowdon), at 3,560 feet, is the highest mountain in England and Wales. Yr Wyddfa refers to the now-vanished tumulus of one of King Arthur's victims, Rhita Gawr. Llyn Llydaw in Snowdonia is supposed to be the lake where Sir Bedevere threw Excalibur when Arthur was wounded at Bwlch-y-Saethau (Pass of Arrows), in his last battle with Mordred. Garnedd Ugain with its adjoining ridge Crib y Ddysgl (Ridge of the Dish) are nearby. Garnedd Ugain comes from carnedd (cairn), and (ugain) twenty, and is named after the XX Roman Legion in nearby Cernarfon. The rare rainbow leaf-beetle has survived in the area since the last Ice Age. The last glacier in Wales, in Snowdonia, melted about ten millennia ago.

SNOWDONIA, BATTLE OF, 798 Somewhere in the mountain massif, Cenwulf of Mercia overcame Caradog ap Meirion, King of Gwynedd, who had ruled from 754.

SPANISH CIVIL WAR 1936-1939 By the end of the Civil War, 33 men of the 177 Welshmen in the International Brigade had been killed fighting Franco's pro-Fascist National Radical troops. Captain David John Jones was known as 'Potato Jones' for his efforts in trying to break Franco's blockade and land a cargo of potatoes in Spain. After Hitler's bombers wiped out the Basque town of Guernica, many Basque children came to Wales and were adopted. Incidentally, recent DNA testing has proven that the Welsh and Basques are genetically identical, proving the Celtic Diaspora from Spain into Wales over 2,500 years ago.

SPORTS The ancient Welsh game, 'cnapan', was played by up to 1,500 naked Welshmen at a time, until the seventeenth century when clothes were worn. It survived until the nineteenth century, with up to 600 participants from rival villages, some on horseback, trying to hit or carry the ball to its destination, usually around two miles away. A bowl of heavy wood was fought over cross-country between villages, as one mob tried to force it into the opposing village. Some claim it to be the spiritual ancestor of RUGBY. Other old games that lasted until the nineteenth century were 'bando', like hockey, and 'chwarae pel', a handball game similar in concept to 'fives'. Chwarae pel was traditionally played against the walls of churches until in the eighteenth-century courts started to be built – there were three in Llantrisant alone. Bando was played between an indeterminate number of players, with deadly inter-village rivalry, and The Margam Bando Boys are featured in a famous song. The most famous teams were Kenfig, Pyle, Margam and Llantwit Major.

SPRING, HOWARD (1889-1965) Cardiff-born, he wrote many popular novels, including *O Absalom!*, later published as *My Son, My Son!*, and *Fame is the Spur*, detailing a Labour politician's rise to power. He achieved great popularity in the USA as well as Britain.

SQUIRES, DOROTHY (1915-1998) Pontyberem's Dorothy Squires was recently probably better known as a wife of Roger Moore, the film actor, but her *Times* obituary called her 'one of the great popular singers of the century, a chanteuse-realiste with few equals when it came to conveying intense emotion'. She starred at the London Palladium, Talk of the Town, Albert Hall, Carnegie Hall and at the Moulin Rouge in Hollywood, 'where her greatest fan was Elvis Presley, who repeatedly asked her to sing *This is My Mother's Day*.' Her life story would make an interesting film – born in poverty, she was once worth £2,000,000 and feted in the USA, but after her bitter parting from Roger Moore died in poverty, much of her earnings lost in divorce litigation. Frank Sinatra called her 'the only British singer with balls'. His daughter Nancy, after hearing Dorothy Squires sing 'My Way' in Los Angeles,

commented 'I think my dad must have been half asleep when he recorded his record'. Even Edith Piaf thought that Squires' recording of *If You Love Me, Really Love Me* was better than her own.

STANDING STONES These can be Neolithic or Bronze Age, and could stand up to 14ft tall, with another 6-8ft under the surface. There are some alignments, but many have been broken up, used as gateposts or burnt for lime and the like. Trellech, the Place of Stones, in Gwent, has three huge standing stones. Many Christian churches were superimposed upon earlier holy sites. Embedded in the porch of Corwen church is Carreg y Big yn y Fach Rewlyd (the 'Pointed Stone in the Cold Hollow'). At Maentwrog, St Twrog's stone stands beside the church porch, as does Maen Llog outside Trallwng (Welshpool) Church. Llaniden and Old Radnor churches are also situated near sacred stones. Four standing stones form part of the churchyard wall at Yspyty Cynfyn. Maen Huail (Huail's Stone) stands in St Peter's Square in Ruthin. Huail, the brother of Gildas, was beheaded on this stone by King Arthur, either for killing Arthur's nephew Gwydre fab Llwyd (according to Caradog's *Life of Gildas*), or for stealing Arthur's mistress (according to Elis Gruffydd's *The Soldier of Calais* Chronicle). Standing stones and Celtic crosses are often associated with holy places (llanau) and saints in Wales. One Welsh treasure now in the British Museum in London is the stone from Llywel near Trecastle in Powys, with inscriptions in Ogham and Latin, and symbols and pictograms on three panels. A cast is now in Brecon museum.

STANLEY, SIR HENRY MORTON (1841-1904) This great explorer, of 'Dr Livingstone, I presume?' fame, once killed five Africans with four shots from his elephant rifle when attacked. He had loaded the gun with explosive charges as a precaution. Born in 1841 in Denbigh, he was the illegitimate son of John Rowlands and Elizabeth Parry, and was brought up as John Rowlands in St Asaf's workhouse. He went to sea as a cabin boy in 1859, was befriended by Henry Morton Stanley of New Orleans, and took his benefactor's name. He fought on both sides in the American Civil War, and in 1867 joined the *New York Herald*. As its correspondent, he travelled to Abyssinia and Spain, and was told by his editor to find Livingstone in 1869, aged just twenty-eight. Stanley found Livingstone at Ujiji in 1871, and explored Lake Tanganyika. His further explorations are detailed in *Through the Dark Continent* and *In Darkest Africa*. He traced the course of the River Zaire (Congo) to the sea 1874-77, and established the Congo Free State (Zaire) from 1879-84. Stanley charted much of the unexplored African interior between 1887 and 1889 when he led an expedition to relieve Emin Pasha (Eduard Schnitzer). Stanley Falls, Stanley Pool and Stanleyville have now been renamed Boyoma falls, Pool Malebo and Kisangani. Between 1874 and 1877 he carved out a huge colony in Central Africa for his friend and employer, King Leopold of Belgium. This Welsh urchin from a workhouse ended up as the most celebrated explorer of his day and an MP, with the Grand Cross of the Order of the Bath.

STANLEY, WENDELL MEREDITH This American biochemist, of Welsh descent, won the Nobel Prize for Chemistry in 1946, for isolating, crystallising and demonstrating that the Tobacco Mosaic Virus was infectious.

STATELY HOMES Some of the best that are open to the public are as follows. The seventeenth-century Tredegar House, Newport, stands in a country park and was the home of the powerful Morgan family. Sir William Morgan entertained King Charles I here. Captain Henry Morgan, the privateer, was a nearby cousin. Godfrey Morgan, Viscount Tredegar, survived the charge of the Light Brigade in 1854. His horse, Sir Briggs, is buried near the house. Here in the 1920's and 30's, Viscount Evan Morgan dabbled in black magic and kept a menagerie of exotic animals. There are events throughout the year. The last Morgan of Tredegar died in Monaco, having spent the family fortunes and sold the house. Bodelwyddan Castle in Clwyd is an outpost of the National Portrait Gallery, with opulent Victorian interiors. Powis Castle has evolved from a border castle to a stately home with a golden state bedchamber dating from 1688, and has strong connections with Clive of India. The superb formal gardens were created between 1688 and 1722 by the Welsh architect William Winde, and are the only formal gardens in Britain of this date which survive in their original form. In the

reign of Edward I, the Gwenwynwyn family, to keep the castle had to renounce all claims to Welsh princedom of Powys, and took up the name De La Pole. Erddig Hall, near Wrexham, has been called 'the most evocative upstairs-downstairs house in Britain'. Chirk Castle was built by Edward I, and has been the home of the Myddleton family since the sixteenth century – the huge iron gates are a true Welsh masterpiece, made by local brothers Robert and John Davies of Bersham between 1718 and 1724. Penrhyn Castle was rebuilt with money from the slate mines, in neo-Norman style, with slate everywhere, even a huge slate bed where Queen Victoria slept. Plas Newydd is a splendid eighteenth century mansion built by the Marquess of Anglesey, one of Wellington's commanders at Waterloo. On horseback, when a cannon ball took off his leg during the battle, he turned to Wellington and exclaimed 'Begod, there goes me leg!' to which the phlegmatic Duke replied 'Begod, so it do!', and carried on supervising the battle. The marquess's artificial leg, made of wood, leather and springs, was the world's first articulated leg, and is on display in the hall's Cavalry Museum. At Ystrad Flur, Strata Florida Abbey, the White Cistercian monks kept a healing cup made of wood from Christ's Cross. Later it transmuted into The Holy Grail, used at the Last Supper and sought in legend by Arthur and his knights. It passed to nearby Nanteos Mansion, where the Powell family became its custodians. Cardiff Castle and nearby Castell Coch were rebuilt and remodelled by William Burges for the Bute family as superb residences.

STATUTE OF RHUDDLAN, 1284 After the death of Llywelyn II in 1282 and his brother Dafydd's execution in 1283, Edward legalised the annexation of Wales, forcing it to be governed by English law instead of Welsh law. Regular circuits by judges brought law to the people. Often judges were the Marcher Lords. Primogeniture was implemented instead of divisible inheritance, and illegitimate children were no longer allowed to inherit. Taking away the Welsh laws was a massive blow to the sense of nationhood, as Edward I well knew. The English system of shires, each with royal officials such as a sheriff and coroner, was instigated and the shires of Cardigan, Carmarthen, Flint, Caernarfon, Anglesey and Merioneth date from this law.

STEELE, SIR RICHARD (1672-1729) From Llangunnor, he founded and co-edited *The Spectator* with Addison, in which he wrote 'the noblest motive is the public good', and that 'there are so few who can grow old with a good grace'. He founded *The Tatler* in 1709, in which his comments included 'every man is the maker of his own fortune', 'reading is to the mind what exercise is to the body', 'let your precept be, Be easy', and 'these ladies of irresistible modesty are those who make virtue unamiable.' Also a writer of comic plays, money troubles forced him to leave London in 1724 and he died in Carmarthen.

STEPHENS, MEIC (1938-) Born in Trefforest, Stephens was educated at Aberystwyth University, Bangor University and the University of Rennes, and has been at the forefront of literary output in Wales. He stood as Plaid Cymru candidate in Merthyr Tydfil in 1966; was Literature Director, Welsh Arts Council (1967-90); Visiting Professor of English, Brigham Young University, Utah (1991-92); Lecturer in Creative Writing (1994-2000) and Professor of Welsh Writing in English (2000-2003) and Emeritus, University of Glamorgan. A White Robe in the Gorsedd of Bards, and a Life Member of the Welsh Academy, Stephens launched *Poetry Wales* in 1965. He has edited, translated and written about 170 books. His publications include the *Writers of Wales* series, several anthologies, The *Oxford Illustrated Literary Guide to Great Britain and Ireland, The Companion to the Literature of Wales,* and the anthology *Poetry 1900-2000 in the Library of Wales.* Stephens edited the poems and prose of Glyn Jones, Rhys Davies, Harri Webb and Leslie Norris. He learnt Welsh, speaks it fluently and all four of his children and ten grandchildren have it as their first language. Has translated the prose of Saunders Lewis, Islwyn Ffowc Elis, Gwynfor Evans and John Gwilym Jones, among others, and writes verse in Welsh. His other books include: *The Literary Pilgrim in Wales; A Semester in Zion,* and a novel, *Yeah, Dai Dando.* He and his wife Ruth (nee Meredith) have lived in Cardiff since 1966.

STONE CIRCLES & HENGES Dating predominantly from the Bronze Age, there can be up to 30 stones in a circle. Many have disappeared over the centuries. At Cerrig Duon, a long avenue of outlier stones leads from the circle to a standing stone or menhir (maen hir = tall stone) about 1,000 yards away. On the Preseli Hills, Gors-Fawr stone circle has fifteen glacier boulders and two pointer stones. The Druid's Circle near Penmaenmawr has a diameter of 80ft, and Llanaber in Merioneth has two stone circles of 120ft and 176ft. An ancient stone avenue of 150ft leads into Llanrheadr ym Mochnant. Sarn-y-Bryn-Caled Timber Circle stood near Powys Castle. Aerial photography showed a prehistoric ritual and funerary site on the floodplains of the Severn, and 1990's excavations showed it to be a huge timber double circle with twenty post pits built *c*. 2100 BCE, a possible prototype henge for Stonehenge. It is thought that the wooden posts could have been linked by wooden lintels. The Welshpool bypass now covers Sarn-y-Bryn-Caled (Causeway of the Dry Hill) in the cause of progress.

STRATA FLORIDA ABBEY (YSTRAD FFLUR, VALE OF FLOWERS) The first Cistercian abbey, founded in 1164 by Robert fitz Stephen, is two miles away from this site, on the banks of the Afon Fflur. Near Pontrhydfendigaid in Ceredigion, the abbey was a daughter house of Whitland, and it seems that the new site was the wish of The Lord Rhys. It was his favourite abbey, and perhaps he wished to distance it from the Norman foundation, with the new building starting in 1184 on the banks of the River Teifi. Under his patronage it became the scriptorium for the native Welsh annals. *Brut y Tywysogion* (*The Annals of the Princes*) was probably recorded here. It became the largest abbey in Wales, in the course of fifty years of building work. King John threatened to destroy it for its Welsh partisanship, and it suffered during the Madog rebellion in 1294. Graves of Welsh princes include two of The Lord Rhys's sons, and traditionally Dafydd ap Gwilym was buried there. A wooden cup, said to be the Holy Grail, was held by the abbey, and went to Nanteos before its Dissolution. The 'Monks' Trod', an ancient road, led from Strata Florida to Abbey Cwmhir in Radnorshire, and was later used by drovers.

STRATA MARCELLA ABBEY A Cistercian foundation, on land given by Owain Cyfeiliog, who came here to die.

STRATHCLYDE As the Britons, the Brythonic Celts were pushed back west by the Germanic invasions from the fifth century onwards. Thus Wales became separated not only from the West Country, but also from the northwest of England (Cumbria) and the southwest of Scotland (Strathclyde, or Ystrad Clud). From this Welsh-speaking part of Scotland came William Wallace, and King Malcolm III (d.1093) praised the support of his 'Welsh' subjects there. 15,000 Strathclyde Welshmen supported King John Balliol in 1296, according to the *Irish Annals*, and thousands fought for Bruce at Bannockburn.

SULLY ISLAND This can be reached at low tide from Swanbridge. There is sea-holly, and the remains of an iron-age fort on the eastern promontory. Some Saxon or Viking raiders were trapped here and killed a millennium ago. It is a SSSI and is twenty-eight acres. On nearby Bendricks Rocks and the Sully shorelines were discovered the only Upper Triassic Dinosaur footprints in Britain, in biped and quadruped modes.

SULLIVAN, JIM BULLER (1903-1977) From Cardiff, he played for Wigan in rugby league and kicked a record number of goals, 2,867, in a glittering career that spanned from 1921-1946. He began his career as Cardiff's rugby union fullback aged only sixteen, and shortly after his seventeenth birthday had the honour of playing for the Barbarians. He also made the most appearances for one club, Wigan – 774 – a record for first-class appearances, and scoring 4,883 points for them. He scored 6,022 points including his career. For 16 consecutive seasons, he was rugby league's top goal scorer, until the advent of World War II. His last season was effectively 1939-1940. Sullivan played rugby league sixty times for Great Britain, Wales and England. He was

top scorer on three British Lions tours, but declined to tour on a fourth. The giant of the game also played for Wales at baseball, a game the Welsh played before the Americans discovered it, and still popular in Cardiff.

SUMMERHOUSES IRON AGE FORT The octagonal summerhouse here was built around 1730, by the Seys family of nearby Boverton Castle, east of Llanilltud Fawr. The Summerhouse is also set within an octagonal enclosure. Adjacent is an Iron Age fort dated 700 BCE to 100 CE. The fort has several ramparts, and is semi-circular with the sea cliff on the south side.

SUNDAY CLOSING ACT 1881 With the chapel building frenzy in the rapidly industrialising parts of Wales in the Industrial Revolution, Nonconformists saw the opportunity to get legislation passed to close pubs on Sunday, in 1881. Chapels were to be the centre of cultural activity, not taverns, and from this time we see the growth of Welsh choirs. This act was one of the very few pieces of legislation that only applied to Wales, and was in force until referenda across Wales from the early 1960's. During the 1980's the last 'dry' district, Dwyfor, had voted to at last allow restricted pub opening on Sundays.

SWANSEA, ABERTAWE The second largest city in Wales is called Abertawe in Welsh as it lies on the mouth of the River Tawe. Its docks were established in 1306 for shipbuilding, and developed rapidly in the eighteenth century. It had become an important port for limestone in the sixteenth century, being shipped out of south Wales for fertiliser. The Industrial Revolution saw an increase in coal exports and Swansea becoming a European centre for copper – smelting from the 1720's, and known as 'Copperopolis' by the nineteenth century (nearby Llanelli was known as 'Tinopolis'). The Swansea Valley was the most important copper-smelting area in the world. In the mid-nineteenth century, Swansea Docks became the biggest coal exporter in the world. The world's first passenger train ran from Swansea to Mumbles in 1907, but the rails were pulled up in 1960 by the city council. Much of the original docks have been redeveloped into a charming marina housing the National Waterfront Museum. This museum opened in 2006, and tells the story of how industry and innovation has affected Wales in the last 300 years. The city centre was badly damaged by German bombing in 1941. Swansea University was recently voted the 'most student-friendly' university in Britain. Swansea people are known as 'Jacks' probably because of the exploits of a dog that saved twenty-seven people from drowning in its docks.

SWANSEA CASTLE It was razed by the Welsh in 1217, and changed hands many times, being first attacked by the Welsh in 1116. Bishop Henry de Gower built a stone castle here in 1306, and it was badly damaged by Owain Glyndŵr in the fifteenth century. The castle was used by the Earl of Warwick as his seat of administration for the lordship of the Gower, and it was almost demolished by Parliamentarians in 1647.

SWEAR WORDS It is entirely in character with the nature of the people that no swear words seem to exist in the original language, today's being derivatives of English, with its rich repertoire of Anglo-Saxon expletives. Thus Welsh has to improvise. I curse any driver who threatens my survival a 'carrot' from the shelter of my car. The Welsh for carrot is 'moron'. Others mutter 'chick peas'. Chick peas in Welsh are 'ffa cyw'.

SYCHARTH CASTLE Outside Llangedwyn in Powys, this motte and bailey belonged to Glyndŵr and was razed by Prince Hal in 1403 along with Glyndŵr's other court at Glyndyfrdwy. Huge amounts of burnt materials were found in the 1960's excavations. The contemporary bard who lived near Owain, Iolo Goch, wrote the following lines about Sycharth:
Encircled by a bright moat
What a fine court! The lake bridged,
A gate for a hundred loads...

Every drink, white bread and wine,
Meat and fuel for his kitchen,
Peaceful haven, home to all...

TABLE TENNIS The unknown Roy Evans, OBE, died in 1998 at the age of eighty-eight. He and his wife played table tennis for Wales, but it was as the head of the International Table Tennis Federation that he was asked to fly to China. He inaugurated the first sporting links with Red China since the Second World War, facilitating Richard Nixon's 'ping-pong diplomacy' and the re-entry of China into world affairs.

TAFF'S WELL Just north of Cardiff, this is only a few yards from the River Taff (Taf), and was used for over 200 years to cure muscular rheumatism. The pale green water is almost identical chemically to that of Bath, and is a constant 67 degrees Fahrenheit. Unfortunately, at present it is closed off to the public. The well used to stand in open fields until a weir re-routed the river nearer to it, and it was used from Roman times until the nineteenth century.

TAFOLWERN CASTLE Built between the Afon Twymyn and the Afon Rhiw Saeson in Powys, it was probably built by Owain Cyfeiliog, when he was given the commote of Cyfeiliog by his uncle Madog ap Maredudd. In 1160, it was taken by Owain Gwynedd, but then captured by Hywel ap Ieuaf, Lord of Arwystli in 1162. Owain defeated Hywel at Llanidloes and rebuilt the castle, returning it in 1165 to Owain Cyfeiliog. However, because Owain Cyfeiliog sided with the Normans, the castle was next taken from him and held by Rhys ap Gruffydd. The Normans then helped Owain Cyfeiliog retake the castle. It was occupied by Owain ap Gwenwynwyn of Powys in the late twelfth century. His grandson Gruffydd was besieged there by a Welsh army in 1244 because of his support for Henry III. Like many Welsh castles, this is an overview of its troubled past. Castles in Wales have histories like few other castles in the world, and there is a far greater density of castles than any other nation, showing both the difficulty of conquering Wales and the determination to fight invasion.

TALIESIN - SIXTH CENTURY Regarded as the greatest of the Welsh bards, it seems Taliesin was the son of Henwg the Bard, St Henwg from Caerleon. St Henwg is said to have travelled to Rome to ask Constantine to send missionaries to Britain. Taliesin was educated at the bardic school of Cattwg (Cadoc) at Llanfeithyn near Llancarfan, and died at Bangor Teifi in Cardigan. A cairn near Aberystwyth may mark Taliesin's burial place. Legends about Taliesin ('Radiant Brow') run through Welsh history and mythology, in association with Arthur, Maelgwn and Bran the Blessed. Sometimes confused with Merlin, the tale of his magical birth was appended to the *Mabinogion* by Lady Guest. He is stated to be the author of the marvellous verse poem *Y Gododdin*. He prophesised Maelgwn Gwynedd's death from plague, and is famous for his prophecy on the future of the British nation:

Their Lord they shall praise,
Their language they shall keep,
Their land they shall lose –
Except wild Wales.

TALLEY ABBEY North of Llandeilo, Abaty Talyllychau was the only abbey in Wales founded by the Premonstratensians, the White Canons. They followed Cistercian ascetic practice, but involved themselves in undertaking duties in the parish. It was founded by The Lord Rhys around 1188, and supported by his descendants.

TALLEY, BATTLE OF, 1213 or 1214 Rhys Grug was defeated near Talley, and fell back to Llandeilo, firing the town and its castle to prevent it being of any use to the English. King John had sent forces to aid Rhys and Owain, the grandsons of The Lord Rhys.

TALLEY CASTLE This is a motte on an isthmus between two lakes, near the abbey.

TATHANA, SAINT (BRAUST) – SIXTH CENTURY Either she or her uncle Tathan, is the founder of Llandathan, Sain Tathan, anglicised to Saint Athan. According to Augusta F. Jenkins, Meurig ap Tewdrig died at Boverton, Arthur's birthplace, surrounded by his family. His daughter Anna (Arthur's sister) and her children Princess Braust (Tathana) and Saint Samson were there. The legend of St Tathana ends with her living in a cell at the mouth of the River Ddawen (Thaw), and recently the author has found the foundations of an unrecorded medieval church at this site, aligned east to west, 25ft by 15ft.

TECHNIQUEST This Science Discovery Centre, in Cardiff Bay, has 170 hands-on exhibits, looking over 'Europe's most exciting waterfront development'. It is the largest activity-based science centre in the UK, with 700,000 visitors a year.

TEILO, SAINT (d. 580) St Teilo was said to have been a cousin of Dewi Sant, born at Penally near Tenby, and a pupil of Dyfrig. He left his monastery at Llandeilo Fawr to escape the Yellow Plague in 547, and after seven years in Brittany returned to Llandaff, possibly succeeding Illtud. In 577, with his monks he accompanied Iddon ap Ynyr in a decisive battle against the Saxons on the banks of the River Wye. St Teilo's skull was kept by the Melchior family near Llandeilo, who up to the 1930's were offering pilgrims drinks of water from the relic to cure their ills. Teilo is the patron saint of horses and apple trees in Brittany, and there are many dedications to him.

TENBY The name is a corruption of Dinbych-y-Pysgod (little fort of the fish), and a small fort overlooks the harbour. It is surrounded by four excellent beaches, and some of the thirteenth-century town walls still stand, with medieval gatehouses. The most famous remaining gateway of this seaside resort is the Five Arches. The town was attacked in 1153, 1187 and in 1260 Llywelyn II burnt the town. In 1157, 'Maelgwn ap Rhys, the shield and bulwark of all Wales, ravaged the town of Tenby and burned it... them man who frequently slew Flemings and drove them to flight many a time.' AUGUSTUS JOHN and ROBERT RECORDE were born here.

TENBY CASTLE On a rocky headland with a narrow neck, most of the remaining masonry is thirteenth century, and it was captured by the Welsh in 1153. With the town, the castle was held by Parliament for most of the Civil War, and beat off two sieges by Gerard's Royalists. In 1648, the Royalists held it for ten weeks but were starved into surrender by Colonel Horton.

TENNIS In 1873, a court was established at Nantclwyd Hall, Llanelidan, and the game of Lawn Tennis first played anywhere in the world, invented by Major Walter Wingfield. He invented and patented nets for the new outdoor game he called 'sphairistike'. The game of tennis had only been previously played indoors.

TEULU This means 'family' and was the Welsh prince's band of mounted and armed retainers, acting as both his bodyguard and a cutting edge in battle. They fought in chain mail, and had a sword, shield and javelin, later replaced by a lance. These horsemen were known as 'uchelwyr' (high, or lofty men), often favouring red tunics. The normal size of the company was 120 men, but that of Llywelyn II was 160 men in 1282.

TEWDRIG (d. 470) King Tewdrig controlled much of southeast Wales, and fought with Constantine the Blessed against the invading Saxons. He is said to have founded the college of Cor Worgan, or Cor Eurgain, later to become famous as Llanilltud Fawr. (Cor Tewdus is marked on old maps of the town). After Constantine's death, Tewdrig allied with Vortigern to keep the peace, and passed on his kingdom to his son Meurig. Tewdrig retired to Tintern, where he was attacked by Saxons. A stone bridge in the nearby Angidy valley is called 'Pont y Saeson', 'Bridge

of the Saxons', and this may be where the fight took place. The enemy were driven off, but not before Tewdrig was mortally wounded. His son Meurig arrived and took his father on a cart to a well in Mathern. A plaque there reads 'By tradition at this spring King Tewdrig's wounds were washed after the battle near Tintern about 470AD against the pagan Saxons. He died a short way off and by his wishes a church was built over his grave' Mathern is the corruption of 'Merthyr Teyrn', 'the site of martyrdom of the sovereign'. In 822, Nennius described the well as one of 'the marvels of Britain', and also referred to the Well of Meurig. Pwllmeurig (Meurig's Pool) is a village there. Meurig was said to be Uther Pendragon ('Wonderful Head Dragon'), leader of the Celtic army), and was the father of Arthmael, the King Arthur of legend.

THEME PARKS The first theme park in Wales was Oakwood, on a site near Canaston Bridge in Pembrokeshire. It attracts almost half a million visitors a year, and has the largest wooden roller coaster in Europe, Megaphobia. It was voted 'best wooden roller coaster in the world' in 1997, and gives passengers a 2.75 G force on one 8oft drop. The 140ft Skycoaster is the largest in Britain, giving the brave an opportunity to free fall bungee-style from the equivalent of fourteen stories, at speeds up to 65mph. Rhyl's Sun Centre cost almost £5,000,000 in 1985, and has 6,400sq m enclosed by glass and a tinted PVC roof. The structure when built housed Europe's only indoor surfing pool, a monorail unique in the world and a 200ft (6om) waterslide. Near Oakwood, the new Bluestone Park has 186 holiday lodges centred around a 'Celtic Village'.

THIRTEEN SHIRES In 1282, Edward I completed his conquest of Wales. He divided it into thirteen shires or counties, and transferred one of these, Monmouthshire, to England. Monmouthshire was subsequently regarded as part of England for legal purposes, so many laws, such as those dealing with the sale of alcohol, covered 'Wales and Monmouthshire'. However it became regarded as part of Wales for other purposes. Part of Bicknor was an exclave of Monmouthshire within Herefordshire and known as Welsh Bicknor (Llangystennin Garth Brenni) The thirteen shires were: Anglesey, Brecknockshire, Carmarthenshire, Carnarvonshire, Cardiganshire, Denbighshire, Flint, Glamorganshire, Merionethshire, Montgomeryshire, Monmouthshire, Pembrokeshire and Radnorshire.

THIRTEEN TREASURES Myrddin, Merlin, procured these 'Thirteen Precious Curiosities of Britain' and sailed away with them in his glass boat, never to be seen again. In legend, he is buried with them on the Island of Enlli (Bardsey Island), off the remote tip of the Llŷn Peninsula.
1. 'Mwys Gwyddno' – 'the Hamper of Gwyddno Garanhir', which will turn meat for one person into meat for a hundred. Gwyddno was 'Dewrarth Wledig', king of the lost lands of Cantre'r Gwaelod, which lies under the waters of Cardigan Bay.
2. 'Cadair, neu car Morgan Mynafawr', 'the Chair or Car of Morgan Mynafawr', which will carry a person wherever he or she wishes to go.
3. 'Cyllel Llawfrodedd', 'the Knife of the Hand of Havoc', a druidical sacrificial knife.
4. 'Modrwy Eluned', 'the Ring of Eluned', which made the wearer invisible. Sometimes the 'Halter of Eluned' is added to the 13 treasures, to make one's mount invisible, and also a stone belonging to Eluned has been included in the past.
5. 'Tawlbwrdd' (Throwboard), a type of chess or backgammon board with men of silver on a surface of gold, who could play by themselves – the origin of computer chess? It was also referred to as the 'Gwyddbwyll board of Gwendolau'. Gwyddbwyll was an ancient Celtic board game (in Irish, 'Fidchell'), meaning 'wood sense'. The board was the world in miniature, and ritualistic combat games were played, possibly to resolve disputes and arguments without resorting to bloodshed. The Welsh Myrddin poems say that Gwendolau was Merlin's lord, who died at the Battle of Arfderydd against his cousins Peredur (Sir Perceval of Arthurian legend) and Gwrgi. A replica of this game predating the ninth century, and described in *The Laws of Hywel Dda*, is now on sale, and two players compete to capture or defend the King.

6. 'Llen Arthur', 'the Veil of Arthur', which made the wearer invisible – this is a later addition to the list.

7. 'Dyrnwyn', 'the Sword of Rhydderch Hael', which would burst into flames from the cross to the point, if anyone except Rhydderch drew it. Rhydderch appears to have been a Celtic King of Strathclyde, who fought against Myrddin's side in the Battle of Arfderydd. This battle, Arthuret, was fought in 575 for a 'lark's nest', possibly the important harbour at Caerlaverock near Dumfries, which translates as Fort Lark. At this battle, possibly because of the loss of his lord Gwendolau, Myrddin is said to have lost his reason after fighting and gaining a golden torc in the battle. Gwendolau's 'faithful company' fought on for six weeks after his death. Dyrnwyn may be the precursor of Excalibur.

8. 'Dysgyl a Gren Rhydderch', 'the Platter of Rhydderch', upon which any meat desired would appear. Sometimes a plate with the same properties that belonged to Rhygenydd is included in the treasures.

9. 'Corn Brangaled', 'the Horn of Brangaled', which could provide any drink a man desired. The Celts were great men for their drink.

10. 'Pais Padarn', 'the Cloak of Padarn Redcoat', which made the wearer invisible.

11. 'Pair Drynog', 'the Cauldron of Drynog', in which nothing but the meat of a brave man would boil.

12. 'Mantell', 'the Robe' that would always keep the wearer warm, which possibly had belonged to Tegau Eufron. The wife of Caradoc Freichfras, her other treasures of a cup and a carving knife are also both sometimes included in the list. This Caradoc 'Strongarm' possibly founded the Kingdom of Gwent in the sixth century, and was the ancestor of a dynasty of Welsh kings.

13. 'Hogalen Tudno', 'the Whetstone of St Tudno', which could only sharpen the weapon of a brave man. Tudno hailed from the lost kingdom of Cantre'r Gwaelod, and his father, Seithenyn, was named as the sluice-keeper who became so drunk that he forgot his duties and allowed the sea to take over the kingdom..

Other Welsh treasures are mentioned in *The Book of Taliesin*. Manawyddan and Pryderi (characters in *The Mabinogion*) are joint rulers of Annwn (Hades), warders of a 'magic cauldron' of inspiration which the gods of light attempt to capture, and which became famous later as 'The Holy Grail'.

After the death of Pwyll, Prince of Dyfed, with his court at Narberth, his widow Rhiannon married Manawyddan, and 'The Three Birds of Rhiannon' were another treasure which could sing the dead to life, and the living into the sleep of death. Their rarity is shown in one of the ancient Triads:

There are three things which are not often heard:
The Song of the birds of Rhiannon,
A song of wisdom from the mouth of a Saxon, and
An invitation to a feast from a miser.

THOMAS, DYLAN MARLAIS (1914-1953) Dylan Thomas is Wales' most well-known literary figure, and Idris Davies' short 1946 poem on Thomas is the best expression of his gifts:

He saw the sun play ball in Swansea Bay,
He heard the moon crack jokes above the new-mown hay,
And stars and trees and winds to him would sing and say:
Carve words like jewels for a summer's day.

He is the Welsh poet in essence, throwing words around like confetti, unlike the more restrained (and Christian) R. S. Thomas. Dylan's famous radio play *Under Milk Wood*, was later filmed in Lower Fishguard with Elizabeth Taylor and Richard Burton. The boathouse near Laugharne Castle, where he wrote much of his work, is open to the public. Buried at

Laugharne in a simple grave, many visitors go to Browns Hotel there, where Dylan used to become famously drunk. He died, allegedly of alcoholic poisoning, on a reading tour of the United States, possibly burnt out as a poet. 1997 evidence points out to malpractice by an American doctor, not treating Dylan for a diabetic coma, as the cause of his death. Probably strongly influenced by Gerard Manley Hopkins, his writings are strongly emotive. The free-form thought processes, refined by dozens of rewrites, have given us poetry that will last forever. Dylan throws thoughts, ideas and words into a magical blender. His *Do Not Go Gentle Into That Good Night* was recently voted the second most popular poem written in English – he asked his dying father to 'rage, rage against the dying of the light', as 'old age should burn and rave at close of day.' In his short life, he kick-started Welsh poetry into word-plays never seen before in the English language. We see in the first lines from *Under Milk Wood:*

It is spring, moonless night in the small town, starless and bible-black, the cobblestreets silent and the hunched, courters'-and-rabbits' wood limping invisible down to the sloe-black, slow, black, crowblack, fishing-boat bobbing sea.

And in his poetry:

The force that through the green fuse drives the flower
Drives my green age; that blasts the roots of trees
Is my destroyer.
And am I dumb to tell the crooked rose
My youth is bent by the same wintry fever.

and:

It was my thirtieth year to heaven,
Woke to my hearing from harbour and neighbour wood
And the mussel pooled and the heron
Priested shore.

THOMAS, EDWARD (1878-1917) A superb poet, he was one of the few Welshmen in history to disdain the English – his book *Wales*, published in 1905, has been in print ever since. His tragic death in the First World War in 1917 robbed Europe of a major poet. A line of his that always is remembered, from *Early One Morning*, is 'The past is the only dead thing that smells sweet.' Leavis called him 'an original poet of rare quality.'

THOMAS, HUGH OWEN (1833-1891) He pioneered orthopaedic surgery across the world, and his 'Thomas Splints' are still used for hip and knee illnesses. Thomas was descended from a long line of famous 'bone-setters' from Anglesey, supposedly descended from a survivor of a shipwreck of the Spanish Armada in 1588. Other sources say that it was a shipwreck in 1745 at the Skerries or West Mouse Island when a young Spaniard struggled to the shoreline. Dyfrig Roberts, a descendant, believes that twins speaking a 'strange tongue' struggled ashore during the Jacobite rebellion, and that they could have been Scottish, Manx or Spanish. One of them was skilful in dealing with bone injuries, and set himself up in Liverpool as a sort of 'quack doctor'. However, all five of his sons qualified as real doctors. The sole shipwreck survivor called himself Evan Thomas, and specialised in settling dislocated bones, passing his skills on to his children. There is a memorial in Llanfair PG to him. Four generations later the 'Thomas Splint' cut fatalities from broken femurs from 80% to 20%, and the splint is now mainly used for children with femur fractures.

THOMAS, R.S. (1913-2000) Ronald Stuart Thomas of Cardiff was a poet-priest, nominated for the 1996 Nobel Prize for Literature. 'RS' became an Anglican priest in 1936, retiring in 1978 to the Llŷn Peninsula. With visions of bleakness and beauty, his work represents the uncompromising conscience of a Wales, under ceaseless alien attack, and tries to work out a difficult relationship with God. R.S. Thomas was fond of calling the Welsh 'sullen' in his inspiring poetry, reflecting that history has made the Welsh wary, with a suppressed national psyche. The 'saeson' (Saxons, i.e. Englishmen) have come with a different language ('saesneg') and more weapons and manpower, steal land, take all the wealth – iron, coal, gold, copper, even water – and own what little is left. This is the underlying motif of his work, forcing to ask if a beneficent God can exist. His poem *Reservoirs* sums up his disgust with abandoned communities {'smashed faces of farms'}, with the alien conifers of the Forestry Commission ('gardens gone under the scum of forests'), with tourist 'strangers' to whom these reservoirs have 'the watercolour's appeal to the mass'. He became, over time, a committed Welsh Nationalist. RS displays a scorn for those complicitous in the loss of language, and the turning of Wales into some quaint theme parks for the richer, more sophisticated English...

> Where can I go, then, from the smell
> Of decay, from the putrefying of a dead
> Nation? I have walked the shore
> For an hour and seen the English
> Scavenging among the remains
> Of our culture, covering the sand
> Like the tide and, with the roughness
> Of the tide, elbowing our language
> Into the grave that we have dug for it.

Ted Hughes has described R. S. Thomas' poetry – it 'pierces the heart', and Thomas' indignation at the way history has treated the Welsh demonstrates this...

> ...an impotent people,
> Sick with inbreeding,
> Worrying the carcass of an old song.

THOMAS, SIDNEY GILCHRIST (1850-1885) Bessemer revolutionised steel-making with his 'process' of using a converter to make bulk steel in 1856. However, he did not realise that it could not be used for iron ores that included phosphorous. He had used pig-iron from Blaenafon, which was phosphorous-free. Phosphorous made steel very brittle, and was present in over 90% of European iron ores, and around 98% of American ore. From 1877-1888 the cousins Percy Carlyle Gilchrist and his cousin Sidney Gilchrist Thomas found out how to remove the phosphorous, and Sidney Thomas died just seven years later, probably as a result of his experiments, and the age of thirty-five. Percy Gilchrist died in 1935, having sold the patents to Andrew Carnegie, who then opened up American steel production. An obelisk in Blaenafon commemorates the cousins for the 'invention (which) pioneered the basic Bessemer or Thomas process'. In 1890, Britain was the world's greatest steel producer, but by 1902 this great invention had allowed Carnegie in America, and Krupp of Essen to propel the USA and Germany into the first two places in steel production. Everyone has heard of the Scot Andrew Carnegie and his philanthropy, but no one knows the Welshmen and the 'Thomas Process'. At least Carnegie had the grace to admit that the 'Carnegie Process' was not his – 'These two men, Thomas and Gilchrist of Blaenavon, did more for Britain's greatness than all the kings and queens put together. Moses struck rock and brought forth water. They struck the useless phosphoric ore and transformed it into steel, a far greater miracle.' In effect, they were the men who created the modern steel industry. Unfortunately, their discovery created the gigantic German steel

industry, which had surpassed the output of Britain by 1895 and played a persuasive part in predisposing Germany to an aggressive war. Perhaps aware that his fortune was due to the work of two Welshmen, rather than any skill on his part, Carnegie gave away nearly all his millions to charities and good works.

THOMPSON, DAVID (1770-1857) Following on the work of John Evans, this Welshman (born in London of Welsh parents, whose family name was Tomos) was the first man to map the Upper Missouri and Upper Mississippi. He is honoured in Canada, being known as 'the greatest land geographer who ever lived', mapping one-fifth of the Continent, almost 4,000,000 sq miles of wilderness.

THORN ISLAND Thorn Island off Dale has a fort that used to hold a garrison of 100 men. The buildings were converted into a ten-bedroom hotel. Nearby Sheep Island has an Iron Age fort.

TIDES Most of the world's coastlines experience a tide of less than 10ft but at Newport the River Usk has seen a high tide of 44ft and a low tide of minus 2ft, on 30 March 2006. This total fall of 46ft is the largest recorded tidal range for a city anywhere in the world. Apart from The Bay of Fundy in Nova Scotia, the Severn Channel experiences the greatest difference between high and low tides in the world. Chepstow in Gwent had a difference in tidal range of over 50ft in 1883, and Barry and Cardiff Docks have regular ranges of around 40ft. This allowed the development of great expanses of mud flats to assist waders and other wildlife. The loss of the Cardiff mud flats when the Barrage was built meant a loss of such wildlife, and the plan for a Barrage across the Bristol Channel would mean an incredible loss of habitat on its dammed eastern side. On its western side, there could be also be higher water levels sporadically, again leading to environmental problems.

TIGER BAY Cardiff's Bute Street and James Street used to be famous worldwide for pubs such as the Bucket of Blood, The House of Blazes, prostitutes and jazz. Many of the great old pubs of 'Tiger Bay', known all over the world amongst seamen, have disappeared, for example The Glendower, the Thatched House, The German Harp, the London Porter House, The Antelope, the Customs House, The Glastonbury Arms, the Cape Horn, The Quebec (which was brilliant for jazz), The Fishguard, The Salutation and The Friendship Ale House. The Grade II 'Big Windsor' down Cardiff Docks just survived and has been renovated as an Indian restaurant. It offered superb French food after the War, but also had a public bar known as the 'snakepit'. Towards the city from Tiger Bay, the Golden Cross has wonderful ornamental tiles, and is probably the most attractive pub in Cardiff internally. The late Ronnie Bird used to keep it. He was a Cardiff 'institution'as a footballer, playing for years on the wing ('Bird on the wing') for Cardiff City.

TIN Cydweli (Kidwelly) Industrial Museum is based at the site of the 1737 tinworks, which was one of Britain's largest, with huge rolling mills, steam engines and sorting and boxing rooms. Nearby is the superb twelfth-century Cydweli Castle, a well-preserved concentric gem. Nearby Llanelli also concentrated on tin, and was nicknamed 'Tinopolis' in the nineteenth century. At this time Swansea had the largest nickel works in the world. From 1730, tinplate was manufactured in Pontypool, breaking the previous German monopoly, and for many years Pontypool 'japanned ware' (such as teapots and serving trays) was famous, being very collectable today. The first American ironworks, at Sagus River in Massachusetts, used Pontypool equipment.

TINTERN ABBEY Just north of Chepstow, and a favourite spot of Wordsworth, this graceful Cistercian abbey was the second in Britain to be founded, in 1131. It was endowed by the Lords

of Chepstow, and the main buildings were completed by 1301. Like nearly all the other abbeys in Britain, it was vandalised in the Dissolution of 1535, its roof stripped, windows smashed and estates confiscated.

TITHE WARS This campaign, to disestablish the church in Wales, was started because Anglicans in Wales had legal privileges over Nonconformists. Violence had broken out with Welsh chapelgoers refusing to pay tithes to the Anglican Church. The tithe was a traditional payment of a tenth of a person's income to the church, but most Welsh people went to chapel. Some of the worst cases of violence were known as the 'tithe wars' e.g. in Denbighshire from 1886-90 when farm labourers were involved in running battles with the police, and a troop of lancers protecting the tithe collectors. The secretary of the Caernarfon branch of the Anti-Tithe League was the young David Lloyd George.

TOLKIEN, J.R.R. (1892-1973) In his 1955 essay *English and Welsh*, commenting on his affection towards the Welsh language, Tolkien recalls how he once saw the words 'Adeiladwyd 1887' (It was built 1887) cut on a stone-slab. It was a revelation of beauty – 'It pierced my linguistic heart.' Welsh was full of such wonderful words, and Tolkien found it difficult to communicate to others what really was so great about them, but in his essay he makes an attempt: 'Most English-speaking people... will admit that cellar door is "beautiful", especially if dissociated from its sense (and from its spelling). More beautiful than, say, sky, and far more beautiful than beautiful. Well then, in Welsh for me cellar doors are extraordinarily frequent, and moving to the higher dimension, the words in which there is pleasure in the contemplation of the association of form and sense are abundant.' He then lists concrete examples like Welsh wybren being 'more pleasing' than English sky. Later, in 1965, Tolkien commented 'Welsh has always attracted me, in sight and sound more than any other, even since the first time I saw it on coal trucks, I always wanted to know what it was about.' For those who see no purpose in the Welsh language or bilingual (i.e. original) road signs, Tolkien used Welsh language structures in his books and was a Professor of Anglo-Saxon and English. He wrote 'If I may refer to my work *The Lord of the Rings* in evidence: the names of persons and places in this story were mainly modelled on those of Welsh (closely similar but not identical) – this element in the tale has given perhaps more pleasure to more readers than anything else in it.'

TOMEN CASTLE Near Dolwyddelan Castle, seemingly its precursor, it was thought to be the birthplace of Llywelyn the Great.

TOMEN-Y-FAERDRE CASTLE Beautifully sited at Llanarmon-yn-Iâl, it is possibly the finest of all Welsh-built earthwork castles.

TOMEN Y MUR ROMAN SITE & CASTLE Near Maentwrog in Gwynedd, the motte was built in the middle of a Roman fort, on the military road between Pennal and Caerhun. There was an amphitheatre, parade ground and bathhouse, and it was occupied after the Romans left. William Rufus built the motte, but he was chased out of Wales by Gruffydd ap Cynan. The *Mabinogion* legend of Lleu, his wife Blodeuwedd and her attempt to murder him was based at Mur Castle.

TOMEN Y RHODWYDD CASTLE Built by Owain Gwynedd near Llandegla in Denbighshire in 1149, to complement his capture of this part of Powys, it is a motte and bailey protecting the Horseshoe and Nant y Garth Passes. It was retaken by Iorwerth Goch ap Maredudd of Powys in 1157 and burnt, but restored by King John in his 1212 invasion. It was one of the last earth and timber castles, with future castles nearly always being built of stone.

TONYPANDY RIOT 1910 The Naval Colliery Company opened a new seam at the Ely Pit

in Penygraig, which was more difficult to work. As miners were paid by the ton mined, not the hours worked, they protested and were locked out of the pit. A strike followed, replacement workers were sent in and the miners picketed, causing riots. Upon 8 November 1910, more than sixty shops in the Rhondda were attacked by miners and one collier, Samuel Rays was killed by police. Colonel Lindsay, Chief Constable of Glamorgan, asked the Home Secretary, Winston Churchill to send troops to restore order. Churchill sent mounted police and London policemen, and then he sent the army, but the fortunately troops were not deployed. The friendship between army officers and pit owners was noted in these days of repression. *The Times* recorded that there was in the Rhondda 'the same oppressive atmosphere that one experienced in the streets of Odessa and Sebastopol during the unrest in Russia in the winter of 1904. It is extraordinary to find it here in the British Isles.' Thirteen miners were tried for 'intimidating a colliery official' but none was imprisoned for more than a few weeks, and matters returned to what passed for normality in these unsettling times. Churchill's sending troops to the Valleys in the twentieth century is yet another forgotten episode in British history.

TOURISM Tourism now accounts for more than 7% of Wales Gross Domestic Product, compared to 5% of GDP for the UK in general. Unfortunately this is mainly less affluent tourism than the rest of the UK, as only 3.3% of overseas visitors to the UK come to Wales. The majority of these are passing through on their way through to Ireland. Spending in Wales accounts for only 1.9% of overseas tourist spending in Great Britain. Tourism is the only industry left in Wales, and needs to be better supported. Unfortunately, efficency and effectiveness are difficult to harness in the public sector. According to RICHARD BOOTH, King of Hay-on-Wye, this author has done more for Welsh tourism than the Wales Tourist Board, which seems to prefer ultra-expensive glossy advertising over intelligent and inexpensive public relations exercises. This author's musing about the possibility of Elvis being Welsh was broadcast all over the world, and was in the press from Japan to Australia.

TRAHERNE, THOMAS (1636-1674) His writings have been recently compared in America, with those of the European philosopher-critics Martin Heidegger, Jacques Derrida and Jacques Lacan. A devout man, his *Roman Forgeries* exposed the falsifying of ecclesiastical documents by the Church of Rome in the ninth century. *His Centuries of Meditations* includes the following lines: 'You never enjoy the world alright, till the sea itself floweth in your veins, till you are clothed with the heavens, and crowned with the stars: and perceive yourself to be the sole heir of the whole world, and more than so, because men are in it who are every one sole heirs as well as you. Till you can sing and rejoice and delight in God, as misers do in gold, and kings in sceptres, you never enjoy the world.' In *Meditations,* Traherne was the first British writer to depict the experience of childhood. His writings were not discovered until 1903, and *Centuries of Meditations, Poems, Poems of Felicity* and his prose work all anticipate the work of William Blake. *Centuries of Meditations* was called by C.S. Lewis 'almost the most beautiful book in English'.

TREACHERY The defining moment that rings through Welsh poetry from the earliest times was the 'Treachery of the Long Knives', where the flower of Celtic nobility was slaughtered at a feast by the Saxon invaders. The next 1,000 years showed the Welsh distrust of Saxon, Norman and Plantagenet motives towards Welsh people and lands. The truth of the matter may never be known, but most Welshmen believe that Llywelyn ap Gruffydd), 'our last prince', was killed through a Norman trap, just outside Builth Wells. The Norman Marcher Lords had a huge history of torture, lies and savagery – they were notoriously without any of the refinements of education or literature. The Norman Hugh the Fat, Earl of Chester, asked Meirion Goch to bring Gruffydd ap Cynan, Prince of Gwynedd, to arrange peace in 1082. Hugh the Fat then clapped Gruffydd in chains, until Gruffydd managed to escape, twelve long years later. The last native King of Glamorgan, Iestyn ap Gwrgant, lived at Llanilltud Fawr. He was in conflict with

Rhys ap Tewdwr, who was encroaching on his lands from the west, so in 1091 he asked Robert Fitzhamon to bring Norman mercenaries from England to help retain his lands. The battle won, the Normans returned to England and Iestyn sent his warriors back to their fields. However, the Normans turned their boats around on that same night and seized the castles along the coast of the fertile Vale of Glamorgan. Iestyn fled to Bristol, and Fitzhamon wrote to William Rufus saying that his conquest of South Wales had been successful. This new and duplicitous Lord of Glamorgan took Boverton, Llanilltud Fawr, Cowbridge, Dinas Powys and Cardiff, and shared the rest of Glamorgan among his Norman retainers.

The Normans did anything to get hold of Welsh lands. Hugh Mortimer blinded Rhys ap Hywel in 1148, to take over his territories around Bridgnorth. Blinding was a common Norman practice – King Henry II personally took out the eyes of his child hostages, the two sons each of Owain Gwynedd and The Lord Rhys. In 1175, William de Braose, the Norman Lord of Brecon and Abergavenny, held vast tracts of land which he had conquered in south-east Wales. Seisyllt ap Dyfnwal, Lord of Upper Gwent, held the manor of Penpergwm and Castle Arnold, for William de Braose as his feudal overlord. De Braose invited Seisyllt and another seventy local Welsh lords to Abergafenni castle for a feast, and to hear a royal declaration. Hidden outside the banqueting hall were soldiers under the command of Ranulph Poer, Sheriff of Hereford. Seated during the feast, the Welsh nobles were massacred by Norman troops. Only Iorwerth ab Owain escaped, snatching a sword and fighting his way out of the castle. The antiquary Camden noted that Abergafenni 'has been oftner stain'd with the infamy of treachery than any other castle in Wales'. William de Braose then raced to Castle Arnold, seized Seisyllt's wife Gwladys, and murdered Seisyllt's only son, Cadwaladr, before her eyes. *The Chronicle of Ystrad Fflur* records the events: 'Seisyll ap Dyfnwal was slain through treachery in the castle at Abergafenni by the Lord Of Brycheiniog. And along with him, Geoffrey his son, and the best men of Gwent were slain. And the French made for Seisyll's court; and after seizing Gwladus, his wife, they slew Cadwaladr, his son. And from that day there befell a pitiful massacre in Gwent. And from that time forth, after that treachery, none of the Welsh dared place trust in the French.' Norman law stated that conquest of Welsh territories by any means whatsoever was fair. In 1182, Seisyllt's kinfolk managed to scale the high walls of Abergafenni and took the castle, but unfortunately de Braose was absent. Seisyllt ap Eudaf had told the Constable of the castle that the Welsh would attack the castle at a certain angle, in the evening. The Normans waited all night for the attack, and were all asleep at dawn, whereupon the Welsh threw up their scaling ladders in the area that Seisyllt had said, took the castle and burnt it to the ground.

Ranulph Poer and de Braose marched to Dingestow (Llandingat) near Monmouth to begin building another castle. The Welsh attacked and Poer was killed in 1182 with many of his knights. De Braose only just escaped with his life. This battle is known from the descriptions of the capacity of the bowmen of Gwent. Arrows could penetrate a width of four fingers of oak. One arrow passed through a Norman's armour plate on his thigh, through his leg, through more armour and his saddle, killing his horse. Another Norman was pinned through armour plating around his hip, to his saddle. He wheeled his horse, trying to escape, and another arrow pinned him to the saddle through the other hip. Like his king, the Norman Marcher Lord de Braose was notable for blinding and torturing any Welshman he could lay his hands on. In 1197 he pulled Trahaearn Fychan through the streets of Brecon behind a horse, until he was flayed alive. Maud de Valerie, de Braose's huge wife, also enjoyed seeing prisoners tortured. With the death of The Lord Rhys, de Braose pushed even more into Welsh territories. However, he fell out of King John's favour, and escaped to France in 1204, leaving his wife and eldest son behind. John took them to Corfe Castle and locked them up with just a piece of raw bacon and a sheaf of wheat – this was this Angevin king's favourite form of execution. After eleven days they were found dead. King John even murdered his nephew Arthur, the son of Geoffrey of Boulogne. De Braose was known to the Welsh as 'the Ogre', and all the great lords brutalised the Welsh – the Laceys, Carews, Corbets, Cliffords, Mortimers, Despensers, Baskervilles and Turbervilles were all vicious, murdering brutes. It was said of Robert of Rhuddlan that he spent fifteen years doing nothing but trying to take

Welsh lands and kill its rightful owners – 'Some he slaughtered mercilessly on the spot like cattle, others he kept for years in fetters, or forced into harsh and unlawful slavery.' The Normans and Angevins left a legacy in Wales of cheating, torturing, raping and stealing that is hardly recorded in British history. The Marcher Earl Warrenne murdered the two eldest sons of Gruffydd ap Madog when he died, to take the lordship of the eldest. This was Glyndyfrdwy, the seventeen-mile long valley of the river Dee, taking in Llangollen, Llandysilio, Llansantffraid and Corwen. However, for some reason he granted this land in 1282 back to Gruffydd Fychan, the third brother. Eventually, Gruffydd's great grandson took over the Lordship, Owain Glyndŵr. In 1318, the last true Lord of Glamorgan, Llywelyn Bren, was ritually tortured to death on the orders of Hugh Despenser, as he said that it was on King Edward II's orders. This was a lie, and Despenser was later executed in the same manner. 1378 saw an entry in the English King's Rolls of the Exchequer, noting the payment to John Lamb for assassinating the last heir to the House of Gwynedd. That fabulous hero Owain Llawgoch was not even safe in France from Edward III's reach.

Gruffydd Vaughan, of Garth in Montgomery, distinguished himself fighting for Henry V, and was knighted on the field of Agincourt for his bravery. He captured the renowned warrior Sir John Oldcastle, the enemy of the Lord of Powys, Harry Grey, and delivered him to Grey at Montgomery Castle. A poem by Dafydd Llwyd describes how Grey next lured Gruffydd, under a lure of safe conduct, into the castle. There he was murdered, for Grey wanted his neighbouring lands. Earlier, in 1400 another Grey, Reginald of Ruthin, tried to capture Glyndŵr by offering him a meeting in 1400 to discuss grievances, but Glyndŵr was warned at the last moment.

TREACHERY OF THE LONG KNIVES It is said that on May Day, the Britons came to Stonehenge or Old Sarum in Wiltshire to meet the Saxon leader Hengist from Kent, to ratify the existing peace, to grant land to the Saxons, and to restore Vortigern (Gwrtheyrn) to power in 472 CE. According to the *Chronicles*, the British were unarmed at a great feast, and the Saxons had concealed knives or daggers ('seaxas'). Hengist shouted 'Nemet oure seaxas', then the Saxons rose up and slew the seated Britons. This 'Plot of the Long Knives' ('Twyll y Cyllyll Hirion') is referred to as the second of the 'three treacherous meetings of Britain'… 'the second was that of the Mount of Caer Caradawg, where the treason of the long knives took place, through the treachery of Gwrtheyrn (Vortigern); that is to say, through his counsel, in league with the Saxons, the nobility of the Cymry were nearly all slain there'. The period of mourning for this terrible event for hundreds of years after was at the annual kindling of the Omen Fires (Coelcerthi) on the last night of October, All Saints Eve. The bard Cuhelyn ap Caw wrote about the event as early as the sixth century, as did the obscure Ymarwar Lludd Mawr 'I know when the battle was caused over the wine feast'. Golyddan's seventh-century *Destiny of Britain* scorns the feeble Vortigern and his dealings with the invading Saxons, before and after the massacre. According to the *Brut Tysilio*, in these times 'a shriek was heard over every hearth in Britain on the night of every May Day, and so struck every man and beast to the heart, that the men lost their strength, the women miscarried, the youth of either sex became senseless, and the beasts and trees unproductive'. The event was allegorised when Llefelys told his brother Lludd ap Beli that 'the shrieks arise from a contest between the dragon of Britain, and the dragon of a foreign nation which on the night of May-Day endeavours to conquer her, and the shriek you hear is given by your dragon in her rage and distress.' He then told Lludd to bury the dragons deep in the earth, so no calamity should befall Britain. These underground dragons resurface in the legends of Merlin and the red dragon of Wales.

TREATY OF FRANCO-WELSH ALLIANCE, 1404 In Spring 1404, Owain Glyndŵr held a formal ceremony where he was proclaimed Prince of Wales, in the presence of ambassadors from France, Spain, and Scotland. Next, Glyndŵr convened a Parliament of Wales in Machynlleth, drawing upon legal precedents set by the great Welsh lawgiver-king Hywel Dda in the tenth century. With a functioning Welsh government, he now sent his brother-in-law John Hamner and his chancellor Gruffydd Yonge to Paris to conclude a formal alliance with Charles VI of

France. The war faction under the Duke of Orleans had gained full control of French policies when the Welsh ambassadors arrived, and the Duke was eager to adopt the Welsh as allies, in the French attempt to resolve the '100 Years War' with England. Louis of Valois, Duke of Orleans, was the younger brother of the mentally unstable Charles VI and had become de facto King. The alliance was quickly concluded, with the French pledging to support Owain with military aid. The treaty was signed by Yonge, Hanmer, the Comte de Vendôme, the Chancellor of France, and by the bishops of Arras, Meaux and Noyon. Charles VI even proclaimed his affinity for the Welsh, by announcing that henceforth his favorite royal dish would be 'toasted cheese', and sent gifts and armour for his ally the Prince of Wales. Unfortunately the Duke of Orleans was brutally assassinated by the men of the Duke of Burgundy in 1407. French policy altered as Burgundy tried to take over France, leaving Wales to fend for itself once more. The French ships and troops now helping Glyndŵr were recalled. Basically, the Welsh nation is still allied with France against England. This has led to the bizarre situation of this author drinking in a bar in Brittany supporting France against England at rugby. The local Bretons were supporting the English against the French, as the French had taken Breton independence and tried to exterminate their language. Under De Gaulle, it was an imprisonable offence to give one's child a Breton name, and the teaching of Breton was forbidden.

TRECASTLE MOTTE & BAILEY Well preserved, it was built around 1095, probably by Bernard de Neumarch, but fell to the Welsh in the 1120's.

TREDEGAR HOUSE On the outskirts of Newport, this fine seventeenth-century brick mansion on a fifteenth-century core is the ancestral home of the Morgans, who lived here from the fifteenth century to 1951. The house and grounds are open to the public.

TREFRIW WELL Near Conwy in Gwynedd, Romans tunnelled into a mountain to find mineral-rich waters bubbling up from a fissure in the rocks. The original Roman cave, and the eighteenth-century stone bathhouse with slate bath can be visited, and the Victorians laid on steamboats from Conwy to take patients to the spa's pump room. The Victorian boom died away, but one can still buy the water in liquid or dried form. The sachets of the iron-rich waters are sold across the world, known as Spatone Iron +. It is the only known iron spa in the world and each sachet provides a person's daily iron requirements, without the negative side effects of iron tablets. (Up to 20% of women have iron deficiency, and around 50% of pregnant women suffer). The Church of St Mary at Trefriw was founded by Llywelyn the Great, and Trefriw Woollen Mill still demonstrates the traditional methods of making Welsh woollens.

TRELLECH CASTLE This is also known as Tump Terrett Castle, and is still 20ft high. A Norman town was planted by the de Clares next to the castle.

TRELLECH LOST CITY This is claimed to have been once Wales's largest urban centre, and is presently being excavated. A manor house with two halls and a courtyard, enclosed with curtain walls and a massive round tower twenty feet across have been discovered. The buildings discovered seem to date from 1300, when the town was reorganised and built in stone, after the attacks by both English and Welsh forces in the previous decade. In 1288 the population of Trellech was larger than that of Chepstow or Cardiff.

TRELLECH STANDING STONES These large Bronze Age monoliths of 'pudding stone' are south of the village. They may have been aligned with the winter solstice on the Skirrid Mountain, the 'Holy Mountain of Gwent'. A fourth stone, on nearby common land, was destroyed in the eighteenth century. The 'Virtuous Well', or St Anne's Well, is east of the village and possessed curative properties. The medieval St Nicholas' Church in Trellech was endowed by Kings Ffernwael ap Ithel and Meurig ap Tewdrig in the sixth century. The church has a

remarkable 1689 sundial showing the Virtuous Well, Harold's Stones and Trellech motte.

TRE'R CEIRI HILLFORT This spectacular hill fort, translated as Town of the Giants, is near Nefyn and possibly the finest in north Wales. It covers one of the peaks of The Rivals (Yr Eifl) near Nefyn. The remains of 150 stone huts can be seen, and the surrounding stone ramparts still stand up to 10ft high in places. It is the largest such site in northwest Europe.

TRETOWER CASTLE An early motte and bailey had a stone keep added in the mid-twelfth century, further fortified in the thirteenth century.

TRETOWER COURT A remarkable survivor of a late medieval defended house, open to the public, it was the successor to the nearby castle from the fourteenth century. It was developed up until the seventeenth century, around a central courtyard. It belonged to the Herberts and then the Vaughans.

TRIADS *Trioedd Ynys Prydein*, the *Triads of the Isles of Britain*, stem from the 'Age of Saints' in the fifth and sixth centuries onwards. They were mnemonics, aids to memory, for the bards to recollect long stories. There are many different versions of the hundreds that have passed down to us. Some are contained in the *Peniarth Manuscript*, some in the *Llyfr Coch Hergest (The Red Book of Hergest)*, some in the *Llyfr Du Caerfyrddin (the Black Book of Carmarthen)* and also in the *Llyfr Gwyn Rhyderch (the White Book of Rhydderch)*. The *White Book* was collated in the early 1300's. Some are recounted below:

The three principal cities of Ynsy Prydain, the Isle of Britain:
Caer Llion upon Wysg in Cymru (Caerleon upon Usk in Cambria);
Caer Llundain in Loegr (London in Loegria, England);
Caer Evrawg in Deifr and Brynaich (York in Deira and Bernicia).
 The three tribal thrones of the Island of Britain:
Arthur as Chief Prince in Mynyw, and Dewi as Chief Bishop, and Maelgwn Gwynedd as Chief Elder;
Arthur as Chief Prince in Celliwig, and Bishop Bedwini as Chief Bishop, and Caradwg Strong-Arm as Chief Elder;
Arthur as Chief Prince in Pen Rhionydd in the North, and Gerthmwl Wledig as Chief Elder, and Cyndeyrn Garthwys as Chief Bishop.
 The three oppressions that came to this island, and not one of them went back:
One of them was the people of the Coraniaid who came here in the time of Caswallawn son of Belli, and not one of them went back, and they came from Arabia;
The second oppression: the Gwyddyl Ffichti(Goidelic Picts), and not one of them went back;
The third oppression: the Saxons, with Horsa and Hengist as their leaders.
 Arthur's three great queens:
Gwenhwyfar daughter of (Cywryd) Gwent;
And Gwenhwyfar daughter of Gwythyr son of Greidiawl,
And Gwenhwyfar daughter of Gogfran the Giant.

TRYWERIN The drowning of Welsh valleys to supply water to England caused a major dispute when Llyn Celyn Reservoir was built, along the Trywerin River. In 1965 the valley of Cwm Celyn, and the village and chapel of Capel Celyn, were destroyed. A simple slate memorial was erected in 1971 commemorating those resting in the graveyard. Wales has plenty of water, but most of it is pumped out to England. The cost of this water in England is cheaper than charged in Wales. Faded graffiti, 'Cofiwch Drywerin' ('Remember Trywerin') can still be seen in parts of Wales. In the Valley of Trywerin, the Welsh-speaking community of Capel Celyn was drowned to satisfy

the water needs of Liverpool. This was despite the fact that water from a valley of a tributary of the Trywerin could have been taken without destroying any homes. A plaque near Trywerin reservoir car park reads: 'Under these waters and near this stone stood Hafod Fadog, a farmstead where in the seventeenth and eighteenth centuries Quakers met for worship. On the hillside above the house was a space encircled by a low stone wall, where larger meetings were held, and beyond the house was a small burial ground. From this valley came many of the early Quakers who emigrated to Pennsylvania, driven from their homes by persecution to seek freedom of worship in the New World'. All the people of the doomed village marched through Liverpool, and only one Welsh MP voted for the Bill in the House of Commons, but Parliament voted by 175 votes to 79 in 1957 to kill the community. (Some MP's abstained from voting, putting their party above their country). Wales has never had an equivalent voice in the Parliamentary affairs of England. Five-hundred members of Plaid Cymru, led by Gwynfor Evans, badly disrupted the reservoir opening ceremony in 1965, but Capel Celyn is still rotting beneath the waters. The irony is that Liverpool's industrial needs have declined so much, that this reservoir need never have been built. It would be a wonderful memorial if it was drained and the land made into a country park.

TSUNAMI There was a high tide in the Bristol Channel on 20 January 1607, and that morning there had been an earth tremor. The sky was blue when serious floods killed between 500 and 2000 people in the low-lying Glamorgan and Monmouthshire coastal areas. Several churches have markings where the tide reached. There is some dispute whether it was a tsunami or a combination of an exceptionally high tide, gale force winds and low air pressures causing a major storm surge. As the sea level has risen by more than a metre since this time, it is estimated that any such recurrence would cost in the region of £15 billion.

TUDOR, HENRY – HARRI TUDUR – HENRY VII OF ENGLAND AND WALES
(1457-1509) The Welsh supported the Lancastrian cause in the Wars of the Roses, and many died in the slaughter at Mortimer's Cross in 1461. One of the Welsh captains, Owain Tudur (Owen Tudor), was captured and beheaded by the Yorkists, and his head was placed on the steps of Hereford Cathedral. Here 'a mad woman combed his hair and washed away the blood from his face, and got candles and set them round his head, all burning, more than a hundred.' This may have been an act of clairvoyance, because Owen Tudor's grandson, Henry, founded the Tudor dynasty that united England and Wales. Henry's father, Edmund, died in Yorkist imprisonment in Carmarthen just three months before Henry was born in 1457.

Henry was born in Wales, of royal Welsh descent, and one of his ancestors was Llewelyn the Great's Justiciar, Ednyfed Fychan, whose heraldic arms were three severed Saxon heads. Brought up by a Welsh nurse, Henry Earl of Richmond was lucky to be alive, even before he raised the Red Dragon of Cadwaladr upon Bosworth Field. Harri Tudur was only fourteen in 1471, the year that the Lancastrian King Henry VI was murdered, and his son Prince Edward killed. Suddenly Harri was the prime Lancastrian claimant to the English crown in the continuing Wars of the Roses. His uncle Jasper Tudur (the Earl of Pembroke) only just managed to help him flee to Brittany, then still a country independent of France, and with a similar language to Welsh. Mayor Thomas White of Tenby had hidden young Henry in cellars which can still be seen. The new English King Edward IV asked for Harri to be handed over, but died soon after and was succeeded by Richard III of York, who killed Edward IV's two sons, the 'princes in the Tower'.

In 1483, Harri Tudur pledged his band of followers that he would marry Edward IV's daughter Elizabeth of York, and thus unite the warring Lancastrian and Yorkist factions. His own lineage went back through his grandfather Owain's marriage to Catherine, widow of Henry V, to the Royal Houses of Gwynedd and Gruffydd ap Cynan, and that of Dinefwr and Rhys ap Tewdwr. In September 1484, Harri barely escaped with his life as he was warned that a group of Breton nobles were going to take him to Richard III. He crossed the border into France, and with the Earl of Oxford and his uncle Jasper, Earl of Pembroke, the Bishop of Ely and the Marquis of

Dorset, prepared to invade Britain. He borrowed money from France, and with 2,000 mainly Welsh, Breton and French troops, landed near his birthplace in Pembrokeshire. Tudur moved through Wales gathering support. Rhys ap Thomas gathered the men of Deheubarth and met Henry at Shrewsbury. So did the men of Gwynedd under Richard ap Hywel of Mostyn. While pleading his cause at Mostyn, King Richard's men from nearby Flint Castle arrived and Henry had to escape by a back window. There is a stained glass commemoration panel of the event in Mostyn Hall, and Henry presented the family with a silver bowl and ewer after the Battle of Bosworth in gratitude.

Many Welshmen believed that Harri was the promised 'mab darogan', 'son of prophecy', to free Wales from the English. Glyndŵr's rebellion had paved the way for this nationalist upsurge. The Lancastrian forces crossed the Severn near Shrewsbury, finally meeting Richard's numerically superior army at Bosworth Field in Leicestershire. This was one of the strangest battles in history. From the west, Henry's force, watched by Richard's mounted scouts, had moved from Lichfield to Leicester, and was making its slow progress towards Bosworth Field. It had swollen from 2,500 to 4,500 soldiers on its journey across Wales. The Earl of Shrewsbury brought 500 men to the scene. From the east of England, Lord Norfolk's loyalist army of 4,000 men was approaching in the opposite direction. Percy of Northumberland was bringing Richard another 3,000 troops from the north. Richard with 6,000 followers was hurrying from the south, and another two armies of the Stanley brothers also arrived at the same time. Of the six main armies, three were uncommitted at the start of the battle. Yorkist armies under the Stanley brothers had pledged to assist Richard III, mainly as Lord Stanley's son was held hostage by Richard, but held back from the battle. The battle was started by the Earl of Oxford leading Henry's men to attack the Duke of Norfolk's army. At the same time, Lord Thomas Stanley led his 4,000 men towards Northumberland's position on a nearby hill. Oxford's force was soon beaten back, and things looked grim for Henry. Around half an hour into the battle, Richard could see Henry and Jasper Tudur, with the standard of the Red Dragon, on the slopes behind Oxford's tired forces. Richard took a great gamble. At the head of 100 men, he charged across to this position, passing William Stanley's army. The Red Dragon was cut down, and the standard-bearer, Sir William Brandon was killed. In the melée, part of the army of 2,500 men under Sir William Stanley charged to help Henry. Lord Thomas Stanley still held his 4,000 men back, near Northumberland's force. Equally, the army supporting Richard under the Earl of Northumberland refused to engage the Lancastrian army, watching the battle develop. Richard and his small force was quickly overwhelmed and Richard killed. The forces of the Lancastrian Earl of Richmond, Henry Tudur, eventually overcame the rest of the Yorkist army of Richard III. Rhys ap Thomas was said to have been knighted on the battlefield for killing Richard of York with his great battle-axe, and supposedly put Richard's crown on Henry's head. Henry VII's personal bodyguard at this battle was the origin of today's 'Beefeaters' at the Tower of London. This 250-strong 'Yeomen of the Guard' was formed of Welshmen in 1485.

Richard's death effectively ended the battle, and Henry's marriage and diplomacy finally ended the Wars of the Roses. A Yorkist invasion force mainly composed of Irish and Germans was bloodily defeated in 1487 at Stoke. The impostors to the throne, Perkin Warbeck and Lambert Simnel, were dealt with. By the standards of the age Henry was extremely merciful to the defeated Yorkists, with few of the executions that had followed previous battles. Despite several threats to the crown, Henry Tudur laid the basis for a stable constitutional monarchy. By the cunning Treaty of Étaples, he took money from the French in return for not fighting them. He built trade and alliances, and under his Royal Commission John Cabot reached Nova Scotia in 1497. Aged only fifty-two, Henry Tudor died in 1509, leaving a peaceful country, full treasury and an uneventful succession. The 'founder of the new England of the sixteenth century', Francis Bacon called him 'a wonder for wise men'. The great historian G.M. Trevelyan pointed out to the influence of Bosworth Field and the Tudors: 'Here, indeed, was one of fortune's freaks: on a bare Leicestershire upland a few thousand men in close conflict foot to foot... sufficed to set upon the throne of England the greatest of all her royal lines, that should guide her through a century of change down new and larger streams of destiny.'

Henry's success had been largely due to Welsh support, and the emissary for Venice reported to the Doge that: 'The Welsh may now be said to have recovered their independence, for the most wise and fortunate Henry VII is a Welshman'. Francis Bacon commented that 'To the Welsh people, his victory was theirs; they had thereby regained their freedom.' Henry VII had brought up his eldest son and heir, Arthur, as a Welsh speaker. Arthur was married with great ceremony to Catherine of Aragon in 1501, cementing the Spanish alliance. Arthur's premature death gave the nation Henry VIII and changed the course of British history – without it Britain would probably still be a Catholic country. And Henry VIII's daughter Queen Elizabeth I oversaw the greatest flowering of culture, in the British Isles, under this Tudor dynasty.

TUDOR, JASPER (1431-1495) Duke of Bedford, he was Henry VII's uncle, and was made Earl of Pembroke in 1452. Jasper was given the Order of the Garter before 1459, which was the year his brother Edmund died in prison. With Henry VI, Jasper won at Ludford Bridge in 1459, took Denbigh Castle in 1460, but managed to escape from the defeat at Mortimer's Cross in 1461. His father Owen was beheaded, but Jasper escaped via Scotland and Ireland. For his support of the House of Lancaster, he was stripped of his honours and attainted as a traitor in 1461. Returning from exile, he was too late to take part in the defeat at Tewkesbury in 1471. With his nephew Henry he managed to escape to Brittany, and guided Henry to adulthood. Jasper tried again to invade England in 1483, and in 1485 accompanied Henry to victory at Bosworth. He was one of the most notable warriors of the Wales of the Roses, fighting for the Lancastrians across Britain. His military experience and renown enabled Henry to make his successful bid for the English crown, and in 1485 all his honours were restored. He became Duke of Bedford, Lord of Glamorgan and Lord-Lieutenant of Ireland.

TURNBULL, MAJOR MAURICE (1906-1944) Cardiff-born, he was capped by the MCC nine times at cricket, and also played for Cardiff and Wales at rugby, after winning a double Cambridge 'Blue' in both cricket and rugby. He was captain of Cambridge and then of Glamorgan at cricket, and was a squash champion also. He was the first Welsh cricketer capped by England, and in 388 first-class innings, he scored 17,544 runs. He was in the first Welsh rugby team to win at Twickenham, in 1933. Turnbull was tragically killed in the Second World War, by a sniper during the D-Day landings.

TWM SIÔN CATI (c. 1530-1609) Tregaron-born, this 'Welsh Robin Hood', used to hide in a cave on Dinas Hill, near Llyn Brianne, from the Sheriff of Carmarthen. Dinas Hill is now a Royal Society for the Protection of Birds Sanctuary, near Llyn Brianne. An educated but illegitimate squire's son, he was a highwayman for a few years, supposedly only robbing the rich. Twm's mother was named Catherine, so he was nick-named 'Cati' after her, but his full name was Siôn ap Dafydd ap Madog ap Hywel Moetheu of Porth-y-Ffin. In 1559 Twm was officially pardoned for his crimes. There are many stories and legends about his trickery in his 'bandit years' before he became 'respectable'. He retired near Cilycwm, as Thomas Jones, a respected Justice of the Peace, landlord, poet and historian, noted for his knowledge of genealogy and heraldry. It is interesting that Robin Hood is the subject of a Disney film and a thriving tourist industry, but never existed, whereas Twm Siôn Cati is unknown.

TWMPATH CASTLE In Rhiwbina in the north of Cardiff, associated with Iestyn ap Gwrgan, the last Welsh Lord of Glamorgan. A similar motte and bailey at nearby Whitchurch was levelled for the type of housing that will last decades rather than centuries.

TWT (LOOK-OUT) HILL CASTLE Just south of Rhuddlan Castle, this large motte still stands nearly 60 feet high. It lies next to the River Clwyd, guarding a crucial ford and was the site of both a Saxon defended settlement and a Welsh prince's palace. It was built by Robert of Rhuddlan in 1073 to consolidate his local lands. William the Conqueror had ordered motte and bailey castles

to be erected to hold Norman conquests in Wales. In 1086, William granted Robert power over all of North Wales beyond Clwyd, for an annual rent of £40. The motte is traditionally placed on the site of Gruffydd ap Llywelyn's palace. The castle and its neighbouring borough, dating from 1056, changed hands several times between the Welsh and Normans before Edward I began construction of Rhuddlan Castle in 1277. The borough had its own church and mint, and silver pennies were minted there from the reign of William I and from *c.* 1180-1215.

TWYN Y BEDDAU, BATTLE OF Twyn y Beddau means 'mound of the graves', and is about two miles from Hay-on-Wye. It is said to mark the site of a battle between Edward I and the Welsh, and the Dulas River is said to have run with blood for days afterwards.

TŶ MAWR HUT GROUP An Iron Age settlement at the foot of Holyhead Mountain, with up to fifty circular huts and evidence of settlement from the Middle Stone Age, Neolithic Age, Bronze Age and Iron Age.

TYWYN On the edge of the Snowdonia National Park, it is the home of the Talyllyn Railway, built in 1865 for the slate trade. The quarries closed in 1947. St Cadfan's Church in Tywyn was founded in the sixth century and possesses St Cadfan's Stone, its sixth to seventh-century inscription being the oldest existing example of Welsh writing.

URDD GOBAITH CYMRU - LEAGUE OF THE YOUTH OF WALES The Urdd was founded in 1922, with 200 boys who responded to an invitation to camp at Llanuwchllyn, Bala, and now comprises 300 youth clubs, 52,000 members and runs an Urdd National Eisteddfod. Gwynfor Evans pointed out the essential difference between Welsh 'nationalism' and other, more sinister forms of national pride: 'When the Urdd was growing strongly in the 1930's there was a powerful youth movement in Germany. The aims and ethos of the Hitler Youth were as different from the Welsh movement as Nazism was from Welsh nationalism, as the three-fold pledge of the Urdd indicates: "I will be faithful to Wales and worthy of her, to my fellow human being whoever he may be and to Christ and his love." The nationalism of the Welsh movement was Christian and international. Handbooks were published for use in Christian services; an Urdd Sunday was held; and in the month of May each year a Message of Goodwill was broadcast to the countries of the world.' The Eisteddfod Genedlaethol Urdd alternates between South and North Wales and is the largest youth festival in Europe - it includes rock music, to help keep minority languages alive, and is open to performers and groups from all over Europe. Carlo Rizzi, The Welsh National Opera's Musical Director, put into perspective the role of eisteddfodau in Welsh culture: 'To me, the Urdd Eisteddfod for young people is a wonderful opportunity for youngsters in Wales to try their skills and forge their characters, giving them the chance to exchange experiences. The renaissance of the Welsh language, with more and more young people speaking it, is another factor which is important in all this. For me it is a very strange experience to attend the eisteddfodau and hear everyone speaking Welsh, even though I have been learning the Welsh language and can now hold conversations in it (perhaps having a Welsh-speaking wife has something to do with this). The language is an indication of the strong will-power of the Welsh people to maintain their own identity. Maintaining this identity also means maintaining their own music. Wales has so many beautiful songs, my favourite being *Myfanwy* by Joseph Parry. Also, I think that the Welsh National Anthem is one of the finest national anthems.'

USK CASTLE It is thought to have been founded, with the town settlement, about 1120 at a place called Brynbuga. It was captured by the Welsh in 1138, and again in 1174, although it had been strengthened by Richard de Clare. The Normans retook it in 1184. The Earl of Pembroke,

William Marshal, strengthened it in 1212-1213, but it was captured by Henry III from Richard Marshal in 1233. Glyndŵr burnt the town in 1402 and 1405 but it is thought that the castle was not taken. The Benedictine Priory was founded about 1170, and part remains in the fabric of St Mary's Church.

USK (BURRIUM) ROMAN FORT Burrium was built around 54 CE, the earliest Roman legionary fort in Wales. The bastide town lies above it, and was built with four gateways, a ditch and a bank for protection against the Welsh. Usk is an Anglicisation of the River Wysg, meaning 'abounding in fish', although the Welsh name for Usk, Brynbuga, denotes the Bridge of Buga. St Dingad settled in Usk, yet another early saint associated with a Roman site, and ALFRED WALLACE was born here.

VACARI, ANDREW (1938-) Andrew Vacari, of Port Talbot, was educated at Neath Grammar School, and is now a millionaire tax exile in Monaco. He studied art with Lucien Freud and Francis Bacon, and Augustus John insisted that the young Vicari painted his portrait, calling him 'one of the great figurative artists of the century'. Vacari is the only artist to have painted the whole royal family of Saudi Arabia. He was also invited by General Norman Schwarzkopf to paint scenes from the 1991 Gulf War. He calls himself 'a Celt and a Latin with an Anglo-Saxon education – a true European'. The Welsh Rugby Union commissioned him to be the official artist for the 1999 Rugby World Cup. Vacari was only the fourth Western artist to be allowed to exhibit in China, following Rodin, Miro and Chagall. He has won the *Prix Européen des Beaux Arts*, and refused to paint Saddam Hussein. *Paris Match* called him 'the King of Painters, Painter of Kings.'

VALLE CRUCIS ABBEY Close to Llangollen, it is named Valley of the Cross because of the nearby Eliseg's Pillar, and was a Cistercian daughter house to Strata Marcella. Its founder was Prince Madog ap Gruffydd Maelor in 1200-1201. It was damaged by English forces in Edward's invasion of 1276-77. It is recorded that the Black Death cut down the numbers of lay brothers and choir monks. The east front overlooks the monks' fishpond. It was the second most prosperous abbey in Wales, after Tintern, and many Welsh nobles are buried there, including Madoc, the great-grandson of its founder and the great-grandfather of Owain Glyndŵr.

VAUGHAN, HENRY (1622-1695) Known as *'The Silurian'*, he practised as a country doctor in the Usk Valley, and is buried at Llansantffraid. His twin brother Thomas was a noted 'alchemist', who 'disseminated a purer conception of God and Man'. However, Henry is the more famous, as one of the 'metaphysical' poets combining insight into nature with deep religious conviction:

> I saw Eternity the other night,
> Like a great ring of pure and endless light,
> All calm, as it was bright;
> And round beneath it, Time in hours, days, years,
> Driv'n by the spheres
> Like a vast shadow mov'd; in which the world
> And all her train were hurl'd.

His vision of the innocent mysticism of childhood was later taken up by Wordsworth.

VIKING ATTACKS The first raiders were from Norway and Denmark, and also Norsemen from their kingdom of Dublin, and they were variously known as 'y llu ddu' (the black host), 'cenheloedd duon' (the black nations), 'y Normayeit duon' (black Normans), 'brithwyr du' (black Picts), 'dieifyl du' (black devils), 'paganaid' (pagans), 'Daemysseit' (Danes) and 'Llychynwyr' (men of Norway). The Norse of Dublin were often called 'Gwyddyl' (Irish, as distinct from 'Gwyddyl Fichti', Irish Picts) or 'gwyr Dulyn' (men of Dublin). Wales was called

'Bretland', Land of the Britons, in Old Norse, and Icelandic and Viking sagas note many attacks on the nation, e.g. by Eric Bloodaxe plundering in the 930's and by Sven, the son of Harald in 995. King Magnus Barefoot, in the Battle of the Menai Straits, killed Hugh the Fat, Earl of Shrewsbury in 1098 as an arrow pierced his eye. Of course, for much of this time England was either partitioned with the Danes, or later ruled by them. There were also attacks on the Welsh/Britons in Strathclyde, Cumbria and the West Country over these years. There are no recorded raids or battles before 795, but the influence of the Vikings is shown in the following timeline:

795 attacks recorded;
835 attacks;
850 (when Cyngen died);
850-870 along Gwent and Glamorgan coasts;
854 at Anglesey;
855 when Rhodri Mawr defeated Horm;
870 attacks recorded;
876 at Anglesey with the fleet sheltering for the winter in south Wales;
877 when Rhodr Mawr escaped to Ireland;
879 when Vikings capture Iago ab Idwal;
890 at Castell Maldwyn;
893 at Buttington, where they were defeated;
895-896 a Danish army wintered in south Wales and ravaged Glamorgan, Gwent, Brecon and Builth;
902 Dublin was captured by the Irish, forcing the Vikings into north Wales, where they were defeated by Hywel ap Cadell and driven towards Chester;
903 pitched battle with Danes under Ingimundr near Holyhead;
904 Danes kill Merfyn ap Rhodri Mawr;
905-910 raids by Eric Bloodaxe of Norway;
918 Vikings have retaken Dublin and attack Anglesey;
915 Vikings ravage Gwent, take Bishop Cyfeiliog who is ransomed by Edmund the Elder;
918-952 cessation of raids;
952-1000 constant attacks on Welsh coasts;
952 two sons of the King of Glamorgan killed;
961 Holyhead ravaged;
963 Tywyn monastery and Aberffraw court attacked;
968 Limerick Norse are driven out of Ireland and defeated in Wales;
971 King Magnus of the Isle of Man and Limerick attacks Penmon monastery;
972 King Magnus's brother Godfridr conquers Anglesey;
979 Iago ap Ieuaf captured by Vikings, who were possibly assisting Hywel ap Ieuaf in Gwynedd;
980 Godfridr at Battle of Hirbarth;
982-1000 constant attacks on St David's;
982 St David's sacked by Godfridr who also ravages Dyfed and beats the Welsh in the battle of Llangwithenawc;
987 Godfridr again attacks Anglesey, and helps Hywel ab Ieuaf defeat Maredudd ab Owain of South Wales and take over Gwynedd at the Battle of Mannan;
988 the monasteries of St David's, Llanbadarn Fawr, Llandudoch (St Dogmael's) near Cardigan, Llancarfan and Llanilltud are sacked;
992 St David's destroyed again and Maredudd ab Owain of Dyfed hires Norsemen to help in a war against Edwin ab Einion, King of Glamorgan;
993 Anglesey is attacked;
997-998 waves of attacks around the Severn;
999 St David's attacked for the fourth time and Bishop Morgeneu killed;

1002 Dyfed attacked;

1005 Brian Boru sends Norsemen to plunder Wales;

1012 Mercians attack St David's using Danish ships; 1022, Canute's men raid Dyfed and St David's;

1039 Meurig ap Hywel of Glamorgan captured and ransomed;

1042 Battle of Pwll Dyfach and also King Gruffydd ap Llywelyn of Gwynedd captured for ransom;

1044 Gruffydd ap Llywelyn had defeated King Hywel ab Edwin of Gwynedd in 1041 at Pencader to try to annexe parts of south Wales. The Norsemen supplied twenty longships and men to help Edwin, but they were beaten by Gruffydd in the estuary of the Towy and Edwin killed. He was succeeded by Gruffydd ap Rhydderch;

1044-52 Gruffydd ap Rhydderch despoiled his own villages and coastlines to make them less attractive for Norse raiders;

1049 Gruffydd ap Rhydderch of Gwynedd allied with Norse mercenaries to attack Gwent Iscoed and take it from King Meurig ap Hywel. Thirty-six longships entered the Usk estuary and plundered the valley, including a manor in England. Bishop Ealdred of Worcester sent an army to fight Gruffydd's invaders, but was defeated after Welsh defectors from his army had alerted Gruffydd;

1053 Gruffydd raids the English border using Norsemen;

1055 Earl Aelfgar of Mercia is exiled and comes to Gruffydd ap Llywelyn's court with eighteen longships full of Norse mercenaries. Gruffydd allies with him, marries his daughter, and invades Hereford. The relics of King Ethelbert are desecrated in Hereford. Edward the Confessor sends Earl herald Godwinsson to negotiate a peace at Billingsley near Archenfield;

1056 Gruffydd and Norsemen again invade Hereford;

1058 Gruffydd and Norsemen and the again deposed Earl Aelfgar ally, to restore Aelfgar to Mercia's throne;

1063 Gruffydd killed;

1075 Gruffydd ap Cynan, raised by a Norse family, brings Norse mercenaries from Ireland and with men from Gwynedd and Robert of Rhuddlan's Normans defeats Cynwrig ap Rhiwallon of Gwynedd and Trahaearn ap Caradog of Arwystli at the battle of Bloody Acre (Gwaed Erw); In the Battle of Bron Erw, near Clynnog Fawr, Trahaearn defeated Gruffydd, and he left for Ireland, via the Skerries;

1077 Gruffydd invades with Norsemen but returns to Ireland;

1081 Norsemen attack St David's for the fifth recorded time, killing Bishop Abraham;

1087 Gruffydd uses a Danish double-edged axe in battle against the Normans of Anglesey. With his Norse followers, he sacked St Gwynlliw's Church in Newport;

1088 Rhys ap Tewdwr of Deheubarth was exiled to Ireland, but returned with Norsemen and won the battle of Penlecherau. Gruffydd ap Cynan is again in Wales with Norsemen, attacking the Normans in Rhos and Tegeingl; Robert of Rhuddlan is killed at Deganwy by Norsemen;

1093 Rhys ap Tewdwr is killed by Normans at Brycheiniog, and his son Gruffydd taken to be protected by the Irish-Norse;

1098 Gruffydd ap Cynan is hemmed in on Anglesey by the Normans and with Cadwgan forced to flee to Ireland; Hugh of Shrewsbury is killed by Magnus Barefoot on the Menai Straits;

1115 Gruffydd ap Rhys of Deheubarth returns from Ireland to try and regain his throne;

1126 Gruffydd ap Rhys is forced to flee to Ireland to join other Welsh refugees from the Norman Conquest;

1137 Gruffydd ap Cynan dies and his son Cadawladr sends fifteen Norse longships to assist his to take Cardigan castle from the Normans. The siege failed and the Norsemen attacked St Dogmael's;

1144 Civil War between Cadwaladr and his brother Owain, whose son Hywel attacked Cadawladr. Cadwaladr sent for a Norse fleet which sailed to Abermenai;

1144 Cadwgan ap Owain Gwynedd is seized for ransom by Norsemen, after hiring them to combat his brother.

WALES ASSEMBLY GOVERNMENT Following the elections of 6 May 1999, Wales had had its own assembly, which from 2003 has taken over functions from the Secretary of State for Wales. Unlike its Scottish counterpart, it has no tax-raising or law-making powers.

WALES' RICHEST MEN & WOMEN According to the Sunday Times 'Rich List' they include the financier Michael Moritz from Cardiff, worth £1,350m who funded Google. Sir Terry Matthews is worth around £1,300m, his fortune made in electronics. He built the Celtic Manor Hotel and golf course at Newport, where the Ryder Cup will be played in 2010. Albert Gubay is worth £650m, mainly from his Kwik Save supermarkets which he sold in 1973. David Sullivan made most of his £575m in the soft-porn industry, and published *The Daily Sport*. Stanley and Peter Thomas, with £250m, made money from selling out Peter's Pies and Cardiff Airport and now deal in property. Lord Heseltine has around £241m from publishing, and Tom Jones the singer is worth around £175m. Catherine Zeta-Jones is valued at £170m, the biotechnology entrepreneur Sir Chris Evans, £158m, and the artist Andrew Vicari, £80m. Sir Anthony Hopkins has £75m and Dave Richards also £75m since he bought the media rights to the world rally championship from Bernie Ecclestone in 2000. Ifor Williams, with £75m, heads Williams Trailers, Britain's leading trailer manufacturer. Gerald Leeke, of the Leeke's department store is valued at £70m and Christopher Brain, the brewery mogul £56m. The philanthropist Dr 'Gren' Thomas from Morriston, Swansea started work in a pit as a teenager before gaining a doctorate in Cardiff University and heading to Canada in 1964. He has a 40% stake in what is possibly the world's richest diamond mine, Diavik in Canada. His daughter Eira Thomas, is the CEO of Stornoway Diamond. It is difficult to estimate his wealth, although this author has been for more than a few beers with him several times in Canada and Wales. After a diamond discovery in Canada, Gren quickly began staking ground east and southeast of that dig for his own company, Aber Resources. Gren used a strategy that he insists is a real mining term: 'closeology'. In any rush to claim stakes, he explains that one has to look for ground as close to the discovery as possible. 'Forget all the other 'ologies' – geology, biology, and the like. Mines tend to be close together. That's closeology.'

WALKER, THOMAS ANDREW (1828-1889) The almost forgotten Thomas Andrew Walker, of Caerwent, built the fantastic Severn Railway Tunnel (1872-1877) and the Manchester Ship Canal, Barry Docks and Preston Docks in Victorian times. When he died (possibly from overwork), Walker was working simultaneously on the Government Docks at Buenos Aires, Barry Docks, Preston Docks and the Ship Canal. The Severn tunnel is over four miles long. The lych gate at Caerwent Church is a memorial to Walker, who lived at Mount Ballan. His gravestone is in St Tathan's Church in Caerwent.

WALLACE, ALFRED RUSSELL (1823-1913) In the 1850's, a young scientist, Alfred Russell Wallace from Usk, working in the Pacific, sent a paper on the tendency of varieties of species to depart from the original type. He sent it to Charles Darwin. Darwin looked at it, and quickly presented it as a joint paper while Wallace was abroad, thereby making his name with the greatest single discovery in the Life Sciences. Wallace is now almost forgotten, while Darwin and *The Origin of the Species* are known the world over. His 'Wallace Line' between the islands of Bali and Lombok, and between Borneo and The Celebes, showed the first biogeographers the division between flora and fauna in similar climates. Wallace had spent four years in the Amazon basin, and another eight years collecting specimens in the Malay Archipelago, the hundreds of islands that make up modern Indonesia. Wallace was the 'greatest field biologist of the nineteenth

century' (*The Song of the Dodo*, David Quammen, published by Pimlico 1996)... and 'is famous for being obscured'... 'for a variety of reasons, some good and some shabby, Darwin received most of the recognition.'

Wallace had a feeling for equality that Darwin lacked. Darwin was independently wealthy, whereas Wallace was apprenticed to a builder aged fourteen, and became a trainee land surveyor in rural Wales. In the 1840's he was employed redrawing property boundaries as common land was enclosed and the rich squirearchy divided up the land – he later called this 'a legalised robbery of the poor'. From 1848 to 1852 Wallace explored South America, but his ship sank on the voyage home, and all his precious specimens were lost (except for those he had sent home earlier). He was in the Malay Archipelago from 1854 to 1862, collecting 125,000 specimens, and in 1869-1870 in Borneo. In Adrian Desmond's and James Moore's biography, *Darwin* (1997), we see Wallace as a 'self-taught socialist' who 'saw humanity as part of a progressive world governed by natural law' and who 'had learned to see morality as a cultural product'. Wallace adapted Malthusian logic on the over-population of mankind to the animal kingdom. Thus Wallace's more rounded theory of selection and evolution was that the environment extinguished the unfit, rather than Darwin's 'competition between species'. He also regarded natives such as the Dyaks in Borneo with admiration for their adaptation to their environment. On the other hand, Darwin was disgusted by the natives of Tierra del Fuego.

'And Wallace was to post the question dismissed by Darwin – what was the purpose of natural selection? Evolutionary forces worked towards a just society, this was the point – "to realise the ideal of perfect man." Darwin accepted nothing so utopian.' In *The Song of the Dodo* we also see Darwin's 'Watergate' (pp 110-114) where some of his lies are documented. Crucial letters went 'missing' and 'somebody cleaned up the file' to give the great man credit for Wallace's work. Unfortunately, this lack of recognition forms a theme running through Welsh scientific discovery. The story of this attractive and humane man, Wallace, not part of the upper-class English establishment, who contributed vastly to science, needs to be widely told. Wallace's books included *A Narrative of Travels on the Amazon and Rio Negro* (1853), *On the Law Which Has Regulated the Introduction of New Species* (1855), *The Malay Archipelago* (1869) and *Contributions to the Theory of Natural Selection* (1870). He also pioneered zoogeography with his 1876 *Geographical Distribution of Animals*. Wallace was before his time – he campaigned strongly for women's suffrage, receiving sneers from the academic community for this, and also proposed the nationalisation of land and socialism. Socialist, Christian, humanitarian, egalitarian and Welsh – one wonders why his work has been suppressed. A naturalist, geographer, anthropologist and biologist, he has been called 'the father of biogeography', and a precursor of ecology. Darwin has the credit, Wallace is forgotten.

WALTER, LUCY (*c*. 1630-1658) From Roch Castle, in Pembroke, she met Charles II at The Hague when he was a refugee from Cromwell, and became his mistress. Edward Hyde wrote that their son James was the result of a secret marriage, and Cromwell and James II also believed that this was the case. This would make Lucy an unknown Queen of England. Her son James, Duke of Monmouth, was kidnapped by Charles to be brought up by the king's mother at court in Paris. James, Duke of Monmouth was executed after leading the Monmouth Rebellion to gain the throne from Charles' brother James II. Charles had two other Welsh mistresses. Moll Davis (Davies) gave birth to 'Lady' Mary Tudor, who married the Earl of Derwentwater. Nell Gwynne gave birth to the Duke of St Albans and the Earl of Plymouth. Lucy Walter gave birth to the legal King of England.

WARS It appears that Wales is alone of all the older nations in the world, in its non-aggressive behaviour, and its non-declaration of invasive wars. However, the last war was declared upon Germany on behalf of England, Scotland, Wales and Monmouthshire. Later, the peace treaty omitted Monmouthshire, so this county is still technically at war with Germany. This anomalous position arose because of Monmouth's position as a kind of 'buffer-state', a no-man's

land between England and Wales, and its administrative control used to rotate between the two countries. Nora Chadwick wrote about the Welsh attitude towards power and aggression: '... the gradual approximation to a Wales united under a single family. It is I think the most remarkable feature of early Welsh history that the union of most of these kingdoms should have come about gradually with no record of conquest and no bloodshed. Those historians who speak of the Welsh as a warlike people see Wales only through the eyes of the Norman conquerors, when the whole country became an armed fortress on the defensive. The early history is very different – a history of peaceful development, of gradual unification by policy, and by a series of royal marriages.' In 1982, Wales became the first nuclear-free country in Europe when all eight of its county councils agreed never to allow nuclear weapons on their soil.

WARS OF INDEPENDENCE We can state that there have been three main wars of independence, apart from the periodic revolts against Norman rule. Interestingly, if Madog ap Llywelyn's revolt of 1294-95 had occurred when Edward I had left the country, it was potentially the greatest war of independence. Wales had been struggling to maintain its borders for over 200 years when Llywelyn II died, so to some extent the war actually lasted from 1067 to the Madog's revolt in 1295. There were several revolts after Glyndŵr's War, including a very strong Welsh involvement in the 1455-1487 Wars of the Roses, leading to the successful Welsh invasion of England in 1485. We can thus make a case for the war lasting from 1067 for 420 years until 1487, and Wales winning it. Forget the '100 Years War', won by France against England – the small nation of Wales won the '400 Years War' against England. The three recognised wars are:
1276-77 – The First War of Independence led by Llywelyn ap Gruffydd, Llywelyn II. An English invasion reversed the gains made by the the Welsh in the Treaty of Montgomery in 1267 when Llywelyn was recognised as Prince of Wales, and ended with the Treaty of Aberconwy.
1282-83 – The Second War of Independence, led by Llywelyn ap Gruffydd, Llywelyn II, which ended with his murder near Builth and his brother Dafydd's execution. The Treaty of Rhuddlan of 1284 punished all Welshmen.
1400-1415 – The Third War of Independence, also known as the Great Liberation War, led by Owain Glyndŵr.

WARS OF THE ROSES 1455-1487 There was a strong Welsh element in this Lancastrian-Yorkist struggle, culminating in its end when Henry VII won at Bosworth Field and Stoke. At Mortimer's Cross in 1461, the Lancastrian Owen Tudor and his son Jasper were defeated, with the main Yorkist contingent being Sir William Herbert's Welsh army. At Edgcote Moor in 1469, William Herbert Earl of Pembroke with an army of Welsh archers and spearmen was defeated. Herbert and his brother were executed and 2,000 Welsh soldiers died. In 1471 at Tewkesbury, Margaret of Anjou's Lancastrians were trying to join up with Jasper Tudor's army when she was defeated at 'the bloody meadow'. Bosworth Field in 1485 saw the eventual Lancastrian victory, solidified with victory at Stoke Field two years later.

WATER Llyn Llawddyn was Wales first reservoir, built in the 1880's as the biggest man-made lake in the world. In the 1890's Birmingham bought the Claerwen and Elan valleys, damming them to make huge reservoirs such as Lake Elan, opened in 1904. Claerwen reservoir is leased for 999 years to Birmingham for 5 pence a year. Birkenhead created Alwen Lake in 1907. Trywerin and Clywedog were dammed, destroying ancient Welsh-speaking communities, despite massive opposition. In 1966 a bomb exploded on the Clywedog Reservoir site, delaying work by six weeks, and John Jenkins was imprisoned. Capel Celyn village and the Tryweryn Valley outside Bala were drowned in 1965 to supply Liverpool. All sixteen farms had Welsh names and Welsh owners. There were massive protests against Tryweryn including sabotage by Emyr Llywelyn Jones, an Aberystwyth student. Six members of the Free Wales Army were imprisoned four years after its opening in 1965, and given gaol sentences of fifteen months for alleged conspiracy against the building of the biggest dam in Wales, Llyn Celyn. (The trial was a sham, covering

up the fact that Special Branch could not break the cell system of MAC – see John Humphries' *Freedom Fighters*). Welsh MP's could not stop any of these reservoirs being built via compulsory purchase. Because of continuing shortages in the southeast of England, there are contingency plans to divert water from the Severn and Wye into England. (The third biggest river in England and Wales, the Trent, is entirely in England, with no water extraction schemes proposed).

WAT'S DYKE Offa's Dyke was possibly built as a border or buffer between Wales and England in the reign of Offa (757-796), but Wat's Dyke was up to 400 years earlier. It is just east of Offa's Dyke, a double ditch and embankment running from Basingwerk Abbey near Holywell to Welshpool, via Buckley, Hope, Llay, Wrexham, Ruabon and Oswestry. The bank was around 26ft wide at its base, still stands up to 6ft tall in places and ran for forty miles. The ditch was on average 19ft wide and over 6ft deep. The successes of King Elisedd (see ELISEG'S PILLAR) of Powys may have led Mercian King Aethelbald of Mercia to build Wat's Dyke. This endeavour may have been with Elisedd's own agreement, however, for this boundary, extending north from the Severn valley to the Dee estuary, gave Oswestry (Croesoswallt) to Powys. Old legends say that the areas between Wat's and Offa's dykes were a sort of 'No-Man's-Land', where Saxons and Britons met to trade.

WEBB, HARRI (1920-1994) From a Swansea working-class family, he went to Oxford University before volunteering for the Royal Navy and serving in World War II. After temporary jobs, he became a librarian in Dowlais in 1954, then in Mountain Ash in 1964. In Merthyr he mixed with pacifists and nationalists, publishing a pamphlet on Dic Penderyn and his first collection of poetry, *The Green Desert*, was published in 1969. After more publications, he suffered a major stroke in 1985. His poems show a radical commitment to Welsh nationalism, and is often deliberately accessible to get his message across to as wide an audience as possible.

WELLS Wells were sacred to the early Celts, and they used the hot springs of Bath before the Romans came to Britain. Aqua Sulis, or Bath, is named after the Celtic Goddess Sulis. There are hundreds of saints' holy wells dating from the fifth century onwards across Wales, most sadly neglected, and there were hundreds more grown over or built upon. There were many 'cursing wells' in Wales, the most noted being the well of Eilian, near Llaneilian-yn-Rhos in Clwyd. To cast a curse, the guardian of the well wrote it on paper and threw it in. The church authorities blocked off this particular well in 1929. Sarah Hughes was said to make £300 a year from the well, years before it passed into the hands of the notorious John Evans, 'Jac Ffynnon Eilian', who had the well water piped into his garden. In 1831 he was imprisoned for illegally obtaining money, and died in 1854. The saying 'fel Ffynnon Eilian' ('like Eilian's Well') was used for many years after to mean great troubles. At Llandrillo-yn-Rhos near Colwyn Bay, a cursing well was still being used in the first part of last century, when a gipsy who had threatened a Welshman by 'putting him in the well' was tried at the local assizes. Up until 1918, the ancient fish-weir here paid a tithe of salmon to the church. Llanbadarn Fynydd well in Powys was used to cure sick animals, used in living memory by farmers bringing dogs, cows and sheep. In Llanddona, Gwynedd, is the famous Ffynnon Oer (Cold Well). It lies near the shore, and was said to have issued forth when three witches landed and commanded it to appear. Bela Fawr, Sian Bwt and Lisi Blac lived by begging, married smugglers and chanted their curses near the 'cold well'. One curse has been translated as:

> Let him wander for many centuries;
> At each step a stile;
> On each stile a fall;
> In each fall a breaking of bone;
> Neither the largest or smallest
> But the neck bone every time.

Brecon Spring Water' is available in most of the major UK supermarket chains, and 'Tŷ Nant' spring water, from a well in Bethania, near Lampeter, is well-known for its distinctive blue bottle. Both are foreign-owned.

'WELSH', FREDDY (1886-1927) Frederick Hall Thomas of Pontypridd was world welterweight and lightweight champion in from 1914-1917. He had crossed the Atlantic, after leaving a Pentre foundry at the age of seventeen, to seek his fortune in America. He remains the only vegetarian known to have won a world championship, and was the first boxer to win a Lonsdale Belt. Between 1905 and 1916, he won 156 out of 158 contests. In 1917 he won 3 and lost 1, did not fight for three years, and then in 1921 and 1922 won 4 and lost two contests. He died penniless, aged forty-one, in a dingy New York apartment and has constantly been rated as one of the best lightweights of all time. The only time he was 'stopped' was when aged thirty-one in 1917 to the twenty-one year-old Benny Leonard in a world title fight. Before that he had been beaten only once in 157 contests. He was inducted into the International Boxing Hall of Fame in 1960 as 'the Welsh Wizard.' The tribute went on to state that from a base in America he fought all the leading American boxers – 'legends such as Johnny Dundee, Battling Nelson, Rocky Kansas and Johnny Kilblane.'

WELSH AMAZON (1696-1788 or 1801) Mared ferch Ifan, Margaret Evans of Nantlle Vale was the innkeeper at the Telyrniau Inn, Gelli, during the great Drws-y-Coed copper-mining operations. She later rowed copper across Llyn Padarn to Penllyn near Llanberis. She was also a blacksmith, shoemaker, harp-maker and boat-builder. A great huntress, she was more than the equal of all the local men, and was recorded as beating up her husband Richard Morris.

WELSH COSTUME The traditional Welsh costume seems to be a survival from Stuart times, which lasted so long in remoter parts, that eighteenth-century English travellers took it to be the national costume. The last sighting of a lady wearing the tall hat seems to have been in 1871 at Llancattwg by Kilvert, and it was still common in Cardiganshire in the 1860's, but dying out in North Wales. The tall, originally beaver, hat had a narrower brim and taller crown in West Wales than in Monmouthshire. The white lace cap worn under the the hat has four rows of goffered frills over the ears, but does not show on the forehead. The dress consists of 'ffedog, pais a betgwn' ('apron, petticoat and gown'). The gown is looped up and pinned behind, or has a tight bodice with a basque. There should be many petticoats, with the top one being usually striped or checked. The aprons are plain white, striped or checked. A shawl (fichu) is worn over the shoulders, and crossed in front and secured at the waist, or tucked into the bodice. Buckled shoes were worn for best, but clogs for everyday wear. Some of the old costumes have been passed down through generations, and some can be seen at The Museum of Welsh Life, Saint Fagans.

WELSH DEVELOPMENT AGENCY (WDA) Wales has a history of creating businesses – the largest shipping corporation in the world, Lloyd's of London, Lloyds Bank, and the stores of Dickins and Jones, Owen Owen, D.H. Evans, Mary Quant, Iceland, Laura Ashley, Lewis's of Liverpool and John Lewis/Waitrose, the last being a very successful partnership of employees. Robert Owen was the founder of the Co-operative Movement. However, since the last war, Wales has only seen the decline of its economic base. The Welsh Development Agency, a quango, was responsible for regenerating the Welsh economy. The WDA was partially successful in attracting foreign firms to Wales, but most have left and the rest have cut back their operations. Indigenous industry has not been assisted, as EU law does not allow this. Other European countries have constantly ignored moronic laws, e.g. the French Government has consistently subsidised its indigenous car industry, so Peugeot, Citroen and Renault still exist in French ownership, with French cars made in France. In Britain, there is no indigenous car industry remaining. The WDA has now been incorporated into the Wales Assembly Government, but still seems ineffective.

WELSH LANGUAGE ACT 1993 This established the principle that Welsh and English should be treated on equal terms in the courts, and in local and central government administration.

WELSH LANGUAGE BOARD A quango set up to encourage more people to speak Welsh, its pronouncements of success seemingly relate to Welsh learners, not to the more widespread use of Welsh as a first language.

WELSH NATIONAL OPERA This was founded in 1946 as an amateur organisation, became professional in 1967, and now employs more than 250 people as one of the most important operatic ensembles in the world. It has had minimal help from the British Government and National Lottery, unlike all the London-based opera companies. The WNO was the holder of the first opera 'Oscar' in the International Music Awards of 1993, for the production of Debussy's *Pelleas and Melisande*. It is now based in the Wales Millennium Centre in Cardiff Bay.

WELSH NOT, NOTE, KNOT This is the reminiscence by Owen Edwards (1858-1920) of the 'Welsh Not'. I have taken Meic Stephens' admirable translation from Edwards' *Clych Atgof* of 1906. This piece of writing still brings tears to my eyes as I think of the systematic abuse of native children, and the natural cussedness and nobility of people like Owen Edwards who kept the language alive against the wishes of authority: 'The school was in Y Llan (Llanuwchllyn, near Bala), a few miles from where I lived. It belonged to the landowner, as did almost the entire district, and his wife, a tall dignified lady, took a great interest in the education of the locality. When I first went to the school it had a schoolmistress. I was taken to the school-house; school had already begun and not a child was to be seen in Y Llan. The schoolmistress appeared, a small woman with piercing eyes, her hands folded in front of her. She spoke a little Welsh, the common people's language, with an English accent; her language, obviously, was English, the gentlefolk's language, the language of the parson from Cardiganshire. She could smile only when speaking English. Her face was very sour because she was forced to degrade herself by speaking Welsh; indeed, it was a sourness I always saw in her countenance, except when her thin face wore a smile to meet the generous lady who paid her wages. I did not listen to her words, and I did not like her face; it brought to mind the nose of a she-fox that I saw once, close up, after dark.

'My boy,' said my mother, 'here is your new teacher. Look at her, take the peak of your cap from your mouth, she is going to teach you everything. Shake hands with her.' She offered me her hand, with a weak smile dying on her face – 'Oh, we shall,' she said (in Welsh), 'we'll teach him everything he needs to know; we'll teach him how to behave.' It was not to learn how to behave that I wanted, but how to make a bridge and build a chapel. A great desire came over me to go home with my mother; but it was with the schoolmistress I had to go. The school's door was opened; I heard a strange din, and I could see the children packed tight on many benches. There were two open spaces on the floor of the school, and I could see two people on their feet, one in each open space. I understood later that they were the assistant master and mistress. The schoolmistress took me to one of them, but I only recall the words 'a new boy' from what she said. I could read Welsh quite well by then, and I was put in a class of children who were beginning to read English. The reading book was one of the SPCK's, and I still loathe those letters, on account of the cruelty I suffered while trying to read from that book.

The teacher was a pleasant fellow, and he was kind to me, but after the reading-lessons he went back to his other pupils. The word soon went round that someone new, and ridiculous at that, had come to the school. Several of the cruel children had their eye on me – I knew about them all, loud-mouthed children from Y Llan most of them were, and they never amounted to much. The teacher had whispered to me not to speak a word of Welsh; but these naughty boys did all they could to make me raise my voice, and in the end they succeeded. I lost my temper and began to speak my mind to the treacherous busybody who had contrived to torment me. As I began to speak my rich Welsh everyone laughed, and a cord was put around my neck, with a heavy wooden block attached to it. I had no idea what it was, I had seen a similar block on a

dog's neck to stop it running after sheep. Perhaps it was to prevent me from running home that the block was hung round my neck? At last it was mid-day, the time to be released. The schoolmistress came in with a cane in her hand. She asked a question, and every servile child pointed a finger at me. Something like a smile came across her face when she saw the block around my neck. She recited some long rhyme at me, not a word of which I could understand, she showed me the cane, but she did not touch me. She pulled off the block and I understood that it was for speaking Welsh that it had been hung around my neck.

That block was around my neck hundreds of times after that. This is how it was done, – when a child was heard uttering a word of Welsh, the teacher was to be told, then the block put around the child's neck; and it was to stay there until he heard someone else speaking Welsh, when it was passed on to the next poor child. At school's end the one who was wearing it would be caned on his hand. Each day the block, as if by its own weight, from all parts of the school, would come to end up around my neck. Today I take comfort from the fact that I never tried to seek respite from the block by passing it on to another. I knew nothing about the principle of the thing, but my nature rebelled against the damnable way of destroying the foundation of a child's character. To teach a child to spy on a smaller one who was speaking his native language, in order to pass the punishment to him? No, the block never came off my neck and I suffered the cane daily as school drew to its close.'

This sad enforcement pattern, taking the language out of the children, was repeated all over Wales for decades, as Victorian England tried to standardise its nearest piece of Empire. In 1799, a traveller to Flintshire noted the education system: 'If therefore, in the colloquial intercourse of the scholars, one of them is to be detected in speaking a Welsh word, he is immediately degraded with the "Welsh lump", a large piece of lead fastened to a string, and suspended round the neck of the offender. The mark of ignominy has had the desired effect: all the children of Flintshire speak English very well.' In 1804, John Evans wrote that 'North Wales is becoming English' and Benjamin Hakin stated 'The language of Radnorshire is almost universally English. In learning to converse with their Saxon neighbours, they have forgotten the use of their vernacular tongue.'

WELSHPOOL Y Trallwng has had a town market since 1263 and holds the largest livestock sales in Wales. The town is full of Georgian and earlier buildings.

WELSHPOOL, THE BATTLE OF, 1400 Owain Glyndŵr's small force was defeated by Henry Burnell at the start of the Great Liberation War.

WELSHPOOL CASTLE Known as Domen Castle, this was the royal seat of Powys before Powis Castle was built. It may have been built in 1111 by Prince Cadwgan ap Bleddyn of Powys. It was taken by the Normans in 1190, and retaken by Gwenwynwyn of Powys. His son Gruffydd plotted against Llywelyn II in 1174, and imprisoned Llywelyn's messengers. Llywelyn destroyed the castle and placed his own men in Gruffydd's territories.

WEOBLEY CASTLE Probably built around 1300, it stands on the Gower Peninsula, and was transformed into a defensive mansion by Sir Rhys ap Thomas around 1500.

WESTON, SIMON, OBE (1961-) Welshman Simon Weston is the visible face of the 1982 Falklands fiasco to Wales – the agonies he suffered from his burns and later operations were recorded for posterity and should be shown to all children contemplating a career in the armed forces, or to any English ministers subsidising arms companies. Forty-three Welsh Guards died on *Sir Galahad*, even though its captain had been implored to disembark the soldiers from his ship, which was a sitting duck target for Exocet missiles. Most of those soldiers were forced to join the army because no other jobs existed for them in Wales. The charity Weston founded in 1988, *The Weston Spirit*, helped deprived youngsters, but collapsed in 2008.

WHISKY American whisky owes its roots to Welsh settlers. Welsh whisky was made from around 365 CE. There was a monastery distillery on Bardsey Island, where whisky was first produced by the monk Rhaullt Hir , but manufacture gradually died out in Wales because of the growth of nonconformist religion (whereby enjoyment was deemed sinful), and by increasing taxation. Irish and Scottish distillers were far enough away from London to disguise or hide their production figures, so whisky today is now associated with those countries. Whisky was started off by fermenting barley, as in today's bourbon whisky, because of the prevalence of barley in Wales. In fact, whisky was distilled beer without hops. Whisky was first used as a medicine, and the distilling process found its way to Ireland with the interlinking with Irish monks, and thence it crossed to the Scottish Western islands. Most later Welsh production was in Pembrokeshire and Cardiganshire, often by farmers using their excess barley. The largest whisky distillery in Wales, R. J. Lloyd Price's 'Royal Welsh Whisky' in Bala, opened in 1887 and closed down in 1906, but at one time was so important that it had a railway line leading to it. Price presented a cask to Queen Victoria when she stayed at nearby Palé Hall. Edward VII was also presented with an enormous commemorative cask of the whisky, on a visit to Bala in 1894. The disused Frongoch works was used to house German prisoners-of-war, and then to imprison Irish rebels after the Easter Rising of 1916. From June in that year until his release in December, internee number 1320 spent his time learning Welsh and devising guerrilla tactics. His name? Michael Collins. Whisky manufacture has been resurrected by a Brecon company, whose original owner, Dafydd Gittins saw an old bottle of Bala whiskey in a bar at Ruthin Castle. The production is now controlled by MDT International, which is targeting Prince of Wales whisky to countries 'where the royals are popular.' There is also a tradition of whisky distilling in Brittany – my favourite is bottled in Lannion, with a label of the black and white Breton nationalist/Finistère colours.

As a result of emigration, the first whisky distillery in America was started by the Evan Williams family, from West Wales, in Bardstown, Kentucky in the early 1700's. They left the family distillery in Dale, Pembrokeshire to set it up, and Bardstown was named after Bardsey Island, the birthplace of whisky. It is still one of the largest distilleries in the USA, selling 2,000,000 cases a year. Kentucky Bourbon dates from this time. Eighty years later, in the early 1800's, the Daniels family from Cardigan, with another Welsh family, the Molows, started up production of the Jack Daniels brand in Lynchburg, Tennessee. In 1866, Jack Daniels became the first registered distillery in the USA. Jack Daniels was born in New York of Cardiganshire parents. The current president of the company is Lem Molow. Jack Daniels Old No.7 Sour Mash is known worldwide. Southern Comfort is also a drink of Welsh origin, first distilled by settlers from a traditional Welsh recipe.

WHISKY GALORE – THE WELSH VERSION On 30 January 1894, the *Loch Shiel* ran into Milford Haven for shelter, carrying whisky to Australia. It was wrecked on the rocks off Thorn Island, near Angle. When the boat broke up, its cargo of bottles of whisky and barrels of gunpowder started to drift into Angle Bay. The Angle lifeboat saved the twenty-seven-man crew, but most of its cargo had been secreted away by villagers. Some looters carted away the barrels, thinking them to be full of whisky. Women packed the legs of their bloomers with bottles, knowing that the Customs and Excise men would not dare to look there. Three people died, two from alcoholic poisoning and one from drowning while trying to gather the whisky. The film *Whisky Galore*, based on a story by Compton Mackenzie, may have been inspired by the wreck of the *Loch Shiel*. In 1999, bottles from the wreck were auctioned for £1,000 per bottle. Angle has The Old Point House Inn, cut off by high tides, which was once used by the pirate John Callice.

WHITE CASTLE (LLANTILIO CASTLE) Outside Llantilio Crossenny in Monmouthshire, it was once painted white, and was one of the Gwent trilateral of castles along with Skenfrith and Grosmont. Moated, it was built in the twelfth-thirteenth century and is a superb example of castle-building.

WHITE, GREY AND BLACK MONKS Fifteen abbeys and priories in Wales commemorate

the Cistercian Order, the White Monks. The Grey Friars (the Franciscans), and the Black Friars (the Dominicans), had eight friaries in Wales by 1275. At this time, Llywelyn the Last had cordial relations with most of these foundations, and the Cistercians commended him to the Pope in his dispute with the Bishop Anian of St Asaf.

WHITLAND ABBEY Founded in 1140 by the Bishop of St David's, Cistercian monks came from Trefgarn, and Whitland became the mother abbey to Cwmhir, Strata Florida and Strata Marcella. The abbey was originally near Carmarthen but moved west to Whitland in 1257, as the Norman lords of Carew and Cemais had stripped the abbey and killed its servants for supporting the Welsh in that year. It also suffered in Edward I's later invasion. Somehow the *Cronica Wallia*, the most valuable monastic chronicle of the period, escaped destruction. Near its ruins are the Hywel Dda commemorative gardens and centre.

WILDE, JIMMY (1892-1969) Jimmy Wilde, variously known as 'The Tylorstown Terror', 'The Ghost with the Hammer in his Hand', or 'The Mighty Atom', was flyweight champion from 1916 until 1923. He lost only 4 fights out of 464. From Quakers Yard, he fought as a flyweight, against men weighing up to 8 stone, but his natural weight was only 6 stone 4 pounds, and he could only ever 'bulk up' to 7 stone 4 pounds. He became World, European and British Champion, beating boxes like Jack Sharkey and Young Zulu Kid in the USA. Gene Tunney called Wilde 'the greatest fighter I ever saw.' He had the longest reign of any undefeated world flyweight champion, of over 7 years. *Boxing Illustrated* in 1993 rated him 'the hardest pound for pound boxer in history', and he is still regarded as the greatest flyweight champion of all time. He won 89% of his fights by knockout and this author is privileged to have met him. Wilde's record between 1910 and 1923 reads: fought 864 times, lost 3 (including 2 of his last 3 fights, one for the heavier World Bantamweight title). He had not fought for 2 years before the much younger Pancho Villa beat him, courtesy of a late low blow after round 2, to take the World Flyweight Championship in 1923. Villa is usually voted the second greatest flyweight of all time.

WILLIAM RUFUS Having utterly failed in his attack in 1094, King William II led another full-scale invasion in 1097: 'William moved a great host without number against the Britons. And the Britons, placing their trust in the Lord of Heaven, avoided the assault of the French. And the French returned home dejected and empty-handed.' *The Chronicle of Ystrad Fflur* noted his death in 1100 thus: 'In this year died William, king of England, who would do nothing just, nor anything that appertained to the commandments of God. He died without heir because he had always used concubines.'

WILLIAMS-ELLIS, CLOUGH (1883-1978) He built the surreal Italianate village, Portmeirion, between 1922 and 1975. The cult 1960's series, *The Prisoner*, starring Patrick McGoohan, was set here, and Portmeirion has been described as 'one of the world's strangest villages'. It was inspired by the architect's many visits to Portofino, and its colourful exterior disguises some important pieces of salvage, such as the ballroom from Emral Hall, now installed in the 'Town Hall'. In the 175 acres of subtropical gardens overlooking the sea, one passes through a gatehouse into a world of grottoes, colonnades, a campanile, a watchtower, and a variety of buildings ranging from Baroque to traditional Welsh, from Classical to Gothic. Williams-Ellis wrote 'Some day, somewhere, I would even assuredly erect a whole group of buildings on my own chosen site for my own satisfaction; an ensemble that would body forth my chafing ideas of fitness and gaiety and indeed be me.'

WILLIAMS, DANIEL POWELL (PASTOR DAN) (1882-1947) Born near Pen-y-Groes in the Amman Valley, he was the founder and first President of the Apostolic Church, the only Welshman to have established a worldwide church. First formed in 1916 as a result of the 1904 Welsh revival, the Apostolic Church is a Trinitarian, Pentecostal denomination with a strong

commitment to mission. There are Apostolic movements in over forty countries, many of which are self-governing. Within the UK the Apostolic Church is represented by approximately 110 churches. The national conference is held annually in Swansea, South Wales and has visitors from several countries attending.

WILLIAMS, DAVID (1738-1816) The minister David Williams, who founded the Royal Literary Fund, was born at Eglwysilian near Caerphilly in 1738. A friend of many eminent thinkers, in 1777 he gave refuge to Benjamin Franklin when he stayed in Wales. Williams advanced Price's philosophy that parliamentarians are trustees of the people, in his *Letters on Political Liberty* in 1782. He defended the American colonists and outlined a schedule for revolution and radical reform. Its French translator was imprisoned in the Bastille. These opinions were regarded so highly that he was asked to become a French citizen by French revolutionaries and to take a seat in their Convention of 1792. He refused, although he accepted an invitation by the Girondists to criticise and amend the draft of the First Constitution of the French Republic. While in Paris the French Foreign Minister, Le Brun, asked Williams to make overtures for peace with England, and he was made an honorary citizen of France. He founded the Royal Literary Fund.

WILLIAMS, EVAN JAMES, FRS (1903-1945) In 1937, Evan Williams of Llanwenog near Llandysul made one of the most important discoveries in physics, detecting a new fundamental particle, the meson. He recognised the pi-meson in Aberystwth using one of the earliest types of cloud chambers. To ensure academic and scientific integrity, he waited for the detection of another particle before publishing. In the meantime, the American, Anderson, detected the particle, did not wait for the expected confirmation, published a paper within a month and received the Nobel Prize. This dash for publicity has echoes in the recent American detection of 'life' in pieces of rock from Mars. Williams was a brilliant user of a new sort of mechanics, quantum mechanics, and was the first to predict the existence of the new atomic particle. Yet again, Wales had no recognition on the world scene.

WILLIAMS, GRACE MARY (1906-1977) Born in Barri, she studied music under Ralph Vaughan Williams and in Vienna, and wrote symphonies, concertos and song cycles, refusing the OBE and a Civil List pension.

WILLIAMS, KYFFIN, RA (1918-2006) From Llangefni in Anglesey, Williams used wedges of oil paint to give the strength of the rocky landscapes and sheep farmers of Snowdonia - his work, like Josef Herman's, is instantly recognisable. He sought to find 'the mood that touches the seam of melancholy that is within most Welshmen, a melancholy that derives from the dark hills, the heavy clouds and the enveloping sea mists.' Kyffin was still actively painting until his death. His two-volume autobiography, and his books *Portraits* and *The Land and the Sea* reveal a great painter, who states 'I was lucky that I was born into a landscape so beautiful I had no need to go elsewhere. There was never any question of what I should paint.'

WILLIAMS, MARGARET (MEGAN) THEODOSIA A ship from Oregrund, Sweden, was wrecked on the Bishops and Clerks Islands in 1780. The crew was said to be rescued by Megan, when she rowed in heavy seas to save them.

WILLIAMS, RALPH VAUGHAN (1872-1958) Of Welsh stock, he was the central figure in the British musical rebirth of the first half of the twentieth century. The *Five Tudor Portraits* and *The Pilgrim's Progress* are fine works among his many symphonies and operas.

WILLIAMS, RAYMOND (1921-1988) Born near Abergafenni, his 1958 book *Culture and Society* redefined culture as a much wider phenomenon than was generally perceived. His rationalisation of the validity of 'popular culture' enabled the discipline of cultural studies to emerge.

WILLIAMS, SIR ROGER (1539/40-1595) From Penrhos in Monmouthshire, he was a soldier of fortune, his first battle being at St Quentin, aged just seventeen. He seems to be the model for Shakespeare's Fluellen. Williams served Spain's Duke of Alva, under General Thomas Morgan in the Low Countries from 1572, fighting at Goes (Tergoes) and the siege of Flushing. Then he served the Duke of Conde against Spain before fighting with Sir John Norris and the Earl of Leicester in the Netherlands. Leicester wrote in 1585: 'Roger Williams is worth his weight in gold, for he is no more valiant than he is wise and of judgment to govern his doings' and Williams was knighted. In 1586, Williams and the Dutch General Scheuk with 160 men fought their way into the Spanish camp as far as Parma's tent before retreating in the face of 2,000 Spanish troops. In that year he was at Zutphen where Sir Philip Sidney died. The Duke of Parma tried to get him to fight for Spain again, against the Turks, but he became Master of the Queen's Horse in 1588, before serving with Willoughby in the Low Countries, with Henry of Navarre in France, and with the Earl of Essex in the raid on Lisbon and at the Groine as Colonel-General. In 1591, serving the Duke of Navarre, he routed Catholics at Dieppe, and in the same year with only 600 men forced the bloodless surrender of Aumale. In 1592 at Rue he personally killed the Albanian leader, George Basti, and pamphlets of his exploits were printed in London. He wrote two books of his actions and was received at court by Elizabeth I in 1595, before succumbing to a sudden illness and being buried with pomp in St Paul's Cathedral.

WILLIAMS, ROWAN (1950-) The first Welshman to become Archbishop of Canterbury (2002), this eloquent Welsh-speaker was born in Ystradgynlais and became a professor of Oxford before being appointed Bishop of Monmouth and then Archbishop of Wales in 1999.

WILLIAMS, WALDO (1904-1971) 'The Poet of Mynachlogddu' (on the Preseli Hills), was a superb Welsh language romantic poet, imprisoned more than once for his pacifism. In the 1950's he refused to pay his income tax while conscription to the armed forces still existed, so bailiffs took away his furniture. He gave up his teaching job, because income tax was deducted from his pay, an element of which went on military expenditure. He despaired of the loss of the Welsh language in the Preseli area, and stood as a Plaid Cymru candidate in 1959.

WHITTINGTON CASTLE, SHROPSHIRE This border castle is an important site in Welsh history, on a triple-banked Iron Age site. Around 600 it was possibly the site of Llys Pengwern (Head of the Marsh), a capital of the Welsh kingdom of Powys. (Pengwern was probably Shrewsbury.) In 656, the Northumbrian Saxons destroyed Llys Pengwern, home of King Cynddylan of Powys, who was buried at nearby Eglwys Bassa (Baschurch). William de Peveril built a Norman motte and bailey earthwork castle within the northern end of the Iron Age fort, and it saw action several times. In 1223, Llywelyn the Great besieged it, as he expanded his princedom into Powys and the Welsh Marches. In 1265, Henry III lost it to Llewelyn ap Gruffydd along with several other border strongholds, but in 1282 it was restored to the Fulk-Warins after the ambush and death of Llewelyn ap Gruffydd.

WILLIAMS, WILLIAM (1717-1791) William Williams of Pantycelin was renowned as Wales' finest poet, along with Dafydd ap Gwilym. An evangelist, he was known as 'Y Per Caniedydd' (the Sweet Singer') and as the first Romantic poet in Wales. Besides superb prose, he wrote over 900 hymns. He was famed throughout Wales as *Pantycelyn*, and *Cwm Rhondda*, his most famous hymn, was originally written in Welsh by Ann Griffiths:

> Guide me O Thou Great Jehovah (Redeemer),
> Pilgrim through this barren land;
> I am weak but Thou art mighty,
> Hold me with Thy powerful hand
> Bread of Heaven, Bread of Heaven,
> Feed me now and evermore,
> Feed me now and evermore.

WILLIAMS, WILLIAM (1726-1791) Called 'the first flower of American culture' and a 'forgotten genius', this privateer was marooned among the Rama of the Miskito Coast in Nicaragua, an experience which gave him the background for *The Journal of Penrose, Seaman*, which is by some years the 'first American novel', an anti-slavery factional account set in the rainforest, and the first story of buried treasure. He inspired and taught the great Benjamin West RA to paint, built the first permanent theatre in America, and was also a poet, painter and music teacher. For further information on this fascinating character and a book which kept Lord Byron up all night reading it, see this author's 2007 '*The First American Novel: Part I The Journal of Penrose, Seaman; Part II The Book, The Author and the Letters in the Lilly Collection.*'

WILLOWS, ERNEST (1886-1926) The '*Father of British Airships*' was born in Cardiff. In 1905, he built his first airship on a playing field in Cardiff's Splott district, and went on to build another four, inventing the variable directional propeller. In 1910, he became the first man to fly a powered aircraft across the Bristol Channel, taking 10 hours, and later that year predicted long-distance travel across the Atlantic for airships. In 1910, less than a year after Bleriot's first powered aircraft crossing across the English Channel, Willows flew his airship *City of Cardiff* from London to Paris. Asquith, Churchill and Lloyd-George watched the takeoff, and the next day he landed in Douai, 100 miles from Paris. He was arrested for non-payment of £30 customs charges. Later, he was carried shoulder-high after landing in Paris, aged just twenty-four. Lacking financial backing, after serving in World War I as a captain in the Royal Flying Corps, Willows ran a barrage balloon factory in Cardiff's Westgate Street. Flying a balloon at a fête in Bedfordshire, the basket broke away and he died aged only forty.

WILSON, RICHARD (1714-1782) Mold-born Richard Wilson, the eighteenth-century landscape artist, was influenced by Claude and Poussin and studied in Italy, and is best known for his scenes of Snowdon and Cader Idris. Wilson co-founded The Royal Academy in 1768, and was championed by Ruskin, but died in poverty. The largest collection of his pictures is in Cardiff, but he is represented in art galleries and museums from Adelaide to Berlin, and from Harvard to Hanover. As John Constable said 'He was one of those appointed to show the world what exists in nature but which was not known till this time,' and Wilson is considered by many to be the true 'father' of English landscape painting.

WIND FARMS Wind turbines are desecrating the remaining unspoilt landscapes of Wales, eyesores in a nation whose only business is tourism. They would not be allowed in areas like England's Lake District, Cotswolds, Chilterns or Peak District. Wales has been stripped of all its minerals, its rocks are being gouged out for building materials, its beaches declining to a point of no return because of sand extraction, its hills covered by the foreign pines of the Forestry Commission, its valleys drowned for foreign-owned water suppliers and now even its air is being taken and its landscape ruined. Hugely subsidised wind power makes no sense in any economic or environmental cost-benefit analysis. The Cefn Croes Wind Farm in the Cambrian Mountains ranks with Trywerin and Clywedog as another shaming disgrace forced upon Welsh people. Wales, for its land area, has more than ten times the amount of wind turbines as England, with far more planned. To meet basic EU targets, there would have to be 12,500 wind farms across Great Britain, which informs one a great deal about the common sense of the policy. Not one nuclear, gas or coal-powered electricity generation station will be decommissioned because of wind power, as wind is intermittent and electricity cannot be stored. Wind turbines will be seen as one of the great economic and political scandals of our times. The RSPB receives a subsidy for supporting wind farms, despite the deaths of countless thousands of raptors to their 180 mph blades. Buzzards and kites are not used to being attacked, and the death statistics that we know of are disgraceful.

WINE In mediaeval times, monasteries produced wine, and before that the native Welsh princes had their own vineyards. In more recent times the Marquess of Bute had large vineyards near Castell Coch. Some of the following vineyards are open to the public. Llanerch Vineyards

near Hensol, which makes white and rose wine and elderflower cordials is for sale. Andrac of Llanvaches, Gwent makes quality sparkling wines. Cwm Deri of Narberth produces white and red country wines and mead, and Tŷ Brethyn near Llangollen makes traditional meads and fruit wines. Other vineyards are Glyndŵr at Cowbridge, Brecon Court at Usk, Tintern Parva at Tintern and Sugar Loaf at Abergavenny.

WISTON CASTLE A well-preserved motte and bailey castle outside Haverfordwest, it was built by a Flemish settler named Wizo before his death in 1130. It was taken by Hywel ab Owain in 1147, and then in 1193 fell to Hywel Sais, the son of The Lord Rhys. Retaken by the Normans in 1195, Llywelyn the Great took it in 1220 and burnt the town around it. It was then abandoned, but the remains of the stone keep are still impressive. One of the best examples of a motte and bailey castle in Wales, it is one of only six with a stone keep on the summit of the motte. It is on the site of an Iron Age settlement.

WOMEN'S RIGHTS Celtic women, such as Buddug (Boadicea) of the Iceni, and Cartimandua of the Brigantes, held real power. In Europe, Queen Teuta fought the Greeks and Romans between 71 CE and 83 CE. Women landowners in Ireland were expected to fight as warriors until saint Adamnan forced a change of the laws in the sixth century. Women in Celtic Gaul were butchers, chemists, doctors and sellers of wine. This equality passed down and was enshrined in the *Laws of Hywel Dda*, who codified the old Welsh laws. In medieval times, Welsh women had amazing rights compared to all their European contemporaries. The union of marriage was a contract rather than a sacrament, whereby the woman received property which remained hers completely and in perpetuity, the exact opposite of the dowry system practised elsewhere. She had equal rights in a divorce case, and if married for seven years, could leave her husband with half of his property. The widow had the same rights on a husband's death, and she could make a will leaving property. In England, women had no right to hold property apart from her husband until an act of 1882. In the nineteenth century, Ernest Reuan wrote: 'It was through the *Mabinogion*' (possibly written by Gwenllian) 'that the Welsh influence influenced the Continent; it transformed, in the twelfth century, the poetic art of Europe and realised this miracle, that the creation of a small nation which had been forgotten had become a feast of imagination for mankind over all the earth... Above all else, by creating woman's character the Welsh romances caused one of the greatest revolutions known to literary historians. It was like an electric spark; in a few years the taste of Europe was transformed.' He carried on to say that this was the first flowering of chivalry that helped raised the status of women in Europe. In 1865, the Welsh colony in Patagonia was the first society anywhere in the world to give women the vote.

WOODBURY HILL 1405 This was the last real invasion of England. Owain Glyndŵr and his French allies invaded England, sacked Worcester and waited on Woodbury Hill for supporters to join who resented Henry IV's usurpation of the English crown, and for Henry IV's army to appear. There was some chivalrous skirmishing in the valley between the armies before Henry retreated back to Worcester. Lacking supporting logistics and an enemy to fight, Glyndŵr returned to Wales. He knew that he could not count on support if he invaded England with a French army – his only hope was to kill Henry IV in battle. After this, Henry IV gathered his strength and again invaded Wales.

WORLD WAR I 100,000 Welshmen had joined the armed forces by May, 1915. 35,000 of the 272,000 Welshmen who eventually fought in the Great War died, with Welsh forces distinguishing themselves in the carnage at the Somme and Mametz Wood.

WREXHAM Wrecsam, near the border, is the most important town in North Wales, and its cattle sales made it a centre for leather working. In the nineteenth century, the industries of brick-

making, coal, steel and brewing helped it to prosper. Britain's first lager was made at the Wrecsam brewery, and Wrexham Lager was for many years the only draught beer available on British ships, as beer spoiled at sea. St Giles Church has the grave of Elihu Yale and its 136ft tower is one of 'the Seven Wonders of Wales'.

WRIGHT, FRANK LLOYD (1867-1959) Frank Lloyd Wright, the leading twentieth-century architect, along with Le Corbusier, was so proud of his Welsh heritage that he called the Wisconsin home he built for himself, Taliesin, after the legendary Welsh bard. Another home and school, Taliesin West, was built near Phoenix, Arizona in 1938. A controversial and daring architect, his weekend home of Falling Water (near Pittsburgh) is famous worldwide, as are the earthquake-proof Imperial Hotel in Tokyo, and the brilliantly designed Guggenheim Museum of Modern Art in New York. His mother had been born in Llandysul and his Welsh upbringing is described lovingly in his sister's book 'The Valley of the God Almighty Joneses' He used Iolo Morganwg's motto of 'Y Gwir yn Erbyn y Byd' (Truth Against the World) and is regarded as 'America's Greatest Architect of All Time'.

WROXETER Viroconium in Shropshire was the palace of the Prince of Powys, Cynddylan, and its burning by Saxons is commemorated in a Welsh epic poem of the seventh to eighth century.

WYNNE-EDWARDS, VERO (1906-1997) According to his obituary (*The Independent*, 11 January 1997) he was 'one of the 20th century's greatest scientific naturalists and original thinkers on population regulation in animals' His 1962 publication *Animal Dispersion in Relation to Social Behaviour* sold an astonishing 350,000 copies world-wide. His thinking was that animals are not always trying to increase their numbers, as Darwinism indicated, but that they are programmed to regulate them by various mechanisms such as territorial behaviour and social displays. He is regarded as one of the twentieth century's greatest scientific naturalists.

WYNNSTAY On the site of the great house of Madog ap Gruffydd Maelor, the founder of Valle Crucis Abbey, is Wynnstay, the seat of the famous Watkin Williams-Wynne family for centuries. As at Llanover Court, this family kept a harpist until the late nineteenth century. Its Grade I Listed kitchen garden is part of a landscaping programme carried out by Capability Brown in 1777-1783.

YALE, ELIHU (1648-1721) The son of a Wrexham man, he was born in America and made his fortune as Governor of Madras, settling back in Britain and buried in St Giles, Wrexham. In 1718 he made the contribution which set up the collegiate school of Connecticut, which became Yale University. The tower of Yale University's Chapel is based upon St Giles' Tower.

YEWS 'Ywen', the Welsh name for the yew tree, was one of the very, very few Welsh worlds that passed into English. Wales has the largest collection of ancient yews in the world, and many churchyard sites with yews bearing over 23ft circumference of trunk. An old phrase was referring to death as 'gorwedd dan yr ywen' (sleeping under the yew). Another saying was 'Is yr Ywen ddu ganghennog dwmpath gwyrddlas cwyd y ben' (Under the black-green branching Yew a grassy mound is soon raised.' Kilvert often described Wales' black yews, for example at Cae Noyadd, Llanvareth and Capel-y-ffin. Early saint sites often have trees of over 30ft girth, e.g. a 39ft yew at St Afan's, Llanfan Fawr. The yew at Llangernyw Church is one of the ten oldest in Britain, and there are similar yews dating from around 1500 years ago, 'The Age of the Saints', at Llansantffraid-in-Elwell, St Brides-super-Ely and Llansantffread in Gwent. Many have been destroyed or removed, but their sites date from the circular llan, before it was replaced by rectangular churchyards. Yew circles are to be seen at some of these sites, e.g. at Overton-on-Dee. Circles of large yews, with up to forty trees of over 16ft girth in a circular churchyard, are unique to Wales, not recorded anywhere else in Britain (except possible remnants at Ashford Carbonnell in Shropshire, once

part of Wales). There are holy yew circles at Halkyn, Cefnllys, LLanspyddid, Nantmel, Llanelly in Brecon, Llanddwywe, Llanycil, Llanfeugan, Llanfihangel-nant-melan, Llanbedr-ystrad-yw at Cwm-du Church and Nantmel.

YNYS PADRIG Middle Mouse Island, the most northerly point of Wales off Anglesey, owes its Welsh name to the legend that St Patrick was shipwrecked there.

YNYS ENLLI Bardsey Island, Ynys Enlli ('The Isle of 20,000 Saints'), can be reached from Aberdaron in a two-mile sea trip. A monastery was founded there in 615, by St Cadfan, but it seems that there was a holy settlement well before that date, as it was an important pilgrimage site at least since the sixth century. It is the reputed burial place of Merlin, and three pilgrimages there were equivalent to one to Rome. A fourteenth-century stone house, 'Y Gegin Fawr' ('the Big Kitchen'), in Aberdaron was where pilgrims rested and ate their last meal before crossing the treacherous waters. In a rock at the foot of Mynydd Mawr facing Enlli is a well called 'Ffynnon Fair' ('Mary's Well') and the pilgrims used to walk down 'Grisiau Mair' ('Mary's Steps') to drink the sacred water, and say their last prayers before setting off from Porth Meudwy ('Hermit's Gateway') to the island. Many came here to die. Apart from the remains of an abbey and some Celtic crosses, there are many nesting seabirds such as Manx Shearwaters, choughs, fulmars and guillemots on the island. Two types of dolphin and leather-backed turtles can sometimes be seen. Wales' greatest living poet, R.S. Thomas, was minister at the twelfth-century Church of St Hywyn (a nephew of Arthur), in Aberdaron, until 'RS' retired in 1978. The church had been founded in the sixth century. Ynys Enlli is a SSSI, and is the sixth biggest Welsh island.

This most holy of Welsh islands was given to St Cadfan by Einion, King of Llyn. Saint Dyfrig and Saint Deiniol were buried here in the sixth century, and Saint Beuno in the seventh century. In 1781, Thomas Pennant wrote of its 'halo of sanctity' when being rowed to visit the island: 'The mariners of Aberdaron seemed tinctured with the piety of the place: for they had not rowed far, but they made a full stop, pulled off their hats, and offered up a short prayer...' Now there are only thirteen people living on the island, who have introduced Welsh Black Cattle to add to the sheep which have been there for generations. The Welsh name for Bardsey, Ynys Enlli, means 'Isle of the Currents', and the two-mile crossing, even by motorboat, has been known to take two hours. Its former name, Ynys Afallach (Isle of Apples), has been associated with Merlin and Avalon. A few years ago, a single stunted apple tree was found on the island, and has since been propagated for sale. It is said that this 'Bardsey Island Apple' dates from Arthurian times. Merlin was said to have hidden his treasure on the island, and Arthur was rowed there to be healed after his last battle with his cousin Mordred.

YNYS LLANDWDWYN Next to Llanddwyn Bay in Anglesey there is Ynys Llanddwyn, Llanddwyn Island, barely attached to the mainland, a nature reserve with breeding shags and cormorants, and St Dwynwen's holy well. It is seventy acres in size, and a SSSI.

YNYS SEIRIOL Off Eastern Anglesey is Puffin Island (Priestholm or Ynys Seiriol), with the site of a monastic settlement founded by St Seiriol in the sixth century. Puffins still actually nest there, but rats are becoming a problem for the birds that live in the burrows there. Ynys Seiriol is a SSSI (Site of Special Scientific Interest) and covers seventy-eight acres. Penmon Priory on the nearby mainland has a remarkable dovecote, and was founded by the St Seiriol and St Cynlas.

YSTRADOWEN (GWYR MAES) BATTLE OF, 1031 or 1032 From *A Topographical Dictionary of Wales by Samuel Lewis* (1833): 'YSTRAD-OWEN, or YSTRAD-OWAIN, a parish in the hundred of COWBRIDGE... Ithel, surnamed Du, or "the Black", Prince of Glamorgan in the tenth century, occasionally resided here; and this place is distinguished in the historical annals of the principality as the scene of a desperate battle between the invading Saxons and the ancient Britons under Conan ab Sytsylt, in the year 1031, in which that chieftain and all his sons were

slain. It derives its name from Owain ab Collwyn, who resided here in a palace, of which the site is marked by a large tumulus near the church, now covered with a thriving plantation. In a field near the village were two large monumental stones, rudely ornamented, which were supposed to have been placed at the head of the graves of Owain ab Ithel and his consort, and thence called the King and Queen stones; but they have been removed for some time. Near the churchyard, in a field adjoining it on the west, there is a very large tumulus, of which not even any traditional account has been preserved. An annual assembly of the bards was held here for many years, under the auspices of the ancient family of Hensol, and the meetings were continued till the year 1721, when the male line of that house became extinct...' The tumulus next to St Owain's Church is a Norman motte. The battle site is recorded on old maps in a field known as *Gwyr Maes,* and dated 1032. Ithel Ddu lived *c.*970-1041, and Cynan ap Seisyllt is recorded as dying in 1027.

YSTRAD RWNWS, BATTLE OF, 1116 In 1109, Prince Owain ap Cadwgan of Powys had seized Princess Nest from her husband, Gerald of Windsor. In 1115, he was knighted by Henry I for service in France. With a small force, he was on his way south from Powys, either to assist in a new Welsh rebellion, or to help put it down for the king. At the junction of the rivers Tywi and Cothi, Gerald's Normans ambushed him and he was killed, with Nest returning to her husband.

ZULU WARS The Victoria Cross is the highest award for gallantry in wartime. The greatest number of VC's awarded in a single action were won at Rorke's Drift over two days in 1879. This was shortly after a British army had suffered a massacre at Isandhlwana. The 1st/24th Foot Regiments had been annihilated, but a detachment of the 2nd/24th held out days later against the victorious Zulu Impi. Just eighty-two men, some wounded, manned the small mission hospital and supply depot, facing 4,000 Zulu warriors. Nearly 1,700 soldiers had been killed at Isandhlwana. Only twenty-seven men died at Rorke's Drift, fighting throughout their flaming encampment. The South Wales Borderers received a Full Battle Honour, and eleven Victoria Crosses were earned in the engagement. When the Zulus retreated, they sang to a brave, outnumbered foe, as encaptured in the 1961 film *Zulu,* directed by Stanley Baker and starring Stanley Baker and Michael Caine.

References

Too many sources have been accumulated over the years to include them all, and all the following books in my possession have been consulted for this work. The new *Welsh Academy Encyclopaedia of Wales* has not been used as the price of £65 for a subsidised book, printed in Malta, is not considered value-for-money. This author tried for many years to interest Welsh politicians and publishers in such a publication, before writing the first Welsh encyclopaedia, *An A-Z of Wales and the Welsh*, which itself took another three years to find a publisher and be printed. All relevant tourist authorities and centres were contacted for relevant photographs for this present work, and only the Vale of Glamorgan responded. Others did not respond or wanted large payments for reproduction rights. Thus, most of the pictures in the book are my own and mainly reflect where I have travelled in Wales since purchasing a digital camera. This *Historical Companion* is an extension of my *An A-Z of Wales and the Welsh* and my subsequent books, and any errors are entirely my own. For further information upon places mentioned in this book, *1000 Best Welsh Heritage Sites* will be published in Spring 2010.

Primary Sources

Breverton, T., *100 Great Welshmen* (Glyndŵr Publishing 2001, new edition 2006)
Breverton, T., *100 Great Welsh Women* (Glyndŵr Publishing 2001)
Breverton, T., *An A - Z of Wales and the Welsh* (Christopher Davies 2000)
Breverton, T., *The Book of Welsh Saints* (Glyndŵr Publishing 2000)
Breverton, T., *The Welsh Almanac* (Glyndŵr Publishing 2002)
Davies, J., *A History of Wales* (Allen Lane/Penguin 1993 hardback)
Evans, G., *Land of My Fathers - 2000 Years of Welsh history'* (Y Lolfa 1992)
May, J., (compiler) *Reference Wales* (University of Wales Press 1994)
The Rough Guide to Wales (1995 paperback)
Morris, J., *The Matter of Wales* (Penguin 1984 paperback)
Williams, G.A., *When Was Wales* (Penguin 1991 paperback)

Secondary Sources

The First American Novel - The Journal of Penrose, Seaman and The Author, The Book and Letters in the Lilly Library (Glyndŵr Publishing 2007)
Allen, J.R., *Celtic Crosses of Wales* (J.M.F. 1978 reprint)
Aneirin Y Gododdin (Gomer Press 1990)
Automobile Association and Wales Tourist Board *Castles in Wales* (hardback 1982)
Barber, C. & Pykit, D., *Journey to Avalon: The Final Discovery of King Arthur* (Blorenge 1993)
Beazley, E., & Brett, L., *North Wales* (a Shell Guide published by Faber in 1991)
Blamires, D., *David Jones: Artist and Writer* (Manchester University Press 1978 paperback)
Borrow, G., *Wild Wales* (Dent Everyman 1939)

Breverton, T., *Glamorgan Seascape Pathways* (Glyndŵr Publishing 2003)

Breverton, T., *The Secret Vale of Glamorgan* (Glyndŵr Publishing 2000)

Breverton, T., *The Book of Welsh Pirates and Buccaneers* (Glyndŵr Publishing 2003)

Breverton, T., *The Illustrated Pirate Diaries* (Harper Collins 2008)

Breverton, T., *Black Bart Roberts - the Greatest Pirate of Them All* (Glyndŵr Publishing 2004)

Breverton, T., *Admiral Sir Henry Morgan - the Greatest Buccaneer of Them All* (Glyndŵr Publishing 2004)

Breverton, T., *The Pirate Handbook* (Glyndŵr Publishing 2004)

Brooks, J.A., *Ghosts and Legends of Wales* (Jarrold 1987)

Brough, G., *Glyndŵr's War - the Campaigns of the Last Prince of Wales* (Glyndŵr Publishing 2002)

Brown, D.A., *Morgan's Raiders* (Smithmark USA 1995)

Carradice, P., & Breverton T., *Welsh Sailors of the Second World War* (Glyndŵr Publishing 2007)

Carradice, P., *The Last Invasion: the story of the French landing in Wales* (Village Publishing 1992)

Conran, T., (translator) *Welsh Verse*

Dafydd ap Gwilym (translated by Rachel Bromwich) *Selected Poems* (Penguin 1985)

Davies, N., *Europe - a History* (Pimlico 1997)

Davies, R.R., *The Revolt of Owain Glyn Dwr* (Oxford University Press 1997

Delaney, F., *Legends of the Celts* (Harper Collins 1989)

Delaney, F., *The Celts* (Harper Collins 1993)

Dixon-Kennedy, M., *Celtic Myth and Legend* (Blandford 1996)

Eluere C., *The Celts: First Masters of Europe* (Thames and Hudson - New Horizons 1996)

Fraser, M., *Wales Volume I: The Background' and 'Wales Volume II: The Country* (Robert Hale - County Books series 1952 hardback)

Gilbert, A., Alan Wilson and Baram Blackett *The Holy Kingdom: The Quest for the Real King Arthur* (Bantam Press 1998)

Gruffydd, W., *Folklore and Myth in the Mabinogion* (University of Wales Press 1950 pamphlet).

Gwyndaf, R., *Chwedlau Gwerin Cymru - Welsh Folk Tales* (National Museums & Galleries of Wales 1995 paperback)

Humphries, J., *The Man from the Alamao - Why the Welsh Chartist Uprising of 1839 Ended in a Massacre* (Glyndŵr Publishing 2004)

Humphries, J., *Gringo Revolutionary - The Amazing Story of Carel ap Rhys Price* (Glyndŵr Publishing 2005)

Jarman, A.O.H. & Hughes G.R., *A Guide to Welsh Literature - Volume I* (University of Wales Press 1992)

Jenkins D., (editor) *Hywel Dda; The Law* (Gomer Press 1990)

Jenkins, I., (editor) *The Collected Poems of Idris Davies* (Gomerian Press 1993) Michael Senior *Portrait of South Wales* (Robert Hale 1974)

Jones, J.G., *A Pocket Guide to the History of Wales* (University of Wales Press 1990)

Kightly, C., 'A Mirror of Medieval Wales: Gerald of Wales and His Journey of 1188' (Cadw 1988) hardback) - coffee-table quality at a soft-back price, a description of not just the journey, but of the Gerald of Wales (translated by Lewis Thorpe) *The Journey through Wales/The Description of Wales* (Penguin Modern Classics 1978)

Laing, L. & J., *The Origins of Britain* (Paladin 1987)

Lewis, E. & P., *The Land of Wales* (B.T. Batsford 1949)

Lloyd, D.M. & E.M., (editors) *A Book of Wales* (Collins 1953)

Lofmarch, C., *A History of the Red Dragon* (Gwasg Carreg Gwalch 1995)

Maud, R., *Guide to Welsh Wales* (Y Lolfa 1995)

McElroy, J., *Jefferson Davis* (Smithmark USA 1995 reprint)

Morgan, G., *The Dragon's Tongue* (Triskel Press 1966)

Owen, T.M., *A Pocket Guide to the Customs and Traditions of Wales* (University of Wales Press 1995)

Palmer, W.T., *Odd Corners in North Wales* (Skeffington 1948)

Parry-Jones, D., (editor) *Taff's Acre - a History and Celebration of Cardiff Arms Park* (Willow 1984)

Pennant, T., abridged by David Kirk *A Tour in Wales* (Gwasg Carreg Gwalch 1998)

Pugh, T.B., (editor) *Glamorgan County History Volume III The Middle Ages* (University of Wales Press 1971)

Redknap, M., *The Christian Celts: Treasures of late Celtic Wales* (National Museum of Wales 1991)

Rees, D., *The Son of Prophecy: Henry Tudor's Road to Bosworth* (Black Raven 1985)

Rees, R., *Heroic Science - Swansea and the Royal Institution of South Wales 1835-1865* (Glyndŵr Publishing 2005)

Richards, A., *A Touch of Glory - 100 Years of Welsh Rugby* (Michael Joseph 1980)

Roderick, A., *The Dragon Entertains - 100 Welsh Stars* (Glyndŵr Publishing 2001)

Sager, P., (translated by David Henry Wilson) *Pallas Guide: Wales* (Pallas Athene 1991)

Stephenson, D., *The Last Prince of Wales* (Barracuda 1983 hardback)

Squire, C., *Mythology of the Celtic People* (Bracken Books reprint 1997)

Stephens, M., (editor) *A Book of Wales - an Anthology* (J. M. Dent & Sons 1987)

The Ordnance Survey Guide to Castles in Britain (1987)

Thomas, D., *The Collected Poems* (New Directions USA 1957 hardback)

Thomas, R.S., *Selected Poems 1946-1968* (Hart-Davis, MacGibbon 1973)

Tuchman, B.W., *A Distant Mirror: the Calamitous Fourteenth Century* (Penguin 1978)

Unknown Britannia after the Romans, being an attempt to illustrate its Religious and Political Revolutions - Only 250 copies were printed, at a price of 20 shillings in 1836.

Valentine, M., *Arthur Machen* (Seren 1995)

Welsh Arts Council *Architecture in Wales 1780-1914.*

Williams, A.E., *A Welsh Folk Dancing Handbook* (The Welsh Folk Dance Society)

Williams, D.L., *John Frost: A Study in Chartism* (Augustus M. Kelley, New York 1969)

Williams, G., *Presenting Welsh Poetry* (Faber 1959)

Williams, G.A., *Welsh Wizard and British Empire: Dr John Dee and a Welsh Identity* (University College Cardiff Press 1980 pamphlet)

Williams, H., *Davies the Ocean: Railway King and Coal Tycoon* (University of Wales Press 1990)

Williams, H., *Welsh Clog/Step Dancing* (bought in the Museum of Welsh Life - no publisher indicated)

Williams, Dr P.N., *From Wales to Pennsylvania - the David Thomas Story* (Glyndŵr Publishing 2002)

Williamson, J.A., *The Tudor Age* (Longmans 1964)

Zaczek, I. *Chronicle of the Celts* (Collins and Brown 1996)

List of Illustrations

All illustrations below are from the authors' collection unless otherwise stated.

1. Tinkinswood Burial Cairn.
2. St Lythan's Neolithic chambered tomb.
3. Remains of Segontium Roman Fort, Caernarfon.
4. Castell Carreg Cennen.
5. Dolbadarn Castle.
6. Gateway to Caernarfon's Town Walls.
7. Hay Castle.
8. Ancient stepping stones over the Ogŵr River. © Vale of Glamorgan Council.
9. Tretower Castle.
10. Grosmont Castle.
11. The Marcher Castle of Goodrich.
12. Whittington Castle in Shropshire.
13. St Donat's Castle. © Lise Hull.
14. Tintern Abbey.
15. Valle Crucis Abbey.
16. Talley (Tal-y-Llychau) Abbey.
17. View from Pilleth Churchyard.
18. St Beuno's Church.
19. St Cewydd's church at Aberedw.
20. St Gwynno's Churchyard at Llanwynno.
21. Medieval Dovecote inside twelfth-century monastic grange at Monknash.
22. St Ilan's Church.
23. Medieval wooden partition wall at Cefn Caer.
24. Tretower Court courtyard.
25. The hall at Tretower Court.
26. Llanelltyd Bridge over the Mawddach.
27. View of the River Dee.
28. Aberglasney House.
29. The Old Market Hall in Llanidloes.
30. Chirk Castle Gates.
31. The Llangollen Chain Bridge.
32. Llangollen Branch of the Shropshire Union Canal.
33. Restored quarrymen's cottages, quarry-master's house and chapel at Nant Gwrtheyrn.
34. Disused Tŷ Uchaf farm in Nant Gwrtheyrn.
35. Old shop front at Pennal.
36. Artificial labyrinth of underground grottoes, Dewstow.
37. Portmeirion Village.
38. Stainless steel sculpture of Llywelyn ap Gruffudd Fychan.

Also available from Amberley Publishing

Finally lays to rest the mystery of who Jack the Ripper was

'Totally fascinating' SIMON SEBAG MONTEFIORE
'A triumph of research' ANDREW ROBERTS
'Exposes the hidden hand behind the Jack the Ripper myth' KELVIN MACKENZIE

The most famous serial killer in history. A sadistic stalker of seedy Victorian backstreets. A master criminal. The man who got away with murder – over and over again. But while literally hundreds of books have been published, trying to pin Jack's crimes on an endless list of suspects, no-one has considered the much more likely explanation for Jack's getting away with it... He never existed.

£18.99 Hardback
53 illustrations and 47 figures
256 pages
978-1-84868-327-3

Available from all good bookshops or to order direct
Please call **01285-760-030**
www.amberley-books.com

Also available from Amberley Publishing

RICHARD REX

The Tudors

'A delight' THES

'The best introduction to England's most important dynasty' DAVID STARKEY

An intimate history of England's most infamous royal family

'The best introduction to England's most important dynasty' DAVID STARKEY
'A lively overview... Rex is a wry commentator on the game on monarchy' THE GUARDIAN
'Gripping and told with enviable narrative skill. This is a model of popular history... a delight' THES
'Vivid, entertaining and carrying its learning lightly' EAMON DUFFY

The Tudor Age began in August 1485 when Henry Tudor landed with 2000 men at Milford Haven intent on snatching the English throne from Richard III. For more than a hundred years England was to be dominated by the personalities of the five Tudor monarchs, ranging from the brilliance and brutality of Henry VIII to the shrewdness and vanity of the virgin queen, Elizabeth I.

£20.00 Hardback
100 colour illustrations
320 pages
978-1-84868-049-4

Available from all good bookshops or to order direct
please call **01285-760-030**
www.amberley-books.com